Images and Ideologies

HELLENISTIC CULTURE AND SOCIETY
General Editors: Anthony W. Bulloch, Erich S. Gruen, A. A. Long,
and Andrew F. Stewart

Images and Ideologies

Self-definition in the Hellenistic World

Anthony Bulloch, Erich S. Gruen,
A. A. Long, and Andrew Stewart

UNIVERSITY OF CALIFORNIA PRESS
Berkeley Los Angeles London

The publisher gratefully acknowledges the contribution provided by the General
Endowment Fund of the Associates of the University of California Press.

University of California Press
Berkeley and Los Angeles, California

University of California Press, Ltd.
London, England

© 1993 by
The Regents of the University of California

Library of Congress Cataloging-in-Publication Data

Images and ideologies : self-definition in the Hellenistic world /
Anthony Bulloch et al.
 p. cm. — (Hellenistic culture and society) ; 12)
 Papers presented at a conference held Apr. 7–9, 1988 at the
University of California at Berkeley.
 Includes bibliographical references and index.
 ISBN 0-520-07526-9 (alk. paper)
 1. Hellenism—Congresses. 2. Mediterranean Region—Civilization—
Congresses. 3. Greece—Civilization—To 146 B.C.—Congresses.
4. Self-perception—Congresses. I. Bulloch, A. W. II. Series.
DF77.I43 1993
938—dc20 92-10371
 CIP

Printed in the United States of America

9 8 7 6 5 4 3 2 1

CONTENTS

PREFACE

The papers in this volume were all delivered in an earlier form at a conference held at the University of California at Berkeley from April 7 to April 9, 1988. The title of the conference was "Images and Ideologies: Self-definition in the Hellenistic World," and it was sponsored by the Departments of Art History, Classics, and History, and by the Graduate Group in Ancient History and Mediterranean Archaeology.

Our purpose in holding the conference was to provide a context for a dialogue between specialists in the different fields of Hellenistic study, and thereby, we hoped, to open up new perspectives in Hellenistic research. Most of those who attended the conference seemed to agree that we had made a successful beginning, and the lectures and the informal discussions that were to be heard outside the conference hall went far beyond the organizers' modest hopes. Consequently we now offer the formal lectures from the conference in revised, and in many cases expanded, form to a wider public, again in the hope that we may stimulate discussion of some of the key issues across the particular fields of history, literature, philosophy, art, and religion. We are under no illusion that in one meeting, or one volume, we could attempt a new synthesis of Hellenistic culture, but we do hope to have taken some steps in that direction. We decided to choose a theme which would focus on an aspect of Hellenistic culture that cuts across all disciplinary boundaries and is cardinal to them all, and we have sought to capture the individuality, the national and personal identity, the cultural exchange and self-consciousness that have long been sensed as peculiarly potent in the Hellenistic world.

The conference was divided into five panels, to cover the fields of history, literature, art, philosophy, and religion, each with two speakers

and a respondent, and we have decided to keep the same format for this volume. We hope that thereby some of the direction and focus achieved by the conference itself will be conveyed to the reader.

A project of this kind could not proceed without the benevolent support and assistance of many individuals and institutions. In addition to the academic departments of the University of California at Berkeley mentioned above, we wish to express our profound gratitude to the College of Letters and Sciences at Berkeley, the Skaggs Foundation, and the Heller Fund of the Berkeley Classics Department for their very generous financial contributions. We have also been particularly fortunate to enjoy the help of Lisa Zemelman, of the Graduate Group in Ancient History and Mediterranean Archaeology, who was unstintingly generous in her work as conference coordinator; Rainer Mack, of the Department of History of Art, who labored long hours getting the text of the papers into publishable shape; and Mary Lamprech of the University of California Press, who was, as ever, endlessly patient and helpful. To them, and to the many others who have helped us prepare both the conference and the volume arising from it, we express our profound thanks.

Anthony Bulloch
Erich Gruen
Anthony Long
Andrew Stewart

The Social and Religious Aspects of Hellenistic Kingship

Introduction

Erich Gruen

Monarchy held no attraction for most Greeks of the classical age. It was an institution characteristically associated with Asia and with barbarism. Aeschylus' *Persae* represented the classic contrast between Hellenic liberty and Persian despotism. Sparta might have her kings, but they were hedged about by a host of competing institutions that defined them more as magistrates than as monarchs. Most other Greek states scorned and rejected the concept. And even the Spartan Demaratus, as portrayed by Herodotus, advised the Persian king that his fellow citizens were free men obedient only to law, not subjects of an autocrat.

The conquests of Alexander, however, burst the confines of that limited world. The expansion of Hellas opened vast realms that had not been envisioned by the polis and could not be governed by its institutions. Monarchy emerged as indispensable, no longer an alien principle but a Macedonian instrument. Alexander brought it from the homeland and sought to blend it with the traditions of the East. His successors, hesitant at first for reasons of politics and diplomacy, eventually embraced it, adopting the title as well as the prerogatives of king. They did not construe their domains in geographical terms. The diadochoi represented themselves as heirs of Alexander, claimants to the throne of a limitless empire—however restricted their holdings may have been in fact. Neither image nor ideology corresponded to reality. But they exercised compelling force in themselves.

Justification for monarchy did not await the Hellenistic age. Plato propounded its virtues and even endeavored to inculcate them in Sicily. Xenophon and Isocrates produced treatises in praise of kings. Aristotle speculated about the advantages of the good ruler, and Theophrastus composed a volume on kingship. Pamphlets then proliferated in the

3

post-Alexander world, a veritable industry of "mirror for princes" pub-
lications. The monarch's hold on power received legitimation not merely
by right of conquest or hereditary succession but through generosity,
protection, administration of justice, and maintenance of stability. Such,
at least, were the formulations of intellectuals. How far the kings paid
attention and how far such standards of virtue were assumed and ex-
pected by the bulk of their subjects remain doubtful. None will doubt,
however, that the Antigonids, Ptolemies, Seleucids, and Attalids recog-
nized the value of projecting a posture and promoting allegiance.

The subject of Hellenistic kingship inaugurated our conference—and
properly so. The institution marked out this era as distinct from its pre-
decessors, constituted its principal organizational feature, and exempli-
fied the tensions generated by grafting the new world onto the old. Con-
tributions to the conference wisely ignored the speculations of ancient
political theorists on the ideals and abstract principles of monarchy.
They directed attention instead to the interrelationships of kings and
subjects and the mutual manipulation of images and ideology.

Two basic problems confronted Greek kings: the fact that they were
Greek and the fact that they were kings. The first presented a challenge
to their control of non-Hellenic peoples, the second complicated their
relations with Hellenic traditions. These ambiguous and entangled mat-
ters go to the heart of Hellenistic history, the association of East and
West and the combination of old and new. The papers of Professors
Bringmann, Koenen, and Walbank bring important and illuminating
perspectives on precisely those issues.

Proud traditions of liberty and autonomy permeated the self-defini-
tion of the Greek polis. Those traditions not only remained vital in the
communities of mainland Greece and the old cities of Asia Minor, they
also formed a fundamental ingredient in the new foundations estab-
lished by the kings in Asia. The monarchs exhibited sensitivity to the
conventions; they regularly pronounced adherence to the autonomy of
individual poleis, according privileges like inviolability (ἀσυλία), free-
dom from taxation (ἀτέλεια), exemption from garrisoning, or the right
to self-government. The award of such prerogatives has generally been
interpreted either as a sincere guarantee of constitutional powers or
(more commonly) as a sham and meaningless facade screening the real
authority of the king and the dependence of the polis. Neither approach
recognizes the true meaning of the institution. Professor Bringmann
does not deal with sloganeering or empty gestures. His paper explores
concrete benefactions bestowed by rulers upon cities within their sphere
of influence: endowments, donations, and subventions. And, more im-
portantly, he poses the pointed question of what advantage the kings
themselves derived from these gifts. The advertisement of generosity

counted for a lot in the Hellenistic world: a display of magnanimity sig-
naled wealth and control of resources, encouraged political backing, and
demonstrated international standing. As for the cities, tangible benefits
do not account entirely for their motivation. Benefactors depended in
turn on beneficiaries, and a relationship of mutual respect, whatever the
realities of power, held high significance both for the self-image of the
cities and for the reputation of the king.

No less delicate were the relations developed between the Hellenic
monarchs and the native populations of Asia. The Greeks had not
come to Hellenize the barbarian nor to assimilate the races. A Greco-
Macedonian ruling class installed itself in the new capitals of the East,
occupying positions of authority in the court, the army, and the bureau-
cracy. Greek was the language of government and of law, and the means
of communication in the world of business. Natives had little access to
status or prestige. The king's power rested on a Hellenic elite. Such is
the general consensus—and fundamentally accurate. Yet it does not tell
the whole story. The ruler needed assent and collaboration from the
ruled. Indigenous traditions could be acknowledged and incorporated
in the new system, thereby allowing a broader sense of community. The
Egyptian evidence supplies our fullest testimony, deftly exploited by
Professor Koenen. The king provided a focal point for two cultures in
that land. Imagery as conveyed by the coinage combined Greek symbol-
ism with Egyptian tradition. Religion supplied a means whereby Hel-
lenes and natives could express allegiance, each in their own ways,
through familiar institutions. The Ptolemies claimed descent from Dio-
nysus and Heracles, with Zeus as ultimate progenitor, a concept com-
fortable for Egyptians who reckoned their ruler as son of Amon-Re.
Queens as well as kings served the purpose. Brother-sister marriages
derived from Egyptian conventions but could claim Hellenic precedent
as allusions to Zeus and Hera. Even "Soter" and "Euergetes," the quin-
tessentially Greek cult names, had native equivalents and spoke to Egyp-
tian sensibilities. And the court poet Callimachus, while directing his
verses to the Greek population of Alexandria, may also reflect Egyptian
royal ideology. Ptolemaic rule expropriated rather than repressed native
observances. The symbolism of ritual and the finding of a place for the
Egyptian elite, notably in the priesthood, helped to solidify that rule.

The comments of Professor Walbank on both papers add valuable
dimensions. He proposes a further agenda for the study of relations
between monarchs and cities, benefactors and beneficiaries; that is, to
extend the investigation both to the ideological roots before the Helle-
nistic age and to subsequent developments at the hands of the Romans.
Such an inquiry will likely turn up some striking continuities. Equally
fruitful is Walbank's suggestion of investigating the patronage associa-

tion between Hellenic rulers and non-Greek citizens and communities. Stimulus provided by the papers leads him to point out a path of future research. The intertwining of royal authority with polis traditions on the one hand and native expectations on the other represents a central characteristic of the age. It needs to be taken seriously not as mere exercise of power or manipulation of attitudes, but as an effort to reconcile diverse traditions and an appeal to the sensibilities of diverse peoples.

The King as Benefactor: Some Remarks on Ideal Kingship in the Age of Hellenism

Klaus Bringmann

Benefactions are the origin of monarchy, and, as Aristotle put it, it was on the benefactors of cities and nations that the honor of kingship was bestowed.[1] Once upon a time, men managed to survive under the leadership of the strongest and, aided by the best among them, they overcame social and moral disorder. Under the rule of kings, men were organized in a commonwealth based on justice. Thus, men owed to monarchy not only their survival, but good order in their lives. It was kingship which represented the principle of just rule, insofar as the aim of rule according to justice is to the benefit of the ruled. Therefore, people were willing to accept the leadership of their benefactors.[2]

This was the political theory derived from speculation on the origin of social and political order. However, this theory reveals the underlying standards of behavior to which a king had to adhere in Hellenistic times. For instance, when rebuking King Philip V for violence, the historian Polybius said: "It would have been the part of a king to do good to all and thus rule and preside over a willing people, earning their love by his beneficence and humanity."[3]

1. Aristotle *Politics* 1286b10–12; 1310b10ff. For the Hellenistic concept of ideal monarchy, cf. now the excellent survey by F. W. Walbank in *CAH*[2] 7.1:75ff. with full reference to the source material and modern literature; for the inscriptions, papyri, and royal portraits, the contributions of W. Schubart are still indispensable: "Das hellenistische Königsideal nach Inschriften und Papyri," *APF* 12 (1937): 1–26; idem, "Das Königsbild des Hellenismus," *Die Antike* 13 (1937): 272–288.

2. Cf. Polybius 6.6.4ff., with Walbank's commentary; Arist. *Pol.* 1285b3ff. (on Homeric kingship) and *Nicomachean Ethics* 1160b3ff.

3. Polyb. 5.11.6 (for the English translations of quotations from Greek literature I am indebted to the editions of the Loeb Classical Library). On Polybius' concept of ideal monarchy, cf. K.-W. Welwei, *Könige und Königtum im Urteil des Polybios* (Herbede, 1963), 123ff.

But what kind of benefactions did Greek cities expect from Hellenistic kings? Greeks no longer lived in that remote age when the foundations of human civilization and political government were established. Without Homer even the memory of heroic kingdoms would have faded away. And above all, Hellenistic monarchy had its roots not in Greece, but in Macedonia and Asia. Greeks lived in city-states and enjoyed self-government. There was no scope for monarchic rule at all. But once monarchy came, the Greeks had to deal with the new situation. Isocrates reminded King Philip II that Greeks were not accustomed to enduring monarchy, while other peoples were unable to live except under the rule of kings.[4] Accordingly, to subjugate barbarian nations to the blessings of monarchy was to benefit them, but to subjugate Greeks would have just the opposite result—the destruction of the political way of life they enjoyed.

Hellenistic kings had to learn to distinguish between their barbarian subjects and their Greek allies. Barbarians were suited for benevolent despotism, the kings were told, while Greeks were willing to acknowledge the superiority of a benefactor only if they were able and willing to protect and support autonomy and self-government. To be sure, beneficence was the underlying principle on which monarchy should be based. But since the general principle had to be applied to different peoples, Hellenistic kings had to take into account their different ways of life. Thus, Aristotle advised King Alexander in an open letter:

> Deal with the Greeks as a leader, with the barbarians as a master, taking care for the former as friends and kinsmen, while treating the latter as animals or plants.[5]

Presumably, Aristotle's recommendation and the similar one of Isocrates were given with regard to colonization.[6] For colonization might relieve Greece of the burden of impoverished exiles. Under the leadership of the Macedonian king, they could settle in new cities and return to the blessings of landed property and self-government. In founding new cities, Hellenistic kings did benefit Greeks in just the same way as, according to theory, kings had done ages and ages ago, when establishing social and political order for the first time.

4. Isocrates *Philippus* 107, on Heracles, ancestor of the Macedonian royal dynasty: ἠπίστατο γὰρ τοὺς μὲν Ἕλληνας οὐκ εἰθισμένους ὑπομένειν τὰς μοναρχίας, τοὺς δ' ἄλλους οὐ δυναμένους ἄνευ τῆς τοιαύτης δυναστείας διοικεῖν τὸν βίον τὸν σφέτερον αὐτῶν.
5. Aristotle F 658 Rose.
6. According to the ancient tradition, the title of Aristotle's open letter to Alexander was "On Colonization." Aristotle's basic idea was shared by Isocrates, *Philippus* 154; cf. E. Buchner, "Zwei Gutachten für die Behandlung der Barbaren," *Hermes* 82 (1954): 378–384. Of course, that plan for colonization relates to the so-called panhellenic program, cf. Bringmann, *Studien zu den politischen Ideen des Isokrates* (Göttingen, 1965), 22, 101ff.

But the founding of new cities was by no means the only benefaction Greeks expected of a Hellenistic king. Whatever he did to support, to protect, and to improve the Greek commonwealth of self-governing cities was appreciated as benefaction (εὐεργεσία). This included, for example, the protection of Greeks from barbarian raids, the preservation or restoration of peace, freedom, and democracy (whatever might be meant by those terms), support in cash and kind, the building of temples, theaters, and gymnasia, the granting of land, and a wide range of privileges such as ἀτέλεια and ἀσυλία.

Both kings and cities vied in pretending that their mutual relations were based on an interchange of benefactions and goodwill (the actual state of their relations notwithstanding). For instance, when King Antiochus III won control of Iasos in Asia Minor, the citizens honored him for the benefactions which he and his ancestors had bestowed on the Greeks in general, and on the city of Iasos in particular. I quote from their resolution:

> The great King Antiochus observes the attitude of his ancestors towards all Greeks, takes care for peace, supports many who tumbled, separately and in common, has set others at liberty instead of slavery, is convinced in general that kingship is established in order to bestow benefactions on mankind, has already previously relieved our city from slavery and has given liberty to her.[7]

And when King Eumenes II accepted the honors that the Ionian League decreed for him, he recapitulated in his letter the several reasons they gave for honoring him:

> Eirenias and Archelaus met me at Delos and handed over a fine and generous decree, in which you began stating that I had chosen from the start the finest deeds and showed myself the common benefactor of the Greeks, that I had faced many great battles against the barbarians, displaying all zeal and care to make sure that the inhabitants of the Greek cities should always live in peace and enjoy the best state of affairs, receiving glory for the attendant danger and hardship, and choosing to stand firm in what concerned the League, in conformity with the policy of my father, and that I had demonstrated on many occasions my attitude in these matters, both in public and in private, being well disposed to each of the cities and helping each of them achieve many of the things that relate to distinction and glory, which through my actions demonstrated my love of glory and the gratitude of the League.[8]

7. Lines 41–48 of the inscription published by G. Pugliese Carratelli, *ASAA* 45/46 (1967/1968): 445ff., no. 2; *ASAA* 47/48 (1969/1970): 40off. For the revised text, cf. Y. Garlan, *ZPE* 9 (1972): 224; *ZPE* 13 (1974): 197f. For interpretation, see F. Sokolowski, "Divine Honors for Antiochos and his Wife Laodike," *GRBS* 13 (1972): 171–176.

8. W. Dittenberger, *OGIS*, no. 763.3–22. For the English translation of inscriptions I

There is no need to stress the point further by quoting more testi-
mony.[9] Instead, I would like to ask some questions. Undoubtedly, the
notion of king as benefactor was an ideal accepted all over the Hellenistic
world; but what about the impact of this ideal on reality? Was there any
impact on economic, social, and political life? What did kings expect
from the cities in exchange for the benefactions they supplied? Were the
relations between kings and cities actually based on beneficence and
gratitude, as documents and literature claim? And what obstacles im-
peded the working of mutual goodwill created by the benefactions? Fi-
nally, we may ask whether the Greeks themselves raised any objections,
on the basis of moral standards or political interest, to the temptation of
accepting gifts.

It goes without saying that there are no complete or simple answers.
These issues can be treated only with reference to a restricted body of
evidence. Thus, I shall not deal with the foundation and liberation of
cities, or with the grant of privileges like ἀτέλεια and ἀσυλία.

I shall consider mainly, but not exclusively, donations in cash and in
kind, or, as Cicero put it in *De officiis,* with beneficence through finan-
cial support.[10] My principal reason is pragmatic: Together with Walter
Ameling I have collected the available evidence on donations and foun-
dations bestowed on Greek cities and sanctuaries by Hellenistic kings
and dynasts, and I am preparing an edition with commentary on that
topic.[11]

The collection of testimonia contains approximately 460 items, in-
cluding seventeen apocrypha (mostly from the Alexander tradition) and
about 140 dubious cases. For instance, when, without any written evi-
dence, modern archaeologists ascribe about thirty-five buildings to the
generosity of Hellenistic kings, the arguments they put forward in sup-
port of such hypothetical ascriptions range from the highly probable to
unconvincing guesswork. Since there is no certainty, it may be prudent
to include all hypothetical ascriptions among the dubious cases.

Two hundred and twenty-one epigraphical testimonia and 147 items
of literary evidence survive. Some donations are attested by two or more
texts, but in only five instances is there an overlap between literary and

am indebted to M. M. Austin, *The Hellenistic World from Alexander to the Roman Conquest*
(Cambridge, 1981), 331f.

9. On the exchange of royal benefactions and public honors bestowed by Greek cities,
cf. now P. Gauthier, *Les cités grecques et leurs bienfaiteurs* (Paris, 1985), 39ff.

10. Cicero *De officiis* 2.52: *nam aut opera benigne fit indigentibus aut pecunia.*

11. The project was made possible by Deutsche Forschungsgemeinschaft. The forth-
coming edition will also include an archaeological commentary prepared under the super-
vision of Professor Hans von Steuben of Frankfurt University.

epigraphical evidence. That may indicate the very fragmentary nature of the source material at hand; also, obviously, our knowledge is limited to a small fraction of the donations that Hellenistic kings actually bestowed on Greek cities and sanctuaries. For instance, when King Mithridates V died, the Roman Senate passed a decree ruling that the king's donations should all be validated.[12] This rule dealt with the Roman province of Asia, and we must suppose that there were numerous donations. But we have only one inscription from which to deduce that King Mithridates conferred a gift on a gymnasium, and this inscription is found not in the province of Asia but on the island of Delos.[13]

Notwithstanding the fragmentary state of the source material, some general conclusions may be drawn from the available evidence. From about 150 BC there must have been a great decline in royal generosity. From the end of the Attalid dynasty down to 30 BC only fifteen pieces of testimony exist, and except for the reconstruction of the Odeion at Athens,[14] these deal with rather small donations.[15] Polybius seems to be quite right in referring to the μικροδοσία that the kings of his time displayed.[16] After 133 BC the number of beneficiaries declines from eighty-five to four: Athens, Delos, Delphi, and Miletus/Didyma. Kings and dynasts had no political motive for bestowing small gifts on the center of Greek culture and on the famous sanctuaries of Delos and Didyma, with the exception of two cases. Characteristically, these two cases occurred during the Second Mithridatic War and on the eve of the Battle of Actium.[17] Why did such a dramatic decline in royal generosity take place? Obviously, with Rome on the scene, everything changed.

Two inscriptions give special evidence of the strain on royal financial power between 160 and 140 BC. An Athenian decree honoring King Pharnaces I and Queen Nysa of Pontus[18] alludes to the king's embarrassment: the king is honored for his willingness to keep the promises previously made to Athens, although unable to do so in the case of other cities. However, even the Athenians must be content with installment

12. The text was published by T. Drew-Bear, *Nouvelles inscriptions de Phrygie* (Zutphen, 1978), nos. 1, 2. Supposedly, the king's donations to private persons were included in the Senate's decree.

13. Dittenberger, *OGIS,* no. 366. According to L. Robert, *JS* (1978): 154ff., the text is indirect evidence for a royal donation to the gymnasium of Delos.

14. Dittenberger, *OGIS,* no. 354.

15. The donors are members of the Ptolemaic dynasty, the kings of Bithynia, Cappadocia, Pontus, and a Galatian tetrarch, Brogitarus.

16. Polyb. 5.90.5ff.

17. Posidonius *FGrH* 87 F 36 = F 253 Edelstein-Kidd; Plutarch *Antonius* 57.2f. Neither Mithridates VI nor Cleopatra VII were able to keep their promises.

18. Dittenberger, *OGIS,* no. 771b15ff.

payments. And in Priene, the citizens honored their rich fellow citizen
Moschion for defraying building expenses in the place of some kings
unable to keep their promises.[19]

The lion's share of the evidence deals with dedications to gods and
sanctuaries. At least 270 items relate to cult and religion, including the
gifts to gymnasia. This might seem striking, but in reality it is not sur-
prising. Cult and religion were a part of public life, a very large part.
There was no such thing as the modern separation of church and state,
and the city had to raise funds for the building and maintenance of
temples and gymnasia, for sacrifices, and for the celebration of festivals
and games.

Daily life was influenced much less by the pressures of war, famine,
or earthquakes than by the recurrence of sacrifices, processions, festi-
vals, games, or the gymnastic exercises of the ephebes. It is no wonder
that Greeks displayed much of what may be called their public way of
life in the areas of cult and religion. On the other hand, Hellenistic kings
were also closely attached to the Greek gods, claiming divine lineage—or
at least divine protection.[20] Thus, inevitably, a good deal of royal gener-
osity involved honoring the gods.[21] For instance, the Seleucids claimed
that the dynasty was descended from Apollo of Didyma,[22] and they pro-
vided large endowments for the god's sanctuary there.

To be sure, royal generosity toward the gods closely related to benefi-
cence toward Greek cities. King Antiochus IV was praised by Polybius

19. *I. Priene*, no. 108, 111ff.; as for the kings possibly referred to—Orophernes, De-
metrius I and II, Ptolemy IV—see C. Habicht, *Chiron* 13 (1983): 32 n. 25.

20. On the relations between Hellenistic monarchy and religion, cf. now Walbank,
CAH[2] 7.1:84ff.; idem, "Könige als Götter: Überlegungen zum Herrscherkult von Alex-
ander bis Augustus," *Chiron* 17 (1987): 365ff.

21. It is impossible to deal here with the archaic roots of dedications to the gods, e.g.,
the close relationship between gifts and sacrifices (cf. W. Burkert, "Offerings in Perspec-
tive: Surrender, Distribution, Exchange," in *Gifts to the Gods: Proceedings of the Uppsala Sym-
posium, 1985*, ed. T. Linders and G. Nordquist, Boreas 15 [Stockholm, 1987]: 43ff.) or the
warrior's (and hunter's) custom of giving a share of his booty to the gods (cf. K. Meuli,
Gesammelte Schriften [Basel, 1975] 2:705ff., 720ff.; W. Burkert, "Krieg, Sieg und die olym-
pische Götter der Griechen," in *Religion zu Krieg und Frieden*, ed. F. Stolz [Zurich, 1986],
70ff.; and W. K. Pritchett, *The Greek State at War* [Berkeley, 1973, 1979] 1:93ff., 2:294ff.).
On the other hand, dedications of Hellenistic kings were meant to demonstrate the image
of the victorious king to the Greek world: on that concept, cf. H.-J. Gehrke, "Der siegreiche
König: Überlegungen zur hellenistischen Monarchie," *AKG* 64 (1982): 248ff. Thus, it is
not surprising that monuments dedicated to the gods of much-frequented sanctuaries con-
veyed political claims and messages to the public. Unfortunately, comprehensive mono-
graphs on that topic are still needed, but for the Attalids, cf. now H.-J. Schalles, *Untersu-
chungen zur Kulturpolitik der pergamenischen Herrscher im 3. Jahrhundert v. C.* (Tübingen,
1985).

22. Dittenberger, *OGIS*, nos. 227, 219; cf. Diodorus 19.90.4 and Iustinus 15.4.3f.

for having behaved in a royal manner in at least two important respects—his benefactions to the cities and the honors paid to the gods.[23] The two aspects should not be separated. The king defrayed the building expenses for the Olympieion at Athens, thus honoring Zeus Olympios and, at the same time, giving Athenians important financial support. Of course, the people of Athens made the arrangements for investing and spending the money they received from the king.

Some inscriptions show how such financial transactions might work. When the Milesians received a large sum from King Eumenes II to pay the building expenses of a new gymnasium, they didn't need the money all at once, and so part of it was invested in short-term loans.[24] Antiochus, the son of King Seleucus I, built a market hall at Miletus and directed that the shops in the hall should be rented and the annual yield transferred to the building budget of the Didymaion. Accordingly, the people of Miletus passed a decree ruling that an inscription should be affixed to the market hall indicating that the building was dedicated to Apollo by Antiochus. They further ruled that all the buildings to be financed from the rents should be regarded as dedicated by the same Antiochus.[25] Thus, the dedication was a display of honor to the god, it secured the founding according to the donor's will and, at the same time, it provided short- and long-term support for the people of Miletus. Ptolemy IV transferred to Thespiae the proceeds of a foundation in Egypt dedicated to the Muses of Thespiae, and it was the people of Thespiae who passed a decree governing the purchase and lease of sacred land.[26] The annual yield was probably used to defray costs of the famous agon in honor of the Thespian Muses.

Erecting large buildings or establishing schools involved much expense. The kings might be short of cash, but they collected huge contributions in kind, especially in grain, from their subjects. Greece, on the other hand, depended to some extent on grain imports. Thus, grain became the main product on which to base devices of indirect finance.

For instance, the Rhodians received from King Eumenes II a large quantity of grain to establish a school fund to provide for teachers' salaries. That quantity of grain was worth from 280 to 460 talents (the difference is due to the known price fluctuations).[27] At an interest rate of

23. Polyb. 26.1.10 and Livy 41.20.5.

24. Cf. the inscription edited by P. Herrmann, *MDAI(I)* 15 (1965): 71ff. and *I. Didyma*, no. 488.

25. *I. Didyma*, nos. 479, 480; Milet 1.7, no. 193a: cf. W. Günther, *Das Orakel von Didyma in hellenistischer Zeit* (Tübingen, 1971), 23ff.

26. The inscription was first published by P. Jamot, *BCH* 19 (1895): 379ff.; cf. M. Holleaux, *REG* 10 (1897): 26ff.

27. Polyb. 31.31.1–3; for grain prices, cf. F. Heichelheim, *Wirtschaftliche Schwankungen*

8 percent, the invested capital might yield from 147,000 to 220,000 drachmas per annum. But it was a long way from the king's promises to the payment of salaries. About 14,000 tons of grain must be shipped and sold, the proceeds had to be loaned out, and the annual rents had to be collected. Rhodian shippers and traders thus maintained their crucial position in the Hellenistic grain trade even after the establishment of the free port at Delos in 166 BC, and they could profit from the transaction.[28] Finally, in trade cities there existed convenient opportunities to lend out money at higher interest and on shorter terms than elsewhere, where economic life was based on agriculture. For instance, Miletus received from King Eumenes II a quantity of grain worth from 160 to 270 talents.[29] This large sum was designed to cover the expense of building a new gymnasium. The money was not needed all at once and was lent out to merchants who, as we happen to know, had been encouraged to increase their trade with the Seleucid realm by receiving from King Antiochus IV the privilege of duty-free trade.[30] When their benefactor died, the city ruled that thirty talents should be detached from the next repayment of merchant loans and the sum transferred to a special account. It was used to purchase grain from the annual yield, and each citizen was entitled to receive a fixed quantity on King Eumenes' birthday.[31]

The few examples I mention show the impact which royal generosity might have on the economy of a Greek city. The kings provided funds for buildings, for the celebration of festivities, for teachers' salaries, for grain, oil, or fuel. In so doing, they made jobs and loans available and supplied grain and timber.

It is by no means surprising that both large and small cities tried to receive donations from the kings, especially in the case of emergencies caused by war, famine, or earthquake. The cities usually took the initiative, and it should be noticed that the ambassadors of Greek cities as well as the Friends of Hellenistic kings played an important role in arranging royal grants. Sometimes the negotiators were both royal Friends and citizens of the leagues and cities involved.[32] And, so far as we can see,

der Zeit von Alexander bis Augustus (Jena, 1930), 51f., 128ff.; idem, "Sitos," RE Suppl. 6 (1935): 887f. On freight rates (which are not taken into consideration above), see Heichelheim, Wirtschaftliche Schwankungen, 91ff., esp. p. 96.

28. On the importance of the Rhodian grain trade, cf. L. Casson, "The Grain Trade of the Hellenistic World," TAPhA 85 (1954): 168ff.

29. Herrmann, MDAI(I) 15 (1965): 71ff.

30. Cf. part 2, 1ff. of the above-mentioned inscription.

31. I. Didyma, no. 488.19ff.

32. The most conspicuous examples are the brothers Kallias and Phaidros of Sphettos,

only in six instances did kings offer spontaneous gifts to Greek cities. Greek interest in royal generosity does not need any explanation. But why did Hellenistic kings lavish large sums on providing Greek cities with the money and goods they needed?

In cases of common interest, of course, the answer is very simple. For example, when Athens between 286 and 279 BC received at her request large sums of money and large quantities of grain from Lysimachus, Ptolemy I and II, Spartocus, Audoleon, and Antipater Etesias, these kings thus gave support to an enemy of their enemy, the Antigonid dynasty.[33] When Rhodes was besieged by Demetrius Poliorcetes, the kings Cassander, Lysimachus, and Ptolemy I were helping their own interests by providing the city with huge quantities of grain and with mercenaries.[34] So were the Antigonids, Attalus I, and other kings by supporting Athens when the city was besieged by Cassander and, later on, by Philip V.[35] In these and many other cases, aid was granted on behalf of a political principle—that the enemy of one's enemy is one's friend. Characteristically, however, the bargain was called benefaction, and the kings involved in bargains of this kind received great honors for securing a city's freedom and autonomy.[36]

But motives are not as obvious in many other instances. For example, we may wonder why King Antiochus IV promised the cities of Tegea and Megalopolis to provide building funds for a theater and a city wall.[37] Recently, Hans Lauter declared that he was at a loss to explain this: "However, why he [Antiochus IV] includes little towns like Tegea among the beneficiaries of his gifts remains doubtful. Perhaps he simply built wherever he was allowed to do so."[38]

Presumably, Polybius came nearer the truth when he said that Antio-

the former an officer in Ptolemaic service, the latter a well known politician in Athens; cf. T. L. Shear, Jr., "Kallias of Sphettos and the Revolution of Athens in 286 BC," *Hesperia* Suppl. 17 (Princeton, 1978): 9ff.; Habicht, *Untersuchungen zur politischen Geschichte Athens im 3. Jahrhundert vor Christus* (Munich, 1979), 59ff. As for Miletus and Milesians, cf. now Herrmann, "Milesier am Seleukidenhof: Prosopographische Beiträge zur Geschichte Milets im 2. Jhdt. v. Chr.," *Chiron* 17 (1987): 171ff.

33. Dittenberger, *Sylloge*[3], no. 374; Plut. *Moralia* 851D–F; *Sylloge*[3], no. 409; Shear, "Kallias of Sphettos," 2ff.; *Sylloge*[3], nos. 370, 371.

34. Diodorus 20.84.1, 88.9, 96.1–3, 98.1, 92.2.

35. Plut. *Demetrius* 10.1; Diodorus 20.46.4; Dittenberger, *Sylloge*[3], no. 334.95ff.; Plut. *Demetr.* 17.1; *IG* 2².894; B. D. Meritt, *Hesperia* 5 (1936): 419ff. (no. 15).

36. Cf. C. Habicht, *Gottmenschentum und griechische Städte* (Munich, 1970), 44ff. passim; Gauthier, *Cités grecques*.

37. Livy 41.20.6.

38. H. Lauter, *Die Architektur des Hellenismus* (Darmstadt, 1986), 17: "Warum er unter die Empfänger seiner Gaben Städtchen wie Tegea . . . einbezog, bleibt gleichwohl zweifelhaft. Vielleicht baute er einfach dort, wo man ihn gewähren liess?"

chus displayed a king's virtue by granting support to cities and paying for honors to the gods. In his *Art of Rhetoric*, Aristotle stressed most concisely the close relationship between glory, honor, and benefaction:

> Honor is the token of a reputation for doing good. . . . The components of honor are sacrifices, memorials in verse and prose, gifts of honor, holy precincts, front seats [at festivals and games], public burial, state maintenance.[39]

Kings were so eager to be honored by Greek cities that they often defrayed their expenses. In 227 BC the Athenians, in return for the political guarantees they received from Ptolemy III, decreed that in addition to religious honors, a gymnasium should be named after the king. Subsequently, Ptolemy took over the building costs.[40] Eumenes II and Attalus II provided money for foundations which allowed the Delphians to pay the expenses of celebrating the festivals they decreed in honor of both kings.[41] When the Ionian League honored Eumenes with a gold crown, a gold statue, and a celebration day added to the league's festival of the Panionia, the king promised to pay for the statue and to provide funds for the celebration arrangements.[42]

Thus, the glory of being a city's benefactor was well documented in public life: through temples and gymnasia bearing his name, through statues, inscriptions, festivals and games, processions of citizens and ephebes, and through recurrent proclamations of the decree honoring the benefactor. Citing the decree of the Ionian League, King Eumenes wrote:

> And you passed a resolution, in order that you might always be seen to be repaying worthy honors to your benefactors, to crown me with a gold crown for valor, and to set up a golden statue in any place in Ionia I wished, and to proclaim these honors both in the competitions you celebrate and in those celebrated in each of the cities.[43]

Both in ancient literature and in epigraphical evidence, the term φιλοδοξία and related ones point out the benefactor's motivation. When characterizing Eumenes II, Polybius ascribed the king's outstanding generosity to his extreme love of glory.[44] He did this by using precisely the

39. Arist. *Rhetoric* 1361a28ff.

40. Pausanias 1.17.2 and *IG* 2².836; cf. A. N. Oikonomides, *The Two Agoras of Ancient Athens* (Chicago, 1964), 52 (no. 2) = *SEG* 21.397 and Habicht, *Studien zur Geschichte Athens in hellenestischer Zeit* (Göttingen, 1982), 112ff.

41. Dittenberger, *Sylloge*³, nos. 671, 672; cf. G. Daux, *Delphes au IIe et au Ier siècle av. J.-C.* (1937), 682ff.

42. Dittenberger, *OGIS*, no. 763.

43. Dittenberger, *OGIS*, no. 763.23ff.

44. Polyb. 32.8.5 (cf. Livy 42.5.3) with commentary of Walbank; similarly, Polyb. 7.8.6 on King Hieron II: εὐεργετικώτατος καὶ φιλοδοξότατος γενόμενος εἰς τοὺς Ἕλληνας.

language of honorary decrees. For example, the Milesians proclaimed that they honored the king because his attitude to the Greeks was marked by love of glory.[45] When the Ionian League wanted to elicit further endowments from Eumenes, they assured him that in this way and in the future, he would obtain everything that relates to honor and glory: πάντων τεύξεσθαι τῶν εἰς τιμὴν καὶ δόξαν ἀνηκόντων.[46]

No doubt honor and glory confer majesty on a king, and at the same time they are devices to exert power upon people. Using this analysis, Cicero discusses the issue of expediency in *De officiis* 2. As is well known, he follows mainly the Hellenistic philosopher Panaetius.[47] Cicero points out that in political life, men in power must not rely on terror, but must take care to obtain affection and admiration, or, to say the same thing in other terms, they must acquire glory.[48] For glory depends on the affection, confidence, and admiration of men. Further, according to Cicero, the origin of affection is beneficence.[49] Supposedly these concepts lie at the root of an ideal which relates beneficence to glory and power. Benefactor and beneficiary are linked together by moral ties. The latter is obliged to be grateful to the former because, as Cicero puts it, no duty is more imperative than that of proving one's gratitude.[50]

A man unable to return the favor in the same measure continues to owe gratitude and loyalty to his benefactor. And since the moral account is not balanced, the benefactor and the beneficiary are not on equal terms. According to Aristotle, it is that kind of inequality which marks the relationship between father and son, forefather and descendant, king and subject: "These friendships then involve a superiority of benefits on one side, which is why parents receive honor."[51]

Thus, although Greek cities bestowed secular and religious honors on kings because of benefactions they received, this did not release them from the duty to be grateful. Both sides were keeping records, so to speak, on giving and receiving. Lycortas, father of the historian Polybius and a prominent statesman, enumerated the benefits that the Achaeans

45. Milet 1.9.307.4f.: πρὸς ἅπαντας μὲν τοὺς Ἕλληνας φιλοδόξως ἀπὸ τῆς ἀρχῆς διακείμενος.

46. Dittenberger, *OGIS*, no. 763.36f.

47. Cf. Cic. *Ad Atticum* 16.11.4; *Off.* 2.60. On Panaetius' lost work and its relation to Cicero's *De officiis*, cf. M. Pohlenz, *Antikes Führertum: Cicero, De Officiis, und das Lebensideal des Panaitios*, Neue Wege zur Antike, 2d. series, vol. 3 (Leipzig and Berlin, 1934), 5f., 17f., 90ff.; M. van Straaten, *Panétius, sa vie, ses écrits et sa doctrine avec une édition des fragments* (Amsterdam, 1946), 276ff.; Bringmann, *Untersuchungen zum späten Cicero* (Göttingen, 1971), 229ff., 268ff.

48. Cic. *Off.* 2.21f., 31ff. (on glory).

49. Cic. *Off.* 2.32: *quae* [i.e., *benevolentia*] *quidem capitur beneficiis maxime.*

50. Cic. *Off.* 1.47: *nullum enim officium referenda gratia magis necessarium est.*

51. Arist. *Eth. Nic.* 1161a20f.

had received from both the Ptolemies and the Seleucids.[52] At the conference in Locris, Philip V recorded the benefactions he and his predecessors provided for the Acheans,[53] and so did Attalus I at Athens and Thebes.[54] We happen to know from an Athenian decree honoring an ambassador of King Antiochus VII that when he addressed the people of Athens he mentioned the benefits of the dynasty and the gratitude of the Athenians.[55] The people of Cyzicus kept a record of the grants of cash and kind they had received year after year from Philetaerus during the Galatian raids into Asia Minor.[56] And in the beginning of the third century BC the Thebans set up a list of the benefactors who supported the reconstruction of the city from 315/4 BC.[57]

To know which benefits were granted or received might be useful, or even necessary. We know, for example, of benefactors who laid claim to gratitude. Lycortas did so in order to recommend a grant of military support that the government in Alexandria had requested.[58] Attalus I did not fail to recall his and his forefathers' benefactions when urging Athens and the Boeotian League to join him in waging war against Philip V.[59] The moral claim on gratitude might even be forged into the sword of moral destruction. At the conference of Locris, Philip V inflicted a moral defeat on the representatives of the Achaean League.[60] He enumerated the benefactions they had received from his predecessors and from himself, recalled the honors they had bestowed on the kings in return, and read out the decree which tied them to the enemies of their benefactors. That was all. There was no need to add another word, for, as Cicero puts it, all men detest ingratitude.[61]

In this way beneficence became a device of policy establishing strong moral ties between kings and cities. No doubt both were in need of those informal ties. Considering the volatile character of their power, Helle-

52. Polyb. 29.24.11–16 with commentary by Walbank.

53. Polyb. 18.6.5 = Livy 32.34.11; for the conference at Locris, cf. F. W. Walbank, *Philip V of Macedon* (Cambridge, 1940), 159ff.

54. In 200 and 197 BC, respectively: Polyb. 16.26.1–6 = Livy 31.15.1–4 and Livy 33.2.1.

55. First published by B. D. Meritt, "Greek Inscriptions," *Hesperia* 36 (1967): 59ff., no. 6. S. B. Tracy, "*IG* II².937: Athens and the Seleucids," *GRBS* 29 (1988): 383ff., has published a revised text and attributes the inscription to the cutter of *IG* 2².937 (ca. 135–123/2 BC). Accordingly, the king referred to must be Antiochus VII Sidetes and not Antiochus IV (as Meritt believed).

56. Dittenberger, *OGIS*, no. 748.

57. Dittenberger, *Sylloge*³, no. 337.

58. Polyb. 29.24.11–16.

59. Cf. n. 54, above.

60. Cf. n. 53, above.

61. Cic. *Off.* 2.63: *omnes enim immemorem beneficii oderunt.*

nistic kings could not afford to rely exclusively on garrisons and on the enforcement of obedience. They were well aware of the fact that they depended more or less on the goodwill of Greek cities. Accordingly, they tried to live up to the standards of benevolence that the cities were expecting.

Thus, it is no longer really difficult to understand why King Antiochus IV conferred benefits on Athens as well as on small towns in the Peloponnese. Glory and gratitude were funds which might bear interest. To be sure, Tegea and Megalopolis were only small towns, but they were both members of the Achaean League, and all kings competed for the league's friendship. It is well known that after losing the war against Rome, the Seleucids took special care to be on good terms with the Achaeans.[62] After all, the goodwill of the Greeks might compensate to a certain degree for the losses the dynasty had recently suffered.

Antiochus was well aware of the fact that his ancestors had done less for the Greeks than had the Ptolemies or the Attalids. As I have pointed out, in 169 BC the Achaean statesman Lycortas demanded military support for the government at Alexandria against King Antiochus IV on the grounds that the Ptolemies had done much more for the Achaeans than had their rivals, the Seleucids.[63] King Antiochus IV was thus determined to make up for the shortcomings of the past, and his achievements in this respect impressed even his Greek critics.[64]

A benefactor was entitled to receive gratitude and loyalty, but political circumstances governed whether he succeeded in making good his claim. Conflicts between moral duty and expediency were by no means remote issues to be discussed by overly subtle people like philosophers and sophists. On the contrary, political decisions were in many instances focused on this very issue. The Achaeans had to face it in 198 BC before deciding eventually to join Attalus I and the Romans in waging war against their benefactor, King Philip V. King Ptolemy II, about 262 BC, reminded the Milesians of the privilege of ἀτέλεια and the grant of land—benefactions they had received from himself and his father, respectively—when he urged the people of Miletus to preserve their friendship and alliance, now under pressure from a military attack launched on the city presumably by Antigonus Gonatas.[65] At the king's

62. Cf., e.g., E. S. Gruen, *The Hellenistic World and the Coming of Rome* (Berkeley, 1984) 2:644ff.

63. Polyb. 29.24.11–16.

64. Cf. Livy 41.20.5; Athenaeus 5.194a = Polyb. 26.1.10, 29.24.13, and the inscription, cited in n. 55, above, which in lines 26ff. refers to the generosity of Antiochus IV toward Athens.

65. Milet 1.3, no. 139.

request, the Milesians swore an oath of allegiance. Nevertheless, they joined King Antiochus II some years later.[66] Lycortas made a great impression on the Assembly of the Achaean League when he enumerated the benefactions the league had received from the Ptolemies. However, he apparently failed to secure the grant of military support which the government at Alexandria had requested.[67] In the struggle for power and influence, Lycortas had to compete with rival claims; and the war raging between the Romans and King Perseus gave the Achaeans good cause for refusing any military support. Of course, political interest and self-preservation might be more compelling issues than the gratitude and goodwill established by former benefactions.

At any rate, no one could deny that a benefactor was entitled to gratitude. This claim might cause uneasiness, at least among the powerful, who hate to be indebted to anyone, and who receive benefactions only to return them with interest. In his *Nicomachean Ethics*, Aristotle states:

> He [the powerful person] is fond of conferring benefits, but ashamed to receive them, because the former is a mark of superiority and the latter of inferiority. He returns a service done to him with interest, since this will put the original benefactor into his debt in turn, and make him the party benefitted.[68]

Further, a man who asked for benefits without being in want completely humiliated himself. For this reason Polybius rebuked the Rhodians for having requested and received large funds to establish a school foundation.[69] According to Polybius, by so doing they lost in some way the dignity of conduct which they were previously accustomed to display. To be sure, the Rhodians had never hesitated to ask kings and dynasts for the supplies they needed. But as Polybius put it, in his digression on the support they received after the earthquake of 227/6 BC, they did so in the manner of equals or even superiors. Two of the benefactors, Hieron II and his son Gelon even bestowed honors on them, "as if," to quote Polybius, "they were still under obligation."[70] But in this case, the benefactors depended on their beneficiaries, at least to a certain degree. Kings and dynasts had to sell their grain surplus in order to get money, and so they needed the services of Rhodian shippers and grain traders.[71]

66. Cf. Dittenberger, *OGIS*, no. 226, and Appian 11.11.64.

67. Polyb. 29.25; cf. Gruen, *Hellenistic World* 2:510f., 655f.

68. Arist. *Eth. Nic.* 1124b9ff.; Cf. H. Kloft, *Liberalitas Principis* (Köln, 1970), 9 n. 23, with reference to further testimony.

69. Polyb. 31.31.1–3 with commentary by Walbank.

70. Polyb. 5.88.4ff., esp. 8.

71. For the crucial importance of the Rhodian grain trade, cf. Casson, *TAPhA* 85 (1954): 168ff.

The Rhodians might ask for aid in emergencies, but they were well aware of the fact that they were entitled to get support in return for the services they themselves had rendered. But when the Rhodians asked King Eumenes II for funds to cover the expenses of teachers' salaries, this kind of interpretation, according to Polybius, was no longer valid. They were not in want of money, we are told, and so they violated the standards of decency when they declined to assume the costs of their children's education. Polybius says:

> Such a gift might perhaps be accepted from his friends by a private person who found himself in temporary straits, in order not to allow his children to remain untaught through poverty, but the last thing that anyone in affluent circumstances would submit to would be to go a-begging among his friends for money to pay teachers. And, as a state should have more pride than a private person, more strict propriety of conduct should be observed in public transactions than in private, and especially by the Rhodians owing to the wealth of the community and their noted sense of dignity.[72]

The very dilemma beneficiaries might face was brought into the open when the Assembly of the Achaean League discussed an offer from King Eumenes II.[73] The king promised to raise funds for the Achaeans to establish a foundation, using the annual proceeds to pay the members of the league's council during its session. But such an impudent offer could not be accepted. The unsettled issue of Aegina outraged the Achaeans. The community of Aegina had been a member of the league. In the so-called First Macedonian War it was conquered by the Romans and handed over to the Aetolians. The Aetolians in turn sold the island to King Antiochus I, father of Eumenes II.[74] Thus, to accept his son's offer would mean nothing less than to harm the Achaeans' own interests and to violate their standards of decency. The very core of the issue was expounded by Apollonidas of Sicyon. I quote Polybius' record:

> For that the council should be in Eumenes' pay every year, and discuss public affairs swallowing a bait, so to speak, would evidently involve disgrace and hurt. Now it was Eumenes who was giving them money; next time it would be Prusias and after that Seleucus. "And," he said, "as the interests of democracies and kings are naturally opposed, and most debates and the most important deal with our differences with the kings, it is evident that perforce one or the other thing will happen: either the interests of the kings will take precedence over our own; or, if this is not

72. Polyb. 31.31.2f.
73. Polyb. 22.7.3, 7.8f., 8.1–13.
74. Polyb. 22.8.10; cf. R. B. McShane, *The Foreign Policy of the Attalids of Pergamon* (Urbana, Ill., 1964), 107.

so, we shall appear to everyone to be ungrateful in acting against our paymasters."[75]

The king's ambassador had endlessly reiterated Eumenes' goodwill and beneficences toward the league. But, after all, what he actually wanted was for the Achaeans to violate their own laws forbidding magistrates and private persons to accept money from kings and so give up their claim to Aegina. In fact, what the king offered was a bribe. Accordingly, Apollonidas brought into the open the king's real intention. He said

> that the sum offered by Eumenes was a gift not unworthy of the Achaeans' acceptance, but that the intention of the giver and the purpose to which it was to be applied were as disgraceful and illegal as could be.[76]

In this way, beneficence is shown in a totally unfavorable light, and it is quite understandable that Cicero, following Panaetius on the whole, is so critical of generosity shown in gifts of cash and kind. Under the noble surface of liberality lurks bribery, marked by the stigma of moral inferiority. All men might agree that glory was to be attained by benefactions, but the philosopher insisted that true glory must only be attached to morality—*virtus*. Now, if the generosity shown by gifts of money is actually cash in exchange for compliance under the guise of virtue, such an infamous transaction should be rebuffed; as Cicero puts it:

> This is, I admit, the meanest and most sordid motive of all, both for those who are swayed by it and for those who venture to resort to it. For things are in a bad way, when that which should be obtained by merit is attempted by money.[77]

Of course, Cicero recognized that statesmen had to consider their nation's interest and that, after all, the money might sometimes be most important. However, it was only out of respect for Pompey's memory that he stopped criticizing men who squander their money on building theaters, colonnades, and new temples. To be sure, that was the very kind of donation Hellenistic kings bestowed on Greek cities, and Panaetius, whom Cicero followed, made no allowance for lavish expenditure on public works.[78] But Cicero did not withdraw his reservations either. On the contrary, he started his treatise on beneficence shown by gifts of money by citing a letter (incidentally, a false one) from King Philip II to

75. Polyb. 22.8.4–8.
76. Polyb. 22.8.1f.
77. Cic. *Off.* 2.21.
78. Cic. *Off.* 2.60.

Alexander: "What mischief induced you to entertain such a hope as that those men would be loyal to you whom you had corrupted with money?"[79] And, as Cicero points out, the promises made by Hellenistic kings to win goodwill and those made by Roman demagogues were all the same.[80]

Of course, severe criticism of this kind might destroy the concept of ideal kingship on which the relationship between kings and cities was based, at least according to official documents. But neither kings nor cities were really interested in eradicating the standards allowing the kings to display, and the cities to accept, royal superiority, each for their own benefit.

At any rate, it would be unfair to reduce the relationship between generosity, glory, and honor simply to the infamous devices of bribery, as the following example will show. After the end of the Third Macedonian War, King Eumenes II went to Italy to get Roman support against the Galatians. But the Senate, disgruntled by his former attempt to negotiate peace between King Perseus and Rome, refused even to receive him.[81] So he went back without achieving anything. At Delos, he received a resolution passed by the Ionian League; the decree honored him as a benefactor of both Greeks and Ionians and assured him of the league's gratitude and goodwill.[82] In this case, the affirmation of loyalty and friendship was almost honest. By fighting against the Galatians, Eumenes had become the champion of the Greeks, and the vile treatment he suffered from the Romans won him, as Polybius tells us,[83] widespread sympathy all over the Greek world. In its resolution, the league reminded the king of his benefactions, which reflected glory and honor upon him, and Eumenes did understand. He answered:

> I accept graciously the honors voted and having never failed so far as lies in my power to secure some glory and honor both to all in common and to each of the cities, I shall try now not to depart from this purpose. May events turn out as I wish, for in this way my actions themselves will demonstrate my policy more convincingly to you. And so that in future by celebrating a day in my name at the festival of the Panionia you might make the whole festival more distinguished, I shall assign to you sufficient sources of revenue which will enable you to celebrate my memory in a

79. Cic. *Off.* 2.53.

80. Cic. *Off.* 2.21: *a quibus aliquid expectant, ut cum reges popularesve homines largitiones aliquas proponunt. . . .*

81. Polyb. 30.19.; cf. Gruen, *Hellenistic World* 2:573f.

82. King Eumenes recapitulated the league's decree in the letter with which he accepted the honors bestowed on him: Dittenberger, *OGIS*, no. 763.3ff.

83. Polyb. 31.6.6.

fitting way. As to the gold statue I shall make it myself, since I wish the favor not to cost anything to the League.[84]

Since sentiments of friendship and mutual goodwill now prevailed, it was not humiliating to accept benefactions which could not be repaid with interest. Even receiving money for paying honors must not appear humiliating. Both the king and the league did what they could. Eumenes referred to that standard, and in a friendship marked by the superiority of one of the parties, the same standard must be applied to the inferior one. Or, as Aristotle puts it:

> This principle therefore should also regulate the intercourse of friends who are unequal: the one who is benefitted in purse . . . must repay what he can, namely honor.[85]

Further, as Aristotle points out, true friendship must be evaluated by the giver's intention.[86] We may assume that in 167 BC the relations between King Eumenes and the cities of the Ionian League approximated the ideal of friendship and mutual goodwill on which official documents were focused. But it was on behalf of this very ideal that the same King Eumenes had insolently attempted to bribe the Achaean League, when his intention was rightly rebuked as disgraceful.

Thus, circumstances determined whether a king acted in accordance with the ideal of royal benevolence or abused it in order to cover his real purpose. A wide range existed between love of glory and common bribery, and it was within this range that Hellenistic kings exercised patronage on behalf of a noble—and ambiguous—ideal.

84. Dittenberger, *OGIS*, no. 41ff.

85. Arist. *Eth. Nic.* 1163b13–15.

86. Arist. *Eth. Nic.* 1163a21–23: ἐν δὲ ταῖς κατ' ἀρετὴν [i.e., φιλίαις] ἐγκλήματα μὲν οὐκ ἔστιν, μέτρῳ δ' ἔοικεν ἡ τοῦ δράσαντος προαίρεσις· τῆς ἀρετῆς γὰρ καὶ τοῦ ἤθους ἐν τῇ προαιρέσει τὸ κύριον.

The Ptolemaic King
as a Religious Figure

Ludwig Koenen

For P. O. Steiner

I. THE JANUS HEAD OF PTOLEMAIC KINGSHIP

Ptolemaic kingship has a Janus-like character, as can be seen in a pair of gold seals (see figs. 1a and b).[1] They represent the portrait of the same king, the left as Greek ruler with the diadem, the right as pharaoh with the double crown of upper and lower Egypt. Even more interesting, in the pharaonic portrait the Egyptian double crown is encircled by the Greek diadem.[2] Thus, the king is officially seen as double-faced, the one

1. I am obliged not only to the organizers of the conference for dragging me into a topic that, although I dearly love it, I did not want to pursue at this time any further, but also to a number of participants in the conference who discussed the topic of my paper in informal gatherings with me. I regret that I do not always recall who said what to me. Special thanks are due to S. M. Burstein, who insisted that the interpretation of *P. Tebt.* 703 by W. Huss (for citation see n. 41) could not be right; further to M. Ostwald and D. Shanzer, who saw an early version of this paper, and to U. Kaplony-Heckel and H.-J. Thissen, with whom I discussed the demotic evidence for the *apomoira*. I also wish to express my most sincere thanks to F. W. Walbank, who was the respondent to my paper but got it only at the last minute and from whose comments and publications I learned more than will be in evidence here. R. Hazzard sent me a detailed and penetrating appraisal and criticism of E. Grzybek's new book on the Macedonian calendar (see nn. 61, 96, and specifically 110). I discussed particular aspects of my interpretation of Kallimachos with G. Schwendner and with graduate students in my seminar on Hellenistic literature: I learned as much from them as, I hope, they learned from me; G. Schwendner brought additional literature to my attention; both he and K. Lord considerably improved the English of this paper; and their requests for clarification forced me to rethink and change crucial details. A. W. Bulloch, S. Hinds, T. Gagos, Donka Markovska, and D. J. Thompson carefully proofread versions of the manuscript, saving me from not only typographical errors. I wish I could have taken more of their suggestions and objections into account than is possible at this late hour.

2. H. Kyrieleis, *Bildnisse der Ptolemäer*, DAI, Archäologische Forschungen 2 (Berlin, 1975), pl. 46.5 and 6; H. Heinen, "Aspects et problèmes de la monarchie ptolémaïque," *Ktema* 3 (1978): 177–199, esp. 194 and pl. III; W. Peremans, "Les Lagides, les élites indigènes et la monarchie bicéphale," in *Le système palatial en Orient, en Grèce et à Rome: Actes du*

face directed toward his Macedonian and Greek subjects and the other, the pharaonic head, toward the Egyptians; but the Egyptian viewer is at the same time reminded that the Egyptian crown is now controlled by the Greek diadem (see also n. 50 [1]); furthermore the features of the

Colloque de Strasbourg, 1985, ed. E. Lévi, Travaux du Centre de Recherche sur le Proche-Orient et la Grèce antiques 9 (Leiden, 1987), 327–343, esp. 327 with a footnote quoting from a letter by H. Heinen; also idem, *Vreemdelingen en Egyptenaren in Ptolemaeïsch Egypte*, Academiae Analecta, 49.1 (Brussels, 1987).

Peremans's article is of great importance for most of this paper; but now see also W. Clarysse, "Ptolemaeïsch Egypte: Een maatschappij met twee gezichten," Handelingen XLV der Koninklijke Nederlandse Maatschappij voor Taal- en Letterkunde en Geschiedenis (1991): 21–38. For a level-headed assessment of present opinions on the question of the relationshp between Greeks and Egyptians, which has shifted from the concept of a mixed culture to that of two cultures living side by side without much interaction, see R. S. Bagnall, "Greeks and Egyptians: Ethnicity, Status, and Culture," in *Cleopatra's Egypt: Age of the Ptolemies*, Catalogue of an exhibition by the Brooklyn Museum (1988), 21–27; cf. also his paper "Egypt, the Ptolemies, and the Greek World," *Bulletin of the Egyptological Seminar* 3 (1981): 5–21; J. Bingen, "L'Égypte gréco-romaine et la problématique des interactions culturelles," in *Proceedings of the Sixteenth International Congress of Papyrology*, ed. R. S. Bagnall, G. M. Browne, A. E. Hanson, and L. Koenen (Chico, 1981), 3–18; also see below, n. 16. Seminal were the views of C. Préaux, now best accessible in her *Le monde hellénistique* (Paris, 1978), esp. 2:543–679, "La culture, critique de l'idée de civilisation mixte"; also see A. E. Samuel, *From Athens to Alexandria: Hellenism and Social Goals in Ptolemaic Egypt*, Stud. Hell. 26 (Louvain, 1983), esp. chaps. 3, "Culture and Society of the Greeks in Egypt," and 4, "The Stability of Greek Culture in Egypt," pp. 63ff.; eundem, *The Shifting Sands of History: Interpretations of Ptolemaic Egypt*, Publ. of the Ass. of Anc. Hist. 2 (Lanham, New York, and London, 1989), esp. chaps. 2, "Two Solitudes," and 4, "The Ideology of Ptolemaic Monarchy"; and N. Lewis, *Greeks in Ptolemaic Egypt: Case Studies in the Social History of the Hellenistic World* (Oxford, 1986). Although areas of osmosis between the two cultures are generally conceded, the pendulum has now swung from the one extreme (mixture) to the other (two separated cultures); see H. Heinen's and D. Delia's reviews of N. Lewis's book: *Gnomon* 62 (1990): 531–534, and *The International History Review* 10.2:309–311, respectively; and especially H. Heinen, "L'Égypte dans l'historiographie moderne du monde hellénistique," in *Egitto e storia antica dall'ellenismo all'età araba: Atti del Colloquio Internazionale, Bologna, 31 agosto–2 sett. 1987*, ed. L. Criscuolo and G. Geraci (Bologna, 1989), 105–135, esp. 108ff.

Many Egyptians will have learned Greek, since Greek was the language of the administration, and Greeks in the countryside needed to pick up some Egyptian (Bagnall, "Greeks and Egyptians," 23); W. Peremans, "Le bilinguisme sous les Lagides," in *Egypt and the Hellenistic World: Proceedings of the Intern. Colloquium, Louvain, 1982*, Stud. Hell. 27, ed. E. van 't Dack, P. van Dessel, and W. van Gucht, 253–280; idem, "Sur le bilinguisme dans l'Égypte des Lagides," in *Studia Paulo Naster oblata*, ed. J. Quaegebeur, Orientalia Lovaniensia Analecta 13 (Louvain, 1982), 2:143–154; idem, "Über die Zweisprachigkeit im ptolemäischen Aegypten," in *Studien zur Papyrologie und antiken Wirtschaftsgeschichte F. Oertel gewidmet* (Bonn, 1964), 49–60; idem, "Notes sur les traductions de textes non littéraires sous les Lagides," *CE* 60 (1985): 248–262; idem, "Les ἑρμηνεῖς dans l'Égypte gréco-romaine," in *Das römisch-byzantinische Ägypten: Akten des intern. Symposions, 1978, in Trier*, Aegyptiaca Treverensia 2 (Mainz, 1983), 11–17; also see J. Quaegebeur, "Cleopatra VII and the Cults of the Ptolemaic Queens," in *Cleopatra's Egypt*, 41–54, esp. 47; L. Koenen, "Die Adaption ägyptischer Königsideologie am Ptolemäerhof," in *Egypt and the Hellenistic World*, 143–190, esp. 145ff.

face are individualized beyond what would be acceptable for an Egyptian artist.[3]

Better known are two mosaics from Thmuis showing a bust of a woman crowned with the prow of a ship (figs. 2a and b). The first one is signed by the artist Sophilos in the upper left corner. Both mosaics date from about 200 BC, but they are copies of an earlier work. Until recently this image was identified as Alexandria; but as has now been argued, it is rather a representation of Berenike II, perhaps as Agathe Tyche.[4] The woman is dressed in Hellenistic military attire. She has large eyes as the Ptolemies usually do, thus expressing her superhuman nature. In her hand she carries a mast like a scepter. A ribbon is fastened on the mast and appears behind her head like the *tainiai* of the royal diadem. The prow of the ship is decorated with what has been described as a sea creature, a wreath of victory, a caduceus, and probably a single cornucopia. The queen's corpulence signals prosperity and ease, in contrast to the impression given by her military attire. On the whole, this is an image of might and power, especially sea power, and of victory, wealth, and abundance. Each of the symbols is Greek, and thus the image addresses the Greeks. Yet the strong symbolism is inspired by the Egyptian tradition.[5] In particular, the fancy and unparalleled crown reminds us of the great diversity of Egyptian crowns, including the large throne which Isis carried on her head.

Measures, images, and rhetoric, however, did not always target either the Greek or the Egyptian audience. On gold octadrachms of Arsinoe II, the second wife of Ptolemy II Philadelphos, which were struck after her death, the head of the queen appears with a diadem, a veil, and a scepter. The latter is similar to scepters in the Greek tradition, but

3. In Ptolemaic times Egyptian art remained idealizing and symbolic; R. S. Bianchi, "The Pharaonic Art of Ptolemaic Egypt," in *Cleopatra's Egypt,* 55–80. The fact that the Egyptian art remained faithful to its own tradition does not preclude the possibility of Greek influence; whatever foreign influences were accepted, they became totally embedded in the Egyptian tradition.

4. W. A. Daszewski, *Corpus of Mosaics from Egypt,* vol. 1, *Hellenistic and Early Roman Period,* Aegyptiaca Treverensia 3 (Mainz, 1985), pls. A and B (after pp. 9 and 40), 32f., 42a, Cat. nos. 38 and 39, pp. 142–160. Comparable ideas are expressed in Augustus' Rome when Livia appears with a mural crown and, thus, is iconographically linked to Kybele/Magna Mater (Sardonyx, after 14 AD; cf. Ceres Augusta from the theater of Leptis Magna); see P. Zanker, *The Power of Images in the Age of Augustus,* Jerome Lectures 16 (Ann Arbor, 1990), 234–236 with figs. 184 and 185 (*Augustus und die Macht der Bilder* [Munich, 1987], 236ff. and Abb. 185f.).

5. The representation of the corpulence of rulers first occurs in Greek art with the Ptolemies; the symbolism of this motif is traditional in Egyptian art. While there is nothing un-Greek in the way the corpulence is represented, the motif and its symbolism are Egyptian. For the representation of the corpulence of Ptolemaic rulers see Kyrieleis, *Bildnisse,* 163f.; for the Egyptian tradition see Bianchi, "Pharaonic Art," 68f.

on closer inspection it becomes clear that the top is formed as lotus leaves and something which by parallels has been explained as a uraeus carrying the sun. Arsinoe III, the wife of Ptolemy IV, carries a similar scepter on a gold octadrachm (fig. 3a); on another gold octadrachm of this queen, the tail of the snake encircles the shaft of the scepter (fig. 3b).[6] A description of the scepter is given in the well-known inscription from Kanopos, where in the year 238 BC the priests gathered for a synod. When princess Berenike had prematurely died during the time of the synod, the priests voted to create a cult for her. A priest was to carry her statue in processions holding her in his arms like a child, and the statue was to have a scepter, which emerged from behind the snake-shaped crown and was like the scepter of goddesses: in particular, it depicted the stem of a papyrus plant encircled by a snake.[7] Her festival was to be similar to the festival of the daughter of the sun-god Re.[8] The goddess protected her father.[9] Thus, in her Egyptian cult the young princess became the protector of her father, the king. It follows that on her Greek coin Arsinoe II was shown precisely in this function: even after

6. W. Cheshire, "Zur Deutung eines Szepters der Arsinoe II. Philadelphos," *ZPE* 48 (1982): 105–111 with pls. IV and V; Kyrieleis, *Bildnisse*, pl. 70.1 and 2 and 88.1–3.

7. *Can.* (*OGIS* 1.56; *SEG* 8.462; W. Spiegelberg, *Der demotische Text der Priesterdekrete von Kanopos und Memphis mit den hieroglyphischen und griechischen Fassungen und deutscher Übersetzung* [Heidelberg, 1922]; A. Bernand, *Le Delta Égyptien d'après les textes grecs* 1.3, "Les inscriptions de Kôm el-Hisn" [Cairo, 1970], 989–1036) 58–64, esp. 61ff. (= 45–54, esp. 51ff.): εἶναι δὲ τὴν ἐπιτιθεμένην βασιλείαν τῆι εἰκόνι αὐτῆς διαφέρουσαν τῆς ἐπιτιθεμένης ταῖς εἰκόσιν τῆς μητρὸς αὐτῆς βασιλίσσης Βερενίκης ἐκ σταχύων δύο, ὧν ἀνὰ μέσον ἔσται ἡ ἀσπιδοειδὴς βασιλεία, ταύτης δ' ὀπίσω σύμμετρον σκῆπτρον παπυροειδὲς ὃ εἰώθασιν αἱ θεαὶ ἔχειν ἐν ταῖς χερσίν, περὶ ὃ καὶ ἡ οὐρὰ τῆς βασιλείας (= τοῦ βασιλίσκου) ἔσται περιειλημένη ὥστε καὶ ἐκ τῆς διαθέσεως τῆς βασιλείας διασαφεῖσθαι τὸ Βερενίκης ὄνομα κατὰ τὰ ἐπίσημα τῆς ἱερᾶς γραμματικῆς. The Egyptian versions show that the phrase ἡ οὐρὰ τῆς βασιλείας refers to the tail of the cobra, not (as A. Bernand translates) to the "queue du diadème." The word is also used to mean "cobra" in 56 (= 46), as is proven by the Egyptian versions (cf. n. 9). See Cheshire, "Deutung," 108f.

8. The reason given by the priests for the institution of a cult in the month of Tybi is that the princess died in that month and that the daughter of Re, the sun-god, had died in the same month. But this is not to be understood as a mere coincidence. Her death was rather seen as a further indication that young Berenike was the daughter of Re (Helios). The young girl was made "queen" right after her birth (*Can.* 47 = Kôm el-Hisn 38: Βερενίκην, ἣ καὶ βασιλισσα εὐθέως ἀπεδείχθη). As such she was the "daughter of Re" (for the king as son of Re, see below, sections II.1.a and c [5]), a title which was already given to queen Hatshepsut ("daughter of Amun"; R. Moftah, *Studien zum ägyptischen Königsdogma im Neuen Reich*, DAI Kairo, Sonderschrift 20 [Mainz, 1985], 103; Quaegebeur, "Cleopatra VII," esp. 45, also refers to the "Amun-associated Divine Wives" of the twenty-sixth dynasty).

9. In this context, the priests say that Re called his daughter "eye of the sun" and "uraeus" (55f. [= 46]: ἣν ὁ πατὴρ στέρξας ὠνόμασεν ὁτὲ μὲν βασιλείαν, ὁτὲ δὲ ὅρασιν αὐτοῦ). In Egyptian thought both the Uraeus and the Eye protect Re, and the "Eye of the Sun" was envisioned as a cobra; both are positioned on the head of King Re.

her death, she was to be the protector of her brother and husband and his kingship. The Greek face and dress with the Greek diadem were thus combined with a symbol of Egyptian kingship.

These first impressions already permit us to stress a methodological postulate that will govern this paper. It is not sufficient to observe that the iconography, or for that matter a cult, a title, a phrase, is either Greek or Egyptian and therefore is addressed either to the Greeks or to the Egyptians. We should rather look behind the appearance and draw attention to the ideas expressed in the Greek or Egyptian forms, and on that level it becomes possible that the idea belongs to the Greek or the Egyptian tradition and yet is expressed in forms and conventions that render the idea understandable for the other segment of the population.[10] The Greek and the Egyptian cultures remained separate to the degree that each of them had to be addressed in its forms of expression and within its own tradition, and yet the ideas behind the different forms of expression could be similar. On this level cultural influences, and even a certain acculturation, are not sufficiently measured by the images in which the ideas of Ptolemaic kingship are expressed. On the other hand, images carry their own traditions and conventions, and, by necessity, these manifestations color the message in which the ideas appear. Hence, translations of an idea from one culture into the other can only be partial, and in a new environment an idea will develop in its own right but will also carry the baggage of the other culture's traditions.

In order to explore our first impressions, let us briefly turn to the social reality of the Ptolemaic kingdom. At the outset I wish to state that the general picture which I shall try to draw will be subject to corrections in details. There was a great deal of variation from place to place and over the period of Ptolemaic rule,[11] but it is safe to say that Ptolemaic kingship indeed had a double face. For the Greeks the king was the βασιλεύς whose ancestors had won the land by their conquest (δορίκτη-τος). While this factor quickly lost importance in Egypt, the state continued to be seen as the affairs (πράγματα) of the king.[12] The Greeks obeyed him, because he enabled them to have a profitable life. There

10. For futher iconographical examples see n. 50.

11. The nature of our fragmented and anecdotal evidence in connection with the researcher's need to generalize leads to constant neglect of this obvious fact. See D. J. Crawford, "The Opium Poppy: A Study in Ptolemaic Agriculture," in *Problèmes de la terre en Grèce ancienne,* ed. M. I. Finley, Civilisations et Sociétés 33 (Paris, 1973), 223–251, esp. 223–228; Bagnall, "Greeks and Egyptians," 21.

12. Cf. L. Mooren, "The Nature of the Hellenistic Monarchy," in *Egypt and the Hellenistic World,* 205–240, esp. 231; on δορίκτητος see A. Mehl, "Δορίκτητος χώρα," AncSoc 11/12 (1980/81): 173–212; for the Greek concept as reflected in the title *Basileus* see E. S. Gruen, "The Coronation of the Diadochoi," in *The Craft of the Ancient Historian: Essays in Honor of C. G. Starr,* ed. J. W. Eadie and J. Ober (Lanham, New York, and London, 1985), 253–271.

were the soldiers and the military settlers with military ties to the ruler;
under Philadelphos there was a group of male adolescents aged between
about fourteen and seventeen who were called "Ptolemaioi." They
formed an age class at a sports contest,[13] and their name indicated that
they were in a special relationship with the king. Moreover, the top ranks
of the military and the administration were connected with the king by
the bond of "friendship." "Friend," φίλος, was an official court title.[14]
They received not only positions of influence but sometimes large es-
tates. Apollonios, the *dioiketes* or head of the Ptolemaic administration,
had a δωρεά of 10,000 *arourai*, or 6,760 acres. This is of course no indi-
cation of the *kleros* that a normal officer would receive; a Greek soldier
could end up with, nominally, 100, 80, 70, or 20 arourai, that is, 68, 54,
47, or only 13 1/2 acres, and it is not even certain that, for example, a
ἑκατοντάρουρος would indeed own 100 arourai. Most Greeks had come
to Egypt in order to make a fortune and at the same time to live an
enjoyable life. They came from everywhere in the Greek world. The list
of victors of a local agonistic celebration of the king's birthday reads as
if it were a panhellenic contest: there were the Macedonian, Thracian,
Thessalian, Samian, Halicarnassian, Boiotian, and Tarentine victors as
well as another victor from Naucratis, the old Greek city in Egypt.[15] In
Egypt a young man could find, in the words of Herondas, "everything
there is and will be: wealth, the wrestling arena, power, peace, renown,
shows, philosophers, money, young men, the temple of the Brotherly
Gods, the king a good ruler, the Museion, wine, all the goods somebody
may desire, and more women, by Hades' wife Kore, than the sky boasts
of stars, and beautiful like the goddesses who once came to Paris to let
him judge their beauty" (1.26ff.). Urbanity and culture were as much an
attraction as the chance to make money, preferably in the city of Alex-
andria but also in the towns and villages throughout the country, where
religious and civic clubs made life tolerable for Greeks. In general terms,
they were the soldiers, military settlers cultivating their kleroi with the
help of subfarmers, professionals, bankers, agents, administrators, and
tax farmers. They were the elite. Yet not all were successful.[16]

13. L. Koenen, *Eine agonistische Inschrift aus Ägypten und frühptolemäische Königsfeste*,
Beitr. z. klass. Phil. 56 (Meisenheim, 1977), 15–17. For the inscription see *SEG* 27 (1977):
1114 and 1305; 33 (1983): 1361; cf. J. Bingen, in *Semaines philippopolitaines de l'histoire et de
la culture thrace*, Plodiv, 3–17 octobre 1980 IV (Sofia, 1983), 4:72–79 (*non vidi*).

14. L. Mooren, *The Aulic Titulature in Ptolemaic Egypt: Introduction and Prosography*, Verh.
AWLSK 37 (Brussels, 1975), 78.

15. *Agonistiche Inschrift;* for a photograph of the stone see E. Bernand, *Recueil des in-
scriptions grecques du Fayoum*, vol. 3 (Cairo, 1981), pl. 42; *SEG* 27 (1977): 1114, 1305; and
SEG 33 (1983): 1361.

16. J. Bingen, "Présence grecque et milieu rural ptolémaïque," in *Problèmes de la terre*,

On the other side, there were also relatively well-to-do Egyptians, frequently from priestly families with close ties to the still rich temples, which continued to keep control over and receive the revenues from their land (ἱερὰ γῆ)[17] and from the state, thus maintaining economic as well as social influence. The temples provided secure and in many cases substantial revenues to their priests, especially since individuals and families could collect the revenues and revenue shares from several priestly functions; the priests enjoyed a number of privileges.[18] Even with the restricted nature of our documentation—many more Greek than demotic papyri have been published—we find some Egyptians in the administration, hence also in functions that gave them control over Greeks; we find indications that there were many more Egyptians in such positions, but, at least since the second century BC, Egyptians tended to use Greek names when they executed Greek administrative functions (as Greeks could use Egyptian names when dealing with Egyptian affairs).[19] Some Egyptians, including priests, served in the regular

215–222; cf. eundem, "Économie grecque et société égyptienne au IIIᵉ siècle," in *Das ptolemäische Ägypten: Akten des intern. Symposions, Sept. 1976, Berlin*, ed. H. Maehler and V. M. Strocka (Mainz, 1978), 211–219 (stressing the Greekness of the economic system).

17. All land seems to have legally belonged to the crown; the ἱερὰ γῆ, as well as the land given to soldiers, settlers, and functionaries, was part of the γῆ ἐν ἀφέσει (for a different view see J. Herrmann, *CE* 30 [1955]: 95–106). Within the administration of the temples, the ἐπιστάτης represented the king; but the individuals appointed to this position came, at least in general, from within the priestly families. In addition to income from ἱερὰ γῆ, the temples received grants from the crown: the σύνταξις and the ἀπόμοιρα; for the latter see section II.1.e; in general see D. J. Thompson, *Memphis under the Ptolemies* (Princeton, 1988), 77, 109–114. The traditional view that the ἱερὰ γῆ was managed by the state almost in the same way as the βασιλικὴ γῆ (C. Préaux, *L'économie royale des Lagides* [Brussels, 1939], 480f., and *Monde hellénistique* 2:378f.) has been seriously challenged by J. Shelton, "Land Register: Crown Tenants at Kerkeosiris" in *Collectanea Papyrologica (P. Coll. Youtie)*, ed. A. E. Hanson, vol. 1, PTA 19 (Bonn, 1976), no. 15, pp. 111–151, esp. pp. 123f. with n. 42.

18: On the economic power of the temples, partly visible in the enormous building programs of Egyptian temples, as well as on the economic and social influence of the priests, see J. Quaegebeur, "Documents égyptiens et role économique du clergé en Égypte hellénistique," in *State and Temple Economy in the Ancient Near East*, ed. E. Lipiński, Orient. Lov. Anal. 6 (Louvain, 1979), 707–729; J. H. Johnson, "The Role of the Egyptian Priesthood in Ptolemaic Egypt," in *Egyptological Studies in Honor of R. A. Parker*, ed. L. H. Lesko (Hanover and London, 1986), 70–84.

19. See Clarysse, "Ptolemaeïsch Egypte," 21–38; eundem, "Hakoris, an Egyptian Nobleman and his Family," *AncSoc* 22 (1991): 235–243, and "Some Greeks in Egypt," in *Life in a Multi-Cultural Society: Egypt from Cambyses to Constantine and Beyond*, ed. J. H. Johnson, Studies in Ancient Oriental Civilizations 51 (Chicago, 1992), 327–341. Among a number of case studies presented in the first of these articles Clarysse points to two brothers, Polemon and Menches alias Asklepiades, sons of Petesouchos alias Ammonios and his wife Thasis, both heads of the village administration of Kerkeosiris in the Fayum toward the

army as officers and soldiers, others, it appears, in special Egyptian elite
units.[20] There also were Egyptians in trade or managing their estates,
notwithstanding the fact that the king nominally claimed ultimate own-
ership of all landholdings and that the size of Egyptian estates was much
smaller than that of Greek estates. According to the surviving evidence,

end of the second century: the former performed the office of epistates, which was usually
administered by persons with Greek names; his brother was the village secretary, the office
which almost always was controlled by men with Egyptian names. Polemon, the epistates,
named his son Petesouchos, after the Egyptian name of the son's grandfather Petesouchos
alias Ammonios. Clarysse concludes that in Ptolemaic Egypt there were indeed two cul-
tures, Greek and Egyptian, which did not meld; yet there was also a group of the popula-
tion which was at home in both cultures: "'s Morgens gaan ze naar het gymnasium, speken
Grieks, lezen Homeros en kleden sich als Grieken, en 's middags gaan ze naar de tempel
en zingen ze misschien Egyptische hymnen. En wanneer ze sterven laten ze zich mummi-
ficeren naar aloud Egytisch gebruik" (p. 35). In this situation names are not a sufficient
indication as to whether an official is Greek or Egyptian. Whereas the names would indi-
cate that at the beginning of the Ptolemaic rule and again in the second and first centuries
BC more Egyptians served in leading positions than during most of the third century BC,
this is no longer a certain conclusion. Moreover, even if our statistics should be correct,
this would not necessarily indicate a deliberate change of policy during the reign of Phi-
ladelphos. For obvious reasons it may have been easier for people already in authority
when Alexander and then the Ptolemies took over to continue in positions of influence
than for the next generation of Egyptians to enter high office. For the evidence see W.
Peremans, "Étrangers et Égyptiens en Égypte sous le règne de Ptolémée 1er," AncSoc 11/
12 (1980/81): 213–226; R. S. Bianchi, "Ptolemaic Egypt and Rome: An Overview," in
Cleopatra's Egypt, 13–20, esp. 13; Koenen, "Adaption," 152 n. 26; for Egyptians in military
service see n. 20.

20. P. Mich. inv. no. 6947 of January 5, 197 BC (unpubl.; cf. Koenen, "Adaption," 149f.
n. 20), refers to one Apollonios, "a soldier of the elite cuirassiers under the command of
officer Anthemides, a Cretan" ('Απολ[λ]ωνίου τῶν 'Ανθεμίδου Κρητὸς ὑπηρέτου θωρακιτῶν
ἐπιλέκτων, lines 11–12). Cuirassiers are elsewhere mentioned only in Polybios (4.12.3, 7;
10.29.6; 11.11.4, 5; 11.14.1, 15); they are semilight, movable troops, clearly distinct from
hoplites and peltasts; in 11.11.4–5 they fight together with Illyrian units. The word ἐπί-
λεκτοι, denoting elite units, occurs elsewhere in connection with μάχιμοι, a term which
has no ethnic connotation per se (K. Goudriaan, Ethnicity in Ptolemaic Egypt [Amsterdam,
1988], 121–125) but still seems to have been used for predominantly Egyptian soldiers (cf.
Herod. 2.141, 164; 9.32) and policemen of low social standing. In the Michigan papyrus,
Apollonios acts as κύριος of Thaÿbastis, a "Syrian" woman, who registered possession of a
female Egyptian slave "in accordance with a royal decree promulgated on November 12,
198 about owners of Egyptians who had been enslaved during the unrest in the country":
κατὰ τὸ ἐκτεθὲν πρόσταγμα (ἔτους) η Φαῶφι β̄ περὶ τῶν ἐχόντων σώματα Αἰγύπ[τι]α ἀπὸ
τῆς ἐν τῆι χώραι ταραχῆς. She paid to the state a fictive price and taxes. Most likely the
slave was Apollonios' booty, and the latter was serving in an "Egyptian" corps under Greek
command. However, the evidence for this assumption is inconclusive. The Egyptian guard
which, according to the traditional translation of a passage in the Pithom Stele, Philadel-
phos is said to have recruited, has become elusive (P. Derchain, ZPE 65 [1986]: 203–204),
although the use of the term mnfyt for the military still seems to point to the μάχιμοι and,
in the context of the decree by priests, to Egyptian soldiers (see E. van 't Dack, "L'armée
de terre Lagide," in Life in a Multi-Cultural Society, 327–341. Although in the third century

in one case the holdings amounted to 80 arourai, or about 55 acres. Only when they belonged to the class of cavalry soldiers could they assemble larger holdings (100 arourai, i.e., about 68 acres): they were then regarded as Greek.[21]

It is sometimes difficult to distinguish between the Egyptian middle and lower class. The farmers of crown land (βασιλικοὶ γεωργοί), whom a previous generation of papyrologists has seen as totally dependent and subject to severe restrictions of their freedom, in short almost as serfs, are now understood as an economically quite diverse group. The size of plots varied considerably, and the farmers of large plots, some of whom managed their land by hiring employees and some by subletting, were rather well-to-do, at least by village standards. Even temples farmed βασιλικὴ γῆ. The farmers of the crown may have been exploited, yet they made a living, had a certain economic freedom, seem to have enjoyed

the number of Egyptians in the Ptolemaic army was apparently low, they became a dominant factor in the second century. See W. Peremans, "Les Égyptiens dans l'armée de terre des Lagides," in *Althistorische Studien Hermann Bengtson zum 70. Geburtstag dargebracht*, ed. H. Heinen, Historia Einzelschriften 40 (Wiesbaden, 1983), 92–102, 85; eundem, "Un groupe d'officiers dans l'armée des Lagides," *AncSoc* 8 (1977): 175–185, "Égyptiens et étrangers dans l'armée de terre et dans la police de l'Égypte ptolémaïque," *AncSoc* 3 (1972): 67–76, and *Vreemdelingen*, 11; W. Clarysse, "Greeks and Egyptians in the Ptolemaic Army and Administration," *Aegyptus* 65 (1985): 57–66; J. K. Winnicki, "Das ptolemäische und das hellenistische Heerwesen," in *Egitto*, 213–230; eundem, *Ptolemäerarmee in Thebais*, Polska Akademia Nauk, Komitet Nauk o Kulturze Antycznej, Archiwum Filol. 38 (Warsaw, 1978). On priests of Egyptian temples who in Greek documents appear as army officers, see J. Yoyotte, "Religion égyptienne et culture grecque à Edfu," in *Religions en Égypte hellénistique et romaine*, Bibliothèque des centres d'études supérieures specialisées, Université . . . de Strasbourg (Paris, 1969), 121–141. On the lack of integration and the presence of economic discrimination see H. Heinen, "Heer und Gesellschaft im Ptolemäerreich," *AncSoc* 4 (1973): 91–114.

21. W. Clarysse, "Egyptian Estate-Holders in the Ptolemaic Period," in *State and Temple Economy*, 731–743; Johnson, "Role," 76f. For Heti son of Petephibis, who through a demotic document left about 100 arourai and an amount of money to his wife and sons in 70 BC (in Panopolis) see Clarysse, "Egyptian Estate-Holders," p. 733, who also points out that Heti "belonged to the mixed Graeco-Egyptian military population." At the time Clarysse also argued that *P. Zen. Pestm.* 38 (middle of the third century BC) attests two 10,000 arourai estates, each as large as the δωρεά of Apollonios with its 6,760 acres, one owned by a Greek, the other by an Egyptian. But, on the basis of a new reading of a demotic papyrus (*P. Sorb.* inv. 746b), Clarysse now revokes his interpretation and, agreeing with L. Criscuolo, regards the μυριάρουροι as local officials, subordinate to the nomarchs ("A New Muriarouros in a Bilingual Text," forthcoming in *Enchoria* 19/20 [1992–93]; L. Criscuolo, "I miriaruri nell'Egitto tolemaico: Note nell'amministrazione dell'Arsinoite nel III secolo a. C.," *Aegyptus* 57 [1977]: 109–122; eadem, "Miriaruri: Nuovi reflessione," *Aegyptus* 61 [1981]: 116–118; S. Heral, "Archives bilingues de nomarques dans les papyrus de Ghôran," *Life in a Multi-Cultural Society*, 132–157, esp. 152–154). The Egyptian title of the official sounds rather grandiose: "The Great of the 10,000."

some security of tenure (although they could contract for different plots at different times), and received privileges including substantial protection from overzealous administrators and agents.[22] A similar picture emerges when we turn to Egyptian soldiers of the second century BC. At the same time, institutional discrimination appears. For example, while, as already stated, a Greek soldier and settler would get an allotment of 68, 54, 47, or 13 1/2 acres and frequently did not have to reside in the countryside, soldiers in less prestigious, by and large Egyptian, units of the military and the police ($\mu\acute{\alpha}\chi\iota\mu\omega$) had to settle for 5 or 3 1/2 acres in the second century. But even for crown tenants, who had to pay a higher total of various levies, arourai of land were regarded as providing sufficient income, at least when combined with other revenues which a farmer could obtain (see n. 22).

Intermingling of Egyptians and Greeks became unavoidable, particularly in the countryside. Perhaps beginning with the third or fourth generation of Greek immigrants, intermarriage created a class of mixed population, among which, in a long process, the differences between people of Greek and those of Egyptian extraction disappeared. Persons frequently used two names. A person of Greek extraction would use his Egyptian name in an Egyptian social environment; in a Greek environment and in governmental or military capacities an Egyptian would be called by his Greek name. People were governed more by their social environment than by their ethnic extraction.

Some case studies illustrate the process. (a) By the middle of the third century, Monimos, an Alexandrian, and his family moved to the Fayum, an environment where marriages between Greek men and Egyptian women were common, and the children of such families had partly Greek and partly Egyptian names. (b) Particularly well known is the case of Dryton the cavalryman who, born in 195 BC, was a citizen of Ptolemaïs in the south of Egypt and belonged to the *politeuma* of the Cretans. In the second part of his life he was stationed in the countryside, mainly in Pathyris, nineteen miles upstream from Thebes. There he married his second (or third) wife, Apollonia, from a local family enrolled in the politeuma of the Cyrenaeans. His wife's family used double names and was of Egyptian extraction, and she became a financially independent woman capable of making loans to others. While Dryton never lost his

22. For a recent discussion of the status of the $\beta\alpha\sigma\iota\lambda\iota\kappa o\grave{\iota}$ $\gamma\epsilon\omega\rho\gamma o\acute{\iota}$ see Shelton, "Land Register," esp. 111–126, and his introduction to *P. Tebt.* 4.1103, which provides precise details about the sizes of the individual holdings, the crops, and the rent; D. J. Crawford, *Kerkeosiris: An Egyptian Village in the Ptolemaic Period* (Cambridge, 1971), 103–105; and J. Rowlandson, "Freedom and Subordination in Ancient Agriculture: The Case of the *Basilikoi Georgoi* of Ptolemaic Egypt," in *Crux: Essays in Greek History Presented to G. E. M. de Ste. Croix*, ed. P. A. Cartledge and F. D. Harvey (London, 1985), 327–347.

Greekness and may even have had some interest in Greek love poetry, his family, which included five daughters and no son, was embedded in an Egyptian environment fostered by the female members of the family. Some of the documents are written in demotic. (c) Finally we may mention the case of Maron, alias Neksaphthis, son of Petosiris. In the second century BC he started his service as an ordinary policeman; but in his long career he was advanced to be "a Macedonian of the cavalry settlers" (Μακεδὼν τῶν κατοίκων ἱππέων), thus belonging to one of the most prestigious units. In this position he had tenure of nominally 100 arourai of land and, as I have already indicated, could now be regarded as a Greek.[23]

In such an environment the distinction between Greeks and Egyptians is problematic; we speak of Greco-Egyptians. But this is a modern concept. In Egypt people were either Greeks or Egyptians (Goudriaan, Ethnicity, 117). Their ethnicity is not sufficiently described, in anthropological terms, as a mere in-group and out-group designation based upon self-ascription or ascription by others; it was not only a social (Goudriaan, Ethnicity, 8–13), but also a legal and political reality. At least in the third and second centuries BC, the change of a person's name and his country of origin was regulated by royal decree, and the authorization of such a change was reserved to the higher administration.[24] It was advantageous to be "Greek." In the middle of the third century Greeks, as well as Persians and women, did not pay the obelos tax, a poll tax levied together with the salt tax, the main poll tax of Ptolemaic times; and teachers of Greek (τῶν γραμμάτων) and sport (παιδοτρῖβαι), priests of Dionysos and some other priests, and the winner of the main contests (the games in honor of Alexander, the Basileia, and the Ptolemeia) and their descendants were exempted from the salt tax: teachers of elementary Greek were as much rewarded as teachers of physical education; both helped to spread the Greek culture and the language needed by

23. Clarysse, "Greeks and Egyptians"; Bagnall, "Greeks and Egyptians"; and J. Quaegebeur, "Greco-Egyptian Double Names as a Feature of a Bi-cultural Society: The Case Ψοσνεῦς ὁ καὶ Τριάδελφος," in Life in a Multi-Cultural Society, 265–272. On Monimos see W. Clarysse, "Une famille alexandrine dans la chora," CE 63 (1988): 137–140; on Dryton see S. B. Pomeroy, Women in Hellenistic Egypt, 2d ed. (Detroit, 1990), 103–124; Lewis, Greeks in Ptolemaic Egypt, 88–103; the paraclausithyron known as Fragmentum Grenfellianum (Coll. Alex. pp. 177ff.; translation in P. Bing and R. Cohen, Games of Venus [New York and London, 1991]: 183–184) appears on the back of the document of a loan which Dryton had received (P. Grenf. I 10); on Maron (no. 616 in F. Uebel's list of cleruchs: Die Kleruchen Ägyptens unter den ersten sechs Ptolemäern, Abh. Berlin 1968, no. 3) see H. Harrauer's introduction to CPR 9, p. 45.

24. BGU 1213 and 1250 [C. Ord. Ptol. ll. 34, 47]; J. Mélèze-Modrzejewski, "Le statut des hellènes dans l'Égypte lagide," in "Bulletin de bibliographie thématique: Histoire," REG 96 (1983): 241–268; on the BGU texts pp. 244ff.

the administrators of the Ptolemaic bureaucracy.[25] In the *philanthropa*
edict of 118 BC, "Greek soldiers," as well as other groups like priests,
crown farmers, and monopoly workers, were exempted from losing part
of their houses to billeting (*P. Tebt.* 5, 168ff.; *C. Ord. Ptol.* 53). This
language implies, of course, that the administration and the legal sys-
tem recognized somebody as being either Greek or Egyptian, and that
"Greek soldiers" were privileged, but along with other, partly Egyptian,
groups important for the government. Thus, the government's motives
were economic and their favors were directed toward the groups they
needed most.

By and large it was still the Greek or Egyptian extraction that counted;
but the system provided avenues for Egyptians to become Greek, as well
as for Greeks to be culturally Egyptianized. In daily life, however, in an
Egyptian village, the differences between the Greeks and the Egyptians
were small. The particular situation must have varied from village to
village and depended on the percentages of the Greek and the Egyptian
population.

Ethnic tension, although poorly documented, is undeniable. The evi-
dence is anecdotal, and we are not told whether ethnic or other forms
of social tensions were involved. Here are a few examples, the first from
the first century BC. In one instance, a Greek cavalryman took away the
cows of an Egyptian Ibis keeper, a very low Egyptian priest, with which
he was plowing. When the priest spoke up against the soldier, the latter
broke into the priest's house and took away whatever he found useful.[26]
Another example brings us to May 5, 218 BC. A Greek settler went to a
small village in the Fayum for some private business. An Egyptian lady
poured urine from a window or door upon him and his coat. A quarrel
arose. The lady tore his coat to pieces, spat in his face, and ran back into
her house when other people intervened. The unfortunate incident in
itself may have had as little to do with ethnic tension as our first example.
But when the Greek complained to the authorities, he stressed that he,
a Greek and visitor, was mistreated by an Egyptian woman (*P. Ent.* 79).[27]

25. See H. Harrauer's introduction to *CPR* 9 and, on the salt tax, cf. J. Shelton, "Notes
on the Ptolemaic Salt Tax under Ptolemy III," *ZPE* 71 (1988): 133–136; the preceding
remarks are deeply indebted to D. Thompson, "Literacy and the Administration in Early
Ptolemaic Egypt," in *Life in a Multi-Cultural Society*, 323–326, and W. Clarysse, "Some
Greeks in Egypt," ibid., 52.
26. B. Kramer and D. Hagedorn, "Zwei ptolemäische Texte aus der Hamburger Pa-
pyrussammlung: 1. Eingabe an den König," *APF* 33 (1987): 9–16.
27. W. Peremans, "Classes sociales et conscience nationale en Égypte ptolémaïque," in
Miscellanea in honorem J. Vergote, ed. P. Naster, H. de Meulenaere and J. Quaegebeur, Or-
ientalia Lovaniensia Periodica 6/7 (1975/76), 443–453, esp. 450; Lewis, *Greeks in Ptolemaic
Egypt*, 61.

Remarkably similar is the story of Ptolemaios, a Macedonian, who in the second century lived in the temple of Astarte within the precinct of the Sarapeion of Memphis in an environment totally controlled by the Egyptian cult. He had entered the nonpriestly service of the deity to escape, at least in part, economic hardship rather than legal persecution, and he shared a room with an Egyptian. He and his twin brother Apollonios, also serving in the temple, were somewhat cultured men with some interest in literature. Apollonios copied part of a Greek translation of the Egyptian narrative of *The Dream of Nektanebos,* but he might have been attracted more by the dream prophecy than by the literary value of the piece.[28] The brothers owned at least part of an astronomical treatise and part of a philosophical text with quotations from Sappho, Ibykos, Alkman, Anakreon, Timotheos, Thespis, Euripides, and others;[29] moreover, there was another papyrus in their possession with two excerpts from comedy, a wife's speech and a monologue. In the papyrus, the former is wrongly ascribed to Euripides.[30] Over the years Ptolemaios submitted several complaints about incidents in which he had been attacked by Egyptian inhabitants of the temple precinct. On November 12, 163 BC, he and his Egyptian roommate were attacked by a group of temple cleaners and bakers; Ptolemaios escaped to his room and his Egyptian roommate suffered the beating. When Ptolemaios complained to the Greek authorities, he likened the event to an attack which the same group of people had made on him during the revolt of Dionysios Petosarapis and stated that he felt harassed although he "was Greek."[31] The attack itself may have been caused by individual circumstances and reasons, but Ptolemaios thought that the reminder of the past revolt and the insinuation of ethnic tension would help him, a Greek, with the Greek authorities. In other cases the inability to understand the other person's language may have played a role. Once a non-Greek, probably Arab, employee of Apollonios' domain complained to Zenon, the chief manager of the estate, about his local supervisor discriminating against

28. Now see L. Koenen, "The Dream of Nektanebos," in *Classical Studies Presented to W. H. Willis,* ed. D. Hobson and K. McNamee, *BASP* 22 (1985): 171–194.

29. See Thompson, *Memphis,* 258f. on *UPZ* 101.

30. *P. Didot.* Both excerpts have been ascribed to Menander (see A. W. Gomme and F. H. Sandbach's commentary [Oxford, 1973], pp. 723–729), wrongly, I think, at least in the case of the monologue.

31. *UPZ* 7.14–22 (addenda p. 648; J. Hengstl, *Griechische Papyri aus Ägypten* [Munich, 1978], no. 38): εἰσεβιάζοντο βουλόμενοι ἐξσπάσαι με καὶ ἀλογῆσαι καθάπερ καὶ ἐν τοῖς πρότερον χρόνοις ἐπεχείρησαν οὔσης ἀποστάσεως, παρὰ τὸ Ἕλληνά με εἶναι. The same argument (παρὰ τὸ Ἕλληνα εἶναι) is repeated in Ptolemaios' complaint about another incident (8.14). Cf. U. Wilcken's commentary and the addenda in *UPZ;* Thompson, *Memphis,* 229; Lewis, *Greeks in Ptolemaic Egypt,* 69–87, esp. 85f.

him by withholding his salary and giving him cheap wine, because he was not Greek (βάρβαρος) and could not speak Greek well.[32] In the cities the situation was even more complicated because residents lived in ethnic quarters which would provide social support[33] as well as foster hostility towards those in other quarters.

Cultural and social separation on the one hand, mixture and amalgamation on the other, sometimes both blending together in the same villages and families, and, hence, unavoidable ethnic friction—all these elements are part and parcel of the same complex social reality.

II. PARTIAL AMALGAMATION OF IDEAS

Undoubtedly, the Greek kings were in an extremely difficult position. There was a socially and ethnically divided population. There was the pride and the power of the victors and, on the other side, the fact that the victorious Greeks were a very small minority in a country they did not understand. There was no concept of "fatherland." Thus, the situation was totally different from the situation, let us say, in Macedonia. The Greeks had come as immigrants, basically on their own or on their ancestors' initiative. The Egyptians had been there for thousands of years, but their interests hardly reached beyond their villages and their possessions. During the last period of pharaonic kingship the country was split between rival dynasties, and the temples, always powerful in Egypt, were no longer restrained by the central government. Thus, the temples and the noble families normally connected with them had become the centers of power. Nevertheless, the concept of ideal kingship and the uniqueness of the Egyptian gods, myths, and rituals still created a feel for what was Egyptian. All this survived the Persian rule but was questioned again when the Greeks conquered the land. The Egyptians had little choice. They generally accepted the Ptolemies as their pha-

32. *P. Col. Zen.* 2.66, 15ff. (cf. P. W. Pestman, *A Guide to the Zenon Archive,* Pap. Lugd.-Bat. 21A [Leiden, 1981], 126): ἅ σύ μοι συνέταξας, οὐθέν μοι δίδω⟨σ⟩ι ἤδη μηνῶν ἐννέα, 'τὸ ἔλαιον' οὐδὲ σῖτον, ἀλλὰ ⟨τὸ ὀψώνιον⟩ παρὰ δίμηνον ὅταν καὶ τὰ ἱμάτι⟨α⟩ ἀποδῷ μοι (ἀποδῷται rather than ἀποδῶμαι or ἀποδῶι μοι ed. pr.; ἀποδῶμαι C. Préaux, see *BL* 3 p. 45) - - - ὁ δέ μοι συντάσσει ὄξος λαμβάνειν εἰς ὀψώνιον. ἀλλὰ κατεγνώκασίμ μου ὅτι εἰμὶ βάρβαρος. δέομαι οὖν σοῦ 'εἰ σοὶ δοκεῖ' συντάξει αὐτοῖς ὅπως τα ὀφειλόμενα κομίσωμαι - - - ἵνα μὴ τῶι λιμῶι παραπόλωμαι ὅτι οὐκ ἐπίσταμαι ἑλληνίζειν. The details about his salary are not clear; oil and grain were not given to him for nine months, while cash was paid to him only bimonthly (if I understand the sentence correctly). On the general importance of this document see Peremans, "Classes sociales," 447; A. Świderek, "La société indigène en Égypte au IIIᵉ siècle avant notre ère d'après les archives de Zenon," *JJurP* 7–8 (1954): 231–284, esp. 274f. and 279; Préaux, *Monde hellénistique* 2:559; Peremans, "Bilinguisme," 257; E. G. Turner in *CAH²* 7.1.156

33. Thompson, *Memphis,* 87.

raohs. The ethnic origin and ties of the pharaoh meant little from the Egyptian point of view as long as he functioned in his role of conquering the daily assault of chaos and renewing the cosmic and hence the social order.[34] This he did by historical deeds as well as by performing the rituals; in fact, historical deeds were perceived as real inasmuch as they were seen as repetitions of the cosmogonic acts which the gods enacted at the beginning of time and still continued to perform daily. All authority, religious or other, was derived from the pharaoh. The only opposition could have come from the priests, who undoubtedly were a center of secular power too. But not recognizing the pharaoh was next to impossible; it implied a denial of the priests' own legitimacy and function.[35] The king was also the ultimate source of livelihood for farmers, landowners, noblemen of ancient lineage, administrators, soldiers, and workers. To use the words of the *Instruction of Seheteb-ib-re* (Middle Kingdom), "He gives food to those who serve him, he nourishes him who treads his path. The king is sustenance, his mouth is plenty, he who will be is his creation. He is the Khnum of everybody, begetter who makes mankind." Similarly, in the New Kingdom, Ramses II addressed quarry workers: "I, Ramses, am the one who creates generations by nourishing them."[36] In Ptolemaic times, Epiphanes is "green life for men" (see section II.1.a with n. 58, and II.1.c [3]). The fact that in the eyes of the Greeks the kingdom was the affairs ($\pi\rho\acute{\alpha}\gamma\mu\alpha\tau\alpha$) of the king points to a secular and largely economic understanding of rulership, but it could be stretched to contain the same obligation as expressed by the Egyptian sentiment.

This situation called for a pragmatic approach on the part of the Ptolemies. The system could be made economically productive and could finance the wars with the other diadochs only by establishing a strong central administration, while at the same time interfering as little as possible with the temples and the religious beliefs of the people. Social separation seemed to provide part of an answer. With regard to the religions, the king's administration let everybody follow his or her beliefs. It is significant, for example, that on the occasion of an Isis festival in 217 BC, probably the Amesysia or festival of the birth of Isis, the lower adminis-

34. Cf. J.-C. Goyon's short remarks in *Cleopatra's Egypt*, 29–39, esp. 30.

35. E. Winter, "Der Herrscherkult in den ägyptischen Ptolemäertempeln," in *Ptolemäische Ägypten*, 147–160, esp. 147f.; C. Onasch, "Zur Königsideologie der Ptolemäer in den Dekreten von Kanopus und Memphis," *APF* 24–25 (1976): 137–155, esp. 139 (with more literature).

36. For the *Instruction of Seheteb-ib-re* from Abydos see M. Lichtheim, *Ancient Egyptian Literature* I (Berkeley—Los Angeles—London, 1973), 125–129, esp. 128; for the speech of Ramses II to the quarry workers see Ahmed-Bey Kamal, "Stèle de l'an VIII de Ramsès II," *Recueil de travaux relatifs à la philologie et à l'archéologie égyptiennes et assyriennes* 30, 213ff., A. Hermann, *Die ägyptische Königsnovelle*, Leipz. Ägyptologische Studien 10 (Glückstadt—Hamburg—New York, 1938), 53–56, esp. 55.

tration did not work and prisoners were sent home, while for the higher administration of the nome, business went on as usual.[37] Greeks in higher positions obviously did not care for this festival; but this attitude did not, of course, prevent them from creating Sarapis, a deity that presented an essentially Egyptian theology in a Greek dress.

The separation was most clearly practiced with regard to the law.[38] The Greeks followed common Greek (basically Athenian) law, while the Egyptians had their own courts, the *laokritai*. By 118 BC the language of contracts determined the competence of the court that was to hear lawsuits involving Egyptian and Greek parties (*P. Tebt.* 1.5.207–220 [*C. Ord. Ptol.* 53; *Sel. Pap.* 210]). This regulation is not necessarily an indication that it had become difficult to distinguish between Egyptians and Greeks, but it was, on the one hand, an attempt to make sure that the court was fully knowledgeable of the traditions, legal requirements, and implications of the contracts essential for the case.[39] On the other hand, the parties had a choice of the law that they wanted to govern their relations when they wrote their contracts, an aspect particularly important in family law where the Egyptian law provided greater protection and independence for women. In all courts, the εἰσαγωγεύς was Greek,

37. T. Caulfield, A. Estner, and S. Stephens, *ZPE* 76 (1989): 241–254, esp. 244f.

38. W. Peremans, "Égyptiens et étrangers dans l'organisation judiciaire des Lagides," *AncSoc* 13/14 (1982/3): 147–159; H. J. Wolff, "The Political Background of the Plurality of Laws in Ptolemaic Egypt," in *Sixteenth Congress of Papyrology*, 313–318; Préaux, *Monde hellénistique* 2:587–601; on the other hand, E. Seidl, in light of his knowledge of demotic documents, believed in reciprocal influence of the two legal systems; see, for example, *Ptolemäische Rechtsgeschichte*, 2d ed., Äg. Forsch. 22 (Glückstadt, Hamburg, and New York, 1962) 2, 182, and 184; and eundem, "Griechisches Recht in demotischen Urkunden," in *Akten des XIII. Intern. Papyrologenkongresses*, ed. E. Kiessling and H. A. Rupprecht, MB 66 (Munich, 1974). Here, as in other areas, both sides of the controversy are partially right; and, in general, separate and parallel legal systems do not preclude the possibility that each system could learn from the other. Women, for example, tended to seek the stronger protection and economic liberty granted to them by the Egyptian law. At the beginning of the Roman time, women in Oxyrhynchus tended to secure their marriages through loans to their husbands, a custom which stands in the tradition of Egyptian marriage loans, but was materialized with the help of the Greek banking system; see T. Gagos, B. E. McNellen, and L. Koenen, "A First-Century Archive from Oxyrhynchos or Oxyrhynchite Loan Contracts and Egyptian Marriage," in *Life in a Multi-Cultural Society*, 181–205.

39. Cases involving farmers of crown land and persons involved in the fiscal administration were exempted from this regulation. The precise text and meaning of *P. Tebt.* 1.5.207–220 is much debated; for recent literature see M.-T. Lenger, *Corpus des ordonnances des Ptolémées, bilan des additions et corrections (1964–1988), compléments à la bibliographie*, Pap. Brux. 24 (Brussels, 1990), 15f.; for the different opinions, on the one hand, J. Modrzejewski, "Chrématistes et laocrites," in *Hommages à C. Préaux* (Brussels, 1975), 699–708 and Lewis, *Greeks in Ptolemaic Egypt*, 128f. with n. 3 on p. 171; on the other hand, P. W. Pestman, "The Competence of Greek and Egyptian Tribunals according to the Decree of 118 B.C.," *BASP* 22 (1985): 265–269. For a brief historical review of the various courts in Egypt see W. Peremans, "Égyptiens et étrangers," 147–159.

and without his cooperation proceedings could not be opened. The king's orders overruled the laws of the Greek as well as the Egyptian system. For good or bad, these orders were a unifying factor. For example, Egyptians as well as Greeks had the right to address ἐντεύξεις (appeals) to the king; in practice they submitted them to the *strategos,* the civil governor of the nome. The petitions are written in the style of a letter but, after declaring the injustice suffered by the petitioner and asking the king for help (δέομαί σου, βασιλεῦ), they frequently combine Greek rhetoric with language that indicates the social structure of an oriental society: "I take refuge with you, King, the common savior of all men, and thus I shall obtain justice."[40] It is safe to say that this way of administering law and justice proceeded from the Greek understanding of the king and his personal ties with his subjects, but soon expressed the reality of an oriental monarchy.

Correspondingly, the administration was expected to administer the king's δίκη with a sense of equity. This is the point of the strong message which at the beginning of the third century BC was sent by a dioiketes presumably to an *oikonomos* who just had been inaugurated into his office (*P. Tebt.* 3.703).[41] The letter is called a ὑπόμνημα and is a summary of preceding oral instructions. The recipient is admonished to protect the crown farmers against officials, to pay scrupulous attention to details, to inspect the crops and the canals, to read files punctiliously, and to attend to his official correspondence meticulously. The dioiketes is sensitive to the difficulties involved in giving general instructions in view of the individual circumstances of each case. It is, however, made absolutely clear that the concern of the dioiketes is focused on avoidance of any financial loss for the crown. There is nothing that sounds un-Greek in the ethics of these instructions, and almost all are very practical and down to earth.

40. e.g. *P. Ent.* 2.11f.: ἐπὶ σέ, βασιλεῦ, καταφυγόν[τες τὸν πάντων] κοινὸν σωτῆρα τευξόμεθα τοῦ δικαίου.

41. Also *Sel. Pap.* 204 (excerpt). The dioiketes was most likely either ['A]θηνόδ[ωρος] or [Z]ηνόδ[ωρος]; the latter could be identical with a high official, possibly a *hypodioiketes,* in the Zenon Archive attested for and after 242 BC (Pestman et al., *Guide,* 332 [no. 4, cf. 6]), the former with the well-known dioiketes of this name whose earliest attestation now is P. Mich inv. no. 6947 of January 7, 197; he also occurs in two other unpublished Michigan papyri (inv. no. 6948 front and back, 193/92 BC; the transcript has been made available to me by G. Schwendner), *P. Köln* 5.221 (ca. 190 BC; see H. Schäfer's introd., pp. 165f.), *P. Yale* 1.36 (now dated 190 BC by Schäfer), *P. Rainer Cent.* 45 (without date). This Atheno-doros (*PP* 15a, in *Addenda,* vol. 9, Studia Hell. 25, perhaps also identical with *PP* 55), was wrongly dated to 232 BC, a date which correctly was regarded as too early for *P. Tebt.* 3.703. For the discussion (in addition to the publications of the aforementioned papyri) see W. Huss, *Untersuchungen zur Aussenpolitik Ptolemaios IV.,* MB 69 (Munich, 1976), 259f., and "Staat und Ethos nach den Vorstellungen eines ptolemäischen Dioiketes des 3. Jh.," *APF* 27 (1980): 67–77, esp. 68f.; E. van 't Dack, *Gnomon* 51 (1979): 350.

One could easily understand that these instructions were given ad hoc. Yet the instructions seem to have a precedent in the instructions with which, in his Theban tomb, Vizier Rekhmire (New Kingdom) describes his detailed judicial, military, administrative, and supervisory responsibilities which, as in the case of the Ptolemaic oikonomos, include inspections of the water supply and the canals. These instructions are accompanied by a poetic and more general speech by the pharaoh with which he inaugurated the vizier. At the end of this speech follows a paragraph of prosaic instructions: "Furthermore, pay attention to the plowlands when they are being confirmed. If you are absent from the inspection, you shall send the chief inspectors and chief controllers to inspect. If anyone has made an inspection before you, you shall question him. May you act according to your charge."[42] This is the same spirit which incited the dioiketes of *P. Tebt.* 3.703 to write his instructions for the new oikonomos;[43] moreover in both cases the instructions seem to have been given in two different forms, in an audience and by a written charge. Hence it may be assumed that such instructions by the pharaoh, and perhaps by high officials as well, were part and parcel of the Egyptian tradition.

The king's philanthropa decrees are related. They mark the beginning of a reign or coalition of joint rulers and, in more general terms,

42. Lichtheim, *Egyptian Literature* 2:21–24, esp. 24 (the translation contains only the pharaoh's inauguration speech and the appendix quoted above); for the text of the detailed instructions of Vizier Rekhmire's duties see J. H. Breasted, *Ancient Records of Egypt*, vol. 2 (Chicago, 1906) §§ 675–711; in addition, the tomb contains Rekhmire's autobiography. Already M. Rostovtzeff in his introduction to the first edition of *P. Teb.* 703 drew attention to the similarity of this text to the instructions for Rekhmire; for more literature see n. 43. R. Merkelbach, "Altägyptische Vorstellungen in christlichen Texten aus Ägypten," in *Mélanges Étienne Bernand* (Paris, 1991): 337–342, esp. 340–342, also compares the catalogue of good deeds by which, in the form of negative confessions (below, section III.3), the head of a village ($\pi\rho\omega\tau\omega\kappa\omega\mu\dot{\eta}\tau\eta\varsigma$) informs the eremite Paphnoutios of his own performance of duties in the administration of his office (*Hist. monach.* 14.13–14 Festugière).

43. S. M. Burstein (in his review of *CAH*[2] 7.1: *CPh* 82 [1987]: 164–168, esp. 167f.) objects to explanations of the instructions of *P. Tebt.* 3.703 in light of the Egyptian wisdom literature (see E. Turner, *CAH*[2] 7.1.147; D. J. Crawford [alias Thompson], "The Good Official of Ptolemaic Egypt," in *Ptolemäische Ägypten*, 195–202). The Egyptian wisdom literature is indeed concerned with rather general, mostly moral or expedient, and frequently almost proverbial, instructions. They are not applicable to a specific office and insofar not comparable to the Ptolemaic instructions. But the instructions for Vizier Rekhmire are similar. W. Huss, "Staat und Ethos," esp. 72ff., invokes the term of wisdom literature, as I did in the original paper. To this S. M. Burstein (see n. 1) objected. "Literature of instruction" (D. J. Crawford) or more specifically "inaugural instruction" is a more appropriate term. Yet these instructions breathe the moral and cultural spirit of the wisdom literature; or in W. Huss' words, the wisdom literature "bildete den Nährboden der Dienstanweisungen."

any other attempt to reorganize the government and to make a new beginning. The king or the joint rulers issue an amnesty, annul debts, reduce taxes, confirm rights and privileges, and take measures to protect their subjects from ·corrupt and high-handed officials and agents. This amounts to a declaration of rights and policies which will inaugurate a new, just, and better era. Again, these philanthropa continue Egyptian tradition.

What appears totally Greek may nevertheless have Egyptian antecedents as well. Thus, the interpretation with which we began and which separates the king into a clearly Greek and an Egyptian image seems to perceive only part of the reality. In fact, the king served simultaneously the Egyptian and Greek functions of his office. To some extent each side of the population had to be aware of, and to tolerate, the other's point of view. A good example is provided by the trilingual decrees of synods of the Egyptian priests (in Greek, demotic, and hieroglyphic). These decrees presumably resulted from complex negotiations and exchanges of drafts between the state and the temples. In 196 BC the synod of the Egyptian priests gathered at Memphis (*Rosettana*)[44] and responded with an honorary decree to the philanthropa issued by Epiphanes on the occasion of his coronation in 196 BC. In a similar fashion the Alexandrian synod of 238 BC expressed thanks to Euergetes for his various benefactions to the country and the temples. In both cases the priests address the Greek as well as the Egyptian population. Their decrees glorify the good deeds of the respective kings and certainly serve the interest of the state. The thoughts follow partly Greek, partly Egyptian patterns,[45] as is exemplified by the fact that the *Rosettana* adds the Egyptian dating formula to the Greek. I shall return to this later (section II.1.a).

Moreover, even from the Greek point of view, something more than a king administering his πράγματα was needed. The bond between the king and his φίλοι, between him and his army, the Greek population of

44. Such synods of Egyptian priests from the temples throughout the country seem to have been requested by the Ptolemies. They were an instrument to control the temples, but the priests were able to use them as a means to extort privileges. See J. A. Evans, "The Temple of Soknebtunis," *YClS* 17 (1961): 49–283, esp. 164–166. For a collection, discussion, and bibliography of these decrees now see W. Huss, "Die in ptolemaiischer Zeit verfassten Synodal-Dekrete," *ZPE* 88 (1991): 189–208.

45. For editions see n. 56; for a brief analysis see Onasch, "Königsideologie"; for more see F. Daumas, *Les moyens d'expression du grec et de l'égyptien comparés dans les décrets de Canope et de Memphis*, Suppl. aux Ann. du Serv. des Ant. de l'Ég. 16 (Cairo, 1952). For a historical comparison of the two decrees see G. Carratelli Pugliese, "Il decreto della stele di Rosetta," *PP* 208 (1983): 55–60. He interprets the *Rosettana* as a document that shows the growing influence of the temples, but also the willingness of Epiphanes to make greater use of the authority of the temples and to solidify his rule by a renewal of traditional aspects of Egyptian kingship (*SEG* 33 [1983]: 1357).

Alexandria, and the Greeks throughout the country was clearly strong enough as long as Egypt flourished politically and economically. But would this bond be enough in times of need and military defeat? There was and could be no concept of a πατρίς and of a Greek deity protecting Egypt and all her inhabitants. The traditional gods of the city hardly fitted into the new world, although Gods like Zeus and Dionysos changed into cosmopolitan gods in the course of time, and a deity like Demeter was worshiped by Egyptians under her Greek name.[46] The gods were remote. Sarapis was one attempt to fill the void, the concept of divine kingship another. Regarding the kings as gods, and thus obliging them to benefit men, was the only way to avoid rendering them tyrants.[47] Thus, the Ptolemaic kings were thought of as descendants of Dionysos and Herakles. Theokritos seems to have written his Herakliskos for an agonistic festival, presumably the Basileia and Genethlia of Philadelphos in 285, when the young prince joined his father as coruler, or at least became crown prince. In the poem young Herakles is described as if he were Philadelphos. Later, in 166 AD, the elevation of Commodus to the position of Caesar was celebrated by a statue that depicted the young prince as Herakliskos killing the two snakes, an event also crucial in Theokritos' poem for Philadelphos. The statue of Commodus is clearly in line with the Ptolemaic tradition, and one wonders whether there once existed similar representations of Ptolemaic kings in the role of Herakliskos killing snakes.[48]

There was an additional legend that had Ptolemy I almost appear as a son of Zeus. Philip, the father of Alexander, had a lover, Arsinoe, herself a descendant of Herakles and sharing most of the ancestors of the house of Philip. When she was pregnant, Philip married her off to Lagos. The child, the later Ptolemy I, was exposed, but an eagle fed him and, extending his wings, protected him from sun and rain. Ptolemaic coins spread the message. On the front they show the face of the ruler

46. J. Quaegebeur, "Cultes égyptiens et grecs en Égypte," in *Egypt and the Hellenistic World*, 306; Peremans, *Vreemdelingen*, 10.

47. Different, and yet ultimately comparable, is the situation of the Greek cities which had to defer a substantial amount of their power and authority to a ruler who was not part of the cities' power structure; seeing this ruler as a god kept intact the traditional ideology of autonomy of the city; see S. Price, *Rituals and Power: The Roman Imperial Cult in Asia Minor* (Cambridge, 1984), 25ff., esp. 29f. For a systematic analysis of the various forms in which the ruler cult developed in Ptolemaic Egypt now see H. Hauben, "Aspects du culte des souverains a l'époque des Lagides," in *Egitto e storia antica* 441–467.

48. For the interpretation of Theokritos' Herakliskos see Koenen, *Agonistiche Inschrift*, 79–86; for Rome see W. H. Gross, *Herakliskos Commodus*, Nachr. Akad. Göttingen, phil.-hist. Kl. 1973, no. 4, *LIMC* IV.2.555, no. 1639. It would make no difference for the argument if the statuette should depict Commodus' brother Annius, who became Caesar at the same time.

and on the back the eagle of Zeus. As brother of Alexander, Ptolemy was the legitimate king of Egypt. He was a descendant of Zeus. He was the exposed child, the child whose father is not quite known and therefore may be divine. Such myths existed among many peoples.[49] In this special case, they implied a concept of Egyptian kingship according to which the king is the son of the highest god, of Amun-Re, the Egyptian equivalent of Zeus. The king was believed to have been fathered by his predecessor acting in the role of Amun-Re (see section II.1.c [5]). The particular image of the wings protecting the baby from sun and rain corresponds to the traditional and common image of the pharaoh protected by the wings of Horus the falcon. On the Ptolemaic coins the eagle of Zeus holds lightning bolts in his talons and, at least in some issues, spreads his wing as if flying up, but certainly not in imitation of the Egyptian falcon's protective gesture. Greek art would not imitate Egyptian art and symbols and adopt its pictorial programme but rather try to express an Egyptian idea in Greek pictures.[50] Hence it was possible to

49. G. Binder, *Die Aussetzung des Königskindes: Kyros und Romulus,* Beitr. z. klass. Phil. 10 (Meisenheim, 1964); for Ptolemy see pp. 72 and 151f.

50. See above, section I. It is, for example, (1) a traditional Egyptian pictorial theme to show an oversized pharaoh single-handedly killing his enemies. The Greeks would express the same idea by presenting the king as a youthful and heroic wrestler. In one of the statuettes (in Istanbul), the wrestler has little wings above the temples of his head. He is Hermes, and the symbol indicating this is Greek. But Hermes stands in for Egyptian Horus, and the entire idea of victorious Horus is Egyptian. In another statuette (in Baltimore) the king wears the Greek diadem, but on his forehead appears the uraeus (cf. the portrait of a Greek pharaoh in fig. 1b). Here the Egyptian symbol is accepted, but complemented by the Greek symbol. In fact, the presence of the Greek diadem makes it clear that the wrestler represents a king, not a god. See H. Kyrieleis, "Καθάπερ Ἑρμῆς καὶ Ὧρος," in *Antike Plastik,* no. 12, edited by F. Eckstein (Berlin, 1973), 133–146; H. Heinen, "Monarchie ptolémaïque," pl. IV and p. 195; Koenen, "Adaption," 170f.; H. P. Laubscher, "Ein ptolemäisches Gallierdenkmal," *AK* 30, Heft 2 (1987): 131–154 esp. 148f. (2) For the Egyptians, the crown prince is young Horus (as is the king, under a different aspect). This theme is expressed by the Greeks identifying the king with Herakliskos (see above and n. 48). (3) Another example is provided by statuettes showing Philadelphos riding on horseback or standing; his head is covered by the skin of an elephant; its trunk is raised so that it looks almost like a uraeus (Kyrieleis, *Bildnisse,* pls. 8.5 and 6; 9.1 and 2; 10.1–3; cf. pp. 115f.). The pictorial representation is Greek. The elephant skin replaces Herakles' lion head, and this skin and the raised trunk are taken from the tradition which represents Alexander with the same elephant skin and the horns of Amun, thus reviving memories of Alexander's expeditions to India and to Siwa (the motif occurs on coins of Ptolemy Soter; see, for example, Kyrieleis, *Bildnisse,* pl. 1.1; G. Grimm, "Die Vergöttlichung Alexanders des Grossen in Ägypten und ihre Bedeutung für den ptolemäischen Königskult," in *Ptolemäische Ägypten,* 103–112). Furthermore, this implies assimilation to Dionysos, the conqueror of the world; precisely this is the claim taken up by Philadelphos. In pharaonic ideology, Egypt is the world and Pharaoh rules the world. Thus the ideas behind this iconographic web formulate the ideology of pharaonic kingship too. (4) An example of Egyptian art incorporating a Greek motif into an Egyptian pictorial program is the representation of Pharaoh in his traditional

see the eagle of Zeus on the coins without thinking of such ramifications, but those who understood the Egyptian ideology would know better.

1. The Eponymous State Cults in Alexandria and Royal Cults in Egyptian Temples

At this point some attention needs to be given to the cult of Alexander and the Ptolemies. The theological concept was Greek. It proceeded from the idea that the deeds of some men had shown them as founders, benefactors, and saviors of their cities, and therefore as heroes or gods. The cult was founded by Ptolemy I Soter in the city of Alexandria (see section II.1.b), and the names of the priests were used for dating all official documents, both state and private, even those of minor importance. Dating by eponymous priests or other officials was a common practice of Greek cities.[51] But the Alexandrian eponymous priesthoods were used not only for the city, but throughout the entire kingdom. For the purpose of dating, it would have been sufficient to count the years of the king, as was the Macedonian as well as the oriental practice.[52] Admittedly, from our point of view eponymous dating is very helpful in determining the date of a document, because regnal years are frequently

posture of killing enemies; but he is converted into a horseman—an allusion to his Greekness (see Philopator on top of the Raphia Stele and Gallus on top of his stele in Philae; and cf. my contribution in L. Koenen and D. B. Thompson, "Gallus as Triptolemos on the Tazza Farnese," *BASP* 21 [1984]: 110–156, esp. 132–134). R. R. R. Smith, *Hellenistic Royal Portraits* (Oxford, 1988), esp. 86–88, denies any influence of Egyptian art on Greek art (he accepts the opposite direction), but his argument concerns the separate iconographical traditions, not the possibility of expressing similar ideas in both traditions. Yet Greek artists adopted not only ideas but also Egyptian iconographic motifs, albeit in Greek stylization. The widely recognized symbolism was too telling to be rejected. The scepters of Arsinoe II and III with lotus and uraeus (figs. 3a and b, discussed at the beginning of this paper) are an example; another is the bronze statuette of Euergetes III as Hermes-Triptolemos alias Thoth-Horus discussed by H. P. Lauscher, "Triptolemos und die Ptolemäer," *Jahrbuch des Museums für Kunst und Gewerbe Hamburg*, vol. 6/7 (1988): 11–40, esp. 11–19. The king carries a lotus leaf on his head, above the middle of the forehead, and is standing on another lotus leaf. The leaf on the head as well as the legs are flanked by pairs of wings, signifying Hermes. The leaf on the head replaces the pharaohs' uraeus; the lotus under the feet recalls the traditional image of Horus on the lotus flower.

51. For a survey see R. Sherk, "The Eponymous Officials of Greek Cities," *ZPE* 83 (1990): 249–288, *ZPE* 84 (1990): 231–295, *ZPE* 88 (1991): 225–260, *ZPE* 93 (1992): 223–272, esp. 259–265 on the eponymous cults in Alexandria and Ptolemaïs (no. 212); the final part will appear in 1993.

52. The Macedonians counted regnal years, but this was also Egyptian practice. The Macedonian year, however, followed a different rationale. The first Egyptian year ran from accession to Thoth 1, the beginning of the next civil year, which then was counted as the second regnal year. The first year could thus be very short. The Macedonians made the accession day the new year's day of the regnal year, at least in principle. Thus, the first year runs from the day of accession till the day before the first anniversary, when the second year begins.

ambiguous. Under the early Ptolemies three different regnal years were used: one according to the Macedonian practice, another according to Egyptian custom, and a third one for the fiscal year.[53] In official documents, dating by eponymous priests supplemented the regnal year; and in this combination, the dating by eponymous priests indicated that the regnal years were counted the Macedonian way. But because of the length of the list of the eponymous priests, dating by eponymous priests was a very cumbersome way to resolve the ambiguity of regnal dating. In short, the practical purpose was hardly a sufficient reason for the creation of a single eponymous cult, not to speak of the ever increasing numbers that flourished in Alexandria and Ptolemaïs. Hence, eponymous dating in Egypt fulfilled, by and large, a symbolic function. On a first level, through the combination of dating by regnal years and eponymous officials, the kingdom represented itself in the double imagery of kingship and Greek city, even if the latter meant little in political reality. On the second level, the eponymous officials were priests, not other state or city officials. The combination of regnal years and eponymous priests of the state cult pointed to the unity between the administrative and religious functions of kingship. And on a third level, the eponymous cults in Alexandria were devoted to Alexander, the founder of the city,

53. The Egyptian calendar was perhaps the most important contribution which the Egyptian tradition gave to the Ptolemaic economy and administration. Already during the reign of Philadelphos, the Macedonian calendar lost all practical importance and became ceremonial, and by 257 BC a certain Numenios being ordered to meet the dioiketes Apollonios in Memphis did not know the Egyptian equivalent to the Macedonian date of the king's birthday (P. Cairo Zen. 4.59541). It is significant that for fifteen years Philadelphos was not bothered by the fact that the Egyptians would not accept the count of regnal years which he had introduced for the Macedonian count in 282 BC. But in 267 BC the need for reform could no longer be denied, and the Egyptian count was changed too (n. 61). By this time the Egyptian calendar had taken over in all other regards. For a while an additional financial year was used, but it was based on the Egyptian calendar; the only difference was its beginning on Mecheir first—that is, in March—thus producing a year that should have been attractive for an agricultural economy. It is not known when this financial year was introduced; but it might be noted that in the year 21 of Philadelphos it practically coincided with the Macedonian regnal year. The financial year was never in general use.

Moreover, when Philadelphos changed the count of the Macedonian regnal year as early as in his first year (282 BC; see n. 61) and the first year became the fourth, he calculated the retroactive first year from his elevation to coregent (possibly on Dystros 12, 285, his so-called birthday; see n. 110 [2 b]) to the next Macedonian new year's day of his own count (presumably Dystros 25, 285; see n. 96). The new first year may have had less than two weeks. The retroactive count was of no practical consequence, but it avoided having the period of Dystros 12–24 occur twice in the same year. The method followed the practice used for the Egyptian regnal year. See nn. 52 and 61; and Koenen, Agonistiche Inschrift, 52f. An attempt by Euergetes to introduce an intercalation system into the Egyptian calendar was an instant failure.

and to the subsequent Ptolemies. Thus the state cult of the city propagated the divine nature of kingship and the kings; the state cult was a means of propagating the ideology of Ptolemaic kingship.[54]

The main facts are well known.[55] We may turn to an example and look at the protocol of the decree of the synod of Egyptian priests assembled in Memphis mainly for the coronation of Ptolemy V Epiphanes in 196 BC; this decree is best known through the Rosetta inscription. It combines the Greek eponymous dating with the Egyptian dating by the royal titulary, the "Great Name," of Epiphanes and is accompanied by the regnal year 9.[56]

a. The Egyptian Royal Titulary of Epiphanes and the Eponymous Priests of His State Cults: The Formulas

The Greek version of the synodal decree of Memphis (Rosetta inscription):

βασιλεύοντος　　　　　　τοῦ νέου καὶ παραλαβόντος τὴν
　　　　　　　　　　　βασιλείαν παρὰ τοῦ πατρός,
κυρίου βασιλειῶν　　　　μεγαλοδόξου

54. The propagandistic use of the dating formula goes beyond these generalities. I have called the Ptolemaic dating formula a seismograph that indicates the changes in both the cult of the dynasty and the power structure (in the edition of P. Köln inv. no. 5063 [*P. Köln* 2.81; *SB* 10763]: "Kleopatra III. als Priesterin des Alexanderkultes," *ZPE* 5 [1970]: 71).

55. J. Ijsewijn, *De sacerdotibus sacerdotiisque Alexandri Magni et Lagidarum eponymis* (Brussels, 1961), 196; P. M. Fraser, *Ptolemaic Alexandria* (Oxford, 1972) 1:214–226; F. W. Walbank, *CAH*[2] 7.1.96–99; Préaux, *Monde hellénistique* 1:255–261; C. Habicht, *Gottmenschentum und griechische Städte*, 2d ed., Zetemata 14 (Munich, 1970), 230ff.; Koenen, "Adaption," esp. 154–170; for the Philopatores also see E. Lanciers, "Die Vergöttlichung und die Ehe des Ptolemaios IV. und der Arsinoe III," *APF* 34 (1988): 27–32; for the modern *fasti* of these priesthoods see G. Van der Veken in W. Clarysse and G. Van der Veken with the assistance of S. P. Vleeming, *The Eponymous Priests of Ptolemaic Egypt*, P. L. Bat. 24 (Leiden, 1983). I restrict myself to a brief survey.

56. *OGIS* 1.90 (*SEG* 8.463; 33.1357; cf. n. 45); for the demotic and hieroglyphic texts in transliterations and all three texts in translation see S. Quirke and C. Andrews, *The Rosetta Stone: Facsimile Drawing* (London, 1988). The upper part of the stone with the first hieroglyphic lines is broken off. The text can be supplied from parallel versions; see Spiegelberg, *Der demotische Text*, 77–86 (parallel Greek text and translations of the Egyptian texts). For the hieroglyphic version of the royal titulary I follow Spiegelberg. In Ptolemaic times, hieroglyphic was a dead language, and the hieroglyphic texts of the bilingual and trilingual decrees are artificial creations. Yet this traditional and formulaic language remains important, particularly in the case of the royal names. See also G. Roeder, *Die ägyptische Religion in Texten und Bildern*, vol. 3, *Kulte, Orakel und Naturverehrung im alten Ägypten* (Zürich and Stuttgart, 1960), 167–190. The only other king for whom a Greek translation of the Egyptian royal titulary is extant is Philopator; see H.-J. Thissen, *Studien zum Raphiadekret*, Beitr. z. klass. Phil. 23 (Meisenheim, 1966); Koenen, "Adaptation," esp. 155 n. 36. For the connection of the Egyptian royal titulary with Greek dating and stylization of decrees see Jean Bingen, "Normalité et spécificité de l'épigraphie grecque et romaine de l'Égypte," in *Egitto e storia antica*, 15–35, esp. 20–24.

 τοῦ τὴν Αἴγυπτον καταστησαμένου
 καὶ τὰ πρὸς τοὺς |² θεοὺς εὐσεβοῦς,

ἀντιπάλων ὑπερτέρου τοῦ τὸν βίον τῶν ἀνθρώπων
 ἐπανορθώσαντος,
 κυρίου τριακονταετηρίδων
 καθάπερ ὁ Ἥφαιστος ὁ μέγας,
 βασιλέως καθάπερ ὁ Ἥλιος

|³ μεγά⟨λου⟩ βασιλέ⟨ως⟩ τῶν τε ἐκγόνου θεῶν Φιλοπατόρων
 ἄνω καὶ τῶν κάτω χωρῶν ὃν ὁ Ἥφαιστος ἐδοκίμασεν,
 ὧι ὁ Ἥλιος ἔδωκεν τήν νίκην,
 εἰκόνος ζώσης τοῦ Διός,

υἱοῦ τοῦ Ἡλίου Πτολεμαίου, |
 ⁴ αἰωνοβίου,
 ἠγαπημένου ὑπὸ τοῦ Φθᾶ

ἔτους ἐνάτου
ἐφ' ἱερέως Ἀέτου τοῦ Ἀέτου
Ἀλεξάνδρου
καὶ Θεῶν Σωτήρων
καὶ Θεῶν Ἀδελφῶν
καὶ Θεῶν Εὐεργετῶν
καὶ Θεῶν Φιλοπατόρων
καὶ |⁵ θεοῦ Ἐπιφανοῦς Εὐχαρίστου
ἀθλοφόρου Βερενίκης Πύρρας τῆς Φιλίνου,
 Εὐεργέτιδος
κανηφόρου Ἀρσινόης Φιλαδέλφου Ἀρείας τῆς Διογένους,
ἱερείας Ἀρσινόης Φιλοπάτορος Εἰρήνης |⁶ τῆς Πτολεμαίου
μηνὸς Ξανθικοῦ τετράδι, Αἰγυπτίων δὲ Μεχεὶρ ὀκτωκαιδεκάτηι ⸺ ⸺ ⸺

The hieroglyphic version (see n. 56):

|³⁸ In year 9 on the fourth of Xandikos, which in the reckoning of the inhabitants of Egypt is the second month of the winter season under the Majesty of

Horus-Re (*Ḥr*)	the Youth who has appeared as king in place of his father
Lord of the Two Crowns (*nb.tj*)	the glorious[57] who has made firm the Two Countries, who has made Egypt beautiful, who in his heart is pious towards the gods

57. The Egyptian versions offer a traditional phrase which is best translated: "great in his might." Hieroglyphic *pḥ.tj* is frequently ascribed to kings and refers to physical strength as well as to power and reputation. The Greek translation interprets the word in the latter sense. See Thissen, *Studien*, 31f.; and Spiegelberg's translation, *Der demotische Text*, 31.

Horus triumphant over Seth of
 Ombos (*Ḥr nb.tj*)

King of Upper and Lower Egypt
|[39] (*njśwt-bjt*)

Son of Re (*s3 Rʿ*)

when . . .

who is green life for men,[58]
Lord of the *ḥb-śd* festival like
 Ptah-Tnn
king just like Re
the heir of the two Father-loving
 Gods
chosen by Ptah
Wsr-k3-Rʿ ("Mighty is the Spirit of
 Re")
Living Image of Amun
Ptolemy
Living forever,
Beloved by Ptah,
the Shining God (= Epiphanes),
the Charitable God
 (= Eucharistos),
the son of Ptolemy and Arsinoe,
 the two Father-loving Gods

b. The Development of the Greek Eponymous State Cults
and Egyptian Temple Cults of the Ptolemies

The protocol of the synodal decree of Memphis combines the Egyptian royal titulary (the king's "Great Name") with the regnal year and with the eponymous dates of the state cults in **Alexandria.** The count of regnal years is part of both the Egyptian and the Macedonian tradition (see n. 52) and thus mediates between the Egyptian and the Greek elements. At Epiphanes' time the priesthood of Alexander contained the series of Ptolemaic rulers from Ptolemy I Soter and Berenike I to Epiphanes, the reigning king; and several other eponymous cults had been added. The development of this formula is characterized by the following steps:

In 290/89 **Ptolemy I Soter,** who claimed the same lineage as Alexander, founded a new cult of Alexander[59] with an eponymous priesthood, at the time called simply the "priest." Ptolemaios himself had already received cultic honors on the island of Rhodes from the league of the Nesiotai and in Ptolemaïs as founder of the city. Moreover, at least once,

58. *w3ḏ ʿn*, green life; Spiegelberg, *Demotische Text,* translates the hieroglyphic text as "lebensgrün für die Menschen." The corresponding demotic text is close to the Greek.

59. At the time when this institution was founded, a cult dedicated to Alexander the founder seems already to have existed in Alexandria. Ptolemy I had buried Alexander first in Memphis, then in Alexandria.

he and his wife Berenike received a dedication as θεοὶ σωτῆρες in Egypt. All these honors were based on specific merits in specific cases, but they went one step farther: on coins Ptolemy Soter wears the aigis of Zeus. He thus appears Zeus-like. The genealogy I mentioned rendered him a descendant of Zeus. But the deification of the Θεὸς Σωτήρ was only established by his son and successor Philadelphos in 280 BC.

Ptolemy II Philadelphos founded a cult of himself and his wife Arsinoe II, probably in 272/1 BC. At this time Arsinoe II already had the name Philadelphos,[60] and she was still alive. Now the title of the eponymous "priest" became "the priest of Alexander and the Θεοὶ 'Αδελφοί,"[61] with omission of the *Theoi Soteres* for whom, however, Phi-

60. Fraser, *Ptolemaic Alexandria* 1:217 and 2:367 no. 228; Koenen, "Adaption," 157, 159.

61. *P. Hib.* 2.199 mentions the priest of Alexander and the Gods Adelphoi for the fourteenth year. Much ink has been spent on the question as to whether the fourteenth year was 272/1 or 269/8 BC. The problem stems from the fact that Philadelphos used different ways of counting his Macedonian regnal year. He began by counting his accession as the starting point (January 6/7, 282), but later changed to a count beginning with his elevation to coregent (presumably on December 15/16, 285). R. A. Hazzard has now shown that Philadelphos changed the count of the Macedonian year already in the course of his first year, so that year 1 (282/1) became year 4 ("The Regnal Year of Ptolemy II Philadelphos," *Phoenix* 41 [1987]: 140–158). In the month of Dios the news of the change had already reached the city of Telmessos (*SEG* 28.1224; M. Wörrle, "Epigraphische Forschungen zur Geschichte Lykiens II," *Chiron* 8 [1978]: 201–246, esp. 201ff.), and hence the reform must have been made before the beginning of that month: according to Koenen, presumably before Sept. 5/6, 282 (*Agonistiche Inschrift*, 91ff.); or according to E. Grzybek, before Aug. 6/7 (*Du calendrier macédonien au calendrier ptolémaïque*, Schweiz. Beitr. z. Altertumsw. 20 [Basel, 1990], 184; Grzybek assumes an additional intercalation, but see n. 110). The fourteenth year of *P. Hib.* 2.199, therefore, counts from his elevation to joint ruler and equals 272/1 BC. According to the Pithom Stele, Arsinoe died in the seventeenth year (reformed count); according to the Mendes Stele in Pachon of year 15 (original count), when the funeral rites were performed over four days in Pachon and culminated on the tenth of that month—hence she died before Pachon 10, that is, before July 5, 268 BC. According to the scholion to Kall. F228.7, she ascended to heaven at the new moon, before the reappearance of the crescent, at least if we accept E. Grzybek's new reading and interpretation: ὡς ἔτι πά(σης) σελήν(ης) ἡρπασμένης (*Calendrier macédonien*, 110–112; P. van Minnen refers me to ἐν ἁρπαγῇ τῆς σελήνης for "at the new moon" in *P. Mag. Gr.* 4.753; E. Grzybek's paleographical description is at odds with what R. Pfeiffer said in favor of Diels' ὡς ἐν πασσελήνῳ ἡρπασμένης [*Kallimachosstudien* (Munich, 1922), 2 n. 1]). New moon occurred on July 2, at 3 AM in Alexandria (H. Goldstine, *New and Full Moons, 1001 B.C. to A.D. 1651* [Philadelphia, 1973], no. 9072), and Arsinoe may have died around July 3, 268 (Grzybek: July 1 or 2 [111f.]).

The determination of year 268 as the year of Arsinoe's death proceeds from the fact that the Mendes and the Pithom Stelai date the event to years 15 (original count) and 17 (reformed count) respectively. In the Egyptian count, Philadelphos changed his regnal years at a much later date, on October 29, 267, when the beginning year was counted as the nineteenth instead of the seventeenth year (Hazzard, "Regnal Year," 147f.; cf. P. W.

ladelphos founded separate cults. But the *Theoi Soteres* appear in the
series of gods by whom, in continuation of pharaonic practice, people
would officially swear. For example, a papyrus of 250 BC testifies that
somebody "swears by King Ptolemy, the son of King Ptolemy and Queen
Berenike, the Soteres, and by Arsinoe Philadelphos, the Gods Adelphoi,
and by the Gods Soteres, their parents."[62]

In his fifth year (243/2) **Euergetes** added his name and that of his

Pestman, *Chronologie égyptienne d'après les textes démotiques*, Pap. Lugd.-Bat. 15 [Leiden,
1967], 18). Hence, the priests of the Bucheum in 271/0 still used the old count from the
accession to sole ruler (283/2; Koenen, *Agonistische Inschrift*, 45). The graffito found in the
building pit of the Satis Temple on the island of Elephantine attests that presumably Ptol-
emy II Philadelphos received a report about the temple in his second regnal year, which
was the twenty-fifth year of his life (U. Kaploni-Heckel, "Zum demotischen Baugruben-
Graffito vom Satis-Tempel auf Elephantine," *MDAI(K)* 43 [1987]: 155–172, esp. 160f. and
165). If we accept his official birthday on Dystros 12, 308/7 BC, the twenty-fifth year of his
life runs presumably from December 25, 282, to January 12, 281 (Koenen; or Novem-
ber 25, 283, to December 12, 282, Grzybek); part of this year falls into his second Egyptian
regnal year in the original count from his accession as sole ruler (November 2, 282 to
October 31, 281). The scribe of the graffito had access to, and used without change, infor-
mation contemporary with the event, which followed the calculation of the regnal years
common in Egyptian documents of that time; hence the dates continue to reflect the old
count of the regnal years. Similarly, the priests of the Mendes Stele (written after the
twenty-first year, that is, after 265/4) retain the calculation from Philadelphos' accession as
sole ruler; hence the year . 15 is 269/8. In contrast, the priests of the Pithom Stele (also
written after the twenty-first year) adopted the new method of counting the years from
Philadelphos' elevation to coregency. Thus, year 17 is also 269/8 (see Grzybek, *Calendrier
macédonien*, 72f. and 106f.). Confirmation for the use of this count may come from a ref-
erence to the king's visit to "Asia" and "Palestine," if this event still belongs with those listed
for the sixth year (Grzybek, p. 72), that is, 280/79, during the Syrian War of Succession
(not during the First Syrian War of 274–271/0 as is commonly believed; see K. Winnicki,
"Feldzug des Ptolemaios Philadelphos," *JJusP* 20 [1990]: 157–167).

My earlier treatments of the date of *P. Hib.* 2.199 came to the same chronological
conclusion for the regnal count and the year of this papyrus, but they were based on wrong
assumptions about the date of Philadelphos' reform of the Macedonian count of the regnal
year ("Adaption," 157 n. 41; *Agonistiche Inschrift*, 43–45 and tables pp. 87–98; also see
A. E. Samuel, *Ptolemaic Chronology*, MB 43 [Munich, 1962], esp. 25–28; Wörrle, "Epigra-
phische Forschungen," 212–216; Clarysse and Van der Veken, *Eponymous Priests*, n. on
17–21). The confusion resulted from my failure to recognize that Philadelphos reformed
the Egyptian calendar at a much later date than the Macedonian calendar.

62. *P. Sorb.* 1.32.4–9 with notes. The list of gods was to grow in a similar way as in the
title of the priest of Alexander (but with reversed order). For example, at the time of
Epiphanes, one would swear "by King Ptolemy, the son of Ptolemy and of Arsinoe the
Gods Philopatores, and by the Gods Philopatores and the Gods Adelphoi and the Gods
Euergetai and the Gods Soteres and Sarapis and Isis and all the other gods" (*P. Petr.*
2.46 [Wilcken, *Chrest.* 110]). Later, of course, the formula was shortened (e.g., *P. Oxy.*
49.3482.28–29 of 73 BC), just as the dating formula was abridged. The inclusion of other
gods corresponds to traditional Egyptian practice; the king could either replace old gods
or be invoked side by side with them (cf. E. Seidl, *Der Eid im ptolemäischen Recht* [1929],
45–48), but the generalization "and all the other gods" is Greek (cf. nn. 172 and 182).

wife Berenike II to the title of the priest of Alexander and the *Theoi Adelphoi;* in the ninth year (238 BC) the Egyptian priests who were gathered at Kanopos followed the precedent of the Greek cult and, in their own cults, added the title of priest "of the *Theoi Euergetai*" to the titles of all priests in the entire country; the Euergetai were σύνναοι of the Egyptian gods. In addition to the existing four classes of priests they created a new class called πέμπτη φυλὴ τῶν Εὐεργετῶν θεῶν.[63] They resolved to enlarge the honors which in the Egyptian temples were already given "to King Ptolemy and Queen Berenike the Gods Euergetai and for their parents the Gods Adelphoi and their ancestors the Gods Soteres" (20–22 [= 15–17]).[64] It is unfortunately not clear whether this refers to separate cults or whether, as seems likely, these cults were meant to be dynastic: the cults of "the *Theoi Euergetai, Theoi Adelphoi,* and *Theoi Soteres.*" But Alexander, the first name to be mentioned in the series of divine names in the Greek title of his priest, is not included in the Egyptian version, and the names are arranged in reverse order.[65] From Euergetes on, we indeed find priests identified as "servants" of the royal couple and of other gods; and in the course of history the ancestors of the royal couple were added and the list grew just as the title of the priest of Alexander kept growing. Later, there were priests identified by the main god of the temple where they served, plus the royal couples from the Philadelphoi or Euergetai on to the reigning king. The theory that the Egyptians worshiped only the deceased kings can no longer be maintained. Although they began their own ruler cult with Arsinoe II (see nn. 68, 69) and, in contrast with the Greeks, only after her death, already with Euergetes this distinction no longer applies. The Egyptian cult developed in the Egyptian temples, while the Greek ruler cult, that of Alexander and of the Ptolemies as well as that of individual kings and queens, developed in Alexandria and other places where the Greeks lived. Greeks and Egyptians followed their own traditions, yet the Greek and Egyptian institutions of the ruler cult fulfilled similar functions. It is essential to realize that the Egyptian priests accepted the Greek cult names of the royal couples. We will return to this below.[66]

63. *Can.,* Greek 24f. (Kôm el-Hisn 19). This resolution was only partly implemented, and the title was merely given to specific individuals; see Thompson, *Memphis,* 134, and below.

64. *Can.,* Greek 33 (Kôm el-Hisn 26), refers to monthly celebrations in honor of the *Theoi Euergetes* which were introduced κατὰ τὸ πρότερον γραφὲν ψήφισμα.

65. Cf. the genealogically arranged series of Ptolemaic kings by whom the official oath was sworn; see nn. 62 and 172.

66. For the preceding paragraph see J. Quaegebeur, "Egyptian Clergy and the Ptolemaic Cult," *AncSoc* 20 (1989): 93–113; for the titles of priests referred to above, see 104f. It is worthwhile to quote Quaegebeur's conclusion: "I have tried to demonstrate that, parallel with the Hellenistic dynastic cult, a native version developed which encompassed,

Philopator, as he was already named as a child, received veneration from the Egyptians early on; after his marriage to Arsinoe III, Theban priests were called "priests of Amun, the Gods Adelphoi, the Gods Euergetai, and the Gods Philopatores." Presumably on the occasion of the wedding (in or before 220 BC) the couple added themselves to the cults of the Egyptian gods in the form in which the Greek dynastic cult flourished in the Egyptian temples.[67] Then, beginning with the seventh year (216/5 BC)—that is, with the year following the Battle of Raphia—Philopator and Arsinoe III were added to the Greek cult and the dating formula. It is certainly unexpected that the inclusion of the Philopatores in the Alexandrian cult was anticipated by first adding them under their Greek names to the Egyptian cults. The road to this initiative was paved by the enthusiasm with which the Egyptian temple had accepted Arsinoe II and, consequently, the *Theoi Adelphoi*.[68]

In the following year, Philopator included Ptolemy Soter and Berenike in the title of the priest of Alexander in their proper chronological order, thus finally establishing the genealogical line of the dynasty. This last step was not followed by the Egyptian dynastic cult, which excluded Alexander and Ptolemy Soter. In the Greek cult, the Ptolemaic god-kings were σύνναοι of Alexander; in the Egyptian cult, they were σύνναοι of the Egyptian gods. Thus, his insertion would have been theo-

from Ptolemy III on, the ancestors as well as the living monarchs. I prefer not to use the passive term 'reception' in connection with the dynastic cult since the higher clergy participated actively in the development of their version of the royal cult, which had always been part of the temple ritual but was adapted to the history of the new royal house." For veneration of the ancestors of the ruling king in Egyptian temples see also Winter, "Herrscherkult." Recently D. Fishwick (following E. Winter) has again asserted that only deceased Ptolemies were worshiped in Egyptian temples ("Statues Taxes in Roman Egypt," *Historia* 38 [1989]: 335–347. For the Egyptian priest of the royal cult, see also E. Lanciers, "Die ägyptischen Priester des ptolemäischen Königskultes (Zusammenfassung)," in *Life in a Multi-Cultural Society*, 207–208.

67. *P. Vatic. dem.* 2037B of Thoth of the third year (October 15 to November 15, 220); the title of the priests occurs in the signature. It is significant that the dating formula of the document does not contain the addition of the *Theoi Philopatores*. Before the document attracted renewed attention, the wedding was dated by J. Quaegebeur to shortly before the Battle of Raphia (June 8, 217 BC; "Documents Concerning the Cult of Arsinoe Philadelphos at Memphis," *JNES* 30 [1971]: 248 with n. 60; for the date of the battle see Koenen, "Adaption," 165 n. 64). For the interpretation of *P. Vatic. dem.* and its far-reaching consequences see Lanciers, "Vergöttlichung." For a discussion of the problems see also Huss, *Aussenpolitik Ptolemaios' IV,* 260–265.

68. See especially J. Quaegebeur, "Ptolémée II en adoration devant Arsinoe II divinisée," *BIFAO* 69 (1971): 191–217, "Documents"; cf. eundem, "Reines ptolémaïques et traditions égyptiennes," in *Ptolemäische Ägypten*, 245–262, and "Cleopatra VII," 42; Thompson, *Memphis,* 126–138. For the material interest that the temples had in founding cults for Arsinoe II see section II.1.e.

logically difficult. Here is the problem: from the Egyptian point of view Alexander could merely have become the first in the series of ancestors; thus he would not have had the primary position which he had in the Greek series, where he was the god who originally and ultimately gave his name to the title of the priest. If, however, it was better to leave Alexander out of the Egyptian cult, then it was also convenient to avoid the introduction of Soter into the series. To be sure, there was no theological problem, and already under Euergetes the priests had decided in principle to include Soter in the series of kings to be venerated in the Egyptian temples. But it seems it was convenient not to add him to the series, since his insertion would have brought the question of Alexander into play. Doing nothing was better, as long as the Ptolemaic kings did not insist that the temples follow the lead of the Alexandrian cult.[69]

In the end,[70] the king became, indirectly, his own priest. **Ptolemy VIII Euergetes II** was priest of Apollo in Cyrene, most likely when he was ousted from Egypt by his brother and resided in Cyrene. Apollo was identified with Horus, and the Egyptian king lived the role of Horus. Being king and priest of Apollo implied a claim to the Egyptian throne. But it also opened the door for a development which let later Ptolemaic kings become priests of Alexander and the Ptolemies, including themselves. **Ptolemy IX Soter II** had this priesthood through almost his entire reign (116–107; and once before [135/4]), **Ptolemy X Alexander** at least for three years (107–105 and 84/3), and **Kleopatra III** at least once (105/4). It was common throughout the Hellenistic world that, in times of economic hardships, Greek cities made the local god or goddess serve as eponymous priest: the deity was her or his own priest. This meant in practical terms that no person wealthy enough had been found and that, hence, the temple of the deity assumed the costs of the priesthood. In this respect, the feature is perfectly Greek. It is also understandable that Ptolemaic kings undertook to fill in and to bear the costs. Yet the fact that they, being kings, implicitly worshiped themselves is without precedent in the Greek institution. The presence of Kleopatra III, a woman, in a male priesthood is even more remarkable. It is reminiscent of Queen Hatshepsut, who was depicted with the male beard of the Egyptian king; but there are closer historical antecedents: in Edfu, Berenike

69. For the silent exclusion of Alexander and Soter see Winter, "Herrscherkult," 156f. ("Ebenso scheint mir der Beginn der Herrscherreihen in den ägyptischen Templen mit Ptol. II und Arsinoe II aus dem hieroglyphischen Material nicht erklärbar"). Cf. Quaegebeur, "Cleopatra VII," 42. For the introduction of the name of Philometor into the title of the dynastic priest see section II.1.d (Philometor).

70. For certain changes under Ptolemy V Epiphanes see E. Lanciers, *ZPE* 66 (1986): 61–63.

II, the wife of Euergetes, received a female Horus-name and thus was regarded as pharaoh.[71]

In addition to these male priesthoods for the king, **queens** also received their separate cult, in Egyptian as well as in Greek temples.[72] The priestesses of their Alexandrian cult became eponymous. Philadelphos created the priesthood of the *kanephoros* of Arsinoe Philadelphos either in 269/8, when Arsinoe II was still alive, as we now know, or more likely after her death in the beginning of July 268 (n. 61).[73] After her death, the king was a god on earth and the queen a goddess in heaven. In 211/0 Philopator added the Athlophoros of his mother, Berenike Euergetis, and in 199/8 Epiphanes included a priestess of his mother, Arsinoe. There were still more changes to come, and some indicated a slow propagandistic Egyptianization of the ideas, albeit not of the forms in which the cults were practiced.[74] Suffice it to say that the Ptolemaic queens took an extraordinary part in the deification. King and queen were the divine couple in the image of Zeus and Hera.

There was a second eponymous state cult of the Ptolemies in Egypt, founded by Ptolemy IV Philopator in **Ptolemaïs** in the south of Egypt, north of Thebes, in 215/4, when he also inserted Ptolemy I into the Alexandrian title of the priest of Alexander. The cult in Ptolemaïs was

71. For documentation of the Ptolemaic priesthoods see Van der Veken's list in *Eponymous Priests;* for the king serving as his own priest see R. Sherk, "Eponymous Officials," *ZPE* 93 (1972): 265; on Kleopatra III see Koenen, "Kleopatra III"; for Berenike's Horusname see Quaegebeur, "Egyptian Clergy," 98 with n. 27; for Hatshepsut see also n. 8 and section II.1.d (Philometor).

72. For the evidence of Egyptian cults see the literature quoted in n. 68.

73. The first securely attested kanephoros is Aristomache daughter of Aristomachos in 267/6. Matela or Metala of *P. dem. Brux.* may now rather be assigned to 259/8; and Eukleia daughter of Aristodikos could have been the first kanephoros *or* could belong to a later year. See Van der Veken, in *Eponymous Priests* 6–7, and Fraser, *Ptolemaic Alexandria* 2 : 366 n. 225.

74. In 131/0 Euergetes II created the eponymous priesthood of the "Hieros Polos of Isis, the Great Mother of the Gods" for his wife and niece Kleopatra III. In this title, the name of the queen is replaced by the name of the deity, and the queen thus appears as a form of an Egyptian deity (cf. Hauben, "Aspects"). For the eponymous cults this was without precedent. Later, in 107/6, the same queen received cults as "Kleopatra Thea Aphrodite also called Philometor" (or "Euergetis"), where at least she retained her Greek cult name and the goddess was called with her Greek name, although she represented Hathor. This priest served "for life" (διὰ βίου; Koenen, *ZPE* 5 [1970]: 73 with n. 15), a form which elsewhere in the Greek world indicated that the priest had paid for it in most cases by an endowment for the future costs of the cult (for all this as well as for another cult name and three more priestesses of Kleopatra III see Sherk, "Eponymous Officials," 263 and 269.) The idea of an eponymous priest holding his office for life defeats the purpose of dating (W. Otto and H. Bengtson, *Zur Geschichte des Niederganges des Ptolemäerreiches,* ABAW, phil.-hist. Abt. 17 [Munich, 1938], 157 n. 3), but, at least in Ptolemaic Egypt, this was never the main purpose of the institution.

originally for **Ptolemy I Soter** and Philopator the reigning king, but over time the cults multiplied and changed. Ptolemy VI Philometor removed himself from the title of the priest of Soter, and instead received a separate eponymous cult for himself and his wife. In imitation of the Alexandrian cult he also added a kanephoros of Arsinoe. There was a tendency to build independent cults for individual kings and queens, but their accumulation reflected the dynastic line as did the title of the priest of Alexander in Alexandria. As Alexander was the core of the Alexandrian cult, so Ptolemy I was the center of the cult in Ptolemaïs. Whereas the eponymous priests of Alexandria were used throughout the kingdom, those of Ptolemaïs were only used in the south. The double list of eponymous priests of Alexandria and Ptolemaïs staged the old Egyptian symbolism of the two countries in a new form: it was the king's ritual duty to unify the Two Countries—that is, in the main meaning of the phrase, Lower and Upper Egypt.[75] Thus now, at least in the south, the Ptolemaic rule presented itself in two different sets of eponymous state cults, each of them stretching from the present ruler or the royal couple back to Alexander and Soter, respectively. The dynastic line that represented the succession, by itself a perfectly Greek thought, was capable of expressing the Egyptian idea of transferring the power of kingship from the ancestors to the reigning king.[76]

c. *The Official Egyptian Titulary of the King in the Protocols of Documents* The Greek dating formula amounted to an ever-growing protocol. Its function in part paralleled the protocol of the old Egyptian dating formula, which only temples continued to use. When it was combined with the Greek formula, the Egyptian preceded the latter. The Egyptian formula is based on the royal titulary or "Great Name" (see section II.1.a) which each king received at his coronation. It consists of five invariable titles (left column), each of which is followed by an individual name (right column). In general terms, the "Great Name" expresses the divine origin of the king, as the Greek dating formula does in a different way. It lacks an elaborate genealogy but lets the king ap-

75. More on this in section II.1.c (2) and (4); W. H. Mineur, *Callimachus: Hymn to Delos* (Leiden, 1984), 165f. on line 168; P. Bing, *The Well-Read Muse*, Hypomnemata 90 (Göttingen, 1988), 136; Koenen, "Gallus," 136 n. 64, and "Adaption," 186f.

76. See also section II.1.c (4); Quaegebeur, "Egyptian Clergy," 96, with a quotation from L. Bell, "Luxor Temple and the Cult of the Royal Ka," *JNES* 44 (1985): 283, stating that in the New Kingdom the rite served "to identify the reigning monarch with the divine ancestors."

The eponymous priesthoods made up the largest portion of the dating formula in official documents, side by side with the brief indication of the year of the king; the formula could get longer than the contract itself. Hence abbreviations were invented, but this is of no immediate interest in the present context.

pear as an incorporation of the gods, the original kings of the country. Thus, in the traditional parts of the name, in the invariable titles (left column), the king appears as the son of the creator god. He is not called a "god," as in the Greek cults. In fact, he is only a god inasmuch as he exercises the creative and protective function of specific gods. He is not a god because honored as a god for his previous deeds, but he is the visible presence of the gods because of his divine office. Therefore, he repeats the deeds which the gods have done in mythical times. The pharaoh does not earn his divinity, but he displays it by playing his role. Despite such differences, it is clear that the Greek formula serves a general purpose similar to the Egyptian titulary. It propagates the king as the divine ruler. A closer, albeit rather quick look at the different elements of the Egyptian "Great Name" and the meaning of the Greek cult names confirms this impression.[77]

(1) "The King" ($\beta\alpha\sigma\iota\lambda\varepsilon\acute{v}o\nu\tau o\varsigma$) translates the Egyptian Horus title (Hr); in the hieroglyphic version of the synodal decree of Memphis, this Horus is identified with the sun-god Re, that is, the god who expresses the cosmic and cosmological power of Re. The corresponding individual name, however, immediately adds "the young, who has received the kingship from his father." Thus, the concept of Horus the sun-god is supplemented with the other aspect of the same god: Horus the child, the son of Isis and Osiris. That Epiphanes was indeed young at the time of his coronation is accidental. Yet his actual youth may have been perceived as expressing precisely the youthful quality claimed by this part of the name. In the context of naming the king, the combination of the two aspects of Horus expresses the belief that the king exhibits the power of Horus the sun-god as well as the idea that he has received the kingship from his father Osiris. While young Horus represents the king on earth, Osiris stands for the dead king, the father and predecessor; both taken together describe the transition of power. The genealogical series of the names of the dynastic priesthood serves precisely the same function.

(2) "The Lord of the Crowns" ($\kappa\upsilon\rho\acute{\iota}o\upsilon$ $\beta\alpha\sigma\iota\lambda\varepsilon\iota\hat{\omega}\nu$) renders the $nb.tj$ title, which literally means "the Two Ladies." This title identified the king as lord of the two crowns of Upper and Lower Egypt or, in the hieroglyphic version, as representing the tutelary goddesses of Upper

77. In the following remarks I shall leave aside the changes in meaning that developed in the long history of the royal titulary in spite of its rather static terminology. For more information see Thissen, *Raphiadekret*, 27–42; J. von Beckerath, *Handbuch der ägyptischen Königsnamen*, Münchener Ägyptol. Studien 20 (Munich and Berlin, 1984), 1–42; H. Frankfort, *Kingship and the Gods* (Chicago, 1948), 46f.; G. J. Thierry, *De religieuze betekenis van het aegyptische koningschap* (Leiden, 1913); A. Moret, *Du caractère religieux de la royauté pharaonique*, Ann. du Musée Guimet, Bibl. d'Ét. 15 (Paris, 1902), esp. 18–32.

and Lower Egypt, Nekhbet and Wadjet. Egypt was mythically regarded as a double kingdom and, through the ritual of the coronation, each king unified the two parts of the country (cf. section II.1.b [end] and (4) below). But this is too abstract. The two crowns were incorporations of the two tutelary goddesses of the double monarchy. By appearing in the crowns of the king, they protect the Two Countries. This idea is picked up in the corresponding names, which describe the king as being glorious, putting Egypt in order, and being pious towards the gods.

(3) The title "The Triumphant over His Enemies" is an interpretative rendition of what originally meant "Horus of (or upon) Gold" or more generally the "Falcon of Gold." In the late period of Egyptian history this was understood as "Horus being victorious over Seth" (*Ḥr nb.tj*); hence the Greek translation. Thus, the title recalls the same myth which we encountered with the first title: when Seth had killed Osiris, the previous king, and had thus pushed the land back into its original chaos, he was conquered by Horus; the land was reestablished and regained the state in which Re had created it from chaos. The following individual name focuses on the same ideas: restoration of life (or rather: the king is life), renewal of the creation by Re, and the permanent renewal by means of a specific festival, the *sed* festival or thirty-year festival (see n. 110 [2a]).

(4) The *njśwt-bjt* title, "The Great King of the Upper and Lower Countries," again stresses the idea of the double monarchy represented in hieroglyphic form by the "Sedge" and the "Bee," the symbols for Upper and Lower Egypt (cf. section II.1.c [2]). It is followed by the individual "prenomen" of the king, which is encircled by a cartouche. Starting with the cartouche of Euergetes, it is here that the Egyptian titulary accommodated the genealogical descent so crucial for the Greek formula: "the descendant of the Gods Philopatores." The idea of descent becomes crucial for the prenomen (cf. n. 76). The filiation is followed by more traditional names assuring that the king has been approved by the gods; thus "Whom Helios Gave Victory" is simply a translation of the Egyptian name User-Ka-Re, literally "Strong Is the Spirit of Re." Moreover, Epiphanes received the name "Living Image of Zeus"; he is on earth what Zeus or, to use the Egyptian name of the god, what Amun-Re is in heaven. According to Egyptian beliefs this indicates that Amun-Re is living in him and that it is Epiphanes who on earth exhibits the might of Amun-Re, his father.[78]

78. The pharaoh is generally the "image of God NN." The hieroglyphic phrase used for Epiphanes is *šhm-'nh-(n)-Jmn*, which in its general sense recalls the name of Tutankhamun (eighteenth dynasty): *twt-'nh-Jmn*. Both words, *šhm* and *twt*, mean "image," but *twt* can also be rendered "complete, perfect"; and Tutankhamun's name may originally have

(5) The same idea appears in the final title: "Son of Amun-Re" (s3 R').
I have already mentioned the legend of the birth of Ptolemy I. In the
language of Greek myth, it reflected the Egyptian beliefs that the king
was the son of, and protected by, the supreme god, that is, by Amun-Re,
who in Greek terms corresponded to both Zeus and Helios. Alexander
was depicted on coins as "Amun-Re," the ram god. Furthermore, the
Macedonian king had marched to the Oasis of Amun in Siwa as soon as
he had taken Egypt and, if for once we can trust Pseudo-Kallisthenes,
had been crowned in the temple of Ptah at Memphis.[79] The march to
Siwa was time-consuming and is dangerous even nowadays. It resulted
from a shrewd calculation. Alexander could count on the fact that he
would be greeted as the Egyptian king, hence as the "son of Amun."
The same would have happened in any other Egyptian temple, but only
the temple of Amun in Siwa had authority in the Greek world. Hence
the message spread to Greece. In Egypt, legends were told illustrating
the fifth title. In Pseudo-Kallisthenes, Alexander is fathered by Nekta-
nebos, the Egyptian king, who appears as Amun. When Alexander ap-
pears on coins with the horn of a ram, this picture expresses his descent
from the ram god Amun.[80]

 The fifth title is followed by the proper names of the king, in the case
of Epiphanes by a transcription of his Greek name "Ptolemaios" and
traditional Egyptian names which further assure that he is "beloved by
Ptah." The latter means more than the English phrase indicates to the

meant "Perfect-with-Life-is-Amun" (G. Fecht, "Amarna-Probleme," *ZAeS* 85 [1960]: 90).
Substituting *shm* for *twt* is replacing an unwanted ambiguity by a meaningful one. *shm* is
not only very commonly used for "image" but originally meant "might." Thus, the Egyp-
tian phrase used for Epiphanes still yields the connotation of "Living Might of Amun." See
E. Hornung, "Der Mensch als 'Bild Gottes' in Ägypten," in O. Loretz, *Die Gottebenbildlichkeit
des Menschen*, Schriften des Deutschen Instituts für Wissensch. Pädagogik (Munich, 1967),
123–156, esp. 137–150 and 143–145; eundem, *Conceptions of God in Egypt: The One and
the Many*, trans. from *Der Eine und die Vielen* (Darmstadt, 1971) by J. Baines (Ithaca, N.Y.,
1982), 135–142.
 79. Koenen, *Agonstische Inschrift*, 29–32; cf. Thompson, *Memphis*, 106: "When Alex-
ander the Great took Egypt in 332 BC, he visited . . . Memphis, where he sacrificed to the
Apis bull and to other gods, celebrating in the city with both gymnastic and musical con-
tests. Arrian, unlike the later *Alexander Romance*, makes no mention of an actual enthrone-
ment ceremony here in the temple of Ptah, but it is clear that in Memphis, sacrificing to
the Apis bull in its native form, Alexander was claiming acceptance as pharaoh among the
Egyptians whom he now ruled." Most recently S. M. Burstein, "Pharaoh Alexander: A
Scholarly Myth," *AncSoc* 22 (1991): 139–145, has argued against any coronation before
that of Epiphanes, and specifically against a coronation of Alexander.
 80. See Grimm, "Vergöttlichung"; R. Merkelbach, *Die Quellen des griechischen Alexander-
romans*, 2d ed., Zetemata 9 (Munich, 1977), 77–82; Koenen, "Adaption," 167; H. Brunner,
Die Geburt des Gottkönigs: Studien zur Überlieferung eines altägyptischen Mythos, Ägyptol. Abh.
10 (Wiesbaden, 1964), esp. 22–31, 42–58; Moftah, *Königsdogma*, 99–106.

modern reader. It attests that Ptolemy is the son of the god, this time the son of Ptah. Or, to use another phrase recently used to explain the meaning: "A ruler described as beloved of a god becomes a form of that god."[81]

The proper names are again encircled by a cartouche. After the cartouche the Greek cult-names ("Epiphanes Eucharistos") are added, a practice which already began with the name of Ptolemy Soter. In the *Rosettana* the cult-names are followed by the proper names of the king's parents. By accommodating the Greek filiation the last two titles of the "Great Name" adopt the propaganda functions of the Greek dating formula. First, there is the filiation of the king with the cult-names of his parents (after the fourth title), then the king's own proper name "Ptolemaios," his own cult-names, and finally again his filiation, this time with the parents named by their proper names.

d. The Meaning of Greek Dynastic Cult-Names In light of the preceding consideration of the Egyptian titulary, it will now turn out that the Greek cult-names capture more of the tenets of the Egyptian titulary than can be assumed at first glance. But again, I will have to restrict the presentation of the evidence to the most important examples.[82]

"Soter" and **"Euergetes"** were names recalling the Greek honors for men who had served their city in an extraordinary way. Yet the same names expressed ideas of Egyptian kingship. In the capacity of his second title the king was the divine protector of his country and of the gods. When Philopator in his *nb.tj* name is called "the savior of men" (cf. section II.1.c [2]), the same Egyptian word is used that appears in the translation of Θεοὶ Σωτῆρες (*nṯrw nḏw;* cf. n. 87). It already occurs in the greeting which the gods extend to Haremheb at his coronation (*nḏy.n* "our protector"); and Sesostris I and Neferhotep I are each called "protector of the gods." Another Egyptian word for the same idea appears in the titulary extant in the temple of Philae: *Shed,* "savior." Similarly the transcription for "Euergetes" is derived from *mnḫ,* an epithet that a later generation gave to King Snofru (fourth dynasty).

"Philadelphos" is originally the name for Queen Arsinoe II; the couple was called Θεοὶ Ἀδελφοί. The name alludes to the mythical marriages of Tefnut the daughter of Shu and her brother Shu, or of Osiris and his sister Isis, who conquered even death and became the exemplar

81. Bell, "Luxor Temple," 290 n. 222; Quaegebeur, "Egyptian Clergy," 101; for the imagery of love as expressing the ideology of Ptolemaic kingship, see Koenen, "Adaption," 157–168, and section II.1.d below.

82. The following is a shortened version of what I said in "Adaption," 152–170; the documentation is given there.

of love; in this capacity Isis was invoked in magic.[83] In the Isis aretalogy from Cyme, Isis calls herself γυνὴ καὶ ἀδελφὴ 'Οσείριδος βασιλέως (6), just as Berenike II and occasionally Kleopatra II are called ἀδελφὴ καὶ γυνή or γυνὴ καὶ ἀδελφή. In the Mendes Stele, Arsinoe II is "sweet with love," an Egyptian term of praise for women. From the Greek point of view, the queen loved the king, her brother, and the king responded with the same love. The ideological importance becomes even clearer when Euergetes and Berenike II are officially represented as brother and sister, when in reality they were cousins by adoption (see n. 170). While such marriages were perfectly acceptable to the Greeks, brother and sister marriage was not. The relationship which, in the case of Philadelphos, Sotades had castigated as an unholy marriage ("You push your prick into the unholy hole"),[84] had become the most holy because, according to Theokritos, it imitated the marriage of Zeus and Hera (Ptol. 130ff.). Similarly, it is praised by Kallimachos (SH 254.2).[85] According to the Greek view, it was the mother's love for their father that made the children similar to him. Thus, the love of the rulers guaranteed the birth of the legitimate successor (Theokr. Ptol. 38–44). "Love" became part of the ideology of Ptolemaic kingship, and this development was strongly influenced by the Egyptian dogma.[86]

83. PGM XXXVI.288f.: φιλίτω με ἡ δεῖνα εἰς τὸν ἄπαντα αὐτῆς χρόνον ὡς ἐφίλησεν ἡ Ἶσις τὸν Ὄσιριν (The Greek Magical Papyri in Translation, ed. H. D. Betz [Chicago, 1986], 276); similarly Suppl. Mag. I 51.8 (D. Wortmann, "Neue magische Texte," BJ 168 [1968]: 80–84, no. 3); cf. D. G. Martinez, A Greek Love Charm from Egypt (P. Mich. 757), P. Michigan XVI, ASP 30 (Atlanta, 1991), 66f. There was a "temple of the great goddess Isis that was named 'Brother and Sister' [P. Oxy. 2.254.2f.: a priest of Ἰσιδ(ος) θεᾶς μεγί(στης) ἱεροῦ Δύο Ἀδελφῶν (read Ἀδελφῶν) λεγομένου]." For Tefnut and Shu, see Cheshire, "Deutung," 109 with n. 37.

84. F 1 Powell (Coll. Alex. p. 238): εἰς οὐχ ὁσίην τρυμαλιὴν τὸ κέντρον ὠθείς.

85. Theokr. Ptol. 130ff., esp. 130–134, and 36–40, where the love of their parents, Soter and Berenike, is described as follows (Gow's translation with slight adjustment): "On her the Queen of Cyprus, Dione's august daughter, laid her delicate hands, pressing them upon her fragrant bosom; wherefrom men say that never yet has any wife so pleased her husband as Ptolemy loved his wife and, in truth, in turn she loved him even more [τᾷ μὲν Κύπρον ἔχοισα Διώνας πότνια κούρα / κόλπον ἐς εὐώδη ῥαδινὰς ἐσεμάξατο χείρας / τῷ οὔπω τινὰ φαντὶ ἀδεῖν τόσον ἀνδρὶ γυναικῶν, / ὅσσον περ Πτολεμαῖος ἐὴν ἐφίλησεν ἄκοιτιν, / ἡ μὰν ἀντεφιλεῖτο πολὺ πλέον]." For Kallimachos see section III.3 on Cat. 66.21f.

86. See section II.1.c (4) and (5). The belief that the king was the son of Amun-Re (as well as of other gods) and that the god had fathered him acting through the agent of his human father, created the special bond of mutual love between king and god, king and father (whether the latter was the biological father or the predecessor), king and spouse and coregent. As, for example, Nefertiti (or rather: Naf-tēta; see Fecht, "Amarna-Probleme," 89) is called the Great Wife of the king whom he loves, thus Arsinoe is "sweet with love" (see above). The king is "beloved by" whichever god is in charge of an individual temple. In the pictorial program of the temple walls, the king receives the kingship from the gods as well as from his predecessor. Both themes are ultimately identical and describe the same belief merely from different although complementary points of view; cf. Winter,

From the Egyptian point of view, Arsinoe's love for her brother is closely related to her beneficence. She is "beneficient towards her brother"; in this epithet the word is used that describes the Egyptian equivalent of **"Euergetes"** (*mnḫ.t n sn-s̱*). Moreover, **"Philopatores,"** the name of Ptolemy IV and his wife Arsinoe III, is from the Egyptian point of view merely a variant of the same set of ideas. The king had received the name Philopator when he was a boy. It designated him as successor. Shortly after his wedding, he added the cult of Philopatores to the Egyptian cults, at least to the cult of Amun. That was four years before he introduced his cult into the Alexandrian dynastic cult (see section II.1.b). This second step followed the Battle of Raphia, in which, as the Egyptian priests issuing the Raphia decree tell us, the king had killed his enemies "like previously Harsiesis" (i.e., Horus). The king received a statue which was called "Horus who protects his father, whose victory is beautiful." This is Harendotes, *Ḥr nḏ ỉt.f*, "Horus the protector [or "savior"] of his father."[87] The love of his father manifested itself in the victory over the enemies of his father. He took revenge and protected his father. The same beliefs were attached to Alexander, who in the *Alexander Romance* is called "the avenger [ἔκδικος] of his father Philip" and of his mother.[88] To give another example, in the Rosetta inscription Epiphanes saved his father and his country when he was crowned.[89] In the ritual he became,

"Herrscherkult." For the Egyptian concept, which also included the love between pharaoh and subject, see Moftah, *Königsdogma*, 49–71. The importance of love is matched by the importance of "knowing" (ibid. passim); cf. Kall. *H. to Delos* 170: ὁ δ' εἴσεται ἤθεα πα-τρός—with the same complementary ambiguity as to whether Soter or Helios is the father (see my "Adaption," 188, 162–169).

87. *Raphia*, dem. 32; see H.-J. Thissen, *Studien zum Raphiadekret*, ad loc. Harendotes, *Ḥr nḏ ỉt.f*, is formed with the same word that is used for translating the name "Soter"; see section II.1.d; H. Bonnet, *Reallexikon der ägyptischen Religionsgeschichte* (Berlin, 1952), s.v.; Daumas, *Moyens d'expression*, 191; and J. G. Griffiths' commentary on Plutarch's *De Is. et Osir.* (Cardiff, 1970), p. 345 on 358B, where Osiris comes from the underworld, trains his son for battle, and asks him what he thinks to be the best deed (τὸ κάλλιστον). Horus answers: "To succour one's father and mother when they have suffered wrong" (Griffiths' translation; τῷ πατρὶ καὶ τῇ μητρὶ τιμωρεῖν κακῶς παθοῦσι). Griffiths argues that the meaning of τιμωρεῖν is "'to succour' rather than 'avenge'" because "Isis τιμωρός cannot refer to revenge since it is Horus only . . . who carries out such action in his defeat of Typhon." But, of course, Isis puts the revenge in the scene when she arouses dead Osiris and gets herself pregnant with Horus. In the myth "protect," "succor," and "avenge" are not distinguishable, and the problem stems from the need of the translator to make a decision in order to suit the different range of meaning in the other language. The Greek is ambiguous; see also n. 88.

88. In a dream Philip sees Amun sleeping with Olympias and finally telling her: κατὰ γαστρὸς ἔχεις ἐξ ἐμοῦ παῖδα, καὶ σοῦ καὶ τοῦ πατρὸς Φιλίππου γενόμενον ἔκδικον (Ps.-Kall. 1.8.1). This is a clear expression of the Egyptian dogma (see section II.1.c [5]). It is phrased with a pun: the "defender of men" (Ἀλέξανδρος) has been conceived by his mother as her and his father's "avenger" (ἔκδικος); he is Horus, or, to be precise, he is Harendotes (n. 87).

89. *Ros.*, Greek 27: ἐπαμύνων τῷ πατρί.

as we may say with Egyptian terminology, "the savior of his father." In this phrase, the term "father" was ambiguous. It referred to the dead king as well as to the gods. Ultimately both meanings were identical. In mythical terms each pharaoh is the avenger of his father; he shows this quality in the succession and, very specifically, in the rituals of the coronation in which he awakens his predecessor to the life of Osiris, the dead king, and restores the order of the world, which through the death of the king had lapsed into chaos.

Originally, the dynastic cult and its organization grew out of Greek thinking, although it aimed at the creation of an institution comparable to the role of pharaoh as god on earth and in office. Hence, Philopator (or rather his advisors) had no hesitations about seeing the cult of the Philopatores added to the Egyptian cults immediately after the wedding. With regard to the Greeks he had to wait until his victory over Antiochos had indeed established him as "Philopator."

"Philometor" is a similar formation. Kleopatra I, the mother of Ptolemy VI, ruled in his place when he was a minor (181–176), and in protocols of documents her name preceded his. It seems that he received the name Philometor right at the beginning of this joint rule.[90] At this point the name was clear in its meaning for the Greeks: it put the son and male partner of the joint rule in the second place and appealed to his obligation toward his mother, who continued to be called *Theos Epiphanes*. From the Egyptian point of view, the land was then governed by Isis with her child Horus. It was only after the death of Kleopatra in the fifth year (177/6) that Ptolemy VI added to the title of the dynastic priest the phrase "and of King Ptolemy Philometor"; in the next year he married his sister Kleopatra II,[91] and in the following, seventh, year his name and his wife's were added to the title of the dynastic priest as the Θεοί Φιλομήτορες. At this point, the title became capable of expressing the set of ideas which we encountered with the name Φιλοπάτωρ. The queen was dead, and the son followed her, receiving de facto the crown from her and taking care of her as dead "Osiris." As Queen Hatshepsut had shown (cf. nn. 8 and 71), theology and ideology made no difference between a male and a female pharaoh; the queen played the male role.

90. In *P. Amh.* 2.42 of the second year, the Θεοί Φιλομήτορες (in the genitive) appear in the title of the priest of Alexander. The scribe should have stopped with the preceding Θεῶν Ἐπιφανῶν; at the time, Kleopatra I continued her cult title Epiphanes (to call her "Philometor" would have been a paradox, indeed), and the young son was included in it. Nevertheless, it is clear that the scribe, knowing the king's name "Philometor," erroneously continued the series of the preceding θεῶν (U. Wilcken in Stähelin, *RE* 11:740f.; cf. H. Volkmann, *RE* 23:1703).

91. It was a children's wedding; Philometor was eleven years old; for his birth in 186 see my discussion in "Die demotische Zivilprozessordnung," *APF* 17 (1960): 11–16, esp. 13f. with n. 2.

In Egyptian eyes, and possibly without the knowledge of the Greeks, the significance may have gone even further. Pharaoh was *Kamutef,* "the bull of his mother." He fathered himself out of his mother, thus eternally renewing the kingship. The king was Min or Horus, "who impregnated his mother." This terrible incest, even more upsetting than the one expressed in the name of Philadelphos, was a consequence of theological and ideological constructs, and therefore did not imply any consummation of the incest. When father and son, predecessor and king, function in the same role of King Horus, then the son as well as the father is the lover of Isis, the mother of Pharaoh. In the role of king, individuals were not distinguishable. They performed the cyclic renewal and guaranteed the eternal permanence of pharaonic kingship.

Finally, I may mention **"Epiphanes,"** a name which again seemed easily understandable for Hellenistic Greeks: the king is a manifestation of the divine, visible to men and not far remote. In Egypt, however, Epiphanes corresponds to the idea of pharaoh as *ntr nfr,* the "good (or "beautiful") god." On the occasion of his coronation at the age of thirteen, he "appeared on the throne," that is, he rose in his role as sungod, whose daily victory over darkness restored Egypt from chaos. Ptolemy V seems to have received this name at his coronation. According to the Egyptian translation, he is the god "who comes forward" (or "the resplendent god"). The identification with Re, the sun-god, is evident; he is, indeed, the son of Re (see section II.1.c [5]).

The discussion of the few remaining names would not add substantially to what already has been said.[92] The names discussed demonstrate that the Greek cult names were selected with great care: they sounded Greek to Greeks and yet Egyptians could recognize their pharaoh. Given the way in which Greeks thought about deification on the basis of deeds and merits, it was a matter of diplomacy to find the right moment for adding the ruling king to the dynastic cult. Occasionally the king would use the popularity of the queen to pave the way (Arsinoe II). In other cases he would have the Egyptian temples make the first step and test the waters (Philopator).[93] In any case, the Greek state cult must not be seen in isolation from the Egyptian cult. In the Egyptian temples the kings, queens, and other members of their family were worshiped under their Greek cult-names, and the Greek rulers entered the Egyptian

92. "Apion" is clear, and hardly needs to be discussed; for "Tryphon" see H. Heinen, "Die Tryphe des Ptolemaios VIII. Euergetes II.: Beobachtungen zum ptolemäischen Herrscherideal und zu einer römischen Gesandtschaft in Ägypten (140/39)," in *Althistorische Studien,* 116–130; Kyrieleis, *Bildnisse,* 163f., who sees the representation of corpulence in pictures of the early Ptolemies in this context (see section I, above, on the mosaics from Thmuis [figs. 2a and b]).

93. See also section II.1.b (2) and (4); for Philopator see section II.1.b (4).

temples as σύνναοι θεοί. The Greek and Egyptian ruler cults, each an institution in its own right, each directing itself to, and appealing to the loyalty of, its own audience, nevertheless reciprocally influenced each other.[94]

e. The Apomoira *for the Temples* In this context we may now turn to a more practical item, the *apomoira,* a tax of generally 16.7% (in special cases, a reduced rate of 10%) on the proceeds from vineyards and garden land. This was most likely a traditional tax paid to the temples at least in late pharaonic times; hence the name of the tax is probably translated from Egyptian: demotic *dni.t.w,* "portion," namely, of the gods.[95] As was mentioned, Philadelphos added a new priesthood, the kanephoros of Arsinoe, to the eponymous priesthood of Alexander in 269 BC when Arsinoe II, his sister and wife, was still alive or, more likely, shortly after her death in the beginning of June of 268 (see section II.1.b with nn. 61 and 73). At that time cults for Arsinoe were founded throughout the country, probably with retroaction to the beginning of the year on March 28/29 (Dystros 25), 268 BC.[96] In order to finance the expendi-

94. Quaegebeur, "Cleopatra VII," 44f. with regard to Arsinoe II; see also his other contributions to this subject (n. 68). Cf. Hauben, "Aspects," 466f.: "Par le blais du culte dynastique, les Ptolémées donc pouvaient relier les gens, aussi bien les Égyptiens que les Grecs, chaque groupe dans sa propre tradition, à l'état ptolémaïque."

95. This possibility emerged in discussions with Professor U. Kaplony-Heckel and Professor H.-J. Thissen. Demotists generally seem to assume that the demotic name is a translation of the Greek ἀπόμοιρα. If so, we would have to assume that the tax itself was a new levy introduced by the Ptolemies. But it seems unlikely that the Greeks would have introduced a new tax for the exclusive benefit of the temples and then, almost as an afterthought, have reassigned the proceeds to the cult of Arsinoe.

96. The date is derived from *P. Rev. Laws* col. 37 (M. T. Lenger, *C. Ord. Ptol.* 18), which in the twenty-third year ordered the farmers of vineyards and gardenland to provide written information on the total harvest for years 18–21 (i.e., for the period before collection through tax farmers began) as well as information on the amount and the temple to which the apomoira was paid in each year; the temples had to submit corresponding information (see above). The beginning of the eighteenth year was obviously the administrative starting point for the appropriation of the apomoira to the cult of Arsinoe. The year began on the evening of March 29, 268, but the vintage would not begin before the middle of July at the earliest. In the calculation of the Macedonian regnal year, I retain Dystros 25 as the Macedonian new year's day (see *Agonistiche Inschrift,* 39–43 and tables; also Pestman, *Zenon Archive,* 215ff. [Pestman's tables start with 260]); Samuel, *Ptolemaic Chronology,* took Dystros 24 as the new year's day, and in this he is now followed by R. A. Hazzard, "Regnal Year"; E. Grzybek, however, *Calendrier macédonien,* follows a suggestion of F. Uebel that makes Dystros 27 the new year's day (*BO* 21 [1964]: 312; *Kleruchen,* 14; but see eundem, "Jenaer Kleruchenurkunden," *APF* 22/23 [1974]: 89–114, and Koenen, *Agonistiche Inschrift,* 41 n. 79; see also n. 113, below). Furthermore, the calculation is based on the assumption that the twenty-five-year cycle, which can be reconstructed from *P. dem. Carlsberg* 9, was not adjusted by one day as Samuel suggested (pp. 58f.). Therefore most dates fall one day earlier than they would fall in Samuel's calculation.

tures, the proceeds from the apomoira were reassigned to the cult of Arsinoe, or more specifically "to sacrifices and libations" in her cult (*P. Rev. Laws* 36.19). We can only guess that the proceeds were meant to serve the cult of the new goddess in both Greek and Egyptian temples.

In a next step, the system of collection of this tax was changed and brought in line with the collection of other taxes by the state. From April 14, 264 BC, the tax was farmed by the highest bidder—a Greek procedure—although the actual collection was left to officials of the state, thus adding additional control. The proceeds in wine and money went to the treasury, and we may assume that the treasury was to transfer them to Greek and Egyptian temples, where they were to serve the new cults of Arsinoe. In short, the administration of this tax was absorbed into the Greek system; moreover, the Greek authorities had it in their power to divide the proceeds between Greek and Egyptian cults.[97]

An exception was made for the temples: they were exempted from paying this tax (*P. Rev. Laws* 36.7–10) and continued to collect it from tenants of their ἱερὰ γῆ.[98] In light of this fact we can now better understand the king's repeated assurances that the temple could keep this revenue. In the *Rosettana* the synod of the Egyptian priests, gathered at Memphis in 196 BC on the occasion of Epiphanes' coronation (see section II.1.a), recognizes that, according to the Greek version, the king "has ordered . . . that the apomoira which is owed to the gods from vineyards and gardens and from other possessions that belonged to the gods during the reign of his father, should remain in place."[99] Similarly, in the philanthropa decree of 118 BC,[100] the joint rulers order that the temples will continue to "receive the apomoira which they used to

97. *P. Rev. Laws* 36 (*C. Ord. Ptol.* 17) and 37. On the so-called Revenue Laws, a collection of regulations regarding tax farming, see J. Bingen, *Le papyrus Revenue Laws: Tradition grecque et adaptation hellénistique*, Rheinisch-Westfälische Akad. d. Wiss., Geisteswissenschaften, Vorträge G 231 (Opladen, 1978), esp. 17f. on the apomoira; Préaux, *Économie*, 165–181, and *Monde hellénistique* 1:378; H. Kortenbeutel, *RE* Suppl. 7:43f. While the tax for gardens was always paid in money, the tax for vineyards was originally paid in wine, although, around 190 BC, payment in money became optional and later obligatory (now see J. Kaimio, *P. Hels.* 1:122–126).

98. *P. Köln* 7.314; cf. K. Maresch's introduction and commentary. A certain Nikaios declares the size of his garden on ἱερὰ γῆ and his estimate of the monetary value of the harvest of 257 BC. He will pay the apomoira to the temple of Herakles. This is the earliest attestation for the actual collection of this tax.

99. *Ros.*, Greek 14–16: προσέταξε - - - / - - - τὰς καθηκούσας ἀπομοίρας τοῖς θεοῖς ἀπό τε τῆς ἀμπελίτιδος γῆς καὶ τῶν παραδείσων καὶ τῶν ἄλλων τῶν ὑπαρξάντων τοῖς θεοῖς ἐπὶ τοῦ πατρὸς αὐτοῦ / μένειν ἐπὶ χώρας. See also *Inscr. Phil.* 2, an update of the *Rosettana*, (dem. 5e–f; hierogl. 6e–7a; W. M. Muller, *Egyptological Researches* [Washington, 1920] 3:63; the corresponding passage in *Inscr. Philae* 1 is very damaged).

100. For the philanthropa decrees see sections I (on *P. Tebt.* 1.5), II, and II.2, as well as the final remarks of this paper.

receive from vineyards, gardens, and other possessions."[101] In other words, the temples retain the apomoira which they used to receive, that is, the apomoira paid by the tenants of their ἱερὰ γῆ.[102] The use of this apomoira from temple land remained unrestricted; it was for the gods in general.

Did the temples lose money, clout, and independence through Philadelphos' appropriation of the apomoira? If we are right in suspecting that the proceeds of the tax from nontemple land was now shared between the Greek and the Egyptian cults, the Egyptian temples would have continued to receive part of it for their cults of Arsinoe. Under Epiphanes the proceedings from the apomoira were earmarked for (Arsinoe) "Philadelphos and the Gods Philopatores."[103] Again we may expect that this was applicable to the Egyptian as well to the Greek cult, but in practical terms the change will not have meant much. The restriction to the cult of Arsinoe and Philopatores was less of a burden than it seems. In the Egyptian temples Arsinoe as well as the Philopatores were worshiped as the ancestors of the ruling kings. When the synodal decree of the Egyptian priests gathered at Kanopos was moved to introduce cults for the ruling couple, the king and the queen were added to the titles of all priests, just as they were added to the Greek priesthood of Alexander; the ancestors were included in the honors (see sections II.1.a

101. *P. Tebt.* 1.5 (*Sel. Pap.* 2.210; *C. Ord. Ptol.* 53), lines 50–53: [προσ]τετάχασιν δὲ κ[αὶ τὴν ἱερ]ὰν γῆν - - - λ[ήμψε]σθαι δὲ / [κα]ὶ τὰς ἀπομοίρας ἃς ἐλάμβαν[ο]ν ἔκ τε τ[ῶν κ]τημάτων καὶ τῶν / [π]αραδεί(σων) καὶ τῶν ἄλλων.

102. Both the *Rosettana* and *P. Tebt.* 1.5 indicate that the tax was paid not only from the produce of vineyards and gardens but also "from other possessions"; such "other possessions" do not figure in the *P. Rev. Laws.* The temples were allowed to continue to collect the traditional tax from their own land. Hence, the range of land subject to this tax may have been wider than that of land subject to collection by tax farmers. See above on the word ἀπόμοιρα as the translation of a fairly broad Egyptian term. The assurances in the philanthropa decrees may, however, indicate that there was at least some anxiety among the temples and the priests that this revenue could be taken away from them.

1 ;. See *P. Petrie* 3.57b (p. 166; reedition of 2.46c [p. 151]; 192/1 BC), lines 7–10: τὸν / ἐγλ ιβόντα τὴν γινομένην ἀπόμοιραν / τῆι Φιλαδέλφ[ου]ʼωι· καὶ τοῖς Φιλοπάτορσι θεοῖς / τῶν περὶ Φιλαδέλφειαν; P. Mich. inv. no. 6977.4, an *enteuxis* most likely of 192/1 BC, edited by G. Schwendner, "Literary and Non-Literary Papyri from the University of Michigan Collection" (diss. Ann Arbor, 1988), no. 14.3–8, pp. 103–112: ὁ ἐξ[ει/ληφὼς μ]ετὰ Ἰμούθου εἰς τὸ ιδ (ἔτος) τὴν ἀ[πόμοιραν] τῆς Φιλαδέλφου καὶ τ[ῶν] Φ[ι]λοπ[ατόρων / θεῶν τ]ῶν οἰνικῶν γενημά[των] καὶ [ἀκρο/δρύων] τῶν περὶ Κερκενσῖρι[ν κα]ὶ ἄλ[λων / . . .] τόπων τοῦ Ἀρσινοΐτου [νομ]οῦ. The Michigan papyrus could also be dated to the reign of Philopator, that is, 209/8; but in the absence of an attestation for the longer name of the tax during the lifetime of Philopator, it seems safer to date the papyrus to Epiphanes. The tax continued to be levied under this full name, but no further kings were added; see *BGU* 4.1216.91–92, dated as late as 110 BC. It is noteworthy that the new Michigan papyrus also uses the usual short form (line 13): τελεῖν τὴν (ἕκτην) τῆι Φιλαδέ[λ]φωι.

and b). An entire new class of priests was established, festivals founded, statues erected, and so on, and the ancestors were part of this. Moreover, inasmuch as Arsinoe and the Philopatores were σύνναοι of the Egyptian gods, the priests may have been able to use some part of the allocation even for their regular cult.[104] The supervision would have been in the hands of the king's representative in the temple, the *epistates*. According to the evidence available, these controllers were selected from priestly families (see n. 17). In short, the fact that this revenue was earmarked for the cult of Arsinoe and, later, the Philopatores, must have been an enticement to introduce the Greek cults into the Egyptian temples, albeit in an Egyptianized form.

Given the extent of the cult of queens and kings we may expect that the apomoira collected by the state was good business for the temples. The proceeds were designated for the cult of Arsinoe at a time when the development of new vineyards and garden land boomed. Much of the land reclamation in the Fayum produced vineyards, because the planting of vineyards was a popular means of creating privately operated land-holdings. Hence, even before the new regulations went into effect, the area of land subject to this tax had grown substantially; all vineyards, except those belonging to the temples, were now subject to this tax. Thus, the total volume of the tax must have been growing far beyond what the temples had been able to collect. Given the growth of the income from the tax, it is not certain whether the temples had less profit from it than at the time when they collected the tax themselves. The state's system was more effective than collection by the temples.[105] By way of analogy, the churches in modern Germany have never been better off than since the state began to collect a tax to finance the churches (the so-called *Kirchensteuer*). In short, the apomoira brought money into the temples, financed the new cults and chapels, and, in spite of the restrictions on the use of the money, was a boost for the economy of the temples.

There remains a reservation: the temptation not to deliver to the cult what was designated to it must have been great when the state was in a crisis, in particular since the temples lacked any means of control. Yet contrary to what has sometimes been said, we have no clear attestation that the apomoira was ever used for secular purposes.[106]

104. Cf. Quaegebeur, "Documents égyptiens," 713f.
105. The impact may have been different in different parts of the country, depending on the number and sizes of gardens and vineyards.
106. Secular misuse of the revenue has been claimed for *P. Köln* 5.221 and *P. Col. Zen.* 1.55. The former (edited and discussed in detail by H. Schäfer) is an account and calculation of payments of apomoira presumably from about 189 BC. After an empty space, the same scribe wrote an instruction (?) for the distribution of wine with reference to an order

2. Dynastic Festivals

In the preceding discussion a distinction was drawn between the Egyptian ideas of divine kingship—which were based on the belief that, by virtue of his office, the pharaoh played the role of the gods, in particular of the gods who created Egypt and her order—and the Greek beliefs, according to which the deeds and the specific merits of the king entitled him to divine honors, in life as well as after death. But we have also seen that the two forms overlap. The Greek cults in the Egyptian temples were treated like Egyptian cults with all the daily rituals and festivals that were performed in Egyptian temples. The names of the new deities could be understood by the priests as expressing, perhaps in odd ways, their own beliefs in kingship. The king was the incarnation of the divine powers residing in the "Great Name" (see section II.1.c). He was, in particular, the son of Helios and the εἰκών of Zeus. The wedding assimilated the divine couple to Zeus and Hera. More generally the Ptolemaic kings and queens were assimilated to and identified with specific Greek as well as Egyptian gods, the kings in particular with Dionysos and Horus, the queens with Aphrodite, Ἀγαθὴ Τύχη, and Isis.[107] Correspondingly the king's enemies were "enemies of the gods," that is, Typhonians or Sethians.[108] The Egyptian nature of such identifications seems to be obvious. Yet the basic thought pattern was not foreign to the Greeks. It will suffice to mention a figure like Salmoneus, who played the role of Zeus, as well as the fact that such identifications spread easily through the Hellenistic world. Thus, it is also necessary to understand the Hellenistic development as deriving from Greek roots. Such identi-

by the dioiketes: one portion is to be used in Ptolemaïs, another portion is to be brought to the military camp in Theogonis for furnishing the wine rations, and a third portion is to be reserved for home consumption in the villages and for furnishing the wine ration of an employee of a scribe. The wine is here used for secular purposes, but with regard to both syntax and content the connection with the preceding account of apomoira is less clear. Moreover, the actual use of the wine does not address the question how the account was settled between the state and the temples; the state may well have transferred money to a temple account. The *Col. Zen.* papyrus is a receipt for amounts of wine; one is taken from the apomoira paid to the goddess Philadelphos and is to be used for the wages of the guards under the recipient's charge. This transaction is subject to analogous difficulties of interpretation; see Préaux, *Économie*, 180f.; for the *Rosettana* and *P. Tebt.* 1.5, which also have been claimed as evidence for secular use of the apomoira, see above.

107. J. Tondriau, "Rois lagides comparés ou identifiés à des divinités," *CE* 23 (1948): 127–146; idem, "Princesses ptolémaïques comparées ou identifiées à des déesses," *BSAA* 37 (1948): 12–33; L. Cerfaux and J. Tondriau, *Le culte des souverains dans la civilisation gréco-romaine*, Bibl. de Théol., 3d series, no. 5 (Tournai, 1957), 189–193, 198–201; Fraser, *Ptolemaic Alexandria*, 236–246; Kyrieleis, *Bildnisse*, 148f., and "Καθάπερ Ἑρμῆς καὶ Ὧρος."

108. *UPZ* 2.199.4; L. Koenen, "Θεοῖσιν ἐχθρός," *CE* 34 (1959): 103–119; conversely the sinners are called "rebels" (*šbl*; see J. Zandee, *Death as an Enemy According to Ancient Egyptian Conceptions*, Studies in the History of Religions 5 [Leiden, 1960], 296). See also Koenen, "Adaption," 174–186, and Onasch, "Königsideologie," 150 with n. 97.

fications with specific gods, however, and in particular the changing of the identifications in accordance with the specific functions the king performed at any moment, are part and parcel of the Egyptian thinking, as we have observed several times.

From the Egyptian point of view, the identification with gods and the Ptolemaic "deification" resulted from the role which the king reenacted in rituals and deeds. At his coronation the king was recognized as the son of Amun; he restored order, reestablished the cults, refounded the temples, unified the Two Countries, overcame chaos, and was victorious over his and his father's enemies so that everything was again as perfect as it was at the time when Amun-Re created the world; he received his royal titulary, the "Great Name," which propagated precisely this set of ideas. The propaganda was accompanied by concrete measures such as the so-called philanthropa, which I mentioned earlier (see n. 100).

The first unambiguously attested coronation is that of Epiphanes, but in my mind there is little doubt that Alexander and subsequently all of the Ptolemies had been crowned.[109] Alexander's coronation and Soter's assumption of the kingship and coronation gave rise to a series of related festivals. They are difficult to trace because they were celebrated according to different calendars, including the so-called Sothis calendar. A further complication results from the fact that all festivals extended over several days. Many details remain questionable, but a relatively clear general picture seems to emerge. The results are summarized in the accompanying table.[110]

109. Elsewhere I have argued the case for Alexander (see section II.1.c [5] with n. 79) and Soter (cf. n. 112), Philadelphos, Euergetes, and briefly Philopator (*Agonistische Inschrift,* see index, s.v. "Krönung"); see also n. 8 on Berenike, the young daughter of Euergetes and Berenike II. Burstein argues against any coronation before that of Philopator (see n. 79), as many have done before.

110. The table combines the one that I gave in *Agonistiche Inschrift,* 101, with the pertinent results of my contribution in Koenen and Thompson, "Gallus," esp. 139–142. For the evidence see these publications, to which in the following notes I will refer only for specific matters. At this point two preliminary comments may be welcome:

(1) Since it affects the argument, I mention that, on p. 139 of my article on Gallus, Pharmouthi 20 is wrongly identified as May 15 according to the Sothis year; the correct date is given on p. 140: March 15.

(2) E. Grzybek, *Calendrier macédonien,* has arrived at different dates for a set of early Ptolemaic dynastic festivals. He reconstructs the Julian equivalents of the Macedonian year for the period from Alexander to Philadelphos with the help of the twenty-five-year cycle of the lunar year (the cycle of *P. Carlsberg* 9; see the end of this note); and assumes an irregular intercalation of the Macedonian calendar (cf. also n. 61). The result supports his understanding of the Pithom Stele. But there is circularity in this argument. I also raise the following objections (cf. now also H. Hauben's review article, "La chronologie macédonienne et ptolémaïque mise à l'épreuve," *CE* 62 [1992]: 143–171):

(a) Grzybek claims that, in the Pithom Stele, the god Atum of that temple is frequently addressed as the king's father, whereas in reality Ptolemy I Soter is meant. Hence, the royal visits and donations mentioned in the inscription took place on royal feasts in honor

Some explanatory remarks will be useful here despite their unavoidably technical character. I proceed in the order of the columns 1–6:
(1) The left column lists the dates of a series of celebrations which, in

of Ptolemy I: in 280/79 on the twenty-fifth, in 270/69 on the thirty-fifth, and in 265/4 on the fortieth anniversary of the accession of Ptolemy I in 306/5; this list "prouve d'une manière irréfutable que c'était le fondateur de la dynastie qui intéressait Ptolemée II au premier chef dans ce document, et non le dieu égyptien Atoum" (79; here I follow R. Hazzard's critique of this statement; see n. 1). No evidence is offered for the specific relevance of this series. The *ḥb-śd*, called τριακοντετηρίς in the *Rosettana*, comes to mind, but this festival celebrated to renew the coronation of a king cannot explain the series of the twenty-fifth, thirty-fifth, and fortieth years: it was not always placed in the thirtieth year of a king, and it was repeated for the first time after four, then after three years (Bonnet, *Reallexicon*, 158–160). And with regard to the claim that the god Atum of the Pithom Stele, addressed as father, is Ptolemy I, I admit that, according to the Egyptian dogma, the earthly father of a king acted in the role of a god when he fathered his successor (see section II.1.c [5]), but such thoughts are different from a direct identification of the king with the god; they do not account for the replacement of the god by the king in his own temple. E. Grzybek, therefore, stresses correctly that this identification would be a Greek feature (p. 80; but see below, n. 116). However, such an identification would not fit with the pattern in which the Greeks influenced the temples. Therefore, the case would need much stronger evidence.

(b) The strongest evidence for seeing Atum as Ptolemy I occurs in a passage registered under year 16 (line 27): the king celebrates the first feast of his father Atum, "[jour] où celui-ci avait uni son corps à la vie, après avoir reçu ce dont il avait besoin dans l'au-delà des mains d'Isis et Nephhys ensemble, le dernier jour du 3e mois de la saison *ȝḥt*" (Hathyr 30, 269 BC, i.e., January 27; p. 87). According to Grzybek, the passage refers to an anniversary of the death of Ptolemy I. Assuming that the Macedonian calendar in this period follows the same pattern as later, January 27 of 269 corresponds to Peritios 10; however, if we posit an additional intercalation, the date is equivalent to Dystros 10. According to Grzybek, Dystros 10 is the date of the Basileia. He refers to the Greek inscription in the Museum of Cairo that, in 267 BC, honors the victors at the Basileia celebrated on Dystros 12, the genethlia of King Philadelphos (Koenen, *Agonistiche Inschrift*). In this inscription, however, the date of Dystros 12 is neither that of the erection nor of the redaction of the inscription, as Grzybek assumes (97 n. 53), but that of the competitions: – – – Ἡράκλειτος – – – ἀγωνοθετήσας καὶ – – – ἆθλα προθεὶς – – – ἔτους ὀκτωκαιδεκάτου Δύστρου δωδεκάτηι γενεθλίοις βασίλεια τιθέντος ᾿Αμαδόκου, τὴν ἀναγραφὴν τῶν νικώντων. That Philadelphos' birthday was celebrated on the Basileia, normally a victory festival in honor of Zeus, is not problematic; but that, according to Grzybek (96–101), it commemorated the death of Ptolemy I is harder to believe. Hence, there is no evidence for celebrations of the death of Ptolemy I on "Dystros 10," and the passage of the Pithom Stele referring to the death of Atum may very well refer to precisely this mythical event; Atum was buried in the *Amduat*. For the festival of the accession on January 7 see below.

The importance of the twenty-five-year Carlsberg cycle for the regulation of the Macedonian calendar in relation to the Egyptian calendar was discovered by A. E. Samuel; this cycle was not invented to determine the equivalents of the Macedonian in the Egyptian calendar and vice versa, but was used probably from the fifth century BC (if not earlier) to control the relationship between the solar and lunar years of the Egyptians; see Samuel, *Ptolemaic Chronology*, 73f.; R. Krauss, *Sothis- und Monddaten: Studien zur astronomischen und technischen Chronologie Altägyptens*, Hildesheimer Ägyptologische Beiträge 20 (Hildesheim, 1985), esp. 28 (with further literature). Its use for controlling the Macedonian calendar constitutes a new application of an Egyptian technique that was readily available.

terms of the Sothis year, fall into the period of January 5 through 9.[111] The series was presumably inaugurated by the date on which Ptolemy I began to use the title of king in Egypt and, perhaps, was crowned. According to the documentation available, this could have taken place around January 6, 304 BC.[112] Philadelphos' accession to the sole rulership and his coronation followed on Dystros 25 (col. 4), that is, January 6/7, 282.[113] This anniversary was celebrated in the Atum temple at Pithom in 279 (January 2–6); in this year the anniversary in terms of the Sothis year coincided with Macedonian Peritios 24–28 (col. 5), which in turn included the monthly celebration of the accession according to the Macedonian calendar (Peritios 25).[114] The accession of Ptolemy III Euergetes

111. I use the term "Sothis year" for a schematic, not an astronomically correct year. For the use of the Sothis year in Egypt see now Krauss, *Sothis- und Monddaten;* further R. Merkelbach, *Isisfeste in griechisch-römischer Zeit: Daten und Riten,* Beitr. z. klass. Philologie 5 (Meisenheim, 1963), esp. chaps. I and VI; at the end of that monograph there is a table which compares several calendars and allows for an easy reading of the Julian equivalents of the Sothis year.

112. The two latest demotic papyri of Alexander IV date from Hathyr of 304 (beginning January 6); November 7, 305 to November 6, 304 was counted as Soter's first year; thus, he was recognized as king somewhere in the course of this year. The two papyri from Hathyr do not establish a firm date after which Soter became king, since the news must have taken some time to travel and there may have been some resistance from Egyptians; up to this point, the years of Alexander IV were continued, although he had died in 310/9 (P. W. Pestman, *Chronologie égyptienne d'après les textes démotiques,* Pap. Lugd.-Bat. 15 [Leiden, 1967], 12f.; T. C. Skeat, *The Reigns of the Ptolemies,* MB 39 [Munich, 1954]. For the Greek world, however, Ptolemy I had already been proclaimed king in late summer 306 (P. Köln VI.247.ii; C. A. Lehmann, "Das neve kölner Historikerfragment," ZPE 72 [1988]: 1–17. The coronation aimed mainly at the Egyptians (Jan. 6; col. 1) may have been repeated two months later within the ritual of the Kikellia, a festival of Isis and Osiris (see col. 2).

113. Dystros 25 (rather than 24 or 27) is the first day of the Macedonian regnal year under Philadelphos, Euergetes, and Philopator; see n. 96.

114. For the anniversary of Philadelphos' coronation see Pithom Stele, lines 6ff. and my arguments in *Agonistische Inschrift,* 58–62. Grzybek, *Calendrier macédonien,* 89–93, argues that, in this text, the accession of Ptolemy I Soter, not of Ptolemy II Philadelphos, is celebrated (cf. n. 110 [2a] and [2b]). In any case, the date recorded in the inscription, Hathyr 7, corresponds to January 6 in 279 BC, the sixth year of Philadelphos in his count from his elevation to joint ruler; in the Sothis year, this day was an anniversary both of the assumption of the kingship by Ptolemy I Soter and of the coronation of Ptolemy II Philadelphos. The Pithom Stele was erected in the year 21, apparently at an anniversary of the coronation; but the priests do not indicate the precise date, presumably because the Egyptian calendar used by the temple would appear to contradict the character of the day as the anniversary of Philadelphos' accession or coronation. In the year 6—that is, 279 BC—the king arrived in Pithom on Hathyr 3, four days before the anniversary; thus the visit extended from Hathyr 3 to 7, January 2 to 6, that is, Peritios 24–28 if there was no additional intercalation, or Dystros 23–27 in the case of an additional intercalation, as Grzybek assumes (see n. 110). It may be noted that in that year the anniversary of Philadelphos' accession, according to the Egyptian calendar, fell on Hathyr 7 or, according to the Macedonian calendar, on Dystros 27, the first day of the Macedonian year under Philadelphos according to Grzybek (see n. 96). But such festivals were celebrated each month, and Peritios 25 would fall into this pattern (for monthly celebrations see n. 120).

Some Ptolemaic Dynastic Festivals

Sothis year		Macedonian year			Egyptian year	Events
(1)	(2)	(3)	(4)	(5)	(6)	
		Dystros 12 (?), January 24/25, 332/1 (?)				BASILEIA, coronation of **Alexander the Great** in Memphis (?)
January 6, 304 (?)					Hathyr 1 (?)	proclamation of **Ptolemy I Soter** as king
	March 4/5, 304	←	←		Choiak 28/29	Kikellia (festival of Isis) and following journey of Osiris; celebrated in 238 on February 16/17
	March 7, 304 (?)	←	←		Tybi 1 (?)	monthly celebration of Ptolemy Soter's acclamation as king and coronation
		Dystros 12, 308				"birthday" of **Ptolemy II Philadelphos,** possibly not the actual date of his birth; coinciding with BASILEIA
		Dystros 12, 285 (December 15/16)				BASILEIA beginning of *joint rule* (or designation as crown prince) of Ptolemy I Soter and II Philadelphos, and "birthday"
January 6/7, 282	→	→	Dystros 25			coronation, *sole rule* of Ptolemy II Philadelphos
January 2–6, 279			→	Peritios 24–28	Hathyr 3–7	visit of Ptolemy II Philadelphos at Pithom temple; celebration of the anniversary of his coronation (in the Macedonian calendar) and of Ptolemy I Soter's assumption of kingship (in Sothis year); consecration of a sanctuary

(continue)

January 7/8, 246		Dios 5		beginning of *joint or sole rule* of **Ptolemy III Euergetes** ("birthday")
	→	Dios 25 (Jan. 27/28, 246)		coronation of Euergetes (on monthly celebration of the festival on Dystros 25)
	Dystros 25	←		*dies imperii* of Euergetes changed from Dios 25 to Dystros 25
March 7, 238			Tybi 17	date of synodal decree of Egyptian priests at Kanopos
July 19 (Thot 19)			Pauni 1	festival in honor of the Gods Euergetai
January? (between Dec. 29, 222 and Jan. 15, 221)	Loios 9/10 ? (= Jan. 6)			succession of **Ptolemy IV Philopator**
	Dystros 25 (?)			*dies imperii* continued under Philopator (?)
July 13 (?)	Dystros 21/22 acc. to Carlsberg cycle; Dystros 30 in schematic equation		Mesore 30, 210 (Oct. 9)	"birthday" of **Ptolemy V Epiphanes**, soon followed by elevation to joint ruler
	possibly Dystros 25 or 27/28 (Oct. 12/13 or 15)		Epag. 3/4 or possibly Thot 1 (Oct. 15)	elevation of Epiphanes to joint ruler, soon after birthday (above) and before November 29
January 1 and possibly 6 (?), 196			Mecheir 17 and 22 (?)	coronation of Epiphanes in Memphis and his anakleteria in Alexandria, respectively

(continue)

Some Ptolemaic Dynastic Festivals (*continued*)

Sothis year		Macedonian year			Egyptian year	Events
(1)	(2)	(3)	(4)	(5)	(6)	
January 5–9						**Victory** festival of Horus the King in Edfu
	March 5, 29				Pharmuthi 20	erection of **victory** stele for **Cornelius Gallus** by the priests of the temple of Isis in Philae (Gallus = Horus)
January 5/6						**Aion** festival in Alexandria, later **Epiphany** of the Christians
	March 5 (in Roman times)					**Navigium Isidis**

NOTE: The arrows indicate which date of a festival produced the date of another festival by way of either a monthly celebration or a passing into another chronological system.

as joint or sole ruler, his "birthday" as it was called in the Kanopos in-
scription, took place on January 7/8, 246 BC. Ptolemy V Epiphanes was
crowned in Memphis on Mecheir 17, January 1, 196, and he celebrated
his Greek *anakleteria* in Alexandria a few days later, possibly on Me-
cheir 22, January 6. The Alexandrian celebrations had the stronger
claim on the date of January 6. Before, the accession of Philopator may
have fallen into the same period (December 29, 222, to January 15, 221);
and some offices thought that his *dies imperii* fell in the month of Loios.
Loios 9/10 would have corresponded to January 6. But after some fluc-
tuation, this king seems to have continued the *dies imperii* of Philadelphos
and Euergetes on Dystros 25.[115] During the same period in early Janu-
ary, the temple of Horus in Edfu celebrated the annual victory festival
of its god, in which the god overcame his enemies and brought the Nile
flood.[116] The Alexandrian festival of Aion and, later, the Christian cele-
bration of Epiphany were observed on the same dates. This should be
no surprise, given the fact that Ptolemaic kings could be identified with
Aion Plutonios, the benefactor of the world,[117] and that Epiphany is also
a festival of Christ's kingship.[118]

(2) In the second column, we first encounter the Isis festival of the
Kikellia and the following journey of Osiris, which were essentially days
of mourning for the death of the god. It was celebrated on Choiak 28/
29. In 304 BC this date corresponded to March 4/5, which, by two days,
preceded a monthly celebration (Tybi 1; March 7) of what might have
been the coronation of Ptolemy I Soter. The repeated coronation at the
Kikellia (Hathyr 1; January 6) might well have been a ritual of this well-

115. For the accession of Philopator between December 29, 222, and January 15, 221,
see the documents discussed by J. Bingen, *CE* 50 (1975): 239–248, and the Panemos Em-
bolimos in *P. Cairo Zen.* 3. The latter indicates that, for some time or in some offices, Loios
was regarded as the month of Philopator's accession (Pestman, *Zenon Archive,* 218 n. 14).

116. In this case, the temple staged Horus' victory over the evil forces that blocked the
arrival of the Nile flood in a lake, because the festival did not concur with the time of the
flood. The king and Horus were seen as doing precisely the same thing. The coronation
of a king was to stabilize the order of nature and specifically to guarantee good floods. In
the festival at Edfu the representative of the king ritually staged the god's mythical deed.
Hence, the dynastic coronation festival amounted to Horus' victory. This is a thought pat-
tern that is different from identifying Ptolemy I Soter with Atum. But it might be possible
to rephrase the relationship between Soter and Atum in such terms (if Grzybek's interpre-
tation of the Pithom Stele were right).

117. A. Alföldi, "From the Aion Plutonios of the Ptolemies to the *Saeculum Frugiferum*
of the Roman Emperors," in *Greece and the Eastern Mediterranean in Ancient History and
Prehistory,* Studies presented to F. Schachermeyr (Berlin and New York, 1977), 1–30. The
argument could be strengthened with the use of Egyptian evidence.

118. This is indicated by the texts of the liturgy; the day is also celebrated as the festival
of the Three Holy "Kings" and their worship of Christ after his birth.

recognized festival (see n. 112): the death of Osiris preceded the acces-
sion of Horus. The date of March 7 was also remembered in the Sothis
year, as is indicated by the following observation. When the Egyptian
priests were gathered at Kanopos in 138 BC and referred to these festi-
vals, the date of Choiak 28/29 corresponded to February 16/17.[119] After
the last major celebrations (February 23) the priests stayed on until
March 7 (Tybi 17), when they issued the Kanopos decree. It seems, then,
that they waited for the anniversary of the coronation of Ptolemy I Soter
on March 7, in which case this festival was calculated in the Sothis year.
In 304 BC, the coronation of Ptolemy I Soter suited the religious char-
acter of the preceding Kikellia and the death of, and mourning for,
Osiris. In the ideology of Egyptian kingship, this god represented the
predecessor of Horus or the governing king (see section II.2.c [1] and
[3]). "Le roi est mort! Vive le roi!"

 The celebration of the coronation date in early March continued to
be observed beyond Ptolemaic history and to run parallel to the cele-
brations at the beginning of January. The priests assembled in Philae
erected a victory stele for Cornelius Gallus on about the same Sothis
date, March 5, that is, on the day of Osiris' journey; in Rome this was
the date of the *Navigium Isidis*. Here we may stress that the choice of the
dates for Soter's coronation was influenced by the meaning of festivals
of the Egyptian religion. But part of the mechanism used, namely the
celebration of monthly festivals, was Greek and was introduced into the
Egyptian temples by the Ptolemies.[120]

 According to the Kanopos decree, celebrations in honor of Ptolemy
III Euergetes and his wife Berenike II were ordered in all Egyptian
temples on the new year's day of the Sothis year (July 19), which hap-
pened to be Pauni 1 of the Egyptian civil year in 238 BC. Whether the
celebrations of the royal couple ever had any importance outside the
temples, we do not know. Under Philopator, the festival of July 19 was
respected but not observed by the higher Ptolemaic administration (see
above, section II and n. 37).

 (3) For the third column we have only the information of a single
inscription which attests that Ptolemy II Philadelphos celebrated his
birthday on Dystros 12 (born in 308 BC; cf. nn. 53 and 110 [2b]) and that
the Basileia was celebrated in an unknown town in the countryside on
this day (March 8). We may further suspect that the Basileia, originally a
thanksgiving feast for victory in honor of Zeus, was officially regarded

 119. *Can.* 51 and 64 (Kôm el-Hisn 41 and 54), where special honors for the deceased
princess Berenike are instituted; for this and the following synchronisms see Merkelbach,
Isisfeste, 36–39, 57f.
 120. For the Greek habit of celebrating birthdays and other religious festivals monthly
see W. Schmidt, *RE* 7.1136; F. Taeger, *Charisma* (Stuttgart, 1957) 1:420.

as Philadelphos' birthday; it was conceivably celebrated on the day that he was elevated to the position of joint ruler or, at least, was declared crown prince (December 15/16 [?], 285 BC). It is further possible that the day was chosen because Alexander may have been crowned on the Basileia which he celebrated in Memphis (331 BC), possibly on Dystros 12 (Jan. 24/25?).[121]

(4) The fourth column begins with the coronation of Ptolemy II Philadelphos and his declaration as sole ruler on Dystros 25, 282 BC, that is, on January 6/7.[122] This accession took place on an anniversary of his father's assumption of the kingship (see above, discussion of col. 1). Thus Dystros 25 became the *dies imperii* not only for Philadelphos, but also for Ptolemy III Euergetes and Ptolemy IV Philopator (cf. n. 113). For part of his reign, however, Euergetes used Dios 25 as *dies imperii;* this day denotes a monthly recurrence of Dystros 25, the day on which his father's accession was celebrated.[123]

(5) Euergetes' coronation (col. 5) was set on Dios 25, that is, on a monthly celebration of Philadelphos' coronation (Dystros 25).

(6) Finally, in the sixth column, we find Ptolemy V Epiphanes' birthday on Mesore 30, 210, that is, October 9. Whether this was the real birthday or only the official one, we do not know. From the point of view of the Egyptian religion, this birthday made the prince appear as born before the great gods were born on the following Epagomenai. In any case, Philopator seized the opportunity and elevated the baby before November 29 to be his coregent. If at the time the twenty-five-year cycle was still used to determine the equivalences of the Macedonian and the Egyptian calendar (see n. 110), the birthday would correspond to Dystros 21/22. It would then be likely that Epiphanes became coruler on Dystros 25 (October 12/13, 210), on the traditional *dies imperii* of the Ptolemies (see n. 113), when he was just three days old. He was the Horus-child on the throne (see section II.1.c [1]; cf. II.1.d, Philometor), a quality that was still very visible when he became sole king and, at the age of thirteen, was crowned and received the name Epiphanes (see section II.1.d, Epiphanes). The road for this elevation of the newborn prince had been prepared in the previous generation when Euergetes gave his daughter Berenike the title "queen" immediately after her birth; she was the "daughter of Re," the equivalent to Horus the Child

121. I tentatively accept E. Grzybek's reconstruction of the Macedonian calendar under Alexander; see his table 1, *Calendrier macédonien,* p. 181. For the problem of Alexander's coronation see n. 79.

122. According to E. Grzybek's reconstruction of the Macedonian calendar, which assumes an additional intercalation, the date is December 7/8, 283 (see nn. 61 and 110).

123. For Philopator's Macedonian new year's day see n. 96.

(see n. 8). We observe, again, that the female members of the family are made to lead the development of the royal cult and ideology.

Our investigation on the dates of accessions and coronations yields mainly three results pertinent to our present considerations. (a) Such dates were celebrated as dynastic festivals and were reused by later kings; (b) but they also created the dates and the raison d'être for Egyptian festivals. (c) The "message" conveyed by the choice of some of the dates follows the Egyptian ideology of kingship. The considerations with which I began and which nicely separated the two faces of Ptolemaic kingship for the Greeks and the Egyptians respectively, are only part of the truth. At least in the area of the ideology of kingship and its propaganda, the two sides influenced each other. The Greeks found it helpful to accept the Egyptian dogma of divine kingship, but they shaped it in accordance with Greek ideas; hence the veneration of queens and kings as gods. Thus the cult of Alexander and the Ptolemies addressed primarily the Greeks, but it was realized in forms that, at the same time, would deliberately meet the expectations of the Egyptian priests and would, therefore, also be directed to the Egyptian population. This was particularly evident in the choice of the cult-names of the kings. In fact, the two populations were not always that clearly separated, especially outside the relatively small areas of concentration of Greek settlers.

The dynastic cult invaded the Egyptian temples and developed by and large along its own lines. In a way, the long eponymous dating formula was an equivalent to the official Egyptian protocol, while this protocol was changed to express the importance which the Greeks attached to the filiation of the king and, hence, to the dynastic line. But even here, the Egyptians could easily adjust to the changes in light of their cult of the pharaoh's ancestors.

The coronation followed the Egyptian rite; it made the divine character of the king evident. For the Alexandrian Greeks the proclamation was sufficient, but not for the rest of the country. Even the anakleteria which in the case of Epiphanes probably took place a few days after the coronation in Memphis assumed an irrational, almost religious, value; they were staged in such a way that they could function as the Greek[124] equivalent to the Egyptian coronation. Soter's proclamation as king, naturally, entered the Egyptian temples, and in Edfu, a place rarely visited by a Ptolemaic king, it became the festival of the divine king Horus. But even in Greek Alexandria the development was finally not different,

124. Pol. 18.55.3: εὐθέως ἐγίνοντο περὶ τὸ ποιεῖν ἀνακλητήρια τοῦ βασιλέως [i.e., young Epiphanes] οὐδέπω μὲν τῆς ἡλικίας κατεπειγούσης, νομίζοντες δὲ λήψεσθαί τινα τὰ πράγματα κατάστασιν καὶ πάλιν ἀρχὴν τῆς ἐπὶ τὸ βέλτιον προκοπῆς δόξαντος αὐτοκράτορος ἤδη γεγονέναι τοῦ βασιλέως. Cf. 28.12.8 (Philometor).

as is evidenced by the transformation of this dynastic festival into an Aion festival and finally into the Christian Epiphany.

In most of these examples, the Greeks influenced the Egyptians and gave them something new to incorporate into their system. Yet in doing so the Greeks reacted to what they experienced in the country and to what they understood to be the expectations of the Egyptians. The Ptolemies, like Alexander before them, knew that they could win the loyalty of the conquered people only if they conformed to their idea of kingship.

III. KALLIMACHOS

At this point the Alexandrian poets, in particular Theokritos and Kallimachos, become important. They demonstrate the struggle of Greek culture to come to terms with the new world and contribute to the self-understanding of the Greek elite. Greek poetry, of course, speaks to the Greeks within the Greek tradition. I shall not suggest that the Alexandrian poets found their audience in the mixed population of the countryside. They directed their poems to an audience that spoke Greek and felt Greek; and yet members of this audience had to administer the affairs of the king in his double role. In poems, therefore, which refer to the king and to ideas of kingship, we may find intersecting levels: the surface meaning in terms of Greek myth and Greek thought and the subsurface meaning in which the Greek narrative and the Greek forms reflect Egyptian ideas. This would show the audience that ideas that appeared to be foreign could still be understood in terms of the Greek mythical and poetical tradition. The poets were not Egyptianizing Greek thoughts, but Hellenizing those Egyptian ideas that had become common in the thinking of the court. Thus the influence of Egyptian ideas on Greek poetry stems paradoxically from the Greek efforts to Hellenize these Egyptian ideas. Here I must restrict myself to a few observations on Kallimachos.[125]

1. The Hymn to Delos

The inspiration Kallimachos received from the Egyptian ideology of kingship as it made itself felt at the court in Alexandria is clearest in his *Hymn to Delos*. But since this has been dealt with elsewhere, I can be very brief.[126] The learned reader easily savors the network of mainly Homeric

125. Cf. T. Gelzer, "Kallimachos und das Zeremoniell des ptolemäischen Königshauses," in *Aspekte der Kultursoziologie: Zum 60. Geburtstag von M. Rassem*, ed. J. Stagl (Berlin, 1982), 13–30.

126. For a detailed discussion see my "Adaption," 174–190, and already "Θεοῖσιν ἐχθρός," 110–112; R. Merkelbach, "Das Königtum der Ptolemäer und die hellenistischen

and Pindaric allusions, and he may even recognize the hymn as witty and thoroughly entertaining but at the same time as a serious realization of the Kallimachean program.[127] What may appear at first glance to be an exhibition of learnedness frequently reveals itself on a closer look to be a hint of the poetical intention. On a Greek level of understanding, the knowledgeable reader admires the novelty in which a traditional form reappears. But most readers will have difficulties in coming to terms with the long prophecy at the center of the poem (although prepared by other prophecies, to be sure), in which Apollo predicts the coming of Philadelphos and raises him to his own level.

At this point, the reader should observe the signs by which the poet indicates that an Egyptian side is involved too.[128] For example, Apollo is born when the Delian river Inopos is swollen with the waters of the Nile flood.[129] In Egyptian myth, Horus is born at the occurrence of the Nile flood and he hides on a floating island. In partial contrast, Delos was floating before the birth and finds its permanent place after the birth. In Apollo's prophecy of the future Ptolemaios, the king is the ruler of the "two continents [ἀμφοτέρη μεσόγεια] and the islands which lie in the sea, as far as to the outmost boundary of the world [i.e., the West] and the area from which the swift horses carry the sun" (the East; 168ff.). As we already saw, Egypt is called "the Two Countries," and it was one of the main duties of the pharaoh to unify these Two Coun-

Dichter," in *Alexandrien: Kulturbegegnungen im Schmelztiegel einer mediterranen Grossstadt*, Aegyptiaca Trev. 1 (Mainz, 1981), 27–35 and now Bing, *Muse*, chap. 3, "Callimachus' Hymn to Delos," 91–143, esp. 128ff. See also n. 86 (Kallimachos); section II with n. 48 and section II.1.d with n. 85 (Theokritos). Fur further bibliography on this hymn see L. Lehnus, *Bibliografia Callimachea 1489–1988*, Publ. del Dip. Arch., Filologia class. e loro trad. (Genoa, 1989), 250–260.

127. This, of course, does not imply that Kallimachos invented his program and then sat down to write his poems accordingly; nor should Kallimachos' remarks on his own poetry be reduced to a mere *post factum* defense (as G. O. Hutchinson does: *Hellenistic Poetry* [Oxford, 1988], 83). His poetical theory most likely developed as he wrote his poetry, and in this sense I speak of the fourth *Hymn* as a realization of his program (see Bing, *Muse*, chap. 3). Admittedly, the word "program" is unfortunate, but in view of the modern discussions, it is better to keep the term. See also Hutchinson, 77, against the "need to see . . . an articulated 'programme', which the works were consciously written to fulfil." He adds: "It may be doubted whether Callimachus had any 'programme' of that kind."

128. For all we know, the *Erigone* by Eratosthenes was another example of a Hellenistic poem meant to be read on two levels, on a Greek and an "Egyptian" one, although the actual audience was Greek. See R. Merkelbach, "Die Erigone des Eratosthenes," in *Miscellanea di studi Alessandrini in memoria di A. Rostagni* (Turin, 1963), 469–526.

129. Kall. *H. to Delos* 205ff.; L. Koenen, "Adaption," 175f.; Bing, *Muse*, 136f.; Mineur, *Hymn to Delos*, 186.

130. For this concept see sections II.1.a and b (with n. 75) and II.1.c (2) and (4).

tries.[130] Moreover, the pharaoh "conquers what the sun encircles." King Echnaton's real dominion is described as "the South and the North, the East and West and the islands in the middle of the sea"; it reaches "as far as the sun shines."[131] Is this parallel accidental? Probably in the sense that the passage on Echnaton expresses widely held Egyptian beliefs and Kallimachos need not to have known this specific passage; but hardly, if we refer to these broad Egyptian beliefs. The passage in Kallimachos' hymn goes on to predict Philadelphos' joint fight with Apollo (ξυνὸς ἄεθλος). Apollo will destroy the Celts attacking Delphi, and Philadelphos will burn a troop of Celts on an island in the Nile. These mercenaries had fought in his service but were now accused of a mutiny.[132] They are characterized as wearing "shameless girdles" (ζωστῆρας ἀναιδέας, 183). The girdle fits the dress of the Celts, and yet it may be borne in mind that, in *The Oracle of the Potter*, ζωνοφόροι is used as technical term for the Typhonians, the evildoers, the enemies of the gods and the king. This prophecy predicts the perfect pharaoh sent by the gods, who will come after an evil time and renew the country as well as the cosmic order. Such prophecies have a long pharaonic tradition from which specifically the term "wearer of the girdle" was inherited.[133] The extant versions of *The Oracle of the Potter* go back to an original composed, I believe, about 116 BC, but Kallimachos seems to have known a much older version. In his time, or in his mouth, the oracle favors the Greeks; around 116 BC *The Oracle of the Potter* was anti-Greek; and in 115/117 AD, another prophecy featuring ζωνοφόροι is directed against the Jews and

131. G. Davies, *The Rock Tombs of El Amarna* (London, 1906) 3:31f.; M. Sandman, *Texts from the Time of Akhenaten*, Bibl. Aeg. 8 (Brussels, 1938), 6–10; J. Assmann, *Ägyptische Hymnen und Gebete* (Zurich and Munich, 1975), 224; for more see Koenen, "Adaption," 186–187 with nn. 119, 120.

132. I disagree with G. O. Hutchinson, *Hellenistic Poetry*, 39 n. 26, who thinks that the scholion's story about Philadelphos hiring mercenaries from Brennus' army is a later fabrication to make sense of Kallimachos' connection of the two victories—that of the god over the Gauls in Delphi and that of Philadelphos over the mutiny of the mercenaries on the island of the Nile. Pausanias mentions only that his army included some 4,000 Gauls whom the king found plotting to seize Egypt and whom he then punished on the island in the Nile. But the historical reality which led Kallimachos to speak of a ξυνὸς ἄεθλος is of minor importance for the interpretation of Kallimachos, although the story helps to show how the poet, by a brief allusion to a historical situation, could make a tenet of the Egyptian ideology look obvious from the point of view of the Greeks.

133. L. Koenen, "Manichaean Apocalypticism at the Crossroads of Iranian, Egyptian, Jewish, and Christian Thought," in *Codex Manichaicus Coloniensis: Atti del simposio Internazionale, Rende-Amantea, Sett. 1984*, ed. L. Cirillo (Cosenza, 1986), 285–332, esp. 328–330 (on the "wearers of the girdle" and its occurrence in the Deir ʿAlla inscription, a Canaanite prophecy from 700 BC).

apparently encourages the Greco-Egyptian population of the country-side.[134]

In view of this, it seems to me that Kallimachos not only understood crucial elements of the Egyptian ideology of kingship but also made poetic use of a prophecy propagating these ideas. He places Greek myths in an artful and witty arrangement of complementary or contrasting images in order to express the Egyptian ideology of kingship as it was accepted and propagated by the court. He made the ideology acceptable by putting the Egyptian prophecy and its ideology into the web of allusions to old Greek poetry.

On one level, then, the *Hymn to Delos* is an exemplary poem, an embodiment of Alexandrian poetics; on the other level, it transforms tenets of Egyptian ideology into the language of Greek poetry. Both levels resolve into unity. The Apollo of the *Hymn to Delos* is the ultimate source of both Kallimachean poetry and Ptolemaic kingship. It is thus that the old Pindaric vision of unity of government and music reappears in a new poetic and social context.[135]

2. Epigram 28 Pf. (2 G.-P.)

The *Hymn to Delos* ends with a hilarious ritual, in which sailors dance around the altar, beating it and biting the trunk of a tree with their hands turned backwards. The modern reader is inclined to take this as a device by which the poet undercuts the seriousness of what he has said before. The poet would thus be ironic in the extreme, toying with his audience. Before coming to such a conclusion, we should try to understand the function of Kallimachean humor, in particular since this will be a crucial factor for our discussion of the *Coma*. As an example I wish to take *Epigram* 28. We must be brief and focus on what is important in the present context.[136] First lines 1−4:

134. This version of the oracle is known from two papyri which, in part, supplement each other. Only one version is published (*PSI* 982 = *CP Jud.* 3.520 [1964], cf. *Gnomon* 40 [1968]: 256); I shall publish the other in the *P. Oxy.* series in the near future. Presently no dependable text of the oracle is available.

135. See *Pyth.* 1; Bing, *Muse*, 110−128 and 139−143; and below, n. 160.

136. My reading of the epigram is indebted to A. Henrichs, "Callimachus *Epigram* 28: A Fastidious Priamel," *HSCPh* 83 (1979): 207−212; also see, for example, E.-R. Schwinge, *Künstlichkeit von Kunst: Zur Geschichtlichkeit der alexandrinischen Poesie*, Zetemata 84 (Munich, 1986), 5−9 (= *WJA* NF 6a [1980]: 101ff.); Gow-Page's commentary 2:155−157; P. Krafft, "Zu Kallimachos' Echo-Epigramm (28 Pf.)," *RhM* 120 (1977): 1−29 (with a critical review of then recent research); see also E. Vogt, "Das Akrostichon in der griechischen Literatur," *A&A* 13 (1967): 85f., and C. W. Müller, *Erysichthon: Der Mythos als narrative Metapher im Demeterhymnos des Kallimachos*, Abh. Ak. Mainz, Geistes- und Sozialwiss. Kl. 13 (Stuttgart, 1987), 36. For further bibliography see Lehnus, *Bibliografia Callimachea*, 295−297.

I loathe the cyclic poem and I do not enjoy
a road which leads many people hither and thither;
I hate a meandering darling, and from a public fountain
I do not drink. I am sick of all that is public.
Lysanies, yeah, you are my hand*some one, hand*some—but before this
is said, echo responds distinctly: "in someone's hand!"[137]

Kallimachos begins this negative priamel with five rejections in four
lines. The first two lines offer two pair of rejections of increasing length;
the next two lines combine two other examples, this time of decreasing
length, with the preliminary conclusion drawn from all four examples.
In the first pair of rejections (lines 1–2), Kallimachos combines his inten-
sive but almost prosaic distaste for cyclic poetry (τὸ ποίημα τὸ κυκλι-
κόν)[138] with an ambiguous refusal dressed in the traditional metaphor
of the highway ("a road which leads many people hither and thither").
That Kallimachos will later take up the metaphor in his prologue to the
edition of the *Aitia* (27f.) in four books and elevate it to a command of
Apollo (see below) stresses the theoretical character of this statement. It
refers to Pindar,[139] who had used the metaphor of riding on a busy street

137. ἐχθαίρω τὸ ποίημα τὸ κυκλικόν, οὐδὲ κελεύθῳ
 χαίρω, τίς πολλοὺς ὧδε καὶ ὧδε φέρει·
 μισέω καὶ περίφοιτον ἐρώμενον, οὐδ' ἀπὸ κρήνης
 πίνω· σικχαίνω πάντα τὰ δημόσια.
 Λυσανίη, σὺ δὲ ναίχι καλός, καλός—ἀλλὰ πρὶν εἰπεῖν
 τοῦτο σαφῶς, Ἠχώ φησί τις· ἄλλος ἔχει.

I find a similar attempt to render the pun in P. Bing and R. Cohen, *Games of Venus*, The
New Ancient World Series (New York and London, 1991), 136: "But you, Lysanias,—oh,
brother!—you're handsome, handsome—but before the words / are out, an echo says 'An-
other has his hands on him.'"

138. The precise meaning of the word is uncertain, and it could indeed be intentionally
ambiguous (H. J. Blumenthal, *CQ* 28 [1978]: 125–127, esp. 127). Later the word over-
whelmingly referred to cyclic poetry, but Numenius uses the word for "common," "conven-
tional," that is, "un-Platonic" (F 20 des Places). The suggestion that Numenius may have
taken this usage from Kallimachos' epigram (Blumenthal), implies that Kallimachos' text
would either unambiguously mean "common" or Numenius misunderstood it in this way.
G. O. Hutchinson (*Hellenistic Poetry*, 79 n. 104) prefers "banal or commonplace poem"; see
also C. Meillier, *Callimaque et son temps*, Publ. de l'Univ. de Lille 3 (Lille, 1979), 124.

139. *Paean* VII.b 10–14 S.-M., with E. Lobel's and B. Snell's supplements, except for
line 12 where I print my conjecture μ[ηδ'; cf. Bing, *Muse*, 104, and eundem, "Callimachus'
Cows: A Riddling *Recusatio*," *ZPE* 54 (1984): 1–13 (with corrections in *ZPE* 56 [1984]: 16),
esp. 2 n. 5:

 κελαδ⌊ήσαθ' ὔμ⌋νους,
 Ὁμήρου [δὲ μὴ τρι]πτὸν κατ' ἀμαξιτόν
 ἰόντες μ[ηδ' ἀλ]λοτρίαις ἀν' ἵπποις,
 ἐπεὶ αὐ[τοὶ ἐς π]τανὸν ἅρμα
 Μουσα[ῖον ἀνέβα]μεν.

for the imitators of Homer—in Kallimachos' terms the authors of cyclic poetry. Thus the knowledgeable reader expects the road metaphor also to speak about poetics, but he soon realizes that in the third example, the first member of the following dicolon (line 3), the poet turns to his rejection of an unfaithful boy. Thus the reader wonders whether the preceding road metaphor should be taken in a similar sense. In a small poem of the sixth century, extant in the *Theognidea,* this metaphor is indeed used for the boyfriend who walks the road to another lover.[140]

Kallimachos' third example means precisely what it says: he hates an unfaithful boy. Proceeding to the fourth rejection, the reader recognizes immediately that, because of the form of the negative priamel, the fountain must represent something detestable, hence not Hippokrene, the fountain of the Muses. He recalls another passage of the *Theognidea* (959ff.) where the poet says that when he drank from a dark-watered fountain (κρήνη μελάνυδρος)—that is, from a deep fountain in a shady place—the water seemed sweet and clean to him; but now the fountain is polluted, water is mixed with water, and the poet will drink from another spring or river.[141] The sense is again erotic. But whereas in the *Theognidea* the fountain is clearly described as dark-watered and then as polluted, Kallimachos' fountain needs no such qualification. At this point the reader notices that Kallimachos throughout the epigram (as well as in his other poetry) mixes prosaic with poetic diction. Line 1, "the cyclic poem" (τὸ ποίημα τὸ κυκλικόν) is a prose expression, a fact which is made more impressive by the contrast to the preceding poetic word (ἐχθαίρω, "I hate"); and the series of things hated ends with σικχαίνω, "I am sick," again a prosaic word.[142] These prosaisms remind the contemporary reader that, in plain language as used in Egypt, the word "fountain" (κρήνη, a word used in prose as well as in poetry) normally denotes a fountain that is public or on an estate where it is used for professional purposes—surely a very popular and hence, for Kallimachos, undesirable place.[143] This is the primary sense needed in the epigram.

140. *Theog.* 599f. (cf. Henrichs, *"Epigram 28,"* 210):

οὔ μ᾽ ἔλαθες φοιτῶν κατ᾽ ἀμαξιτόν, ἣν ἄρα καὶ πρὶν
ἠλάστρεις, κλέπτων ἡμετέρην φιλίην.

141. *Theog.* 959–962:

ἔστε μὲν αὐτὸς ἔπινον ἀπὸ κρήνης μελανύδρου,
ἡδύ τί μοι ἐδόκει καὶ καλὸν ἦμεν ὕδωρ·
νῦν δ᾽ ἤδη τεθόλωται, ὕδωρ δ᾽ ἀναμίσγεται ὕδει·
ἄλλης δὴ κρήνης πίομαι ἢ ποταμοῦ.

142. Henrichs, *"Epigram 28,"* 209 n. 5; on κυκλικόν see n. 138.

143. Suffice it to refer to *BGU* 3.999.1.6 and 2.5, ἡ ἐν Παθύρει κρήνη (99 BC). For

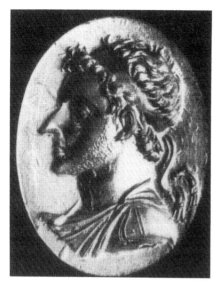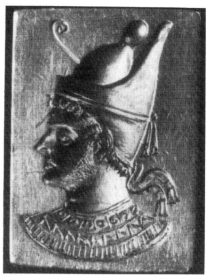

a. b.

1. Golden seals, middle of 2nd cent.; Louvre Bj 1092 and 1093; from
H. Kyrieleis, *Bildnisse der Ptolemäer,* Arch. Forsch. 2, DAI (Berlin, 1975), pl. 46.

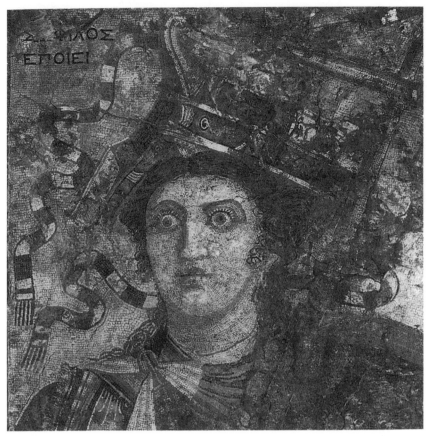

2 a & b. Berenike II from Thmuis (Tell Timai), Greco-Roman Museum in Alexandria inv. no. 21739 and 21736, Photos by D. Johannes, from W. A. Daszewski, *Corpus of Mosaics from Egypt* I, Aegyptiaca Treverensia 3 (Mainz, 1985), pl. A (after p. 7; cf. pll. 32 and 42a; cat. no. 38) and B (after p. 40; cf. pl. 33; cat. no. 39). Also see, e.g., E. Breccia, *Le Musée Gréco-Romain,*

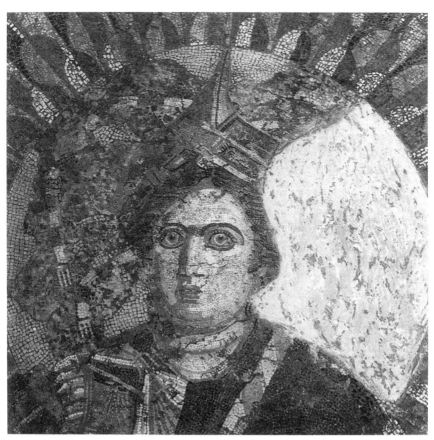

1925–1931 (Bergamo, 1932), pll. A, LIV 196 (both [a]) and LIII 194 (b),
M. Rostovtzeff, *The Social and Economic History of the Hellenistic World* (Oxford,
1941) I pl. XXXV; cover of F. W. Walbank, *The Hellenistic World* (Cambridge,
Mass., 1982), both (a).

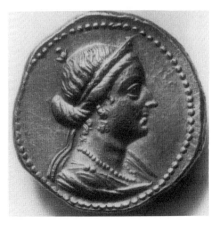
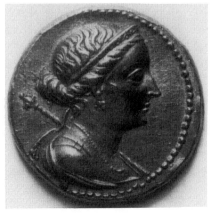

a. b.

3. Gold octadrachms with portrait of Arsinoe III in the British Museum (*BMC Ptolemies* 67, 1–2, pl. 15.6) and in Glasgow, from H. Kyrieleis, *Bildnisse der Ptolemäer*, Arch. Forsch. 2, DAI (Berlin, 1975), pll. 88.1–2 (cf. pp. 102f.); see also J. N. Svoronos, Τὰ νομίσματα τοῦ κράτους τῶν Πτολεμαίων, pll. 39.1–3 and 42.1, 4.

All four first members of the priamel can be taken in a literal meaning: rejection of cyclic poetry, a crowded street, an unfaithful lover, and a public fountain. But the second and fourth members express also metaphorical meanings, again amounting to rejection of both popular poetry and an unfaithful lover. Thus, the metaphorical meaning of the street and the fountain vacillates between the parameters determined by the two rejections that have literal meaning only.[144] Moreover, the layers of the literal and metaphorical meanings prepare for the fifth member of the negative priamel, the generalization summarizing all levels of interpretation: I am sick (cικχαίνω) of everything that is popular.

The following cap or climax (lines 5–6) turns the priamel, already presented in hilarious artistry, on its head. Taking up the erotic elements, Kallimachos begins the positive conclusion of the negative priamel as one should expect. "Lysanies, yeah, you are handsome, handsome:" *nekhi kalos kalos.*" Expressions like Καλλίας καλός are common confessions by which a Greek lover declared his love to a boy. Kallimachos repeats the adjective, as did the girl addressing Daphnis in Theokritos' (?) *Boukoliastai* 2 (8),73. Such duplication is both archaic and colloquial, as a Greek reader conscious of his language would hear instantly.[145] But as soon as the audience believes it understands the epigram, its expectation is deceived. Kallimachos seems himself to walk the popular road, but at the same time the repetition prepares for the effect of the echo. He plays only with the echo of his last words: *nēkhi kalos kalos;* and it is broken twice. When the first echo arrives, its very beginning is broken off: only *allos* is heard, and before this echo reaches the second *kalos*, this word is made inaudible by the return of the second

other examples see Preisigke, *Wörterbuch* and Demonstration Disk no. 6 of the Duke Data Bank of Documentary Papyri (DDBDP), distributed by the Packard Humanities Institute. All examples are later than Kallimachos, but I have no doubt that κρήνη was thus used in Kallimachos' time too. A full study on Kallimachos' use of plain language is still a desideratum.

144. Henrichs, "*Epigram* 28," 209 n. 6, demonstrates that περίφοιτον ἐρώμενον (3) cannot be understood as a metaphor for comedy, as has been suggested by R. F. Thomas, "New Comedy, Callimachus, and Roman Poetry," *HSCPh* 83 (1979): 179–206.

145. For "NN is beautiful" in inscriptions, on vases, and in literature (e.g., Aristoph. *Wasps* 98f.) see K. J. Dover, *Greek Homosexuality* (Cambridge, Mass., 1978), 111–114, 120f.; F. Lissarrague, *The Aesthetics of the Greek Banquet*, trans. A. Szegedy-Maszak (Princeton, 1990; original title: *Un flot d'images: Une esthétique du banquet grec* [Paris, 1987]), 59–61 and 85 ("the boy is beautiful" at a play of Kottabos on a red-figured cup of ca. 490, in Florence, J. D. Beazley, *Attic Red-Figure Vase-Painters* [Oxford, 1963], 121/1). For the duplication of καλός cf. also Kallim, *Epigr.* 29.3 Pfeiffer; 5.3 Gow-Page (line 1065), and cf. A. Henrichs, "Riper Than a Pear: Parian Invective in Theokritos," *ZPE* 39 (1980): 7–27, esp. 12 n. 9 (with literature).

echo *(n)ekhi*. In turn the second echo weakens and immediately fades away. Thus all that is produced is *allos ekhī*.[146]

In part the pun is based on the pronunciation αι > ε and ῑ > ει, which at the time did not yet dominate the scene but was obviously used by some people. Kallimachos himself plays in other poems with the pronunciation of αι > ε and η > ει > ῑ,[147] and the only additional surprise in the echo's pun is the fact that the ῐ of ναίχι becomes ῑ of ἔχει in the metrical position at the end of the line, where a short vowel would be lengthened by the following pause. There may be an additional sound effect: the ῑ, the last sound of the echo (and the epigram), imitates the echo as slowly fading away. Kallimachos plays with pronunciations which at his time occurred but were not frequent; and it might have been precisely for this reason that he found such puns intriguing.

Another related element of this pun is the fact that at the moment when the climax (Lysanies) is topped and the reader's expectation is turned upside down, Kallimachos uses the emphatic ναίχι, a word which may not have been as rare as its attestations in the surviving literature suggest.[148] In the context of the poem the use of the emphatic word

146. I.e., *(nekhi k)alos̱ (kalos n)ĕkhī* (*kalos kalos*). The right explanation was given by K. Strunk, "Frühe Vokalveränderungen in der griechischen Literatur," *Glotta* 38 (1960): 74–89, esp. 84f.

147. For the exchange of these vowels and diphthongs see Strunk, "Vokalveränderungen," 77–83 and 83–87 respectively. For αι > ε, he refers to Kall. *Aitia* F 75.36 (*Akontios and Kydippe*), where the ἐτήσιαι are derived from αἰτεῖσθαι, and to one example each from Hesiod (*Theog.* 207–210) and Herodotos (5.92); rare examples appear in the papyri already in the fourth and third centuries BC (E. Mayser, *Grammatik der griech. Pap. der Ptolemäerzeit*, 1.1, 2d edition by H. Schmoll [Berlin 1970], 85f.). For η > ει > ῑ, Strunk points to Kall. *Hymn to Apollo* 97 and 103, where ἰὴ ἰὴ παιῆον is explained as ἵει, ἵει, παῖ, ἰόν (see also F. Williams, *Callimachus, Hymn to Apollo* [Oxford, 1978] ad loc.); the pun is already Pindaric (see now K. O. Lord, "Pindar in the Second and Third Hymns of Callimachus" [Diss., University of Michigan, Ann Arbor, 1990], 59); but Strunk does not offer any example for η > ῑ; in papyri, particularly in private documents, the spelling of ει for short and long ι appears in the course of the third century BC, especially at the ends of words (Mayser, *Grammatik*, I.1, 6of.). In Attika such misspellings were much slower to appear (αι > ε and ῑ > ει do not appear before Roman times; see L. Threatte, *The Grammar of Attic Inscriptions* (Berlin and New York, 1980) 1 : 190ff. and 295ff., but this fact does not affect the argument.

148. Also Kall. *Epigr.* 52.3 Pfeiffer (6 Gow-Page, line 1065; in prayer); Soph. *Oed. Tyr.* 684; Aristoph. *Thesm.* 1183, 1184, 1196, 1218, ναίκι ναί, ναίκι ναίκι, ναί ναίκι in the pronunciation of the excited Scythian policeman; Men. *Sam.* 296 and *Epitrep.* 873; Plato *Hipparch.* 232A; Heliod. 2.26.3; Sozom. 6.18.6 (all affirmative answers; cf. Dion. Thrax. *Ars gramm.* 1.78.3; Suidas s.v.). The grammarian Herodianus (*Gramm. Graeci* 3.1.9 and 506, etc.) and Eust. (in *Il.* 1.167.27) merely discuss the accent. So far as I can find, the word is not used in papyri, but occasionally in dipinti and graffiti (*SEG* 24.73; Threatte, *Grammar*, 13.04 p. 261 and 15.011b p. 269); cf. Modern Greek, ναίσκε, analogue to ὄχι, "often amplified to M ὄχικα (i.e., ὄχι καλέ [!] . . .), ὄχεσκε . . . and, after it, ναίσκε 'yes in-

seems to sound somewhat droll. The emphasis precedes the peripateia. What makes the pun burlesque, however, is its content. Lysanies, who for a moment seems to be the climax of the priamel, is somebody else's darling. Kallimachos' likes are not better than his dislikes. The humorous reversal of the climax depends on the meaning of the sentence as well as on the play with the sound pattern.

The climax of the priamel undercuts, first, its positive conclusion, that Kallimachos loves Lysanies. This boy is not what his name promises, and he puts no end to his lover's heartache.[149] The name was actually in use, and Lysanies could therefore be a real person. But I doubt that this is the reason why Kallimachos invokes this name. He rather stands for this type of boy. He is public property and thus must belong to what Kallimachos hates. Second, the entire buildup of the negative priamel is undercut. Does the joke therefore negate the seriousness of Kallimachos' erotic dislikes? That is hardly the case. And is it inconceivable that Kallimachos meant to rescind his hatred of the cyclic (and other bad) poetry? The punch line makes fun of his own way of life and of his poetic principles; but his seriousness and his laughter are two sides of the same coin. What otherwise would have been an inflated, boastful, overserious poetical credo, is deflated by the humor and thus kept in civilized human proportions. It does not provoke rejection; it becomes acceptable.

We should bear this in mind as we now return to Ptolemaic kingship, specifically to Kallimachos' poem *The Lock of Berenike*. There we will find a deflation even of the sovereign, but done in such a way that, with a broad smile, even his apparently overwhelming power is put into a human context of friendship and love.[150]

3. The Lock of Berenike

As far as we can tell, Kallimachos is more subtle in the *Lock of Berenike* than in the *Hymn to Delos*. The poem centers on the concept of divine kingship. Its imagery suggests in poetic playfulness that the queen, the

deed,'—all these lengthened forms being considered, in popular parlance, as politer than ὄχι . . . and ναί respectively" (A. N. Jannaris, *An Historical Greek Grammar* [London, 1897], p. 480, § 2061). The survival of the word into Modern Greek allows some doubt as to whether the word was indeed as uncommon in the earlier stages of the language as it seems to us. W. Schulze called ναίχι "einen Strassenausdruck" (*Kleine Schriften* 706, quoted by Strunk, "Vokalveränderungen," but this is hardly substantiated by evidence. Cf. E. Schwyzer, *Griechische Grammatik*, vol. 1 (1977), 624.

149. Here I follow a suggestion communicated orally by T. Gagos.

150. Cf. G. O. Hutchinson's general statement (*Hellenistic Poetry*, 32): Kallimachos' "work characteristically explores the effects which lie between absolute seriousness and entire deflation. One must not seek, therefore, to resolve the poetry into either extreme— nor even rest content with asserting that it belongs to neither."

"daughter" of the new deity Arsinoe II, must be divine too. The deification of the queen is anticipated by the catasterism of the lock.

The *Lock of Berenike* may be dated to September 245 BC, when the astronomer Konon detected the constellation of the lock after its heliacal rising.[151] This was about two years before Euergetes added Berenike II and himself to the Alexandrian cult of Alexander and the Gods Adelphoi (section II.1.b [3]). Thus, both Konon's "discovery" and Kallimachos' poem reflect the mood at the court, which may even have initiated the disappearance of the lock.[152] If the hair can become a star, the queen should be divine too. This is an urbane compliment, significant of the atmosphere of the court and of the way in which the issue of divine kingship was accepted and playfully propagated.

The poem can be understood within the parameters of the Greek tradition,[153] and yet the entire institution of divine kingship developed in Egypt under the influence of the Egyptian reality. Hence we will take our clue from Kallimachos, and in a few passages question whether there is an additional Egyptian side to it. But as in the case of the *Hymn to Delos*, "Egyptian" will refer only to the layers of Egyptian beliefs which at the time were easily accessible to the Greeks.

Three preliminary reminders are essential before we begin our reading of the *Lock of Berenike*. (1) The *Lock* was the last poem of the *Aitia*.

151. See also below. For the heliacal rising on September 2–8 as well as for other astronomical data relevant for the interpretation of the poem see N. Marinone, *Berenice da Callimaco a Catullo* (Rome, 1984), esp. 29–44. Recently an attempt has been made to advance the date to September 246, because around September 10 of that year the planet Venus, alias the morning star, would be relatively close to the Coma Berenices. The planet, of course, is the star of Aphrodite, that is, in the present context, of Aphrodite-Arsinoe. An allusion to this star could be expected (S. West, "Venus Observed? A Note on Callimachus, Fr. 110," *CQ* 35 [1985]: 61–66). But, according to Catullus, Kallimachos must have dated the catasterism to the heliacal rising of the following year (as is maintained by common opinion): Euergetes became sole ruler on January 27/28, 246 (Dios 25). When, later in the year, he went to war, the queen promised the sacrifice of her lock, but the promise was only fulfilled *after* his return around September 3, 245. Cat. 66.33–34: *atque ibi me cunctis pro dulci coniuge divis / . . . pollicita es, / si reditum tetulisset. is haut in tempore longo / captam Asiam Aegypti finibus addiderat. / quis ego pro factis caelesti reddita coetu / pristina vota novo munere dissolvo.* There is no reason to postulate a different chronology for Kallimachos. Hence, part of the chronology proposed by H. Hauben for the Syrian war of 246/5 should be revised. H. Hauben, "L'expédition de Ptolémée III en Orient et la sédition domestique de 245 av. J.-C.," *APF* 36 (1990): 29–37. For a bibliography on the *Lock*, see Lehnus, *Bibliografia Callimachea*, 104–113.

152. West, "Venus Observed," 62 n. 7, 63 n. 14; H. P. Syndikus, *Catull: Eine Interpretation*, Impulse der Forschung 55 (Darmstadt, 1990) 2 : 199 n. 4.

153. That Kallimachos' *Lock of Berenike* is exclusively based on Greek traditions was defended by H. Nachtergael in "Bérénice II, Arsinoé III et l'offrande de la boucle," *CE* 55 (1980): 240–253.

In all likelihood, Kallimachos edited the *Aitia* in two steps; the first edition consisted of books 1 and 2 only, which are cast in the form of a story told by the narrator, Kallimachos, about his dream encounter with the Muses: his initiation as successor to Hesiod (the *somnium*), his questions, and the Muses' answers.[154] In his old age Kallimachos expanded the work of his younger days with two more books, mainly a collection of etiological poems which he had written over the years. He also added (a) the prologue against the Telchines (F 1.1–40) and (b) an invocation of the Muses in which the poet seems to have called upon them to remind him of the earlier encounter when they answered his questions;[155] and (c) he reworked the epilogue of the earlier edition (F 112), which now was to bridge the *Aitia* and the *Iambs*[156] in the fashion in which transi-

154. I follow P. Parsons' theory, essentially a combination of R. Pfeiffer's and E. Eichgrün's theories: "Callimachus: Victoria Berenices," *ZPE* 25 (1977): 1–50, esp. 49f.; cf. Fraser, *Ptolemaic Alexandria* 2:106f. nn. 11 and 12. For the structure of the first two books as a dialogue with the Muses, see now A. Harder, "Callimachus and the Muses: Some Aspects of Narrative Technique in *Aitia* 1–2," *Prometheus* 14 (1988): 1–14; Harder is mainly interested in explaining the dialogue with the Muses as an innovative and playful transformation of epic "dialogues" into a "diegematic" presentation.

155. P. Bing, "A Note on the New 'Musenanruf' in Callimachus' *Aetia*," *ZPE* 74 (1988): 273–275; this is an addendum to an observation by A. Kerkhecker, "Ein Musenanruf am Anfang der *Aitia* des Kallimachos," *ZPE* 71 (1988): 16–24; cf. also Hutchinson, *Hellenistic Poetry*, 81 n. 109.

156. For the epilogue as bridge to the *Iambs* see D. L. Clayman, "Callimachus' *Iambi* and *Aitia*," *ZPE* 74 (1988): 277–286. On lines 9–10, χαῖρε, Ζεῦ, μέγα καὶ σύ, σάω δ' [ὅλο]ν οἶκον ἀνάκτων / αὐτὰρ ἐγὼ Μουσέων πεζὸν [ἔ]πειμι νομόν, R. Pfeiffer observed that [ἔ]πειμι may very well be a pun on ἴαμβος, which the ancients frequently derived from ἰέναι (R. Pfeiffer, "Βερενίκης πλόκαμος," *Philologus* 87 [1932]: 179–228; reprinted in *Kallimachos*, ed. A. D. Skiadas, Wege der Forschung 296 [Darmstadt, 1975], 100–152, esp. 150–152). He also drew attention to the fact that these lines imitate the transition formula of Homeric hymns (ad loc.): esp. *Hom. h.* 13.3 χαῖρε θεὰ καὶ τήνδε σάου πόλιν, ἄρχε δ' ἀοιδῆς and the epigram in Polybius 4.33.2 (Kallisthenes, *F. Gr. Hist.* 124 F 23; D. L. Page, *Further Greek Epigrams* [Cambridge, 1981], p. 428f. with note; cf. also *Hom. h.* 16.5, 19.48, 21.5). For these formulas connecting Homeric hymns to other hymns or epic performances see N. J. Richardson on *Hom. h.* 2.495 (σεῦ δ' ἐγὼ ἀρξάμενος μεταβήσομαι ἄλλον ἐς ὕμνον combined with χαῖρε formula *Hom. h.* 5.292f., 9.7–9, 18.10–12) in *The Homeric Hymn to Demeter* (Oxford, 1974), 324f.: αὐτὰρ ἐγὼ καὶ σεῖο καὶ ἄλλης μνήσομ' ἀοιδῆς (with preceding χαῖρε formula: *Hom. h.* 3.545f., 4.579f., 10.4–6, 19.48f., 28.17f., 30.17–19; cf. 25.6f. χαίρετε, τέκνα Διός, καὶ ἐμὴν τιμήσατ' ἀοιδήν· / αὐτὰρ ἐγὼν ὑμέων τε καὶ ἄλλης μνήσομ' ἀοιδῆς; similarly 27.21f., 29.13f., 33.17–19) and further variants (31.18f. χαῖρε, ἄναξ, πρόφρων δὲ βίον θυμήρε' ὄπαζε· / ἐκ σέο ἀρξάμενος κλήσω μερόπων γένος ἀνδρῶν / ἡμιθέων ὧν ἔργα θεοὶ θνητοῖσιν ἔδειξαν; cf. 32.18–20; see also 3.165–178 with Thuc. 3.104). For the practice of the ancient editors of Homer and Hesiod to connect different poems of their author's corpus through such transitions see *Il.* 24.804a (extant in two different versions), *Theog.* 1019–1922, and *Erga* 828. The latter passages might have been written by the author of the *Catalogue* and of the *Ornithomanteia*, respectively, if the last one was not written by Hesiod; cf. M. L. West, *The Hesiodic Catalogue of Women* (Oxford,

tional lines connected the *Iliad* with the *Aithiopis*, Hesiod's *Theogony* with the *Catalogue*, and the *Erga* with the *Ornithomanteia*. Moreover Kallimachos' wording recalls the fashion in which a number of "Homeric" hymns close with transitional lines that lead into another hymn or epic performance. To this we will return. Suffice it here to draw attention to the fact that Kallimachos gives the traditional feature a new function by using it as a bridge from one genre to the other.[157]

Sandwiched between the invocation of the Muses in the prologue to the later edition (above, [a]) and the *somnium* of the earlier edition (F 2), there survives a reference to the number 10 in a passage that is almost

1985): 126–128 and his note on *Erga* 828 in Hesiod, *Works and Days* (Oxford, 1978), 364. I presume that it was in this tradition (and therefore very likely) that Kallimachos intended to link parts of the complete edition of his work.

I do not see that the use of rolls instead of codices—an argument of Wilamowitz's resuscitated by Knox ("The Epilogue to the *Aetia*," *GRBS* 26 [1985]: 59–65)—has relevance; see Clayman p. 279 and cf. M. West in his commentary to *Theog.* 1019ff.; "Another possibility is that the lines were added at the end of an ancient roll containing the *Theogony* as a reclamant, enabling the reader to identify the roll he was to read next" (Hesiod, *Theogony* [Oxford, 1982], 437). Knox argued that the end of the epilogue does not refer to the next roll containing the edition of the *Iambs*, but merely expresses the poet's intention of writing the *Iambs*. Moreover, in a forthcoming article (*ZPE*, early volume of 1993, pp. 175–178) he tries to establish that the epilogue was placed at the end of the fourth book by a later editor, thus agreeing with Alan Cameron's thesis (*Callimachus and His Critics*, forthcoming, Princeton University Press; *non vidi*). Knox believes that the Florentine scholia are based on an edition that displayed the epilogue at the end of the second book, and he compares the epilogue at what originally was the end of Ovid's *Ars Amatoria* (2.734–744). However, Ovid added two explanatory lines when he continued (2.745f.) and, with this correction, the "epilogue" was not as patently misleading at its old place as Kallimachos' αὐτὰρ ἐγὼ Μουσέων πεζὸν [ἔ]πεμι νομόν would have been.

Knox also reminds me by letter of the end of the *Amores*, where Ovid announces the end of his elegiac poetry (3.15.19: *inbelles elegi, genialis Musa, valete*) and his intentions at the time to turn to tragedy as a more serious form of poetry (*corniger increpuit thyrso graviore Lyaeus;* see, for example, H. Fränkel, *Ovid: A Poet between Two Worlds* [Berkeley, 1945], chap. 5: *Medea*). If the passage indeed indicates Ovid's turn to the *Medea*, then it contains an autobiographical statement made at the time when he had begun to work on the *Medea* and therefore unrelated to the order in which the poet may have wanted to see his poems in the final edition, all in contrast to Kallimachos, who arranged the second edition of the *Aitia* as an old man (1.6, 32–36). Nevertheless, the end of the *Amores* seems to have been inspired by Kallimachos' epilogue, although Ovid reverses the Greek poet's move to a less serious genre.

E. Eichgrün, "Kallimachos und Apollonios Rhodios" (Diss. Berlin, 1961), 68, thought that the πεζὸς νομός of Kallimachos' epilogue refers to his return to his work as librarian in the Museion; but this would render the last line of the *Aitia* a rather banal statement.

157. Kallimachos plays with this habit: transitional lines seem to turn separate poems into a cycle; but in Kallimachos' case the continuation is in a different genre. Both form and content separate the edition of his works from the negative connotations of a "cycle" and turn the old into a new concept. The use of this feature in the Hesiodic corpus might have made it attractive to Kallimachos.

totally lost. The London scholion explains this as the total number of the Muses or as their traditional number plus either Apollo or Arsinoe (F 2a.5–15 Pfeiffer 2 p. 102). Kallimachos clearly did not tell his readers who was added to the Muses, but the queen was an obvious candidate (see also the Florentine scholion ad F 1.45f. Pfeiffer 1 p. 7). This section of the poem may well come from what was originally the prologue of the edition of the first two books; but it was reworked and turned into the front piece of the device framing the edition of the four books. The epilogue participated in the same fate. Part of it was clearly written to cap the first edition: Kallimachos mentions ἐμὴ μοῦσα (his poetry; in the nominative) and the Charites as well as the ἄνασσα (both in the genitive). The Charites may be meant to remind the reader of the first *aition* of book 1 (on the Charites; F 3–7 with *SH* 249A), while the "lady" or "queen" recalls either Berenike or Arsinoe. Then a quotation from the beginning of the *somnium* follows.[158] This framing device connects the epilogue clearly with the early edition of books 1 and 2.[159] But then Kallimachos reworked the epilogue so that it would serve the later edition of the entire books 1–4 and now create a transition to the *Iambs*. The transitional link (line 9) imitates the transitional formulas of Homeric hymns (see n. 156). Hence it is preceded by "All hail, Zeus, also to you, and preserve the entire house of the lords." This line is preceded by another: "Hail, and bring (even) richer grace." The recipient of this first prayer is not known, but must be a deity of poetry, most likely Apollo. This, then, takes up the mention of Apollo in the prologue of the edition of the entire four books (F 1.21–29), and at this point the epilogue forms a framing device with the prologue of the later edition.[160] The meaning of ἄνασσα and οἶκος ἀνάκτων shifted correspondingly: from Philadelphos and Arsinoe II in the edition of books 1 and 2 to Euergetes and Berenike II in the edition of the entire four books.[161] Therefore,

158. Pfeiffer ad F 2.1–2; cf. C. A. Faraone, "Callimachus Epigram 29.5–6," *ZPE* 63 (1986): 53–56, esp. 55 n. 9.

159. Knox, "Epilogue," thought that the entire epilogue also originally belonged to the edition of books 1 and 2; this must be modified in light of n. 155.

160. F 112.8f.:

χαῖρε, σὺν εὐεστοῖ δ᾿ ἔρχεο λωϊτέρῃ.
χαῖρε, Ζεῦ μέγα καὶ σύ, σάω δ᾿ [ὅλο]ν οἶκον ἀνάκτων.

See n. 156 and also the discussion later in this section. For line 8 as directed to Apollo, see M. Puelma, "Kallimachos-Interpretationen II. Der Epilog zu den 'Aitien,'" *Philologus* 101 (1957): 247–268, repr. in *Kallimachos*, ed. Skiadas, 43–69. The double invocation—to Apollo to reappear with greater gifts, and to Zeus to protect the family of the king—points to the concept of the unity of poetry and government; see above, section III (1) with n. 135 and Puelma, repr., 48f.

161. Cf. Pfeiffer, "Βερενίκης πλόκαμος," repr. 152.

the same shift must apply to the tenth Muse of the prologue. What in the early edition (books 1 and 2) meant Arsinoe, may in the later edition (books 1–4) refer to Berenike. The framing between prologue and epilogue was a characteristic feature of both editions. Later, when discussing the end of the *Lock of Berenike,* we shall have to come back to this feature.

Books 3–4 lack the kind of structural coherence which the narration of his talks with the Muses provides, but they are nevertheless held together by a frame: the first poem is the *Victoria Berenices* (*SH* 254–269), which begins with an invocation of Berenike, "the holy blood of the Brotherly Gods."[162] The last poem is the *Coma Berenices.* Berenike functions in the third and fourth books in the same manner in which Arsinoe does in the first two books.

(2) The papyrus which records the Greek fragments of the *Lock of Berenike* omits Catullus' lines 79–88 and, on the other hand, adds a closing distich. Especially the latter fact confirms the suspicion that Kallimachos made some changes in his *Lock* when he added books 3 and 4 to the earlier two books of the *Aitia* (see below). Most likely the papyrus contains the original version of the poem whereas Catullus followed the version inserted into the *Aitia.*[163] Below I shall analyze this original version, but because of the very fragmentary nature of the Greek, I will frequently resort to the text of Catullus.

(3) A fundamental difference between Kallimachos and Catullus is the gender of the lock; Kallimachos' lock is male (πλόκαμος), Catullus' lock is female (*coma*). Both poets had words of the other gender at their disposal, although Kallimachos might have been restricted by the name given by Konon to the constellation. On the other hand, Kallimachos must have been in a position to influence this name; and, in any case, he

162. *SH* 254.2: νύμφα, κα[σιγνή]των ἱερὸν αἷμα θεῶν. On the Θεοὶ ᾿Αδελφοί see section II.1.d.

163. Cat. 66.79–88 is either an addition by Catullus (as most scholars now assume; see for example, Hutchinson, *Hellenistic Poetry,* 323f.) or by Kallimachos for his second edition. For a relatively recent discussion of the question see Marinone, *Berenice,* 59–67. The passage offers an additional *aition* for a sacrifice of ointment before connubial sex (79–80, *nunc vos optato quas iunxit lumine taeda / non prius unanimis corpora coniugibus / tradite*). If such a sacrifice is offered by her *quae se inpuro dedit adulterio* (84), it will not have the desired effect (87f., *concordia, amor adsiduus*). The contrast between the two groups of women makes it clear that the sacrifice to the lock is not a custom of the wedding night (as commentators believe), but part of the woman's preparation for making love when she puts on her perfumes. This interpretation fits the lock's complaint that he never received such ointments when he was on the head of the queen, then still a virgin (see later in this section and n. 200); and therefore this *aition* is much better integrated into the context of the poem, as modern critics believe (see, for example, West, "Venus Observed," 64f. n. 24).

was free to choose the gender of the other hairs.[164] But when Kallimachos' lock tells us that the hairs which remained on the queen's head longed for him, these are termed female hairs (κόμαι) and called "sisters" (51). The lock is distressed that he is no longer on the head of the queen (76). His fate substitutes for, and replaces, the temporary separation of the queen from her brother and husband. Thus, the separation of the lock from the queen and the separation of the king from his sister-wife are functionally related. The former replaces the latter. The use of the male or female gender clearly adds a specific flavor to the poem. In order to retain the almost sexual tension created by Kallimachos' male lock, I will treat the lock in my translations and paraphrases as male when I refer to Kallimachos and to Catullus' original, although the use of the male pronoun will sound strange.

We now turn to the poem. Using the traditional form of *Rollengedicht* (or dramatic monologue)[165]—a form as old as Archilochos' *Iambs* (e.g., F 19 W.)—Kallimachos lets the curl, cut off from the head of the queen, tell us his story. The narrator needs no introduction. He begins with the event which is most important for him: Konon's discovery of the catasterized lock both in the air (ἐν ἠέρι, 7) and in his maps of the stars (cf. 1: ἐν γραμμαῖσιν). No new star needed to be discovered; only the shape of the constellation, now known as πλόκαμος or *coma*, had to be recognized. From this event, which is most important to the narrator, he jumps back in time to a brief explanatory mention of Berenike's vow at the beginning of the Syrian war to sacrifice a lock from her head (9–11), and to the wedding of the royal couple (11; 13–18). The lock states, with some exaggeration, that the king went to the war immediately after the wedding[166]—in reality about half a year after his accession and presum-

164. For the male gender of Kallimachos' lock (pace K. Gutzwiller, "Callimachus' Lock of Berenice," *AJPh* 113 [1992] 359–385, esp. 374; I regret that, due to the recent appearance of this article, I could not use it more extensively) see 7f.: με - - - τὸν Βερενίκης / βόστρυχον; 62: Βερ]ενίκειος καλὸς ἐγὼ πλόκαμος; and 63: λουόμενόν με; cf. 47: τί πλόκαμοι ῥέξωμεν; only the other hairs appear as κόμαι – – – ἀδε[λφεαί (51). We shall not begrudge this lock his craving for perfumes. What else could even a male lock drink (77: πέ]πωκα)? Men used perfumes, at least at the wedding (H. Herter, "Die Haaröle der Berenike," in *Medizingeschichte in unserer Zeit: Festgabe für E. Heischkel und W. Artelt zum 65. Geburtstag*, ed. H. H. Eulner, G. Mann, G. Preiser, R. Winau, and O. Winkelmann [Stuttgart, 1971], 54–68, esp. 68 n. 70 [repr. *Kallimachos*, ed. Skiadas, 186–206, esp. 205 n. 70; also in *Kleine Schriften* (Munich, 1975), 417–432]. A little change like πλοκαμίς would have changed the gender of Kallimachos' lock. Catullus could have called the lock and the constellation *crinis*.

165. Cf., for example, Schwinge, *Künstlichkeit*, 69–71.

166. There were political reasons for this war. But it should also be said that the pharaoh was expected to engage in warfare immediately after his accession: thus he fulfilled

ably well after the wedding (cf. n. 151). In the lock's report, however, the wedding, the beginning of the war, and the vow of the sacrifice form a unit of almost simultaneous events. Up to the wedding and the events following it, the narrator turned backward in time ("rückläufig," Kroll), but from here on the narration will follow the chronological order: the departure of the king (19–32) with the vow of the lock (33–35), then the king's victory and the redemption of the vow to sacrifice a lock (36–50), and next the catasterization: first the mourning of the sister hairs (51f.); second, a gust of wind that carried the lock into the sea (52–58); third, the rising of the lock as a constellation before sunrise (59–64); and fourth, his arrival in his new heavenly position (65–76). With these events the lock's story reaches again the point from which it departed: his discovery by Konon (1–9). But this is not yet the end. Remembering that he has never tasted perfumes, he asks for such sacrifices (89–92; also Catullus 79–88 [see (2) above]). His request constitutes an additional *aition* (or two) which, from the point of view of the story, points into the future, that is, into the time of the reader of the poem. The basic structure of the narrative, then, starts out with the most important event from the point of view of the narrator, jumps back to the earliest part of the story, and from there on follows the chronological order till it reaches the event from which it began and, passing beyond that point, reaches out to a later event and the presence of the original reader. This narrative structure, particularly known from Pindar and used by Kallimachos elsewhere with elaboration and complications, has been called "complex lyric narrative" in differentiation from the "simple lyric narrative" which omits the last step and ends when it has returned to its beginning.[167] By using the *aition* as the element which continues the story beyond the point of its departure, Kallimachos varies the scheme. There are other complications, like the occasional mention of past events outside the narrative frame of the story and the very emotional reactions and reflections on the main steps of the narrative. But these we cannot examine in the present context.

his role of being Horus victorious over Seth and avenging his father; see E. Hornung, "Politische Planung und Realität im alten Ägypten," *Saeculum* 22 (1971): 54f.; Koenen, "Gallus," 123 with n. 30.

167. The third type of narrative, not relevant in our context, follows strictly the chronological order; because of the frequency of its occurrence in Homer, it is called the "epic narrative." See W. J. Slater, "Pindar's Myth," in *Arktouros: Hellenic Studies Presented to B. M. W. Knox on the Occasion of His 65th Birthday*, ed. G. W. Bowersock, W. Burkert, and M. C. J. Putnam (Berlin and New York, 1979), 63–70, esp. 63–65; the concept is based on W. Schadewaldt's observations, *Iliasstudien*, 3d ed. (Darmstadt, 1966), 83ff. For narrative structures in Kallimachos and his use of rather complicated and elaborate versions of "complex lyric narrative," sometimes with flashbacks and flash-forwards into events outside the narrative frame, see Lord, *Pindar*, 50–73, 146–157.

When the lock describes Konon's work with due learnedness, he also establishes the theme of love (line 5): it is love that brings Selene down from the starry heaven, and love that turns Berenike's lock into a constellation of stars. The queen had pledged the lock "to all the gods" for the safe return of her husband from his war. As is seen in Catullus' translation, the two wars, the *nocturnae rixae* and the real war (*vastatum finis iverat Assyrios*) are set in contrast to each other (11ff.). Not much is said about the real war, as if the lock wanted to state that love, not history and war, are the métier of the poet. In other words, the lock sticks to Kallimachos' program.[168]

Interrupting the narration of his fate, the lock begins to ask himself questions about the amusing behavior of brides on the wedding night, thus anticipating the reader's reaction to the story (15ff.). But, in answering these questions, the lock amusingly alludes to Berenike's love and tears at the separation from her husband and asks her teasingly as if she were present: "Or did you bewail, not the empty bed when you were left alone, but the sad departure of your dear brother?" (21f.).[169] We saw earlier that indeed the love between queen and king, in particular the love between brother and sister, had come to describe the holy nature of kingship, in spite of the Greek distaste for such marriages (section II.1.d, Philadelphos). Moreover, as we were reminded (see [1] above), Kallimachos begins the second part of the *Aitia* (books 3 and 4) by invoking Berenike II, the "blood of the Brotherly Gods." There the use of the word "blood" is pointed, since Berenike was the daughter of Magas, Philadelphos' brother by adoption.[170] In the *Lock* Kallimachos accepts the official version of Euergetes and Berenike II as a brother-and-sister couple, and yet in his witty way he removes the seriousness. Thus, the marriage of brother and sister—unbearable to Greek ears and yet, as we saw (section II.1.d, Philadelphos), an essential issue of the ideology of Ptolemaic kingship—appears to be the most natural thing in the world.

The lock continues his story (35ff.): the victorious king returned, and the queen cut off a lock of hair. In teasing words the lock apologizes to the queen for having left her; he swears by her head from which he has been cut, and adds: "May whoever has sworn falsely get what he deserves" (41).[171] An additional playful element is revealed by the fact that

168. I owe this observation to B. A. Victor, at the time a participant in my course on Kallimachos.

169. *an tu non orbum luxti deserta cubile, / sed fratris cari flebile discidium?*

170. Philadelphos' father, Ptolemy I (Euergetes' grandfather), had adopted Berenike's father, Magas, on marrying Magas' mother.

171. *digna ferat quod si quis inaniter adiurarit.*

the official Ptolemaic oath was sworn by the names of the king and the queen. The practice was pharaonic, albeit in a Greek dress.[172] Both in good Greek form and close to Kallimachos' words, the oath regularly contained the phrase: "If I swear the truth, may I do well; if I swear falsely, may I suffer the opposite."[173] Of course, the lock swears by the queen's head from which he comes, and by her life. In the context of the poem the lock conveniently forgets the king.

As the lock tells us in his oath, he left the head of the queen against his will: twice *invita* (39f.)[174] Catullus' *invita* corresponds to Kallimachos' ἄκων: he has not committed any ἁμάρτημα. Iron has cut even Mount Athos for Xerxes, as the lock says again with hilarious exaggeration. Kallimachos calls Mount Athos the "spit of your *mother* Arsinoe."[175] If Euergetes and Berenike are brother and sister, then Arsinoe is also Berenike's mother, concludes Kallimachos.

Two approaches need to be combined in order to understand Arsinoe's "spit": (a) one is Greek and learned, (b) the other is a play with Egyptian thoughts and symbols.

(a) On the one hand, the "spit" alludes to Sophokles' almost proverbial expression: "Athos casts his shadow on the back of the Lemnian cow."[176] The "cow" was a statue on the island of Lemnos which, before *sunset*, was struck by the shadow of Mount Athos, the "spit." By itself, however, this explanation does not explain why Kallimachos lets the sun pass directly over Mount Athos, when from the vantage point of an Alexandrian observer such a northerly route is impossible.[177]

172. Cf. section II.1.b and n. 62. The Greek version unavoidably consists of the cult names of the kings and the inclusion of the entire genealogical line; at the time of Euergetes the oath has the following form (*SB* 2.5680.4ff; 220 BC): ὀμνύω βασιλῆα Πτολεμαῖον τὸν ἐκ βασιλήως Πτολεμαίου καὶ βασίλισσαν Βερενίκη[ν] καὶ θεοὺς Ἀδελφοὺς καὶ θεοὺς ⟨Σωτῆρας⟩ [Εὐεργέτας, pap.] τοὺς τούτων γονεῖς καὶ τὴν Εἶσιν καὶ τὸν Σάραπιν καὶ τοὺς ἄλλους ἐγχωρίους θεοὺς πάντας καὶ θεὰ[ς] πάσας – – –. For "all gods and goddesses" cf. the oath of Hippokrates (n. 182). At the end of the oath of *SB* 5680: εὐ[ορκ]οῦντι μέμ μοι εὖ εἴη, ἐφι[ο]ρκοῦντι [sic] δὲ ἔνοχον εἶναι τῆι ἀσεβ[είαι].

173. Compare Catullus' phrasing (n. 171) with the wording of the oath: εὐορκοῦντι μέν μοι εὖ εἴη, ἐφορκοῦντι δὲ τἀνάντια (e.g. *P. Sorb.* 1.31.13f.; 250 BC) or similar phrases (n. 141; 229 BC). Cf. E. Seidl, *Eid*, 22–26; Pfeiffer, "Βερενίκης πλόκαμος" 100–153, esp. 105, and cf. Marinone, *Berenice*, 162f.

174. For the repetition of *invita* see above, section III.2 with n. 145.

175. 43ff.:

[ἀμνά]μω[ν Θείης ἀργὸς ὐ]περφέ[ρ]ετ[αι,]
βουπόρος Ἀρσινόη⌊ς μ⌋ητρὸς σέο, καὶ διὰ μέ[σσου]
Μηδείων ὀλοαὶ νῆες ἔβησαν Ἄθω.

176. *TrGF* 4 F 776R: Ἄθως σκιάζει νῶτα Λημνίας βοός. The correct explanation was given by G. L. Huxley, "Βουπόρος Ἀρσινόης," *JHS* 100 (1980): 189f.; cf. Marinone, *Berenice*, 175–176.

177. It was this reason that convinced Pfeiffer that [ἀμνά]μω[ν Θείης ἀργὸς ὐ]περφέ[ρ]ετ[αι] (Cat.: *progenies Thiae clara supervehitur*) refers to the wind and not to the sun (see his commentary ad loc. and "Βερενίκης πλόκαμος," repr., 110f.).

(b) On the other hand, the scholiast tells us that "spit" means "obelisk," thus providing us with a synonymous word and with a different clue. According to Egyptian symbolism, the top of the obelisk was struck by the first rays of the sun. Hence in the *morning* Athos "is passed over by the sun," and the question of an Alexandrian viewpoint does not enter the interpretation. Moreover, there was a famous obelisk in front of the unfinished temple of Arsinoe.[178] In other words, the true obelisk of this goddess is Mount Athos, where the rays of the sun appear in the morning.

The "spit" of Athos belongs to Arsinoe II, who before her marriage to her brother Philadelphos was married to Lysimachos. Lysimachos' realm was based in Thrace but, at the height of his power, included Macedonia and the Chalcidice among many other possessions; these were Arsinoe's realms too.[179] At the time of our poem, in the Third Syrian War, Ptolemaios III Euergetes had again extended his claims to the north at least as far as Thrace. In short, the phrase βουπόρος Ἀρσινόης μητρὸς σέο contains a territorial claim (although to our knowledge Euergetes was never able to materialize it).[180] But this claim is dressed in metaphorical language alluding to the morning rays of the sun ("Arsinoe's obelisk") and the wide casting of the evening shadows ("Arsinoe's spit"); the two explanations complement each other. They describe the journey of the sun which, as we have seen, defines the realm of the Egyptian king and pharaoh (section III.1). In addition, the Greek side of the explanation is rooted in a learned allusion to poetry, but this learnedness remains subordinate to Kallimachos' poetical intentions.

The lock deplores that he was forced to leave the head of the queen (who after all was the one who cut him off). Even Mount Athos had to submit to the force of iron when Xerxes built the canal for his fleet. What could a small lock do against iron? There follows a magnificent curse of the first inventors of iron, the Chalybes known from Aischylos (48ff.). Irony abounds; it feeds on the contrast between the curse and

178. See Fraser, *Ptolemaic Alexandria* 2 : 1024.

179. For the extension of Lysimachos' realm see E. Will, *Histoire politique du monde hellénistique*, 2d ed., Ann. de l'Est (Nancy, 1979), vol. 1, part 1, chap. 2A. For a brief period after the death of Lysimachos, she was also married to Ptolemaios Keraunos, whom his troops proclaimed as "king of Thrace and Macedonia" and who made Arsinoe queen. He tried to strengthen his claim to this throne through this marriage. But since this marriage ended with the murder of Arsinoe's children Lysimachos and Philippos, Kallimachos will not have wished to remind Berenike and the audience of this period of Arsinoe's participation in the rule of Thrace and Macedonia. Mount Athos is also the place where gods watch what is going on (*Hymn to Delos* 125ff.; F 228.47f. [see below]).

180. Will, *Histoire* 1.2, chap. 4C2 Adoulis inscription and 3 ("Les acquisitions lagides en 241"); R. S. Bagnall, *The Administration of the Ptolemaic Possessions outside Egypt*, Col. Stud. in the Class. Tradition 4 (Leiden, 1976), 159f. Euergetes had to cut short his campaign because of an insurrection in Egypt; see Hauben, *Expédition*, esp. 32ff.

the small present occasion, which is trivial for the reader, but not for the curl.[181] The precise sequence of the following events remain the secret of Kallimachos and the gods; but the most likely scenario is this: on the grounds of the temple of Arsinoe Aphrodite Zephyritis—the recently deified goddess who passed for Berenike's mother—on Cape Zephyrion, Berenike cut off and dedicated the lock to this goddess and, to be sure, to all gods.[182] The sister hairs were still longing for him—and Kallimachos may have imagined that they did so during the ceremony (51)—when Zephyr, the west wind, caught the lock and swept him into the sea,[183] the "(pure) bosom" of Arsinoe Aphrodite. From there the new constellation would rise on the next morning before sunrise,[184]

181. Cf. Syndikus, *Catullus* 2:210: "Aber hier sind die Bilder so hoch gegriffen, dass die Diskrepanz zwischen Bild und Gemeintem komisch wirkt."

182. 8: πᾶσιν ἔθηκε θεοῖς ≈ Cat. 66.9f., *quam multis illa dearum* / . . . *pollicita est,* and 33f., *me cunctis . . . divis* / . . . *pollicita es:* Compare, for example, the addition "all gods and goddesses" in oaths of the Ptolemaic period (see nn. 62 and 172; *Hist. Alex.* 3.17.33 Kroll) but also in classical Greece: *Hippocr. oath* 4.628 Littré, "I swear by Apollo the physician, by Asklepios, Hygieia, Panakeia, and all gods and goddesses" (ὄμνυμι Ἀπόλλωνα ἰητρὸν καὶ Ἀσκληπιὸν καὶ Ὑγείαν καὶ Πανάκειαν καὶ θεοὺς πάντας τε καὶ πάσας); Euripides *Medea* 752f., "I swear by Gaia and the bright light of Helios and by all gods," ὄμνυμι Γαῖαν φῶς τε λαμπρὸν Ἡλίου / θεοὺς τε πάντας); Aristoph. *Thesm.* 272–274 and *Clouds* 1239; Lib. 32.12; cf. O. Zwierlein, "Weihe und Entrückung der Locke der Berenike," *RhM* 130 (1987): 274–290, esp. 267; G. Friedrich, *Catulli Veronensis liber* (Leipzig and Berlin, 1908), 406. Since Arsinoe shared temples with many gods, she was in a position to make this sacrifice accessible to her fellow immortals. When the catasterism made the lock visible to all gods (and men), the dedication to all gods was fulfilled, but more grandiosely than one might have expected.

183. ἤ[λ]ασε (see apparatus in n. 184) suits the wind. If ἤ[ρπ]ασε could be read (see ibid.), this would recall the use of this word as a metaphor for dying. Suffice it to refer to Kall. *Epigr.* 41 Pf. (4 G.-P.): ἥμισύ μευ ψυχῆς ἔτι τὸ πνέον, ἥμισυ δ' οὐκ οἶδ' / εἴτ' Ἔρος εἴτ' Ἀΐδης ἥρπασε, πλὴν ἀφανές. The Dioskouroi snatch away Arsinoe II from her death (see below); for the same metaphor in Egyptian texts see Zandee, *Death,* 85–87.

184. 51–58:

ἄρτι [ν]εότμητόν με κόμαι ποθέεσκον ἀδε[λφεαί,]
καὶ πρόκατε γνωτὸς Μέμνονος Αἰθίοπος
ἵετο κυκλώσας βαλιὰ πτερὰ θῆλυς ἀήτης,
ἵππο[ς] ἰοζώνου Λοκρικὸς Ἀρσινόης,

55 ἤ[λ]ασε δὲ πνοιῇ με, δι' ἠέρα δ' ὑγρὸν ἐνείκας
[Κύπρ]ιδος εἰς κόλ⌊πους θῆκεν⌋ [ἄφαρ καθαρούς]
⌊αὐτή⌋ μιν Ζεφυρῖτις ἐπὶ χρέο[ς ἔνθ' ἀπεπέμψεν]
[κεῖνο Κ]ανωπίτου ναιέτις α[ἰγιαλοῦ], . . .

54 λοκρικος *PSI* 1092 : λοκ[ρ]ιδος *P. Oxy.* 2258 (also schol.); *elocridicos* Cat. (which originated from *loc̆ricos* [Lobel]); cf. n. 189 **55** ἤ[λ]ασε Skiadas, Ardizzoni, Gallavotti, Marinone; cf. West, "Venus Observed," 62 n. 9: ἤ[ρπ]ασε Lobel and Pfeiffer, although both thought that the supplement is too long and that it is difficult to read ἀ]ρπασθῆνα[ι in the scholion on the bottom of the page; the published photographs do not allow a definite answer, particularly as they show the left part of the papyrus not quite in the right position. I am happy with the]ρ in the scholion, but I agree that it is hard to imagine how ρπ fits in

washed by the sea (λουόμενος, cf. 63) like other stars.[185]

The west wind is described in very dense and symbolic language: he is the brother of the Aithiopian Memnon, hence the son of Dawn (Eos) the mother of the winds (Hes. *Theog.* 378). The Aithiopian Memnon was the last hero killed by Achilleus; and the Greeks connected him with monuments in Egyptian Thebes in the south of the country, close to Aithiopia. But these facts help little to explain the appearance of the brother of Memnon in Kallimachos' *Lock*. Nor is this west wind called "brother of Memnon" in order that he, as the son of Dawn, may be an appropriate vehicle for transporting the lock to heaven.[186] This he does

the lacuna of the main text **55f.** Cf. Cat. *isque per aetherias me tollens auolat umbras / et Veneris casto collocat in gremio.* **56** θῆκεν [ἄφαρ καθαροὺς Ardizzoni; ἔθηκεν schol.; cf. West, 63 with n. 19

For the interpretation given above, see West, "Venus Observed," who, for the sea as the "bosom" of a goddess, refers to *Il.* 6.136f. (Thetis receives Dionysos κόλπῳ when the young god jumps into the sea). For the dedication of the lock in the temple at Zephyrion (thus Hyginus *Astr.* 2.24) and not in an imaginary pantheon in Alexandria see also G. Huxley, "Arsinoe Lokris," *GRBS* 21 (1980): 239–244; against the pantheon also Zwierlein, "Weihe," 274–280. The wind caught the lock, when the sister hairs were still longing for him (51; Cat.: *lugebant, cum . . . / obtulit . . . ales equos;* καὶ πρόκατε). Kallimachos seems to imagine them as being present in mournful longing when the lock is cut off and suddenly a gust of wind carries the lock away. In this case the queen would have to be present, too. But these details result from a very tentative reading of the passage. The scenario given above deviates in two major points from the one we read in Hyginus (*Astr.* 2.24), according to whom the lock disappeared in the temple on Cape Zephyrion during the night; the king got angry but was appeased by Konon's detection of the lock among the stars. The anger of the king, however, seems to be either histrionic or part of a secondary story, because the whole event was probably staged by the court (see above at n. 152). It is also easier to imagine that the wind could carry away the lock before he was deposited on the altar presumably in a box (see Zwierlein, "Weihe," 277f.).

Zwierlein reconstructs a different scenario: Berenike cut her lock off probably in Alexandria, in the open air where all the gods could see it; but Zephyr immediately carried him to the temple on Cape Zephyrion. In the real world, this corresponded to the normal transportation of the lock to the same temple, where the lock disappeared at night. The main difficulty for this interpretation is line 8, ἔθηκε, which can hardly be understood as "setting up a prize" (ἔθηκε / [εὐχομένη]; thus Zwierlein, "Weihe," 280), at least if Kallimachos used the same verb in line 56, where, in a similar context, the word (supplied from the scholion) denotes the deposition of the lock in Aphrodite's bosom, that is, the sea. Moreover, the miraculous intervention of the wind is more likely to explain the puzzling disappearance of the lock than to replace the transportation in the real world. Finally, Zwierlein correctly stresses the *cum inversum* and καὶ πρόκατε, but the intervention of the wind follows the mourning and the longing of the sister hairs, which could have been going on for some time.

185. *Od.* 5.6: λελούμενος ὠκεανοῖο; cf. *Il.* 5.275; see Pfeiffer's note in his edition of Kallimachos and, for example, West, "Venus Observed," 62 n. 8.

186. ". . . and it is most suitable that Zephyros, son of Eos the Dawn and half brother of Memnon, should be the messenger who bears the lock to the queen-goddess," that is, to Aphrodite, whose "heavenly home is the planet Venus, the morning and the evening star" (Huxley, "Arsinoe Lokris," 242).

not do, as we have just seen. The lock rather follows his new nature and, before sunrise, begins his daily journey. With regard to Memnon's brother, however, there is another detail that may be helpful: in Quintus Smyrnaeus, the epic poet some 500 years younger than Kallimachos, the wind gods carry their fallen brother Memnon from the Trojan battlefield to his burial place on the Mysean river Aisepos (550–569, 585–587).[187] This part of the story is probably much older. If so, then Kallimachos' invocation of one of these wind gods as "brother of Memnon" introduces a heroic model for the rape of the lock. Why should Memnon's brother not do again what he once did to save his brother?

Next we are told that Zephyros lets his "swift" wings circle (53: κυκλώσας βαλιὰ πτερά). This picks up a proverbial phrase which first occurs in a fable told by Archilochos, where the eagle "circles the swift wings" (λαιψηρὰ κυκλώσας πτερά, 181.11 W.); elsewhere "words" or "love" are also said to travel in the same way. Kallimachos changes one word of the phrase (λαιψηρά), partly, but not exclusively, for metrical convenience. βαλιὰ πτερά also recalls Balios, one of the horses of Achilleus in the *Iliad*, fathered by Zephyr, "that 'flies' with the speed of the winds" (16.149) and "runs with the breeze of Zephyr, which they say is the lightest thing of all" (19.415f.).[188] Kallimachos avoids the name of Balios; instead he uses an etymological pun.

Further, the wind that moves his wings like an eagle is the Locrian horse of Arsinoe with the purple girdle (54).[189] The girdle identifies Ar-

187. See R. Pfeiffer's reference to Quintus Smyrnaeus 2.553f. ("Βερενίκης πλόκαμος," repr., 122).

188. That Zephyr is the son of Eos does not prevent Kallimachos from assimilating him, in a playful allusion, to Balios, the son of Podarge the Harpy and Zephyr. R. Pfeiffer had difficulties with this ("Βερενίκης πλόκαμος," repr., 121). Kallimachos' phrase (line 53) was later taken up several times by Nonnos (see Pfeiffer's note in his edition, ad loc.); cf. also Sappho's description of the sparrows (ὦκεες στροῦθοι) carrying Aphrodite's carriage through the air: πύκνα δίνεντες πτέρ(α) (F 1.11) and the two eagles in *Od.* 2.151 τιναξάσθην πτερὰ πυκνά (D. Page, *Sappho and Alcaeus* [Oxford, 1953], p. 8 on lines 11–12).

189. For the reading see n. 184 (apparatus); both readings, Λοκρικός and Λοκρίδος, are old. Ovid called Arsinoe "Locris" (*Ibis* 352; cf. Huxley, "Arsinoe Lokris") and this may indicate that he read Λοκρίδος in Kallimachos (or in Catullus). It is generally agreed that, even so, "the horse of Locrian Arsinoe with the purple girdle" could be understood as *enallage;* thus it would still be the horse—that is, the south wind—that would be Locrian. But G. Huxley has argued that Arsinoe could be called Locrian in her own right: she is identified with Aphrodite, and the planet Venus played an important role in the cults of the eastern and western Locrians of mainland Greece. Thus, Arsinoe would be called Locrian because, as Aphrodite, she would be the morning and evening star. The use of this epithet would direct the reader to the importance of the planet Venus in the poem. But while I see the importance of Aphrodite for the catasterism of the lock, I do not find a special function of the planet Venus in this poem (see also n. 151).

sinoe with Aphrodite. The rape of the lock is engineered by the deity who should have the greatest understanding: the mother and predecessor of the queen, who is herself a manifestation of Aphrodite and an epiphany of the love of the queen and sister. In Theokritos it is Aphrodite who snatched away (ἁρπάξασα) Berenike I, the mother of Philadelphos and Arsinoe II, before she reached Acheron; and she made her immortal (*Ptol.* 46ff.; *Adon.* 106ff.). The servant of this Arsinoe is destined to pick up the lock and to sweep him most likely into the sea, as I said. He is Locrian, that is, he comes as the west wind from Lokroi on the south Italian coast; it hits the temple precinct of Zephyrion, and it is most likely here that he catches the lock. A Pompeian painting shows Zephyr in human shape and with huge wings, carrying Aphrodite on his shoulders and wings.[190]

But this wind is also described as a horse, and the winged wind-horse has caused many headaches. Winds, we are told by interpreters of this poem, are horsemen, not horses, at least before Quintus Smyrnaeus and Nonnos.[191] But on the poetical level, the horse is the consequence of the

190. Casa del Naviglio (6.10.11); E. Schwinzer, *Schwebende Gruppen in der Pompejanischen Wandmalerei*, Beitr. z. Arch. 11 (Würzburg, 1979), pl. 4.2; Zwierlein, "Weihe," 289. Some twenty-five years ago I saw a silver statuette in an antiquities shop in Cairo (and I have photographs of it), which depicts an eagle stretching out his wings; on the wings rest a bearded man and a woman; the man puts his right arm around her shoulder. I suspect that, alluding to the rape of Ganymede, it depicts the journey to a blessed afterlife. Cf. nn. 193, 194.

191. In classical and Hellenistic times winds were not pictured as horses, although this has been suspected (see K. Neuser, *Anemoi: Studien zur Darstellung der Winde und Windgottheiten in der Antike* [Rome, 1982], esp. 11 n. 32 and 155–157); it is only in and after the third century AD that the four winds were described as horses pulling the chariot of Zeus riding from the ocean to heaven (Quint. Smyrn. 12.189–195) or as the wind-horses pulling Zeus's *winged chariot* in his fight against Typhon (Nonnos 2.422f.: ἑζόμενος πτερόεντι Χρόνου τετράζυγι δίφρῳ, / ἵπποι δὲ Κρονίωνος ὁμόζυγες ἦσαν ἀῆται). This is an adaptation of an earlier concept according to which Zeus rides a chariot of *winged horses* in this fight (Apollod. 1.6.3, hence attested for the first century BC and probably older). Zwierlein, "Weihe," 286f., correctly points out that Apollodoros does not identify the horses with winds. In Quintus and Nonnos he prefers to think of anthropomorphic winds pulling Zeus's chariot, because anthropomorphic winds could pull a chariot too, and, in other passages of Nonnos, the winds are imagined as anthropomorphic. But in 2.524ff., when they fight with Typhon they are real winds; unfortunately, however, this passage has been suspected to be a later addition (see R. Keydell, "Eine Nonnos-Analyse," in *Kleine Schriften* [Leipzig, 1982], 485–514, esp. 487 [= AC 1 (1932): 173–202, esp. 175]; see Zwierlein, "Weihe," 287). Thus Zwierlein can conclude that even in Quintus and Nonnos the winds pulling the chariot of Zeus are not necessarily perceived as winds. After elimination of Nonnos 2.524ff., this conclusion is unassailable; and yet it seems to carry skepticism too far.

It would be easy to bring the Greek text into agreement with the general Greek view of winds as horsemen: "Anyone who would still prefer a horseman could restore the Ho-

allusion to Homeric Balios, as I have just argued. We are not supposed
to imagine the picture; we rather recognize the pun: the wind functions
like the Homeric horse Balios, swift like the wind.[192] According to Quin-
tus Smyrnaeus, it is the destiny of Achilleus' divine horses, Balios and
Xanthos, to bring Neoptolemos, Achilleus' son, by order of Zeus to the
Elysian fields.[193] Horses were known to have performed similar tasks
in earlier literature. When Poseidon raped Pelops, he transported him
on golden mares (χρυσέαισι τ' ἀν' ἵπποις) to Zeus's lofty house (Pind.
Ol. 1.40–43). But such ideas were not restricted to literature. From the
middle of the third century through the second century BC terracotta
vases of unusual shape are found in South Italian tombs: the upper part
of these vases is molded in such a way that the front halves of two, three,
or four horses appear galloping upward. On top of the vases are stands
for one or more figures, sometimes winged and sometimes not. Paint-
ings on the vases show, among other things, winged figures and horses.
The vases with the chariots pulled by horses represent the journey of
the soul to heaven. In short, the horses are connected with the idea
of snatching man from death and bringing him to his final home.[194]

meric ἱππό[τ'] instead of ἵππο[ς]. . . . Of course, the cogency of this supplement depends
on one's view of the corresponding line in Catullus" (West, "Venus Observed," 63 n. 13).
Indeed, Catullus' *ales equos* precludes this escape.

192. O. Zwierlein now interprets the "horse" as a metaphor for the function in which
Zephyros as a young man carries off the lock ("Weihe," 288).

193. They serve first Poseidon, then Peleus, Achilleus, and finally Neoptolemos:

τὸν καὶ ἐς Ἠλύσιον πεδίον μετόπισθεν ἔμελλον
Ζηνὸς ὑπ' ἐννεσίῃσι φέρειν μακάρων ἐπὶ γαῖαν
(3.761–762).

194. See K. Meuli in his epilogue to J. J. Bachofen, *Gesammelte Werke*, vol. 7, *Unsterblich-
keitslehre der orphischen Theologie, Römische Grablampen*, ed. E. Kienzle et al. (Basel, 1958),
473–534, esp. 498–509. In this function horses are occasionally presented with wings,
and that as early as the sixth century BC (A. Furtwängler, "Bronzewagen von Monteleone,"
in *Kleine Schriften* 2 [1913], 314–330, esp. 328 with pl. 2). K. Meuli also refers to Herakles
driving in a chariot pulled by centaurs (loc. cit., 500f.; *LIMC* 4.2.538, no. 1428, cf. 4.1.809;
Meuli was aware of the different interpretation by F. Matz, *"Belli facies et triumphus,"* in
Festschrift für C. Weickert [Berlin, 1955], 41–58); Herakles is more frequently depicted as
riding the horses and the chariot sent to him by Zeus for his last journey. It was, I think,
the connection of such sepulchral notions with Plato's myth of the chariot of Nous circling
around the idea of the beautiful which, at the latest in Middle Platonism, led to the philo-
sophical notion of the soul riding into the world in a πνευματικὸν or αὐγοειδὲς ὄχημα
("chariot" but also "horse" or any other animal that is ridden). After death the soul re-
turned in the same way to heaven. This thought became popular not only in Neoplatonism
but also in gnostic and patristic authors. Here is not the place to discuss this; see A. Hen-
richs and L. Koenen, *ZPE* 19 (1975): 72–74 n. 29* and *ZPE* 44 (1981): 291–293 n. 416;
D. Hagedorn, U. Hagedorn, and L. Koenen, *Didymos der Blinde: Kommentar zu Hiob 4.1*,
PTA 33.1 (Bonn, 1985), 15f. with n. 24.

In South Italy the soul was also represented as riding on a horse to heaven.[195] Kallimachos may give us a deliberate hint with his Zephyros coming from Lokroi on the South Italian coast.[196]

Like horses, the winds of Greek mythology have experience in transporting gods and the dead to heaven.[197] A wind is, of course, the most natural agent to snatch a curl. Thus, the bold, partly self-contradictory combination of imagery may appear less forbidding. To sum up: (a) Rider and horse are inseparable, and specifically, (b) horses were believed to have transported mortal beings to heaven; moreover (c) the winds were known to have done the same and, in particular, (d) the wind is the most natural agent to snatch a curl and, in the case of Berenike's lock, may even have done so. Thus, combining these elements, Kallimachos might have taken the liberty of letting the horse stand in for the rider and act as the gust of wind that carried the lock away.[198] In the third century, this image of the wind-horse will reappear (but see n. 191).

The mythical examples and religious beliefs about horses and winds converge upon each other: under both images, the catasterism of the lock appears as death, a point which was not lost on Catullus (51f. *mea fata sorores/lugebant*). To this we shall return.

The lock continues his report (59ff.). The wind, after all, had only to transport him to the sea; from there he rose with the other stars to his place in heaven,[199] presumably at the heliacal rising so that Konon would notice the new lights. The belief that the dead become stars, or live on stars, is both Egyptian and Greek. The lock, however, does not enjoy, or at least claims not to enjoy, his new status and returns to his complaints (69f.). The passage is very fragmentary, but it is clear that, within his

195. F. Cumont, *Recherches sur le symbolisme funéraire des Romains*, Service des Antiquités (en Syrie et au Liban), Bibl. arch. et hist. 35 (Paris, 1942), 502f. addendum to p. 149; cf. the same set of ideas in Gaul, ibid., 505, addendum to p. 218 (a woman galloping to heaven).

196. There was a friendly relationship between Syracuse and Alexandria during the reign of Hieron II over Sicily and of Philadelphos and Euergetes over Egypt. See H. Hauben, "Arsinoé II et la politique extérieure," in *Egypt and the Hellenistic World*, 99–127, esp. 103.

197. For the winds transporting gods and immortal men and women to heaven see also Pfeiffer, "Βερενίκης πλόκαμος," repr., 122f.; for the winds in the sepulchral context see Neuser, *Anemoi*, chap. 7.4, pp. 212ff.

198. Cf. Marinone, *Berenice*, 197f. On the basis of Zwierlein's interpretation of the catasterism (n. 184) one could also argue that Kallimachos may have conflated what happened on earth (transportation of the lock to the temple of Arsinoe Aphrodite on horseback or in a chariot) and what happened on the divine level (Zephyr snatching the lock and bringing it to the same temple).

199. Pfeiffer, "Βερενίκης πλόκαμος," repr., 132.

report, the lock now addresses Nemesis when he takes up his new position among the stars (71ff.):

> [Be not] angry, [Rhamnousian Virgo (sc., Nemesis)! No] bull (i.e., the proverbial heavy weight that blocks the tongue) will hinder my word [. . . not even if] the other stars [tear my] insolence to shreds, limb [by limb]. . . . Things here give me not as much delight as distress because I no longer touch your head whence, when the queen was still a virgin, I drank much plain oil, yet I had not the pleasure of the lush ointments of married women. You, Queen, when, on the festival's days, you look at the stars and propitiate divine Aphrodite, you may not leave me, your own hair, without ointment, but rather give me large tributes.[200]

The personification of the lock as a constellation of stars, and his bravery in facing "dismemberment of his insolence" for speaking the truth, is hilarious in the extreme, all the more so if we recall the Egyptian beliefs behind it. [ταμεῖν] θράσος (if this is what Kallimachos wrote) is a metaphor similar to Plutarch's ἐκκόψας τὸ θράσος (*Mor.* 767E), and Catullus translates it correctly.[201] Yet the reader familiar with Egyptian thought is reminded that, according to Egyptian beliefs, the dead were threatened with being cut into pieces;[202] and, in a court of law, they had to confess their deeds and omissions. Such "negative confessions" became an oath which the priests of Isis swore at their initiation. In the new context, the negative confession was mixed with promises of what the new priest would not do.[203] Our lock has already sworn by the queen

200. 71–78: [παρθένε μὴ] κοτέσῃ[ς Ῥαμνουσιάς· οὔτ]ις ἐρύξει
 ⌊βοῦς ἔπος⌋[]η . . . [].[].βη
 [οὐδ᾽ ἂν ἐμὸ]ν [μ]ελεῖ[στὶ ταμεῖν] θράσος ἀστέρες ἄλλοι
 []νδινειε.[]ọσọσọι[.] τεκ.[.]ω·
75 ⌊οὐ⌋ τάδ⌊ε⌋ μοι τοσσήνδε φ⌊έ⌋ρει χάριν ὅσσ[ο]ν ἐκείνης
 [ἀ]σχάλλω κορυφῆς οὐκέτι θιξόμεν[ος,]
 ἧς ἄπο, παρ[θ]ενίη μὲν ὅτ᾽ ἦν ἔτι, πολλ⌊ὰ πέ⌋πωκα
 λι⌊τ⌋ά, γυναικείων δ᾽ οὐκ ἀπέλαυσα μύρων ---

71 παρθένε R. Merkelbach (*ZPE* 1 [1967] 218) μὴ and οὔτ]ις Lobel Ῥαμνουσιάς Barber **73** οὐδ᾽ ἂν ἐμὸ]ν and ταμεῖν] θράσος (). θράσος Pfeiffer) Merkelbach ("e.g.") μ]ελεῖ[στὶ Lobel (δίχα Σ) **75** Lobel **78** the continuation is only extant in Catullus' translation

Nemesis had a temple at Rhamnous in Attika, and the constellation Virgo was identified by some authors with Isis (Ps.-Eratosth. *Catast.* 9; see Merkelbach, "Kallimachos, Locke der Berenike," loc. cit., 69–79).

201. 73: *nec si me infestis discerpent sidera dictis.*

202. Zandee, *Death,* esp. 16f.

203. *PGM* 2.XXXVII (*Greek Magical Papyri,* p. 278; M. Totti, *Ausgewählte Texte der Isis- und Sarapisreligion,* Subsidia Epigraphica 12 [Hildesheim, 1985], no. 10) and R. Merkelbach, "Ein ägyptischer Priestereid," *ZPE* 2 (1968): 7–30 (reedited as *P. Wash. Univ.* II.71 by K. Maresch and Z. M. Packman, also Totti no. 9); further see Merkelbach, "Fragment eines satirischen Romans: Aufforderung zur Beichte," *ZPE* 11 (1973): 81–87 (edited as *P.*

that he did not commit a sin: *invita . . . cessi, invita* (38f.). He has now taken his position among the constellations of Virgo, Leo, and Callisto, and before Boötes.[204] In Hellenistic times, all these stars were connected with Isis and her myths. The constellation of Virgo was identified with her; and this constellation was also called *Dike* or *Iustitia*.[205] In short, appearing at his new place, the lock addresses the heavenly Virgin or Nemesis/Isis (alias Aphrodite) and, in accordance with Egyptian ideas, promises: "I will not be silent," "I will not enjoy my new life," both confessions contrary to what should be expected from the pious, but reflecting the lock's anger and anticipating his destructive mood (see below). But the next confession turns back to his past: "I have not drunk the lush ointments (the perfumes) of married women." At the beginning of his new life as star, our lock behaves according to the Egyptian ideas of initiation, but in his emotional turmoil he turns part of them upside down. This is certainly funny, but in the overall context of this poem Kallimachos should not be misunderstood as taking a low shot at Egyptian ideas.

There is one more aspect to the lock's confession. He did not receive lush ointments when Berenike was not yet married. In the fifth *Hymn* Kallimachos presents Athene as an athlete running the double course like the Lacedaemonian stars (the Dioskouroi) and "rubbing in plain olive oil."[206] The crucial word for "plain," λιτά, is again rather prosaic

Oxy. 42.3010 by P. Parsons). J. Quaegebeur considers whether the initiation oath discussed here is a fragment of the *hieratikos nomos Semnuthi* (i.e., the ḏm'-ntr or "holy book"; cf. Merkelbach, "Priestereid," 11f.), a collection of laws which were of importance for priests ("'Loi sacrée' dans l'Égypte gréco-romaine," *AncSoc* 11/12 [1980/81]: 227–240, esp. 235f.). The motif was taken up by Roman poets; see L. Koenen, "Egyptian Influences in Tibullus," *ICS* 1 (1976): 127–159, esp. 129, and "Die Unschuldsbeteuerungen des Priestereides und die römische Elegie," *ZPE* 2 (1968): 31–38; W. D. Lebek, "Drei lateinische Hexameterinschriften," *ZPE* 20 (1976): 167–177, esp. 174ff.; O. Raith, "Unschuldsbeteuerung und Sündenbekenntnis im Gebet des Enkolp an Priap," *StudClass* 13 (1971): 109–125. An echo of the negative confessions of the oath of the Isis priests also survived among Egyptian monks: *Hist. monach.* 11.6 Festugière (see Merkelbach, "Altägyptische Vorstellungen," 339–342 and above, n. 42). Cf. n. 217.

204. See the map in Marinone, *Berenice*, 41.

205. Merkelbach, "Erigone," esp. 483; see also L. Koenen, "Der brennende Horusknabe," *CE* 37 (1962): 167–174.

206. 23ff., esp. 25f.: λιτὰ λαβοῖσα / χρίματα, τᾶς ἰδίας ἔκγονα φυταλιᾶς; she just needs a comb to set her hair after she has cleansed it with oil (32: λιπαρὸν σμασαμένα πλόκαμον), in stark contrast to Aphrodite, who expends great care on her locks (21ff.); Athene rejects μύρα and ἀλαβάστρως as well as χρίματα μικτά (12–16). Before she got married to Euergetes, Berenike behaved very similarly to Athene; in turn, the context of the *Loutra* is much indebted to Theokritos' *Helen* (see A. W. Bulloch, *Callimachus: The Fifth Hymn*, Cambridge Classical Texts and Commentaries 26 [Cambridge, 1985], 131ff. on lines 23–28), *pace* F. T. Griffiths, who would prefer "a common allusion to the Ptolemaic festivals and the myth imported with them" (*Theocritus at Court*, Mnemosyne suppl. 55 [Leiden, 1979], 89).

and in literature a latecomer.[207] This fact makes the use of the word even
more significant. Thus Berenike, for as long as she is not married, seems
to behave like Athene; now, as a married woman, she is rather like Aph-
rodite. On one level, this is an urbane and surely welcome compliment
on her chastity;[208] on another level, the comparison of Berenike's behav-
ior with that of the deities may constitute, from the Greek point of view,
a claim for Berenike's deification; both before and after her marriage,
she has done, and continues to do, what a goddess has done. But this
also supports his claim to worship according to the Egyptian point of
view: she plays the role of the goddesses.[209]

There remains an ambiguity. The phrase "I had not the pleasure of
the lush ointments of married women" may refer either to the time when
Berenike was unmarried or to the time after the marriage.[210] If the sen-
tence is taken in the latter sense, the queen will only have changed her
way of life and turned to lush ointments after her husband had returned
from the war. Admittedly, during her husband's absence in the war she
would not have had any use for myrrh. But not even the wedding would
have given the lock an opportunity to taste real perfume.[211] The lock can
hardly mean this. Hence, we return to the other interpretation: The lock
complains that he received plenty of plain oil but no myrrh when Bere-
nike was unmarried. He chooses not to speak about the time between
the queen's wedding and her husband's return from war, when the lock
was sacrificed. In terms of historical time, this is a period of one and a
half years; and her husband was probably at home during the first half

207. See Bulloch, *Fifth Hymn*, 135 on line 25 λιτά; in the *Loutra* the prosaic character
of this word is not in contrast to the use of the literary σμασαμένα; for in Hellenistic
Greek the latter word is not restricted to literature (see ζμήσασθ[αι] in *P. Ent.* 87.3 of 221
BC; for the discussion see Bulloch, *Fifth Hymn*, 143 on line 32).

208. For the sexual connotations of the use of myrrh, in contrast to the virgin's use of
plain olive oil, see now L. Holmes, "Myrrh and Unguents in the *Coma Berenices*," *CPh* 87
(1992): 47–50. Also cf. n. 163.

209. The argument presumes that the *Lock of Berenike* was written after the fifth *Hymn*,
and this would date the hymn before 245 BC. The similarity between the two passages
seems to establish some relationship between the two poems. I do not see much point in
having the hymn refer to the *Lock;* but it is possible that the idea of young athletic women
using plain oil had caught Kallimachos' attention and he mentioned it in two places without
intending to create an allusion. Athletes, of course, used plain oil, but they were men. For
the date of the fifth *Hymn* see Bulloch, *Fifth Hymn*, 38–43 (Bulloch does not discuss the
passage, but he notes the parallel).

210. On the ambiguity of this passage see Herter, "Haaröle."

211. H. Herter was worried about this problem but acquiesced by having Berenike just
behaving like this. "Aber seit wir das Original haben, müssen wir uns damit zufrieden
geben, dass die schöne Königin sich im Brautstande doch nicht gleich zu zahmeren Sitten
bekehrt hatte. Oder sollte die Locke dem Hofpoeten falsch berichtet haben?" ("Haaröle,"
68; repr., 206).

of the year. The lock surely had a rhetorical interest in not mentioning the few happy months, when he experienced the myrrh on the queen's head among his sister hairs. But what interest did Kallimachos have in the lock's oblivion?

Greeks performed the sacrifice of hair both as a pledge and as a nuptial rite.[212] Arsinoe III is celebrated in an epigram by Damagetos as having sacrificed a lock at her wedding to Philopator.[213] In our lock's mind the two events, wedding and pledge, are merged (see above). There may be, just may be, a further merger. Hellenistic Egyptians cut their hair also in the mourning for Isis, as did Erigone in her mourning for Ikarios, presumably in Eratosthenes' *Erigone*.[214] This ritual of mourning is, of course, different from a votive sacrifice of locks,[215] but the fact that Kallimachos sees the sacrifice under the metaphor of death may indicate that he blurs the distinctions. A terracotta piece, originally part of a vessel, seems to show Isis pulling out her hair. It has reasonably been argued that this Isis figure should be explained in the tradition of the royal *oinochoai*. Thus, it would most likely represent Isis as enacted either by Arsinoe III or Kleopatra I.[216] Berenike may have done just the same. Her "mother" Arsinoe was worshiped as Isis.

The claim (and at the same time confession—see above) that the lock never had the pleasure of real ointments may be carried one step further. The longing of the sister hairs for the lock and of the lock for perfumes may have a sexual connotation too. As long as the lock was on the queen's head and neither he nor his sister hairs received perfumes, he had no opportunity to enjoy sex.[217] But if we are indeed expected to perceive a flash of such connotations in the lock's claim, then they remain in the background, more in the reader's fantasy than in what the lock tells us.

212. See Nachtergael, "Bérénice II."

213. *AG* 6.277 (1375–1378 G.-P.). It has been argued that the queen is called Πτολεμαίου παρθένος and the poem, therefore, should refer to an occasion before the wedding, namely the Battle of Raphia (see, e.g., Gow and Page's commentary, 2:224). Since the battle took place at least three years after the marriage (see section II.1.b, Philopator), this argument can no longer be maintained. Hence, Arsinoe III sacrificed her lock most likely in a ritual preparatory to her wedding.

214. Merkelbach, "Erigone."

215. To this extent I agree with G. Nachtergael, "Bérénice II," also idem, "La chevelure d'Isis," *AC* 50 (1981): 584–606.

216. D. B. Thompson in *Eikones* (dedicated to H. Jucker), ed. R. A. Stucky, I. Jucker, and T. Gelzer, Antike Kunst, Beiheft 12 (Bern, 1980), 181–184.

217. For the use of ointment by bridegrooms see n. 164. The Egyptian priests' oath (n. 203) prescribed the following confessions among others: οὐ μέμιγμαι μ[ετὰ παιδὸς ἄρρενος· οὐ μ]έμιγμαι μετὰ ἀ[λλοτρίας γυναικὸς --- (*P. Wash. Univ.* II.71.i.22f.). These confessions are in accord with the confessions of the Book of the Dead, chap. 125 (see R. Merkelbach's commentary).

The lock proceeds to request his share when Berenike worships her "mother" Aphrodite-Arsinoe (*diva Venus*) on her festivals. These include the Arsinoeia. He asks for "libations" of myrrh. Since this request is an *aition*, we may conclude that offerings of myrrh played a part in the real world of the festivals of Aphrodite-Arsinoe. In technical terminology, "libations" of myrrh or ointments fall under the broad category of "offerings of oil" (ἐλαιόσπονδα). The little that is known about libations of oil in Greek cults seems to indicate that these offerings were connected not only with the cults of deities but also with those of the dead. Libations of wine to the dead, specifically to the deified queens, are known to have been part of the Alexandrian cults, including the Arsinoeia.[218] The offering of myrrh by Berenike to her deified mother, the new Aphrodite, fits this mold, and so would the same offerings to the constellation of Βερενίκης πλόκαμος if, indeed, such a cult was established. The lock, too, is deceased and resurrected, and thus entitled to a hero's offerings. But, of course, the rather somber background disappears both in the joyful celebration of the real festivals and in the hilarious situation in Kallimachos' poem, in which a simple lock, cut from the head of his queen, asks for the stuff that he missed most in his lifetime, and in which a queen offers the myrrh to what once was her own curl! Kallimachos felt that myrrh was the appropriate gift for the lock. Once again, his banter entertains his royal reader as well as his general audience.

The partly hopeful and serene, and partly entertaining, image of the queen raising her eyes to the stars while also giving libations of oil to her lock is abruptly ended by the lock's final outburst: may the stars perish, and may Aquarius and Orion—two constellations far apart from each other—shine beside each other, that is, may the starry sky collapse, if only he could reside on the head of the queen.[219] Such feelings are genu-

218. For "oil offerings" as offerings of myrrh see C. Mayer, *Das Öl im Kultus der Griechen* (Würzburg, 1917), 55ff.; W. Ensslin, however, understood oil offerings as a propitiation essentially not different from offerings of other liquids like milk and water (*RE* 16.2484–2486 s.v. νηφάλεια). But myrrh is a different matter, and both kinds of offerings must have existed. In Theokr. *Aipol.* 53f. Lakon gives milk and oil to the nymphs; and the effect of the oil is in contrast to Komatas' goatskin that stinks even more than Komatas himself (51f.). For the wine libations in Ptolemaic cult and presumably on the Arsinoeia see D. B. Thompson, *Ptolemaic Oinochoai and Portraits in Faience: Aspects of the Ruler-Cult* (Oxford, 1973), 69f. and 74f.

219. 93f.: *sidera corruerint utinam! coma regia fiam:*
 proximus Hydrochooi fulgeret Oarion!

There is enough Greek text extant to confirm that Ὑδροχ[όος and Ὠαρίων were mentioned by Kallimachos. The text of the Latin is a conjectural, but convincing, restoration of a corrupt text. See Marinone's discussion of several conjectures, *Berenice*, ad loc.

inely connected with mourning. "If the beloved person dies, then the world can go to hell."[220] In the Ἐκθέωσις Ἀρσινόης, Kallimachos' poem on the death of Arsinoe II, the queen is snatched away by the Dioskouroi and brought to heaven.[221] Philotera, Arsinoe's sister, who has recently died, and presently is visiting Lemnos, sees the fire and is terrified as she does not know yet that the fire comes from her sister's pyre. She sends Charis to the top of Mount Athos to report what she sees: "Which city was destroyed and is ablaze? I am frightened! . . . Is Libya struck by evil?" The mourning is such that a whole city, an entire country seems to be afire.[222] In the Πλόκαμος Kallimachos plays with such feelings. In a way, the lock is mourning himself.

The emotional wish that heaven be destroyed if he has to live separated from his queen is an effective end of the poem. Again, from the point of view of the lock, the emotions are justified; and yet in an objective measure they seem to be exaggerated and therefore comic. The ambiguity of serious and comic remains unresolved till the end of the poem.

The Greek papyrus containing the pre-*Aitia* version of the poem (see reminder [2] above) adds one more distich. All that is recognizable is "Hail to you, dear to your children" (χ[αῖρε,] φιλὴ τεκέεσσι]). *Iuxta lacunam* we will not change τεκέεσσι to τοκέεσσι. If Berenike had given birth, or was with child, at the time, the lock would surely have told us so. Hence it is not she who is addressed by this sign-off formula. Moreover, φιλὴ τεκέεσσι fulfils a function similar to the χαῖρε invocation at the end of the epilogue: "All hail, Zeus, also to you, and preserve the entire house of the lords" (above, n. 160). Such closings are characteristic of hymns (above, n. 156), and such a prayer can reasonably be directed only to Arsinoe, who has just shown her divine power in the catasterism

220. K. Meuli, "Entstehung und Sinn der Trauersitten," *Schweiz. Arch. f. Volkskunde* 43 (1946): 91–109; repr. in *Gesammelte Schriften*, ed. T. Gelzer (Basel, 1975) 1:333–351.
221. Dieg. X 11f.: φησὶν δὲ αὐτὴν ἀνηρπάσθαι ὑπὸ τῶν Διοσκούρων. Her "rape" occurs when the moon is "raped" (new moon); see n. 61.
222. F 228, esp. 49ff.; cf. Fraser, *Ptolemaic Alexandria* 1:668f. How real and destructive the mourning could become is illustrated by the events at Caesar's death, when veterans, matrons, and others not only threw weapons, clothes, and jewelry into the pyre but also set fire to the houses of Caesar's murderers. There was a plan to set the Capitoline Temple ablaze. A similar outbreak of chaos occurred at the pyre of P. Clodius. In both cases the circumstances were responsible for the charged emotions which called for revenge. Yet the ritual of the mourning itself provided the frame in which the natural emotions broke all restraints of the ritual. For the events on Caesar's and Clodius' deaths see A. Alföldi, *Studien über Caesars Monarchie*, Bull. de la Soc. Royale des Lettres de Lund (Lund, 1953), esp. 65–69. Alföldi refers to the "sakralen Anstrich" of these "anarchistisch–wütenden Brandstiftungen" (68).

of the lock and, by this very deed, demonstrated her concern for her "children," Berenike and Euergetes.[223]

 There remains a further question: Why did the poet delete the final χ[αῖρε] when he arranged the *Lock of Berenike* as the last poem of the *Aitia?* We may recall what was said earlier about the structure of the *Aitia* (reminder [1] above). The first two books were originally framed by Arsinoe, and the unity of the structure rested on the presentation of the *Aitia* as a dialogue between Kallimachos and the Muses. The unity of the third and fourth books was achieved through framing them with poems closely connected with Berenike. Thus, having the last poem end with Arsinoe would have seriously interfered with the structure of books 3 and 4. Furthermore, we just resorted again to the epilogue which followed the Πλόκαμος and ended with a double χαῖρε to Apollo and Zeus (above, n. 160). Kallimachos plays again with the formula adapted from the style of the hymns. A preceding χαῖρε at the end of the *Lock* would have produced an unwelcome duplication; and thus it would have stolen the surprise from the end of the *Aitia*. In sum, Kallimachos had good reasons for dropping the last distich with the χαῖρε when he inserted the *Lock* into the larger work.

 We have postponed the last question: Who speaks the hymnic sign-off greeting to Arsinoe?[224] Since we have recognized that the address is to Arsinoe, it is hard to believe that this final "hail" is spoken by the lock. At the most, he might have directed a final farewell to Berenike, his queen—which is not possible, as we saw. After his last "Heaven may go to hell," the lock has nothing to add. Hence, it must be the voice of the poet—silent up to this point—who intervenes at the end in a hymnic address to Arsinoe. Her catasterism of the lock anticipated the future elevation of the Theoi Euergetai. In this act she has demonstrated her love for "daughter and son." She is beloved by her children and answers with her love for them. As we saw before, "love" was a central element in the ideology of Ptolemaic kingship, the love between the reigning couple as well as the love between them and their predecessors (section II.1.d). Arsinoe's love for her brother and husband manifested itself in the love for, and from, her children. Thus, "dear to your children" expresses precisely the ideology that later led the Euergetai to call their

 223. R. Pfeiffer in the addenda, 2:116; idem, *History of Classical Scholarship* (Oxford, 1968), 123 n. 2; Fraser, *Ptolemaic Alexandria* 2:1026; Marinone, *Berenice*, 67 with n. 34; Gelzer, "Kallimachos," 22f. On this point I am particularly indebted to the latter, who discussed the passage with me after my lecture and caused me to change my view.
 224. The same problem occurs in other poems by Kallimachos, for example, in the second *Hymn*.

son Philopator and that finally was expressed by the name of Philometor. But while the love of the ruling couple was a dynastic theme, it also suited the poet's genre.

The concept of divine kingship with a reigning couple as "brother and sister" and with "love" as a constitutive element of this ideology is wrapped in lighthearted wit. Kallimachos plays with institutions which, in part, were of Egyptian origin but generally accepted by the Greeks at the time. A good example was the oath sworn in the name of the king. Moreover, the poet seems to have included allusions that went beyond the Greek cults. If we understand him correctly, he uses the symbolism of the obelisk and its connection with the cult of the sun-god to mark territorial claims and plays with the Egyptian ideas of afterlife and the cult of Isis. But, I admit, these allusions are perhaps less crucial for the interpretation of the *Lock of Berenike* than the Egyptian *Oracle of the Potter* is, for example, for the *Hymn to Delos*. Since the time of that hymn, the ideas of kingship had become less strange; they were almost totally Hellenized.

The poet himself steps back. Almost the entire poem is spoken by the lock, and this fact gives the poem distance as well as humorous flair. The lock is overexcited, but the reader readily forgives a lock. The poet steps in only at the last moment, turning the lock's speech almost into a hymn and thus playing with the genre. A hymn should have started by naming the deity at the very beginning; but there we have a reference to Konon, who is addressed in almost hymnic style. It begins with an *aition* of some sort: the astronomer has found a new constellation. Only at the end the reader finds out that the poem is in lieu of a hymn almost furtively directed to Arsinoe.[225]

▼ ▼ ▼ ▼ ▼

This paper began with the two different faces of the Ptolemaic king, one Greek and the other Egyptian, both two images of the same thing. In the course of the discussion, I hope, the two faces appeared clearly related to each other and less independent of each other than we tend to believe.[226] The forms in which the ideology of pharaonic kingship was

225. This still works nicely for the *Lock of Berenike,* a relatively small poem. At the end of the *Aitia,* a poem in four books, the χαῖρε becomes merely part of the transitional sign-off formula, although the formula allows the poet briefly to address the unity of poetry and kingship (see above, section III.1).

226. Elsewhere ("Adaption," 144) I have illustrated the relationship between the two cultures by the model of two overlapping circles. The overlapping portions of the circles illustrate the area of overlap of the cultures and their reciprocal influence upon each

presented to the Greeks were different from the traditional images and rituals in which the pharaoh continued to be seen by the Egyptian population; but the ideas of pharaonic kingship were translated into Greek forms. The kings created Greek cults which, against a Greek background, expressed the ideas of a divine kingship according to which the deeds of the king were equivalent to the deeds of the gods; the king and the line of his ancestors appeared as the gods on earth. For the Egyptians the indigenous temples mediated between the Greek kings and their own traditions, and again, the king and his ancestors appeared as the descendants of the gods. The temples created cults which, within their own tradition, translated Greek royal cults into Egyptian forms of worship. But the kings also addressed both parts of the population directly by measures such as the philanthropa decrees. When ideology was expressed in the form of tax reductions, remissions of debts, protection from officials, and amnesties, few Greeks or Egyptians found fault with it.[227]

Egyptian kingship was based on mythical thinking, which was a thing of the past for educated Greeks. It was a long time ago that the heroes had left this world, because the city-states had not much room for them. But the world of myth and mythical thinking had survived in poetry and reappeared in the tales of Hellenistic poets, in their imagery and the elusive art of allusion. The hero of old was the thing closest to a divine king on earth. This fact made poets like Kallimachos so valuable for Philadelphos and Euergetes. He presented central ideas of the Egyptian kingship so that they sounded serious and playful at the same time; and he was able to capture the foreign ideas in a web of literary allusions so that they seemed part and parcel of the Greeks' own past. Homer, Hesiod, and Pindar were most useful for this purpose. The kingship that was a political reality appeared tolerable through the viewing glass of his poetry. It was this poetry that enabled Kallimachos and his fellow intellectuals to live in the new country and even to enjoy its strange beliefs and customs with dignity.

We began with representations of Ptolemaic kingship in art; we will end with a metaphor. As we saw earlier, it was the duty of the Egyptian king to "unify the Two Countries" at his coronation and in a series of

other; everything outside the overlap indicates the areas of coexistence of separate cultures. Both models, that of mixed cultures and that of cultures coexisting without influencing each other, are insufficient. But the model of overlapping circles is insufficient, too. It is too static and, as an image, reflects only the surface.

227. On the philanthropa (see n. 100) as emanating from the ideology of kingship see Samuel, *Shifting Sands* 78f.; L. Koenen, *Eine ptolemäische Königsurkunde (P. Kroll)*, Klass. Phil. Studien 19 (Wiesbaden, 1957), 1.

ritual and historic acts. "The Two Countries" was interpreted in various ways: Upper and Lower Egypt, the two banks of the river Nile, the north and south of the earth. Under the Ptolemies it became the king's prerogative to unify Greek and Egyptian thought in the symbolism and reality of his office and person.

Response

Frank Walbank

The two excellent papers that precede furnish an auspicious opening. The general title of this segment is "The Social and Religious Aspects of Hellenistic Kingship," and both papers show that these two aspects are largely inseparable. They have also shown clearly that the institution to which we give the name of Hellenistic kingship was invariably and inevitably accompanied by tension in the relationships which it established or inherited—in particular, the relationship between kings and Greek cities and that between the Greco-Macedonian ruling class and the Egyptian populace, each with its separate concept of monarchy, which made up what Professor Koenen has described as the Janus-headed society of Ptolemaic Egypt. That tension, which is so clearly evident in both instances, arises out of the existence, side by side, of two elements, both with their own traditions, yet forced by historical events to come to terms with each other. If I may quote a comparison, which Professor Koenen has employed elsewhere, it is as if we were looking at two intersecting circles; and it is in the area of overlap between them that the really interesting things take place.

I

As Professor Bringmann has so clearly demonstrated, one of the main devices which enabled the king and the Greek city to live together with a minimum of friction was for the king to be seen as a benefactor. There were of course other roles which he filled and which can be traced in the terminology of honorary decrees: those of liberator and savior come to mind, and an analysis of how the king fulfilled the expectations which these aroused would be enlightening. But to study his role as benefactor

is especially rewarding. In most cases it involves on the one hand a transfer of material wealth, which can be measured, and on the other the creation of attitudes of response which are nonetheless real and important for not being susceptible to measurement. As Professor Bringmann has pointed out, such benefactions are not of course to be thought of as something peculiar to the relationship between kings and Greek cities in the Hellenistic age. Much the same thing can be traced earlier in the gifts made by the Sicilian tyrants to Greek cities and religious centers or by the kings of Macedonia to Athens—to quote only two examples. And to go in the other direction, a glance at the *Res Gestae* will show the same system of benefactions accompanied by boastful listing and, it was always hoped, appropriate gratitude, as a central feature of the ideology which attended the setting up of the Roman empire. But the relationship is especially noteworthy in the period we are concerned with. An important feature of it, to which Professor Bringmann has drawn attention, is that in a majority of cases the initiative for acts of benevolence came from the recipients: the kings did not *volunteer* gifts but responded to requests. In this context I should like to underline one feature of the transaction which he mentioned in passing—the role played in these exchanges by Friends of the king, who often hailed from the cities in question. This aspect of the benefaction would, I think, merit closer examination along the lines followed in Gabriel Herman's recent book, *Ritualised Friendship and the Greek City*.[1] Such a study might throw yet further light on the way in which royal benefactions were arranged and in so doing illuminate yet another channel running from the king to the city and vice versa. It is not, I think, irrelevant that in the relationship of *xenia*, out of which the increasingly institutionalized Hellenistic *philoi* in some sense developed, exchange of gifts played a fundamental part.

In marshaling his argument Professor Bringmann has drawn widely on the dossier of benefactions which he has assembled, and this has had the enormous advantage of allowing him to quantify many aspects of the benefactor role of the kings. One result, which I found especially interesting, was the statistical confirmation of Polybius' grumble about the growing meanness of kings in his own time. We know now that this was not just an example of the *topos* "things ain't what they used to be!" and we have been offered a shrewd guess at the cause—the Roman intrusion into the Hellenistic world, which grew increasingly onerous and decisive from around the middle of the second century. Both for the cities and for the kings there was now a new force to be reckoned with, that of the Romans; and it was more and more in this direction that gratitude came

1. Cambridge, 1987.

to be aimed—with a significant effect on city or federal policy, as can be seen from the Achaean volte-face at the conference in Locris in 198. This growth in the importance of Rome is of course well known; but its significance in this context is well illustrated by some of the material assembled by Simon Price in his book *Rituals and Power*,[2] which, though primarily concerned with Roman imperial cult in Asia Minor, has some interesting things to say about the forerunner of that cult in Hellenistic Greece. It is not without relevance to the decline in importance of the Hellenistic kingdoms and the reduction in the number of benefactions made by the kings to the cities that in the second century we begin to find Greek cults directed toward Rome or toward individual Romans, of whom Flamininus is a notable example. A Delphic inscription containing a *senatus consultum* of 112 dealing with a dispute between Athens and the *Technitai* of Dionysus mentions sacrifices offered to "the universal Roman benefactors." But, as Price points out, it is increasingly individual Romans who are singled out as benefactors and the recipients of gratitude—as indeed individual Greeks, like Diodorus Pasparus at Pergamum, who were not kings, attract gratitude and even cult for engineering benefits from Rome. In this atmosphere Hellenistic kings were increasingly negligible.

An important section of Professor Bringmann's paper deals with the *rewards* of benefactions, the other side of this two-way institution: partly of course *glory*, but also a claim on gratitude—a topic which, not surprisingly, exercised writers and philosophers. We have been reminded of Stilpo, who wrote on *Euergesiai;* and Cicero seems to have drawn on Panaetius for much of his *De officiis*—though indeed one must always exercise caution in arguing from Cicero back to Panaetius. For the institution to work properly both the benefaction and the gratitude had to be right in both quantity and quality. And here two potential causes of embarrassment have been identified—both, as one might expect, on the side of the recipient. One arose when the inferior and receiving party had accepted the benefaction but for one reason or another was unable to furnish the expected *quid pro quo*. As Professor Bringmann observes, in practice states did in the last resort what it was in their interest to do. But even when they could not be fulfilled, the demands of gratitude were nevertheless strongly felt, as we can see from the debate in Locris over whether the Achaeans should abandon Philip V for Rome. There is however another source of embarrassment—what to do when the benefaction itself appears to be unacceptable. Professor Bringmann quotes the telling incident of Eumenes II's offer in 185 to give the Achaeans 120 talents so that the interest might be used to pay members

2. *Rituals and Power: The Roman Imperial Cult in Asia Minor* (Cambridge, 1984).

of the federal council for their attendance at meetings, an offer angrily rejected as the equivalent of a bribe. It is clear from this example and others (such as the loss of face suffered by Rhodes when it accepted Pergamene money to pay its schoolteachers—assuming that Polybius' criticism of this benefaction was shared by others) that benefactions had to be carefully weighed, since they would be subject to the scrutiny of public opinion both within and without the state concerned.

Here, I suggest, may lie a partial explanation of the fact that out of a hundred clear examples which permit conclusions on this subject there are only six in which the initiative for the benefaction came from the kings. There was always the risk that a proffered gift which had not been solicited, like that of Eumenes to the Achaeans, might court a rebuff. That example, taken from the small number of cases where the would-be benefactor clearly took the initiative, together with the important role often played in the operation by Friends of the king with a connection in the city concerned, suggests that despite the desirability of benefactions to both parties, the preliminary negotiations leading to them were delicate and required special care. For the approval of public opinion clearly mattered greatly in such a transaction. Indeed, to the recipient such approval was in a sense the counterpart of the glory that accrued to the benefactor. The reputations of both parties were clearly linked together in the popular mind and received advertisement on public occasions. In 157, for example, the historian Aristotheus of Troezen visited Delphi and was granted *proxenia* and other customary honors for his "recitations" (*akroaseis*) there (*Syll.* 702). Other similar examples lead us to assume that praise of Delphi will have figured prominently in his subject matter; but, notably, what is mentioned in the inscription from which we learn of the affair is his *high praise of the Romans,* by this date Delphic benefactors.

The special concern of Professor Bringmann's paper is the benefactions made by kings to *Greek cities* in the Hellenistic period. I have already suggested that it might be useful to extend the study of the relationship involved both backward and forward from the period with which we are concerned. But there is another and more relevant extension which should perhaps be made within the Hellenistic world itself. The concept of *euergesiai,* though it plays so important a part in the lubrication of the relations between the kings and the Greek cities lying within their kingdoms or spheres of interest, has also a wider application. Susan Sherwin-White, in a recent essay on Seleucid Babylonia (which forms the first chapter in a volume on Hellenism in the East, edited by her and Amélie Kuhrt),[3] has argued that, while satrap in Bab-

3. *Hellenism in the East: The Interaction of Greek and Non-Greek Civilizations from Syria to Central Asia after Alexander* (London, 1987).

ylonia between 319 and 315, Seleucus, through patronage, built up a strong power base which in 312 enabled him to reestablish himself as governor (and eventually as king) there after his expulsion by Antigonus three years earlier. Diodorus (19.91) speaks of the *eunoia* of the Babylonian population (though, as Mehl argues in his recent biography of Seleucus,[4] this excluded the Chaldaeans), and the concessions made to secure that *eunoia* can be plausibly guessed (though they are not listed in Diodorus). They will be tax immunities, such as Eumenes employed at about the same time to build up a troop of 6,300 Cappadocian cavalry (Plut. *Eum.* 4) and such as we find mentioned in the Babylonian cuneiform text of the so-called *Dynastic Prophecy*, edited by Grayson in 1975,[5] a document which probably dates to the reign of Seleucus I. The reference there to tax exemption (the Babylonian word used is *zakutu*) is thought by Dr. Sherwin-White to be exemplary of what was to be expected from the good king. But we also know of other Seleucid benefactions, such as the return to Babylon of lost religious works, the renewal of subventions for sacrifices (suspended under the Achaemenids), the repair of temples at Babylon and Uruk, and the granting of *ateleiai* to individual recipients. My perhaps not very novel point is that the benefaction/gratitude complex of actions and reactions is one which extends well beyond the Greek cities and must be regarded as a basic constituent of Hellenistic sovereignty wherever it is found.

II

Professor Koenen's paper also deals with a subject which illustrates the tension that is present, in this case, between the Greco-Macedonian governing class, including of course the army, and the Egyptian population in general. The bias created by the preponderance of available Greek sources has in the past led us, not without some plausibility, to think of the Egyptians largely as the lower ranks in society, but Professor Koenen has reminded us, salutarily, that they also included an elite: landowners, traders, and (under Philadelphus) even some soldiers. Especially in the early, inadequately documented years before Philadelphus, the new rulers, faced with the problem of understanding, let alone organizing, the unique kingdom of Egypt, must have relied in all kinds of ways on the collaboration of Egyptians, and that at many levels. Manetho will not have been an isolated phenomenon. In his paper Professor Koenen has

4. *Seleukos Nikator und sein Reich,* vol. 1, *Seleukos' Leben und die Entwicklung seiner Machtposition,* Studia Hellenistica, no. 28 (Leuven, 1986).

5. A. K. Grayson, *Babylonian Historical-Literary Texts,* Toronto Semitic Texts and Studies, no. 3 (Toronto, 1975), chap. 3.

selected some aspects of this mixed society for close examination and has produced further evidence to add to that which he has assembled in earlier papers. He shows the extent to which we can trace an interpenetration of the Greek and Egyptian worlds, especially concerning the role of the king and how the two communities regarded him.

What he has done is, essentially, to indicate the various ways in which the two sections of the population of Egypt attempted to relieve the tension, to reconcile many of the differences existing between them, and so to reduce the danger of a breakdown in coexistence. The strategies adopted centered on the role of the king because he, Ptolemy, was at the heart of both communities, embodying two different concepts of royalty. In each case this concept was essential to the functioning of society as the Greeks and Egyptians respectively interpreted it. On the one hand, the Greco-Macedonian monarchy, which was now firmly established not only in Egypt but throughout the successor states of Alexander's empire, had ideological roots in Greek philosophy and religion, but even more in the military character of the events which led to the setting up of those states by men who had fought to found their "spear-won" kingdoms. On the other hand, we have the centuries-old role of Pharaoh reenacting divine rituals which are closely bound up at every turn with the land of Egypt and its unique geography. By contrast, the Hellenistic king held his rank and could exist and function quite separately from his kingdom. Antigonus I is simply King Antigonus, not the king of any particular land—though in practice of course a territorial base was highly desirable as a source of wealth, resources, and manpower. In the case of Macedonia, where the Antigonids were regarded as the successors of the Argeads, the ruling house was linked closely with the country. But that was exceptional, and at an earlier date Demetrius Poliorcetes remained a king (not the "king of Macedon") even after he had been expelled from his kingdom there. The contrast with Pharaoh could not be more striking; and it is such stark contrasts that account for the dichotomy embodied in the system of cultural and religious apartheid by which the Macedonian conquerors originally sought to solve the problem of governing two races, radically different but living perforce side by side.

However, as Professor Koenen has illustrated in an exemplary fashion, this apartheid was breached in many ways, since in practice it was in the common interest of both communities—the Greco-Macedonian ruling class and the Egyptian populace, of which the priesthood was increasingly the major representative—to establish religious forms and rites which would carry significance for both. Not all of them came off. The synthetic cult of Sarapis, for instance, was devised to appeal to both people: why this made little impression in Egypt yet took on a rather odd life of its own *outside* Egypt is not yet clear.

Professor Koenen devotes an important part of his paper to discuss-
ing one area in which the usual cultural barriers were successfully
breached. I am thinking of his comparison of the very different Greek
and Egyptian dating formulae as recorded (in Greek) in the Pithom and
Rosetta inscriptions and the way in which both, though so different in
form, were used in those decrees to achieve a single end—the validation
of the transmission of royal power—and, as a corollary, his analysis of
the titles given to the Ptolemies in the dynastic cult, all of them carefully
chosen to symbolize aspects of royal power which had a significance,
though not an identical significance, for both racial communities. For
both Greeks and Egyptians saw the king as involved in a vitally impor-
tant, but different, relationship with the divine world. For the Egyptians
the king reenacted the role of the gods in what seems like a timeless
ritual. For them the generations of father and son, Osiris and Horus, the
living and the dead, are fused. Both relationships and status are fluid:
son or husband, sister or wife, man or god, the boundaries are not firm.
What matters above all is the correct ritual, intimately connected with
the temple ceremonies and ultimately, of course, with the Nile flood and
the well-being of Egypt. Pharaoh, like the Fisher King of Arthurian leg-
end, must set his land in order. For the Greeks and Macedonians, on the
other hand, the king is someone who has merited divine honors through
his accomplishments, which include winning the land of Egypt—or Syria
or Macedonia—by his victories. In Greek fashion he is even identified
with specific Greek gods, whereas to the Egyptians the gods are incar-
nate in Pharaoh *because he is Pharaoh.*

In the course of his discussion of the various ways in which Ptolemy,
while keeping the two cultures separate, was nevertheless successful in
reconciling them, Professor Koenen has raised several interesting ques-
tions. There may be some bold persons who will want to take him up on
his argument concerning the dates of the early Ptolemies and how they
came to be associated with Egyptian festivals. But leaving that I will pass
now to the last section of his paper, in which he points out some of the
Egyptian themes and echoes in Callimachus' poems, in particular the
Hymn to Delos. Here I should like to make a brief comment on the line
in which the king rules over "*amphotere mesogeia* and the islands that lie
in the sea." In his recent commentary on this hymn, W. H. Mineur has
suggested that the words *amphotere mesogeia* refer specifically to Lower
and Upper Egypt from the point of view of someone looking up-country
from Alexandria.[6] This seems to me likely and easy to fit into Professor
Koenen's view of the passage. But could I perhaps fly a kite and suggest

6. *Callimachus, Hymn to Delos: Introduction and Commentary,* Mnemosyne, supplement
no. 83 (Leiden, 1984).

that there may be a reference here to the belief known to Herodotus and discussed by Strabo, while commenting on Polybius, that it was the Nile that formed the boundary between Asia and Africa (Libya)? On that assumption—not everyone accepted it—the "double inner land," the *amphotere mesogeia,* of Egypt might then be the two sides of the Nile, the two fertile strips which are so impressive to anyone traveling along the river. In Callimachus' allusive verse this need not exclude a reference at the same time to the upper and lower kingdoms as well.

At this point I should perhaps pause to confess that I had already drafted the last few lines when my attention was drawn to a note in the joint article of Professors Koenen and Dorothy Burr Thompson on the Tazza Farnese,[7] from which I ascertained not only that the Egyptians used both the expressions "Two Banks" and "Two Lands" to embrace the entire world, but also that there is ancient evidence that lends some support to my suggestion, in fact a poem in the *Anthologia Palatina* (9.235). There Crinagoras combines the idea of "Two Lands" with that of "Two Banks of the Nile." So my suggestion is far from original. Still, I put it forward!

As regards another detail, this time in *The Lock of Berenice,* I should just like to say that in a poem written in 245 a reference to Mount Athos as Arsinoe's spit or obelisk, touched by the rays of the rising sun, and implying a territorial claim to Macedonia, would suit me very well. In a recent publication, I argue that Antigonus Gonatas' naval victory over Ptolemy's ships off Andros is to be dated to 246 or, more probably, 245.[8] Depending on whether the poem was written before or after the news of that battle, the reference to Arsinoe's spit could be a challenge or a defiant retort. But in either case the naval campaign, whether already fought or merely in prospect and preparation, could provide a suitable context for the allusion—if allusion it is.

But what I should like to understand better is the meaning of this light, learned, and allusive verse, with its Egyptian resonances, in social and political terms. Professor Koenen seems to me uncontrovertibly right about its tone. But what conclusions can we draw as to how far Callimachus' Greek readers would recognize the more recondite Egyptian allusions? And had Callimachus a personal interest in "making the ideology acceptable"? Or should we assume that the poet reflects Ptolemaic propagandist aims in the way that the *Ara Pacis* or the *Aeneid* reflects those of Augustus? Was it important to Philadelphus that the Greek elite of Alexandria should comprehend the Egyptian aspect of

7. BASP 21 (1984): 136 n. 64.
8. N. G. L. Hammond and F. W. Walbank, *A History of Macedonia,* vol. 3, *336–167 B.C.* (Oxford, 1988), 587–600.

their king? And if so, why? Would it, in fact, help to smooth the king's relations with the more eminent among his Egyptian subjects and in particular the priesthood if they knew that some members of the Greco-Macedonian intelligentsia were awake to native Egyptian traditions? Or can we even envisage a Hellenized Egyptian elite, including men like Manetho, who might read Callimachus and take pleasure in the Egyptian references?

After that, a final point. Both papers raise economic issues, which I have so far not mentioned. Professor Bringmann draws attention to the important economic implications of royal benefactions, which often had far-reaching repercussions in spreading wealth not only in the lands of the recipient state but also in the donor's. And Professor Koenen has realized an interesting point in relation to the *apomoira* tax, levied on vineyards, garden lands, and (it now appears) other lands as well, which was diverted to the benefit of the deceased Arsinoe and collected by the temple authorities between 269 and 264, after which it began to be collected by state officials. Professor Koenen has now pointed out that an unpublished Cologne papyrus (*P. Köln.* inv. no. 20764) confirms that the temples were exempted from paying this tax on ἱερὰ γῆ yet continued to collect it from their tenants and were permitted to use its proceeds for the gods in general. He has also shown that the appropriation of the apomoira on nontemple lands did not in fact result in any loss of money, prestige, or independence for the temples, since its diversion to Arsinoe (and, from the time of Epiphanes, to Arsinoe and the Philopatores) concerned the Egyptian cult no less than the Greek. Indeed, as Arsinoe and the Philopatores were *synnaoi* of the Egyptian gods, the allocation may have gone in part to the maintenance of their regular cult. In view of the considerable increase in the amount of land under vineyards, the temples therefore probably drew more revenue from the apomoira from nontemple lands than when they collected the tax themselves. If that is true, we must nevertheless ask why the authorities preferred to have the collecting done by state officials; and I think the answer to that must lie in Professor Koenen's important qualification, namely, that in a time of crisis, and there were plenty of those from the late third century onwards, it was an immense advantage actually to have one's hands on the money. It was, in fact, a form of insurance.

SAN FRANCISCO HILTON ON HILTON SQUARE

WE INVITE YOU TO THESE FINE RESTAURANTS
for your enjoyment and convenience
LOBBY BAR CAFE ON THE SQUARE CITYSCAPE

Reservations 1-800/HILTONS

Identity and Crisis
in Hellenistic Literature

Introduction

Anthony Bulloch

Ever since Choerilus of Samos (*S.H.* 317) suggested, toward the close of the fifth century BC, that earlier poets composed in a condition of purity and innocence, and that, by contrast, contemporary writing was somehow hackneyed and defiled (for those are the clear implications of his reference, in v. 2, to a time "before the meadow was mown," with its connotations of a religious sanctity still preserved), critics have seen the post-Classical period as one that is inevitably inferior to all that went before. Even the modern historian, seemingly in pursuit of objective truth derived from external evidence and a strict methodology, is often driven by a powerful subconscious need to believe in a state of grace, an earthly paradise from which mankind has fallen into its present sullied state. So Minoan Cnossus, for example, becomes a "historical" Phaeacia, the world now lost to us of a people who knew only the ways of peace, despite abundant evidence from the art that survives from the great palace, corroborated by myth, that the social and religious thinking of the inhabitants of Cnossus was full of unintegrated primitive impulses of violence and destruction; the Archaic and Classical periods become the short-lived decades of an exemplary society parallel to our own in its ideals and aspirations; and the post-Classical world, the Hellenistic, comes to represent decline and inferiority, marked in every field, to be disputed occasionally by scholars such as Wilamowitz, but never essentially in question for the historiographical mainstream. Thomas Gelzer's paper provides the historical and conceptual background for a study of this phenomenon, and Peter Parsons lays out many of the particulars, including a striking reminder how many of the Greeks themselves even in the first century BC succumbed to theories of decline and spoke of stylistic "depravity" and linguistic "corruption," and how often canons of

great writers consisted exclusively of figures from the Classical and Ar-
chaic periods. And Albert Henrichs challenges us to reconsider the no-
tions that underlie the definition of "Hellenistic" with his detailed ex-
amination of Menander and the recently discovered fragment of the
poem *Meropis*.

The most central issue, of course, in the question of "identity" in the
Hellenistic period, and particularly in Alexandria in the third century
BC, is to what extent individual writers were independent and free from
the constraints of the past; this was a preoccupation of many Hellenistic
writers themselves, and it continues to be a primary concern of modern
historians and critics. The ancient writers often circle around the issue
raised earlier by Choerilus and proclaim, in varying degrees, their indi-
viduality (always within the accepted bounds of the convention of *mimesis*
and *imitatio*, of course), but it is striking how the modern interpreter
often adopts an uneasy or inconsistent position. A figure such as Diony-
sius Scytobrachion may be cited, as he is very appositely by Peter Par-
sons, for his "domestication and rationalization" of traditional material,
and the same tendencies may be seen in poets such as Theocritus or
Callimachus; but the poets are often analyzed, and their language and
diction especially so, as if they were primarily regressive traditionalists,
seeking to vary and renew but never dislodge their Homeric "model."
What is common to both, surely, and very significant, is that the mythog-
rapher and the poet, whether recounting a myth or maintaining a cer-
tain set of stylistic or linguistic features, seek both to renew and to pre-
serve at the same time.

Among the practitioners of oral poetry in an earlier, nonliterate, age,
these aspirations are not the least in conflict with one another (as Albert
Lord has demonstrated very clearly): preservation and renewal are two
complementary aspects of the living tradition of oral poetry and its
transmission as an essential art from one generation to the next. So too
the writers of the Hellenistic age (and particularly in the third century
BC) patiently seek to keep the past alive for the future: they are not mere
bookmen, for all the stylistic features and turns that we may catalogue,
but truly creative writers. And the really striking phenomenon is that
almost all the major writers of this time succeed in achieving some kind
of inner creative balance: the weight of the past is almost always ac-
knowledged without sacrificing the creative vitality of the present. Dio-
nysius Scytobrachion, for example, may well revamp and incorporate
critique of the myth into the myth itself, but the critique does not ac-
tually prevent the storytelling. The story goes on, even if the fire-
breathing bulls are seen as poetic fantasy for the Taurians; the warrior
continues to advance, Alexander-like, a pioneer at the edge of the
known world, and a new prose romance is born. Similarly when Theoc-

ritus presents the achievements of the baby Heracles in a context that satirizes and diminishes the once-heroic Amphitryon, or Callimachus exposes the social embarrassment of having a bulimic son like Erysichthon, the myths *are* being preserved and transmitted, whatever shifts of emphasis may be involved. It is an essential feature of living myth that it moves with the times and is continuously reshaping, and that quality of the process of renewal is no less a feature of the literate and "self-conscious" Hellenistic period than of the earlier preliterate or Classical time. The fact that we often find it difficult to see what exactly is going on in writers such as Theocritus or Callimachus, or are discomforted by what we do seem to find, is merely a function of the complexity of the subject and the sparseness of our evidence, not an indication that the rules are now completely different: our unease as readers and critics is often a sign of the inadequacy of the evidence available, and of the limitations of our own perspective, rather than a failing of the Hellenistic writers we are trying to understand. For what seems to stand out about the early Hellenistic period is the high degree of success that so many writers had in developing an integrated awareness of the past alongside their own identities. As we know well from our own times, modernist artists do not always preserve and sustain a line of continuity; the urge to break with the great tradition, to reject it and even to destroy it, is sometimes overwhelming, as the adolescent child often needs to overthrow the whole generation of parents in the quest for its own identity. Hellenistic writers, on the other hand, such as Callimachus (fr. 1.20) or, later, Antipater (*A.P.* 7.409) are clear that their great predecessor Homer is Zeus among poets: he is an Olympian, representative of order and civilization in its highest form, and eternal, not a Titan, a giant who is destined to be deposed by the up-and-coming, superior generation.

What emerges most strongly from these papers is the great diversity of the period. We look for an underlying identity and unifying set of features that give definition to the age, and what strikes us over and over again, from many different perspectives, is pluralism and variety. Our contributors did not set out to prove this, and, indeed, they come from quite different perspectives, but the true theme which they and other contributors in other sections help identify is multiculturalism, one of the preoccupations also of our own time.

Transformations

Thomas Gelzer

A fascinating—and extensive—task has been set before us, the fulfillment of which, however, will certainly not be easy within the scope of this paper.[1] I cannot, and this is something which must be taken for granted, here embark on a history of literature or a report on current research, but must limit myself to what I can say about the topic by way of thesislike statements that will lead to discussion, without detailed argument and illustrated by only a handful of examples. As it happens, practically all the concepts that I shall want to make use of in the course of my exposition are polysemous: their meaning, even the justification for using them at all, is disputed. So I must briefly say how I intend to understand them here, of course without any claim thereby to be providing them with a binding definition in general.

I

Firstly, what do we mean by *Hellenistic literature?* The difficulties that literary historians have met with in defining and delimiting Hellenistic literature have been brought to the fore briefly by R. Kassel in a thorough historical investigation.[2] The concept of "Hellenism" is modern; as is well known, it stems from J. G. Droysen, who introduced the term in his *Geschichte des Hellenismus* in 1836. But Droysen left neither its con-

1. I wish to thank my colleagues Christoph Schäublin and Christoph Eucken for discussing this paper with me and for their helpful suggestions, as well as Mr. Richard Matthews for translating it.
2. R. Kassel, *Die Abgrenzung des Hellenismus in der griechischen Literaturgeschichte* (Berlin and New York, 1987).

notation nor its time boundaries precisely defined, nor did he always use the term in the same way. Others then transferred it to isolated cultural phenomena of a period now designated as "Hellenistic"; its application to literature followed the hesitant path of trailblazers such as Erwin Rohde and especially Wilamowitz in his *Hellenistische Literatur von 320 bis 30 v. Chr.* in 1905. The literature of this period had previously been designated as *Alexandrian,* which was a term by no means without its justification in the facts. However, Wilamowitz used the new designation to wage a campaign against the passing of derogatory judgments on "Alexandrianism" on the part of proponents of classicism. In 1924 his *Hellenistische Dichtung in der Zeit des Kallimachos* comprised the zenith of his presentation of this new outlook, but what he meant by it was in fact the poetry of only a very limited period of time.

In casting about for ancient precedent in establishing this distinction we can notice that in the realm of the theory of literature and art, and perhaps only there, there were attempts, apparently, at a definition of this period; not, however, in the realm of political history. It is in the realm of the theory of literature and art that we find the first impulse to classification into periods, leading to later, similar classifications in the realm of political and cultural history. This impulse is that of the proponents of classicism,[3] and the periods it envisages are, more or less, those which concern us. In Latin we see it in Cicero's *De oratore* (55 BC) and in his *Brutus* and *Orator* (46 BC); in Greek, somewhat later, in Dionysius of Halicarnassus. The proponents of classicism (whom I shall hereinafter call *classicists,* whereby I mean not simply "students of ancient literature," but "advocates of the *classical* norms of this literature") distinguish three periods, as is well known: the first is that of good writers, later to be designated as *classici scriptores.* It is followed by a period of decline whose scope very largely corresponds to that which we are here calling "Hellenistic," and then by a third period, again a "good" one, in which—following the creative principle of μίμησις/*imitatio* and with recourse to the best classical models—literature (and art) of a new kind can be produced.[4]

Regarding literature, this theory has its first practical application in the area of rhetoric. But "rhetoric," to be sure, means something over

3. Cf. Gelzer, "Klassizismus, Attizismus und Asianismus," in *Le classicisme à Rome aux iers siècles avant et après J.-C.,* Fondation Hardt, Entretiens 25 (Geneva, 1979), 1–41 (discussion, 42–55); for the terminology (German and English), cf. M. Brunkhorst, *Tradition und Transformation: Klassizistische Tendenzen in der englischen Tragödie* (Berlin and New York, 1979), 4–21.

4. Cf. H. Flashar, "Die klassizistische Theorie der Mimesis," in *Classicisme à Rome,* 79–97 (discussion, 98–111); F. Preisshofen, "Kunsttheorie und Kunstbetrachtung," in *Classicisme à Rome,* 263–277 (discussion, 278–289).

and above the mere art of speaking. Rather, it entails a general higher education resting on a basis of ἐγκύκλια μαθήματα,[5] and in addition to the three prose genres (to wit: history, oratory, and philosophy), the list of its literary precedents gives pride of place to poetry. All four genres in turn comprise Quintilian's famous parallel lists of model authors in both languages.[6] The classicists (in the sense adopted here) designated the orators of this degenerate middle "Hellenistic" period as *Asiatici;* they were held to be representatives of "Asianism," irrespective of whether or not they came from Asia. Ancient classicists themselves did not always delimit this middle period clearly or proceed from the same points of view: most of them make the Hellenistic period begin with the death of Alexander the Great, thereby proceeding from an event of predominantly political importance, while others find their point of departure in the appearance of figures belonging to the art of speaking itself: thus perhaps Demosthenes' successors, or the historian-orator Hegesias, are viewed as the founders of Asianism. And likewise the beginning of the subsequent "classicist" period cannot be delineated unambiguously either.

We should now attempt to delineate more precisely just what we choose to regard as "Hellenistic literature" in what follows. Here certain drastic limitations are called for. First of all we shall confine ourselves to the first of our four genres, that of the poets, leaving prose literature unexamined. There are two main reasons for this. The first is the fact that of the literary prose of this period almost no complete work has been preserved, precisely because the classicists did not deem such pieces to be literary works of art. What we do possess—such as, for example, a few letters by Epicurus or parts of the historical work of Polybius—has (as in the case of technical writings) been preserved only because of its content. The second reason, which is complementary to the first, is that it is just Hellenistic poetry which by its novelty succeeded in leaving an extraordinarily strong imprint. Among the Greeks this imprint can be traced as far as Nonnus and his successors, but among the Romans it had been earlier and more explicitly recognized as a poetic program ever since Catullus and Lucretius, and then by Horace, Vergil, and the elegiac poets, to name but a few. By way of contrast with the despised prose writers of this period, it was precisely the poets—and just those poets who will be dealt with in what follows—who for their part

5. Cf. H.-I. Marrou, *Histoire de l'éducation dans l'antiquité* (Paris, 1965), 151–336; ἐγκύκλια μαθήματα, Dionysius Halicarnassensis *De Thucydide* 50.

6. Quintilian *Institutio oratoria* 10.1.46–131; the same four genres already in Dion. Hal. Περὶ μιμήσεως, cf. *Epist. ad Pomp.* 3.1.

became classical models of *imitatio,* as is evident in the very fact of their mention in the lists of Quintilian to which I have referred above.[7]

Two limitations, of a certain methodological significance, within the Hellenistic poetry to be dealt with in this study should also be mentioned. Firstly, that imposed by the time boundaries of the period. Here, too, there are very different ways of approach, as is well known. The problem of classification into periods has always been a problem of points of view. One can propose to call "Hellenistic" the poetry of a period of political history, perhaps from the death of Alexander to the Battle of Actium; or one can, as the editors of the *Supplementum Hellenisticum* have done, set the limits of this period at 300 and 1 BC for practical reasons.[8] Another point of view, which is that adopted here, results in period divisions which derive from the poetry itself and need not necessarily coincide with periods of political history. A foothold for this approach is provided by the specific task which lies before us, namely, to give special preponderance in this investigation to the issues of identity and crisis. Putting the problem in this way presupposes that the production of literature does not proceed uniformly and in unbroken continuity but is punctuated, if not by full-scale interruptions, then at least by turning points characterized by crises.

In our investigation we may permit ourselves to draw on the tripartite scheme devised for rhetoric by these ancient classicists and apply it to poetry by analogy. We shall then try to interpret as "crisis" the process of transformation that lies between the beginning of new Hellenistic poetry and the end of its preceding classical counterpart. We can then understand as the beginning of Hellenistic poetry that point in time at which it finds its new identity. In doing so we shall find ourselves directed toward Callimachus above all others, who together with his library catalog also put together an implicit "history of literature." From that point on, production proceeds for a certain length of time according to the principles newly established, until a subsequent crisis shakes the foundations of this identity, thus creating a need for new creative principles. That would then be the crisis that points the way forward from Hellenistic to classicist poetry. This later crisis is harder to come to grips with than the former, as we shall see.

A second limitation concerns the scope and character of the poetry to be included in our study. Konrat Ziegler, in his somewhat unjustly ne-

7. Quint. *Inst. or.* 10.1.54f.; Quintilian mentions some of them precisely because they were esteemed by Roman poets (especially Horace).

8. The options of the historians of literature are compiled by Kassel, *Abgrenzung des Hellenismus.*

glected booklet, *Das hellenistische Epos*,[9] rightly insists that alongside the
poetry of Callimachus and his circle a broad stream of poetry comes in
at the same time, yet not following his principles or doing so only to a
very limited extent.[10] Rather, it maintains the traditional pattern of "cy-
clic epic" which Callimachus had rejected. In terms purely of bulk, this
"traditional" poetry, of which moreover very little has been preserved,
seems considerably to have exceeded that of the Callimacheans, but—
and this is the point—the shape it persisted in taking did not correspond
to the claims of that poetry's recently acquired identity, so that we may
here leave it completely out of account.

We shall also leave out New Comedy, from Menander onward. True,
it also exercised a very strong influence, and that too among the Ro-
mans, but nonetheless it took shape on the basis of quite other presup-
positions, and with quite other intentions as to its effects, than that new
style of poetry that I wish to consider in what follows. New Comedy
comprises a stage in a stream of tradition that reaches a long way back
and also endures for a long time to come, but the public it is aimed
at—the common people gathered in the theater—is different from the
poetry-reading public of Hellenistic times, for whom poetry was indeed
something to be *read*. New comedy was not this, but was rather intended
for immediate success on the occasion of a once-only stage performance
and was thus meant to be *heard*, even though no longer exclusively in
Athens.

It is, then, not by chance that the new poetry's center of production
lies outside Athens, in a place as weak in tradition as Alexandria, so that
it would, at a minimum, be acceptable to designate the poetry that we
are going to turn our attention to as "Alexandrian," provided that this is
dissociated from any negative value judgment. In order to pursue our
inquiry into its identity and into the crises that led to it and again led
away from it, we should again follow up one of the leading threads of
this conference, namely, poets' definitions of themselves and, to further
this, any useful indications given by their contemporaries. As regards
the identity of the new poetry, we should consider it with a view espe-
cially to its political (in the broadest sense) or social function, and not
only in view of its purely artistic qualities as art for art's sake, a judgment
that this very Alexandrian poetry has now and again tempted its readers
to make.[11]

9. K. Ziegler, *Das hellenistische Epos: Ein vergessenes Kapitel griechischer Dichtung* (Leipzig, 1966); referred to by H. Lloyd-Jones, "A Hellenistic Miscellany," *SIFC* 77 (1984): 58.

10. There were, however, poets other than those who wrote epics (cf. n. 70, below).

11. So, recently, E.-R. Schwinge, *Künstlichkeit von Kunst: Zur Geschichtlichkeit der alexan-drinischen Poesie*, Zetemata 84 (Munich, 1986).

II

The *crisis* that precedes the self-definition of Hellenistic poetry begins much earlier, at the end of the fifth century, and extends over quite a long stretch of time. The utterances of the poets and the symptoms that enable us to recognize this crisis in poetry are interrelated with the crisis of the πόλις, attested by Thucydides, Aristophanes, Plato, and Demosthenes, who are our primary witnesses for it. But these utterances do not coincide in time so neatly with striking events of political history such as, for example, the end of the Peloponnesian War (at the beginning of our period), or the power takeover in Greece after Chaeronea by the kings of Macedon, or, later, the foundation of the Hellenistic empires by Alexander and the Succession. In the first instance this concerns quite different genres of traditional poetry and also of prose literature, which we shall now illustrate by means of a few examples.

Even before the end of the Peloponnesian War, Aristophanes makes it clear, in the *Frogs* of 405 BC, that great tragedy has come to an end with the death of Euripides and of Sophocles shortly after him. Fifteen years after the collapse of Ancient Athens in the defeat of 403, he presents *Plutos*, the last play that can still be counted as Old Comedy; and in the following years he leaves the *mise-en-scène* of *Kokalos* and *Aiolosikon,* already to be considered as so-called Middle Comedy,[12] to his son Araros. In respect of their origins, tragedy and comedy are both specifically Athenian genres, and even after these break points they do not cease to exist but continue in another form within the framework of the lasting institution, the Athenian Theater Festival. The festival is itself transformed in a manner corresponding to changed conditions, as, for example, by the abolition of the post of χορηγός and the introduction of a civil servant called the ἀγωνοθέτης in his place, probably in the time of Demetrius of Phaleron.[13] Productions also increasingly become more generally "Hellenic" so as to facilitate their presentation outside Athens.

On the other hand, because their institutional and social preconditions had ceased to exist, other genres of poetry came to a complete standstill, such as the choric *epinikia* for sports victories on the part of the old aristocracy,[14] for which we have one late piece of evidence in the

12. For "Middle Comedy," cf., e.g., R. L. Hunter, *Eubulus: The Fragments* (Cambridge, 1983), 4ff.
13. Transfer of the *choregia* for comedy to the *phylae* after 329; first *agonothetes* attested 306 BC, cf. H.-J. Mette, *Urkunden dramatischer Aufführungen in Griechenland* (Berlin and New York, 1977), xvi; A. W. Gomme and F. H. Sandbach, *Menander: A Commentary* (Oxford, 1973), 23.
14. For the social change and its consequence for the appreciation of the games and

fragments of the song for the spectacular victory of Alcibiades in 416 BC.[15] The period following the Peloponnesian War saw the falling into disfavor of the *chorus*,[16] in which citizens had in a variety of functions expressed their degree of identification with their community. Whereas, up until the *Frogs*, the chorus had, as representative of the civic body in Old Comedy, continued to sing the *parabasis* and other cartoon-type songs and generally to play a major role, in *Ecclesiazusae* it is confined to a shadow of its former self, and in *Plutos* it is almost completely absent. These two comedies are direct evidence for the inner connection between the crisis of poetry and the crisis of the πόλις.[17]

From the end of the fifth century onward we also have statements by poets who express their own opinions on the crisis of their art. Among them are the famous lines from the preamble to the *Persica*, by Choerilus of Samos, in which he deems as happy

> the man who at that time knew how to sing as servant of the Muses, before the meadow was mown. But now, after everything has been broken up and the arts have come to an end, we are so to speak the last ones remaining in the field, and look where one may it is just no longer possible to come across a newly harnessed steed.[18]

Heroic epic has thus reduced the scale of its activities, but for this art in earlier times Choerilus cites Hesiod with Μουσάων θεράπων and with his chariot (that of the Muses), an image much loved by Pindar and Bacchylides.[19] Further, his words are then taken up by Callimachus and other poets of his time. But even this genre has not entirely ceased to exist, since Choerilus has introduced a new element in the deeds of historical heroes and thereby opened up for epic a new area of application that goes far beyond that of Hellenism.

One remark that has been quite rightly associated with this is the outcry in the *Porphyra* of Xenarchus,[20] a poet of later Middle Comedy, that "poets are nothing but tittle-tattle; they give rise to nothing new, but each of them simply twists what he has to say in all directions." In the *Poiesis* of Antiphanes we also find reflections on the difficulties of achiev-

for their participants, cf., e.g., I. Weiler, *Der Sport bei den Völkern der alten Welt* (Darmstadt, 1981), 96f., 118f.

15. "Euripides" *PMG* 755, 756 Page.

16. Cf., e.g., J. Irigoin, *Histoire du texte de Pindare* (Paris, 1952), 12f.

17. Cf. Gelzer, "Aristophanes 12 (Nachtrag)," *RE* Suppl. 12 (1970): 1536–1538.

18. H. Lloyd-Jones and P. Parsons, eds., *Supplementum Hellenisticum* (Berlin and New York, 1983) 317 (hereafter cited as *Suppl. Hell.*).

19. Hesiod *Theogonia* 100; for further references, cf. Lloyd-Jones and Parsons, *Suppl. Hell.*, 317.

20. F 7 *CAF* 2.470f. Kock.

ing a consistent, newly created treatment of comedy in a σύγκρισις with tragedy, in which (he claims) everything is much simpler because what happens there is already known to the spectator in advance, from mythology.[21]

Awareness of a turning point in poetry can therefore be established as early as the end of the fifth century, the period of the later Sophists. Given, however, that we shall not wish to count the "artistic prose" of a Gorgias or an Isocrates as Hellenistic literature, even though such prose exercised a great deal of influence on "Asianism," the end of the fifth century does not seem to me to be the right time from which to date Hellenistic poetry.[22] At the same time, from that point onward and right through the fourth century we can observe by and by the coming into existence of the *preconditions* that permit that poetry to find its *new identity* and further to exercise a far-reaching effect, and this in spite of the harsh demands which it places upon its public.

Right from the beginning—from the *Frogs* of Aristophanes and Choerilus' preamble—awareness of the difficulty of creating new poetry goes hand in hand with a singularly high *appreciation of the great poets of earlier times*. As a symptom of the general recognition of this state of affairs it is common to draw attention to the re-presentation of ancient tragedies, which can be documented from 386 BC onwards.[23] At the same time, it is also true that certain tragedies of Aeschylus had already, in the fifth century, been re-presented after his death.[24] Then, in the last third of the fourth century, in the time of Lycurgus, the "canon" of the three great tragedians was officially consecrated insofar as the texts of their tragedies became definitively fixed in the notorious "state copy," the original of which is supposed to have found its way to Alexandria.[25]

21. F 191 *CAF* 2.90f. Kock.

22. Beginning of Hellenistic poetry with the death of Euripides and Sophocles, cf. Lloyd-Jones, "Hellenistic Miscellany," 55, referring to K. J. Dover, *Theocritus: Select Poems* (London, 1971), lxi.

23. Cf. Mette, *Urkunden dramatischer Aufführungen*, xv; 339 BC, first production of an old comedy. We do not know, however, whether the old tragedy of 386 was one of the "Three Great Tragedians," and it is improbable that the play produced in 339 was from Old Comedy. For the problems arising from his competition with the old tragedians, cf. Astydamas' epigram on the occasion of his victory in 340 BC, D. L. Page, ed., *Further Greek Epigrams* (Cambridge, 1981), 115–118, at just the time when, from 341 to 339, tragedies by Euripides were re-presented three times over; cf. Mette, *Urkunden dramatischer Aufführungen*, 91.

24. Cf. S. Radt, *Aeschylus*, vol. 3 of *TrGF* (Göttingen, 1985), 56–58; contra, but unconvincing, G. O. Hutchinson, *Aeschylus: Septem contra Thebas* (Oxford, 1985), xlff.

25. Cf. R. Pfeiffer, *Geschichte der klassischen Philologie: Von den Anfängen bis zum Ende des Hellenismus* (Reinbek b. Hamburg, 1970), 109, 237; for Aristophanes (in the *Frogs*), Aeschylus, Sophocles, and Euripides are the three great tragedians. Aristotle, however, in his

At about the same time Aristotle defines the qualities of poetry, taking as his point of departure the works of the recognized Old Masters. According to his teleological construction, poetic genres developed from primitive, improvised beginnings to the point at which they found their "nature," that is, their completely filled-out, perfect form.[26] The three genres that occupy the center of the stage in his treatment of the art of poetry—epic, tragedy, and comedy—reached this uppermost level with poets who were at work far before his own time: Homer, Sophocles, and Aristophanes.[27]

What this means is that the best poetry belongs to the past and that alongside the need for recognition and exegesis of it there develops an *interest in the history of poetry*. There are indications of this much earlier, perhaps as early as Ion of Chios, then more obviously in Glaukos of Rhegion, who may be still in the fifth century. Aristotle then put the history of single genres on a new, scientific basis with his documentary filing system, which in the case of drama means his *didaskaliai*. Also, the victory lists put together by Hippias of Elis for Olympia at the end of the fifth century and by Aristotle and Callisthenes for Delphi could have been used for the dating of choral *epinikia;* but whether Aristotle actually used them for this purpose is not known to us.

Another factor is that the older poetry, which had become historical (and this includes drama), is no longer seen as essentially destined for performance, but is *to be read from books*. Aristophanes' *Frogs* testifies to the reading of a tragedy of Euripides shortly after that poet's death.[28] Enjoyment of the effect of *reading* tragedy is clearly ranked by Aristotle as something obvious and in immediate juxtaposition to that of a performance.[29] What this means is nothing less than that ancient poetry has now definitively become "literature," or poetry to be read. The conclusion that literary production was as a matter of course geared more to reading than to oral performance by the author becomes evident earlier in the realm of prose than in that of poetry, for example in the books of the Ionic so-called "nature philosophers" and of Heraclitus and the medical writers. Further, this tendency is on the increase from the end

Poetics, almost completely neglects Aeschylus, cf. G. Xanthakis-Karamanos, *Studies in Fourth-Century Tragedy* (Athens, 1980), 23, 31.

26. Aristotle *Poetica* 1448b20ff.; for the theory, cf. W. Kranz, "Die Urform der attischen Tragödie und Komödie," *NJbb f.d. klass. Altertum*, Bd. 43, Jg. 22 (1919): 145–168.

27. Arist. *Poet.* 1448a25ff. How far fifth-century tragedy had become "historical" for Aristotle is evidenced by, among other things, the fact that he views it through the dramatic technique of the fourth-century tragedians. Cf. Xanthakis-Karamanos, *Fourth-Century Tragedy*, 18–20.

28. Aristophanes *Ranae* 52f.

29. Arist. *Poet.* 1462a17f.

of the fifth century onward, and this in genres that are aimed at a wider public than the earlier ones (for example, the *History* of Thucydides) and above all in that genre which, as far as its original purpose is concerned, was least suited for reading in the study but aimed for the immediate effect to be gained specifically by means of oral delivery: rhetoric. By way of example it will suffice to name Isocrates, who is known to have put together all his works (with the exception of a few letters) in the form of speeches, none of which however were actually delivered. The speeches of the "logographers" are likewise in the written medium: they were produced, and later published, for persons other than their authors, and this is also true of the orators who—Demosthenes is an example—did indeed deliver their speeches but then disseminated them in the form of pamphlets. Plato took it for granted that speeches and philosophical writings can be read. We know that in intensive discussion he gives preference to oral persuasion over the written treatise for the art of speaking and for teaching;[30] but his own philosophical writings and those of his contemporaries in fact presuppose a public with extraordinarily avid tastes in reading material.

If for the moment we choose to ignore works considered expressly as "didactic poetry"[31] (for example, those of the "philosopher poets," Xenophanes and Parmenides and their followers), about whose original manner of delivery we have no information, then we notice that *poetry* aimed specifically at being read and not at being somehow performed comes only later on to be recognized and produced as such. In this connection it is important to realize that the poetry even of a downright *poeta doctus* such as Antimachus of Colophon—who together with his contemporary, Choerilus of Samos, is regarded as one of the early trailblazers of Hellenistic poetry—met with no success when delivered orally in front of his fellow citizens or Lysimachus. His manner of speaking was singularly full of glosses and his scholarship ranged far beyond that of ancient epic, to the point that what he had to say remained quite incapable of being taken in on the basis of a once-only aural reception. Only the younger Plato is supposed to have formed an adequate appreciation of him, and allotted Heraclides the task (though not until after his death) of gathering his poetic writings together, namely—and this is the point—as poetry to be read. In any case it would seem that what Plato appreciated most was not so much his artistic skill as the *ethos* of his *Thebais,* because of its pedagogical implications. Later he was, as it

30. Cf. Plato *Phaedrus* 274bff. and the often discussed references in K. Gaiser, "Testimonia Platonica: Quellentexte zur Schule und mündlichen Lehre Platons," in *Platons ungeschriebene Lehre* (Stuttgart, 1963), 441ff.

31. Cf. Arist. *Poet.* 1447a28ff.

were, rediscovered by the Hellenistic poets on account of his *Lyde,* which provided them with a model for a narrative catalogue poetry in the form of elegy, and just because of its learned language, which they were immediately able to use and imitate.[32] But even he is not yet himself a Hellenistic poet in the sense of the new identity of poetry, which remained unformulated until Callimachus and his contemporaries. Nothing is known of any reflection by Antimachus on the configuration of a new poetry, and his artless narrative style, which simply listed events one after another in long stretches of chronological sequence, contradicted everything that the new poetry was trying to achieve.[33] Because of that, Callimachus rejected his *Lyde* (though others had esteemed it highly) as "a fat and inelegant book," even though he himself made use of parts of it.[34]

A precondition of this "culture of the written word" is a παιδεία including *knowledge of the ancient poets.* Not only the orators (for example, Lycurgus in *Against Leocrates*) but also Plato continually cite and refer to the ancient poets, and that in spite of Plato's doctrinaire rejection of Homer and the tragedians as "educators of the Greeks."[35] Both Plato and Isocrates describe the education which they impart in their schools as φιλοσοφία (cf., previously, Thucydides 2.40.1);[36] and the Athenians, who accumulate and pass judgment on everything of value, even when it comes from outside Athens, consider themselves to be the teachers of Greeks everywhere: indeed, according to Isocrates, what makes a man a Greek is not so much where he comes from but his Attic παιδεία in the λόγοι.[37] Other Greeks also come to Athens, or send their sons to study there. Let us recall in this connection that in his *Cyprian Orations* Isocrates develops a concept for the *education of princes* in which he gives Nicocles the following piece of advice:

> Don't imagine that you should remain ignorant of any of the much-respected poets or teachers of wisdom, but rather become a listener of the former and a pupil of the latter.[38]

32. Cf. B. Wyss, *Antimachi Colophonii Reliquiae* (Berlin, 1936; reprint, 1974), T 1–3; praefatio, xlff.; xxixff. studia Homerica.

33. Cf. Wyss, *Antimachi Colophonii Reliquiae,* ixff. (*Thebais*), xxiff. (*Lyde*); and fragments found after Wyss's edition, Lloyd-Jones and Parsons, *Suppl. Hell.,* 52–79.

34. Cf. Antimachus T 14ff. Wyss; Callimachus F 398 Pfeiffer, Lloyd-Jones and Parsons, *Suppl. Hell.,* 78; Philitas, ibid. 675 (= Schol. Flor. ad Call. F 1.9–12) and Wyss, xlviff.

35. Pl. *Respublica* 595a–608b.

36. For Isocrates' and Plato's evaluation of the poets, cf. C. Eucken, *Isokrates: Seine Position in der Auseinandersetzung mit den zeitgenössischen Philosophen* (Berlin and New York, 1983), 243ff.

37. Isocrates *Panegyricus* (4) 46ff.

38. Isoc. Ad *Nicoclem* (2) 13; for the education of princes, cf. Isoc. *Antidosis* (3) 69f. and

Contemporaneously there are now also in other πόλεις schools not only
of elementary but of higher philosophical education, in nearby Megara
as in distant Cyrene. It would seem that in the course of his journeys
Plato was in contact with them, as with those of the Pythagoreans in
Italy, Sicily, and Thebes. Later we see men such as Heraclides giving
instruction in Heraclea on the Black Sea and Aristotle in Assos and Pella,
to name but a few. One example, and that one with far-reaching effects,
of the way in which such an education was considered to be a prerequi-
site for political leaders, even outside Athens, is provided by Philip II
of Macedon, who had his son and successor Alexander educated by
Aristotle.[39]

Finally, the fourth century also saw the formation of that institution
which was to permit the systematic exploration of the history of poetry,
as indeed of most other disciplines as well: libraries. Collections of books
had indeed existed much earlier, but the fourth century sees philosophi-
cal schools founding libraries as the basis of their scientific research.
Plato already seems to be relying on a collection of relevant texts for
discussion in the Academy and for the elaboration of his writings, and
Aristotle's comprehensive library, which was still to be used by Theo-
phrastus, has become famous primarily because of its strange later his-
tory, which may never be fully clarified.[40]

III

All this points the way toward some of the important preconditions for
the production—and above all for the possibilities of achieving an ef-
fect—of those Hellenistic poets who were able to come out on top of the
crisis that had been inflicted on poetry since the end of the fifth century.
It also explains the apparent paradox as to why this relatively small num-
ber of *learned poets,* addressing themselves exclusively to a small intellec-
tual elite of educated persons, were able to bring about a decisive break-
through vis-à-vis the great number of the rest.

Ptolemy I proceeded on the basis of these preconditions when he
found himself faced with the task of establishing a new empire in Egypt,

W. Jaeger, *Paideia* (Berlin, 1947) 3 : 145ff.; for the *Cyprian Orations,* cf. Eucken, *Isokrates,*
213ff.

39. Even though the influence of Aristotle's education ought not to be overrated, the
very fact that he made Alexander acquainted with the *Iliad* is of great importance, cf. H.
Flashar, "Aristoteles," in *Die Philosophie der Antike,* H. Flashar, ed. (Basel and Stuttgart,
1983) 3 : 232.

40. Cf. I. Düring, *Aristotle in the Ancient Biographical Tradition* (Göteborg, 1957) T 42a–d
(337f.).

on colonial soil, in a foreign environment, and with it a new center. As regards culture, literature, and—our exclusive concern here—especially poetry, he addressed himself to this task with abundant energy, but acting throughout not as innovator but as one with an extremely perceptive regard both for tradition and potential, in which matters he was well advised by competent experts. He also had his son and successor educated by scholars, namely, by Philitas of Cos, who was both scholar and poet, ποιητὴς ἅμα καὶ κριτικός (i.e., exponent of ancient poetry with a famous work on glosses),[41] and by the Peripatetic Straton of Lampsacus.[42] On the advice of Demetrius of Phaleron (pupil and friend of Theophrastus, who also wrote on Homer and other poets) Ptolemy founded the *Mouseion*,[43] a research institution modeled on the *Lykeion*, in the palace area of Alexandria. He also founded the famous library in the Mouseion. Its first librarian, Zenodotus of Ephesus, described as a pupil of Philitas and really the founder of Alexandrian philology, is named as the third teacher of the heir-apparent and the other children of the king; his later successors in office included several educators of princes, among them the polymath Eratosthenes, who was the first to style himself φιλόλογος and was himself also a poet.

A magnificent array of such scholar-poets could be seen at work at these institutions: Callimachus and others whose names and philological achievements have been comprehensively and lovingly tabulated by Rudolf Pfeiffer; there is no need to reel off a list of them here. But what we should remember is that there had always been princes and tyrants who attracted poets to their court, even in Macedonia itself, where Ptolemy himself came from. There had also already been poets who were also scholars: we have already mentioned the well-known case of Antimachus; and libraries too had already existed elsewhere. Furthermore, not all those who wrote poetry in Alexandria were themselves γραμματικοί, not even one of the greatest among them, Theocritus; they did not all participate in the work of these institutions.

But what must be especially emphasized is that neither in a material nor in an intellectual sense is the new poetry to be regarded as the prod-

41. Strabo 14.675; cf. Pfeiffer, *Geschichte der klassischen Philologie*, 116f.

42. For the new meaning of philosophy, about 300 BC, as *ars vitae*, cf. A. Dihle, "Philosophie—Fachwissenschaft—Allgemeinbildung," in *Aspects de la philosophie hellénistique*, edited by H. Flashar and O. Gigon, Fondation Hardt, Entretiens 32 (Geneva, 1985), 185–223 (discussion, 224–231).

43. Pfeiffer, *Geschichte der klassischen Philologie*, 123f., 133, was skeptical of Demetrius' influence upon the conception of the Mouseion and the Library, whereas now it is almost universally accepted; cf., e.g., P. M. Fraser, *Ptolemaic Alexandria* (Oxford, 1972) 1:315, 321; F. Wehrli, "Demetrios von Phaleron," in *Philosophie der Antike*, 560, who considers it probable.

uct of these newly established institutions. Rather, it is the achievement of individual poets whom the king and his advisors tried systematically to attract to Alexandria from elsewhere, and—not always successfully— to keep there. But it is beyond dispute that this policy also had its successes. By means of the education of princes by poets and scholars of this kind, the interests of the king filtered down through several generations,[44] reaching a zenith in the reigns of Philadelphus, Euergetes, and Philopator.

Now something on the position of poets and poetry in society: First and foremost, it did not depend on the material security of those poets who received their income from the king, but on the example that the king himself gave by the esteem in which he held them and by the bonds he established between them and his house and court. Victor Ehrenberg appropriately describes the significance of the king in the new Hellenistic empires: "The monarch alone was the embodiment of the state," and "when all is said and done the state [which had been brought into existence by conquest and was maintained through civil and military power exercised by the king] was the king's private property."[45] And the example furnished by the king was then followed by society, as dependent on him, with the development of the new monarchies. He would gather around himself a circle of personalities whose loyalty to him was rewarded with his favor, and as "friends" ($\phi\acute{\iota}\lambda o\iota$) of the king, these would comprise something like a new imperial nobility. Here is just one example of the esteem of these men for poets: the powerful admiral (*nauarchos*) Callicrates of Samos, who played a dominant role in naval and religious policy throughout the empire during the reign of Philadelphus, had two epigrams written for him by Posidippus on the occasion of his erection of a temple to Arsinoe-Zephyritis, just as Sostratus (builder of the famous lighthouse on the island of Pharos) had done before him.[46]

The artistic qualities of this new poetry meet the demands of $\pi\alpha\iota\delta\varepsilon\acute{\iota}\alpha$, and this legitimizes the exercise of power on the part of its exponents. Literary patronage had always been a weight-bearing column of monarchical propaganda. By means of its panhellenic character, dissociated from any local function, the new poetry also satisfies the needs of a cos-

44. The fact is explicitly recognized by, e.g., Eratosthenes: Powell, *Coll. Alex.* 35.13–18.

45. V. Ehrenberg, *Der Staat der Griechen,* part 2: *Der hellenistische Staat* (Zurich, 1965), 195f.

46. A. S. F. Gow and D. L. Page, eds., *Hellenistic Epigrams,* 2 vols. (Cambridge, 1965), 3100–3125; cf. the poem for Arsinoe's wedding, Lloyd-Jones and Parsons, *Suppl. Hell.,* 961, most probably also by Posidippus; cf. also the commission of epinician poems by Callimachos for a queen (*Victoria Berenices,* Lloyd-Jones and Parsons, *Suppl. Hell.* 254–268 C) and for a royal minister ($\Sigma\omega\sigma\iota\beta\acute{\iota}ov$ $v\acute{\iota}\kappa\eta$, Call. F 384 Pfeiffer).

mopolitan society that comes and goes in the new Hellenistic empires after the decline of the old city-states, or finds a new home in those empires. In addition, papyrus discoveries enable us to see that the reading of poets was also very popular among Ἕλληνες in an alien environment far from the capital of the empire, and we also know about poems by the new poets who were already being read there in the third century, such as the *Victoria Berenices* by Callimachus and the *Hymn to Demeter* by Philicus.[47] We have up to this point spoken only about Ptolemaic Egypt, not because there was nothing comparable elsewhere—there was!—but because Egypt serves as the best example since it is the place about which we are best informed.

It is also worthy of note that efforts to perform *dramatic poetry*—that is, comedies and tragedies—in the new cities of Alexandria and Ptolemaïs have not left any palpable traces behind them.[48] What we know of the so-called tragic *Pleiad* is practically only names; the satire *Menedemus* by Lycophron belongs to Eretria, not to Alexandria; and no one would want to maintain that the excessively long enigmatic speech that comes in the *Alexandra* (if it really is by Lycophron) was actually intended for tragic performance. And the status of the *Mimiambi* of Herondas in this regard, when compared, say, with the *Women at the Adonis Festival* of Theocritus, is questionable, to say the least. Neither have the new cults produced any *cult poetry*, or at least none that ancient critics of literature found interesting.[49] All this contrasts with New Comedy, and also with tragedy and satyr plays, performances of which were continued by force of ancient tradition, above all in Athens, but also elsewhere.[50] The new poetry, on the contrary, is, by its very nature, poetry to be read.

IV

This leads us to the question of the *newly found identity* of specifically Hellenistic poetry, here to be outlined in a few sentences only, since the

47. Lloyd-Jones and Parsons, *Suppl. Hell.*, 254–268 C, 676–680, cf. 990.

48. Cf. Fraser, *Ptolemaic Alexandria* 1 : 618–623 with notes.

49. Poetry for Alexandrian cults, cf. Fraser, *Ptolemaic Alexandria* 1 : 615ff.; the *Hymn to Demeter* by Philicus (who was himself a priest of Dionysus: ibid. 652) was not a cult hymn, but a gift to the poet's fellow grammarians (Lloyd-Jones and Parsons, *Suppl. Hell.*, 677), cf. Lloyd-Jones and Parsons, *Suppl. Hell.*, 990; for Callimachus' religion, cf. A. W. Bulloch, "The Future of a Hellenistic Illusion: Some Observations on Callimachus and Religion," *MH* 41 (1984): 209–230.

50. K. Ziegler, "Tragoedia," *RE* 6 A, vol. 2 (1937): 1967–1981, investigates the reasons for the almost complete loss of Hellenistic tragedy and pleads against unwarranted disregard for it.

task of a full answer to this question falls to Peter Parsons. As far as poets' self-definition is concerned we may regard as central those programmatic utterances that Callimachus comes up with in the prologue to his *Aitia*, in the *Hymn to Apollo*, in his epigrams, and occasionally elsewhere.[51] One thing that characterizes these poets' new awareness of their art is the simple fact that they ostentatiously parade their knowledge and formulate artistic judgments on ancient poets and on their contemporaries.[52] They can also be picked out as members of a "society of the mind" by the way in which they cite each other, implicitly correct each other, play with each other in epigrams with mutual cross-reference to one another, and thereby try to outdo each other; this is true even of those who live far apart from one another.[53] By no means all of them composed poetry in Alexandria, or need even ever have been there. Their aesthetic curiosity and their judgments on matters of taste are directed not only to poetry but also to art (painting, sculpture, handcrafts), and their ἐκφράσεις and epigrams show that they are familiar with the art theories of their time.[54] A key word in their evaluation of the new poetry is λεπτότης, which means "finesse" or "connoisseurship" but also denotes something funny, something playful in rubbing shoulders with the Old Masters. Both Leonidas of Tarentum and Callimachus use this word for their judgments on Aratus,[55] taking as their stimulus the acrostic in *Phenomena* 783–787.[56] They do not mean thereby that Aratus lacks seriousness in the business of exercising his art: on the contrary, the *Phenomena* is a σύμβολον ἀγρυπνίης.[57] The use that the new poets make of their classical predecessors for the new shape they give to poetry distinguishes them diametrically from classicist μίμησις. They extract what is rare, recherché, unknown, or unfamiliaŕ from works belonging to all manner of genres, and from obscure poets (for example

51. Cf. A. W. Bulloch, "Hellenistic Poetry," in *The Cambridge History of Classical Literature*, vol. 1, *Greek Literature* (Cambridge, 1985), 556ff., and a good survey by B. Effe, *Hellenismus*, vol. 4 of *Die griechische Literatur in Text und Darstellung* (Stuttgart, 1985) 83ff.

52. Cf. the convenient collection by M. Gabathuler, "Hellenistische Epigramme auf Dichter" (Diss. Basel, St. Gallen, 1937).

53. Cf. A. Ludwig, "Die Kunst der Variation im hellenistischen Liebesepigramm," in *L'épigramme grecque*, edited by O. Reverdin, Fondation Hardt, Entretiens 14 (Geneva, 1967), 299–334 (discussion, 335–348).

54. Cf. Gelzer, "Mimus und Kunsttheorie bei Herondas, Mimiambus 4," in *Catalepton: Festschrift B. Wyss*, ed. C. Schäublin (Basel, 1985), 96–116; G. Zanker, *Realism in Alexandrian Poetry* (London, 1987).

55. Gow and Page, *Hellenistic Epigrams*, 2573–2578, 1297–1300.

56. The acrostic has only recently been discovered by J.-M. Jacques, "Sur un acrostiche d'Aratos," *REA* 62 (1960): 48–61; cf. Bulloch, "Hellenistic Poetry," 602.

57. Callimachus, Gow and Page, *Hellenistic Epigrams*, 1300.

the writer of a Μεροπίς),[58] and give it a new lease on life in an act of combination whose chief purpose is to surprise.[59] The phenomenon, so aptly described by Wilhelm Kroll as the "Kreuzung der Gattungen," can arise only because for the new poets their ancient predecessors have quite lost any cultic or other social function they might once have possessed, and thus, reduced to the status of pure "Lesepoesie," stand freely available for any degree or combination of admixture.[60]

The ancients put the beginning of this new poetic art in the work of Philitas of Cos, thus a whole generation before Callimachus. No definition of his poetry has come down to us from the poet himself, and we are left with the observation that an extraordinary degree of respect is accorded to him by Hermesianax, Callimachus, and Theocritus, and that he is quoted by Apollonius of Rhodes.[61] In Quintilian's lists he takes second place, after Callimachus.[62]

A question now arises. Is the withdrawal of poets from the practical exercise of their art in the community to the solitude of the scholar's study, leading to a refined, exquisite, or, in some cases, esoteric poetry of the intellect, to be understood as a failure to live up to their responsibility in the new monarchies? It is true that tendencies toward withdrawal from identification with the civic community can indeed be detected in a variety of areas during the crisis of the πόλις in the fourth century, for instance in the philosophy of Epicurus, in the withdrawal of New Comedy from the political arena to the personal and private sphere, and then in a preference for what is idyllic, homely, and picturesque in Hellenistic poetry and art; and these things run parallel to the acquisition by the intelligentsia of a vested interest in the new military monarchies. Among contemporary writers, the Pyrrhonic Skeptic Timon depicts this aspect in terms of caricature when he writes of the philologues in the Mouseion, "In Egypt of the many tribes a lot of them are fed, penned up in bookish precincts, endlessly bickering in the bird cage of the Muses." He also satirizes Ariston the Stoic as a flatterer of

58. Lloyd-Jones and Parsons, Suppl. Hell., 903 A; cf. A. Henrichs, "Zur Meropis: Herakles' Löwenfell und Athenes zweite Haut," ZPE 27 (1977): 69–75.

59. "Classicist" μίμησις in opposition to Hellenistic use of the old poets, cf. Gelzer, "Klassizismus," 33ff. and Flashar, "Klassizistische Theorie," 85ff.

60. W. Kroll, "Die Kreuzung der Gattungen," in Studien zum Verständnis der römischen Literatur (Stuttgart, 1924), 202–224; "Kreuzung der Gattungen" had, however, already begun in the fourth century, cf. Bulloch, Callimachus: The Fifth Hymn (Cambridge, 1985), 35f.

61. Cf. Bulloch, "Hellenistic Poetry," 544f.; Philitas together with other forerunners, Pfeiffer, Geschichte der klassischen Philologie, 116–128.

62. Quint. Inst. or. 10.1.58.

King Antigonus.[63] But Timon's public is also that of our new poets, and an appreciation of his *Silloi* with its criticism, as put in the mouth of Xenophanes, and its refined parody of Homer depends on the same literary education on the part of his readers.[64] In this way attempts have been made to interpret the artificiality of the new Hellenistic poetry, even in its most outstanding representatives, as an expression of the ideology of refusal.[65]

But, as Ehrenberg rightly states,[66] not only was the Hellenistic monarchy "faced with a real challenge by, among other things, its mission to govern large territories with a very disparate population," but also "it was at the same time prepared for this in a number of different ways"—and this preparation (an intellectual preparation) was at the hands of Athenians such as Isocrates and Demetrius of Phaleron.[67] What the monarchy stood for was the resolution of the crisis of the old city-states.

Further, there are certain poems by two poets who themselves were from monarchical states[68] that should be understood in this fashion. The poets in question are Theocritus and Callimachus. All we can do here is select a few examples from the realm of the "praise of princes," an area notoriously tinged by ideological prejudice. It is in fact just the praise of princes that we find abundantly represented in its vulgar forms in this mainstream poetry, at odds with the new direction of taste, and not, say, only in epic.[69] Let us recall to mind just the paean for the reception of Demetrius Poliorcetes in Athens in 291 BC, which had become notorious even in ancient times.[70] Yet long before this Isocrates had written his encomium of Evagoras as a philosophical mirror for princes: in literary

63. Lloyd-Jones and Parsons, *Suppl. Hell.*, 786, 780.

64. This appears to apply also to the rest of his (completely lost) poetic writings.

65. Cf. Schwinge, *Künstlichkeit von Kunst*, 42, 44ff.

66. Ehrenberg, *Staat der Griechen* 2 : 191.

67. For philosophical preparation and justification of the Hellenistic monarchy, cf. P. Grimal, "Les éléments philosophiques dans l'idée de monarchie de Rome à la fin de la république," in *Aspects de la philosophie hellénistique*, 233–273 (discussion, 274–281), esp. 245ff.

68. So were Posidippus of Pella (cf. n. 46, above), Eratosthenes of Cyrene (cf. n. 44, above) and others. For their attitude toward Hellenistic monarchs, cf., e.g., Bulloch, "Hellenistic Poetry," 556ff. (Callimachus), 570ff. (Theocritus); Effe, "Hellenismus," 48 (Theocritus), 83 and 161f. (Callimachus).

69. Thirty-nine epic writers who wrote about historical heroes, Lloyd-Jones, "Hellenistic Miscellany," 58.

70. Powell, *Coll. Alex.* 173–175; cf. Bulloch, "Hellenistic Illusion," 209ff. with n. 1; Effe, "Hellenismus," 168ff.; for further poems of this kind, cf., e.g., Hermodotus, Lloyd-Jones and Parsons, *Suppl. Hell.*, 491, 492.

terms, as a new invention, namely the prose hymn by which he claimed
to excel even Pindar.[71] Theocritus and Callimachus present educated
Greeks of their time with a portrayal of the Hellenistic monarchs as le-
gitimate, in such a way as to insert those monarchs into the tradition of
ancient heroic Greek kingship.[72] In the *Charites*[73] Theocritus not only
presents his compliments to Hieron II as a guarantor of his glory, but at
the same time, drawing delicately on Simonides and Pindar, he presents
his own picture of the princely patron, of his summons to defend the
city against the Carthaginians, and of his own conception of a poet's task,
to the lauded monarch. In the *Victoria Berenices* Callimachus has a more
conventional task to perform: praise of the queen as winner in the horse
races at the Nemean Games. Of course, he reaches immediately for his
Pindar and Bacchylides, as is obvious right from the beginning. All I
want to concentrate upon here is the form of address he uses for the
queen: he does not use the name Berenike ("bringer of victory"), which
would indeed have been quite appropriate, but figurative expressions
pregnant with symbolism, such as "Nymph, holy blood of the divine
brother gods."[74] Following the usage of the pharaohs, she is presented
as the daughter of the sibling-marriage of her parents, and thereby also
as the sister of her royal spouse, which is how she is honored by her
subjects in temple inscriptions. However, Berenike was not really the
daughter of these "parents," but of Magas of Cyrene and Apama. The
"holy blood" is an image for this politico-cultic fiction which permitted
the queen to join the ranks of the "god-kings." What could a Greek bring
himself to believe regarding this "god-kingship?" Callimachus meets this
conflict head-on with the term of address, $\nu\acute{\nu}\mu\phi\alpha$, which he also uses for
Hera, Hebe, and the deified Arsinoe.[75] Homer had already used it for
heroines such as Helen and Penelope.[76] Thus, $\nu\acute{\nu}\mu\phi\alpha$ leaves a broad area
open between deity and heroized humanity. This is just one example
from a whole system of such modes of expression that can be detected
in Callimachus.[77] Borrowing from Homer's mythology, he has created a

71. Isocrates, *Euagoras* (9) 7–11, *Antidosis* (15) 166; cf. Jaeger, *Paideia* 3:147.

72. Cf. the significance of Achilles and the *Iliad* for Alexander the Great (cf. n. 39,
above).

73. Theocritus *Idylls* 16.

74. Callimachus *Victoria Berenices*, Lloyd-Jones and Parsons, *Suppl. Hell.*, 254.2.

75. Callimachus *Hy.* 4.215 (Hera); F 202.73 Pfeiffer (Hebe); F 228.5 Pfeiffer (Arsinoe);
cf. in addition F 66.2 Pfeiffer (Amymone); F 788 Pfeiffer (an unknown woman; Pfeiffer
suggests Ariadne or Phyllis).

76. Homer *Iliad* 3.130 (Helen); Homer *Odyssey* 4.743 (Penelope).

77. Cf. the material collected by Gelzer, "Kallimachos und das Zeremoniell des ptole-
mäischen Königshauses," in *Aspekte der Kultursoziologie: Festschrift M. Rassem*, ed. J. Stagl
(Berlin, 1982), 13–30; contra, Schwinge, *Künstlichkeit von Kunst*, 49ff.

new one of his own in the apotheosis of Arsinoe after the death of this candidate for deification.[78] But Theocritus, too, in his *Encomium of Ptolemy* (Ptolemy II), has his hero's father, namely Ptolemy I, enthroned in heaven in the company of his forebears Zeus and Heracles.[79] The new cult of Arsinoe-Zephyritis is referred to by Callimachus in an epigram dealing with a young girl's dedication of a shell (the poem's narrator is actually the shell)[80] and again in that intriguing poem, the *Lock of Berenike*, which includes a cultic *aition* for brides.[81]

The new poetry's understanding of itself, appealing as it did to the education of an elite, fulfilled a genuine need. This is evident in its explosive expansion to all parts of the Greek world. We can see this first and foremost in the writers of epigrams,[82] but also in the parallels which Alexandrian institutions had at the courts of other Hellenistic princes. We need name only the library set up by Antiochus II (Antiochus the Great) in Antioch, placed under the direction of the poet and grammarian Euphorion of Chalcis, still in the third century.

V

Once this taste, or rather style, had become established it served as a medium of writing poetry for several generations. This style had so to speak become *de rigueur,* even though it seems with time to have lost the attraction of novelty and the experimental boldness that it visibly possessed at least in the case of Callimachus and his contemporaries. Then how long did this direction of taste hold the field? We cannot here unambiguously establish a clearly articulated *crisis* such as we were able to do in the case of that which began at the end of the fifth century. This may be partly because of the extremely poor survival rate of later Hellenistic poetry, but what can be said about it has recently been masterfully wormed out of our few surviving texts by Anthony Bulloch.[83]

As previously, no detectable break points are provided by political

78. Callimachus F 278 Pfeiffer; cf. the similarity of the myths concerning Arsinoe's ascent to heaven, the *Coma Berenices* (F 110.51ff.); the imagery in Posidippus (?), Lloyd-Jones and Parsons, *Suppl. Hell.,* 961; and in Theoc. *Id.* 17.23ff.

79. Theoc. *Id.* 17.13–33; cf., e.g., Heracles as ancestor and example of kingship for Philip II in Isocrates *Philippos* (5) 105–118.

80. Gow and Page, *Hellenistic Epigrams,* 1109–1120.

81. Callim. 110. 79–88 (surviving only in Catullus 66, cf. Pfeiffer, *Geschichte der klassischen Philologie,* ad 1.); for its relationship to the cult of Arsinoe-Zephyritis, cf. O. Zwierlein, "Weihe und Entrückung der Locke der Bereinke," *RhM* 130 (1987): 274–290.

82. Cf. Ludwig, "Kunst der Variation," 299ff.

83. Bulloch, "Hellenistic Poetry," 606–621.

events such as, say, the destruction of Corinth by Mummius in 146 BC or the expulsion from Alexandria of Aristarchus and the group of scholars associated with him, which Ptolemy VIII brought about in the following year.

There are really only two poetic genres out of which we can gain a certain notion of continuity and discontinuity, both of which came into their own in the Hellenistic period. These are the genres of *bucolic poetry* and the *epigram*. Of post-Theocritan bucolic we know the work of two bucolic poets, but only a very modest amont of it, and that partly with uncertain identification. Both occur in the second century: Moschus, the grammarian from Syracuse, a pupil of Aristarchus; and Bion of Phlossa, near Smyrna. The anonymous *Epitaphios Bionos* bewails not only the death of Bion but together with it that of Δωρὶς ἀοιδά, which is assumed to stand for "bucolic poetry."[84] Is this anything more than a rather baroque compliment for the poet, of whom we unfortunately know so little? Or should we take it with the same seriousness as we do Aristophanes' statement in the *Frogs* that with Euripides' and Sophocles' deaths tragedy has come to an end? An indication that the genre was considered as having reached its conclusion can be seen in the undertaking by Artemidorus of Tarsus, not much later in the first century, to bring together in a single collection the scattered βουκολικαὶ Μοῖσαι, thus creating a corpus.[85]

The position with epigrams is similar. Either at the end of the second century or else right at the beginning of the first, Meleager of Gadara put together his *Garland,* in which the majority of all surviving Hellenistic epigrams have come down to us. He himself continued to write poetry in the same style, albeit without much originality, and often with visible reference to the great models.[86]

It must be pointed out that Greek poetry does not evidence a decisive move towards *classicism,* such as we find in art after the end of the second century, or in rhetoric and rhetorical historiography. According to Dionysius of Halicarnassus such a move is associated rather with the influence of Rome,[87] and it was Rome too that saw the creation of the great Latin classicist poetry of the Augustans.[88] It is clear that Greeks who had

84. [Mosch.] 3.11f.

85. Page, *Further Greek Epigrams,* 113–114.

86. See, with good examples, Ludwig, "Kunst der Variation," 314ff.; "Anerkennung des Vorbildhaften," ibid., 311.

87. Dion. Hal. *Or. vet.* 3.1; for the prose, cf. F. Lasserre, "Prose grecque classicisante," *Classicisme à Rome,* 135–163 (discussion, 164–173); for the art, P. Zanker, "Zur Funktion und Bedeutung griechischer Skulptur in der Römerzeit," in *Classicisme à Rome,* 283–306 (discussion, 307–314).

88. For the historical implications of Augustan classicism, see G. W. Bowersock, "His-

come to Rome in the first half of the first century, such as the grammar-
ian Tyrannion and the scholar-poet Parthenios, contributed decisively to
the stimulus for this. At the same time, Greek epigrammatists in the
Garland of Philip (from the Augustan period and later) also display a
clear rejection of the poetry of Callimachus, of Erinna, and of the schol-
arship of the Alexandrian grammarians Zenodotus and Aristarchus. Ex-
amples are Antipater of Thessalonica,[89] who was a client of L. Calpur-
nius Piso Frugi, and who, out of opposition to Callimachus and his
school, went back to singing the praises of the ancient poets: Homer,
Archilochus, Alcman, and Aeschylus.[90] There is also Antiphanes,[91] and
finally Philip himself,[92] who makes fun of those poets, characterizing
them as "super-Callimachuses" (ἐρικαλλιμάχους).[93] On the other hand,
it is Callimachus (as a poet) and Aristarchus (as a critic) whom the Ro-
mans took as their models.[94]

It was here in Rome, the world state that had replaced the Hellenistic
empires, that decisive changes were to take place in the way that poets
formed an awareness or an internal image of themselves; and it is a
matter of centuries—in the Roman imperial period, in fact—before
Greek poets once again come to the fore. But they now do so with a
distinct orientation backward in time, in both the linguistic and the lit-
erary spheres, *poetae docti* standing firmly in the tradition of Callimachus.

torical Problems in Late Republican and Augustan Classicism," *Classicisme à Rome*, 57–75
(discussion, 76–78), esp. 72ff., and Zanker, "Zur Funktion und Bedeutung," 290ff., 303ff.

89. Gow and Page, *Garland of Philip*, 185–190.

90. Ibid., 185–190, 135–140, 141–144.

91. Ibid., 771–776.

92. Ibid., 3033–3040, 3041–3046; cf. Herodicus of Babylon, Page, *Further Greek Epi-
grams*, 233–238 (= Lloyd-Jones and Parsons, *Suppl. Hell.*, 494), whose date is, however,
uncertain.

93. Gow and Page, *Garland of Philip*, 3046.

94. Horace *Ars Poetica* (= *Epist. ad Pisones*) 450.

Identities in Diversity

Peter Parsons

"Alexander civilized Asia," so says Plutarch, "Homer was read, and the sons of Persians and Susians and Gedrosians recited the tragedies of Sophocles and Euripides."[1] Oddly enough, we have a scattering of material on stone and papyrus to support this airy statement. *Epicharmea* at the Memphite Serapeum;[2] schoolboys copying the same line of Euripides at Egyptian Thebes[3] and Armenian Artaxata;[4] a hymn to Apollo at Susa,[5] a philosophic dialogue at Ai Khanoum,[6] even (though a little later?) Greek iambics alongside the Hebrew and Aramaic of the caves of Murabba'at[7]—in the Hellenistic age, Greek literature could stalk a world stage. It was, perhaps, a world of faster communication and more intensive circulation. Plato, in anecdote at least, had needed to send an agent to Colophon to collect the poems of Antimachus;[8] in the third century, works of Menander and Theophrastus reached Egypt with relative speed. Athens and Rhodes were centers for a book trade;[9] story put

1. Plutarch *Moralia* 328D.
2. E. G. Turner, "A Fragment of Epicharmus? (or 'Pseudoepicharmea'?)," *WS* (NF) 10 (1976): 48–60.
3. U. Wilcken, *Griechische Ostraka aus Aegypten und Nubien* (Leipzig and Berlin, 1899), 1147.
4. C. Habicht, "Über eine armenische Inschrift mit Versen des Euripides," *Hermes* 81 (1953): 251–256.
5. *SEG* 7.14; M. P. Nilsson, *Opuscula selecta*, vol. 2 (Lund, 1952), 492.
6. Claude Rapin, "Les textes littéraires grecs de la trésorerie d'Aï Khanoum," *BCH* 111 (1987): 232–244.
7. P. Benoit, J. T. Milik, and R. de Vaux, *Discoveries in the Judaean Desert*, vol. 2, *Les Grottes de Murabba'at* (Oxford, 1961), 108; C. Austin, *Comicorum Graecorum Fragmenta in papyris reperta* (Berlin and New York, 1973), 360.
8. Antimachus T 1 Wyss.
9. Athenaeus 3B.

the holdings of the Alexandrian library at 500,000 rolls.[10] The modernization of Greek book-hand, traceable in Egypt from the late fourth century to the mid-third, has been put down to increased production in Alexandria itself; and to judge from the few samples surviving, Ai Khanoum, Derveni, and Tebtunis shared a graphic as well as a linguistic *koine*. The text of Homer established by Alexandrian critics displaced all others, in Egypt and eventually in the Mediterranean world: that is a remarkable tribute to the possibilities of scholarly diffusion.

The literature created over so vast an area, in so many genres and to such vast bulk, would be difficult enough to characterize if we had it all; as it is, we make do with fragments. Drama is effectively lost, except Menander; so are the more traditionally minded poets; so is rhetorical prose and literary theory. Two of the most remarkable minds, Eratosthenes and Posidonius, appear to us only in scattered quotations. If we try to plot historical development, we have a further difficulty: so little is known of the fourth century either (we cannot, for example, prove or disprove Wilamowitz's guess that "Alexandrian" poetry continues a style already existing in the islands and Asia Minor; now that we have a possible example of such local work, the bumbling *Meropis*, scholars dispute whether to date it to the third century[11] or to the sixth[12]).

We can try to identify the age by limiting it. Thomas Gelzer has spoken of the crises which begin and end it; what is curious is their disparity. Alexander represents a geopolitical crisis, perhaps, but not a literary one; at the end, there is a literary crisis with geopolitical overtones. Historically, the bringers-up of Droysen's baby have attached more importance to the former, and yet the historical perception of the epoch has relied heavily on the second. Writers of the Early Empire present a uniform model. Callimachus and polish, but not genius, says Ovid;[13] the dull Aratus, the limited Theocritus, the unranked Apollonius fall off Quintilian's reading list[14] ("Longinus" was to damn them as "faultless").[15] Dionysius of Halicarnassus, arriving in Rome in the same year that Cleopatra fell, told his new patrons that oratory since Alexander had succumbed to Asian depravity.[16] Linguistic Atticists

10. P. M. Fraser, *Ptolemaic Alexandria* (Oxford, 1972) 1:328f.

11. H. Lloyd-Jones and P. Parsons, eds., *Supplementum Hellenisticum* (Berlin and New York, 1983) 903A (hereafter cited as *Suppl. Hell.*). Latest text: A. Bernabé, *Poetarum Epicorum Graecorum . . . Fragmenta*, vol. 1 (Leipzig, 1987), 131.

12. H. Lloyd-Jones, *Academic Papers: Greek Epic, Lyric, and Tragedy* (Oxford, 1990), 21–29.

13. Ovid *Amores* 1.15.14.

14. Quintilian *Institutio oratoria* 10.1.54.

15. [Longinus] *Subl.* 33.5.

16. Dionysius of Halicarnassus *Vet. or.* 1.

looked for the origins of verbal corruption—and found them in Hyperides and Menander. The "inventors" listed by Clement of Alexandria include no Hellenistic innovation except the term *grammatikos;*[17] the longer and more eccentric list of Pliny the Elder[18] admits a few more great names—Carneades and Posidonius in philosophy, Berossus in astronomy, Antidorus in scholarship,[19] Asclepiades of Prusa in medicine, in geometry and mechanics Archimedes, Ctesibius, and Philo. That allows for influential philosophers and for advances in science and technology, but the only new Hellenistic contribution to literature is scholarship. Small wonder that a chrestomathy of the second century[20] lists the Alexandrian libraries alongside the inventors (all antique and mostly mythological) of military operations and armaments. Even the romantic picture of universal Hellenism could become another illustration of human restlessness.[21]

So nineteenth-century historians set the marker with Alexander: it was then that liberty yielded to tyranny, oratory to rhetoric, art to artifice. This chimed agreeably with romantic—and racial—nationalism: the model must be the pure, unforced effusions of an athletic citizenry, not the bookish lucubrations of their successors, formalist, sycophantic, and cosmopolitan. Times change. We owe to Rudolf Pfeiffer another image of the same scheme. With Alexander begins the age of scholarship and rediscovery; after the run-down fourth century, the Renaissance; the new poets, a generation of Petrarchs, study the old poets and are inspired to a new poetry, not less valuable. We ourselves might update a little: to the cosmopolitan, experimental, and self-consciously sophisticated Paris of the 1920s. But the accumulation of evidence, and the deconstructive spirit, has recently tended to play up the continuities. The quoting and allegorizing of earlier poets goes back to the late sixth century;[22] chronology, euhemerism, linguistic and rhetorical theory to the Sophists; in the fourth century, Antimachus mined Homer, perhaps even edited him;[23] we see the crossing of genres in Archestratus, who combines periegesis and epic, and parodies both, in the interests of a gastronomy which keeps one eye on the *Fresswelle* of Middle Comedy and the other on the fads of current dietetics; and Erinna, whose poem transfuses Sapphic material into epic meter and Doric dialect. Ephorus and Ctesias began romantic history, Isocrates and Xen-

17. Clement of Alexandria *Stromateis* 1.16.77.
18. Pliny *Naturalis historia* 7.29.107–38.127.
19. R. Pfeiffer, *History of Classical Scholarship*, vol. 1 (Oxford, 1968), 157.
20. *P. Oxy.* 1241.
21. Seneca *Cons. Helv.* 7.
22. M. L. West, *Studies in Greek Elegy and Iambus* (Berlin and New York, 1974), 180.
23. N. G. Wilson, *CR* (NS) 19 (1969): 369.

ophon biography, the Atthidographers antiquarian history, Aristotle systematic philosophy and encyclopedic research; the Derveni papyrus shows that the line-by-line exposition of literary texts—however wrong-headed—was already practiced. If one wants an epoch, it should come with Euripides,[24] or indeed with the Sophists; if one wants a model, the third century can stand as Baroque or Rococo to the fifth-century Renaissance.

Whatever the beginnings, the final reaction does give us some reason for treating the period as a unit. The difficulty, clearly, is to impose any structure. We could look for a political frame: when Ptolemy VIII expelled the learned professions from Alexandria, they scattered over the cities and islands to produce a renaissance of cultural life—so said a contemporary historian;[25] it was perhaps the end of an epoch when Mark Antony gave the Pergamene library to Cleopatra.[26] We could look for a geographical pattern of schools or styles. We could look for the overlapping dynamic of genres (the joke-epigram blossoms as the sentimental epigram fades) and of generations—such is Fraser's picture of Alexandria, a first generation of immigrants, with a lively interest in Egypt, a second generation which turned itself resolutely to Greece, then new generations of native Alexandrians and a general decline.[27] But generally we look in vain.

Nothing remains, then, but the subjective. I want simply to illustrate some possible identities: literary men in relation to their profession and to their audience; to their unhellenic surroundings and their Hellenic inheritance; to literary tradition and to current ideologies, as exemplified in experiments, rivalries, and sloganizing. Poetry and Egypt will play a disproportionate part. The dangers are clear enough, as in all attempts to write literary history: you pigeonhole individualists, subdue divergent pressures to the idea of a "period" (difficult enough when you deal with a shorter timespan and a localized literature, set off by a psychologically significant event—the death of Augustus, say, or of Louis XIV or Queen Victoria) and look for dividing lines, new beginnings, universal characteristics, and unique preoccupations, when in fact it is normally not a question of absolute novelties but of novel emphases. In Hellenistic literature such emphases are hard to catch and harder to prove, since we lack so much of what was written and so much of earlier writing. But some at least of the themes have their place also in discussions of the art, thought, and religion of the age.

24. K. J. Dover, *Theocritus: Select Poems* (London, 1971), lxxi.
25. Pfeiffer, *Classical Scholarship* 1 : 252.
26. Plut. *Antonius* 58.
27. Fraser, *Ptolemaic Alexandria* 1 : 552.

I. WRITERS AND SCHOLARS

Philosophoi was the old word for intellectual, and the Fellows of the Museum are still so called in Roman times.[28] But new designations came into vogue: *kritikos, grammatikos, philologos,* the last attributed to Erastosthenes.[29] The writer's self-respect might hinge on two things: patronage and *esprit de corps.* Patronage took two forms: personal and institutional. The tradition of the monarchic court was a long one; Antigonus Gonatas, Ptolemy II, Antiochus III, the Pergamenes continued the line of Polycrates, Hiero, and Mausolus. It is notable how crisp and unservile is the manner in which scientist addresses monarch.[30] Poets continue to balance their gift of immortality against the patron's gift of goods;[31] if earlier hints of indigence become positive assertions of poverty, that may simply symbolize the superiority of a slender Muse.[32] Chrysippus addressed works to none of the kings: that could be thought a sign of arrogance.[33] At the same time, the establishment of the Museum, of libraries and gymnasia and literary *agones,* provided institutional support. Ptolemy II exempted "teachers of letters" from the salt tax, and we do not know how much further the kings anticipated the systematic Roman exemption of the learned professions.[34] More informally, a group could be seen, or could see itself, as such: Philicus addressed his *Hymn to Demeter,* a metrical novelty, to the *grammatikoi;* Timon satirizes the bookish monks of the Museum; Callimachus brings on Hipponax to settle the scholars' quarrels.[35] One sees early signs of the global academy. Apollonius of Perga was inspired to write the *Conics* by Naucrates, who visited him in Alexandria, dedicated the book to Eudemus, whom he had met in Pergamum, and asked for a copy to be sent to Philonides, whom they had both met in Ephesus.[36] Archimedes sent theorems to Conon in Alexandria, the one man who would really appreciate them, as he writes

28. Ibid. 2:450 n. 84 (*philologoi* in Strabo; *philosophoi* corrected to *philologoi* in Call. Dieg. 6.3).

29. Pfeiffer, *Classical Scholarship* 1:156ff.

30. Apollonius of Perga *Conica* book 4 praef. (if Attalus is a monarch); Archimedes 2.216 Heiberg; Eratosthenes ibid. 426.

31. A. S. F. Gow, *Theocritus* (Cambridge, 1952), n. on 16.30f.

32. G. Capovilla, *Callimaco* (Rome, 1967) 1:202ff. (but the evidence is thin). A boast in Roman poets, at least: R. G. M. Nisbet and M. Hubbard, *Commentary on Horace Odes Book II* (Oxford, 1978), n. on 2.18.10; F. Cairns, *Tibullus* (Cambridge, 1979), 20.

33. Diogenes Laertius 7.185.

34. Salt tax: Fraser, *Ptolemaic Alexandria* 2:870 n. 2; cf., on the Museum, 470 n. 84. Roman categories: Ann Ellis Hanson, ed., *Collectanea Papyrologica: Texts Published in Honor of H. C. Youtie* (Bonn, 1976) 2:441.

35. Lloyd-Jones and Parsons, *Suppl. Hell.* 677, 786. Callimachus F 191 Pfeiffer.

36. Ap. Perg. *Conica* books 1 and 2, praeff.

with admiring affection.[37] Anthologies (Meleager, Philip) and technical works are dedicated to private friends. If there is some tendency to specialize—scholarship and poetry, technical prose and artistic prose, take separate roads, a first step to distinguishing Academia and Bohemia[38]— there is also astounding versatility: Eratosthenes is the classic example. Disciplines overlap: Aratus versified Eudoxus, Nicander Apollodorus; Apollonius Rhodius endowed Medea with a nervous system; orators are bidden to know poetry, history, philosophy;[39] philosophy provides the framework for scholarship and the categories of history; poets and prose writers take a larger interest in the visual arts.[40]

II. AUDIENCES

It was the charge of the nineteenth century that these learned professions wrote only for urban coteries. That is not wholly true. If we dip into the Egyptian rubbish dumps of the third century, we can see what circulated in the Hellenic backwoods.[41] (Of course, very few papyri survive, and they may not be representative; the real arbiter is the Egyptian water table.) Homer heads the list; Hesiod, Archilochus, Stesichorus, Tyrtaeus; Thucydides; Sophocles and Euripides (including anthologies); Timotheus; Lysias, Alcidamas, Plato, Xenophon; *Rhetorica ad Alexandrum* and Diocles of Carystus; wise sayings of "Simonides" and of "Epicharmus." There are writers of the early third century: Chares, Menander, Theophrastus. More remarkable, there are contemporary poets: Philicus' *Hymn to Demeter*, Callimachus' *Victory of Berenice*. Over the next two centuries, we find more third-century authors—Cercidas and Phoenix among moralists, Callimachus again, and more epigram; Chrysippus; Sosylus and possibly Duris. Among *adespota* there is an unexpectedly high proportion of anthologies. Readers, it seems, like Alexandrian scholars, took more interest in verse than in prose; but it is not true, as is sometimes said, that the Hellenistic poets were ignored. Straight philosophy and rhetoric seem clear losers.

Similarly with the reading of individuals.[42] Among Zeno's papers, in Philadelphia under Ptolemy II,[43] we find a scrap of (perhaps tragic) lyric,

37. Archimedes 1.4, 2.2 Heiberg.
38. A. Dihle, *Griechische Literaturgeschichte* (Stuttgart, 1967), 384.
39. E. Stemplinger, *Das Plagiat in der griechischen Literatur* (Leipzig, 1912), 109.
40. See below, p. 170.
41. Some basic material: William H. Willis, "Census of the Literary Papyri from Egypt," *GRBS* 9 (1968): 203–241.
42. W. Clarysse, "Literary Papyri in Documentary 'Archives,'" *Stud. Hell.* 27 (1983): 43–61.
43. P. W. Pestman, *A Guide to the Zenon Archive* (Leiden, 1981) 1 : 189.

with its music,[44] and two epitaphs, no doubt local but of solid workmanship, on his dead hunting dog.[45] He orders for his brother a work, it seems, of Callisthenes.[46] A memo from Nicarchus has on its back the first line of Aeschylus' *Mysians;*[47] another correspondent drops into iambics;[48] a schoolboy copies a jokey hexameter.[49] At the Serapeum of Memphis, towards the middle of the second century, Ptolemy son of Glaucias was using copies of Chrysippus, and perhaps Eudoxus,[50] as scrap paper; he and his brother copied out passages of drama and two epigrams of Posidippus; the brother copied also the *Dream of Nectanebos.*[51] Similarly with school exercises and school textbooks[52]—Homer, Euripides, New Comedy, Epigram: contemporary light verse alongside the classics. Overall, it seems paradoxical that poetry, even difficult poetry, circulated more widely than the age's colossal output of informative and diverting prose.

III. GREEKS AND NON-GREEKS

A chrestomathy of circa 100 BC shows a fair world view:[53] the great rivers and mountains take in Spain, Italy, Mesopotamia, and India, as well as mythical and actual Greece. The wider horizons might have added realism to Socrates' self-definition: not an Athenian, not a Greek, but a citizen of the world.[54] The enlightened, like Eratosthenes, divided mankind into good and bad, not Greek and barbarian.[55] But of course there are differences.

1. There are Hellenes and Hellenes. An epigrammatic admirer of Zeno apologizes for his Cypriot origins;[56] "If I am a Syrian, so what?"

44. *TrGF* 2.678.
45. Lloyd-Jones and Parsons, *Suppl. Hell.* 977.
46. W. L. Westerman, C. W. Keyes, and H. Liebesny, *Zenon Papyri*, vol. 2 (New York, 1940), 60 (with M. David, B. A. van Groningen, and E. Kiessling, *Berichtigungsliste der griechischen Papyrusurkunden aus Aegypten*, vol. 3 [Leiden, 1958], 44).
47. F 142 Radt.
48. C. C. Edgar, *Zenon Papyri in the University of Michigan Collection* (Ann Arbor, 1931), 77; Fraser, *Ptolemaic Alexandria* 2 : 864 n. 429.
49. C. C. Edgar, *Zenon Papyri*, Catalogue général des antiquités égyptiennes du Musée du Caire, vol. 4 (Cairo, 1931), 59535.
50. U. Wilcken, *Urkunden der Ptolemäerzeit*, vol. 1 (Berlin and Leipzig, 1927), 111.
51. Ibid., 81.
52. Philadelphia Ostraca (see E. Livrea, "La morte di Clitorio," *ZPE* 68 [1987]: 21–28); O. Guéraud and P. Jouguet, *Un livre d'écolier du III^e siècle avant J.-C.* (Cairo, 1938).
53. H. Diels, *Laterculi alexandrini* (Berlin, 1904).
54. J. Diggle, *Euripides: Phaethon* (Cambridge, 1970), n. on line 163.
55. Strabo 1.4.9.
56. *Anthologia Palatina* 7.117.

says Meleager, "The whole world is my fatherland"[57]—the cliché (Cynic by adoption) sounds defensive. This is the snobbery which bursts out in Dionysius of Halicarnassus: Johnny-come-lately oratory from the sewers of Asia, Mysian or Phrygian or some Carian nastiness.[58] And it may have a reality. The finest example of "Asian" rhetoric does, of course, come from Commagene. The difficulty lies in identifying local schools in an age of migration. We can point to centers: some net exporters, like Gadara, "the Athens of the Assyrians,"[59] and Tarsus, whose citizens enjoyed an admirable education but went abroad to be finished and rarely returned;[60] some importers, Athens, Alexandria, Pergamum, Rhodes. Some specialized: there were many philosophers in Athens, few in Alexandria; Alexandria eschewed allegory in interpreting Homer, Pergamum fostered it; Cos retained its name for medicine. But what of the Euboean culture that Wilamowitz once posited: was it taken to Pella by Persaeus, to Alexandria by Lycophron, to Pergamum by Antigonus of Carystus, to Antioch by Euphorion?

2. In another way, Greeks unite against barbarians. There was, after all, a long tradition of distrust and curiosity, now reinforced by the insecurities of a scattered élite. The literary men reacted in various ways.

(a) One could ignore the new world, as the ladies in Theocritus' Alexandria—Alexandria next to Egypt, not in it—exchanged Doric chat in streets made safe from the sinister natives.[61] Schoolchildren in the Fayum, and near Artaxata, were in the second century still learning Macedonian months.[62] The poets of Alexandria might as well be writing in another place; they compose hymns, but not to Sarapis.

(b) One could inquire into it. Some geographers produced new information and observation: Megasthenes' India, Agatharchides' Red Sea, much fresh and individual in Posidonius. There were historians who profited, Polybius from his stay in Rome, Apollodorus as a citizen of Parthian Artemita.[63] There were materials translated or adapted from the native languages: the histories of Manetho and Berossus and Mago the Carthaginian,[64] the Septuagint and (if you believe it) the voluminous writings of Zoroaster.[65] But Greek writers did not learn the languages

57. *Anth. Pal.* 7.417.

58. Dion. Hal. *Vet. or.* 1.

59. *Anth. Pal.* 7.417.2.

60. Strab. 14.5.13.

61. Theocritus 15.47.

62. See n. 4, above; Guéraud and Jouguet, *Livre d'écolier.*

63. *FGrH* 779.

64. F. Susemihl, *Geschichte der griechischen Literatur der Alexandrinerzeit* (Leipzig, 1891–92) 1:830.

65. Fraser, *Ptolemaic Alexandria* 2:436 n. 745.

themselves;[66] the Greek imperialists made no such contribution to oriental scholarship as their successors of the eighteenth and nineteenth centuries.

(c) One could absorb and dominate it. "Alexandria educated both Greeks and barbarians," said Menecles of Barca;[67] the civilizing mission bulks large in the Alexander legend. Sometimes the barbarians responded: in Hellenized Palestine, Ezekiel transformed the Exodus into a Greek tragedy; Theodotus transposed Samaritan battles into Homeric formulae; Philo compiled the history and marvels of Jerusalem in hexameters so loaded as to foreshadow Nonnus; and the author of "Joseph and Asenath" modeled himself on the rising Greek novella.[68] Sometimes the Greeks responded: at the lower level, one Greek schoolboy copied the *Dream of Nectanebos*, another attributed the Delphic Maxims to the sage Amenothes;[69] through magic and astrology, Eastern wisdom percolated into higher literature. But very often the effect was to subvert the Orient into the mystically picturesque. Bokkhoris was the subject of elegant elegiacs by Pancrates;[70] here are the first stages of Ninus and Sesonchosis.[71] Myth, utopianism, and literary reminiscence outperformed the new geographic and ethnographic observations: Greeks saw Babylon through Herodotus, not through Berossus;[72] Euhemerus constructed a South Sea paradise in the interests of atheism, Iambulus of Stoicism. Persians were really Argives, if they descended from Perseus;[73] Agatharchides protested in vain at such continuities of mythogeography.[74]

IV. LITERARY INHERITANCE

Another identity was that within the Greek literary tradition: the inheritance and what to do with it.

That inheritance could now be seen in full and systematic form: I need mention only the 120 books of Callimachus' *Pinakes*. The distinction between the classics and the postclassical continued to harden.[75]

66. Ibid., 720 n. 16.
67. *FGrH* 270 F 9.
68. S. West, "*Joseph and Asenath:* A Neglected Greek Romance," *CQ* 24 (1974): 70–81.
69. Wilcken, *Urkunden der Ptolemäerzeit* 1:81; Fraser, *Ptolemaic Alexandria* 2:954 n. 51.
70. Lloyd-Jones and Parsons, *Suppl. Hell.* 602.
71. G. Anderson, *Ancient Fiction* (London, 1984), 6–9, even finds Sumerian material in *Daphnis and Chloe.*
72. Most recently, A. Kuhrt and S. Sherwin-White, *Hellenism in the East* (London, 1987), 33.
73. Jacoby on *FGrH* 306 F 7 gives the history of this idea.
74. Fraser, *Ptolemaic Alexandria* 2:774 n. 167.
75. Pfeiffer, *Classical Scholarship*, 1:203.

There were canons of the best authors (three tragedians, nine lyric poets, and the like). Culture heroes stood in public places: in the Pergamene library, Alcaeus, Herodotus, Timotheus;[76] pilgrims to the Memphite Serapeum ran into Homer, Pindar, Protagoras, and Plato.[77] Fictional epitaphs on dead authors became a flourishing genre.

These classics one could worship and emulate; or, by reaction, parody and undermine.

The cult of Homer flourished; Ptolemy IV's temple was only one of many, decorated with statues of the cities who claimed him; the claims multiplied to suit glamor and power—Athens, Egyptian Thebes, finally Rome. Galato painted Homer vomiting, and the other poets drawing from the pool.[78] Some set out to overbid: Timolaus' *Iliad*[79] added an extra line to each of Homer's; Sotades' *Iliad* transposed Homer bodily into the louche oriental rhythm of the Sotadean.[80] There were parodies and irreverent imitations: the *Egyptian Iliad* dealt with sucking pig;[81] the *Battle of the Frogs and Mice,* and of the Mice and the Weasel, represent more consistent parody of Homeric warfare.[82] Hesiod had catalogued the mistresses of gods and heroes; Phanocles catalogued their boyfriends (so perhaps did the *Ehoioi* of Sostratus).[83] Others opened the attack direct: on the morals of the mighty dead (Hermesianax catalogued the desperate passions of all poets and philosophers since Orpheus, the treatise περὶ παλαιᾶς τρυφῆς the sins of great monarchs and thinkers)[84] and on their originality (Plato took the dialogue from Alexamenus, and bought the *Timaeus* from the Pythagoreans—that is already fourth-century;[85] by imperial times the plagiarisms of Sophocles fill a whole book[86]). Gossip became an industry: when Archippe left her lover Smicrines to

76. M. Fränkel, *Die Inschriften von Pergamon* (Berlin, 1890), 198–200. It remains uncertain who were the other two honorands, Apollonius and Balacrus (G. Richter, *Portraits of the Greeks* [London, 1965] 2:247).

77. M. Pietrzykowski, *Rzezby Greckie z Sarapeum Memfickiego* (Warsaw, 1976), 145 (French summary): the identity of many of the statues is disputed. Dorothy J. Thompson, *Memphis under the Ptolemies* (Princeton, 1988), 116f.

78. Aelian *Varia historia* 13.22.

79. Lloyd-Jones and Parsons, *Suppl. Hell.* 849. Pigres had anticipated the idea: but is S. Hornblower, *Mausolus* (Oxford, 1982), 30 n. 194, really right to put him in the fifth century?

80. Powell, *Coll. Alex.,* 239.

81. Lloyd-Jones and Parsons, *Suppl. Hell.* 496–497.

82. H. Schibli, "Fragments of a Weasel and Mouse War," *ZPE* 53 (1983): 1–25.

83. Powell, *Coll. Alex.,* 106; Lloyd-Jones and Parsons, *Suppl. Hell.* 732.

84. Powell, *Coll. Alex.,* 96; U. von Wilamowitz-Moellendorff, *Antigonos von Karystos* (Berlin, 1881), 47.

85. Aristotle F 72 R (*P. Oxy.* 3219 F 1.8); Lloyd-Jones and Parsons, *Suppl. Hell.* 828.

86. Stemplinger, *Plagiat,* 33f.

live with the aged Sophocles, Smicrines remarked "she is like an owl; they always roost on tombs"[87]—such was the edifying and reliable information that the reader could find in Hegesander of Delphi. Hand in hand went the tendency (which we inherit) to explain an author's works from his life and to infer his life from his works (Satyrus' *Life of Euripides* survives as an example; Philochorus, if he himself refused to see an allusion to the death of Socrates in Euripides' *Palamedes* [*FGrH* 328 F 221], had shown a rare critical spirit). Here gossip joins hands with philosophy: the work actualizes the character.[88]

V. IMITATION AND AESTHETICS

In this culture, the choice of a model, or the choice of one work as a model rather than another, declares ideological identity. Thus Callimachus despises the cyclic epic, or boosts Hesiod, or prefers Mimnermus' shorter poems to his long ones.[89] In oratory, the Rhodian school chose Hyperides, others Isocrates, others Demosthenes.[90] The other choice must have been the mode of imitation. The Hellenistic age inherited two issues: one philosophical, the relation between representation and reality (external mimesis), the other rhetorical, the relation between stylist and stylistic model (internal mimesis); the second intersected a third, the relation between inspiration and technique. Epicurus' rejection of rhetoric, Callimachus' insistence on *techne*, Polybius' polemic against tragic history continue these themes. The theoretical treatments have perished. But there are two overlapping points to bear in mind, if we think that *mimesis* and *zelos* provided the conceptual base for literary controversy. (1) Hellenistic authors may have seen their models differently from us. Hegesias claimed Lysias as his model; we see no likeness, except simpleminded syntax.[91] Scholars looked for historical allusions in Pindar and saw his myths as digressions:[92] what does that imply for his poetic "imitators"? (2) Judgments of dead authors, at least later, show how wide a concept was "imitation." Archilochus and Stesichorus counted as *zelotai* of Homer, Herodotus and Plato as *Homerikoi*:[93] that implies a very free choice of similarities, in vocabulary, matter, or grandeur. Some thought

87. Athenaeus 592B.

88. Dihle, *Griechische Literaturgeschichte*, 407.

89. Callimachus *Epigrammata* 28, 27; F 1 Pfeiffer.

90. Dion. Hal. *Opusc.* 1:308 U-R.

91. E. Norden, *Antike Kunstprosa* (Stuttgart, 1958) 1:134.

92. M. R. Lefkowitz, "The Pindar Scholia," *AJPh* 106 (1985): 269–282 = *First Person Fictions* (Oxford, 1991), 147–160.

93. D. A. Russell, *"Longinus" On the Sublime* (Oxford, 1964), n. on 13.3.

Aratus a *zelotes* of Homer, others of Hesiod: that is a literary, not a scholarly judgment.

Certainly manner plays a central part. About 280 BC, a soldier of the garrison at Elephantine wrapped his private papers in a fine papyrus of drinking songs.[94] One addresses Memory, mother of the Muses: ἄρτι βρύουσαν ἀοιδὰν / πρωτοπαγεῖ σοφίαι διαποίκιλον ἐκφέρομεν, "we bring forth a newly blooming song, diversified with first-creating art." Novelty, skill, variety are themes we hear much of.

Novelty of matter. Pfeiffer has remarked that knowledgeability has a better reputation in the Hellenistic age. Earlier philosophers drew a significant contrast between knowledge and *nous;* nothing is more empty than polymathy, says the satirical Timo.[95] But Aristeas visualized men more inventive and learned than those before;[96] Strabo saw learning as a requirement for the geographer.[97] Aristotle already thought polymathy a great stimulus and the cause of many troubles in education. But in the second century a school on Teos was giving a prize for it, alongside reading, writing, and drawing.[98] Writers delight to cite their sources, and argue with them. ἀμάρτυρον οὐδὲν ἀείδω, says Callimachus, and duly cites "old Xenomedes" for a Cean story.[99] Scholar poets show off their knowledge; the rare myth, the Homeric gloss which hints at wide reading in the source and in the commentaries. The out-of-the-way fascinates: so Apollodorus, discussing the epithets of Athena, cannot resist quoting extracts from an old poem he had come upon, not because it was relevant but because of the "peculiarity" of the story.[100] Conversely, the Borgesian art of source-deception flourishes: Euhemerus does not expect us to believe in his Panchaic inscription,[101] or Satyrus in the λόγιοί τε καὶ γεραίτατοι Μακεδόνων whom he cites for Euripides' death.[102]

Novelty of form. Novelty is not an innovation; the newest song is best received, says Telemachus.[103] Nor is it necessary. Many, perhaps most, Hellenistic authors followed the beaten track. Rhianus' *Herakleia* and *Messeniaka* continue themes and language of earlier epic;[104] the deeds of

94. *PMG* 917; *Iambi et elegi graeci* (West) *Adespota eleg.* 27. A new discussion of the poems by F. Ferrari in *SCO* 38 (1989): 181–227.

95. Pfeiffer, *Classical Scholarship* 1 : 138; Lloyd-Jones and Parsons, *Suppl. Hell.* 794.

96. Aristeas *Epist.* 137.

97. Strab. 1.1.1.

98. F 62 R; Charles Michel, *Recueil d'inscriptions grecques* (Paris, 1900) 913.8.

99. F 612; 75.54.

100. *P. Köln* 3.126.

101. *FGrH* 63 F 3, ch. 43.3.

102. Satyrus, *Life of Euripides* F 39 xx.

103. Homer *Odyssey* 1.315f.; Stemplinger, *Plagiat*, 131.

104. Rhianus (?): Lloyd-Jones and Parsons, *Suppl. Hell.* 923, 946.

Antiochus I or Mark Antony were celebrated as if Callimachus had never uttered.[105] The *Cyropaideia* gets adapted to Alexander, Attalus, and Caesar.[106] But "new-creating art" too displays itself in great variety. We can begin with the pleasures of simple ingenuity. The pattern poems are well known. Castorio's *Hymn to Pan* has metra which can be read in any order.[107] Acrostics make their appearance in Nicander, anagrams in Lycophron.[108] A papyrus of the first century offers trimeters which begin and end with the same letters (a local Egyptian composition), palindromic hexameters, hexameters which contain all the letters of the alphabet.[109] Riddles are collected, made into epigrams, adapted to mathematics.[110] The pleasure in virtuosity shows in lists of poetic words;[111] it was a brother of Cassander, and founder of Uranopolis, who referred to his barber as "the mortal-shearer."[112] *Paignia* is a title (of Sophistic origin) of books of Cynic parodies, equally of epigrams or elegies by Philitas.[113] *Leptos* becomes a buzzword of the poets (again, a Sophistic inheritance).[114] In didactic verse, elegance in expressing the difficult outweighed the intellectual competence of the author: Nicander's *Georgics* were a long way from the soil, said Cicero;[115] Aratus' version of Eudoxus held the field, even after Hipparchus exposed its errors. Elegance reaches structure as well as expression. In the epyllion (to use the modern term), a long central digression diversifies the main story: the speech of the crow in the *Hecale,* the description of the golden basket in Moschus' *Europa.* In the *Aetia,* poems were balanced in length and subject; one part perhaps united by the dialogue of the Muses, the other framed by two court pieces.[116] In Euphorion, brief mythological riddles are linked as a string of curses; an anonymous poet proposes to tattoo his enemy, each anatomical area to have its image of some mythical sinner.[117] Unity in variety.

105. Ibid., 723, 230.

106. Stemplinger, *Plagiat,* 274.

107. Lloyd-Jones and Parsons, *Suppl. Hell.* 310.

108. Nicander *Theriaca* 345–353 (and cf. Aratus 783–787); Lloyd-Jones and Parsons, *Suppl. Hell.* 531.

109. Lloyd-Jones and Parsons, *Suppl. Hell.* 996.

110. Ibid., 201.

111. Ibid., 991.

112. Heraclides Lembos ap. Athen. 98E.

113. Powell, *Coll. Alex.,* 92.

114. Lloyd-Jones and Parsons, *Suppl. Hell.* 108; cf. Callimachus F 1.11 Pfeiffer.

115. Cicero *De oratore* 1.69.

116. Most recently on this problem, A. Kerkhecker, "Ein Musenanruf am Anfang der Aitia des Kallimachos," *ZPE* 71 (1988): 16–24.

117. Lloyd-Jones and Parsons, *Suppl. Hell.* 970. See now Marc Huys, *Papyri Bruxellenses Graecae,* vol. 2 (Brussels, 1991), who publishes a new fragment of the papyrus, with the preceding column of the poem, and suggests Hermesianax as author.

Another source of variety is the tension between form and content, and between content and treatment. The mixing of genres is central to the experimental literature of the age (and the easier, when social change detached a genre from its original culture or performing context). That is true at the general level (rhetoric continues to conquer history and to take over themes and diction from poetry) and at the more particular (epigram extends to mime and paradoxography,[118] biography invades dialogue,[119] Machon switches the *chreia* from philosophers to prostitutes[120]). We can consider formal aspects (meter and dialect) which were traditionally linked to genre, and aspects of content (myth and realism).

Among meters, the poets of the period inherited the hexameter (to which Callimachus and his followers gave an extra refinement), the elegiac, the dramatic iambus, and lyric and epodic meters. The experimenters proceeded in different ways. (1) By extension. The iambic trimeter extends to longer poems (witness the *Alexandra* of Lycophron, a riddle in the form of a *rhesis* as long as a complete tragedy) and to didactic uses; the all-conquering elegiac is now used for hymns, epinicia, love lyrics, paradoxography, and medicine.[121] (2) By selective revival. It is a notable fact that no poet we know of imitated the song stanzas of Sappho and Alcaeus (although they continued to be sung into the Roman period): individual *kola* only were taken over[122] and used stichically or in additional epodic forms. (3) By innovation. Boiscus and Philicus tell us that their extravagant meters were their own invention;[123] how many more, we cannot tell. It is worth noting—given the general question how far such apparent experiments affect the poetic *koine*—that one epodic pattern known from epigrams of Callimachus and others turns up also in a contemporary inscription from distant Ithaca.[124]

Dialect and genre had gone together. Thus, doctors of whatever city might write Ionic and utter Doric, in deference to Hippocrates;[125] it was a revolution when Diocles of Carystus wrote in Attic. For prose in general, the fourth century had established Attic as the norm; it was eccentric of Archimedes to write his own Syracusan (an extension of the prin-

118. Lloyd-Jones and Parsons, *Suppl. Hell.* 125–129.

119. Satyrus, *Life of Euripides.*

120. Fraser, *Ptolemaic Alexandria* 1:621.

121. F. Jacoby, *Apollodors Chronik* (Berlin, 1902), 61; Lloyd-Jones and Parsons, *Suppl. Hell.* 18, 690.

122. Lloyd-Jones and Parsons, *Suppl. Hell.* 1001.

123. Ibid., 233, 677.

124. W. Peek, *Griechische Vers-Inschriften,* vol. 1, *Epigramme* (Berlin, 1955), 102. Cf. *Epigr. Gr.* 874a (with M. L. West, *Greek Metre* [Oxford, 1982], 152); *SEG* 7.14 (the acrostic hymn from Susa, glyconic + pherecratean, West, *Greek Metre,* 141).

125. Men. *Aspis* 367.

ciple that technical prose is not subject to artistic norms). But in verse, as the spoken dialects declined, literary dialect intensified. Writers imitating Hipponax wrote hyper-Ionic.[126] Much more striking was the move out of genre: thus Callimachus' sixth *Hymn* combines the traditional meter of the hymn (hexameters) with the traditional dialect of choral lyric (Doric). Theocritus too combined heroic meter with material from the prose mime; to the mime his Doric might be historically appropriate—but it was a double coup if, as has been suggested recently, his Doric was actually that spoken in contemporary Alexandria.[127]

Myth was a traditional material. You could achieve novelty by selection: the rare, the quaint, and the erotic.[128] But you could achieve it also by treatment. Thus, Theocritus took the story of young Heracles and the snakes, told heroically in the first *Nemean:* diction and meter remain heroic, but the characters behave like a bourgeois household roused by a burglar. Thus Dionysius Scytobrachion took the story of the Argonauts, told in lyric by Pindar and in hexameters by Apollonius, and transmuted it into a kind of prose romance.[129] He gave the expedition a new leader, Heracles, he changed the plot to bring in the rescue of Hesione from the monster, and he explained the fire-breathing bulls (*tauroi*) as poetic fantasy for the murderous Taurians. The chivalrous warrior advancing through exotic but not fabulous territories—the Alexander image is clear enough. Thus, domestication and rationalization gave myth new dimensions.

Realism should stand at the other pole; and perhaps in mime it did so, with cartoon sketches of low life. But mime too had its literary inheritance and its transformation of genre. Theocritus draws on Sophron but casts his material in hexameters. Herodas takes a different model, Hipponax. His go-between, his pimp, his schoolmaster might be contemporary characters, but they speak scazons in archaic Ionic. His *Ladies at the Temple* drifts into another genre, the *ekphrasis* of works of art. And his *Dream,* in which he presents himself as a small dirt farmer, turns out to be an assertion of artistic inspiration and artistic fame; he cannot say "the pig is thirsty" without invoking a rare and portentous poeticism (αὐονή, 8.2). So new realism is cast in the form of old realism; the result is simply unreal.

Let me end by looking at a few works, chosen impressionistically, which may illustrate some of the themes mentioned.

1. Among philosphers and moralists, it is the Cynics who show the most literary enterprise; this sophistication of the unwashed makes a

126. I. C. Cunningham, *Herodas: Mimiambi* (Oxford, 1971), 211–217.
127. C. J. Ruijgh, "Le dorien de Théocrite," *Mnemosyne,* 4th ser., 37 (1984): 56–88.
128. Lloyd-Jones and Parsons, *Suppl. Hell.* 456, 964.
129. J. S. Rusten, *Dionysius Scytobrachion* (Opladen, 1982), 93f.

curious contrast with the uncouth prose of the Epicureans. Crates used the typical title *Paignia* for a book in which parodies of Homer and Solon served to attack Stilpo and to recommend poverty.[130] Phoenix of Colophon adopted the meter and language of Hipponax. Cercidas took over the dactyloepitrite meter, Doric dialect, and elaborate compounds of dithyramb.[131] Menippus of Gadara—well, almost nothing is known of this most influential of authors. Anciently, he exemplified the principle of *spoudaiogeloion;*[132] by inference, he began that combination of prose and verse which, after diversifying into comic fiction,[133] returned to philosophy in Boethius. He came from Gadara, overlooking the Sea of Galilee (it was also to produce Meleager and Philodemus), only recently in the Greek orbit;[134] does that foreignness explain his originality?

2. Apollodorus of Athens worked with Aristarchus in Alexandria, left in the diaspora, dedicated his *Chronika* to Attalus II, and eventually returned to Athens.[135] He worked conventionally on Homer, notably a commentary on the *Catalog of Ships;* and on Comedy—Sophron, Epicharmus, and the courtesans of Athens (Aristophanes of Byzantium had catalogued 135; Apollodorus' list was longer). Less conventional was his treatise *On the Gods*, which related the gods' functions to their epithets, gathered from a wide reading of recondite literature.[136] Less conventional still was the *Chronika*, four books covering 1040 years, from the fall of Troy to his own time. The foundation was Eratosthenes' chronology, with archons in place of Olympiads; philosophy and poetry came into it, as well as politics and history. Verse is the medium: not the didactic hexameter, but normal Koine Greek expressed in a loose comic iambic.[137] There is some precedent in the *Chreiai* of philosophers and the naughty anecdotage of Machon; and the form caught on, for geography, astronomy, medicine, and grammar.[138] The meter was chosen, an imitator said, for clarity and memorability.[139] What sort of audience had Apollodorus in mind for this combination of bald fact and chatty form, as monstrous in its way as Lycophron's *Alexandra*?

3. Lastly, back to Callimachus and to the latest work to be added to

130. Lloyd-Jones and Parsons, *Suppl. Hell.* 347.

131. West, *Greek Metre*, 139f.

132. J. F. Kindstrand, *Bion of Borysthenes* (Uppsala, 1976), 47f.

133. Petronius *Satyricon; P. Oxy.* 42.3010; M. W. Haslam, in *Papyri . . . edited . . . in honour of Eric Gardner Turner* (London, 1981), 8.

134. Emil Schürer, rev. G. Vermes, F. Millar, and M. Black, *The History of the Jewish People in the Age of Jesus Christ*, vol. 2 (Edinburgh, 1979), 132–136.

135. Fraser, *Ptolemaic Alexandria* 1:471, 2:683f. *FGrH* 244.

136. Rusten, *Dionysius Scytobrachion*, 30ff.

137. Jacoby, *Apollodors Chronik*, 67–69.

138. Ibid., 70.

139. Pseudo-Scymnus, *FGrH* 244 T 2.34–35.

his oeuvre, the elegy on the victory of Queen Berenice at the Nemean Games.[140] The shape is simple: a proem; the myth, at length, the story of Heracles and the Nemean lion and the foundation of the Games; and, presumably, an epilogue. Now, the poem calls itself an Epinician; the first line combines words from Pindar's fourth *Nemean* with motifs from two other poems; the general structure—a long narrative broken off by the poet himself—recalls the fourth *Pythian*, also written for a Cyrenean monarch. The thematic structure—myth as *aetion* of the games and their prize—looks both to *Olympian* III (where Heracles founds the Olympic Games and imports the olive crown) and to Bacchylides XIII (where Heracles subdues the lion, and a bystander, no doubt Athena, foretells the founding of the Games). Callimachus, we know, "arranged" the poems of Pindar and Bacchylides.[141] Pindaric, then; but in the wrong meter, elegiacs. The proem tells how the good news came from the land of Danaus and Io to the land of Helen and Proteus—Egypt firmly placed as a mythical appendix of Argos. The myth begins. Heracles speaks: he narrates the history of his bow and his family, Argive by origin, then comments on the state of the countryside, where only brambles and wild pears grow from the drystone walls. The other party turns out to be Molorchus, an old peasant; he explains how the ravages of the Nemean lion have left the fields deserted and barren; to add to his misfortunes, there is also an invasion of mice. The mice are duly described and the traps set for them. Heracles goes on his way, slays the lion; Athena stands by and predicts that one day the Greeks will hold games on this very spot; Heracles returns to Molorchus, crowned with wild parsley; and so to Argos. Now, Heracles is grand myth; where Callimachus found (or did he invent?) Molorchus, we do not know; but certainly the old man occupies half the poem as we have it. There are two sets of contrasts: between the young hero and the old rustic, and between the simple peasant and the language which invests him. The vine trunks are unpruned, he says—"trunks" is a Cypriot gloss; his wife takes down the bacon with a forked pole—"pole" is a Homeric rarity.[142] Both contrasts are played up in the long bravura passage on the mousetraps. A plague of mice did figure in an obscure local myth, but they add quasi-realistically to the elegant sketch of rural squalor, and Molorchus' hunting of them deliberately parallels the lion hunt of Heracles (*sintai*, they are called, like lions in Homer; the tails with which they dip the oil from the lamps are

140. Lloyd-Jones and Parsons, *Suppl. Hell.* 254–269. On the Mousetrap: E. Livrea, "Der Liller Kallimachos und die Mausefallen," *ZPE* 34 (1979): 37–42; idem, "Polittico Callimacheo," *ZPE* 40 (1980): 21–26.

141. F 450; Lloyd-Jones and Parsons, *Suppl. Hell.* 293.

142. Lloyd-Jones and Parsons, *Suppl. Hell.* 257.25, 259.2.

alkaiai, properly of a lion's tail).[143] This rococo confection, then, combines it all: court panegyric, domesticated heroism, ironic contrast, far-fetched myth, old Greek etiology—all in a homage to Pindar which studiously avoids his meter, his seriousness, and (except for a word or two here or there) his language. Callimachus' relation to Pindar is indeed one paradigm of the Hellenistic transformation of the past; βαιὰ ἐν μακροῖσι ποικίλλειν[144] might characterize the new poetry as a whole. Not to travel on Homer's well-worn wagon road, to pluck the fine flower of poetry[145]—these are Pindaric images which recur in the prologue of the *Aetia* and in the epilogue of the *Hymn to Apollo:* the knowing reader is transported in ideology as well as in details to that remote and sumptuous world. And what reader was that? Molorchus made a deep impression on later poets (though, so far as I know, none at all in art); yet the very papyrus which preserves the text, copied within a generation of the poet's death, carries a prose paraphrase between the lines: not all readers were knowing readers.

So much for impressions. I end with some questions.

1. *Crisis and response.* If the Hellenistic age began with a crisis, of what sort was it? Novelty, *philotimia*, the overreaching of predecessors, is a recurring theme in Greek civilization: what was different this time? One can say, certainly, that reaction to the fourth century explains much: philosophy against Plato, rhetoric against Demosthenes and Isocrates (one group aims at pseudonaiveté after Lysias, the other at grandiose conceit after the Sophists), poetry reaching back over an age of prose and democracy to an age of aristocratic mannerism. But no doubt that is too simple. Continuities are clear; I suspect that rhetorical theory, and rhetorical education, as developed in the fourth century, played a much more determining part in the new literature than we can now perceive. And in all this, how relevant was the geopolitical crisis? More monarchs means more money; that is a practical view. The psychologist's view might be different: the bibelot poetry and folkloristic antiquarianism, the combinatorial amiabilities of New Comedy, the rectilinear cities, universal histories, systematic philosophies, and encyclopedic textbooks show the Hellenistic Greeks variously denying or dominating the unease of widened horizons: the key to the age is cultural agoraphobia.

2. *Ideology and identities.* Polarities define identities: Hellenic/barbarian, miniaturist/megalomaniac, experimental/traditional, pragmatic/tragic, universal/local, versatile/specialist; piety/rationalism, inspiration/technique, pleasure/instruction. To define systematic ideologies is much

143. Ibid., 259.29, 23.
144. Pindar *Pyth.* 9.7.
145. *Pae.* 7b.11f., *Isthm.* 7.18f.

harder. Certainly there were philosophies, which spoke of the nature of history or the value of poetry; it is not clear whether they were as universally influential as (it seems) in the Roman period. But were there also aesthetics? In practice, some poets pursued the brief, the rare, the polished, the obscure. Was that a "Callimachean program," or just a slogan asserting a taste? When Callimachus and Polybius both recommend rivals to be brief and selective,[146] does it signify? λεπτός is a buzzword of poets, ἰσχνός a technical term of rhetoric; λιτός describes a Stoic virtue, λεπτομερής applies to the elements of fire and air. Did contemporaries feel these as part of a single value system? Beyond literature, how great an analogy with the visual arts was felt, or should be perceived? Do the epigram and the terracotta show a single zeitgeist? Hellenistic poets like to describe works of art, but their own work seems to have no effect on iconography; we have the Pergamene altar, but no contemporary poet is known to have written a Gigantomachy: does *that* signify? A writer should be eclectic, just as Zeuxis used five different models for his Helen: does this passing remark of Cicero[147] derive from a developed theory of *mimesis*? Certainly, if one wanted a pocket description of Callimachus' work, one would take his own description of the toys brought by Athena to the infant Artemis[148]—πολλὰ τεχνήεντα ποι-κ[ίλ]α γλ[υφῆι / παίχν[ια]. Is it fanciful to think that both poetry and rhetorical prose develop visual qualities: ἐνάργεια, static elaboration, the frozen moment?

I have no answers.

146. Callimachus F 1; Polybius 12.25i.6–9.
147. Cic. *De inventione* 1.
148. F 202.27.

Response

Albert Henrichs

The combined expertise of Professors Gelzer and Parsons ranges over a wide area of Greek literature from the classical to the imperial period. Gelzer's work covers the classical antecedents as well as the later imitators of Hellenistic poetry from Aristophanes to Musaeus, and his interest in ancient literary criticism and in the concept of classicism reveals a theoretical bent that has also shaped his approach to the present topic. Parsons, as one of the most eminent contemporary papyrologists, is an "artificer of fact."[1] His edition of the Lille Callimachus and collaboration in the *Supplementum Hellenisticum* have provided us with magnificent research tools that open up new and difficult areas of Hellenistic poetry. With their different backgrounds and interests, Gelzer and Parsons make a provocative team, ready to approach the tantalizing topic of "Identity and Crisis in Hellenistic Literature" from opposite directions. Gelzer can be described as the theoretician and Parsons as the practitioner in the definition and exploration of both terms, "identity" and "crisis"; they have resorted here to a practical division of labor that leaves Parsons with the task of establishing identities and Gelzer with that of diagnosing the crisis. Their combined effort thus reconsiders the entire entity conventionally known as "Hellenistic literature"—an entity so firmly established that the organizers of this conference had every right to take it for granted. In the end, after extensive scrutiny, the entity stands essentially intact, but not without a poignant reminder that many common assumptions about the period and its literature remain controversial, and that major tasks lie ahead. Above all, there is room for a new

1. H. C. Youtie, "The Papyrologist: Artificer of Fact," *GRBS* 4 (1963): 19–32 (reprinted in *Scriptiunculae* [Amsterdam, 1973–75] 1:9–23).

and comprehensive history of Hellenistic literature which treats prose in the same depth as poetry and confronts the fundamental issues of periodization, continuity, and literary identity raised by Gelzer and Parsons.[2]

Both scholars accept in principle the standard modern chronological framework, according to which the Hellenistic period lasted from the death of Alexander the Great to the Battle of Actium, or from 323 to 31 BC.[3] Furthermore, they both assume a long period of transition which lasted for the better part of the fourth century and produced the characteristics we call "Hellenistic."[4] Apart from these shared assumptions, the two papers differ widely in range and perspective. Whereas Parsons covers the entire timespan from the reign of Ptolemy I to the Augustan era, with minute attention to consistent features and attitudes that lie beneath the diversity and the quick pace of literary production, Gelzer

2. F. Susemihl's admirable if dated *Geschichte der griechischen Literatur in der Alexandrinerzeit,* 2 vols. (Leipzig, 1891–92), remains the only comprehensive account. Neither volume 2.1 of W. Schmid and O. Stählin's *Geschichte der griechischen Literatur,* 6th ed. (Munich, 1920), nor the treatment of Hellenistic poetry and, on a much smaller scale, prose in volume 1 of the *Cambridge History of Classical Literature* (Cambridge, 1985) is designed to replace it.

3. This definition of the Hellenistic period goes back well beyond Johann Gustav Droysen's *Geschichte des Hellenismus* (1836–43) to the eighteenth century, and ultimately to ancient critics such as Dionysius of Halicarnassus. According to Dionysius, the decline of the "old philosophic rhetoric" began at the time of the death of Alexander the Great (ἀρξαμένη μὲν ἀπὸ τῆς ᾿Αλεξάνδρου τοῦ Μακεδόνος τελευτῆς) and continued into his own lifetime, the age of Augustus, when the return to the classical models signaled a new beginning (*De oratoribus veteribus* 1f.; see below, n. 6). On the modern history of the term "Hellenistic" and on the current state of the debate, see R. Bichler, *"Hellenismus": Geschichte und Problematik eines Epochenbegriffs* (Darmstadt, 1983), as supplemented by R. Kassel, *Die Abgrenzung des Hellenismus in der griechischen Literaturgeschichte* (Berlin and New York, 1987), esp. 4, 15f. The conventional chronology has been challenged most recently by H.-J. Gehrke, *Geschichte des Hellenismus* (Munich, 1990), 3, 129–131, who begins his book with the accession of Alexander the Great in 336 BC rather than his death. Although Gehrke accepts the Roman conquest of Egypt as the end of the Hellenistic period, he includes the cult of Mithras, a later phenomenon, in his treatment of Hellenistic religions and is in principle prepared to extend the boundaries of Hellenistic culture all the way down to the beginning of the Islamic era in the seventh century AD. An equally broad definition prevails among New Testament scholars, who emphasize the continuity of postclassical Greek culture, especially in the areas of religion and philosophy.

4. This too represents the common view, as formulated, for instance, by G. Krahmer, "Stilphasen der hellenistischen Plastik," *MDAI(R)* 38/39 (1923/24): 138–184, at 139: "Das IV. Jahrhundert stellt sich mir bis zu seinem Ende als eine langsame Entwicklung dar, was in dieser Arbeit nur leicht gestreift werden kann. Etwas Neues, Andersartiges, eine neue Epoche scheint mir erst die Statue des Polyeuktos, der Demosthenes, zu bringen, zu der natürlich auch Übergänge führen. Darum sei mir für diese Untersuchung aus praktischen Gründen . . . gestattet, mit dem Worte Hellenismus die Alexanderzeit und die Frühzeit der Diadochen, also die Zeit bis ungefähr zum Jahre 300 v. C., nicht einzubegreifen."

concentrates on the interplay of continuity and change that links the literature of the late classical period with the new cultural and poetic impetus centered in Alexandria. By setting prominent Alexandrian poets such as Callimachus and Theocritus against the background of the literary tradition that preceded and followed them, he searches for significant breaks in continuity, which he defines as "crises," at the beginning and end of the Hellenistic period. It is this gradual emergence of the Hellenistic out of the classical, and the eventual formation of a new classicism, that occupies most of Gelzer's attention. Parsons, though far from unaware of the problem of demarcation and transition, leaves their discussion to Gelzer and jumps *in medias res,* into the classification of individual authors and generic traits that make Hellenistic literature an entity in its own right. In addition to poetry, Parsons also includes the numerous genres of Hellenistic prose in his wide-ranging survey, while Gelzer confines himself to poetry.

In the first part of my response, I will discuss Gelzer's notion of the literary crisis and, more briefly, Parson's analysis of authorial identities, on their own terms, that is, separately from each other. Separating the crisis from the identities has the advantage of maximizing the best strengths of both scholars. At the same time, however, the separate treatment leaves us with a series of poetic crises that occurred at the extreme periphery of Hellenistic poetry without affecting the core of that poetry or the identities of its poets; conversely, the separation of the concept of literary identity from that of literary crisis, taken in its broadest sense, raises the uncomfortable prospect of authorial identities that are intrinsically clear-cut, well defined, and unproblematic.

The idea of crisis in literary studies is a multiple one. It can involve the shaping of a literary character or the establishment of the identity of an author, or it can reflect the vicissitudes of ancient or modern criticism. Each of these perspectives suggests ways of making relevant connections that link the twin concepts of identity and crisis and bring them into sharper focus. In my concluding sections, I propose to move in that direction by exploring two crises of criticism. I shall first turn to Menander and his controversial literary identity, which seems to elude classification—Hellenistic or classical? A classic or an unending set of variations on predictable literary themes? The way we answer these questions has as much to do with the individual scholarly identities of Menander's modern critics and with the conceptual categories they bring to their task as with Menander himself. Then, in the final section, I shall evoke a revealing incident in the history of ancient criticism and Hellenistic literature, when Apollodorus of Athens, a scholar as well as a poet, discovered an anonymous epic poem, the *Meropis,* and tried to define the literary identity of its author by looking at its plot. Heracles, the central

figure in the poem, is shown in a moment of extreme crisis. The manner
in which the epic hero handles the crisis he confronts should tell us
something about the quality of the poet and his place in literary history.
Yet critics are sharply divided over the date and ambience of the *Meropis;*
in this instance, at least, the crisis of the hero has turned into another
crisis of criticism.

I. A CRISIS WITHOUT IDENTITY AND IDENTITIES WITHOUT CRISIS

Few readers will seriously disagree with Gelzer's judicious comments on
the formation, nature, and cultural ambience of Alexandrian poetry.
But they are prefaced with reflections on the inner rhythm of literary
history which call for a critical response. The one argument that seems
particularly controversial has to do with Gelzer's thesis that the "new
identity" achieved by Alexandrian poets in the first half of the third cen-
tury was the direct result of a momentous "crisis in poetry" which had
occurred in the preceding century.[5]

Well aware of the problems inherent in any attempt to divide Greek
literature into successive periods, Gelzer differentiates its Hellenistic
phase from the classical phase that preceded and the post-Hellenistic or
imperial phase that followed it.[6] His next step, however, is more pre-
carious. He postulates that the three phases, classical, Hellenistic, and
imperial, were separated by transitional periods, and these he defines as
"crises." The crisis that marked the transition from classical to Hellenis-
tic began, according to Gelzer, around 400 BC and lasted for almost an

5. Already three decades ago, W. Wimmel, *Kallimachos in Rom: Die Nachfolge seines apol-
ogetischen Dichtens in der Augusteerzeit,* Hermes-Einzelschriften 16 (Wiesbaden, 1960),
93–98, argued that the "new poetry" represented by Callimachus was conceived in re-
sponse to "die Krise des Dichtens," which Wimmel dated to ca. 400 BC.

6. Ultimately derived from ancient rhetorical theory, this conventional periodization
of Greek literature was apparently adopted for the first time by Friedrich August Wolf
(1759–1824) in his lectures on Greek literature, published in 1831. Its ancient model is
the cycle of classical perfection, Hellenistic decline, and Augustan renaissance advocated
by Dionysius of Halicarnassus in his treatment of Greek rhetoric (see above, n. 3). On the
history of the standard periodization of Greek literature see Kassel, *Abgrenzung des Hellen-
ismus,* 4, 18f.; on Dionysius' periodization of rhetoric see T. Gelzer, "Klassizismus, Attizis-
mus und Asianismus," in *Le classicisme à Rome aux iers siècles avant et après J.-C.,* H. Flashar,
ed., Fondation Hardt, Entretiens 25 (Vandoeuvres and Geneva, 1979), 1–41, esp. 32
("jene typisch klassizistische Konstruktion der Einteilung der Zeit in drei Perioden"), and
K. Heldmann, *Antike Theorien über Entwicklung und Verfall der Redekunst,* Zetemata 77 (Mu-
nich, 1982), 122–131; on similar periodizations in ancient criticism, see H.-G. Nesselrath,
Die attische Mittlere Komödie: Ihre Stellung in der antiken Literaturkritik und Literaturgeschichte,
Untersuchungen zur antiken Literatur und Geschichte 36 (Berlin and New York, 1990),
341–345.

entire century. In his eyes it was a literary crisis, more specifically a crisis of poetic self-confidence, as one might call it, and not a political one.[7] He finds its symptoms in "the poetry itself," that is, in self-conscious statements about the contemporary state of poetic genres culled from one epic and three comic poets.

The earliest of Gelzer's witnesses is Aristophanes in the *Frogs*, who "makes it clear . . . that great tragedy has come to an end with the death of Euripides and of Sophocles." The next witness is Choerilus, who in the proem to his epic on the Persian Wars dramatizes the difficulty of finding new material for epic poetry (F 2 Bernabé = Lloyd-Jones and Parsons, *Suppl. Hell.* 317). He complains that most of the suitable terrain has been claimed by previous poets, and that the art of poetry has "reached its limits"—ἔχουσι δὲ πείρατα τέχναι. As we move from the late fifth into the fourth century, a similar concern with poetic invention is voiced by two representatives of Middle Comedy. Xenarchus compares poets who are uninventive and repeat the same themes over and over again with fishmongers who make desiccated fish look fresh by sprinkling them with water (F 7 Kassel/Austin). Finally, the prologue speaker of Antiphanes' *Poiesis*—perhaps Poetry personified— argues that comic poets are required by the conventions of their genre to be much more inventive than poets of tragedy (F 189 Kassel/Austin).[8]

Three of the four texts invite direct comparison. By putting a premium on invention and originality, Xenarchus and Antiphanes comically recall a criterion of poetic craftsmanship that can be traced back via the poets of Old Comedy to Pindar; it was to become *de rigueur* among Hellenistic poets.[9] Disguised as an elaborate *captatio benevolentiae*, the

7. Gelzer hints at a connection between the "crisis in poetry" and "the crisis of the πόλις" attested by Thucydides, Aristophanes, Plato, and Demosthenes. It is to be hoped that the eventual publication of his Sather Lectures, "Witnesses of Crisis in the Greek City-State" (1987) will bring the protean term "crisis" into sharper focus.

8. It surely amounts to special pleading to describe the Xenarchus fragment as an "outcry." The comparison with fishmongers is as conventional as the emphasis on novelty (see below, n. 9)—in Amphis (F 30 Kassel/Austin) and Alexis (F 16 Kassel/Austin) the high-handed behavior of Athenian *strategoi* is compared to the combination of arrogance and benign neglect with which fishmongers treat their customers; cf. Nesselrath, *Mittlere Komödie*, 294f. n. 26.

9. Xenarchus F 7.1f. Kassel/Austin: οὐδὲ ἓν / καινὸν γὰρ εὑρίσκουσιν; Antiphanes F 189.17f. Kassel/Austin: ἀλλὰ πάντα δεῖ / εὑρεῖν, ὀνόματα καινά; cf. Aristophanes *Clouds* 547 (parabasis of revised version): αἰεὶ καινὰς ἰδέας εἰσφέρων σοφίζομαι; Ar. *Wasps* 1052 (parabasis): καινόν τι λέγειν κἀξευρίσκειν; Pherecrates F 84.1–2 Kassel/Austin (parabasis): ἄνδρες, προσέχετε τὸν νοῦν / ἐξευρήματι καινῶι; Pindar *Nemean Odes* 8.20f.: πολλὰ γὰρ πολλᾶι λέλεκται, νεαρὰ δ' ἐξευρόντα δόμεν βασάνωι ἐς ἔλεγχον ἅπας κίνδυνος (a "gnomic priamel," E. L. Bundy, *Studia Pindarica* [Berkeley and Los Angeles, 1986], 40 n. 16). Passages such as these ultimately reflect the fifth-century debate on inventiveness and

same topos lies behind Choerilus' programmatic proem, which calls attention to his innovative approach to epic poetry.[10] I submit that far from providing evidence for a crisis of poetry, such statements represent conventional voices in an ongoing dialogue on poetics between the poets and their audiences that stretches far back into the classical and archaic past.[11]

Even if these texts may be read as reliable witnesses for poetic self-definition in the pre-Hellenistic period, they reflect an awareness not of a poetry in crisis but, as I read them, of poets who strive to explore new avenues of expression. They serve as a reminder that any literature that is alive and well must call its own identity into question, and must do so consciously. The growing pains which can still be felt beneath the mixture of nostalgic retrospection and caustic wit found in all four of Gelzer's witnesses reflect the creative tension between continuity and change, that is, between the poet's recognition of the "burden of the past" and his inner compulsion to find his own poetic voice. Poetic acknowledgements of the creative process tend to be couched in a provocative language that is either defensive or defiant. Choerilus adopted a stance that puts him on the defensive. Working within a time-honored genre, he asserted his own identity by pretending to bow to his predecessors. By contrast, his contemporary Timotheus, the creator of a new dithyrambic music, defied previous poets by turning his back on them: "I don't sing in the ancient mode, for my new mode is better. . . . Away with the ancient Muse!"[12] Timotheus and Choerilus represent opposite

originality that had both a cultural and a technical dimension—discussion of πρῶτοι εὑρεταί on the one hand and rhetorical guidelines for εὕρεσις (*inventio*) on the other. For emphasis on novelty in Hellenistic poetry, see below, n. 12, and Parsons at nn. 94–124.

10. Cf. N. Hopkinson, *A Hellenistic Anthology* (Cambridge, 1988), 1 (on Lloyd-Jones and Parsons, *Suppl. Hell.* 317): "Choerilus' response to this problem was an epic poem which dealt, unusually, with a recent historical subject—the Persian Wars." Hopkinson recognizes an affinity with Callimachus' equally programmatic prologue to the *Aetia* (F 1.1–40 Pfeiffer). But unlike Choerilus, Callimachus refrained from the despondent rhetoric of epigonism and adopted the more assertive convention of the priamel to distance himself from the poetic tradition and to assert his own exclusiveness in no uncertain terms (*Epigrammata* 28; cf. A. Henrichs, *HSCP* 83 [1979]: 207–212, and E.-R. Schwinge, *Künstlichkeit von Kunst: Zur Geschichtlichkeit der alexandrinischen Poesie* [Munich, 1986], 4–9).

11. Cf. E. W. Handley, "Comedy," in *Cambridge History of Classical Literature* 1 : 412 on Antiphanes F 189 (see above, n. 9): "We need to take what he says about tragedy and comedy much more as advertising material for the kind of play he is presenting than as documentation."

12. Timotheus F 796 Page: οὐκ ἀείδω τὰ παλαιά, / καινὰ γὰρ ἀμὰ κρείσσω, followed by ἀπίτω μοῦσα παλαιά. In his *Persians*, Timotheus describes how the Spartans took him to task "because I disparage the ancient Muse by new hymns" (τι παλαιοτέραν νέοις ὕμνοις μοῦσαν ἀτιμῶ: F 791.211f.; cf. U. von Wilamowitz-Moellendorff, *Timotheos, Die Perser* [Leipzig, 1903], 64–73). P. Bing, *The Well-Read Muse: Present and Past in Callimachus and the*

attitudes toward the poetic tradition that stem from an identical need for artistic self-definition.

Thus, as far as I can see, Gelzer's concept of a literary crisis does not find support in the meager remains of fourth-century poetry. The true Achilles' heel of Gelzer's argument, however, is its failure to take sufficient account of the sudden transformation of the Greek world in the wake of the tremendous political, territorial, and cultural changes brought about by the exploits of Alexander the Great and the activities of his successors.[13] It is true that Alexander did not change the course of Greek literature overnight, but it is equally true that his conquests and cosmopolitanism created a different climate which offered unprecedented opportunities for new ventures in literature. For many of the writers of his time, Alexander was not a distant figure; for some he was a patron. We know of at least one dramatic performance at which Alexander himself was present. In 324 BC the satyr play *Agen*, by a certain Python, was performed at the Dionysia—not in Athens or Pella, but in the Macedonian military camp on the banks of the Hydaspes. In retrospect the occasion was truly a literary event. Instead of satyrs, the characters were contemporary political figures. The extant prologue scene describes a satirical ghost-raising ritual reminiscent of Aeschylus and appropriately performed by Persian magi near the reeds of a lake. But no Tiresias or Darius returned from the dead to predict the future. Instead the hetaira Pythionike was brought up from the underworld to comfort her lover, the notorious Harpalus, who had just defected from Alexander. The unabashed topicality of this play and its performance at a traditional Dionysiac festival in a place far removed from any Greek polis exemplify the powerful alliance of new political forces and widened horizons that shaped even the most conventional genres of literature in ways unimaginable before the new age inaugurated by Alexander.[14]

Hellenistic Poets, Hypomnemata 90 (Göttingen, 1988), 22, compares the anonymous song 851 (b) Page: Μοῦσαν . . . καινὰν ἀπαρθένευτον, οὔ τι ταῖς πάρος κεχρημέναν ὠιδαῖσιν; as well as Boiscus of Cyzicus, Lloyd-Jones and Parsons, *Suppl. Hell.*, 233.1: καινοῦ γραφεὺς ποιήματος; and Philicus of Corcyra, ibid. 677: καινογράφου συνθέσεως . . . δῶρα. Both of these latter poets experimented with new meters (cf. Parsons at nn. 121–124). From Parson's treasure-house (at n. 94) I add *Carm. conviv. PMG* 917 (c) 3f. Page: ἄρτι βρύουσαν ἀοιδὰν / πρωτοπαγεῖ σοφίαι διαποίκιλον ἐκφέρομεν, "diversified with first-creating art" (Parsons).

13. Parsons disagrees with Rudolf Pfeiffer, who thought that Alexander inaugurated a renaissance of letters, "the age of scholarship and rediscovery." Nevertheless he seems slightly more inclined than Gelzer to take political constellations into account and to recognize the significance of the momentous events that took place during the last third of the fourth century: "Alexander represents a geopolitical crisis, perhaps, but not a literary one."

14. Python (?) *TGF* 91 F 1. The play is variously ascribed to Python of Catana (other-

In the course of the fourth century, Greek attitudes toward literature doubtless changed, in Athens as well as elsewhere, and so did the standard of taste, as Gelzer has shown so well: a gradual recognition of old masters and an emerging notion of the classic; performance giving way to books; a new concept of literature produced for individual consumption in the public library or the private study, dissociated from the social institutions of an earlier period; an interest in literature as a historical phenomenon and the creation of the history of literature as a discipline, including the formation of a canon. Gelzer puts these new developments in proper perspective when he recognizes them as the earliest manifestations of features typically associated with *Hellenistic* literature. But is a period of transition, however momentous, by definition one of "crisis?"

The problem lies partly in the interpreter's own outlook and his choice of words. The word κρίσις is a highly specialized term in Greek medical literature, where it describes the state of a patient whose life hangs in the balance. Applying this term to the condition of an entire body of literature comes close to falling into the Romantic trap of treating literature and literary genres as if they were biological organisms that pass through successive stages of birth, maturation, and death. Thus understood, a crisis could lead to the unnatural or premature death of the literary patient, for example classical literature. We are obliged, I think, to remind ourselves that the analogy is powerful but misleading. Literature and art do not behave like biological organisms, which are preprogrammed; actual history, including the history of literature, is infinitely more complex, and less predictable, than the alternating pattern of decline and revival postulated by Gelzer.[15]

On Parsons' paper I have much less to say. In a magisterial display of hard facts which speak for themselves, he reexamines the basic elements of Hellenistic literature in the light of new discoveries—the infinite variety of genres, styles, meters, modes of expression, and authorial stances that constitute its core. More than one hundred names of Helle-

wise unknown), to the orator Python of Byzantium, or even to Alexander himself. Cf. B. Snell, *Scenes from Greek Drama* (Berkeley and Los Angeles, 1964), chaps. 5–6, esp. 105–108 (revised as *Szenen aus griechischen Dramen* [Berlin, 1971], chap. 4, esp. 109–113). On the controversial date of the *Agen* see H. Lloyd-Jones, *Gnomon* 38 (1966): 16f. (reprinted in his *Greek Epic, Lyric, and Tragedy* [Oxford, 1990], 215f.).

15. The notion of a recurrent literary crisis ultimately reflects an outmoded classicistic model of literary history and merit. Its numerous nineteenth-century predecessors include the Schlegel brothers' theory of the rise and decline of tragedy from Aeschylus via Sophocles to Euripides, which Nietzsche adopted in his *Birth of Tragedy*. See N. Himmelmann-Wildschütz, "Der Entwicklungsbegriff der modernen Archäologie," *Marburger Winckelmann-Program 1960* (1961), 13–40, esp. 20f., on the "circulus vitiosus" of cyclical theories. In essence Himmelmann's criticism also applies to Gelzer's model.

nistic authors, helpfully organized by more or less traditional categories, suggest the complexities hidden behind the topic of identity, which the conference has set itself the task of considering. Parsons presents us with a pluralistic world of many different literary identities which not only coexist but overlap and interact. By correlating individual authors with generic literary categories, he shows that the same Hellenistic author can often be identified in more than one way and that the deliberate crossing of boundaries is a persistent hallmark of Hellenistic literati.

It is difficult to unravel Parson's tight fabric. His judgment is admirably sound, but I sense a note of frustration—genuine caution or Oxonian understatement?—that I am reluctant to share. He says: "Nothing remains, then, but the subjective. I want simply to illustrate some possible identities: literary men in relation to their profession and to their audience; to their unhellenic surroundings and their Hellenic inheritance; to literary tradition and to current ideologies, as exemplified in experiments, rivalries, and sloganizing." Are we to understand that Hellenistic literature, as currently understood, is mere quicksand, constantly shifting and without fixed boundaries or content, and that the modern concept of "Hellenistic" is nothing but a conglomerate of subjective impressions, *quot homines, tot sententiae*? This is indeed the conclusion reached by Reinhold Bichler in his recent monograph on the modern history of the "Hellenismusbegriff" and its inherent problems.[16] Parsons himself is perhaps not quite as skeptical as he sounds. After all, he has mapped long stretches of the Hellenistic literary landscape with such skill and accuracy that, using his map as a guide, the disoriented and the disillusioned should find it much easier from now on to locate the elusive entity known as Hellenistic literature.

Parsons and Gelzer cover a lot of ground. They move so fast that they rarely pause to consider the distinctive identity of a given author and his work. In Gelzer's treatment, the individual poets disappear behind the artistic or cultural roles assigned to them in the grand scheme of things. Parsons marshals an impressive array of names and personalities, yet his very inclusiveness leaves us still looking for what constitutes the essential identity of the period and of the major authors who represent it. Aware of the imbalance, both scholars have tried to remedy it by singling out individual authors for more detailed consideration. Gelzer returns to Theocritus and Callimachus near the end of his presentation to consider them in some detail as court poets who cultivated the "Praise of Princes."

16. I agree with Gehrke, *Geschichte des Hellenismus,* 130, that the modern concept of "Hellenismus" is not quite as ill-defined and lacking in definite characteristics as Bichler suggests. But as Bichler, *"Hellenismus"* (see above, n. 3), reminds us, our understanding of the term "Hellenistic" needs to be constantly reexamined if the concept is to remain viable.

Parsons pays a final tribute to Callimachus in his digression on the *Victory of Berenice,* whose text and exegesis owe so much to his papyrological and interpretative skills. When they point to individual poets and their place in literature, Parsons and Gelzer open a door out of the constraints posed by the separate treatment of identity and crisis. I propose to follow their example by focusing, in the remainder of my response, on two other figures that suggest ways in which identity and crisis are interrelated.

Far removed from one another in time, talent, and the impact they have made on posterity, Menander and Apollodorus represent two distinct literary identities, the playwright and the scholar poet. Apart from the fact that both of them composed iambic verse and that Menander is quoted once or twice in the extant fragments of Apollodorus, these two men have nothing in common.[17] But they happen to illustrate the dilemma of critics, both ancient and modern, who do not know what to do with poets whose place in literature is ambiguous. Apollodorus' rudimentary attempt to classify an obscure epic poet and the long-standing modern disagreement over Menander's literary status suggest the existence of a different and more tangible type of recurrent literary crisis than the one contemplated by Gelzer. Although it remains doubtful that the new poetic identities associated with Hellenistic literature were produced by a "crisis in poetry," it is one of the lessons of literary history that poets whose date, quality, or distinctiveness is controversial have produced prolonged crises of criticism. Such crises rarely change the overall picture of Greek literature, but they deeply affect our appreciation of individual authors and their literary identity.

II. THE CASE OF MENANDER: A CRISIS OF IDENTITY?

Menander poses intriguing questions of period, canon, and reception. His name stands for the genre of New Comedy, a designation which separates him sharply from the earlier and more "classical" poets of Old and Middle Comedy.[18] Yet the genre which he represents and the dramatic tradition in which he stands link Menander intimately with the final stage of classical Athens and its literature. Born of Attic parents in 342/1, he was still a toddler and unaware of the momentous course of events when Greece lost its independence to Philip of Macedon. In 323, the year in which Alexander died, Menander reported at age eighteen for military duty as a classmate of Epicurus, whose postclassical cast of

17. Apollodorus *FGrH* 244 F 112 = Menander F 323 Körte. Apollodorus is also the source of Philodemus *De piet.* p. 42 G. = Menander F 841 Körte.

18. See below, n. 26.

mind is all too conspicuous. One has only to think of Epicurus' indifference to public affairs, his rejection of rhetoric, the gracelessness of his technical prose, and his antimythical and antitragic separation of gods and men. Menander's first play dates from around 321; his last production falls in the initial decade of the third century, at the height of the reign of the first Ptolemy, who may have tried in vain to attract the playwright to Alexandria.

In biographical as well as literary terms, Menander is a truly transitional figure who straddles the fence, no matter where we decide to draw the line that separates the late classical from the early Hellenistic period. His milieu is that of the Athenian city-state, but his outlook is cosmopolitan and his humanity universal; he writes verse that often reads like prose; his idiom is Attic, but every now and then his vocabulary and syntax foreshadow later Hellenistic usage; some of his less conventional characters, never before seen on the dramatic stage, were typical fourth-century figures who could look forward to a bright future in the Hellenistic world. I am thinking in particular of the pairs of young lovers who successfully overcome obstacles and cross social boundaries in their pursuit of personal happiness, of the mercenary soldier who fights in distant lands, and of the goddess Tyche who claims that she is holding everybody's fortune in her hands.[19]

It is much easier to assess Menander's importance for European literature as a whole than to determine his place in the history of Greek letters. The problems that face us in Menander are intimately connected with the identity of the Hellenistic period, conceived as a coherent literary phenomenon. Historians of Greek literature either include him under the Hellenistic rubric or treat him as a classical author who almost missed the boat.[20] Eric W. Handley has recently called Menander "a poet of the Hellenistic Age," but, more often than not, New Comedy is ex-

19. In the *Aspis* Menander introduces Tyche as the prologue speaker and Kleostratos as a soldier of fortune who returns to Greece with rich spoils from battlegrounds in Asia Minor. Tyche's stage epiphany (97–148) epitomizes her prominent role in New Comedy (e.g., Philemon F 9, 125 Kassel/Austin; Menander F 295, 417, 467f., 637 Körte) and inaugurates her ubiquitous presence in the Hellenistic and Roman world. Cf. Wilamowitz, *Hellenistische Dichtung in der Zeit des Kallimachos* (Berlin, 1924) 1:76f.; idem, *Der Glaube der Hellenen* (Berlin, 1931–32) 2:298–309; M. P. Nilsson, *Geschichte der griechischen Religion*, (Munich, 1967–74) 2:200–210; F. W. Hamdorf, *Griechische Kultpersonifikationen der vorhellenistischen Zeit* (Mainz, 1964), 37–39; H. Lloyd-Jones, *GRBS* 12 (1971): 194f. (reprinted in his *Greek Comedy, Hellenistic Literature, Greek Religion, and Miscellanea* [Oxford, 1990], 24).

20. Kassel, *Abgrenzung des Hellenismus*, 16f.: "Eine wirkliche Crux der Periodisierung ist dagegen die Neue Attische Komödie. [Examples for both classifications follow.] Hier bleibt offenbar einiges zu klären, was mit dem literarhistorischen Problem des jeweils größeren oder geringeren Gewichts der Zugehörigkeit zu Zeitalter und Gattungstradition zu tun hat."

cluded from treatments of Hellenistic poetry, a designation that has become virtually synonymous with Alexandrian poetry.²¹ In some ways, it is true, the two poetic traditions lie worlds apart: Menander's plays entertained local Athenian theatergoers, whereas the Alexandrian poets had an audience in· mind whose taste was more exclusive and whose background was more panhellenic. No wonder that Menander tends to suffer by comparison with them. The former Regius Professor of Greek at Oxford, who edited Menander's *Dyskolos* shortly after its first publication in 1959 and who did much for our understanding of the more recent plays, once said that he would not hesitate to exchange a hundred lines of Menander for one line of Callimachus.²² Like attracts like—by combining wit with learning, Callimachus naturally appeals to learned critics who share his virtues. Menander's best strengths lie elsewhere, in his character drawing and humane touch, qualities which were perhaps more at home in Athens than in Alexandria—Callimachus emulates them in the *Hekale,* the most Attic of his poems.

Menander continues to divide students of Greek literature. In their passing comments on him, Gelzer and Parsons seem to disagree on his place in Hellenistic poetry. Parsons mentions Menander as the sole surviving representative of Hellenistic drama and as an example of rapid communication between Athens and Alexandria under the first Ptolemies—the plays of Menander "reached Egypt with relative speed."²³

21. Handley in *Cambridge History of Classical Literature* 1:423. Wilamowitz, "Die griechische Literatur des Altertums," in *Die griechische und lateinische Literatur und Sprache,* 3d ed., Die Kultur der Gegenwart 1.7 (Leipzig and Berlin, 1912), first published in 1905, treated Menander under the rubric "Hellenistic Period (320–30 BC)"; two decades later, however, he considered him too "remote from the new spirit" of Alexandria for inclusion in his *Hellenistische Dichtung* (1:168). In his *Griechische Literaturgeschichte* of 1967 (2d ed., Munich, 1991), Albrecht Dihle discussed Menander and Philemon as Hellenistic dramatists. By contrast, the author of the most recent book on Hellenistic poetry follows the example of Wilamowitz and excludes Menander; for G. O. Hutchinson, Menander is neither classical nor Hellenistic—he belongs in a postclassical twilight zone, and his comedies "do not assist us greatly" (*Hellenistic Poetry* [Oxford, 1988], 10).

22. Sir Hugh Lloyd-Jones made this remark more than twenty years ago under the fresh impression of a papyrus fragment of Callimachus newly discovered in the collection of the University of Michigan and subsequently included, with a significant new reading, by him and Peter Parsons in their *Supplementum Hellenisticum* as no. 250. His comments on three of Menander's best plays suggest that he would part with some lines more readily than with others: *GRBS* 7 (1966): 131–157 (*Sikyonios*); *GRBS* 12 (1971): 175–195 (*Aspis*); and *YClS* 22 (1972): 119–144 (*Samia*) (reprinted in *Greek Comedy,* 7–25, 31–76). He eloquently defends "the great poets of the third century" against modern critics of Alexandrianism in his "Hellenistic Miscellany," *SIFC* 77 (1984): 52–72 (reprinted in *Greek Comedy,* 231–249).

23. The earliest known text of Menander, the *Sikyonios* papyrus, was penned in Egypt within a generation or two of the poet's death. If this is what Parsons means by "relative

The reception of Menander outside Attica and in the Hellenistic world is indeed a crucial aspect of his literary identity, which hovers intriguingly between his dual role as the last heir of Attic comedy and the trailblazer of a new form of European comedy. Like Parsons, Gelzer recognizes Menander's importance, but he does not recognize him as a Hellenistic poet. As defined by Gelzer, Hellenistic poetry is the exclusive domain of the "new poets" of Alexandria, who created "the new poetry."

Novelty is a crucial element in Gelzer's definition; oddly enough, he excludes from Hellenistic poetry the νέος κωμικός Menander along with the rest of New Comedy.[24] Three of Gelzer's four witnesses for the "crisis of poetry," Aristophanes, Antiphanes, and Xenarchus, were poets of Old and Middle Comedy who routinely bragged about their "new" poetic strategies, καινὰ ἐξευρήματα.[25] Yet their innovations hardly changed the nature of the genre; it was rather Menander whom the Alexandrians themselves recognized as the true innovator. Compared to his predecessors, Menander represents indeed a "new" and more refined form of comedy.[26] But if one compares him, as Gelzer implicitly does, with the *poetae noui* of the Alexandrian and neoteric canon—poets who came after him and whose repertoire included every conceivable genre except drama—he looks inevitably like a poet from an earlier age. Novelty is a relative quality in poets, as well as an elusive criterion in literary studies. Whether a poet is considered innovative or not depends not only on the "originality" of his work, but also on the expectations of his audience and the judgment of his critics.

speed," the pace of dissemination was yet too fast for the skills of that particular scribe—his copy abounds with serious mistakes (see the critical apparatus of R. Kassel's standard edition: *Menandri Sicyonius*, Kleine Texte 185 [Berlin, 1965]).

24. The exclusion of Menander goes back to Wilamowitz, *Hellenistische Dichtung* (see above, n. 21); so does the designation "die neue Dichtung" as a programmatic name for Alexandrian poetry (*Hellenistische Dichtung* 1:52, 70–72, 148–151). As used by Gelzer, the terms "new poetry" and "new poets" reflect his own theory of a poetic crisis followed by a new beginning. But the majority of modern critics reserve the term "New Poets" for the modish Roman poets of the late Republic who emulated Euphorion rather than Ennius and to whom Cicero refers disparagingly as *poetae noui* and νεώτεροι (W. Clausen, *HSCP* 90 [1986]: 159–170). If "it is improbable in the extreme that they called *themselves* the 'new' or 'neoteric' poets" (A. Cameron, *HSCP* 84 [1980]: 127f.), it is even more inconceivable that their Alexandrian predecessors would have done so (see below, n. 44).

25. See above, n. 9.

26. The term νεωτέρα/νέα κωμῳδία implies not only that Menander's New Comedy is more recent than Old and Middle Comedy, but also that it is more innovative (see n. 9, above, on Pindar's use of νεαρά) and different in quality (Nesselrath, *Mittlere Komödie*, 333). Susemihl, *Geschichte der griechische Literatur* 1:426f. n. 88, credited Callimachus or Aristophanes of Byzantium with the invention of the three periods of Attic comedy; Nesselrath, *Mittlere Komödie*, 172–187, favors Aristophanes.

Modern critics are free to choose the perspective that suits their agenda. Gelzer justifies his choice by insisting on the difference between poetry composed for performance and poetry composed for reading. The genuine Hellenistic poets, he argues, belonged to a "culture of the written word" and wrote with a reading public in mind, whereas Menander's plays were intended for performance before a live audience.[27] But not every scholar is prepared to deny Menander a place in Hellenistic literature on these grounds as long as the relevance of such criteria as performance, recitation, and reading aloud or silently is open to discussion.[28] The classification of Menander by period is likely to remain controversial, precisely because he exemplifies the transition. There is a growing awareness, however, that his art, if not Alexandrian, is nevertheless "Hellenistic."[29]

The problematic nature of the criteria invoked to fit Menander into one period or another brings up a second question: the literary and poetic issues raised by our attempts to define his poetry, and how these issues in turn are vitally affected by our understanding of Hellenistic aesthetics. For a proper appreciation of Menander's art it hardly matters whether he is labeled classical or Hellenistic as long as it is understood that his plays contain features which fit both descriptions. The overall continuity of the dramatic form, which connects Menander with Euripides and the drama of the fourth century, must carry the same weight in the literary classification of his plays as his various innovations in dra-

27. Here too Gelzer echoes Wilamowitz, who defined Hellenistic poetry as "Rezitationspoesie, die zur Lesepoesie wird" (*Hellenistische Dichtung* 1 : 149, cf. 52). But unlike Wilamowitz, Gelzer makes no allowance for recitation.

28. Gelzer acknowledges that dramatic poetry continued to flourish on a reduced scale during the Hellenistic period. Much of the best nondramatic Alexandrian poetry was in all probability also intended for initial recitation to small groups of fellow poets, patrons, or friends before it was circulated in written form; this was true as well for the many less familiar types of poetry—cultic, lyric, mimetic—that were performed before very mixed audiences throughout the Hellenistic period. Callimachus' first *Iambus* envisages a Hipponax redivivus dictating one of his fables to an assemblage of Alexandrian scholars (F 191 Pfeiffer)—a sarcastic fiction, no doubt, but one that has all the more bite if it was inspired by actual poetry readings in Alexandria. Cf. B. Gentili, *Poetry and Its Public in Ancient Greece: From Homer to the Fifth Century* (Baltimore and London, 1988), 169–176 (on patronage, recitation, and performance in the postclassical period); and A. W. Bulloch, *Callimachus: The Fifth Hymn*, Cambridge Classical Texts and Commentaries 26 (Cambridge, 1986), 8 ("clearly written for recitation before an educated audience associated with the royal court at Alexandria"). D. Obbink, "Hymn, Cult, Genre" (forthcoming), recognizes "performance" as an essential feature of hymnic poetry, including the extant corpus of Hellenistic hymns; performance can entail ritual enactment (as in various cult hymns) or literary evocation (as in Callimachus *Hymns* 5 and 6).

29. I take it to be symptomatic that Gehrke opens his recent survey of Hellenistic literature with Menander (*Geschichte des Hellenismus*).

matic technique, narrative structure, or character drawing. What is more important, but also closely linked to the question of the period to which Menander belongs, is his quality as a playwright.

Menander's deceptive simplicity, moralizing stance, and predictable plots have not been universally admired. Modern literary criticism of Menander began on a decidedly negative note around 1800, when Friedrich and August Wilhelm Schlegel pronounced their verdict; this was a century before the sands of Egypt released his first plays. According to the Schlegel brothers, the tragedies of Euripides are filled with telltale signs of literary and cultural decline which foreshadow the "mixed and derivative" genre of New Comedy and set the stage for Menander, who is urbane and philosophically inclined but whose plots and characters are "monotonous."[30] In more recent times, one of Menander's harshest detractors, a historian of Alexander the Great and the Hellenistic period, described him as "the dreariest desert in literature."[31]

Even his most sympathetic readers are less than lavish with praise. Wilamowitz, still Menander's most brilliant interpreter, admired the "uniformity and purity" of his style but castigated the provincialism of the social milieu from which his characters are drawn.[32] His target was not so much Menander per se as the Athenian society depicted in his

30. F. von Schlegel, *Studien des klassischen Altertums*, Kritische Friedrich-Schlegel-Ausgabe 1 (Paderborn, 1979), esp. 12, 14f., 33, 60–68. A. W. von Schlegel touched upon Euripides, New Comedy, and Menander in his Berlin lectures of 1802/1803, published by Jacob Minor as *Vorlesungen über schöne Litteratur und Kunst* (Heilbronn, 1884) 2:105 ("mixed and derivative") and 358; his more detailed comments can be found in the Vienna lectures of 1808: "Vorlesungen über dramatische Kunst und Literatur, Erster Teil," in *Kritische Schriften und Briefe*, E. Lohner, ed. (Stuttgart and Berlin, 1962–67) 5:100–110, 115–130, 156–168. The Schlegel brothers disagreed on the period of Greek literature to which Menander belonged. Whereas Friedrich Schlegel regarded the poets of New Comedy as the representatives of the last and "weakest" stage of Attic literature, his brother assigned them to the Hellenistic period, which he described as "learned and artificial"; cf. Kassel, *Abgrenzung des Hellenismus*, 16f. Both Schlegels clearly considered New Comedy second-rate, but like Winckelmann before him, Friedrich Schlegel appreciated the best qualities of Menander insofar as they could be gleaned from the scarce fragments or from his Roman imitators.

31. W. W. Tarn and G. T. Griffith, *Hellenistic Civilization*, 3d ed. (London, 1952), 273.

32. Wilamowitz, *Kleine Schriften* (Berlin, 1935–72) 1:269. By emphasizing the "purity" of Menander's Attic diction, he condemned the poet's Atticist critics (see below, n. 37). The questionable concept of Menander's stylistic "uniformity" is borrowed from Plutarch's eulogy of Menander in his "Comparison of Aristophanes and Menander" (in particular the phrase ἡ δὲ Μενάνδρου φράσις . . . μία τε φαίνεσθαι καὶ τὴν ὁμοιότητα τηρεῖν, *Moral.* 853 D–E), where it seems to refer to the uniformity of the playwright's style, which transcends the diversity of his dramatic characters. Against Plutarch's theory of a "single style" in Menander, see F. H. Sandbach, "Menander's Manipulation of Language for Dramatic Purposes," in *Ménandre*, ed. E. G. Turner, Fondation Hardt, Entretiens 16 (Vandoeuvres and Geneva, 1970), 113–136.

plays—its "provincial confinement," the "dreariness and frivolity" of the "Athenian philistines" with their "narrow conventions" and "misery of life."[33] He treated the characters of Menander as real-life Athenians and took them severely to task for their lack of higher motivation: "The entire genre is diminished by the fact that the life so faithfully mirrored by Menander was so narrow and philistine and the people so totally deprived of ideas, solely attentive to the pursuit of common pleasures in their youth, and of common profit in their old age."[34] But literary realism is not the same thing as historical reality, and the notion that the plays of Menander constitute a mirror image of Athenian society during the last quarter of the fourth century is no longer tenable. The new plays have given us a better idea of what Aristophanes of Byzantium might have had in mind when he said that Menander "imitated life."[35] The breastfeeding that takes place offstage in the *Samia* (265ff.) and the discovery of the decomposed corpse along with the battered shield reported in the *Aspis* (68ff.) are fine examples of a realism capable of generating enormous dramatic momentum that keeps the action going until the various confusions are resolved. The soldier believed to have died on the battlefield eventually returns home alive (*Aspis* 491ff.), and the wet nurse who has been mistaken for the baby's mother is replaced by the true mother in a mirror scene that sets the record straight and prepares the happy resolution and closure (*Samia* 535ff.).

Does Menander rank as a classic? Given his tremendous influence on Roman comedy, not to mention the subtle Menandrean echoes in Catullus, he surely ranked as a classic in antiquity.[36] But such value judgments

33. Wilamowitz, *Kleine Schriften* 1:229, 269.

34. Wilamowitz, "Griechische Literatur des Altertums," 196. His verdict was inspired by Theodor Mommsen's biting condemnation of New Comedy (*Römische Geschichte*, 9th ed. [Berlin, 1902–4] 1:889ff.); cf. R. Kassel, "Wilamowitz über griechische und römische Komödie," *ZPE* 45 (1982): 271–300, esp. 294.

35. Syrianos *In Hermog.* 2.23 Rabe = Menander test. 32 Körte = Aristoph. Byz. test. 7 Slater; cf. Nesselrath, *Mittlere Komödie*, 181 n. 92. On Menander's realism see E. W. Handley, *The Dyskolos of Menander* (London, 1965), 12–14, who reminds us that reading Menander as if his plays were a mirror of real life amounts to the documentary fallacy ("his plays are plays and not documentary records"). Despite the caution urged by Handley, the traditional literal reading of Aristophanes' dictum looms large in G. Zanker, *Realism in Alexandrian Poetry: A Literature and Its Audience* (London and Sydney, 1987), 110f., 145, 149: Menander was preoccupied with "the representation of everyday life" and "portrayed the lives of people in Aristotle's 'average citizen' category" (cf. Aristotle, *Poetica* 1448a4ff.). Zanker ultimately echoes Wilamowitz (see *Menander, Das Schiedsgericht* [Berlin, 1925], 164; "Griechische Literatur des Altertums," as quoted in the text above at n. 34).

36. See E. W. Handley's inaugural lecture, *Menander and Plautus: A Study in Comparison* (London, 1968), which opened a new era in the study of Roman comedy by comparing for the first time scenes from Plautus with their Greek original; E. Fantham, "Roman Experi-

are never cast in stone; they tend to change, not only over time but also from person to person. Literary taste, personal preference, and special pleading play as important a role in these matters today as they did in antiquity. In the eyes of Aristophanes of Byzantium, Menander ranked second only to Homer; by contrast, the Atticists of the imperial period preferred the purity of Attic diction in the comedies of Aristophanes to the alleged "anomalies" of Menander's Greek.[37] His name disappeared from the ancient canon of school authors at some time in late antiquity, but the reasons for his declining fortunes remain obscure.[38] His plays were no longer copied after the seventh century; Byzantium ignored him. Beginning in 1898, successive papyrus finds have put the criticism of the poet and his art on a new foundation. The modern revaluation of Menander which they inaugurated is still in progress. His enhanced status is reflected in the number of new editions, commentaries, and monographs that have appeared in recent years. He is also one of the few Greek authors with less than impeccable classical credentials included in many graduate reading lists. After more than a millennium of inaccessibility, misappreciation, and mixed reviews Menander appears to have finally rejoined the exclusive circle of "canonical" authors.

In important respects, the distinctive quality of Menander is hardly in doubt—his name is permanently attached to Athenian drama, New Comedy, and five-act plays in which domestic conflicts dominate. We cannot, however, easily assign him a niche in periodizing schemes of literary history; the crisis of his Hellenistic identity is likely to remain.

III. THE IDENTITY OF THE POET AND THE CRISIS OF THE HERO: APOLLODORUS AND THE *MEROPIS*

The name of Apollodorus of Athens (ca. 180–110 BC) occurs repeatedly in Parsons' pages, both as the author of a chronographic compendium of Greek political and cultural history written in iambics and as the collector and interpreter of divine epithets in a prose work ambitiously entitled "On the Gods" (Περὶ θεῶν). A substantial new fragment of that

ence of Menander in the Late Republic and Early Empire," *TAPhA* 114 (1984): 299–309; R. F. Thomas, "Menander and Catullus 8," *RhM* 127 (1984): 308–316.

37. Aristophanes of Byzantium as quoted in *IG* 14.1183 (= Menander test. 61c Körte); Phrynichos *Ekloge* 394 and 401 Fischer (= Menander test. 46 and F 357 Körte). Cf. Wilamowitz, *Kleine Schriften* 1:254, 328–331; idem, *Schiedsgericht*, 156–160; D. Del Corno, *Menandro: Le commedie* (Milan, 1966) 1:70f., 81–85.

38. Cf. Wilamowitz, *Kleine Schriften* 1:247 n. 1; idem, *Schiedsgericht*, 171 (where he dates the disappearance of Menander in the time of the iconoclastic controversies); A. W. Gomme and F. H. Sandbach, *Menander: A Commentary* (Oxford, 1973), 2 n. 5; P. E. Easterling in the *Cambridge History of Classical Literature* 1:39.

work came to light on a Cologne papyrus. Published in 1976, it has received considerable attention.[39] The fragment is part of Apollodorus' extensive treatment of the epithets of Athena. Embedded in his discussion is a series of quotations from a hexametrical poem called *Meropis*, which gave an epic account of Heracles' Coan adventures. In his introduction to these excerpts, Apollodorus recalls how he discovered this unknown epic and what his first reaction was:

περιεπέσομεν δὲ ποιήμασιν, ἐφ᾽ ὧν ἦν ἐπιγραφὴ Μεροπὶς οὐ δηλοῦσα τὸν ποήσ⟨α⟩[ντα].

I came upon a piece of poetry[40] bearing the title *Meropis*, with no indication of who composed it.

After a summary of the poem's narrative, he continues:

ἐδόκει δέ μοι τὰ ποήμα[τα] νεωτέρου τινὸς εἶναι· διὰ [δὲ] τὸ ἰδίωμα τῆς ἱστορίας [ἐξε]λάβομεν αὐτό.

The poem looked post-Homeric to me. I excerpted (?) it because of the peculiarity of the story.[41]

Apollodorus' comments are a rare specimen of Hellenistic scholarly prose; what is more, they are paradigmatic of the constraints as well as the opportunities that defined Alexandrian scholarship. He had discov-

39. Koenen and R. Merkelbach in *Collectanea Papyrologica: Texts Published in Honor of H. C. Youtie*, A. E. Hanson, ed., part 1, PTA 19 (Bonn, 1976), 3–26; B. Kramer in *P. Köln* 3.126; Lloyd-Jones and Parsons, *Suppl. Hell.* 903 A; H. Lloyd-Jones, "The *Meropis*," in *Atti del XVII Congresso Internazionale di Papirologia* (Naples, 1984) 1 : 141–150 (reprinted in his *Greek Epic*, 21–29); A. Bernabé, *Poetarum epicorum Graecorum testimonia et fragmenta* (Leipzig, 1988) 1 : 131–135 (with full bibliography). Additional fragments of Περὶ θεῶν: FGrH 244 F 88ff., with Jacoby's commentary; *P. Oxy.* 20.2260, 37.2812; J. S. Rusten, *Dionysius Scytobrachion*, Papyrologica Coloniensia 10 (Opladen, 1982), 30–53.

40. Πο(ι)ήματα normally means "poems," but as a synonym of ἔπη it can also introduce "consecutive lines of a single poem" quoted as an excerpt (P. J. Rhodes on Arist. *Ath. Pol.* 5.3, the earliest instance): Dion Hal. *Antiquitates Romanae* 1.41.3, τὰ δὲ ποιήματα ὧδ᾽ ἔχει (followed by Aesch. F 199.1–3 Radt) versus Apollodorus' εἶχεν δὲ [τὰ ἔ]πη οὕτω (followed by *Meropis* F 1 Bernabé). As used by Apollodorus, however, πο(ι)ήματα refers to a single epic poem of unknown length, the *Meropis*. Half a century ago, in his discussion of Cicero *Ad Quint. fratr.* 2.9.3 *Lucreti poemata*, F. H. Sandbach had come to the conclusion, now invalidated by Apollodorus, that the plural πο(ι)ήματα could not denote a continuous poem (*CR* 54 [1940]: 75–76).

41. The supplement [ἐξε]λάβομεν, first proposed by Koenen and Merkelbach, in *Collectanea Papyrologica,* has been universally accepted, but it involves two anomalies. The required meaning "to excerpt" appears to be unattested elsewhere, and the singular αὐτό agrees, exceptionally, with the plural πο(ι)ήματα of the preceding sentence, perhaps because Apollodorus was thinking of one poem (previous note). Alternative supplements such as [ἀνε]λάβομεν αὐτό ("I recapitulated it") or [ὑπε]λάβομεν αὐτό ("I assumed so") seem to be less likely.

ered a new poem, perhaps in the library at Alexandria or Pergamum, whose mythical material fascinated him. But when he tried to place the poet and his work in the history of Greek epic, he ran into difficulties. His papyrus gave the title but not the author, who was anonymous, like most of the other poets of early epic—ὁ τὴν Τιτανομαχίαν ποήσας, ὁ τὴν Φορωνίδα συνθείς, ὁ τὰ Ναυπάκτια συγγράψας, and in the same vein ὁ τὴν Μεροπίδα [ποήσ]ας.⁴² Undeterred, Apollodorus yielded to his two most basic philological instincts—his sense of curiosity and his desire to preserve this find for posterity. He excerpted it, thus assuring its survival into the next century, when Philodemus would quote the *Meropis* from Apollodorus, and ultimately into modern times.⁴³

The *Meropis* is not a good poem, but are its shortcomings those of archaic, classical, or Hellenistic poetry? Apollodorus' own dating criterion was crude but functional. Is the poem Homeric or post-Homeric? he asked.⁴⁴ The poem is certainly nowhere near Homer in tone, or texture, as Apollodorus saw. His modern heirs can't do much better, but the terms of the question have changed. In the current debate over the *Meropis*, scholars ask themselves whether the poem is Hellenistic or pre-Hellenistic. By addressing the identity of the *Meropis* in these terms we admit ignorance of much of the history of Greek epic in the archaic and classical period; at the same time, we recognize the special status of the Hellenistic age and its literature, including the rich and varied corpus of Hellenistic epic.

Parsons and Sir Hugh Lloyd-Jones justified the inclusion of the *Meropis* in their *Supplementum Hellenisticum* by assigning it a date in the fourth or third century. To account for the poem's complete lack of Al-

42. For these and similar titles see Henrichs, "Ein Meropiszitat in Philodems *De Pietate*," *Cronache Ercolanesi* 7 (1977): 124f.; Bernabé, *Poetarum epicorum Graecorum*, on *Titanomachia* test. 2, F 1, 4; *Phoronis* F 1, 3, 5; *Naupaktia* F 2, 3, 6, 8, 10, 11; *Meropis* F 6.

43. Apart from Apollodorus, Philodemus in *De pietate* is the only ancient witness for the existence of the *Meropis*. Gelzer cites the *Meropis*, without commenting on its date, as a characteristic instance of the tendency of the "new poets" of Alexandria to rediscover "obscure poets" and to give them "a new lease on life." It is surprising to see Apollodorus included among the "new poets"; the iambic verse of his *Chronika* was modeled on Menander and New Comedy, a genre which Gelzer does not consider Hellenistic (see above, section I).

44. In the parlance of Aristarchus, one of Apollodorus' teachers, οἱ νεώτεροι are poets writing after Homer—Hesiod, Ibycus, Pindar, the three tragedians, Antimachus, Callimachus, and Aratus, to mention only a few, are all νεώτεροι, just like the poet of the *Meropis*. When Cicero speaks of the *poetae noui* of Rome and Gelzer of the "new poets" of Alexandria, they redefine the Aristarchean term to signal the emergence of a new "modernism" which was not only post-Homeric but postclassical (for Gelzer) and post-Ennian (for Cicero). See Cameron, *HSCP* 84 (1980): 135–141; Rusten, *Dionysius Scytobrachion*, 32; Lloyd-Jones and Parsons, *Suppl. Hell.* 944.6 (commentary).

exandrian finesse, we would have to assume that its author did not live on Cos, as his interest in the island's mythology might suggest, but in one of the remotest cultural backwaters of the Hellenistic world. In addition, he must have taken so little pride in his work that he wished to remain anonymous. All of this is very unlikely. One also wonders how an obscure provincial poem that lacked antiquity would ever have come to Apollodorus' attention. Not surprisingly, the *Meropis* would be the only specimen of this kind that survived. In a separate article, Lloyd-Jones therefore took a different view and argued for a date in the sixth century. He points to the un-Hellenistic awkwardness of much of the Homeric imitation found in the *Meropis* and compares its "lumbering and pedestrian narrative" with the "flatness and dullness" of the "sub-Homeric style" found in the fragments of the *Cypria* and the *Phoronis.*[45] This is indeed the poetic ambience in which the *Meropis* seems to belong; both its narrative structure and its diction suggest very strongly that its author should be regarded as an epic poet of the late archaic rather than the Hellenistic period.

Already Apollodorus noticed the peculiar narrative (τὸ ἰδίωμα τῆς ἱστορίας) of the *Meropis*, which centers on a Coan adventure of Heracles that almost cost him his life.[46] The hero confronts a monstrous aborigine, Asteros, who turns out to be invulnerable. Three times Heracles aims his arrows at Asteros, and each time the arrow bounces off Asteros' impenetrable skin "as if from an unbending rock." As the crisis reaches its climax, "a bitter anguish seized Heracles." He is saved from certain death by the sudden appearance of Athena. She descends accompanied by roars of thunder, and makes her epiphany:

> κ[αί νύ] κεν Ἡρακλῆα κατέκτ[ανεν], εἰ μὴ Ἀθήνη
> λάβρον [ἐπεβρόν]τησε διὲκ νεφέων κα[ταβᾶ]σα·
> πληξαμένη θέν[αρι] δ᾽ ἀπαλὸν χρόα πρόσθ[ε φαάν]θη
> Ἡρακλῆος ἄνακτ[ος· ὃ δ᾽ εἴ]σιδεν ἄσθματι θυίω[ν]
> [γνῶ τε] θεόν. (F 3)

> And (Asteros) would have killed Heracles, if Athena had not
> thundered mightily as she descended through the clouds.
> Striking her delicate flesh with her palm she appeared before
> lordly Heracles. And he, raging with his breath,
> noticed and recognized the goddess.

After the recognition Athena instructs Heracles to retreat, but her speech is not preserved. As soon as the hero is out of harm's way, she

45. Lloyd-Jones, "The *Meropis*," 149 = 28. Bernabé too assigns the poem to the sixth century.

46. On the Coan myth of Heracles, including the flaying of Asteros by Athena, see Koenen and Merkelbach, *Collectanea Papyrologica*, 16–26.

turns to Asteros and impales him with her spear ("immortal casts are not like mortal casts"). At once "the dark gloom of death sets upon his eyes," and he expires. The episode ends with Athena flaying Asteros' body, anointing the hide with nectar (or ambrosia), and wrapping it around her as a protective armor. Rather oddly, she leaves the scene with the skinned corpse of Heracles' enemy—hands, feet, and all—dangling around her body.[47]

Even more peculiar than the poem's narrative is its diction. The poet of the *Meropis* can tell a conventional story, however haltingly, but when he tries to depict the emotions of Heracles and Athena, he settles for vacuous cliches which stay on the surface of his characters and fail to reveal their inner dimension. Athena inexplicably "strikes her delicate flesh" (πληξαμένη θέν[αρι] δ' ἀπαλὸν χρόα) as she comes to Heracles' rescue.[48] In comparable moments of imminent danger, three Homeric heroes, Achilles, Patroclus, and Odysseus, slap their thighs to express grief or tension (*Iliad* 15.397 = *Odyssey* 13.198: ὣ πεπλήγετο μηρώ; *Il.* 16.125: μηρὼ πληξάμενος); Metaneira too "strikes both her thighs" because she is beside herself with fear when she finds out that Demeter has been hiding her son in the fire (*Hymn. Hom. Dem.* 245f.: κώκυσεν δὲ καὶ ἄμφω πλήξατο μηρὼ / δείσασ' ὧι περὶ παιδὶ καὶ ἀάσθη μέγα θυμῶι).[49] Invariably we are told how the impulsive behavior reflects the hero's or heroine's feelings. By contrast, the *Meropis* leaves us wondering why a goddess powerful enough to succeed where Heracles fails is so upset in the first place. Is Athena beating her thighs because she fears for Heracles' life? Or does she rather knock her breast the way Odysseus "knocked his breast" (*Od.* 20.17: στῆθος δὲ πλήξας) to reassure himself before he addressed his heart? The emotional intensity of Athena's

47. *Meropis* F 6.4 Bernabé: αὐταῖς σὺν χ[είρεσσι καὶ] εὐρήεσσι πεδίλοις, a description inspired by poetic images of Heracles dressed in the equally impenetrable skin of the Nemean lion (Henrichs, *ZPE* 27 [1977]: 69–75). Apollodorus' paraphrase (σύν τε τοῖς [πο]σὶν καὶ ταῖς χερσὶ περιθέσ[θα]ι) indicates that the idiosyncratic poet of the *Meropis* used πεδίλοις ("boots") catachrestically for πόδεσσι (cf. Homer *Iliad* 20.189, 21.564: ταχέεσσι πόδεσσιν). Lloyd-Jones, "The *Meropis*," 148 = 28, reads χ[ειρῖσι], a Homeric hapax, and renders "with armguards and wide footguards" fashioned by Athena out of the hide. An Athena in oversized, makeshift footwear would make an even more remarkable sight; but the large πέδιλα fit the giant better than the goddess.

48. Commentators cannot decide whether the ἀπαλὸν χρόα struck by Athena is that of Asteros (whose skin is hard like a rock), Heracles, or Athena herself. They seem not to notice that πληξαμένη must be reflexive, as in the four Homeric passages quoted in my next sentence.

49. Ares "struck his stout thighs" (Hom. *Il.* 15.113: θαλερὼ πεπλήγετο μηρώ) when he heard of his son's death. Donald Lateiner draws my attention to S. Lowenstam, *The Death of Patroklos: A Study in Typology* (Königstein, 1981), 31–67, who interprets the Homeric gesture of thigh-slapping as an "omen of death."

epiphany is evident, but its effect is seriously undermined by the inadequacy of the motivation.

Nor does the *Meropis* give an adequate idea of Heracles' condition. Heracles is unquestionably in dire straits. His state of mind at the moment Athena makes her epiphany is described in two words, ἄσθματι θυίων, which recall Homeric formulas of the type οἴδματι θύων (*Il.* 21.234, 23.230) and λαίλαπι θύων (*Od.* 12.400, 408, 426). Compared with Homer's word pairs, the collocation of ἄσθματι and θυίων is highly incongruous. Powerful agents such as λαίλαψ or οἶδμα are needed to generate the destructive fury conveyed by the verb θύω/θυίω. But the breath of Heracles does not have the same power as the wind or the waves. On the contrary, the standard epic use of ἄσθμα suggests a seriously diminished strength; in Homer ἄσθμα and ἀσθμαίνω are clear symptoms of physical exhaustion, injury, or imminent death.[50] Is Heracles breathing hard only because he is fighting Asteros, or is he literally at his last gasp? A Heracles whose strength or resolve has been weakened would be consistent with his predicament, but the inherent force of θυίω seems to require the opposite scenario, namely that Heracles is going strong and panting with rage.[51] Unlike Homer, Pindar, and Apollonius of Rhodes, the poet of the *Meropis* does not understand that the semantic fields of ἄσθμα and θύω are virtually incompatible. Once again he has created an ambiguity which undercuts the coherence of one of his central characters.

Both diction and narrative suggest that this poem that so intrigued Apollodorus is not in its various inadequacies Hellenistic but rather archaic. Even an extremely provincial poet writing in the late fourth or early third century would have been more conscious of Homeric diction, and more consciously derivative, than the poet who composed the *Meropis.*[52] On the other hand, the structure of a Hellenistic epic would differ profoundly from Homer in ways entirely foreign to this poem. This impression is confirmed if we briefly compare Heracles' crisis in the *Meropis* with another crisis, one that marks the turning point in the voyage

50. Panting from physical exhaustion: Hom. *Il.* 10.376, cf. Ap. Rhod. *Argon.* 1.1256, 2.85, 431; from injury: Hom. *Il.* 15.10, 241, 16.109; death rattle: Hom. *Il.* 5.585 = 13.399, 10.496, 16.826, 21.182, *Hymn. Hom. Ap.* 359, cf. Pind. *Nem.* 10.74: ἄσθματι δὲ φρίσσοντα πνοάς (of Castor dying). *Meropis* F 4.1 Bernabé shows Heracles on his feet and leaving the scene shortly after Athena's epiphany. If he was near death, Athena must have revived him.

51. Cf. Hom. *Il.* 1.342: ὀλοῇσι φρεσὶ θύει; 11.180 and 16.699: ἔγχεϊ θῦεν; 22.272: ἔγχεϊ θύων; cf. Pind. *Pyth.* 3.32–33: μένει θυίοισαν ἀμαιμακέτωι (of Artemis "furious with irresistible rage"); Ap. Rhod. *Argon.* 3.755: πυκνὰ δέ οἱ κραδίη στηθέων ἔντοσθεν ἔθυιεν (of Medea in love).

52. Lloyd-Jones, "The *Meropis*," 149 = 28.

home of the Argonauts as Apollonius of Rhodes depicts it. Some of the differences have to do with the vastly different abilities of the two poets; still, such a comparison will sharpen our eye for the distinctive qualities of a decidedly Alexandrian articulation of the heroic crisis by the foremost epic poet of the Hellenistic period.

The Jason of the *Argonautica* represents a new type of epic hero, defined more by his weaknesses than his strengths. Self-doubts, despondency, and a general incapacity to act decisively—his ἀμηχανίη—are among his most conspicuous traits. When he rises to the occasion, he succeeds because others supply the qualities he lacks; when he fails, he does not succumb to the superior strength of an external enemy, like the Heracles of the *Meropis*, but is paralyzed by his inner complexities and eclipsed by the very forces that enable him to accomplish his task. Yet it is precisely from his numerous failings that Apollonius' Jason derives his unique character and persuasive power as a literary figure.[53]

Nowhere is Jason's lack of leadership more serious, and his paradoxical role as the reluctant catalyst of heroic endeavor more obvious, than when the *Argo* lies becalmed in the shoals of the Syrtis and the Argonauts find themselves stranded in the Libyan desert—the longest and most desperate crisis in the entire epic (*Argonautica* 4.1223–1392). Once they recognize the desolation that surrounds them, Jason and his crew are overcome by anguish—ἄχος δ' ἕλεν εἰσορόωντας (4.1245). Variations of the same formula mark the height of the heroic crisis and the imminence of divine intervention in the *Iliad* (*Il.* 1.188: Πηλείωνι δ' ἄχος γένετ') as well as in the *Meropis* (F 2.4f. Bernabé: πικρ[ὸν δ' ἄ]χος ἔσχεθεν Ἡρακλ[ῆα] / [ὧς] ἴδεν). In both episodes, Athena's epiphany follows within a few lines. In the *Argonautica*, however, the crisis as well as the ἄχος of the heroes is prolonged, magnified, and internalized for more than sixty lines until it becomes a symbolic death (4.1245–1304). First, the Argonauts wander aimlessly along the beach like ghosts; then, at nightfall, they tearfully embrace one another, veil their heads, and lie down in the sand each in a separate place, ready to die; throughout the night Medea's Colchian maidservants perform the ritual lament, while Jason remains secluded and speechless. Only when the heroes have lost all hope does the long-delayed epiphany finally take place. But instead

53. Recent attempts to define the paradox of Jason's heroism differ widely, but coincide in a reading that recognizes Jason's various "flaws" as the uniform source of his new heroic vitality; see G. Lawall, "Apollonius' *Argonautica*: Jason as Anti-Hero," *YClS* 19 (1966): 119–169; C. R. Beye, *Epic and Romance in the Argonautica of Apollonius* (Carbondale, 1982), 77–99 (Jason as love hero); R. L. Hunter, "'Short on Heroics': Jason in the *Argonautica*," *CQ* 38 (1988): 436–453 (on Apollonius' recasting of less than heroic features of the Homeric hero and, more surprisingly, of ephebic initiation).

of Athena or Hera, the two Olympian protectresses of the Argonauts, a triad of local divinities, the Heroines of Libya (ἡρῶσσαι Λιβύης), appear to Jason in his seclusion and predict a safe return to Greece.[54]

Without exception, the epiphany scenes in the *Argonautica* drastically rewrite the scenario of divine self-revelation that has formed the conventional conclusion to a heroic crisis since Homer. In Apollonius, the major Olympian gods remain either silent or invisible. Apollo appears twice but does not speak; Athena's intervention at the Clashing Rocks is seen and described by the poet as narrator, but the heroes cannot see their goddess; and finally, on the return voyage, Hera leaps down from heaven only to emit one inarticulate shout that directs the Argonauts back onto the correct course.[55] Unlike the Olympian gods, the enigmatic Libyan Maidens, who are described as χθόνιαι θεαὶ αὐδήεσσαι by Apollonius (4.1322), do speak in an articulate voice that is also prophetic. But their revelation takes the form of a riddle, which the Argonauts must solve if they want to return home; by contrast, the instructions which the Homeric Achilles and the Heracles of the *Meropis* receive from Athena are self-explanatory and unambiguous.

Even at the very conclusion of the crisis, Apollonius introduces another un-Homeric complication by turning the heroic crisis into a battle of wits that reveals Peleus and not Jason as the hero of the moment. Once again Jason becomes here an ambivalent hero who combines heroic and unheroic qualities—on the one hand, his inability to solve the riddle briefly intensifies the crisis; on the other hand, he alone among the Argonauts is visited by the Libyan Maidens and receives their revelation.

The heroes of Apollonius, Jason in particular, live in a world different from that of Heracles and Athena in the *Meropis*. They face different problems, the gods reveal themselves differently, and the nature of the heroic crisis itself is different. I have tried to suggest some reasons why the differences are so great as to make it virtually certain that the *Meropis*, the poem that caught the attention of Apollodorus and divides modern critics, does not belong in a Hellenistic ambience. Apollonius' Jason

54. The most interesting and detailed study of Jason's encounter with these goddesses is N. E. Andrews, "The Poetics of the Argonautica of Apollonius of Rhodes: A Process of Reorientation. The Libyan Maidens" (PhD diss. Harvard, 1989).

55. Athena: Ap. Rhod. *Argon.* 2.537–538, 598–603; Apollo: 2.669–684, 4.1694–1718 (cf. Callimachus, Lloyd-Jones and Parsons, *Suppl. Hell.* 250–251 and F 18 Pfeiffer); Hera: 4.640–644. The unconventional absence of communication between Olympian gods and mortals in Apollonius has been noticed by L. Klein, "Die Göttertechnik in den Argonautika des Apollonios Rhodios," *Philologus* 86 (1931): 18–51, 215–257, esp. 236, 253; and more poignantly by H. Fraenkel, *Noten zu den Argonautika des Apollonios* (Munich, 1968), 539 n. 172.

is a Hellenistic hero. He too will continue to raise controversy because as a literary figure he is himself the product of a controversial and crisis-prone period, but the controversy is of a very different nature.

Karl Reinhardt has shown that the concept of the hero in literature, which prominently includes the heroic crisis, is itself prone to crisis. In periods of profound cultural change, the heroic ideal is accepted reluctantly or not at all, and the literary hero changes his identity or is even in danger of losing it. Reinhardt referred to the deconstruction of the hero in the first half of the twentieth century poignantly and paradoxically as "die Krise des Helden." In the conclusion of his essay, he hinted that the best solution to the crisis involving the hero might be to come to terms with the crisis in the hero himself.[56] In the context of Greek poetry, Reinhardt associated the crisis of the hero particularly with the end of the fifth century and with Euripides; we can, it seems to me, profitably extend the concept of the hero's crisis not only to Apollonius of Rhodes but to other Hellenistic poets and genres as well.[57]

56. K. Reinhardt, "Die Krise des Helden" in *Tradition und Geist: Gesammelte Essays zur Dichtung*, C. Becker, ed. (Göttingen, 1960), 420–427 (reprinted in *Die Krise des Helden und andere Beiträge zur Literatur- und Geistesgeschichte* [Munich, 1962], 107–114), at 427 = 114: "Das beste Mittel, um die Krise um den Helden zu überwinden, wäre, wie ich glaube, die Krise im Helden selber." In a subsequent essay, Reinhardt applied the concept of the heroic crisis in both its literary and its cultural sense to Euripides in "Die Sinneskrise bei Euripides," *Tradition und Geist*, 227–256.

57. I am grateful to Professor Anthony W. Bulloch, Sir Hugh Lloyd-Jones, and Professor Richard Thomas for various improvements.

Self-definition in Hellenistic Art

Introduction

Andrew Stewart

Hellenistic consumers of what we now call "art" lived in a society that was riven with internal tensions. Alexander had changed the Greek world forever, but the polis was still there; its norms were still intact and its institutions still functioned. Even its most treasured possession, its political freedom, was often explicitly guaranteed by the kings who had now inherited Alexander's legacy of empire. Yet such guarantees only showed how much things had changed since the fourth century: as Aeschines observed, even during Alexander's own lifetime, the Greek poleis were now beholden to the victor and subject to his whim (3.132–134). Demetrios of Phaleron put it even more harshly: Lady Luck had given the Macedonians the whole world, until such time as she decided to change her mind (Polybius 29.21.1–6).

Hellenistic art registers this state of affairs in a number of ways. Archaic and Classical Greek art had developed their characteristic forms in the service of the independent polis, and its genres—the temple, the athlete statue, the gravestone, the votive relief or picture, and so on—were closely bound up with the polis's needs. Now, not only did the sheer extent and diversity of the Hellenistic kingdoms have a fragmenting effect upon the hitherto fairly unified traditions of architecture, sculpture, painting, and the minor arts, but the appearance of new patrons, from kings and courts to half-Hellenized Levantines or Bactrians, encouraged the appearance of new, often diametrically opposed, modes and styles. Finally, to compound the confusion, the fourth-century masters had already achieved such a daunting command of ways and means that many traditional genres were now all but closed to further development.

The papers of Professors Smith and Zanker, and Professor Ridgway's

response to them, assess the impact of this situation upon two classes of Hellenistic sculpture, the portrait and the gravestone. These were public monuments, a context in which the self-image of Hellenistic men and women was most self-consciously developed and presented. In keeping with recent thinking in the history of art, these papers do not ask how this or that aspect of Hellenistic self-awareness, achieved elsewhere by another process, is *reflected* in the works they address. Instead, they treat these portraits and gravestones as cultural forms in their own right, as loci in which and through which Hellenistic men and women came to understand and cope with the circumstances in which they lived. Using literature and inscriptions alongside the monuments, they introduce us to that rich constellation of practices and artifacts which the Hellenistic world developed in order to codify, perpetuate, and project its ideas and its values.

Professor Smith's paper begins by reminding us of two crucial developments in late Classical culture: the increasing separation of roles in the citizen body of the polis, and the simultaneous elaboration of visual languages of dress, coiffure, gesture, and posture that could speak to these roles. Yet in the early Hellenistic cities, these languages have to include not merely the traditional citizen audience in their address, but another: the kings and their friends. Philosophers and orators take on the roles of defenders of the polis and standard-bearers for its values, and their portraits increasingly come to register their self-importance in these roles. Meanwhile, the kings develop a language of power, one based on forms that had long been traditional for divine or heroic beings, but now incorporating subtle distinctions that identify them as "first, last, and in the middle, the most excellent of men" (Theokritos 17.3–4).

Juxtaposed in city squares or sanctuaries, as they so often were, the two iconographies must have had a much sharper effect upon the observer than, seen in isolation, they do today; opinions would be polarized and ethical distinctions reinforced. Further work in this field might profitably focus on the ongoing effects of such lack of closure, taking what historians of sculpture have hitherto tended to see only as internal stylistic or iconographic developments, and rethinking them as products of the tensions generated by the continuing tug-of-war between these two poles of Hellenistic society.

Professor Zanker's paper returns us to the immediate confines of the polis proper, tackling two interrelated and oft-debated issues: the existence of local schools of sculpture in particular regions or cities, and the existence of local cultural traditions. In the case of Hellenistic Smyrna, he shows that the one predicates the other: that certain local cultural norms were sufficiently powerful to invite concretization in the city's fu-

neral monuments, and sufficiently distinctive to enable us to read them at two thousand years' remove.

The value system that he disinters shows not only considerable continuities with the Classical period but also a considerable degree of adaptation to the realities of life in the Hellenistic; the reliefs themselves mix tradition and novelty to present us with an intriguing picture of a society that is deeply conservative and self-conscious about the image it projects, in death as in life. (In a welcome aside, Professor Zanker remarks that the virtues these reliefs celebrate are civic, not class virtues; this is not the bourgeoisie alone that speaks in these monuments, but the whole polis collective.) Yet such conservatism is not total and unalloyed: women, for example, are dressed in the up-to-date fashions that identify them as sex objects par excellence, even while their poses and gestures remain eloquent of feminine modesty and decorum. The epigrams, too, offer a counterpoint—perhaps even a safety valve—to the overall self-repression of the images, in their open evocation of personal grief and pain.

Professor Ridgway offers further nuances to both of these papers. She correctly remarks that the situation vis-à-vis the gravestones is more complicated than one might think: dates are insecure and distribution not quite as tidy as appears at first sight. In addition, she emphasizes one more distinctive feature of the stelai: their borrowings from the repertoire of Classical and Hellenistic votive reliefs. They thus emerge as quasi votives to the dead, and on this plane link up with a class of monuments that are amply attested by inscriptions but have almost totally vanished today: the free-standing *naiskoi* with statues of the dead in the guise of Hermes, Demeter, and other gods and heroes before which cult was offered to the dead.

She further notes that the issue of the superhuman also obtrudes into the territory covered by Professor Smith's paper, and produces instances in which the fault lines between the various genres of public portraiture may not have been so clear-cut as we would like to suppose. As ever, our analysis will have to cope not only with the all but crippling losses we have sustained in the material record, but with the incredible diversity of the Hellenistic world, its variety from kingdom to kingdom, from region to region, from city to city, and last but not least, from person to person.

Kings and Philosophers

R. R. R. Smith

This paper looks at the meanings of different styles of portrait statue in the early Hellenistic period—in particular at portraits of kings and philosophers.[1]

By the later fourth century there had evolved a whole range of portrait styles that could be chosen in order to express a person's position and role in life. It is remarkable with what ease we seem to be able to distinguish, often with no documentation, athletes, orators, philosophers, and kings (fig. 1). I want to look quite simply at how and why this should be so and what roughly it means. What was the purpose of the visual stereotypes we are inclined to take for granted?

First, a word on the functions of the statues and on portrait style. Extrinsically, portrait statues were expensive, imposing, lifesize bronzes that functioned as the most highly valued currency in the benefaction-and-honors system of the Hellenistic city, and we hear a lot about them in literature and inscriptions.[2] Honorific statues were the most important concrete symbols of the honor or *timē* with which cities repaid benefactors. Kings were the most powerful benefactors and so received the most statues—being bronze, however, few have survived. Philosophers received few statues. Some of these were public statues, but probably more were quasi-public, set up in their academies and schools, often at their deaths.[3] We have many major examples (partly) preserved in excellent Roman copies.

1. I am very grateful to the late P. H. von Blanckenhagen for discussing this paper with me. It grew out of my work on royal portraits and develops an argument sketched in R. R. R. Smith, *Hellenistic Royal Portraits* (Oxford, 1988), chap. 11 (hereafter cited as *HRP*).

2. Discussed at length in Smith, *HRP*, chap. 3.

3. Public statues: (1) Zeno: Diogenes Laertius 7.6; (2) Epikouros: Diog. Laert. 10.9;

Intrinsically, a portrait statue expressed key defining aspects of its subject: that is, where he or she stood in the broad scheme of things. This was its visual function. I think that we are now beyond worrying about whether these people *really* looked like this. The point is they wanted to and no doubt tried to. What we call portrait style is made up of both art and real life. Life contributes the externals of real appearance—beards, hairstyles, clothes. We are all familiar with the potency of these aspects of self-presentation in life. Art simply makes the chosen self-image convincing and coherent.

I am concerned here with the late fourth and third centuries, the heyday of the kings and philosophers. Normal practice has been to treat all the portraits as a single phenomenon and to arrange them in one line of chronological development. There was some formal development in third-century portraits, but more significant, I think we will see, are the different portrait modes that correspond to different historical categories of person. What I want to do is to connect the most important changes and differences to broad historical circumstances, in particular the problematic relationship of the kings and the Greek cities.

In the early Hellenistic period, the Macedonian kings were a new form of political power outside and above the city-states, and a major theme of early Hellenistic history was the difficult relationship between city and king. The relationship was negotiated by a variety of means. The kings used diplomacy and benefactions. The cities offered honors and cults to the king, and their philosophers were tireless in offering free advice to kings in kingship treatises that prescribed correct royal behavior. Most of the philosophers we know about had defined their views on kingship in such a *Peri basileias* treatise. The philosophers were the city's intellectual spokesmen in its ideological confrontation with the kings.

I want to look first at the range of portraits used by leaders inside the cities, then to look outside, at kings and dynasts, to see what factors and ideas molded the various ways they were represented.

PHILOSOPHERS AND CITY POLITICIANS

The evolution of portraits in the Classical city can be seen as the creation of image styles for the different kinds of public roles emerging in Greek society. In the fifth century there had been just two main categories: youthful athletes and bearded elder citizens, whether writers or states-

(3) Chrysippos: Pausanias 1.17.2 and Cicero *De finibus* 1.39. Statues in schools: (1) Plato: Diog. Laert. 3.25; (2) Aristotle: Diog. Laert. 5.15, 51; (3) Straton?: Diog. Laert. 5.64; (4) Lykon: Diog. Laert. 5.69.

men. Writers and generals, for example, were not essentially different kinds of political being. A striking lack of visual differentiation between poets and generals was recently made plain when a fifth-century portrait type, long thought to be of the Spartan general Pausanias, turned out, in an inscribed example, to be in fact the poet Pindar.[4] This shows how far fifth-century writers and politicians used the same visual identity.

In the fourth century there began major separation of public roles in society, for which were created recognizably different modes—general, orator, philosopher. I look first at the philosophers, then come back to the politicians.

The notion of the man of thought, separate from the executive man, goes back to the portrait of Sokrates. The idea appears partly formed in the portrait types of Plato and Aristotle (fig. 2a)[5] and is brilliantly worked up in the retrospective portrait of Euripides, already in the 330s (fig. 2b).[6] This is a clear representation of the idea, current in the fourth century, of Euripides as the philosophical poet.[7]

The great period of the philosopher portrait was the third century, when it reached its widest range of expression. Instead of placing the relevant heads in a chronological line, it is worth asking what connection the considerable variation of philosophic portrait styles has to the orientation of the different schools. We miss a lot of potential subtlety here due to gaps in our secure identifications. But we can distinguish, I think, two major strands: on the one hand, the Cynic-Stoic image, on the other the Epicurean.

The Cynic is the most typically "philosophic" image, well expressed in the Hellenistic Antisthenes portrait (fig. 2c):[8] long, unkempt hair; straggling beard; crumpled, decaying features—expressive of an ostentatious disregard for vain appearances the better to concentrate on inner thought and moral purity. The Stoic founder Zeno was a radical of this kind, and Stoic self-representation came clearly to be modeled on that of the Cynics.

4. G. M. A. Richter, *Portraits of the Greeks*, abridged ed., R. R. R. Smith (Ithaca, N.Y., and London, 1984), 176–180. See now R. R. R. Smith, "Late Roman Philosopher Portraits from Aphrodisias," *JRS* 80 (1990): 132–135, pls. 6–7; J. Bergemann, *AM* 106 (1991): 157–158.

5. Aristotle (Vienna): G. M. A. Richter, *The Portraits of the Greeks*, 3 vols. (London, 1965), 173, no. 7, figs. 976–978 (hereafter cited as *POG*). Sokrates and Plato: Richter, *POG*, 109–119, 164–170.

6. Euripides (Naples): Richter, *POG*, 135, no. 13, figs. 717–719.

7. Euripides unusually *sophos*: Plato *Respublica* 568a and Aischines 1.151; the *skenikos philosophos*: Athenaeus 4.158e, 13.561a. Cf. L. Giuliani, *Bildnis und Botschaft* (Frankfurt, 1986), 139.

8. Antisthenes (Vatican): Richter, *POG*, 180, no. 1, figs. 1037–1039.

In the portrait of the Stoic Chrysippos (fig. 2d)[9] we have the most developed or intensified representation of this morally uplifting contrast between outer bodily decay and the vitality of the inner mind. More specifically, we may perhaps interpret this as a representation of Stoic *pneuma*, "vital breath or energy," and its connection with Stoic *logos*. We are shown that part of the universal mind that was lodged in the mortal sage Chrysippos.

The Epicureans used a quite distinct philosopher style. Two features stand out: good grooming and sameness. First, sameness. The portraits of the three school leaders, Epikouros, Metrodoros, and Hermarchos, cultivated a clearly related image type—a sort of philosophical dynastic likeness (figs. 3a–c).[10] This portrait homogeneity surely reflected both the close-knit or "family" structure of the school and the fixed nature of Epicurean doctrine. Epicurean thought was codified by the founder and remained unchanged to a quite unusual degree.

Second, grooming—a feature of Epicurean appearance noted in antiquity, explicitly in contrast with Stoics and Cynics.[11] The Epicureans have a well-ordered, harmonious appearance, with artfully arranged beards and hair. This is combined with a certain air of distance or hauteur, very different from the more "humble" Cynic-Stoic image. The Epicureans seem less concerned to take an overtly "ethical" stance. The two "junior" leaders have regular, rather bland features and a kind of placid impassivity which is intended, I think, as an expression of *modestia* beside the Master. The Epikouros portrait is more vigorous; its aggressive knitting of the brows is a strong ideal element that represents the Master's superior intellectual *deinotēs*.

Next to the philosophers, on the same wavelength, as it were, but further along the band, come the city politicians: the orators and generals. They have shorter, more well-kempt beards and neater hairstyles, and use a more dynamic, outgoing posture, expressive of executive capability. Good examples are the orator Aischines and the general Olympiodoros (figs. 4a–c).[12] They are presented as mature in years but with-

9. Chrysippos (British Museum): Richter, *POG*, 192, no. 9, figs. 1118–1120.

10. Epikouros and Metrodoros (Capitoline Museum): Richter, *POG*, 195, no. 1, figs. 1149–1150, 1153 = 201, no. 1, figs. 1230–1232. Hermarchos (Budapest): Richter, *POG*, 204, no. 16, figs. 1306–1309. See also V. Kruse-Bertoldt, "Kopienkritische Untersuchungen zu den Porträts des Epikur, Metrodor, und Hermarch" (Diss. Göttingen, 1975); B. Frischer, *The Sculpted Word: Epicureanism and Philosophical Recruitment in Ancient Greece* (Berkeley, 1982); and esp. H. Wrede, "Bildnisse epikureischer Philosophen," *AM* 97 (1982): 235–245.

11. Alciphron *Epist.* 3.19.3. On this and other contrasts between Stoic and Epicurean self-presentation, see esp. F. Decleva Caizzi's paper in Part Five.

12. Aischines (d. 314) (Naples): Richter, *POG*, 213, no. 6, figs. 1369–1371. Olympio-

out the insistence on aging and mortality seen in many philosopher portraits.

Between the Aischines and the philosophers—that is, in portrait conception—stands the remarkable Demosthenes (fig. 4d).[13] This was a posthumous statue set up in 280, and, with hindsight and probably as a deliberate reaction to the Aischines, it injects into the orator-politician image a whole layer of philosopher iconography. Demosthenes wears a simple himation with no tunic—a clear borrowing from philosopher images (cf. figs. 1c, d). The statue has a plain, "artless," four-square stance and conveys an internalized air, one of troubled introspection. It is a central monument for understanding the visual self-identity of the early Hellenistic city.

Portraits of early Hellenistic city leaders, then, spread across a spectrum from politicians to different kinds of philosophers. A nameless statue in the Capitoline (fig. 1d)[14] provides a full philosopher figure to set at the other end of this spectrum from the Aischines. It was a flabby, aged body, draped in a himation, with a tousled, aggressive portrait head. The figure has bare feet and so is perhaps a Cynic. Although to be read as opposed in this way—well-dressed orator-about-town (Aischines) versus scruffy thinker (Capitoline statue)—the politician and philosopher have things in common, showing they belonged to the same polis environment. They breathe the same civic air. Most important are simple identifying externals, like beards and himatia—these were basic signs of being a city person rather than a royal or court person. They also share some expressive features, like apparently real age and individualizing physiognomies. They are both essentially "ethical" portraits that emphasize the human and moral worth of their subjects.

KINGS

From the same time but quite separate are the portrait images of Alexander and the kings (figs. 5, 6). The kings created a quite new mode of portrait image, one that seems designed to express the essentials of their new style of kingship. We may examine its main components as follows: (1) external attributes, (2) the royal portrait head, (3) the royal body or figure.

A royal statue could wear and hold a variety of royal and divine at-

doros (active ca. 300–280; portrait known in single copy in Oslo): Richter, *POG*, 162, figs. 894–896.

13. Demosthenes (Copenhagen): Richter, *POG*, 219, no. 32, figs. 1398–1402.

14. Richter, *POG*, 185, figs. 1071 and 1074 (under "Menippos," but unidentifiable).

tributes, but generally there is a striking lack of emphasis on regalia. This well reflects the minimal character of Hellenistic royal ceremonial. (There seems to have been very little royal ritual associated with Hellenistic kingship.) A regular attribute of the statue was probably a spear that the figure leans on and holds with an arm raised (fig. 1a).[15] Originally it had simple military meaning but soon, in this pose, it became a symbol of royal power. It may allude directly to, or represent visually, the important justification of the Hellenistic kingdoms as "spear-won land."[16]

The only invariable attribute of the kings was the diadem, a band of flat white cloth worn around the head. This was not a crown, not an Achaemenid insignia, but simply a Greek headband promoted to take particular royal meaning. Someone invented an etiology for it—that it had been borrowed from the conquering Dionysos and that it symbolized victory.[17] This may represent the official view of its origins. (Dionysos was the most important divine model for Hellenistic kingship and victory its single most important legitimating feature.) The diadem soon became the single exclusive symbol of Hellenistic kingship, and, like many good symbols, it was in origin perhaps empty of precise meaning.

Divine attributes (like the aegis or animal horns) could be used to suggest more specifically godlike status. But they were employed only very sparingly; other, less obvious, less overt means were usually preferred. In the major portrait of Demetrios Poliorketes copied in the herm in Naples, the king wears small bull's horns which state an association with the god Dionysos (fig. 5b).[18] Images of Dionysos himself, however, generally did not wear bull's horns. Demetrios and other kings took the well-known association of Dionysos with bulls and gave it a new kind of visual prominence associated primarily with themselves—that is, the horns refer as much to the king as to the god.[19] The kings thus avoid a

15. Bronze ruler statuette (Baltimore): D. G. Mitten and S. F. Doeringer, *Master Bronzes from the Classical World* (Mainz, 1967), no. 132; Smith, *HRP*, 154, no. 13.

16. For a thorough examination of this concept, see A. Mehl, *AncSoc* 11/12 (1980/81): 173–212.

17. This origin is recorded by Diodorus Siculus 4.4.4 and Pliny *Naturalis historia* 7.191. See more fully, Smith, *HRP*, 34–38.

18. Smith, *HRP*, no. 4.

19. It has often been thought that Demetrios' horns refer to Poseidon. The bull-horned and bull-formed nature of Dionysos was, however, much stronger in contemporary minds, especially after Euripides' *Bacchae,* than bull associations of Poseidon. Poseidon appears on the reverse of coins of Demetrios as a protecting deity of the admiral king, but this does not imply that the horns of the royal portrait on the obverse necessarily refer to Poseidon. In the light both of the powerful Dionysian associations of bulls and bull's

direct divine equation. The horns express not that the king is Dionysos
but that he is like Dionysos, or has Dionysos-like powers.

The royal head was modeled broadly on a combination of Alexander
and young gods and heroes. It was intended to have a Dionysian éclat:
smooth, youthful, dynamic, godlike. The early Hellenistic royal portrait
refers clearly to Alexander but is careful to define itself as recognizably
different (fig. 5b). Alexander portraits have the longer hair of Greek
heroes, like Achilles, and the distinctive *anastole* of hair over the fore-
head (fig. 5a).[20] The early kings wear a thick wreath of hair, but it is not
as long at the sides and back, and they carefully avoid the *anastole*, which
was Alexander's personal sign.

The same can be seen in the physiognomy. The royal face draws on
ideal heads of gods and heroes but is careful to avoid confusion with
them, by formal adjustment or by introducing a (more or less slight)
layer of individuality. The portraits define the king as like the gods but
different. They forge a distinctive royal style.

Oriental influence on the Hellenistic royal image has sometimes been
posited. The portraits we have, however, provide no real evidence for "in-
terpenetration." There is little that cannot be explained in Greek terms—
either in attributes or in style. For example, bull's horns are found on
Mesopotamian images; but they are also used on pre-Hellenistic Greek
images. Bull's horns played an important part in Greek terminology
about Dionysos,[21] and we should prefer this meaning. Greco-Egyptian
royal portraits[22] may seem to be good examples of stylistic interpenetra-
tion, but these images, as we can tell from their use of native hard stones
and Pharaonic format, were for Egyptian consumption. The influence
here is all one way: Alexandrian royal portraits may affect the traditional
Pharaonic images of the king, but the reverse is hard to detect.[23]

The third-century royal portrait head had a considerable range of
variation, but with clearly definable limits. We may take two aspects:
(1) apparent age and physiognomy, and (2) hairstyle.

The king usually looks young or ageless—that is, about twenty to

horn and of the direct association of Demetrios with Dionysos in contemporary sources
(for example, *ap.* Athenaeus 6.253d; Plutarch, *Demetrios* 2), a reference to Dionysos was
surely the preferred meaning. For Dionysos and the bull, see esp. E. R. Dodds, *Euripides:
Bacchae,* 2d ed. (Oxford, 1960), xi–xxv.

20. V. Poulsen, *Les portraits grecs* (Copenhagen, 1954), no. 31—from or reflecting an
Alexander statue of the early Hellenistic period. Most recently on Alexander portraits, see
the full study by A. F. Stewart, *Faces of Power: Alexander's Image and Hellenistic Politics* (Berke-
ley, 1993).

21. See Dodds, *Euripides: Bacchae,* xviii.

22. Full collection in H. Kyrieleis, *Bildnisse der Ptolemäer* (Berlin, 1975).

23. Kyrieleis, *Bildnisse der Ptolemäer,* argues this case, but to this writer not convincingly.

thirty-five, not younger, rarely older. Some kings, especially in the first generation, who were in fact in their seventies or eighties, can use a more mature image but never one near their real age. This was the case, for example, with the two great dynasty founders, Ptolemy Soter and Seleukos Nikator (fig. 5c).[24] In the Naples bronze, Seleukos has a wreath of hair and dynamic posture, signifying "king," and strong mature features, signifying "older king," but he is not near his real age (probably about sixty to seventy) at the time of this portrait.

The limiting case in the portrayal of real-looking features is provided by the nonroyal dynast Philetairos of Pergamon (fig. 5d).[25] He has a dynamic posture but short, flat hair (no diadem, of course) and heavily jowled, "unroyal" features.

Hairstyle was a highly expressive and important variable in royal portraits. This is especially well shown by the two versions of a head from Pergamon (fig. 6).[26] The head was originally made when the sitter was still merely a prince or dynast, because (although this has not been noticed) it clearly wore no diadem in the first version. Later, a diadem and the thick wreath of hair were added separately, no doubt when he took the kingship. The circumstances well suit Attalos I in the 230s and support the traditional identification of the head as this ruler.

The adjustment dramatically alters the portrait's effect. In the second version it becomes a textbook royal portrait: smooth, ageless features; thick hair; dynamic posture. These express the Hellenistic king's unique status: like a god, like Alexander, but subtly different from both.

The same can be seen in the styling of the royal figure. There were no prerogatives in royal statue types. As far as we can tell the king's statue was most commonly naked, with or without a chlamys over the shoulder. Since both gods and athletes had been shown naked for a long time, this carried no special meaning for the kings. We have few examples, but it seems clear that the king's statue was set off subtly by distinctions of style and posture.

If we compare a high-quality ruler statue, like the Terme Ruler (fig. 1b),[27] and an athlete of comparable quality (like the Getty bronze),[28] it is extraordinary that with no documentation and with so much in com-

24. Seleukos (Naples): Smith, *HRP*, no. 21. Ptolemy: ibid., nos. 46–47.

25. Philetairos (Naples): Smith, *HRP*, no. 22.

26. Attalos I (Berlin): Smith, *HRP*, no. 28.

27. Smith, *HRP*, no. 44. It does not really matter for this purpose whether one thinks the statue a Macedonian prince or a Republican dynast looking like one (so, most recently, P. Zanker, *Augustus und die Macht der Bilder* [Munich, 1987], 15, fig. 1). I am concerned only with the body type. There are other examples (e.g., fig. 1a, above), but none of such high quality.

28. J. Frel, *The Getty Bronze* (Malibu, Cal., 1982).

mon—nudity and youth—it is still so easy to tell the ruler from the ath-
lete. It is not simply due to differences in pose; this is a matter of body
language. The ruler statue borrows the basic figural schemes of the ath-
lete, but adjusts or intensifies their effect. It uses an exaggerated, athletic
muscle style as a metaphor of power.

We may return and compare the city elders (figs. 2–4). The kings
had, of course, to pay respect to the ideology of ethical kingship that was
constantly recommended to them by the philosophers; but, for their
portrait image, their visual identity, they had their own concerns: to
be Alexander-like, charismatic, godlike. Morality made visual was very
much secondary. It is still remarkable that there is a complete lack of
significant overlap between portraits of kings and of civic leaders. Each
uses exclusive defining elements in both external appearance and style.
The kings are naked and godlike; they may wear a chlamys but never a
himation; and they are clean shaven. The city leaders, on the other
hand, are shown as mortal flesh and blood, seem always to wear at least
a himation or chlamys, and have beards. Only four kings, out of well
over fifty whose portraits we know, wore a beard.[29]

Some cosmopolitan city-men no doubt shaved, and we have one or
two examples, most notably Menander (fig. 3d);[30] but there remains no
stylistic overlap, no chance of taking Menander for a prince. We may
suspect that many of the kings' adherents in the cities, the locally based
Friends of the king (philoi),[31] would have adopted this manner of self-
presentation, but we cannot prove it without sure identifications. We
may say that in this respect Menander was clearly presenting himself as
a man of the new age. Generally, as far as we can see, the external signs
of being a court and royal person versus a city and nonroyal person seem
to have been used in an exclusive way. This opposition was played out
from head to body. The aging, diffident statue of Demosthenes makes a
deliberate contrast with the ideal assertion of power in the naked Mace-
donian ruler figures (figs. 1a, b).

CONCLUSION

The evolution of the third-century city portraits on the one hand, and
that of the royal portraits on the other, can each be understood in their

29. Discussed in Smith, HRP, 46 n. 2.

30. Menander (Venice): Richter, POG, 231, no. 15, figs. 1573–1576—important ver-
sion, from Athens, preserving tunic and mantle from the statue. For the reconstruction of
the statue, see now K. Fittschen, AM 106 (1991): 243ff.

31. On royal Friends in the cities, see the study by G. Herman, Talanta 12/13 (1980/
81): 103–149.

own terms. The city portraits carry on from the fourth century; the royal images are something new. But their exclusive differences also surely reflect the need for a sharper self-definition on either side of the ideological gap between the kings and the cities. In the city portraits, there is a clear stepping up of the human and "ethical" components; and this can be read in some respects as the response of the city intellectuals and politicians to the divinizing, eternally youthful images of the kings. As the kings claimed godlike status, so the cities sought to disclaim it in the portrait style of their leading citizens.

On the other side, for the kings, the realistic, "ethical" portraits of the city worthies contained ideas that they wanted expressly to avoid in their images—infirmity, mortality, a sense of moral struggle. The kings and the city thinkers, in spite of all their efforts at mediation—by kingship treatises and diplomacy—were involved in a basic ideological conflict. It is aspects of this conflict that their separate portrait styles were designed to express.

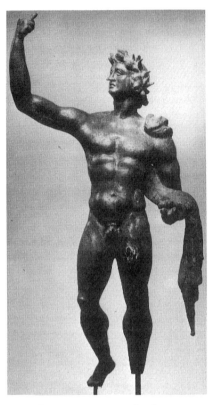 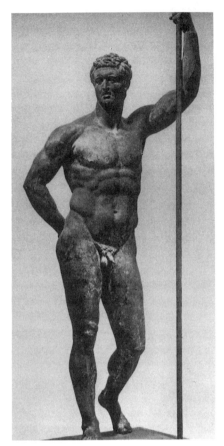

1. a. Bronze statuette of ruler, 3d–2d cent. BC (Walters Art Gallery, Baltimore). Photo: Walters Art Gallery.

b. Bronze statue of ruler, 3d–2d cent. BC (Terme Museum, Rome). Photo: DAI, Rome.

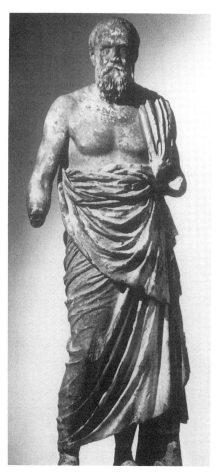

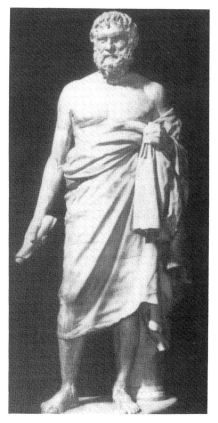

c. Statue of a philosopher, 3d cent. BC
(Delphi). Photo: Phaidon Press.

d. Statue of a philosopher, 3d cent. BC
(copy: Capitoline, Rome).
Photo: Phaidon Press.

2. a. Aristotle, later 4th cent. BC (copy: Kunsthistorisches Museum, Vienna). Photo: Phaidon Press.

b. Euripides, 330s BC (inscribed copy: Museo Nazionale, Naples). Photo: Phaidon Press.

c. Antisthenes, later 3d cent. BC (inscribed herm copy: Vatican). Photo: Phaidon Press.

d. Chrysippos, late 3d cent. BC (copy: British Museum). Photo: Phaidon Press.

3. a. Epikouros, 270s BC (inscribed herm copy: Capitoline, Rome). Photo: Phaidon Press.

b. Metrodoros, 270s BC (inscribed herm copy: Capitoline, Rome). Photo: Phaidon Press.

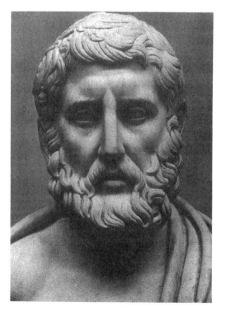

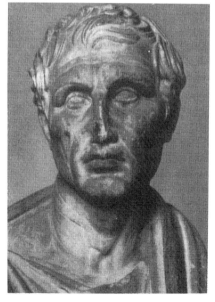

c. Hermarchos, mid-3d cent. BC (copy: Museum of Art, Budapest). Photo: Phaidon Press.

d. Menander, early 3d cent. BC (copy: Seminario Patriarcale di S. Maria della Salute, Venice). Photo: Phaidon Press.

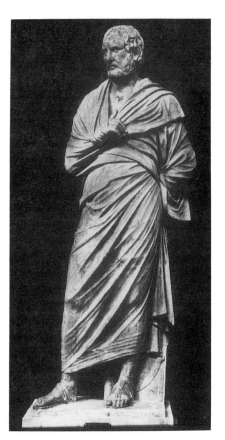

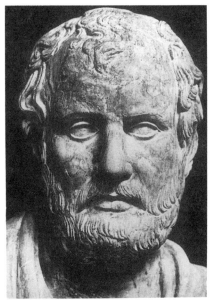

b. Aischines, head of 4a.
Photo: Phaidon Press.

4. a. Aischines, late 4th cent. BC
(copy: Museo Nazionale, Naples).
Photo: Phaidon Press.

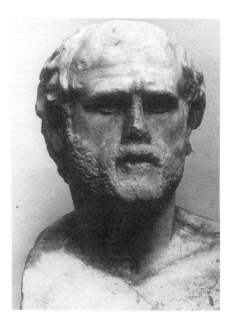

c. Olympiodoros, early 3d cent. BC
(inscribed herm copy: National
Museum, Oslo).
Photo: Phaidon Press.

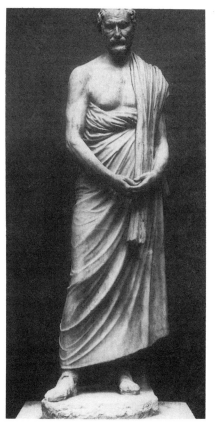

d. Demosthenes, 280 BC (copy:
Glyptothek, Copenhagen).
Photo: Phaidon Press.

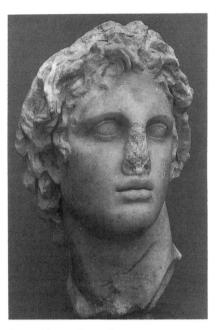

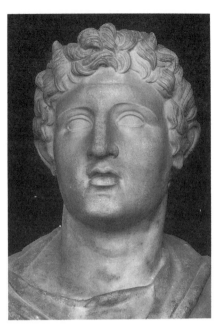

5. a. Alexander, 3d cent. BC (Glyptothek, Copenhagen, cat. 441). Photo: author.

b. Demetrios Poliorketes, early 3d cent. BC (herm copy: Naples). Photo: Phaidon Press.

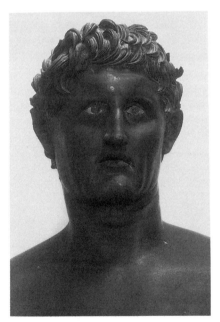

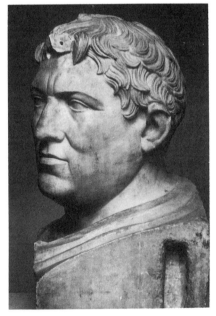

c. Seleukos Nikator, early 3d cent. BC (bronze copy as bust: Museo Nazionale, Naples). Photo: Phaidon Press.

d. Philetairos, ca. 280–260 BC (herm copy: Museo Nazionale, Naples). Photo: *AvP* 7.1, pl. 31.

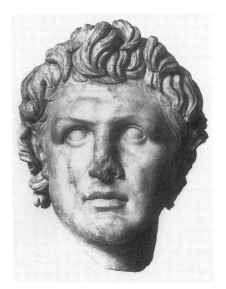 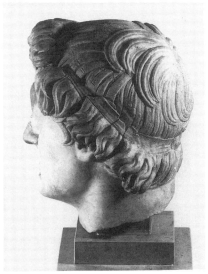

6. a–b. Attalos I, 230s BC (Pergamon Museum, Berlin). (a) Photo: *AvP*
7.1, pl. 31. (b) Photo: DAI, Rome.

The Hellenistic Grave Stelai from Smyrna: Identity and Self-image in the Polis

Paul Zanker

The cities of the Greek East, on the islands and along the Ionian coast, experienced a dramatic economic revival in the second century BC.[1] They enjoyed royal protection and patronage and, at the same time, profited from the political stability guaranteed by Rome.

Kings and private donors rivaled one another in building stoas, gymnasia, bouleuteria, and theaters. But the more beautiful these cities became, the more their civic life tended to harden into ritual. Living in the shadow of such all-powerful patrons, the Greek cities tried to preserve their identity by looking back to past glory. In the gymnasium the education of youth followed the Attic model of Isokrates. Artists and writers drew inspiration from Classical antecedents.

At the same time, daily life in the private sphere was enriched as never before. Much greater importance was attached to the furnishing of a house with mosaics and paintings, expensive furniture, and silverware. Women wore elegant clothes and precious jewelry. It is as if society were seeking some compensation for the new restrictions on political life.

Although there is an abundance of preserved inscriptions, we learn little of how the populations of such cities really saw themselves. Even the longest texts speak of the same rituals that preoccupied the assembly and the council, especially the generosity of the *euergetai* and the honors conferred on them and on other deserving citizens. But we hear hardly

1. This study was promoted by the Kommission zur Erforschung des antiken Städtewesens/Bavarian Academy of Sciences, Munich. I wish to thank Professor H. A. Shapiro for the translation of this paper. The manuscript was completed and sent to the editor in autumn 1988.

anything of what concerned the individual, or of the shared values that bound individuals together.

There is, nonetheless, one other rich source of original evidence as yet not really studied from this viewpoint: the countless grave reliefs of the second and first centuries. For ten years now we have had available the admirable corpus of East Greek stelai by E. Pfuhl and H. Möbius.[2] But for our purpose it is difficult to use, since the authors have arranged the reliefs strictly typologically, making the "language" of these reliefs hard to decipher. Only when grouped by provenance and in a roughly chronological sequence do they begin to speak more clearly.

The purpose of grave reliefs had always been to praise the exemplary character of the deceased, either alone or together with relatives still alive, to show their ethical qualities, accomplishments, service, and social status. The essential conformity of their visual language allows us to interpret grave reliefs as evidence from commonly acknowledged values. To some degree the stereotypical pictorial elements of the stelai should be comparable to the topoi of funerary speeches, though regrettably none is preserved from the Hellenistic period.[3] Just as in such eulogies, values are evoked in visual imagery like slogans, and certain patterns remain unchanged over long periods of time. But occasionally, historical currents that provide an interesting picture of a changing mentality seem to leave clearer traces in visual iconography than in literary texts constrained by formula.

Most Hellenistic stelai are not earlier than the second century BC, and they continue into the first. If we try to order the vast body of material roughly by city or region of origin, it is immediately evident that individual cities and areas preferred certain iconographic models and figure types, or even used them exclusively. In order to secure a firm basis for interpretation, we must consider the most important of these local groups in isolation from one another. In the limited space available here I should like to attempt this for the reliefs from Smyrna.

This choice is justified by the fact that the Smyrnaean reliefs constitute one of the most extensive groups, that they have a homogeneous nature, and that they are often of high technical quality. But, as I have intimated above, the results of such a case study must not be turned into broad generalizations, even though stelai sharing many features have been found in a variety of other cities, including Ephesos, Sardis, and

2. E. Pfuhl and H. Möbius, *Die ostgriechischen Grabreliefs*, 2 vols. (Mainz, 1977–79) (hereafter cited as P.-M.). See also E. Pfuhl, *JDAI* 20 (1905): 47ff.; idem, *JDAI* 22 (1907): 113ff.

3. D. A. Russell and N. G. Wilson, eds., *Menander Rhetor* (Oxford, 1981); J. Stoffel, *Die Regeln Menanders für die Leichenrede* (Meisenheim, 1974).

Kyzikos. In addition, the question of how the self-image tentatively re-constructed here fits into the broader cultural context of Smyrnaean society must, for the time being, remain open.

Stelai from Smyrna are relatively easy to recognize, even when the provenance is unknown or questionable. In addition to general conditions of style and iconographic peculiarities, the best criteria are the unique architecture of the stele and a remarkable external characteristic (figs. 1, 2). There is an honorific wreath carved above the figures on many stelai containing the inscription ὁ δῆμος followed by a name and patronymic in the genitive. Since, however, by no means all the figures represented are so designated and the naming of the demos is always omitted in the case of children and of persons whose names are not yet given on the stele as they were still alive, it appears that this is a form of public honor for the dead unique to Smyrna, one awarded to many, though not all, citizens.[4] I cannot pursue here the interesting implications of this and also will not discuss the attribution of individual stelai. The reader may refer to the corpus by Pfuhl and Möbius and form his or her own judgment.

This study is based upon a body of about 140 reliefs, most of which probably belong to the second half of the second century BC.[5] A relative chronological sequence could be worked out on the basis of stylistic analysis but is not essential for the purposes of this paper. There is, however, one fact which can considerably diminish the results of this study: we have no information about the cemeteries or funerary monuments to which these stelai belonged. How did the viewer see these reliefs displayed? Did several stand side by side, as in Attic cemeteries of the Classical period? Does the standard size of the stelai correspond to a standard size of burial precinct, or were these stelai incorporated in tomb monuments of varying types that would have indicated the family's social status? At present we do not have the means to answer these sorts of questions.

4. Cf. G. Petzl, *Die Inschriften von Smyrna*, vol. 1 (Bonn, 1982). The inscription ὁ δῆμος alone, in a wreath, occurs frequently on those more simple stelai without relief decoration. The whole question ought to be considered, within a broader context, by an epigraphist.

5. Following are the reliefs published in P.-M. which I assign to the "Smyrna Group" of the second and early first century BC: 109, 112, 114, 130 (?), 132, 140, 143, 145, 149, 156, 158, 159, 160, 161, 162, 167, 168, 169, 170, 250, 251, 253, 254, 255, 256, 257, 258, 259, 260, 268, 320, 341, 343, 376, 382, 392, 395, 397, 405, 406, 407, 408, 409, 410, 413, 414, 415, 419, 434, 435, 436, 437, 443, 444, 448, 487, 505 (?), 529, 530, 531, 532, 535, 536, 539, 540, 543, 545, 554, 555, 558, 559, 564, 567, 568, 569, 572, 573, 604, 634, 640, 646, 647, 660, 662, 693, 704, 729, 730, 749, 753, 766, 798, 804, 810, 830, 831, 852, 854, 855, 858, 861, 863, 867, 868, 872, 873, 878, 899, 906, 907, 908, 918, 925, 978, 989, 990, 991 (?), 994, 1030, 1036, 1045, 1052 (?), 1096, 1102, 1430, 1432, 1433, 1436, 1439, 1440, 1450. To these may be added two stelai in Petzl, *Inschriften*, nos. 23 and 24; and three recently acquired by the Basel Antikenmuseum.

I

On a Classical Attic stele, family members turn to one another, the key figures often joined in a handshake. Posture and gesture become paradigms of the society's ethical norms. The various schemata of standing and sitting and the arrangement of the figures according to their status are all signs that have specific meanings. Both the dead and the living are represented, with few exceptions, with beautiful faces, "beautiful" meaning ideally proportioned and without expression.[6] The only figures that appear mourning are servant girls and slave boys. Attributes and ornament are usually omitted altogether.

On the Hellenistic grave stelai from Smyrna (and many other cities), by contrast, the figures stand beside each other like statues, looking out at the viewer. There are clear indications that these deliberately imitate or include quotations from public honorific monuments or lavish funerary aediculae. The poses of the figures are precisely those of statues, and occasionally a socle or base is indicated.[7] In addition, the most elaborate of the stelai take the form of small aediculae.[8] In Smyrna, there are also the characteristic wreaths with the inscription ὁ δῆμος inside. This type of honor from the popular assembly may be considered a kind of substitute for the much sought-after golden wreaths conferred jointly by the boule and the demos. It transforms the tomb into a kind of small public monument. The extensive series of empty socles itself bears eloquent testimony to the important place of honorific statues in the agoras of Hellenistic cities.[9] Such a statue was the quintessential expression of public recognition by one's fellow citizens. Some people set one up in their own homes when they were denied a public one, as is evident from the case of Kleopatra and Dioskourides on Delos (fig. 3).[10] The poses match those on the Smyrna reliefs exactly, and we may conclude that the latter truly reflect the commonly accepted self-image of the free citizen.

The pose of the body, the position of arms and head—these are the key elements of the visual language in which these figures are expressed.

6. See, most recently, B. Schmalz, *Griechische Grabreliefs* (Darmstadt, 1983), with full bibliographies. There is still no thorough iconographic study of the Classical Attic grave relief.

7. E.g., P.-M. 1 nos. 532, 831; 2 no. 1475 (from Miletos); more common on the later reliefs.

8. E.g., P.-M. nos. 405, 415, 539.

9. E.g., M. Schede, *Die Ruinen von Priene* (Berlin, 1964), 48, fig. 57. See also W. Höpfner and E.-L. Schwandner, *Haus und Stadt im klassischen Griechenland* (Munich, 1986), 86, fig. 68 (Kassope).

10. R. Lullies and M. Hirmer, *Griechische Plastik*, 4th ed. (Munich, 1979), pl. 279; *Inscriptions de Délos*, ed. F. Durrbach et al. (Paris, 1937), no. 1987.

Added to these is a rich assortment of attributes (absent from Classical stelai) which are to be read as symbols of the praiseworthy qualities of the deceased.[11] Among these attributes are male and female servants, usually also rendered in miniature. Again in contrast to the Classical grave relief, the difference in scale vividly emphasizes a difference in social status. Let us now attempt in more detail to decipher the individual elements of the pictorial language.

<div align="center">II</div>

The men on the Smyrna reliefs are often depicted in a manner similar to Classical Athenians of the fourth century (fig. 4). The way the drapery falls or clings and the restrained movement match the honorary statues and grave reliefs of the fourth century, except for one interesting difference: the men now always wear an undergarment beneath the chlamys.[12] This also distinguishes them from the philosophers, who even into the Hellenistic period retain their by now stereotyped "weather-beaten" image. We may surely see in this adherence to traditional standards of conduct a conscious reference to what Greeks in many areas already saw as their past greatness.

The depiction of the standing male figure in the Classical schema, wearing a mantle, permits only a limited number of variations. The most significant of these is the pose of the arms, all the possibilities ultimately aiming at the same effect: a relaxed pose, controlled movement, expressing sophrosyne.[13] The most popular schema of the fourth century, with the right forearm, uncovered, held horizontally across the body and the right hand holding a drapery fold falling from the left shoulder, is now rarely used (fig. 4).[14] Instead, the right arm is usually tightly wrapped in the mantle (fig. 2).[15] That this arrangement is meant above all to show the arms in a position of confinement is confirmed by the equally popular pose of the left arm, and even the left hand, wound in the mantle (fig. 5).[16] This is the most powerful token expressing "restraint" in one's appearances in public. There is indeed a close correspondence here with behavior in real life, as the terracotta statuettes of

11. E. Pfuhl, *JDAI* 20 (1905): 47ff., 123ff.

12. I owe this observation to Professor B. S. Ridgway.

13. B. Fehr, *Bewegungsweisen und Verhaltensideale: Physiognomische Deutungsmöglichkeiten der Bewegungsdarstellung an griechischen Statuen des 5. und 4. Jh. v. Chr.* (Bad Bramstedt, 1979).

14. E.g., P.-M. no. 356.

15. E.g., P.-M. no. 250.

16. E.g., P.-M. nos. 158ff.

actors in New Comedy, playing the role of the "earnest young man," attest.[17]

Beyond this general significance, pose and stance were probably also meant to carry a more specific reference to political activity in the boule and *ekklesia*. This is suggested in particular by several reliefs that depict men in poses very similar to those of fourth- and early third-century statues of Aischines (fig. 2) and Demosthenes.[18] These are surely not, however, meant to invoke famous statues and particular role models,[19] but rather to praise an exemplary standard of conduct in an appearance before the demos. The particular motifs in question are the supporting of the left arm on the hip, the bending of the arms and stiffness of the wrist, and the advancing of the free leg. Demosthenes claims that his rival Aischines would imitate the great orators of the fifth century when speaking, standing still as a statue, with his hand always in his cloak.[20] The statue put up in his honor, preserved in Roman copies, seems to celebrate this public manner as a sign of self-assured competence. The motif of the lowered, linked hands, meanwhile, recalls the statue of Demosthenes. Despite considerable variations—in the statue the fingers are interlaced, while in most reliefs the right hand holds the left wrist—the message is again one of keeping the arms motionless while speaking. In the statue, however, the motif is endowed with a heightened pathos. The sculptor Polyeuktos wanted to show that Demosthenes was full of energy, that it was hard for him to remain still, but that, thanks to his own willpower, he managed to conform to the proper stance. In this way the statue may be seen as a deliberate contrast to that of Aischines.[21] The workshops that produced the grave reliefs used both motifs equally, in order to set varying accents while expressing the same basic, highly prized standards of conduct.

Unlike the women, who are always idealized and youthful, men are occasionally portrayed as individuals, even with indications of advancing

17. M. Bieber, *The History of the Greek and Roman Theater*, 2d ed. (Princeton, 1961), 94, fig. 338; idem, *Ancient Copies* (New York, 1977), fig. 589.

18. "Aeschines pose": P.-M. nos. 341, 646; "Demosthenes pose": P.-M. nos. 529, 532, 634, 1102; Petzl, *Inschriften*, pl. 2, no. 24.

19. G. Lippold, *Die griechische Plastik* (Munich, 1950), 314, pl. 108:3; 303, pl. 108:2; M. Bieber, *The Sculpture of the Hellenistic Age*, 2d ed. (New York, 1961), figs. 194–197, 218–221.

20. Demosthenes 19.251f., 255; 18.129. Cf. Fehr, *Bewegungsweisen und Verhaltensideale*, 50ff.

21. My interpretation is at odds with psychological readings like that of T. Dohrn, *JDAI* 70 (1955): 50–65. The connection suggested here with funerary reliefs cannot be used as an argument for the "tragic" interpretation of the gesture in the statue of Demosthenes. Honorific statues had their own well-established tradition and purpose—to celebrate, not lament.

age (figs. 6 and 7, 8 and 9).²² This is evidently a mark of distinction, as is
the seated pose of older men, to which I shall return shortly. On Late
Classical Attic grave reliefs one can already trace the way in which ad-
vancing age is accompanied by ever more positive associations.

Two stelai with particularly striking portraits have in the background
a cornucopia on a pillar (figs. 6 and 7).²³ The single or double cornuco-
pia is several times associated with individuals who held a priestly of-
fice.²⁴ We may thus infer that this symbol, which is no doubt derived
from the double cornucopia of the Ptolemies,²⁵ signifies not just a gen-
eral prosperity but, more specifically, *euergesia*. Anyone who could buy
himself a priesthood was entitled to be regarded as a benefactor.

At this point we may already suspect that the Smyrna reliefs, despite
their evident dependence on more monumental honorific or funerary
monuments, reflect not the self-image of a "middle class" (which I think
did not exist), but rather a value system acknowledged alike by all free
citizens.²⁶ The men on the stelai thus far considered could be said to
present themselves as conservative, adhering fully to traditional behav-
ioral norms of the Classical polis. But other elements and new figure
types can change the accent and introduce into the image new standards.

Among attributes, the most important is surely the book roll. We see
these often together with writing implements, tablets, and chests, on a
pillar or ledge in the background (figs. 2, 10), in the hands of the nearly
ubiquitous little slaves,²⁷ or frequently held by the men themselves
(fig. 6).²⁸ The left hand may even be freed from the mantle for this
purpose. The image, which would in later times become endlessly popu-
lar, was something new in the second century BC and, as we shall see,
is of considerable interest as a symbol of the educated and cultivated
man. The book roll indicates education and literary and philosophical
interests. Its great popularity reflects the increased importance attached
to a man's intellectual training and pursuits in the course of the Hel-
lenistic age.²⁹

22. E.g., P.-M. nos. 156, 159, 170, 831, 855; also a recently acquired relief in the Basel
Antikenmuseum, inv. BS 243.

23. P.-M. nos. 156, 170.

24. P.-M. nos. 170, 405, 872.

25. N. Kyrieleis, *Bildnisse der Ptolemäer* (Berlin, 1975), 164. Cf. Schmalz, *Griechische
Grabreliefs,* 238f.

26. Even the stelai without relief decoration do not necessarily imply a lower social
status, as the wreaths with honors from the demos show. Cf. Petzl, *Inschriften,* passim.

27. A good example is P.-M. no. 109.

28. P.-M. nos. 158ff.

29. Pfuhl, *JDAI* 22 (1907): 113ff. On the significance of a literary education in Helle-
nistic Greece see H. J. Marrou, *Histoire de l'éducation dans l'antiquité* (Paris, 1965), esp.
151–160, 292–307, 323–336.

On Classical Attic grave stelai of the fourth century only women are shown seated, and once in a while old men, on account of their infirmity.[30] The Smyrna stelai likewise seem to depict the older men seated, but here the motif makes an unambiguously positive statement (figs. 8 and 9, 11). The man is sometimes shown elevated and on an elaborate piece of furniture; he is a figure of authority. On some stelai he rests his head on one hand, sunk in meditation.[31] This is not, however, a sign of mourning, as Pfuhl and Möbius believe, but rather characterizes him as a thinker. A comparison with third-century statues of philosophers shows that these were indeed the models.[32] The iconographic parallel reveals the tremendous impact of the great thinkers of the past on those in search of a new identity. On one relief, now in Winchester College (fig. 12),[33] a dignified gentleman lectures, while ticking off his arguments on the fingers of his right hand, somewhat like the familiar statue of Chrysippos.[34] His wife is depicted as a priestess of Demeter. Clearly this is a distinguished family that played a major role in public life. Having oneself portrayed as a thinker and reader was evidently considered no less suitable than the traditional Classical type, at least for older men.

The new image as reader or thinker was widespread in the Hellenistic cities of the East. Sometimes the philosophically inclined citizen is shown seated on a proper philosopher's armchair,[35] and even the popular type of the funerary banquet did not preclude the use of this imagery.

There is a particularly fine example from Byzantium of the early first century BC (figs. 10, 13).[36] The deceased, an elderly man with ravaged face, points to the globe, like the muse Urania or one of the Seven Sages on a well-known mosaic in Naples.[37]

The great effort of thinking may occasionally be read in the faces of these "intellectuals," and this in turn has a bearing on the problematical interpretation of Late Hellenistic portraiture. What the modern viewer perceives as exertion or even grief in these portraits is no doubt meant only as a sign of mental activity.[38] Apparently the distinguished citizen

30. E.g., H. Diepolder, *Die attischen Grabeliefs des 5. und 4. Jhs.* (Berlin, 1931).

31. P.-M. nos. 831, 852, 854, 855.

32. Cf. the so-called Kleanths: G. M. A. Richter, *The Portraits of the Greeks*, vol. 2 (London, 1965), figs. 1106ff. That the "thinker" pose was already well known and popular in the third century is suggested by, e.g., Plautus *Miles* 209f. (ed. F. Leo). I owe this reference to Professor Hermann Tränkle.

33. P.-M. no. 855.

34. Richter, *Portraits* 2 : 190, fig. 1144.

35. E.g., P.-M. no. 854.

36. Well illustrated in P.-M. no. 2034. See also N. Firatli, *Les stèles funéraires de Byzance gréco-romaine* (Paris, 1964), no. 33, pl. 8; with p. 165 (L. Robert).

37. Richter, *Portraits* 1 : 81, fig. 316.

38. See G. Hafner, *Späthellenistische Bildnisplastik* (Berlin, 1954); A. Stewart, *Attika* (Lon-

considered this a quality as worthy of celebration as physical strength, prosperity, good breeding, and other traditional virtues. Indeed, it was only the life of the mind that the Greeks now had to offer their new masters. The steady flow of Roman pupils into the flourishing philosophical schools of Athens and Rhodes attests to the success of the Greeks in promoting this intellectual image.

III

The stelai for youths and young men help confirm what we have observed thus far. While Classical stelai celebrated both athletic prowess and ethical virtue in equal measure in their depictions of the nude youth, on Hellenistic reliefs the youths are almost always clothed, and the only figures shown naked are the little slave boys. In the second century, at Smyrna and elsewhere, there was a distinct reluctance to show a youth or young man nude, and at most a partly bared breast might indicate an ephebe.[39] *Paides* and ephebes often appear beside a herm of Herakles or Hermes, the standard symbols of the gymnasium and palaistra (fig. 14).[40] The deceased may rest his hand on the herm, to suggest that he enjoyed a proper upbringing and has died young. Just as for adult men, intellectual training is stressed too, in the form of book rolls and writing tablets. Artists did not hesitate to exaggerate this aspect, as in the relief of a young man whose slave opens a container full of book rolls to show the deceased person's great enthusiasm for his studies (fig. 15).[41]

On the many stelai that emphasize in this way the importance of intellectual training, it is equally clear that athletic training was no longer the primary focus of Greek paideia. The ideal of a well-rounded education first formulated by Isokrates seems now to have taken root as a universal attitude.[42]

Victories in athletic or musical competition are not represented as

don, 1979), figs. 17ff. and passim; P. Zanker, "Zur Bildnisrepräsentation führender Männer in mittelitalischen und campanischen städten zur Zeit der Späten Republik und der julisch-claudischen Kaiser," in *Les "bourgeoisies" municipales italiennes aux IIe et Ier siècles av. J.-C.* (Naples and Paris, 1983), 252ff.; L. Giuliani, *Bildnis und Botschaft* (Frankfurt, 1986), 156f.

39. E.g., P.-M. nos. 140, 646. The motif is more common in other cities, e.g., P.-M. nos. 117 and 150 (Rhodes), 137 (Erythrai).

40. P.-M. nos. 114ff. Pfuhl's interpretation of this object as a tomb marker is untenable.

41. P.-M. no. 132.

42. Marrou, *Histoire de l'éducation*, 131ff.; G. Mathieu, *Les idées politiques d'Isocrate* (Paris, 1925; reprinted 1966), 33ff. For the literary testimonia on *sophrosyne* as the highest virtue of the individual and the state, see Mathieu, *Idées politiques*, 129. I am indebted to Thomas Gelzer for numerous references in this area.

such, only alluded to in the form of a palm or wreath. On a particularly fine example in Oxford,[43] the deceased crowns himself with a wreath; in the background we see his tomb, an expensive monument bearing the young man's marble urn (fig. 16). Athletic achievement is now less important than the victor's proper ethical stance, which is expressed in the modest pose he assumes.

Boys and youths thus enjoy some of the same types of praise as adult men but assume a distinctly modest appearance. Typical of them are the lowered head and gaze shyly directed at the ground, as on the ephebe on the Oxford relief. This expresses their *aidos,* a quality to which the Classical period had attached great importance.[44] The Youth from Tralles is a particularly powerful expression of this.[45] In adult men, on the other hand, we may read the vigorous gestures and occasionally upturned head as symbols of energy.[46]

The symbol "Aidos" illustrates how even what appears to be a perfectly natural pose or stance can take on a specific meaning in the pictorial vocabulary of the reliefs.

Young people do not belong to a world of their own. At the tenderest age they are already viewed in their role as future citizens, whether men or women. Even very young girls are already depicted as little ladies. "Sweet Nikopolis," whose epigram speaks of her "endearing whisper and gentle babbling little mouth," died at age two,[47] but she already has her own servant girl (fig. 17). Naturally, the herms, books, and tablets of the stelai for youths are nowhere to be found on those for girls.

Indeed, even for boys of rather tender years, reference is made to the paideia that they would have enjoyed, had they only lived. On the well-known relief of Amyntes in the Louvre (fig. 18)[48] a shield in the pediment proclaims his *arete,* while on the wall of the naiskos hangs the framed wreath which would have been his, had he lived to achieve his life's goal. The boy himself, meanwhile, plays and crawls about, like the child he is, trying to defend the fruit he holds from a hungry cock. The

43. P.-M. no. 149.

44. Cf. Fehr, *Bewegungsweisen und Verhaltensideale,* 18 nn. 108, 120.

45. H. Sichtermann, "Der Knabe von Tralles," in *Antike Plastik,* no. 4, ed. W. H. Schuchhardt (Berlin, 1965), pls. 39ff.; H. P. Laubscher, *MDAI(I)* 16 (1966): 125ff.

46. P.-M. nos. 159, 161. Rather different is the ephebe in no. 160, whose musical talent is most emphasized by means of the (outside Smyrna) not infrequent element of lyre or kithara.

47. P.-M. no. 392; cf. nos. 395, 397, 753, 749; W. Peek, *Griechische Vers-Inschriften,* vol. 1, *Grab-Epigramme* (Berlin, 1955), no. 1512; idem, *Griechische Grabgedichte* (Berlin, 1960), no. 228.

48. P.-M. no. 804. See now H. von Hesberg, "Bildsyntax und Erzählweise in der hellenistischen Flächenkunst," *JDAI* 103 (1988): 316, fig. 3.

lively scene, however, is presented as if it were a sculptural monument, on a molded socle containing the child's name, his playthings lined up in front. This example shows especially clearly that we cannot expect a unity of time and space on the reliefs. The artists make allusion to a variety of themes and subjects and arrange the elements at hand so artfully that sometimes a seemingly deliberate narrative context results. In looking at the relief of little Amyntes we are apparently meant simultaneously to remember the child as he was in life, at play, to think of the costly monument that his parents set up to his memory, and to be sadly reminded, by the herm, shield, and wreath, that he died so young.

IV

The image of women on the reliefs is almost more stereotypical than that of the men.[49] With few exceptions, sculptors depict all women in the same pose, the so-called *pudicitia* type (cf. figs. 1, 3, 19, 20, 21, 22).[50] This is true even of the few seated women, whose maturity, as for men, is presumably conveyed in this manner. The type enjoyed considerable popularity throughout the Hellenistic world. It must reflect the image of women at this time. But before interpreting the meaning of this statue type, I would like first to consider what it is about women that the reliefs celebrate.

A relatively small variety of attributes and iconographical tokens expresses the female virtues and qualities considered worthy of praise. Instead of a book roll a woman has jewelry or items from her toilette. Large, usually open jewelry boxes, mirrors, alabastra, and combs are displayed on a shelf or pillar in the background, or are held by servant girls. The sun hat and fan also belong here: the woman is a creature of luxury, preening and delighting in little pleasures (cf. figs. 9, 20). We never see her engaged in any activity or holding anything in her hand. The wool basket, a traditional attribute almost indispensable on the stelai (cf. figs. 1, 20), is thus no longer primarily a symbol of the housewife who actually did her housework, but evidently had a broader connotation, as a symbol of feminine virtue and obedience.[51] In fact the reliefs take great pains to make it clear that the deceased was so well off that she never had to lift a finger. Even the most modest stelai include a slave

49. P.-M. nos. 413ff, 532ff.

50. Bieber, *Ancient Copies*, 129ff., figs. 612ff. Cf. A. Linfert, *Kunstzentren hellenistischer Zeit* (Wiesbaden, 1976), passim, with further references.

51. Cf. the well-known relief of Monophila from Sardis, with the accompaning epigram: P.-M. no. 141; Peek, *Griechische Versinschriften*, vol. 1, no. 1881; von Hesberg, "Bildsyntax und Erzählweise," 313f.

girl—usually two, though two is the limit.[52] It is as if to say, the proper household requires a staff of two, and any more would be excessive. Theokritos' poem about the women at the festival of Adonis (15, 24; 68f.) suggests that in this instance too the visual image is an accurate reflection of real life.

Just how closely the pictorial language of the stelai is able to reflect real-life situations is evident on those few reliefs that depict a woman leaving home to appear in public (fig. 23).[53] She moves slowly in her tight, elaborately draped mantle, while servants fuss over her in a flurry of activity. Parasols on the shelf conjure up the setting in our minds,[54] a picture already familiar from the world of Early Hellenistic terracottas.

Two servant girls always assume complementary poses, just like the two slave boys on the stelai for men (figs. 20, 22). While one looks attentively toward her mistress, the other stands immobile, waiting for her next command.[55] Sometimes the servants display their diligence in caring for the children. Nurses enjoyed a higher status and thus are depicted on a larger scale (fig. 23). A garment falling from the shoulder is a typical sign of a nurse's dedication.[56] A servant's devotion reflects well on her mistress.

The children in such scenes may be distinguished from the little servants primarily by their liveliness, though otherwise they function just as much as attributes (figs. 21, 23).[57] Bearing children is a woman's duty, though no more than two are ever shown. This too may reflect a sense of propriety, when we recall that exposure of children was expected, especially of girls in prosperous families. Women rarely pay attention to their children, or even notice them. Compared with the images of intimacy between mother and child on Attic grave reliefs,[58] the different iconographic conventions of Hellenistic stelai are especially striking. Here the image of statuesque dignity is clearly more highly prized than the expression of emotion. This is astonishing, in view of the well-known preoccupation of Hellenistic poetry and art with feminine psychology.

This observation suggests a more general characteristic of the iconography of the Smyrna stelai, which is also true of most other Hellenistic

52. P.-M. nos. 413ff.

53. P.-M. nos. 382, 506 (from Istanbul), 545.

54. E.g., P.-M. nos. 437, 539.

55. E.g., P.-M. no. 414. The same is true of the two slaves regularly accompanying a man; cf. P.-M. nos. 161ff.

56. P.-M. nos. 382, 443. The garment slipping off occurs often on little servant girls, e.g., no. 435, and on the maid looking down from above on no. 646.

57. P.-M. nos. 419, 415, 443.

58. E.g., Diepolder, *Die attischen Grabreliefs*, pl. 40. Cf. H. Rühfel, *Das Kind in der griechischen Kunst* (Mainz, 1984), 149ff.

funerary reliefs: the stelai are never concerned with private or personal matters, only with a public presentation embodying universally accepted norms of behavior. The stereotyped forms are the products of conscious constraints. Was it perhaps the fear of being misunderstood or committing a faux pas? Within this seemingly open commercial city on the coast was a society that must have been tightly constricted indeed.

One result of all this is a noticeable difference between the messages conveyed by the funerary epigrams and by the reliefs. Hellenistic epigrams invariably speak of personal misfortune: the loss of both children at once, the early and tragic death of a family member, most of all the grief and suffering of the survivors. The imagery of the epigrams is sometimes downright pathetic and moving. Yet everyone in the reliefs, both the deceased and their survivors, displays the expected, exemplary behavior, without a sign of grief or pain.[59]

A wealthy household is, of course, an accepted standard of success, and the world of women, itself so closely tied to the home, was better suited to expressing this idea than that of the men. One especially elaborate relief conveys the family's prosperity through a carefully rendered aedicula with Ionic columns, a doorpost with lavish curtains, and an unusually large jewelry box (fig. 21).[60] Another relief, reworked in modern times, with the addition of a modern inscription, shows, to the right of the deceased, her own rich tomb, including a statue of a siren playing a threnody on the flutes (fig. 22).[61] Epigrams praise the fine and expensive tomb monument as a token of a husband's love, a means of publicly proclaiming a wife's virtues. The stele with the heavy curtains also displays a kithara, to celebrate the dead woman's musical accomplishment, as do the epigrams.

But why, we may ask, were the *pudicitia* type and related forms so popular? What connotations were evoked by this type, repeated endlessly on the grave reliefs? Why did the same Hellenistic artists who often stuck quite closely to Late Classical models in rendering the men in honorary statues and grave reliefs so utterly refashion their women?

Hellenistic female statue types invariably emphasize hips and breasts, a departure from Late Classical types (cf. fig. 3). In fact, a corresponding change in proportions is evident in sculpture from the Early Hellenistic

59. Cf. the selection of epigrams in Peek, *Griechische Grabgedichte*, 88ff. Among the stelai from Smyrna, P.-M. no. 1102 (= Peek, *Griechische Versinschriften* 1 : 701) is a characteristic example. A mother has lost both sons, her husband, and her brother, yet her image does not betray the slightest trace of grief.

60. P.-M. no. 415.

61. P.-M. no. 419.

on.[62] The eroticism is also emphasized in the draping of garments. Both the transparency of the drapery and the way it is wrapped tightly about the body produce the same effect, but they also remind us of the precious fabric and exquisite workmanship. Beauty and wealth go hand in hand. An attractive wife was surely considered among a man's most valued possessions, and it is, after all, his fantasies that shape the Hellenistic image of women. Refined and luxurious fabrics help to underline the charms of the female body and, at the same time, show off the family's prosperity.[63] We may at first wonder how the eroticism was reconciled with the well-known strict puritanical standards of conduct for married women. Certainly a glance at other Hellenistic genres, such as the terracotta dancers,[64] leaves little doubt that the erotic connotations of these forms is intentional.

But beauty in the sense of physical attraction and sensuality is but one of several qualities sought in a woman, alongside restraint, decorum, modesty (in Greek, *sophrosyne, kosmiotes, aidos, eutaxia, semnotes*).[65] Pose, gesture, and expression must convey the whole range of qualities. The *pudicitia* type probably has nothing to do with mourning; rather, of all the Late Classical statue types, it best conveys modesty and restraint. Both arms and hands are completely hidden, which almost automatically results in a gentle bend of the head. There is literary evidence that both elements were indeed associated with behavioral norms (Plutarch *Praecepta coniugalia* 142). But, Plutarch goes on to say, propriety and seriousness in a woman should not lead to harshness and unfriendliness. She should be surrounded by *charis*, "so that, as Metrodorus [the pupil and friend of Epicurus] says, she does not, with all her virtue, make herself hateful." And indeed, these women in statues and reliefs, though looking so modest, with oblique gaze, not infrequently wear a smile (fig. 24). The paradigm of women on Classical grave stelai seems less constrained than on Hellenistic reliefs. Virtue is now more narrowly defined and is linked more directly to erotic charm. This may reflect the fact that in the second century the institutions of hetairai and pederasty had lost impor-

62. R. Horn, *Stehende weibliche Gewandstatuen in der hellenistischen Plastik, MDAI(R)* Ergänzungsheft 2 (1931).

63. On the famous *vestes Coae* see *RE* 11 : 1475 s.v. "Kos."

64. E.g., a statuette from Myrina in the Louvre: *Encyclopédie photographique de l'art* (Paris, 1936) 2 : 212f.; S. Mollard-Besques, *Catalogue raisonné des figurines et reliefs en terre-cuite,* vol. 2, *Myrina* (Paris, 1963), pl. 129 and passim.

65. Cf. J. Pircher, *Das Lob der Frau im vorchristlichen Grabepigramme der Griechen* (Innsbruck, 1979); A.-M. Vérilhac, "L'image de la femme dans les épigrammes funéraires grecs," in *La femme dans le monde méditerranéen,* vol. 1, *Antiquité,* edited by A.-M Vérilhec and C. Vial (Paris, 1985), 85–112.

tance—at least in accepted ideology—while marriage and family were most highly valued.

One series of stelai, for priestesses of Demeter, employs a very different, almost grandiose statue type, one that allows much freer movements of the arms (fig. 25).[66] Interestingly, this type also occurs on the Pergamon Altar. Evidently, sculptors turned to the more flamboyant repertoire of Pergamene court art to find an expression of imposing dignity.[67]

This group of Demeter priestesses really deserves a separate investigation. But for our purposes it must suffice to mention one important point, the great variation in quality. Among the twelve or so stelai in this small group is one of the finest and most elaborate of all the stelai from Smyrna (no. 405), along with several whose workmanship is rather primitive. There is an equally wide range of sizes, from no. 407, at only 88 cm in height, to the familiar relief in Berlin which, at 1.56 m, is one of the largest of all. Since all of these represent priestesses of Demeter, we cannot infer from a difference in size a difference in family wealth. Perhaps the contrasts between large and small were mitigated by the setting within the funerary precincts. In any case, as this instance makes clear, we cannot make inferences about the social status of a family from the artistic quality and size of the stele.

Married couples and other members of the family are often depicted together on the stelai, just as in Classical funerary art.[68] But whereas on the fourth-century reliefs the dead and the living turn toward one another, the Hellenistic stelai from Smyrna usually present each figure like an individual statue (figs. 19, 24). Almost all look directly out of the frame, at the viewer, and the scene of *dexiosis* is rarely encountered.[69] The statuary type thus precludes the possibility of depicting the family bond. One customer's dissatisfaction with the standard type is evident from the tender and moving scene on a stele found reused in the Grinzinger Cemetery in Vienna (fig. 26).[70]

The sculptor evidently had in his repertoire no way of indicating personal emotion or tenderness, yet this is just what the patron, in direct violation of normal practice, wanted. With the awkward position of the right hand, utterly inappropriate to the figure type, the artist has tried

66. P.-M. nos. 405–410, 529, 531, 872. Add the new relief in Basel, Antikenmuseum BS 244, and in Izmir, *EpigrAnat* 3 (1984): 59f, pl. 4a.

67. Cf. the so-called Tragodia: Bieber, *Sculpture*, fig. 473; Horn, *Gewandstatuen*, pl. 18.2.

68. P.-M. nos. 524, 539, 543, 554ff., 861, 846.

69. P.-M. nos. 693, 704, 872ff., 1052, 1096f., 1102. Several of these should be dated in the late second or early first century.

70. P.-M. no. 524f. Despite stylistic similarities, this is not Smyrnean.

to fulfill that wish as best he could. But this is a unique exception, and in general there is hardly any deviation from standard figure types.

This is especially clear in those rare reliefs that represent three adults. On one of these, still in Izmir (fig. 27),[71] a young man, who must be the principal figure, stands between a man clad in a chlamys and standing in the Aischines pose and a woman of the *pudicitia* type. The young man is depicted as the victor in an athletic competition by means of a servant with wreath and palm, a Herakles herm in the background, and his own bare chest. The man and woman are no doubt his parents. They have their own servants, the larger servant girl, looking on from above, belonging to the woman. Thus, each of these figures as they stand side by side is to be read as an individual unit. Even a most unusual relief, like that in Leiden (fig. 28),[72] cannot be interpreted as a "scene" depicting the grieving family. Rather the qualities emphasized are "reflection" and education. Looking beyond the young man standing at right, we see in the background a particularly large chest of book rolls on a pillar.

V

If we consider all the Smyrna stelai as a group, there emerges a remarkably coherent picture, but one not entirely free of internal contradictions. Though adherence to the traditional values of the Classical polis is quite strong, certain changes in emphasis with respect to Classical grave reliefs are unmistakable. The pictorial vocabulary is broadened, more subtly nuanced, and enriched, like the vocabulary of the Hellenistic epigram. More aspects of life are now visually rendered: literary education and intellectual pursuits; prosperity and the life of leisure, even erotic charms. But these ideals, though accepted by all the citizens, are now presented as the means to private, individual fulfillment. The life of the individual was, to be sure, still circumscribed within the narrow confines of the polis, which defined everything from the proper number of children and slaves to the correct size of the grave stele. At least this is how the world of the reliefs presents itself. No individual makes reference to his own particular accomplishments or tries to overshadow his fellow citizens, even at a time when in nearby Pergamon a flashy court style was at its height, almost crying out to be imitated. The artists of

71. P.-M. no. 646.
72. P.-M. no. 861. Cf. H. Möbius, in *Festschrift A. Rumpf* (Krefeld, 1952), 117, pl. 28.2, where the pose of the seated man, leaning on his hand, is interpreted as a gesture of mourning.

Smyrna and their patrons must have consciously rejected this "Asiatic" style and held fast to their own standards, including aesthetic ones.

I earlier observed that the size and quality of the reliefs do not enable us to draw inferences about the wealth or social status of the families. Given the large proportion of fragmentary reliefs, a statistical comparison can produce only very rough indications.[73] Though the height varies from a low of 40 cm to a high of 1.70 m, the great majority of stelai with standing figures fall in the range 80 to 120 cm, while those for children are about 50 cm. There is, furthermore, no correlation between iconography and the size or technical quality of the stelai.

A few reliefs are instructive as the exceptions that prove the rule. The standard types of men and ephebes did not include one expressing military valor. Yet a small group of eight reliefs depicts warriors in settings removed from the polis and in an elevated vocabulary that even permits the use of heroic nudity (fig. 29).[74] But it is not the nudity of the Classical athlete; rather it is an arresting element drawn from the new iconography of kingship.[75] The isolation of the warrior, his elevation above his fellow citizens into a heroic sphere, only underlines the problematical relationship between a polis like Smyrna, utterly lacking in military might, and the great superpowers with their mercenary armies. In other cities and regions, by contrast, warriors and weaponry play a greater role and are more integrated into the overall iconography.[76]

Most of the stelai from Smyrna, so homogeneous in style and iconography, must belong to the years about 170 to 100 BC, that is, after the city had won its independence under the protection of Rome in 189 and before the Mithridatic wars.[77] Those few reliefs which probably fall into the first century already betray a dissolution of the common pictorial vocabulary.

VI

In order to draw reliable historical influences, we would have to submit the grave stelai of other cities to a similar analysis and compare the re-

73. The statistics are based exclusively on the material published in P.-M. I am indebted to Derk Wilm von Moock for help.

74. P.-M. nos. 1430, 1432, 1439, 1440f. See also a fine relief recently acquired by the Basel Antikenmuseum. On the "officer's garment," cf. the stele of Polybios: P. C. Bol and F. Eckstein, in *Antike Plastik*, no. 15, ed. Eckstein (Berlin, 1975), pl. 11.40ff.

75. Cf. Bieber, *Sculpture*, fig. 429.

76. This is particularly true of banquet reliefs, the so-called hero reliefs, and stelai in registers, such as P.-M. 2, pls. 204:111; 208:1429. But cf. also the relief found in Smyrna, P.-M. no. 647, which combines the heroic type with figure types from the world of the polis.

77. T. J. Cadoux, *Ancient Smyrna* (Oxford, 1938).

sults. In so doing we would find that some other cities and regions, such as Delos, Rhodes, Samos, Kyzikos, Byzantium, and the cities of north-west Greece,[78] evolved distinctive sculptural forms and iconographies for funerary reliefs.

In Delos, for example, the iconography of Classical Attic grave reliefs lives on, and we find numerous paired figures turned toward each other and joined in a handshake, women seated on klinai, and (as in Rhodes too) quotations from famous works of art. In Samos, Kyzikos, and Byzantium, the banquet relief is the dominant type, while in Rhodes and Halicarnassus the hero cult becomes a standard type. Here funerary altars to a great extent take the place of stelai. Finally, in Epirus and northwest Greece, stelai do not represent the deceased at all, though they do imply a rich and subtle repertoire of nonfigural motifs.

Trade and commerce notwithstanding, no international iconography from grave reliefs arose. Greek cities of the second century evidently remained, to a considerable degree, culturally closed societies that cherished their own traditions and values.

Yet despite the variety of iconographical patterns in individual cities, many of the same ideas and values inform the reliefs from disparate areas. Both the Delian stelai and the banquet reliefs celebrate the new paradigm of the intellectual. The seated women on the stelai from Delos, even in their classicistic poses, are creatures of luxury so symptomatic of the new age; and the banquet reliefs, with furniture and table prominently displayed, offer a perfect opportunity to advertise a family's prosperity.[79]

Stelai similar to those from Smyrna have been found in many other places, of course, especially in the nearby cities, but also in some more distant areas. Thanks largely to a shared Greek heritage, elements of the pictorial vocabulary were apparently understood everywhere, making possible the export of stelai and the use in other cities of symbols favored in Smyrna or vice versa. Unfortunately, the means of transmission can hardly be reconstructed, but this is not crucial for our purpose here.

What is, however, striking and calls for an explanation is the fact that the banquet relief, which comprises the majority of the reliefs in nearby cities like Kyzikos, is completely absent from the second-century stelai from Smyrna. The widespread popularity of the banquet relief,[80] hark-

78. Cf. the references in Schmalz, *Griechische Grabreliefs*, XIV. See also R. Horn, *Samos XII: Hellenistische Bildwerke auf Samos* (Bonn, 1972), and, for Kyzikos, E. Schwertheim, *Die Inschriften von Kyzikos und Umgebung* (Bonn, 1980).

79. E.g., P.-M. 2, nos. 1526 (Samos), 1544 (Erythrai), 1883 (Samos), 1908 (Teos), 1915f. (Samos), 1961.

80. See P.-M. 2:353ff.

ing back to an ancient tradition, as well as the Hellenistic funerary altar, would require an extensive separate investigation. The use of the ritual meal as a setting is in itself almost emblematic of the new sense of withdrawal into the private sphere. The return to a heroic image may reveal private religious beliefs which now come to the surface with the decline in interest in the community of the polis. In any event, a shift in values toward the private sphere and the life of pleasure seems to me unmistakable. The sharply increased interest in the luxurious furnishings of private houses in this same period is consistent with such a trend.[81]

The contrast in self-image between a citizenry that prefers to represent itself in death with the standard type of the banquet relief and the people of Smyrna, who instead put their communal values in the foreground, may at first seem considerable. But most likely the absence of banquet reliefs in Smyrna has no relevance to the actual importance of hero cult in the city.[82] Rather, in Smyrna the image presented in funerary art was simply considered a more public, "political" matter than elsewhere, so that the banquet relief was perhaps considered too "private" a form for this purpose. In other words, the Smyrnaeans attached great importance to the perpetual evocation of their collective norms and values and, at the same time, to the suppression of the private and personal sphere in funerary imagery. As the popularity of the banquet relief and funerary altar elsewhere shows, this had already become a rather conservative attitude. The adherence in Smyrna to the values of the polis, especially in the statue types, seems somewhat forced. There is a sense of beliefs that feel threatened. It seems to me symptomatic of greater changes that the imagery of stelai like those from Smyrna so quickly disappeared after the Mithridatic wars, while the banquet relief still had a long life ahead of it.

81. M. Kreeb, *Untersuchungen zur figürlichen Ausstattung delischer Privathäuser* (Chicago, 1988).

82. It is interesting to note, in this regard, that there are a few reliefs that incorporate elements of the iconography of hero reliefs, such as P.-M. 1, nos. 647 and 693 (with a horse head) and 1096 (a small predella panel with veneration of a hero).

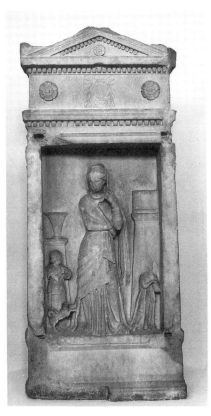

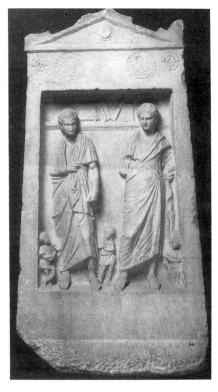

1. Oxford, Ashmolean Museum;
P.-M. no. 435. Courtesy of Ashmolean
Museum.

2. Leiden, Rijksmuseum, inv.
no. Pb. 25; P.-M. no. 341. Kommission
zur Erforschung des antiken
Städtewesens/Bayerische Akademie
der Wissenschaften, Munich; photo by
V. Brinkmann.

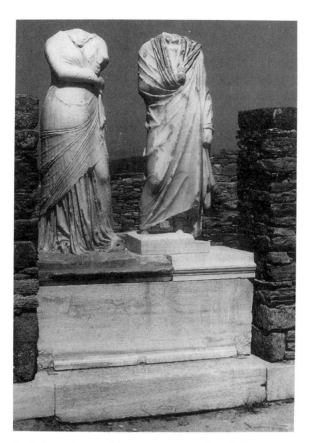

3. Delos, House of Cleopatra, portraits of Kleopatra
and Dioskourides, 138/7 BC, *in situ*. Courtesy of
École Française d'Archéologie, Athens.

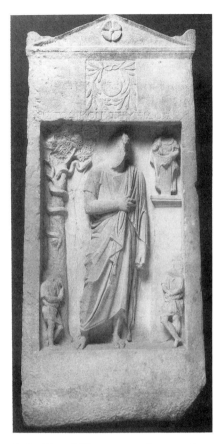

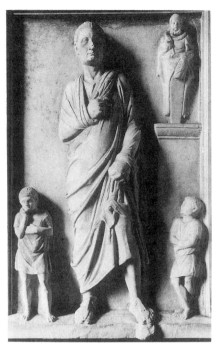

5. Ince Blundell Hall; P.-M.
no. 161. Courtesy of Deutsches
Archäologisches Institut, Berlin.

4. Leiden, Rijksmuseum, inv. no. S.N.
Ns. 1; P.-M. no. 256. Kommission
zur Erforschung des antiken
Städtewesens/Bayerische Akademie
der Wissenschaften, Munich; photo
by V. Brinkmann.

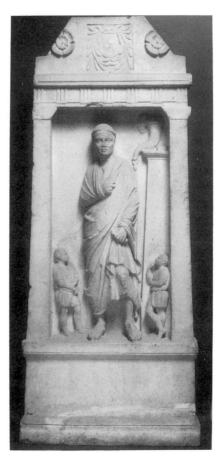

6. Leiden, Rijksmuseum, inv.
no. Pb. 27; P.-M. no. 170. Kommission
zur Erforschung des antiken
Städtewesens/Bayerische Akademie
der Wissenschaften, Munich; photo
by V. Brinkmann.

7. Detail of fig. 6.

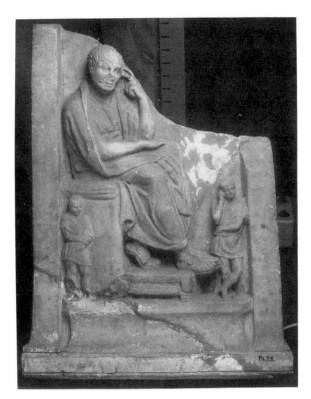

8. Leiden, Rijksmuseum, inv. no. Pb. 75; P.-M.
no. 831. Kommission zur Erforschung des antiken
Städtewesens/Bayerische Akademie der
Wissenschaften, Munich; photo by V. Brinkmann.

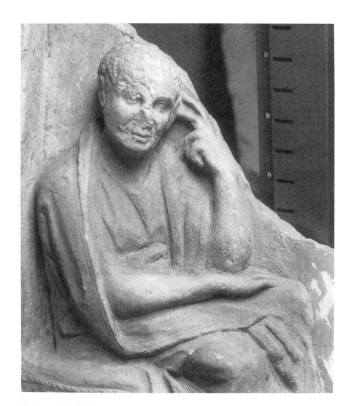

9. Detail of fig. 8.

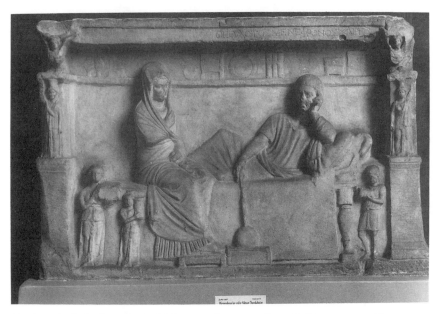

10. Istanbul, Archaeological Museum, inv. no. 4845; P.-M. no. 2034. Courtesy of Deutsches Archäologisches Institut, Berlin.

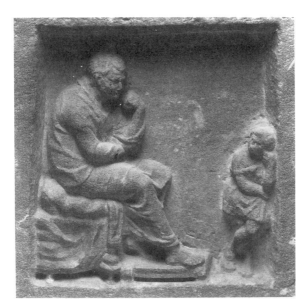

11. Leiden, Rijksmuseum, inv. no. S.N. Ns. 2
(detail); P.-M. no. 830. Kommission zur Erforschung
des antiken Städtewesens/Bayerische Akademie der
Wissenschaften, Munich; photo by V. Brinkmann.

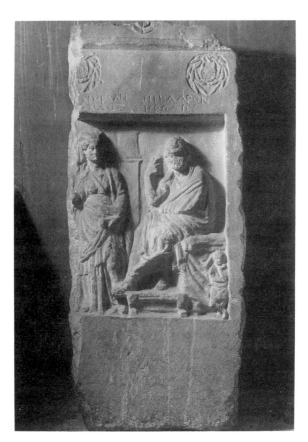

12. Winchester College; P.-M. no. 855. Courtesy of
Deutsches Archäologisches Institut, Berlin.

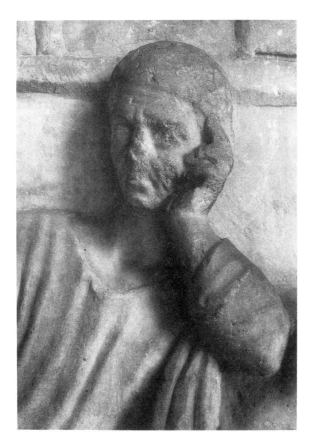

13. Detail of fig. 10.

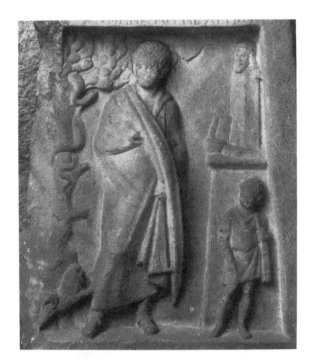

14. Leiden, Rijksmuseum, inv. no. I. 91/8.3 (detail);
P.-M. no. 114. Kommission zur Erforschung des
antiken Städtewesens/Bayerische Akademie der
Wissenschaften, Munich; photo by V. Brinkmann.

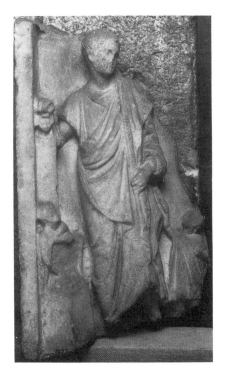

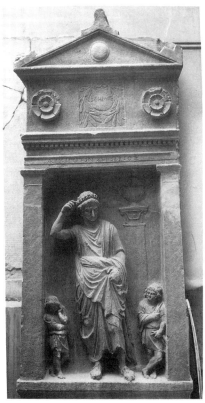

15. Leiden, Rijksmuseum, inv.
no. Pb. 77; P.-M. no. 132. Kommission
zur Erforschung des antiken
Städtewesens/Bayerische Akademie
der Wissenschaften, Munich; photo
by V. Brinkmann.

16. Oxford, Ashmolean Museum,
inv. no. 1947.271; P.-M. no. 149.
Courtesy of Deutsches Archälogisches
Institut, Berlin.

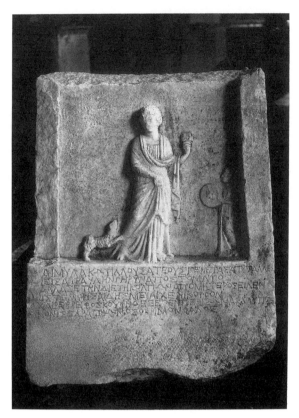

17. Formerly Izmir, Protestant School; P.-M.
no. 392. Courtesy of Deutsches Archäologisches
Institut, Berlin.

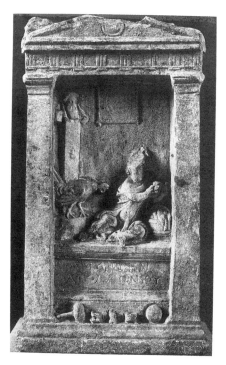

18. Paris, Louvre; P.-M. no. 804.
Courtesy of Deutsches Archäologisches
Institut, Berlin.

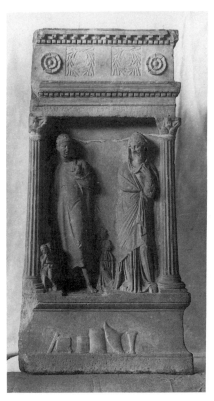

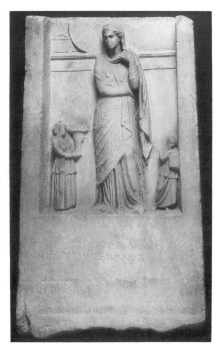

19. Oxford, Ashmolean Museum;
P.-M. no. 539. Courtesy of Deutsches
Archäologisches Institut, Berlin.

20. Leiden, Rijksmuseum, inv.
no. Pb. 26A; P.-M. no. 437.
Kommission zur Erforschung des
antiken Städtewesens/Bayerische
Akademie der Wissenschaften,
Munich; photo by V. Brinkmann.

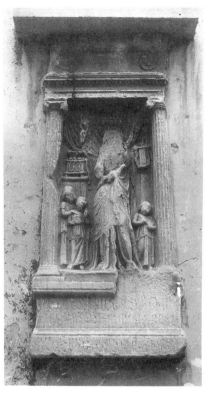

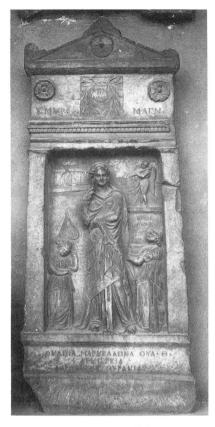

21. Formerly Izmir, Armenian School; P.-M. no. 415. Courtesy of Deutsches Archäologisches Institut, Berlin.

22. Verona, Museo Maffeiano; P.-M. no. 414. Courtesy of Deutsches Archäologisches Institut, Berlin.

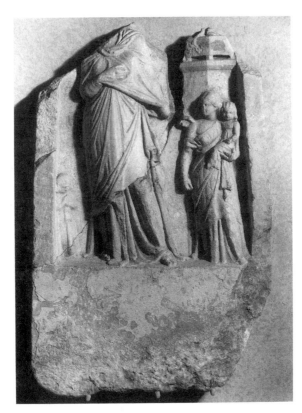

23. Madrid, Museo Arqueologico Nacional; P.-M.
no. 382. Courtesy of Deutsches Archäologisches
Institut, Berlin.

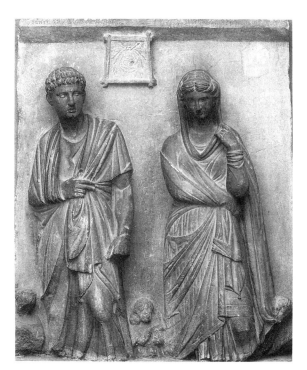

24. Vienna, Kunsthistorisches Museum, inv.
no. 1052; P.-M. no. 567. Courtesy of Deutsches
Archäologisches Institut, Berlin.

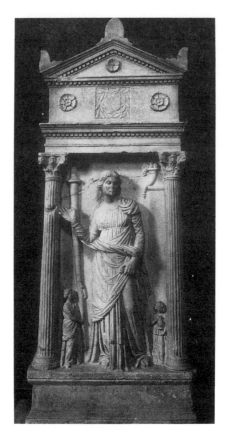

25. Berlin, Staatliche Museen, inv.
no. Sk. 767; P.-M. no. 405. Courtesy
of Deutsches Archäologisches Institut,
Berlin.

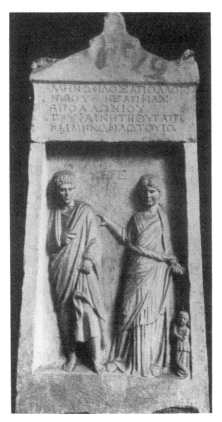

26. Vienna, Cemetery of Grinzing;
P.-M. no. 524. Courtesy of Deutsches
Archäologisches Institut, Berlin.

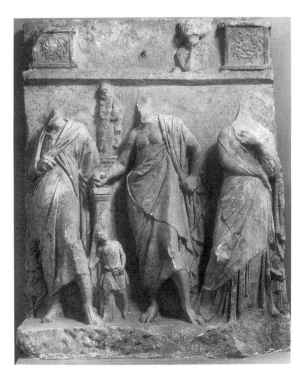

27. Izmir, Kulturpark, inv. no. 519; P.-M. no. 646.
Courtesy of Deutsches Archäologisches Institut,
Berlin.

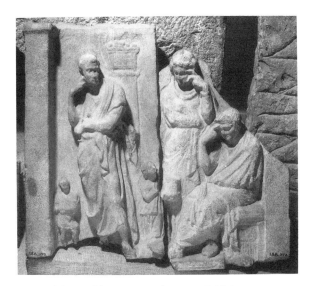

28. Leiden, Rijksmuseum, inv. no. L.K.A. 1170;
P.-M. no. 861. Kommission zur Erforschung des
antiken Städtewesens/Bayerische Akademie der
Wissenschaften, Munich; photo by V. Brinkmann.

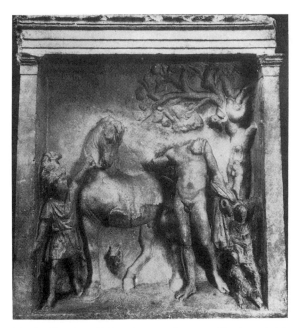

29. Berlin, Staatliche Museen, inv. no. Sk. 809; P.-M.
no. 1439. See P.-M. pl. 210: 1439.

Response

Brunilde Sismondo Ridgway

It is a pleasure to have to respond to two papers that so well complement each other.[1] Although Professor Smith has spoken in general terms of kings and philosophers, without focusing on a specific area, and Professor Zanker has chosen to limit his inquiry to the vocabulary of gravestones in ancient Smyrna, both have produced a coherent and stimulating picture—one that emphasizes the value of scholarship and philosophical thinking in the eyes of the common citizen, as contrasted with the heroic and idealized persona intentionally projected by statues of rulers. It is easy to agree with much of what both speakers had to say, and there is little to object to, despite their attempt at generalization. There are, however, some nuances that could be introduced, and some questions that could be asked; and, in my capacity as respondent, I take it that I should function as the *advocatus (advocata?) diaboli* to present a different, or at least a critical, point of view. I shall empha-

1. I have left the text of my response as I delivered it on the occasion of the symposium, on the basis of written versions of Professors Zanker's and Smith's papers that had been made available to me in advance. Professor Smith had already altered some of his points by the time of his presentation, as I could note verbally and impromptu. Professor Zanker has now kindly sent me the latest form of his text, in which some of my comments have even been taken into account. I believe the reader would be best served by my retaining the original form of my reply, which more closely reflects the discussion at the time of the symposium. My response was accompanied by slides; most of the monuments I cite can however be traced through the work on East Greek gravestones by E. Pfuhl and H. Möbius, *Die ostgriechischen Grabreliefs*, 2 vols. (Mainz, 1977–79), whose sequential numbers I give in parentheses; see also my *Hellenistic Sculpture I: The Styles of ca. 331–200 BC* (Madison, 1990).

size those statements that seemed to me particularly significant in each
paper, and I shall mention my own reservations or suggestions, as the
case may be.

I

I begin with Professor Zanker's paper, because his material is all original,
available at first hand, without problems of identification or of "transla-
tion" at the hands of a Roman copyist. It is the funerary sculpture of a
city that seems best represented for the period between about 170 and
100 BC, during which Smyrna may have played a limited role in political
events, happy to remain under Roman protection and influence. One
cannot fail to ask why so little seems to survive from the third century,
and this is perhaps the moment to acknowledge a similar dearth of
sculptural information from other parts of the Hellenistic world at that
time. I have recently attempted a survey of sculpture from circa 331 to
200 BC and have found relatively few monuments that can be attributed
to that chronological span with any confidence. I can also confirm what
Professor Zanker has pointed out: despite contacts and trade through-
out the Hellenistic world, one cannot speak of an international style,
although some iconographic elements, and some specific types, have a
wide distribution. In his own words, each Asia Minor city of the second
century seems to be a relatively closed cultural entity, strongly relying on
local traditions and standards. Yet two cautionary points should here be
considered.

The first concerns the dating of the Smyrnean stelai. As far as I know,
an approximate chronology is reached primarily on the basis of style.
Epigraphy and prosopography may have played a role, but if so, it must
have been minimal. Since men and women on these gravestones are de-
picted according to *fourth-century* formulas, our evaluation focuses on
technical and stylistic renderings, or on the appearance of the "accesso-
ries" with which these reliefs are so abundantly provided. Yet nothing
assures us that some monuments may not be earlier, others later than
the traditionally assigned chronology for those very reasons of tradition-
alism and conservatism pointed out above. If no international style ex-
isted—as I also believe—we may be wrong in dating monuments every-
where on the basis of the few fixed points we have *at other sites*. To my
knowledge, Smyrna itself has provided no such firmly dated monument.

The second consideration concerns distribution. Professor Zanker
has correctly pointed out that the general appearance of a Smyrnean
stele—with its pediment, rosettes, wreaths often inscribed *ho demos*, and
figures primarily in frontal pose—is so distinctive that geographic attri-
butions can be made even when provenience is uncertain. In fact, several

of the gravestones he mentioned as examples are in European collections and have an unknown origin. To these should however be added others—conveniently gathered in the corpus compiled by Pfuhl and Möbius—that are in fact very similar, yet are definitely known to come from elsewhere: from Rhodes (163), Samos (164), Odessos (165), Kyme (171), Ephesos (417), Sardis (418), Chios (544), and Arabli, near Sardis (546). Professor Zanker has certainly mentioned this fact, but he has stressed a relative geographic proximity. To me, it would seem that typology may be more diffused, and therefore less city-specific, than suggested, with whatever historical implications this distribution may carry. A few stelai, moreover, may have had the same mass-production origin that can be surmised for some of the fourth-century Attic gravestones: the *dexiosis* so frequently used for married couples is occasionally identified by inscriptions as depicting father and daughter (704), and a traditional frontal pair turns out, on the same evidence, to be brother and sister (543). This "anonymity" of the types stresses their formulaic character, and may therefore reinforce Professor Zanker's claim on the desirability of a projected image; but it also weakens the aspects of patronage and personal preference that should be behind certain ideological choices.

Along these lines, I may comment briefly also on the difference—pointed out by Professor Zanker—between the epitaph and the representation. The sorrow and the bereavement occasionally expressed by the inscriptions are seldom apparent in the expressions of the individuals portrayed (be they the living left behind, or the dead), and sad poses, if at all rendered, seem to be solely the prerogative of the accompanying servant figures. This situation may again be attributed to sculptural mass production, only the epitaph having been specifically commissioned for a given situation or individual. On the other hand, I cannot help noticing that this may well be the case with sculpture and poetry in general. Hellenistic verses on the Aphrodite Knidia, or even Myron's cow, verge on hyperbole in describing the beauty and realism of these monuments, yet the very periods in which Praxiteles and Myron worked would speak against the likelihood that such superlatives might apply. By the same token, I am personally leery of equating Hellenistic epigrams and "Hellenistic" large-scale monuments, such as erotes or satyrs, for which no firm dating is available and no original may be extant. Would we have "guessed" the appearance of the stelai, if only the epitaphs had survived? And if the answer to this question is negative, how safe is it to assume that greater correspondence existed, either in subject matter or in characterization, between literature and monuments?

If I may push this line of reasoning a bit further, let us consider the effects that "mass production" (for want of a better term) may have had

not only on the imagery of the stelai but also on their style. Professor Zanker has pointed out how different the Smyrnean gravestones are from allegedly contemporary Pergamene "pathetic" works—to be sure, there are very few stelai from Pergamon—with the significant exception of the few warrior stelai, for which heroic overtones are adopted from the imagery of the ruler. In these reliefs, aesthetic expression is firmly related to content, and a more baroque style predominates, while the pantherskin saddles on the horses and the snakes around the background trees emphasize the superhuman quality of the representation. Style, therefore, appears to be related to subject matter; or could it even be determined by social status—a different class—as contrasted with the more pedestrian and conservative style of the bourgeoisie? Perhaps the few "horseman's" monuments were specifically commissioned, and thus could emerge from the mainstream of everyday production. If so, we would have another proof that style and iconography are not primarily conditioned by time and geography.

To my mind, what is most striking in these "soldier's" stelai is their similarity to votive reliefs. Not just the heroic nudity, but also the horse, the tree, and the snake combine to create the same atmosphere of the "Funerary Banquet" reliefs so conspicuously absent from the Smyrnean repertoire, as pointed out by Professor Zanker. One fragmentary stele from Smyrna (1450), also dated to the second century BC, adds a high pedestal supporting the statuette of a peplophoros in slightly archaistic style; from her hand hangs a tragic mask, which has been taken as an allusion to the cult of the Muses and the musical competitions in their honor held on Hellenistic graves. I shall return to this musical component. For the moment, let me suggest that some elements of what I call the "bourgeois" stelai—for lack of a better term—also imply heroization.

Perhaps the most obvious is the scale of importance. The servant figures ubiquitous in the gravestones are so improbably smaller than the deceased as to be comparable to the human worshipers in votive reliefs to Asklepios or other divinities. That they seem unaware, in a few cases, of the presence of their masters adds to the effect of ghostly apparition of the latter. The frontal poses stressed by Professor Zanker for the principal charácters—what makes them so similar to honorary statues set up in funerary naiskoi—may therefore also be taken as a heroizing element, meant not to isolate them from each other, but rather to establish contact between the dead and the *spectators*, the visitors to the grave, very much in the line of Hellenistic *votive* reliefs, as noted by Hausmann in his book on the subject. As such, I would distinguish them from the free-standing monuments set up in Hellenistic agoras, sanctuaries, or even private houses—although the case of the Delian Kleopatra and Dioskourides is

certainly rare. In such monuments, the tone is civic and contemporary; in the gravestones, as I see it, the tone is otherwordly and superhuman. Note, for instance, that even some bourgeois characters in all their clothed decency are accompanied by bearded snakes (256, 160, 414, 1096, where tree and snake are in an inset below the main panel). And I am not entirely sure that herms signify solely the world of the palaistra and the gymnasion; some of the men portrayed next to them, besides being fully clothed, look mature and bearded (646?, 141 ff., 161, 256), and the allusions may be religious rather than athletic. Herakles, after all, was also a symbol of triumph over death.

Even the women on the stelai carry overtones of divinization. The very large torches and the poppies they hold allude not only to their priestly functions, but also to the goddess herself. Most of the figures veil their heads with the mantle (872, 405ff.; 530), but on the Winchester relief (855) the woman wears an unusual kerchief. I am reminded of the headcover of some Egyptian heads, and even of the standing Hermaphrodite in Florence, which has been connected with Egyptian rites in another context. The male figure on the Winchester stele is indeed in a philosopher's pose, counting on his fingers like Chrysippos' statue, as pointed out by Professor Zanker. And I would agree with his comment that a hand to the head means thought rather than mourning, although not in all instances.

We should perhaps reconsider the types so clearly described by Professor Zanker. For the standing male figures he has suggested affinity to the Aischines and the Demosthenes statues—not as a direct dependence, yet nonetheless as a conscious allusion, to endow each citizen with the qualities associated with great orators and politicians, especially learning, action, and philosophy. This reading, confirmed by the many "attributes" in the background, is certainly correct, and Professor Zanker's comments have been highly illuminating. I would add, however, a few refinements.

The one concession probably determined by the Asia Minor environment is the addition of a tunic under the mantle, in a tradition of male modesty that goes back to the Archaic period. But even the types may bear further definition. I find the Demosthenes type quite rare. In fact, the distinctive arrangement of the mantle, leaving the upper torso bare, and the specific interlacing of the fingers recur only on one second-century relief, from Kyzikos, that is not even the main scene but a side panel on a stele (111; for the main panels, 1398, 1945; cf. 664, from Aydin, for the clasped hands of a heavily mantled figure). This rarity may mean that the Demosthenes statue by Polyeuktos never became a "type" in the standard sense of the word—and was therefore not used as a stock or formulaic body, perhaps because the association with the

specific individual, rather than with his civic status, was too strong. Or perhaps the Demosthenes—a private, family portrait after all, even if set up in the Athenian agora—carried with it connotations of defeat and helplessness.

The position with arms crossed, one hand holding the wrist of the other, is more often rendered (e.g., 529, 530, 532), but to me seems quite different, and is in fact used even for one of the servant figures in many stelai (569, 564–565, 557, 250, 256, 161). Given also the variation in the costume, the similarity with the Demosthenes is all but lost.

The Aischines type is much more common (191–251), but even commoner is another rendering, almost in mirror image as far as the ponderation is concerned; the weight of the body is supported by the proper right leg, and the forward left leg bends in the same direction as the head, in a pose more closely comparable to the so-called Sophokles type (e.g., 156ff., 170). Yet we cannot be entirely sure that the formula began with the Lykourgan statue of the playwright, nor can we assume that the Athenian monument was the direct influence behind the Asia Minor renderings. The one obvious difference, which usually obtains also with the Aischines type, is that the left arm is held not behind but in front of the figure, and is accompanied by a swirl of the mantle tip that suggests motion. If such readings were not inevitably subjective, I would interpret the variant as a much more active pose and therefore intended for a different allusion. Occasionally, two men on one stele assume opposite and balancing stances, so that one is like the Sophokles, the other like the Aischines type (341); but the intent here seems to provide complementary images, for aesthetic rather than for conceptual purposes. Margarete Bieber has treated this mantled type, first in a lengthy article and then in her book on Roman copies.[2] She has traced its history into Roman times, through more than six centuries, as the phenomenon of the *Romani palliati*—Romans in a Greek himation, which is called in Latin the *pallium*—and has come to the conclusion that the formula was used to convey not a specific occupation, but a bookish person, an educated man of any profession, very much in keeping with Professor Zanker's viewpoint.

According to Professor Zanker, this was the one recourse, the one point of superiority the Greeks could oppose to the pervading Roman authority in their area. Yet I wonder whether Italic influence was not already sufficiently widespread to leave its mark even on these stelai. To focus first on a minor but significant detail among the *realia* of the stelai:

2. M. Bieber, "*Romani palliati,* Roman Men in Greek *Himation,*" *Proc Phil Soc* 103 (1959): 374–417; *Ancient Copies: Contributions to the History of Greek and Roman Art* (New York, 1977), chap. 11, pp. 129–147.

the type of footwear many deceased wear, with a pronounced *lingula*, seems adapted from Italic fashions. As for the ideological meaning, certainly the Romans themselves favored oratory, culture, and active civic life. By the mid-second century BC, there were enough Romans in Asia Minor that the contrast between cultures must have been considerably diminished, especially in the melting pots of the Asiatic cities.

I have already mentioned a possible second source of influence on the stelai by speaking of Egyptian headdresses, and Professor Zanker himself has pointed out a Ptolemaic derivation for the cornucopiae visible among the background attributes of some Smyrnean gravestones (156, 158, 170; 405). They too, for me, are signs of heroization rather than of priestly functions, prosperity, and *euergesia*. On one monument (872), the hieroglyph of the crossing horns may complement the *dexiosis* of the main composition, and—as for the Ptolemies—stand for the marital union attested by the funerary inscription.

One final comment on female iconography. A Smyrnean stele in Madrid (382) renders the woman in the costume of the so-called Venice Muse, one of the types included in the "Apotheosis of Homer" relief by Archelaos of Priene. It is remarkable that this should be the only example of an allusion that should have come naturally to the carvers, given the frequent comparisons of women to the Muses elsewhere. In fact, some stelai include sirens with women (e.g., the recut gravestone in Verona, 414; cf. 1096), not—as I believe—to suggest the husband's lament, but to symbolize the lyrical skills of the deceased. If "Archelaos' Muses" were in fact copied after prototypes by Philiskos of Rhodes set up in Asia Minor, as suggested by Pinkwart, their omission from the Smyrnean repertoire is worth noting. I have elsewhere suggested another possible interpretation for the "Apotheosis of Homer" and its dating.[3]

In summary, I would agree with Professor Zanker that specific connotations prevailed in the imagery of the Hellenistic gravestones from Smyrna—connotations of civic and intellectual activity for the men, luxury and religiosity for the women, prospective careers of equal value for children and the prematurely dead. But I would place more emphasis on the affinity of the reliefs to votive monuments, as made explicit by the wreaths and the dedication by the demos. This interpretation may explain the relative scarcity of Funerary Banquets and of "victorious rider" reliefs, of which the Smyrnean naiskoi would form the local counterpart. Along these lines, I would see most features as signifiers of heroization, for both men and women, and would acknowledge influence

3. *Hellenistic Sculpture I*, 257–266; see also my "Musings on the Muses," *Festschrift für Nikolaus Himmelmann*, Bonn Jhb BH 47 (Mainz, 1989), 265–272.

not only from the Egyptian, but also from the Roman sphere. Conservative formulas for the main types, albeit accompanied by creative accessories and novel compositions, bespeak "mass production" and highlight the difficulties of dating Hellenistic sculpture.

<p style="text-align:center">II</p>

Heroization is also the main theme of Professor Smith's paper—the early Hellenistic idealization of the ruler in an image of perennial youth, as contrasted with the intentional aging of a philosopher's portrait, in psychological and ethical contraposition. Here again I find few grounds for disagreement and much that is enlightening; there are therefore only a few points to which to call attention.

First of all, our conception of philosophers' portraits is based primarily on statues that are known to have been erected *in Athens*. They survive only in Roman copies and thus add to our uncertainty about proper identification and original setting, but it must be admitted, on historical grounds, that Athens was the city most directly concerned with the philosophical schools. If this is so, it is perhaps dangerous to extend the generalization to all the Hellenistic cities, although the Smyrnean stelai certainly provide a measure of confirmation.

Moreover, that monarchy was a new concept for the polis applies again primarily to Athens and central Greece. Sparta had a long tradition of kingship, albeit sui generis; Macedonia, naturally, was the very *fons et origo* of the new form of government, again because of a line of rulers going back at least a century. The Asia Minor cities, whether willing or unwilling, had long been under Persian "protection"; satrapies and local dynasties in Lycia, Karia, and other non-Greek areas of Anatolia and the Syro-Phoenician coast were established forms of monarchical rule; and in Egypt the pharaoh continued to be not only a human sovereign but an acknowledged divinity. Even the Sicilian cities, which did not have true kings, had certainly been exposed to splendid tyrants who for all intents and purposes acted as royal authorities. The many new foundations in the Hellenistic East knew no other form of government. It would almost seem as if only, or primarily, the democratic Athenians needed much convincing through new ideological imagery and iconography.

On the other hand, that a certain divinity was always thought to attach to the Macedonian rulers is shown by the alleged descent of the royal line from Herakles (Hdt. 8.138). The ultimate hint of a divine connection was certainly given by the chryselephantine statues of his family which Philip II commissioned for his tholos at Olympia—in an evocation of ancestral ties that seems to have been popular in the second half of

the fourth century, as shown for instance by the Daochos monument at Delphi. Dionysos' victories in the East need not have been fabricated from whole cloth just to provide Alexander with an apposite model, if we believe that the tradition of the Amazonian foundation of Ephesos may have been current as early as the time of Pindar. A youthful, horned Dionysos type known through several replicas has been attributed to Praxiteles—perhaps erroneously, but in any case it seems to have nothing to do with Alexander. A horned Zeus Ammon existed as a type from the fifth century BC, and Alexander's association with it goes back to his consultation of the oracle and therefore to his connections with Egypt. It is easy to imagine that the trappings of divinity, such as horns attached to fillets or animal skins worn over the head, were suggested by a pharaonic artistic tradition that did not hesitate to mingle human with animal traits. This is an old, not a new approach, and what is novel is solely its application to rulers of Greek origin. Even the aigis of the Alexander statue as *ktistes* of Alexandria had to be explained in terms of a Macedonian chlamys and the shape of the new city, to those who were not of Egyptian origin. *Female* heads with bull's horns on the forehead have also been identified as Ptolemaic queens, but in association with the mythological character of Io.[4]

I would be wary of identifying confidently as specific Hellenistic rulers some of the portraits coming to us from Roman villas at Herculaneum and Pompeii. Or, to be more precise, I am not sure that those portraits, even if correctly identified, go back to original statues contemporary with the individuals depicted. A recent publication has stressed that several of the heads from the Villa of the Papyri have no satisfactory numismatic or other likeness;[5] and I wonder whether they were just imaginary reconstructions of historical personages without reference to an official portrait. That we are still uncertain about our interpretations is shown by the fact that serious authorities read the bull's horns as an allusion to Poseidon, rather than to Dionysos; while the famous statuette from Herculaneum of the so-called Demetrios Poliorketes has goat's, not bull's horns at all. An ingenious explanation connecting with Pan not only the Antigonids but also the Ptolemies has been proposed, but cannot be verified on the coinage, which is our primary basis for identifications. It is entirely possible, moreover, that a numismatic tradition was not converted into sculptural reality until much later, since even some colossal stone portraits from Delos that *may* have carried separately attached horns could belong to the first rather than the third century BC.

4. B. Freyer-Schauenburg, "Io in Alexandria," *Röm Mitt* 90 (1983): 35–49.
5. A. Houghton, "A Colossal Head in Antakya and the Portraits of Seleucus I," *AK* 29 (1986): 52–61.

Other acknowledged traits of divinity, such as the *anastole* and the thick
wreath of hair, recur—it should be pointed out—in other types. It is a
moot point whether the *anastole* originated with Zeus or with Alexander,
since the mutual allusion is certain; but it should be noted that the ren-
dering is found also, for instance, on the river Orontes at the feet of the
Tyche of Antioch, or on some Giants of the Pergamon Altar. The wreath
of hair is seen at its most luxurious on the so-called Anapauomenos at-
tributed to Praxiteles, and it becomes distinctive of many other allegedly
Hellenistic satyrs and *Mischwesen*.

By the same token, I am not sure that the so-called Attalos I in Berlin,
with recut hair, truly depicts that Pergamene king. (As a side issue: if the
Attalids went to the trouble of fabricating a descent from Herakles, why
is the Herculean imagery absent from their presumed portraits?)[6] The
specific identification of the Berlin head is based on tenuous grounds:
the fact that no coins of that monarch exist, and that other Attalid pro-
files are known and look different; the provenience from Pergamon; the
style in keeping with the king's chronology; perhaps even the heroic size.
Yet, if I understood correctly, Professor Smith has also suggested that
the typical ruler image is life-sized, at least during the early Hellenistic
period. Certainly many later images of alleged Hellenistic rulers are
larger than life, and this heroic dimension must have functioned as a
virtual attribute.

Heroic nakedness has also been mentioned as a preferred rendering,
without recourse to the "crude strategy of a cuirassed statue." I wonder
whether our conception would change, were we able to see the many lost
monuments of rulers from Athens, Pergamon, Delos, and other cities.
The equestrian statue of Demetrios Poliorketes from the Athenian
Agora carried a sword, probably a helmet, and may have been in full
armor. The Attalid dedications on the Pergamene akropolis and at Delos
would also have worn some form of battle dress, given their commemo-
rative nature and to judge from the depiction of the Alexander Sar-
cophagus from Sidon. If the marble equestrian figures from Lanuvium
now in the British Museum are indeed copies of the Granikos monu-
ment by Lysippos, as advocated by Coarelli and others, cuirasses seem to
have been standard for Alexander and his companions in battle. All such
bronze statues, because of their difficult reproduction in the more frag-
ile marble, are those that would most likely be irretrievable for us, and
probably unrecognizable even if surviving in the shape of a herm bust
or a single head. Could the perceived difference between royal and city
portraits be our problem, rather than an ancient fact? One monument

6. O. Palagia, "Imitation of Herakles in Ruler Portraiture: A Survey, from Alexander
to Maximinus Daza," *Boreas* 9 (1986): 137–151.

exists in which the gap between ruler and philosopher, youthful and heroic man of action versus old man of thought and letters, may have been bridged.

The Sarapieion at Memphis, with its hemicycle of portrait statues, has traditionally been seen as a gathering of philosophers and poets including one statesman in their midst—Demetrios of Phaleron, because of his position as librarian of the Alexandria Museum under Ptolemy I, after his departure from Athens. This identification was based on the bearded herm on which the figure leans, taken to be a herm of Sarapis because of its spiral curls and tall headdress. A different interpretation, advanced in 1976 by M. Pietrzykowski, would see in the herm an Indian Dionysos, and would recognize Alexander in the leading figure, whose (attributed) head wears a diadem. Another statue from the hemicycle would be Ptolemy I, because of eagles carved on the base. The men of letters are identified as Pindar, Plato, Protagoras, and Homer—and, less positively, Thales, Hesiod, and Diogenes. A third-century date may be questionable for the group, but a Hellenistic chronology is undoubted.

What, then, of Professor Smith's argument? In its basic proposition, it must be considered correct, even if exceptions may be cited. Taken together, both these papers have expanded our understanding of Hellenistic self-images at various levels and have opened our eyes to new readings of familiar monuments. We are indeed grateful to our speakers.

Self-identity in Politics and Religion

Introduction

Anthony Bulloch

Apollonius writing to his brother Ptolemaeus in Egypt in the mid-second century BC curses at him for his profound belief in divine revelation through dreams at the Serapeum (*P. Par.* 47 = A. S. Hunt and C. C. Edgar, *Select Papyri: Non-Literary Selections* 100): "You are full of lies, and your gods likewise, for they have cast us into a great forest where we could die. . . . I can never hold up my head in Tricomia again for shame." A little more than a century later Marc Antony processed into Ephesus as Dionysus, with a full retinue of bacchants, satyrs, and Pans, equipped with ivy, *thyrsoi,* and the musical instruments of the god (Plutarch *Antony* 24); meanwhile King Antiochus I of Commagene set up his great monument on top of the wild Taurus Mountains with cult images of Zeus-Oromasdes, Apollo-Mithras-Helios-Hermes, and Artagnes-Heracles-Ares and a long text commending piety and ancestral worship (including sacrifice and festivals) to his children and grandchildren (Dittenberger, *OGIS* 383). Religion and social identity in the Hellenistic period can seem almost bewilderingly complex and confusing, and the papers in this section attempt to clarify the issues by focusing on people's relation to the gods, the central social and civic values of the time, and the extent to which "religion" included a sense of political community.

Folkert van Straten counsels caution in interpreting the votive material, which is patchy and partial as evidence. Certainly the geographical distribution of the surviving record is skewed in favor of particular areas in Asia Minor, and we could do with more continuous and representative remains from Egypt and the mainland, but the evidence does lead van Straten to some clear and convincing conclusions. He observes an increasing separation of worshiper and deity in the iconography of the reliefs, and an increasing verticality in their relationship. Now it may be

true that votive reliefs provide more direct contact with ordinary people than the literary texts that have survived from the period, but even these monuments could be afforded only by people above a certain economic level, and we have always to allow for the use of conventional collections of designs provided by the sculptors. In any case, a coincidence of outlook between the votive reliefs and literary texts may well be significant, and there are some telling parallels to be observed.

For example, in Apollonius Rhodius' *Argonautica* the gods are generally absent by contrast to epic works from the Archaic period, just as some of the votive reliefs from the Hellenistic period now omit representation of the gods altogether. And when the gods are present, there is a qualitative difference in the *Argonautica*. In Book 2.669ff., for example, Apollo appears unexpectedly to the Argonauts when they are on the island of Thynias: he comes suddenly from the outside, sweeping through the air and passing on without stopping, and his epiphany offers no intimacy between god and men but merely brings disruption, an earthquake on the island, scaring all of the heroes into averting their gaze as the god passes through. This is, to be sure, a distant god, as "vertical" in his relationship to the Argonauts as any divinity on the votive reliefs. Again, the fine vignette describing the departure of the ship *Argo* from Pagasae (1.519–558), a thoroughly "pregnant" moment in the epic, and one charged with significance, explicitly places the gods *above* the whole scene, looking down from the heavens (547), with the nymphs observing from the superior heights of Mount Pelion (549f.), even while Jason, leader and captain, stands amidships (the fact that he is compared at this point to the god Apollo [536ff.] serves only to underscore the distance between the men and the real gods).

The social world of the *Argonautica* is one that is very disturbed at several fundamental points, and from time to time modern readers have been tempted to see this as a reflection of the alienation of life in the modern Hellenistic cities, and the difficulty that men and women had establishing a true sense of identity and purpose in their communities. There may be something to this, but it is as well to be reminded by Adalberto Giovannini's analytical survey that at the civic level, at any rate, there was an extended sense of community identity with the polis, and a sense of commonwealth, with great emphasis on international collaboration, among communities. The pleasant sociability of the gymnasium and the theater, and the sense of cultural identity which participation in them imparted, are a long way from the despairing isolation of the Argonautic heroes huddled separately in the sand and waiting to die when they lose their way in the North African Syrtes (4.1259ff.), and although Apollonius' vision, repeatedly expressed in the *Argonautica*, of a lonely and fractured society may have had a lot of personal validity

to it, it is precisely an individual poetic vision and not a documentary report. Few poetic texts correlate simply with the societies from which they come.

The durability of the political, religious, and social institutions of the Hellenistic period was impressive, as both Adalberto Giovannini and Albrecht Dihle point out, and a source of personal stability as well as identity. Giovannini stresses the social dimension, Dihle the political, and the difference is partly illustrative of the need for further research on the key documents, especially the epigraphical; but in part it is a difference of emphasis, made possible by the very flexibility which Hellenistic communities could offer their inhabitants. In Homeric times, a Phoenix exiled from his *oikos* was essentially cut off from his very identity (*Iliad* 9.434ff.) and was extraordinarily fortunate to find even a partial refuge with some security; by the third century BC Thyonichus can actually recommend his lovesick friend Aeschinas to move from mainland Greece to Ptolemy's Egypt (Theocritus 14.55ff.), and the move will be in search of opportunity and self-betterment. This difference is a profound one, as Dihle stresses, for it betrays a definition of the self which has shifted radically in comparison to the Archaic period, and this marks a profound change in the political conditions of society; but at the same time, through all the religious ferment, it is the old gods that endure. When Antiochus I set up his monument to piety high in the wild range of Nimrud-Dagh, it was Zeus, Apollo, Hermes, and Ares to whom he turned.

Images of Gods and Men in a Changing Society: Self-identity in Hellenistic Religion

Folkert van Straten

Self-identity or self-definition in religion is, I think, about the place a person assigns himself in relation to the gods he worships.[1] It is about the nature of the relationship between gods and men as perceived by the worshipers, and it will take account of such questions as: Is this relationship primarily a personal one, between the individual worshiper and his god, or is religion rather looked upon as a matter of the community, in which the individual partakes only, or mainly, by virtue of his membership in that community?

To study this aspect of Hellenistic religiosity, we might examine its expression in literature. I shall not do that, for a couple of reasons. The first has at least a semblance of respectability: in ancient literature the ideas and beliefs of a pretty thin layer of society are rather overrepresented. The second reason is that I do not feel in the least qualified to pursue that subject. So I shall leave literature aside. Someone like Aelius Aristides may not take kindly to being left out of the discussion altogether; therefore I may mention him once or twice, but otherwise I shall focus on another class of evidence.

For self-identity in Hellenistic religion did not find expression exclusively in words; it also manifested itself visually, in *images*. In the archaeological material we find numerous representations of men and gods. Among these, representations on votive reliefs, which have an explicit religious content, showing gods and men together in a context of worship, may best lend themselves to our purpose. The archaeological

1. The drawings for figs. 1, 2, 4, 8, 14, 15, 16, 18, 19, 20, 29, 30, 31 were made by Margreet Wesseling.

evidence brings us into contact with broader layers of the population, with the common people, so to speak; and it may have the additional advantage that self-definition here is perhaps on the whole less self-conscious than in our literary authors.

Inscriptions, especially votive inscriptions, are an indispensable complement to the votive reliefs. For the present, however, though keeping an eye open for relevant epigraphical data, I will concentrate mainly on the representational evidence.

To round off the introductory self-definition of this paper: Hellenistic religion, as I see it, in Greece and the more or less Hellenized parts of Asia Minor continued through the Roman period. The most typical traits of Hellenistic votive reliefs may best be brought out by comparing, or contrasting, them with similar monuments of another period, such as their Classical predecessors.

A typical (if better than average) Attic votive relief of the fourth century BC comes from the sanctuary of Artemis at Brauron (fig. 1).[2] It is of the usual rectangular shape, more wide than it is high, and wide enough to accommodate all the figures, divine and human, that the dedicator wanted represented. According to the inscription on the architrave the relief was set up, in accordance with a prayer, by Aristonike, wife of Antiphates from the deme Thorai. We see Aristonike together with her extensive family approaching Artemis, who is standing on the right. A number of children of various ages are present (Artemis Brauronia was especially invoked in connection with pregnancy, childbirth, and child care). In front of the family procession there is a bovine sacrificial victim, restrained at the altar by a servant who holds the *kanoun*. In the rear, a maid is carrying the *kiste* on her head. The goddess is much taller than her worshipers, but all figures are standing on the same level, close together, sharing one architecturally framed space.

Let us compare this with a late votive stele from Kula in Lydia Katakekaumene (fig. 2).[3] An inscription informs us that the relief was set up by one Erastros, together with his spouse and their children, in accordance with a prayer to *Theos Hosios kai Dikaios*. The stele has the upright format that is typical of the later East Greek votive reliefs, and the fig-

2. Brauron 1151 (5): A. K. Orlandos, "Brauron," *Ergon* (1958): 35, fig. 37; I. Kontes, "Artemis Brauronia," *AD* 22 A' (1967): 195, pl. 104a; S. Karouzou, "Bemalte attische Weihreliefs," in *Studies in Classical Art and Archaeology: A Tribute to Peter Heinrich von Blanckenhagen*, ed. Gunter Kopcke and Mary B. Moore (Locust Valley, N.Y., 1979), 111–116, pl. 33.2; *LIMC* "Artemis," no. 974.

3. Manisa 1944: P. Herrmann and K. Z. Polatkan, "Das Testament des Epikrates und andere neue Inschriften aus dem Museum von Manisa," *SBWien* 265.1 (1969): 50, no. 7, fig. 14; *TAM* 5.1 (1981): 85, no. 248.

ures are arranged on four different levels. In the top panel, in a world all of his own, the God Holy and Righteous is represented on horseback. The dedicator and his family, all depicted frontally, occupy the lower levels. The god too presents a frontal face. One might say that, in contrast with the horizontal relationship between man and god in the Classical relief from Brauron, we have here a vertical relationship. But it would perhaps be more accurate to say that in this relief the composition suggests very little relationship at all.

I would not be surprised if a sneaking suspicion has crept upon the reader that by the choice of these two monuments I may have prejudiced or at least unduly simplified the issue. To try to sketch a more nuanced picture let us retrace our steps and look at the votive reliefs of the Classical period and their development in the Hellenistic age in more detail.

It is easily ascertained that the closeness between goddess and worshipers which attracted our attention on the relief from Brauron is in no way exceptional in the Classical period. Indeed examples of an even closer proximity are not hard to find. On an early Classical relief from the Athenian Akropolis a craftsman sitting behind his workbench is seen handing his *aparche* to Athena, who appears to be physically present in his workshop.[4] A late fifth- or early fourth-century relief from the Athenian Asklepieion shows Hygieia extending her hand and touching, or almost touching, the head of a man standing on the left (fig. 3).[5] In this case there is a large altar between the worshiper and his god, clearly marking, one might think, the boundary between the human and divine worlds. The altar, however, in view of its function, should probably be regarded as a link rather than a demarcation point. And anyway, in many instances no altar is represented, so gods and men move even closer together, as on the modest votive relief of a haulier from the same Asklepieion.[6]

On another relief of unknown provenance there is also no altar be-

4. Athens AkrM 577: G. Dickins, *Catalogue of the Acropolis Museum* (Cambridge, 1912) 1 : 117. E. Mitropoulou, *Corpus 1: Attic Votive Reliefs of the Sixth and Fifth Centuries BC* (Athens, 1977), no. 29, fig. 48; F. T. van Straten, "Gifts for the Gods," in *Faith, Hope, and Worship: Aspects of Religious Mentality in the Ancient World*, ed. H. S. Versnel (Leiden, 1981), 93, fig. 32.

5. Athens NM 1338: J. N. Svoronos, *Das Athener Nationalmuseum* (Athens, 1908–37), 257f., pl. 38.3; K. Sudhoff, "Handanlegung des Heilgottes auf attischen Weihetafeln," *Archiv für Geschichte der Medizin* 18 (1926): 238, pl. 10.5; H. K. Süsserott, *Griechische Plastik des 4. Jahrhunderts v.C.: Untersuchungen zur Zeitbestimmung* (Frankfurt, 1938), 108f., pl. 16.2; U. Hausmann, *Kunst und Heiltum: Untersuchungen zu den griechischen Asklepiosreliefs* (Potsdam, 1948), 176, no. 127; Karouzou, "Bemalte attische Weihreliefs," 111–116, pl. 33.1.

6. Athens NM 1341 +: L. Beschi, "Rilievi votivi attici ricomposti," *ASAA* 47/48 (1969/1970): 86ff., fig. 1.

tween the god seated on the left (he may be Zeus Meilichios or some similar deity) and the worshipers approaching from the right (fig. 4).[7] Here, right at the god's feet, a baby is crouching on the ground, reaching up his tiny hands. This visually direct and effective way of commending a child to the god's care by putting him in front of the other worshipers, immediately before the god, recurs in several other votive reliefs.[8]

As we saw earlier, fourth-century votive reliefs often have an architectural frame consisting of a bottom ledge, two antae, and an architrave topped by something like the lateral edge of a tiled roof. It has been suggested that this type of frame reflects the stoa which formed part of so many sanctuaries.[9] This opinion seems to find support in a curious votive monument from the Athenian Asklepieion, which has been treated in depth by Professor Ridgway.[10] It was carved out of a single block of marble and consists of a relief depicting the usual procession of worshipers in an architectural frame and, attached to it, at right angles on the left, a higher naiskos containing the deities. It may be that the sculptor of this monument was exceptionally literal-minded, and that in general we should not take the conventional architectural frame as reflecting any specific type of building. However that may be, the frame does have the effect of binding together the figures enclosed within it

In votive reliefs to the Nymphs the same effect may be achieved by an irregular frame suggesting the rocky mouth of a cave. The piece from Ekali in Attika illustrated here (fig. 5),[11] dating from around 300 BC, shows a group of worshipers on the left of a rustic altar and the three Nymphs and Acheloos on the right, all inside the cave.

It is interesting to compare this with a Hellenistic votive relief from Thessaly (fig. 6, second century BC?).[12] Here we have, to the right of an altar, Artemis, Apollo, and, sitting on a rock, probably Bendis. Four wor-

7. Padua MC 820: F. Ghedini, *Sculpture greche e romane del Museo Civico di Padova* (Rome, 1980), 18ff., no. 2.

8. O. Walter, "Die heilige Familie von Eleusis," *ÖJh* 30 (1937): 60; idem, "Die Reliefs aus dem Heiligtum der Echeliden in Neu-Phlaleron," *AE* (1937): 1.103; van Straten, "Gifts for the Gods," 89ff.

9. G. Neumann, *Probleme des griechischen Weihreliefs*, Tübinger Studien zur Archäologie und Kunstgeschichte 3 (Tübingen, 1979), 50f.; see also Karouzou, "Bemalte attische Weihreliefs," 111–116.

10. Athens NM 1377: Svoronos, *Athener Nationalmuseum*, 294, pl. 48; Hausmann, *Kunst und Heiltum*, 167, no. 11; B. S. Ridgway, "Painterly and Pictorial in Greek Relief Sculpture," in *Ancient Greek Art and Iconography*, ed. W. G. Moon (Madison, 1983), 193–208, figs. 13.4a–b.

11. Athens NM 3874: W. Fuchs, "Attische Nymphenreliefs," *MDAI(A)* 77 (1962): 246, Beil. 66.1; C. M. Edwards, "Greek Votive Reliefs to Pan and the Nymphs" (Diss., New York, 1985), 703ff., no. 71. I am not convinced by Edwards's argument for a later date.

12. Volos 573: *Einzelaufnahmen* 3401b; *LIMC* "Apollon," no. 959.

shipers stand on the left. The sculptor somewhat illogically combined a sort of cave frame, familiar from the Nymph reliefs, with the conventional architectural frame. But in contrast to the previous relief, only the three deities are included within the cave: the worshipers are outside.

Some gods on Classical votive reliefs may occasionally appear in non-human shape. Zeus Meilichios in particular is portrayed as a snake in more than one instance.[13] But even then care is taken to dispose the figures in such a way that the theriomorphic god and the human worshipers are close together, facing each other directly.

In exceptionally distressing circumstances, for urgent prayers, Greek worshipers would sometimes kneel before their gods in the traditional attitude of the supplicant (*hiketes, hiketis*). A fourth-century relief from Piraeus (fig. 7) is one of a series featuring a kneeling female worshiper.[14] It strikes me that the predominant impression this scene makes is not one of prostration and self-humiliation, but rather one of extreme closeness. That this is intentional may be inferred from the fact that the boy servant leading the sacrificial animal, who would normally be in front of the worshipers, has been moved to the rear, in order that the woman may kneel immediately in front of the god and reach out and touch his knees.

Later votive reliefs with kneeling worshipers are very rare. There is one in the Uşak museum, belonging to the class of the confessional stelai, as is clear from the inscription (fig. 8).[15] Two female worshipers are represented, one of whom is kneeling. But no gods are there to be touched.

Now let us return for a moment to the end of the Classical period and try to trace the development of votive reliefs from then onward in a little more detail. On some late fourth- or early third-century reliefs the gods seem to be slightly more aloof. On a votive relief from the Athenian Asklepieion (fig. 9), Hygieia, though standing nearest to the worshipers, is not facing them.[16] And the same was probably true of Demeter on a relief from Eleusis (fig. 10).[17] It would be stretching the evidence, I

13. E.g., Athens NM 3329: S. Karouzou, *National Archaeological Museum, Collection of Sculpture: A Catalogue*, Archaeological Guides of the General Direction of Antiquities and Restoration 15 (Athens, 1968), 147; E. Mitropoulou, "Attic Workshops," *AAA* 8 (1975): 122, no. 4, fig. 4.

14. Athens NM 1408: Svoronos, *Athener Nationalmuseum*, 357f., pl. 65; O. Walter, "Kniende Adoranten auf attischen Reliefs," *ÖJh* 13 Beibl. (1910): 233; van Straten, "Did the Greeks Kneel before Their Gods?" *BABesch* 49 (1974): 159–189, no. 1, fig. 1.

15. Uşak 1.3.74: unpublished.

16. Paris Louvre 755: Süsserott, *Griechische Plastik*, 123, pl. 25.4; Hausmann, *Kunst und Heiltum*, 178, no. 146, fig. 5; J. Charbonneaux, *La sculpture grecque et romaine au Musée du Louvre* (Paris, 1963), 119; van Straten, "Gifts for the Gods," 84f., fig. 16.

17. Eleusis: Süsserott, *Griechische Plastik*, 123f., pl. 25.1; G. E. Mylonas, *Eleusis and the*

think, to call this a general tendency of the period, but in the light of what follows it is worthwhile to note that the phenomenon occurs.

Unfortunately the study of succeeding developments is hampered by a certain discontinuity in our material. The rich flow of votive reliefs produced in Athens from the later fifth through the fourth centuries dries up almost entirely around 300 BC. Why this should have happened is not quite clear, but there may be a connection with the prohibition of grave reliefs by Demetrios of Phaleron in 317–316 or shortly afterward.[18] We might imagine that votive reliefs were produced as a sort of sideline by workshops whose main income depended on the sale of grave reliefs. When these were no longer in demand, the bottom fell out of their business, and then within one generation Attic votive reliefs practically came to an end as well.[19] Hereafter in Greece proper, votive reliefs are deplorably thin on the ground.

The thread may be picked up, however, one or two centuries later in the northwestern part of Asia Minor. A considerable number of votive reliefs of later Hellenistic and Roman date survive, especially from Kyzikos and Byzantium and surrounding areas. Let us look at a few examples.

A relief from Kyzikos now in Copenhagen (fig. 11) was dedicated, so we read in the inscription, by Pytheas son of Dionysios, on behalf of himself and his wife and children, to *Theos Patroa* in accordance with a prayer.[20] The monument is in the form of an upright stele, only part of which is occupied by the rectangular relief panel. From the left, four worshipers and a boy leading the sacrificial sheep approach the altar. In the background, behind the altar, there is a tree. The goddess, Meter, is seated on the right. She is represented frontally, not facing her worshipers.

Another relief (fig. 12), also from the Kyzikos area, is dedicated to

Eleusinian Mysteries (Princeton, 1961), 195, fig. 74; A. Peschlow-Bindokat, "Demeter und Persephone in der attischen Kunst des 6. bis 4. Jahrhunderts," *JDAI* 87 (1972): 152 R47; G. Schwarz, *Triptolemos: Ikonographie einer Agrar- und Mysteriengottheit*, Grazer Beiträge, Supplementband 2 (Graz, 1987), 201 R9, fig. 32.

18. K. Friis Johansen, *The Attic Grave-Reliefs of the Classical Period: An Essay in Interpretation* (Copenhagen, 1951), 13.

19. The reemergence and increase in production of Attic grave reliefs (and votive reliefs) in the late fifth century BC may be explained along similar lines; see e.g., M. Robertson, *A History of Greek Art* (Cambridge, 1975), 364f.

20. Copenhagen NM 4763. This relief appears to have been overlooked by E. Schwertheim, "Denkmäler zur Meterverehrung in Bithynien und Mysien," in *Studien zur Religion und Kultur Kleinasiens: Festschrift für Friedrich Karl Dörner*, ed. Sencer Sahin, Elmar Schwertheim, and Jorg Wagner (Leiden, 1978) 2:791–837, and by M. J. Vermaseren, *Corpus Cultus Cybelae Attidisque*, vol. 1, *Asia Minor* (Leiden, 1987).

Apollo Krateanos, and there are two sheep, but otherwise the monument has the same components arranged in a similar way.[21]

A votive relief from a sanctuary near Apameia on the Propontis (fig. 13) depicts Zeus, and again he is rendered in full frontal view.[22] His eagle perches on a branch of the now familiar tree behind the altar. On the left there is one worshiper, who must be the priest Asklepiades mentioned in the inscription; a maid carrying a rather flat basket or tray on her head and holding a pitcher in her right hand; and a boy with a sheep. The date of this stele is given in the inscription as the year 174, which may be either 123 BC or 89 AD, depending on whether the Bithynian or the Sullan era is meant, or even somewhere in between.[23]

The same pattern recurs in another Mysian relief, dedicated to Zeus Aithrios, which was tentatively dated to the second century BC by Robert.[24] Here, however, the upright format of the stele is taken advantage of in order to add another relief panel underneath, showing a second sacrificial animal: a bull whose head is forced to the ground by means of a rope fastened to its horns and passed through a ring which is visible in the bottom left corner.

The next stele, which may be slightly later, again displays two relief panels (fig. 14).[25] But there is a significant difference in the disposition of the figures. The upper panel is now entirely taken up by the gods. They are identified by the inscription as Zeus Megistos (on the right), Apollo Bathylimeneites (who is represented twice, in the type of an Archaic kouros and in more contemporary form), and Artemis (on the left). The human worshipers are now relegated to the lower panel, together with the sacrificial bull, which is about to be stabbed to death.

This near allocation of separate relief panels to human and divine figures, though it was never a general rule, is found in many other reliefs from the same area. In one, dedicated to Zeus Olbios by the priest Euodion, the altar is represented twice, thus constituting a link between the

21. Vienna I439: L. Robert, "Apollons de Mysie: Apollon Krateanos," in *Hellenica*, vol. 10 (Limoges, 1955), 137ff., pl. 152; R. Noll, *Griechische und lateinische Inschriften der Wiener Antikensammlung* (Vienna, 1962), 27f., no. 31.

22. Athens NM 1486: Svoronos, *Athener Nationalmuseum*, pl. 112; T. Corsten, *Die Inschriften von Apameia (Bithynien) und Pylai* (Bonn, 1987), 47ff., no. 33. On its provenance from Triglia near ancient Apameia on the Propontis, see P. Perdrizet, "Reliefs mysiens," *BCH* 23 (1899): 592–599, no. III, and L. Robert, "Inscriptions de la région de Yalova en Bithynie," in *Hellenica*, vol. 7 (Limoges, 1949), 42f.

23. On the various possible chronologies, see Robert, "Inscriptions," and Corsten, *Inschriften*.

24. L. Robert, "Documents d'Asie Mineure," *BCH* 107 (1983): 545ff., fig. 1: "hellénistique, on dirait du IIe siècle a.C."

25. Instanbul inv. 4407: L. Robert, "Apollon Bathylimenitès," *Hellenica*, vol. 10 (Limoges, 1955), 125–133, no. 25, pls. 19.3, 38.2.

upper panel, occupied by Zeus, and the lower panel, where Euodion and his family and assistants are sacrificing a bull (fig. 15).[26] This dedication was made at the god's own command (*kathos ekeleusen*), so we should be careful not to jump to conclusions and take the arrangement in separate relief panels as an indication that all direct contact between gods and men was lost. But there is distinctly less feeling of nearness.

Meter Tolypiané is depicted in the top panel of a stele now in Istanbul (fig. 16).[27] Underneath we see eight male worshipers, members of some sort of club; and a servant leading two sheep to a large altar.

An incomplete relief in the Louvre must have displayed a similar arrangement (fig. 17).[28] Very little remains of the top panel, which again was occupied by a Meter figure: Meter Kotiané, according to the inscription. In the surviving lower panel Meter's cymbals are seen hanging from a tree next to the altar. In the background, behind the altar, is the maid, carrying the flat basket or tray on her head. From the left approach the sacrificial servant with a sheep, a worshiper in woman's clothes, and a slightly smaller figure holding a double flute. My colleagues generally insist on describing the worshiper in woman's clothes as a woman.[29] The inscription, however, which incidentally fixes the date of the monument at 46 BC, informs us that it was dedicated by a certain Soterides, who was a *gallos* of Meter, and as such may be expected to wear female attire.[30] Soterides offered the stele to Meter for the safety of his companion Markos Stlakkios, who had sailed to Libya as a member of the contingent sent by Kyzikos to help Caesar against the Pompeians and had been made a prisoner of war. Then the goddess appeared to

26. Istanbul inv. 1909, from Kavak: Edhem Bey, "Relief votif du Musée Impérial Ottoman," *BCH* 32 (1908): 521–528, pls. 5–6; G. Mendel, *Catalogue des sculptures grecques, romaines et byzantines*, vol. 3 (Constantinople, 1914), no. 836; L. Robert, "Reliefs votifs de Derkoz," *Hellenica*, vol. 10 (Limoges, 1955), 45; van Straten, "Daikrates' Dream: A Votive Relief from Kos and Some Other Kat'onar Dedications," *BABesch* 51 (1976): 11, figs. 20–21.

27. Istanbul inv. 676, from Deble Köy/Bandirma: Mendel, *Catalogue des sculptures*, no. 850; A. Schober, "Vom griechischen zum römische Relief," *ÖJh* 27 (1931): 52, fig. 73; Schwertheim, "Denkmäler zur Meterverehrung," 817, no. II A 11, pl. 194.27; Vermaseren, *Corpus Cultus* 1:95, no. 389, pl. 63.

28. Paris Louvre 2850, from Kyzikos: Charbonneaux, *Musée du Louvre*, 76; *Syll*[3] 763; Schwertheim, "Denkmäler zur Meterverehrung," 810f., no. II A 3, pl. 192.23; M. J. Vermaseren, *Cybele and Attis: The Myth and the Cult* (London, 1977), 29, fig. 15; idem, *Corpus Cultus* 1:94, no. 287, pl. 62.

29. E.g., Charbonneaux, *Musée du Louvre*; Schwertheim, "Denkmäler zur Meterverehrung"; Vermaseren, *Cybele and Attis*; idem, *Corpus Cultus*.

30. See van Straten, "Daikrates' Dream," 11f., fig. 22; compare also a self-dedication of a *gallos* from Pisidia, inscribed *Menéas gállos heautón*, depicting a long, robed figure: G. E. Bean, "Notes and Inscriptions from Pisidia," *AS* 9 (1959): 71, no. 5, pl. 15a.

her *gallos* in a dream and informed him that Markos had been taken
prisoner but could be saved from serious danger by invoking the god-
dess. Here the inscription breaks off, but I do not think we should feel
too worried about Markos, for the existence of the votive offering proves
that his story had a happy ending.

In the Mysian votive reliefs we have seen so far, the Classical Greek
tradition is still fairly strong, although we could observe some interesting
shifts in man's perception of his relationship with the gods. We encoun-
ter a more diluted version of the Classical heritage when we travel far-
ther inland in Lydia and Phrygia. These regions have yielded consider-
able series of votive reliefs, mostly of the second and third centuries AD.

A relief from Kula in the Katakekaumene (fig. 18), dated to 257/8 AD,
shows *Theos Hosios kai Dikaios* on the upper level and underneath three
worshipers at an altar.[31] The arrangement is strictly paratactical, and all
figures are rendered in full frontal view. Here we are back at the point
where we were earlier, and where very little expression of any close re-
lationship between man and god is evident.

Perhaps someone would object that this is merely a matter of style
and that not too much meaning should be read into it. I readily concede
that we are constantly at risk of overinterpreting this sort of thing, but
in the present case there may be some corroborative evidence for the
contention that these compositional characteristics are meaningful.

In a Lydian stele of the second century AD (fig. 19), for instance,
which is dedicated to the Great Men (*Megas Meis Axiottenos Tarsi basi-
leuon*), the small figure of a human worshiper might easily have been
accommodated on the same level as the god.[32] There, a cloak is repre-
sented, about the theft and recovery of which the inscription informs us.
The poor sinner, however, is relegated to a specially prepared box in the
basement.

And there is another point. Among this class of late Lydian (and
Phrygian) votive reliefs we find an increasing number where either the
god or the worshipers are not represented at all.

An example of worshipers and no gods (something that is extremely
rare on Classical Greek votive reliefs), is provided by a stele, also from
Kula, dated at 196/7 AD (fig. 20).[33] It was dedicated to Artemis Anaeitis

31. Manisa 1945: Herrmann and Polatkan, "Testament des Epikrates," 50, no. 8,
fig. 16; *TAM* 5.1 (1981): 85, no. 247.

32. Reported to have been found near Köleköy, dated at 164/5 AD: P. Herrmann, "Er-
gebnisse einer Reise in Nordostlydien," *Denkschriften Wien* 80 (1962): 30, no. 21; E. Lane,
Corpus Monumentorum Religionis Dei Menis, vol. 1 (Leiden, 1971), no. 69; *TAM* 5.1 (1981):
50, no. 159.

33. Boston MFA 94.14: Lane, *Corpus Monumentorum*, vol. 1, no. 63; C. Vermeule,

and Men Tiamou. The dedicator and his wife and two children are represented in frontal pose, the right hand raised in the familiar gesture of worship. They face the viewer or, in a broader sense, they face the world, testifying to and proclaiming the omnipotence of the gods: *martyrountes tas dynam(e)is ton theon*, as the inscription states with a phrase that recurs regularly in this class of stelai.

The counterpart to this type of representation may be illustrated by one of a series of reliefs from Phrygia dedicated to Zeus Ampelites (fig. 21).[34] The god is portrayed as a frontal bust, with a powerful hand, and the cattle, *ta hyparchonta*, for the sake of which the dedication was made, are quite literally placed under his protection. But the dedicators themselves are absent.

So much for a general sketch of the development of the expression of self-identity on Classical Greek and later Greek and less and less Greek votive reliefs. Before we go on to some special categories, we should perhaps at this point take a moment to consider whether the development sketched above may in fact be taken as a continuous line of development in any real sense.[35] The material, examples of which have been presented so far, falls more or less naturally into three classes: (1) votive reliefs of the Classical period (mostly Attic, but other parts of Greece have produced similar monuments); (2) votive reliefs from the Greek cities of northwest Asia Minor (Byzantium, Kyzikos, etc.) and their surrounding areas; iconographically these form a reasonably coherent series, starting in the Hellenistic age and continuing into the Roman imperial period; and (3) late votive reliefs from sanctuaries in Lydia and Phrygia, dating from the imperial period.

The first two groups may certainly be looked upon as representatives of the same tradition (with regard both to their iconography and to the religiosity of which they are the visual expression), if for the purpose of this survey we loosely think in terms of Greek religion in general, ignoring its rich local and regional diversity. To understand the iconographic link between the first and the second group, we should, of course, be aware of the fact that votive representations of worshipers and gods oc-

"Dated Monuments of Hellenistic and Graeco-Roman Popular Art in Asia Minor: Ionia, Lydia, and Phrygia," in *Mélanges Mansel* (Ankara, 1974) 1 : 119–126, pl. 61; I. Diakonoff, "Artemidi Anaeiti Anestesen: The Anaeitis-Dedications in the Rijksmuseum van Oudheden at Leyden and Related Material," *BABesch* 54 (1979): 151, no. 32, fig. 19; *TAM* 5.1 (1981): 104, no. 319.

34. Van Straten, "Gifts for the Gods," 104, fig. 48; see Robert, "Documents d'Asie Mineure," 529–542: "Zeus Ampélitès," for a series of similar reliefs.

35. I thank Professor Henrichs for his suggestion that some clarification of my position on this point might be useful.

curred not only on stone reliefs but also, and in far greater quantities, on painted wooden votive plaques and on small metal reliefs.[36] We may envisage these common votive representations, very few of which survive, as a constant undercurrent of votive iconography.

Linking the third class of votive reliefs (which in itself is rather loosely knit anyway) to the second is more of a problem. Religion as practiced in the sanctuaries of Lydia and Phrygia in the second to third centuries AD was certainly not in the mainstream of later Hellenistic religion. Therefore, although it may be interesting to observe that some of the developments seen in votive reliefs of the second group continue to a more extreme degree in the third, we should remember that this may be only part of the picture.

By way of addendum I would like to add a few remarks on dedications of some special categories of people, for whom a closer than average bond with the gods may be expected: the sick, dreamers in general, and founders of sanctuaries.

For the Classical period we have an abundance of data regarding the specific cult practices and the expressions of private religiosity in sanctuaries of healing deities such as Asklepios and Amphiaraos. I need only mention Aristophanes' *Ploutos*, the *Iamata* inscriptions from Epidauros, and the votive reliefs from the Asklepieia in Piraeus and Athens and the Amphiareia in Oropos and Rhamnous.

Figure 22, a relief from the Athenian Asklepieion, is one of a series showing the patient reclining on a couch, in the *enkoimeterion* perhaps, and being visited during his sleep by an apparition of the healing god.[37] Here one deity, probably Asklepios himself, is sitting at his bedside, and one of Asklepios' sons is standing at the patient's head, on the right. The patient, in his dream vision, stretches out his hand, acknowledging the presence of the gods. In sickness, when the personal need for the gods is felt most poignantly, their nearness may be experienced most clearly. After the Classical period, reliefs of this kind are hardly to be found.[38] But that does not mean that the experience they illustrate no longer occurred. Asklepieia flourished throughout the Hellenistic and Roman ages, and we may easily bridge the centuries by using this relief to illus-

36. For some literary testimonia on less durable votives, see van Straten, "Gifts for the Gods," 78ff.

37. Athens NM 1841: Svoronos, *Athener Nationalmuseum*, pl. 133; Sudhoff, "Handanlegung des Heilgottes," 237, pl. 11.4; R. Herzog, *Die Wunderheilungen von Epidauros: Ein Beitrag zur Geschichte der Medizin und der Religion*, Philologus Suppl. 22.3 (Lepizig, 1931), 79, n. 27; Hausmann, *Kunst und Heiltum*, 178, no. 151; van Straten, "Daikrates' Dream," 3, fig. 8; Mitropoulou, *Attic Votive Reliefs*, 71, no. 143, fig. 203.

38. A rare example from the second century AD: van Straten, "Gifts for the Gods," 98, fig. 42.

trate the description of an apparition of Asklepios as given more than half a millennium later by Aelius Aristides:

> It was revealed in the clearest way possible, just as countless other things also made the presence of the god manifest. For I seemed almost to touch him and to perceive that he himself was coming, and to be halfway between sleep and waking and to want to get the power of vision and to be anxious lest he depart beforehand, and to have turned my ears to listen, sometimes as in a dream, sometimes as in a waking vision.[39]

Dedications made on the strength of a dream vision were not, of course, restricted to the cult of Asklepios. Many other gods appeared in person to their worshipers and, judging from the inscriptions, with increasing frequency during the Hellenistic and Roman periods. In the terminology of these inscriptions the worshipers often present their gods as powerful absolute rulers who give explicit commands (*epitage, prostagma, keleusis*, etc.).[40]

Founders of sanctuaries, one would expect, may also display a rather special personal relationship with their gods. Founding a sanctuary might well be a deciding factor in determining one's religious identity. Let us meet some founders. First, Telemachos of Acharnai, who was portrayed on the monument which commemorated his foundation of the Athenian Asklepieion in 420/19 BC and which has been painstakingly reconstructed from its *disjecta membra* by L. Beschi.[41] The two sides of this amphiglyphon show the interior and the exterior of the newly founded sanctuary, and on one side there is also an indication of the Asklepieion in Piraeus, whence Asklepios had come to Athens. Telemachos himself, however, is in no way different from any other worshiper on any other votive relief of the same period. In the inscription on the pillar supporting this relief, though it is extremely succinct and matter-of-fact, we may perhaps detect a certain amount of self-confidence and pride. Telemachos declares, and he emphatically repeats it in another inscription,[42] that he was the first to found the sanctuary of Asklepios and Hygieia and the sons and daughters of Asklepios.

Not much later in Phaleron we encounter a female founder of a sanctuary in a small way: Xenokrateia, who dedicated a shrine to Kephisos and the gods who shared his altar (*xunbomoi theoi*).[43] The relief (fig. 23)

39. Aelius Aristides *Sacred Tales* 2:31f., trans. Edelstein.

40. See van Straten, "Daikrates' Dream," 12–13 and App.

41. L. Beschi, "Il monumento di Telemachos, fondatore dell' Asklepieion Ateniese," *ASAA* 45/46 (1967/1968): 381–436; idem, "Il rilievo di Telemachos ricompletato," *AAA* 15 (1982): 31–43.

42. *IG* 2².4355.

43. Athens NM 2756: Svoronos, *Athener Nationalmuseum*, 493ff., pl. 181; Walter, "Reliefs

shows Xenokrateia and her young son Xeniades in the midst of these gods, and in very close contact with Kephisos, who is attentively bending over toward her. Here Xenokrateia's special status seems to be expressed in the somewhat exceptional iconography of the relief.

A fascinating founder in the Hellenistic age is Artemidoros of Perge. He had served in Egypt under the first Ptolemy and later retired to the island of Thera, where he founded a complex of altars and sanctuaries near the main gate of the town.[44] Reliefs were carved in the living rock, showing animals and attributes of the gods. The altar in figure 24 is inscribed: "Of Homonoia. Artemidoros son of Apollonios from Perge, in accordance with a dream." And then, in verse: "The immortal altar of Homonoia was founded here for the city in accordance with a dream by Artemidoros who hails from Perge."[45] Next to the eagle, on the right in figure 25, we read: "To Zeus Olympios. The high-flying eagle, messenger of Zeus, an everlasting foundation by Artemidoros for the city and the immortal gods." Underneath is a more general statement: "Imperishable, immortal, ageless, and everlasting are the altars of all the gods for whom Artemidoros as priest founded a sanctuary."[46] The lion (on the left in figure 25) is dedicated *Apolloni Stephanephoroi*, and the verse inscription reads: "The lion, dear to the gods, was made by Artemidoros in the holy precinct, a monument of the city."[47] Over the *piloi* and stars (fig. 26), attributes of the Dioscuri, is written: "An altar for the Dioscuri, savior gods who come to the aid of those who invoke them, was made by Artemidoros of Perge."[48] The dolphin (fig. 27), of course, belongs to Poseidon (*Poseidoni Pelagioi*): "In the untiring rock Artemidoros made a dolphin for the gods, men's best friend."[49]

In these and numerous other inscriptions Artemidoros is establishing his self-identity in no small way. His name is mentioned in every dedication, often twice over. He insists that the altars and reliefs are everlasting (*ageratos, athanatos, aenaos, aphthitos*). With some of the gods Artemi-

aus dem Heiligtum der Echeliden," 1.97–119; Süsserott, *Griechische Plastik*, 97ff.; Hausmann, *Griechische Weihreliefs* (1960), 63f., fig. 33; A. Linfert, "Die Deutung des Xenokrateiareliefs," *MDAI(A)* 82 (1967): 149–157; M. Guarducci, "L'offerta di Xenokrateia nel santuario di Cefiso al Falero," in *Phoros: Tribute to B. D. Meritt*, ed. D. W. Bradeen and M. F. McGregor (Locust Valley, N.Y., 1974), 57–66; Mitropoulou, *Attic Votive Reliefs*, no. 65.

44. *IG* 12.3.421–422, 863, 1333–1348; *Thera* 3.89ff.; U. von Wilamowitz-Moellendorff, *Der Glaube der Hellenen*, vol. 2 (repr. Basel, 1973), 16, 176, 382ff.; M. P. Nilsson, *Geschichte der griechischen Religion*, 3d ed., vol. 2 (Munich, 1974), 189ff.; van Straten, "Daikrates' Dream," 18, figs. 23–26.

45. *IG* 12.3.1336.
46. *IG* 12.3.1345.
47. *IG* 12.3.1346.
48. *IG* 12.3.1333.
49. *IG* 12.3.1347.

doros' relationship seems to have been a very direct one. Homonoia, as we saw, made her will known to him through a dream. And Artemis Pergaia, together with Pronoia, personally saw to it that he lived to a very old age (probably ninety-three).[50] Artemidoros' religiosity was of a distinctly individual nature, but his foundations were not a merely private matter. Like a real *euergetes* he founded his sanctuaries for the city (*tei polei*), as he repeatedly assures us.

Among the reliefs we find Artemidoros' own portrait (fig. 28), which is curiously reminiscent of coin portraits of Ptolemy I.[51] Around it, in his rather imperfect poetry, he has written: "A monument for Thera, and as long as stars rise in the sky and the foundation of the earth remains, Artemidoros' name is not forsaken."[52]

Now that we have tried to look into the visual expressions of religious self-identity of the common people, and of some not so common people, I would like to broach one final subject: the question of individual versus communal religiosity. Signs of increasing individualism have been recognized in Hellenistic religion, and earlier, in the late fifth and fourth century BC.[53] Can we detect such symptoms in the archaeological material?

One might be tempted to point to the fact that the Classical votive reliefs, which are so numerous especially in fourth-century Athens, are all, with very few exceptions indeed, private dedications. At first sight that would seem to indicate a strong individualistic tendency in the religiosity of that period. But I think we should look again. In the first place, as we have seen, the votive reliefs often do not show one individual worshiper, but whole families, even if according to the inscription the dedication was made by only one person. So they are private, but not so very individual. Secondly, at the same time that so many private votive reliefs were produced in Athens, several sacred laws were inscribed on stone. These laws contained cult regulations and sacrificial calendars for the state as a whole, or for individual demes, the Marathonian tetrapolis, and so on, and bore witness to a vivid interest in the communal, civil aspect of religion. Both aspects of religion, the communal and the private, flourished. Both aspects are already mentioned, and distinguished, in Drakon's law: "People should worship the gods and the local heroes, communally (*en koinoi*) in accordance with the ancestral laws, privately (*idiai*) according to their means."[54] A similar distinction between communal and private religious observances is seen in a sacred law from

50. *IG* 12.3.1350.
51. E.g., G. K. Jenkins, *Ancient Greek Coins* (New York, 1972), figs. 556, 562.
52. *IG* 12.3.1348.
53. E.g., Nilsson, *Geschichte der griechischen Religion*, 3d ed., 1:804ff., 2:250.
54. Porphyry *De abstinentia* 4.22.

Thasos of the fourth century BC,[55] which prescribes the sacrifice of specific animals to Dionysos and then adds: "and private worshipers whatever they want (*hoi de idi[otai hoti an]: thelos[in]*)." And later even such a typically civic affair as Hellenistic ruler cult had its private aspects too, as Louis Robert has shown in his classic study, "Sur un décret d'Ilion et sur un papyrus concernant des cultes royaux."[56]

In the Classical period the distinction between communal and private cult is interestingly reflected in the relative frequency of various species of sacrificial animals. In fourth-century Attic sacrificial calendars (fig. 29) there is a distinct preponderance of sheep: 57 to 58.4 percent of all sacrifices recorded, compared to 20.8 percent pigs or piglets and 3.5 to 7.4 percent cows and bulls. In the contemporary votive reliefs with sacrificial representations (fig. 30) the pigs and piglets score much higher: 49.5 to 50.5 percent, as against 28.5 to 32.5 percent sheep and 9.5 to 13.5 percent cows and bulls. I have argued elsewhere that the explanation for these different patterns is to be found in the prices of the victims.[57] The animals for the communal sacrifices mentioned in the sacrificial calendars are, on the average, more expensive than the private sacrifices of the votive reliefs.

How do the later votive reliefs from Asia Minor compare with these patterns? They are rather surprising. Among the sacrificial victims on these reliefs (fig. 31) pigs or piglets appear to be entirely absent, and sheep and cows or bulls each account for approximately 50 percent of the total. In other words, the sacrificial victims on these reliefs are, on the average, far more expensive than the private, or even the communal sacrifices of Classical Athens. This probably reflects the greater affluence of the region, though there may be other contributing factors.

So far we have somewhat shortsightedly concentrated on the opposition between the private individual and the civic community. There is, however, a third category: the smaller social group or club with a religious objective. Such groups might be loosely or more tightly organized. One may think, on the one hand, of the people who accompanied Sostratos' mother to the shrine of the Nymphs near Phyle, in Menander's *Dyskolos*. Mattresses are provided and hampers with food, and the sacri-

55. F. Sokolowski, *Lois sacrées des cités grecques: Supplément,* École française d'Athènes, Travaux et mémoires 11 (Paris, 1962), no. 67.

56. L. Robert, "Sur un décret d'Ilion et sur un papyrus concernant des cultes royaux," in *Essays in Honor of C. Bradford Welles,* ed. A. E. Samuel, American Studies in Papyrology 1 (New Haven, 1966), 175–210; P. Frisch, *Die Inschriften von Ilion* (Bonn, 1975), 84–91, no. 32.

57. Van Straten, "Greek Sacrificial Representations: Livestock Prices and Religious Mentality," in *Gifts to the Gods: Proceedings of the Uppsala Symposium, 1985,* ed. T. Linders and G. Nordquist = *Boreas* 15 (1987): 159–170.

fice is depicted as quite a social happening. Too much so, in fact, for the taste of the fretful neighbor.

More strictly organized, on the other hand, were the religious associations of *orgeones*, usually dedicated to the cult of one deity or hero.[58] A votive relief in the Louvre, with a hero and heroine at banquet, may present a rare picture of such an association of *orgeones* consisting of (at least) fourteen bearded men in two rows.[59]

As Nilsson put it, "Vereine und Klubs hat es immer gegeben. . . . Die Blütezeit des Vereinswesens aber war die hellenistische Zeit."[60] And indeed, among the later Hellenistic votive reliefs from northwest Asia Minor, dedications of social or religious associations seem to form a distinctly higher percentage than in Classical Greece. Occasionally this enhanced social aspect of religion is also expressed in the relief representations.

A stele from Apameia on the Propontis (fig. 32), dated either 119 BC or 93 AD,[61] was dedicated to Apollo and Meter Kybele by a group of *thiasitai* and *thiasitides*. The upper panel shows the familiar sacrificial scene. Underneath, the members of the *thiasos* are enjoying a festive banquet, enlivened by musicians and a dancer, and with a copious supply of drink and souvlakia.[62]

To sum up. To draw general conclusions from our observations would probably not be wise, in view of the rather one-sided concentration on the archaeological evidence. With this reservation, however, we may note that the worshipers in the course of the Hellenistic period seemed to experience an increasing verticality in their relationship with the gods,

58. W. S. Ferguson, "The Attic Orgeones," *HThR* 37 (1944): 62–140; idem, "Orgeonika," Hesperia Suppl. 8 (1949): 130–163.

59. Paris Louvre 956: J.-M. Dentzer, *Le motif du banquet couché dans le proche-orient et le monde grec du VIIe au IVe siècle avant J.-C.*, Bibliothèque des Écoles françaises d'Athènes et de Rome 246 (Paris and Rome, 1982), 622 R472, fig. 693.

60. Nilsson, *Geschichte der griechischen Religion* 2: 117. Also, of course, F. Poland, *Geschichte des griechischen Vereinswesens* (Leipzig, 1909), esp. 514–534, "Geschichtliche Überblick."

61. See n. 22, above.

62. Athens NM 1485, from Triglia near ancient Apameia: Svoronos, *Athener Nationalmuseum*, pl. 112; Perdrizet, "Reliefs mysiens," no. II; Robert, "Inscriptions," 30–44; Schwertheim, "Denkmäler zur Meterverehrung," 119f., no. II A 13; *LIMC* "Apollon," no. 964; Corsten, *Inschriften*, 47–56, no. 35; Vermaseren, *Corpus Cultus*, 81, no. 252, pls. 50–51. See also the votive relief London BM 817, from the Kyzikos area: A. H. Smith, *A Catalogue of Sculpture in the Department of Greek and Roman Antiquities, British Museum*, vol. 1 (London, 1892), no. 817; Perdrizet, "Reliefs mysiens," pl. 4; *GrInscrBM* 4.2.1007; A. Bélis, "L'aulos phrygien," *RA* (1986): 31, fig. 9; idem, "Kroupezai, scabellum," *BCH* 112 (1988): 325 (in both articles by Bélis the relief is curiously misrepresented as a "stèle funéraire"). The illustrations of the Athens and London reliefs are confused in Nilsson, *Geschichte der griechischen Religion* 2:666, pl. 14.

not unlike the position of subjects to an absolute ruler. The same phenomenon has been observed by scholars who have studied the epigraphical and literary evidence, and it has been explained as a reflection of the contemporary society.[63] At the same time, at the lower end of this vertical relationship, on the human level, horizontal relationships in the form of socioreligious clubs became more and more important.

63. See, e.g., H. W. Pleket, "Religious History as the History of Mentality: The 'Believer' as Servant of the Deity in the Greek World," in *Faith, Hope, and Worship,* ed. Versnel, 152–192. For a different approach, see P. Veyne, "Une évolution du paganisme gréco-romain: Injustice et piété des dieux, leurs ordres ou 'oracles,'" *Latomus* 45 (1986): 259–283. See also B. Gladigow, "Der Sinn der Götter," in *Gottesvorstellung und Gesellschaftsentwicklung,* ed. P. Eicher (Munich, 1979), 41–62.

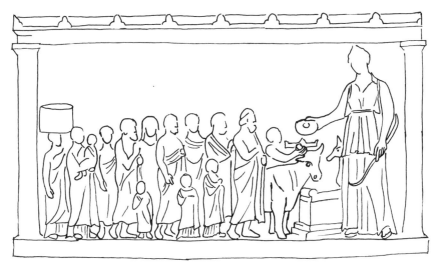

1. Brauron 1151 (5): votive relief from Brauron.

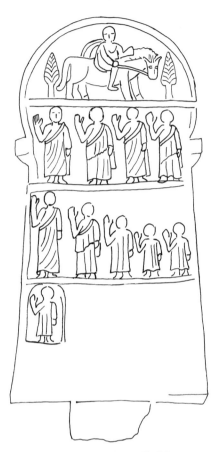

2. Manisa 1944: votive relief from
Kula (Lydia).

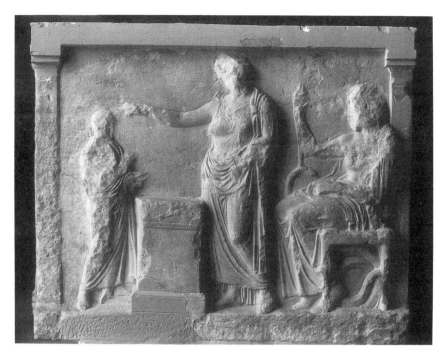

3. Athens NM 1338: votive relief from the Asklepieion in Athens. Courtesy of the National Archaeological Museum, Athens.

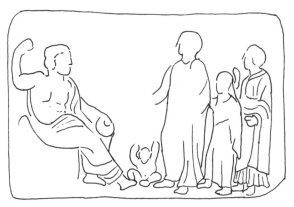

4. Padua MC 820: Greek votive relief.

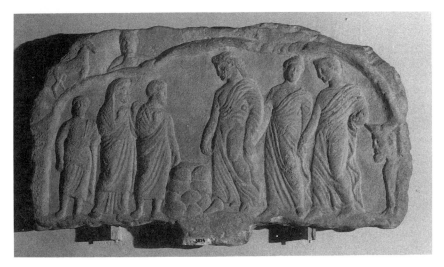

5. Athens NM 3874: votive relief from Ekali (Attika). Courtesy of the National Archaeological Museum, Athens.

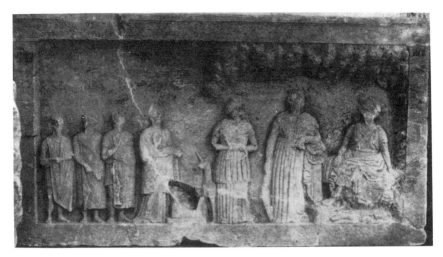

6. Volos 573: votive relief from Thessaly.

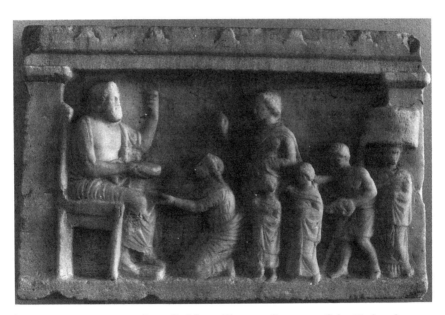

7. Athens NM 1408: votive relief from Piraeus. Courtesy of the National
Archaeological Museum, Athens.

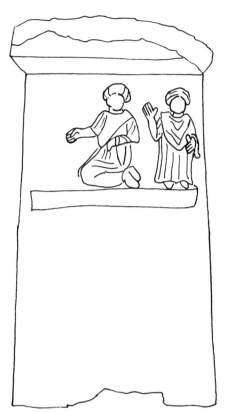

8. Uşak 1.3.74: votive relief.

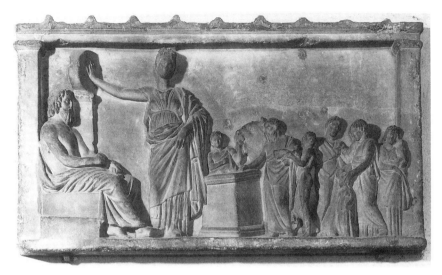

9. Paris, Louvre 755: votive relief from the Asklepieion in Athens. Courtesy of the Musée du Louvre, Paris.

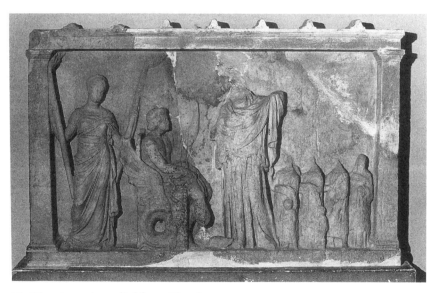

10. Eleusis: votive relief from Eleusis.

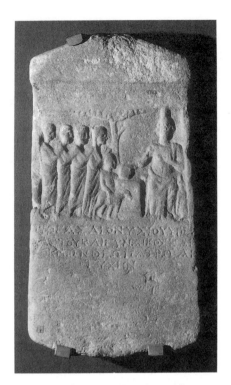

11. Copenhagen NM 4763: votive
relief from Kyzikos. Courtesy of the
National Museum, Copenhagen.

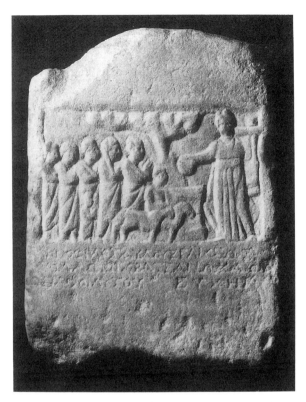

12. Vienna Kunsthistorisches Museum 1439: votive
relief from Mysia. Courtesy of the Kunsthistorisches
Museum, Vienna.

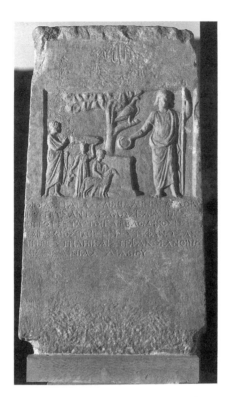

13. Athens NM 1486: votive relief
from Apameia on the Propontis.
Courtesy of the National
Archaeological Museum, Athens.

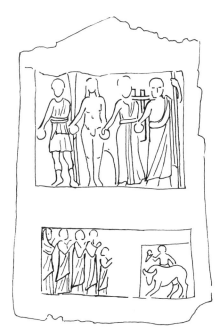

14. Instanbul inv. 4407: votive relief
from Mysia.

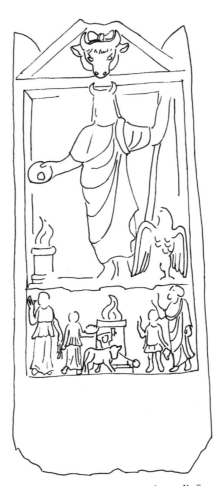

15. Istanbul inv. 1909: votive relief
from Mysia.

16. Istanbul inv. 676: votive relief
from Mysia.

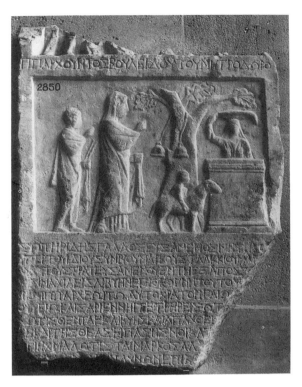

17. Paris, Louvre 2850: votive relief from Kyzikos.
Courtesy of the Musée du Louvre, Paris.

18. Manisa 1945: votive relief from
Kula (Lydia).

19. Votive relief from Köleköy
(Lydia).

20. Boston MFA 94.14: votive relief
from Kula (Lydia).

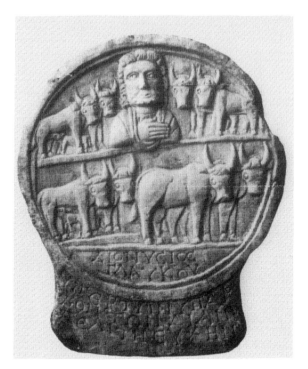

21. Votive relief from Phrygia.

22. Athens NM 1841: votive relief from the Asklepieion in Athens. Courtesy of the National Archaeological Museum, Athens.

23. Athens NM 2756: votive relief from Phaleron (Attika). Courtesy of the National Archaeological Museum, Athens.

24. Altar of Homonoia, sanctuary of Artemidoros of Perge, Thera.

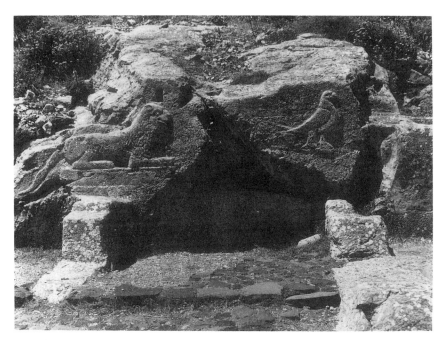

25. Altar of Zeus Olympios, sanctuary of Artemidoros of Perge, Thera.

26. Altar of the Dioscuri, sanctuary of Artemidoros of Perge, Thera.

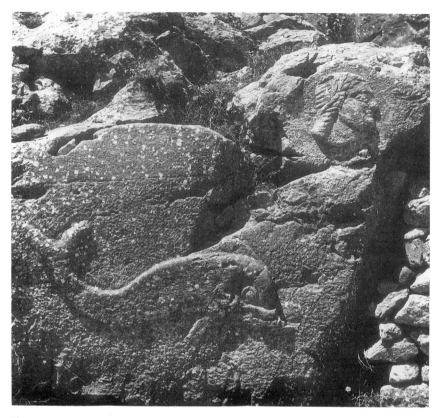

27. Dolphin of Poseidon, sanctuary of Artemidoros of Perge, Thera.

28. Portrait of Artemidoros, sanctuary of
Artemidoros of Perge, Thera.

29–31. Relative frequency of sacrificial animals. 29. Frequency in Attic sacrificial calendars (Classical period).

30. Frequency in votive reliefs from mainland Greece (Classical period).

31. Frequency in votive reliefs from Asia Minor (Hellenistic–Roman period).

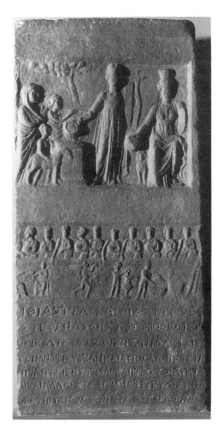

32. Athens NM 1485: votive relief
from Apameia on the Propontis.
Courtesy of the National
Archaeological Museum, Athens.

Greek Cities and Greek Commonwealth

Adalberto Giovannini

People who live together for a long time develop common ways of communicating with each other, a common language and common rules of behavior, common values, and common beliefs that together go to make up their culture. As long as these people remain an isolated group, they have no awareness of the specificity of their culture; they just live it. But if they come into contact with people who are different, they analyze their values and rules of behavior by comparing them with the values and rules of the others. If they are strong and self-confident, they will gain from this confrontation a sentiment of superiority; they will feel themselves confirmed in their identity. But if they are weak and insecure, their identity will soon be lost.

Through colonization and commerce, the Greeks came into contact with other people and civilizations, in particular with the East and with Egypt, very early. And although the Eastern civilizations were far more advanced than their own, the Greeks soon developed an astonishingly strong feeling of self-confidence and even superiority. They borrowed from their neighbors their knowledge and their technology and created out of it a culture of their own that rapidly surpassed that of their teachers in almost every field. This feeling of superiority was reinforced in the Classical period as a result of the victories of the Persian Wars: cultural superiority and political strength went together. The confrontation between Greeks and barbarians was in every respect to the advantage of the Greeks.

All this was to change in the fourth century with the decline of the Greek city-states and the rise of Macedonia that resulted in the Battle of Chaeronea, the foundation of the Corinthian League, and the conquests of Alexander the Great. From the point of view of the Greeks, or at least

the majority of them, the rise of Macedonia and the conquest of the East was not a victory of Hellenism over the barbarians; they could not identify themselves with the Macedonians and their kings. These were enemies of the freedom of Greece; they were tyrants, and they were responsible for the decline of the Greek world. The vain efforts of the Greek states to get rid of the Macedonian hegemony after the death of Alexander the Great and the repeated comparison of Macedonia with the Medes allow no doubts about these feelings.[1]

It is a fact that the conquest of Asia and the creation of the Hellenistic kingdoms only accelerated the decline of Greece. Its fate no longer depended on the deliberations of the assemblies at Athens, Sparta, or Thebes; the real decisions were now taken at the courts of Pella, of Antioch, or of Alexandria. Many of the ablest men left their country to take up rewarding positions in Asia or in Egypt. The poor left, too, in order to find a living as mercenaries or a piece of land as colonists. The proud cities of Greece became beggars who asked for material help from the kings, for corn, for schoolmasters, or for the building of porticoes. They flattered them, they voted them divine honors, and they tried to play one power off the other in order to preserve a minimum of independence.

The fate of those who went away as mercenaries or as colonists was not much better. They were uprooted and demoralized; they were deprived of their usual way of life and were threatened in their identity. After the death of Alexander, the Greeks he had settled in his eastern foundations revolted because they longed for Greek customs and way of life (Diod. 18.7.1: ποθοῦντες μὲν τὴν Ἑλληνικὴν ἀγωγὴν καὶ δίαιταν). According to Dionysius of Halicarnassus (1.89.4), many Greeks

> living among barbarians had in a short time forgotten all their Greek heritage, so that they neither spoke the Greek language nor observed the customs of the Greeks nor acknowledged the same gods nor had the same equitable laws by which most of all the spirit of the Greeks differed from that of the barbarians.

Polybius is not much more optimistic about the Greeks of Alexandria, who were just a little better than the barbarian mercenaries who lived there, because they came from Greek stock and had not forgotten Greek customs (34.14.5). The corollary of the geographical expansion of Hellenism in the East was the risk of dilution and dissolution.

Still worse was to come with the Roman conquest. In a few decades,

1. See the Athenian decree calling the Greeks to rebellion against Macedonia after the death of Alexander (Diodorus Siculus 18.10.3) and the decree of Chremonides (*Syll*[3] 434/5.10f.).

the Roman Senate became the only arbiter of Greek affairs. There was no longer the possibility of playing one power off against the other; the Greek states now enjoyed just so much freedom as was acceptable to Rome. Greece suffered from the exactions of the Roman governors and generals, it was stripped of its works of art without the compensation of material help in case of distress. For, if the Romans claimed to be philhellenes, if they respected the "liberty" of the Greek cities under certain conditions, they gave no money for corn or for teachers. The Greeks were humiliated, they were compelled to flatter the Roman governors and generals even when they hated them, they had to hear themselves despised as unworthy of their ancestors, as effeminate and degenerate. It is no wonder that people despaired of the future and, as Polybius says (36.17), no longer wished to marry and to rear children, so that many parts of Greece became deserted and fallow.

And yet, despite these vicissitudes and misfortunes, the Greeks were able to preserve their identity remarkably well. Even in the worst conditions, even as exiles or as slaves, they preserved the awareness that they were the heirs to a great culture that was different from all others. They were proud of their way of living and thinking. The humiliation of economic and political decline was to a certain degree compensated for by the admiration for Greek civilization. Hellenism was extraordinarily attractive, and the Greeks were conscious of this attractiveness. It was attractive for the Jews, who had the greatest difficulties in reconciling their love for Greek culture with their religious beliefs. It was attractive also for the Romans: at the time of Strabo, for instance, Neapolis was an important center of Hellenic culture; many Romans who took delight in this way of living fell in love with the place and settled there (Strab. 5.4.7, C 246).

"Culture," "civilization," "habits," and "values" are very vague notions. People belonging to a common culture can feel and live it in quite different ways. For educated people it is literacy, poetry, music, and works of art that are important. The common past, too, may play this role. Strabo insists at the beginning of his *Geography* (1.2.3, C 16) on poetry, music, and mythology as the essential elements of education in Greek cities. Ephorus laments that the Thebans neglected the value of learning and of intercourse with mankind and cared only for the military virtues; and Strabo, who quotes the statement of Ephorus (9.2.2, C 401), adds that in dealing with the barbarians force is stronger than reason. For others, it is the behavior toward foreigners that characterizes the civilized man. For Eratosthenes, the expulsion of foreigners was a practice common to all barbarians as opposed to the traditional hospitality of the Greeks (Strab. 17.1.19, C 802). Dionysius of Halicarnassus saw a proof of the Greek origin of the Romans in the fact that Rome was

the most hospitable and friendly of all cities (1.89.1). Diodorus blames the Phoenician city of Aradus for not respecting the sacred rights of ambassadors and suppliants, for breaching the ties of kinship (33.5.2). The Gauls of Narbonensis admired the Greek rhetors and physicians (Strab. 4.1.5, C 181). For many Romans, Greek culture was synonymous with fine cooking and good wines, with Corinthian vases and beautiful jewels.

But I am not competent to expound on the nature of Greek civilization. The purpose of my contribution is more limited and less ambitious: I shall try to describe how the Greeks lived their culture in their everyday life. The necessary condition for the development and survival of a civilization is communication, regular intercourse, and social life. There can be no civilization if people live like the Cyclopes of the *Odyssey*, dwelling by themselves in their own caves, without assemblies and laws, caring nothing for one another (*Od.* 9.112f.; it is worth noting that Aristotle quotes these verses at the beginning of the *Politics*). Every organized society has its own ways of bringing people together, officially or otherwise: meeting places, religious or profane ceremonies, feasts and festivals, rituals for rejoicing or mourning, and so on. And the specific form of Greek social life was, of course, the polis.

THE HELLENISTIC POLIS

The ancient authors, the historians, the orators, and above all the philosophers, have taught us to regard the Greek polis as a political entity, in the sense that the polis is, or ought to be, a free and sovereign city-state. As Aristotle says (*Pol.* 1280b30f.): "A polis is not merely the sharing of a common locality for the purpose of preventing mutual injury and exchanging goods. . . . It is a partnership of families and of clans in living well and its object is a full and independent life." For modern historians the last words are the most important: they see in the political sovereignty (αὐτονομία and ἐλευθερία) and, if possible, the economic self-sufficiency (αὐτάρκεια) the essential features of the true polis, and they translate the word *polis* as "city-state" or simply "state." In their view, a Greek city that is not wholly autonomous is not really a polis; a real polis must, therefore, constantly fight for its autonomy and independence, it is necessarily individualistic and egoistic;[2] and the logical

2. See G. Glotz, *La cité grecque* (Paris, 1928), 1, 35–38; W. W. Tarn and G. T. Griffith, *Hellenistic Civilization*, 3d ed. (London, 1952), 79ff.; V. Ehrenberg, *The Greek State* (Oxford, 1960), 92ff.; H. Kreissig, "Die Polis in Griechenland und im Orient in der hellenistischen Epoche," in *Hellenische Poleis*, ed. E. C. Welskopf (Berlin, 1974), 2: 1074–1084; K.-W. Welwei, *Die griechische Polis* (Stuttgart, 1983), 9ff.; R. Duthoy, "Qu'est-ce qu'une *polis*?" *LEC* 54

conclusion of this conception is that the Hellenistic period is the end of the Greek polis.[3]

This definition is correct insofar as the majority of the poleis actually were or had been, at some time in their history, independent city-states. It is also a fact that, since the times of the Persian Wars, "autonomy and freedom of the Greeks" was a much-used slogan against hegemonic powers whether Greek or barbarian.[4] But it is not true that sovereignty was the essential feature of the polis. The cities founded by Alexander the Great and his successors in Asia and Egypt were not sovereign, their status was fundamentally different from that of the old cities of Asia Minor, they enjoyed only a precarious and revocable autonomy, but they were nonetheless poleis.[5] The cities of the Macedonian kingdom[6] and, in my opinion, also the members of the so-called federal states[7] had the same kind of precarious autonomy: they had no sovereignty of their own, they enjoyed only a limited autonomy depending totally on the will of the central government, but they were called poleis all the same. I believe that the definition of the polis as a city-state is misleading and does not denote its specific nature, its difference from all other communities in other civilizations.

A Greek polis was first of all a community of people living together, "a partnership of families and of clans in living well," to use the words

(1986): 3–20. Critical, but without alternative, W. Gawantka, *Die sogenannte Polis* (Stuttgart, 1985).

3. Most explicit in defense of this conception is the great French scholar G. Glotz, *Cité grecque*, 448: "Elles (the battle of Chaeronea and the foundation of the League of Corinth) donnent une date précise à ce grand événement, la fin de la cité grecque." See also Tarn and Griffith, *Hellenistic Civilization*, 79: "Man as a political animal, a fraction of the *polis* or self-governing city state, had ended with Aristotle."

4. For the period after Alexander, see now E. S. Gruen, *The Hellenistic World and the Coming of Rome* (Berkeley, 1984) 1: 133ff. It is interesting to note that the argument was already used by Dionysius I against Carthage (Diod. 14.47.2).

5. For the fundamental difference between the status of the old Greek cities of Asia Minor and that of the foundations of Alexander and his successors, a difference that was not recognized by A. Heuss and E. Bikerman in their well-known controversy, see D. Magie, *Roman Rule in Asia Minor* (Princeton, 1950) 1:56, 2:827.

6. See A. Giovannini, "Le statut des cités de Macédoine sous les Antigonides," in *Ancient Macedonia: Papers Read at the Second International Symposium Held in Thessaloniki, 19–24 August, 1973* (Thessaloniki, 1977), 465–472.

7. See A. Giovannini, *Untersuchungen über die Natur und die Anfänge der bundestaatlichen Sympolitie in Griechenland* (Göttingen, 1971), 71ff. My conclusions have been almost unanimously rejected, in particular by F. W. Walbank, "Were There Greek Federal States?" *SCI* 3 (1976/77): 27–51. But this disagreement is based precisely on the traditional view that a polis is necessarily a "state." There is also in the literature on Greek "federal states" a failure to distinguish between local autonomy and sovereignty: Swiss communes enjoy a large amount of autonomy, they even grant their citizenship, but they are not states.

of Aristotle. Like all communities that enjoy some autonomy, the poleis had decision-making assemblies and common authorities. Like most communities of the world, they had civic cults and temples to express their unity. Meeting places, popular assemblies, temples, and cults are not particular to the Greek poleis, they are universal features of communities in general. But the poleis had forms of social life of their own that were the expression of Greek culture and that fundamentally differentiated a Greek polis from all other communities in the world. These specific forms of social life were concretized in buildings that were exclusively Greek, that is, the gymnasium and the theater: every polis had or was supposed to have a gymnasium and a theater;[8] barbarian cities did not.[9] Everybody knows of course that athletic training and music were the basis of Greek education and culture; but, surprisingly enough, the standard works on the Greek polis practically neglect the gymnasium and the theater as constitutive elements of the community.[10]

First, the gymnasium.[11] Originally, the gymnasium had been the citizens' training place for war. They had to acquire there the physical strength and collective discipline necessary for hoplite tactics.[12] For Aristophanes, the gymnasium was the essential element of the good old education of the winners of Marathon and he blames the young men who frequent the warm baths and chat instead of training in the palaestra (*Clouds* 1043–54). In the *Phoinissae* of Euripides (366–68), the exiled Polynikes is full of tears as he sees again the altars of the gods and the gymnasium where he had been trained. And it was said of the Boeotians that they owed their military superiority to their intense training in the gymnasium (Diod. 15.50.5 and 17.11.4).

In the Hellenistic period, the gymnasium still kept its function as a training place for future soldiers. The physical preparation of boys that ended with the epheby was everywhere the basis of the education of citizens. There they practiced fighting with arms, throwing the javelin,

8. For Pausanias (10.4.1) a town that possessed "no government offices, no gymnasium, no theater, no marketplace, no water descending to a fountain" hardly deserved to be called a polis.

9. Diod. 1.81.7, for instance, points out that the Egyptians did not practice the physical training of the gymnasium.

10. Kreissig, "Polis," and the authors he quotes (1077), simply "forget" the theater and the gymnasium. Ehrenberg, *Greek State*, 150, 155, mentions the gymnasium as the local cultural center of the polis, but only by the way. Duthoy, "Qu'est-ce qu'une *polis*?" 15, enumerates, among other buildings of the city, the theater and the gymnasium.

11. See J. Delorme, *Gymnasion: Étude sur les monuments consacrés à l'éducation en Grèce* (Paris, 1960), esp. 421ff.

12. See Delorme, *Gymnasion*, 24ff.; R. T. Ridley, "The Hoplite as Citizen," *AC* 48 (1979): 508–548, convincingly connects the origin of the gymnasium with the introduction of hoplite tactics in the seventh and sixth centuries.

and archery.[13] But the gymnasium also became more and more a place of intellectual and political education where philosophers and rhetors dispensed their teaching; it was, at the same time, a place of pleasure and entertainment, where physical training was now an aim in itself, a way of relaxing body and mind.[14] A Hellenistic gymnasium was a complex building with porticoes and baths, with rooms and exedrae for discussions and teaching.[15] It is significant that Pyrrhus, who had been called to help by the Tarentinians but did not want to fight for them "while they remained at home in the enjoyment of their baths and social festivities, closed down the gymnasia and the public walks, where, as they strolled about, they fought out their country's battles in talk" (Plut. *Pyrr.* 16, 2). The gymnasium had by now become what was, in Aristophanes' eyes, a degenerate and corrupting environment.

But if it had partly lost its original purpose, the gymnasium was now an attractive and pleasing place to spend one's time. It was now the locus of an intense social life. Quite significantly, the gymnasia of the Hellenistic period were no longer situated outside the walls of the city, as in the Classical period, but in its center, near the agora and the other public buildings.[16] The gymnasiarchy became one of the most prestigious magistracies, if not the most, but at the same time the most expensive. This is abundantly attested by the honorary decrees for gymnasiarchs who generously spent their money for the oil, the salary of the trainers, and sometimes for the adornment of the gymnasium itself.[17] To spend money on the building or the decoration of a gymnasium was the best demonstration of philhellenism a king could give: King Herod the Great provided gymnasia for several Greek cities and also offered the city of Cos a fund for the maintenance of its gymnasium.[18]

13. On the training of ephebes in the Hellenistic period see O. W. Reinmuth, "A New Ephebic Inscription from the Athenian Agora," *Hesperia* 43 (1974): 246–259. M. Launey, *Recherches sur les armées hellénistiques* (Paris, 1950) 2: 813–874, defends the theory that the training at the gymnasium was primarily devised as a preparation for service in the Hellenistic armies (this view has been rejected by Delorme, *Gymnasion*, 469ff.).

14. See M. Rostovtzeff, *Social and Economic History of the Hellenistic World* (Oxford, 1941) 2 : 1058–1060; C. A. Forbes, "Expanded Uses of the Greek Gymnasium," *CPh* 40 (1945): 32–42; Tarn and Griffith, *Hellenistic Civilization*, 95ff.; Delorme, *Gymnasion*, 374ff.

15. See the description of the gymnasium by Vitruvius *De architectura* 5.11. As Delorme, *Gymnasion*, 489ff., points out, the gymnasium described by Vitruvius, with its warm baths, is an Italian adaptation of the original Greek gymnasium, which had only cold baths (but see the complaints of Poseidonius about the βαλανεῖα of the Syrian gymnasia, *FGrH* 87 F 10).

16. See Delorme, *Gymnasion*, 441ff.

17. See, e.g., *OGI* 764 (Pergamon); *Syll*[3] 577 (Miletus); *Syll*[3] 578 (Teos); *Bull. ép.* (1966): 273 (Istros); *BCH* 109 (1985): 597ff. (Messene).

18. Josephus *Bellum Judaicum* 1.21.421–423. Several examples of donations of kings,

In fact, the attractiveness of Greek culture for the Jews, the Romans, and other people was largely due to the gymnasium and the way of life it symbolized.[19] At the time of the Maccabees, the Hellenized High Priest Jason undertook to mold his fellow citizens into the Greek character (πρὸς τὸν Ἑλληνικὸν χαρακτῆρα τοὺς ὁμοφύλους μετέστησε) and asked King Antiochos Epiphanes for permission to rename the citizens of Jerusalem Antiocheis and to build in the Holy City a gymnasium and an ephebeion (2 Macc. 4.9–10; Jos. Ant. 12.5.241). The revolt of the Maccabees put an end to this attempt and Jerusalem remained Jerusalem, but the Jews of the diaspora tried to be admitted to the gymnasium and to participate in the ephebeia, in particular in Alexandria.[20] The Jews of the Seleucid kingdom obtained the privilege of getting money for oil from the gymnasiarchs, so that they might use their own oil (Jos. Ant. 12.3.119). Of the Romans we know of, Scipio Africanus was the first to exchange his Roman toga for a Greek himation and to stroll about in the gymnasia and read Greek books while staying in Sicily at the end of the Hannibalic War (Liv. 29.19.12; Plut. C. Mai. 3.7). Athletic games were first performed in Rome in the year 186 (Liv. 39.22) and became more and more frequent in the last century of the Republic.[21] Antony held the gymnasiarchy at Athens (Plut. Ant. 33.4) and at Tarsus (Strab. 14.5.14, C 674). At Neapolis, where many Romans came to enjoy the Greek way of life, there were gymnasia and ephebeia (Strab. 5.4.7, C 246). And finally, Roman baths, those monumental symbols of ancient culture which even Christians were eager to attend,[22] are nothing other than the last stage of the transformation of the gymnasium into a place of leisure and entertainment.

Pleasant for body and mind, the gymnasium was felt to be less a civic duty than a social privilege, just as it had been a privilege of the aristocracy at the time of Homer (see especially Od. 8.158ff.). Only free-born citizens had access to it. In Egypt, those who had been at the gymnasium, οἱ ἐκ τοῦ γυμνασίου, constituted a kind of local aristocracy.[23] The splendid law of Beroia, published by the late J. M. R. McCormack, stipulates

especially of the Attalids, have been collected by L. Robert, Études anatoliennes (Paris, 1937), 85 nn. 2, 3; 201; 451f. See also Bull. ép. (1939): 400; Pol. 5, 88; Paus. 1.17.2.

19. See Delorme, Gymnasion, 424ff.

20. See V. Tcherikover, Corp. Pap. Jud. (Cambridge, Mass., 1957) 1:55ff. I am not convinced by the opposite view of A. Kasher, "The Jewish Attitude to the Alexandrian Gymnasium in the First Century AD," AJAH 1 (1976): 148–161. I have not seen the dissertation of R. R. Chambers, "Greek Athletics and the Jews" (University of Miami, 1980).

21. See N. B. Crowther, "Greek Games in Republican Rome," AC 52 (1983): 268–273, who argues that athletic games were performed in Rome before the second century.

22. See, e.g., Tertullian Apologeticus 42.4; Cypr. Epp. 76.2.4 and De hab. virg. 19; Eusebius Historia ecclesiastica 5.1.5.

23. See Delorme, Gymnasion, 424ff.

that slaves, freedmen, prostitutes, and tradesmen were to be excluded.[24] Access for foreigners seems to have been very restricted, in particular in the case of Jews, and reserved for the Hellenized elites.[25] The gymnasium was really felt by the Greeks to be a symbol of their cultural superiority, a symbol they were not ready to share.

And now the theater, where the musical festivals, usually called the Dionysia, took place. The increasing success of musical games is no less impressive than the development of the gymnasium: both, in fact, go together. As we know from numerous inscriptions, every Greek city had its annual music festival. Inscriptions show also that flautists, citharists, actors, and dancers were no less famous, that they enjoyed the same privileges as boxers or runners. Their growing importance is attested by the creation of guilds, the *technitai* of Dionysus. The most renowned were the *technitai* of Teos, those of Athens, and those of the Isthmus; but there were also guilds of *technitai* in Cyprus, in Egypt, and in Sicily.[26]

But the inscriptions attesting the existence of the Dionysia or of other music festivals are not, for the most part, concerned with the festivals themselves. They are decrees for friends and benefactors of the city, they express the city's recognition or goodwill in the form of grants of honors and privileges. These honors were to be solemnly proclaimed at the musical or sometimes at the gymnic festivals the city organized every year.[27] The proclamation was to be made by the herald at the beginning of the festival, immediately after—or sometimes even before—the religious offerings. They were of the kind: "The demos crowns and honors X or Y for his goodwill and merits." It was also a rule to invite to the festivals, and to seat in the front rows, friends and benefactors of the city by granting them the *proedria*. Thus, the annual festivals in the theater were not only an artistic performance; they were also a social and civic event, the public recognition, in the presence of all citizens and of invited friends, of the gratitude and goodwill of the city to her friends and benefactors.

These benefactors and friends could be individuals, citizens, or for-

24. J. M. R. McCormack, "The Gymnasiarchal Law of Beroea," in *Ancient Macedonia* (Thessaloniki, 1977) 2:139ff., B 27ff. = *SEG* 27.261.

25. See Delorme, *Gymnasion*, 1.1. The fact that the emperor Claudius strictly prohibited the Jews of Alexandria from taking part in the gymnasiarchic and cosmetic games leads us to suspect that this was a main cause of the conflicts with the Greeks (*Select Papyri* no. 212.92f.). In Antioch, the privilege of the Jews of getting money for oil (Jos. *Antiquitates Judaicae* 12.3.120ff.) aroused serious discontent among the Greeks.

26. See F. Poland, *RE* 5 A (1934), col. 2474ff., s.v. "Technitai"; A. Pickard-Cambridge, *The Dramatic Festivals of Athens* (Oxford, 1953), 286ff.

27. Usually the honors were proclaimed at the Dionysia: see L. Robert, *Op. min. sel.* (Paris, 1969) 1:73. But proclamations at the gymnic festivals are also attested (see, e.g., *IvMagnesia* 101.18f. and *IG* 2/3² 456b, 4f.

eigners. They could be kings and dynasts. They were often other poleis. For there were ties of friendship and recognition not only between cities and individual citizens or foreigners, between cities and kings or dynasts, but also between cities and cities. And this leads me to a most fundamental but almost ignored function of the Greek polis: the polis as the subject of social relations with other poleis.

RELATIONS BETWEEN POLEIS AND POLEIS

Works dealing with the relations of the Greek cities with each other are mainly interested in the conflicts between hegemonic powers and cities striving to preserve their autonomy, or between hegemonic powers, or between cities and their neighbors. There is an immense literature on the great hegemonies of the Classical and the Hellenistic periods. Much has been written on war, on treaties and conventions, on symmachies. The overall impression is that war was the "normal" relation among Greek cities and that peace was only a temporary interruption of this "normal" state of war.

But a careful and unprejudiced examination of the evidence, especially of the inscriptions, reveals a rather different picture. We discover that the Greek cities assiduously cultivated relations with each other and that these relations were essentially friendly and pacific. Their distinguishing mark is that they did not belong, for the most part, to the field of international relations that states maintain with other states as such, but were the kind of relations people living together in a community practice with friends, relatives, and neighbors. That is, relations such as those involved in paying visits, in helping or asking for help, in giving and receiving presents, in participating together in common ceremonies and festivals. These relations were not really "interstatal" but "interhellenic." The subjects of these relations were not the Greek states as states, but the poleis in their quality as specifically Greek communities, quite independently of their juridical status.[28] These "social" relations were a particularity of the Greek commonwealth just as the relations of clientship were a particularity of Roman society. The Greek world was in fact a community of communities bound together by an intense network of ties of friendship and kinship and other moral obligations.

There is no comprehensive study of these social relations between polis and polis. They are briefly evoked in the classic handbooks, mainly as a symptom of the decline of the polis in the Hellenistic period.[29] Louis

28. See Giovannini, *Untersuchungen*, 84–86.
29. See, e.g., Glotz, *Cité grecque*, 412ff.; Rostovtzeff, *SEHHW* 2:1109; Tarn and Griffith, *Hellenistic Civilization*, 79ff.; Ehrenberg, *Greek State*, 103ff.

Robert, who was the first fully to realize their importance, unfortunately never wrote the monographs he projected on this topic. But he showed the way. It remains to gather, to complete, and to exploit systematically the material scattered in his immense production. It is a considerable enterprise, of which I can here only sketch out the main lines.

The dominant feature of these relations is the solidarity of the Greek communities, their readiness to help each other in different ways. The best-documented example, one that is typical of the Hellenistic period and more particularly of the second century, is the sending of judges to help cities unable by themselves to settle pending law cases.[30] The remarkable feature revealed by the decrees for foreign judges (we have more than two hundred) is that the cities that were in such an embarrassing position never resorted to individual specialists but always asked another polis to send them some able men of its choice. The decrees not only express the gratitude of the city for the judges; they not only underline their zeal and their incorruptibility; they also thank the city that sent them, praising its good choice and insisting on the ties of friendship and goodwill that bind both communities. It is equally significant that at the proclamation of the honors at the Dionysia, the proclamation for a city always precedes the proclamation for the judges it had sent.

Another much-practiced form of solidarity was mediation or intercession, that is, the intervention in a conflict to convince the parties of the need to come to an agreement or to plead with the stronger in favor of the weaker. It seems that arbitrations of conflicts, which were more and more frequent in the Hellenistic period,[31] were often the result of mediation or intercession. At the great siege of Rhodes by Demetrius Poliorcetes in 305/4, more than fifty envoys from Athens and other cities asked the king to come to terms with the Rhodians (Diod. 20.98.2). The Rhodians themselves were assiduous ambassadors for peace: they were particularly active during the Social War of 220–217 (Pol. 5.24.11 and 28.1; 5.100.9) and, at the same time, in the war between Antiochus III and Ptolemy IV (Pol. 5.63.46). Magnesia on the Maeander offered her

30. See Magie, *Roman Rule* 2:963 n. 81; L. Robert, "L'histoire et ses méthodes," *Encyclopédie de la Pléiade* (Paris, 1967), 467–469 = Robert, *Die Epigraphik der klassischen Welt* (Bonn, 1970), 26–28; idem, "Les juges étrangers dans la cité grecque," in *Xenion: Festschrift für P. J. Zepos,* ed. E. von Caemmerer (Athens, 1973) 1:765–782; A. J. Marshall, "The Survival and Development of International Jurisdiction in the Greek World under Roman Rule," *ANRW* 2.13 (1980): 636–640.

31. On arbitration in Greece, the standard works remain the old dissertation of E. Stone, "De arbitris externis quos Graeci adhibuerunt ad lites et internas et peregrinas componendas quaestiones epigraphicae" (Göttingen, 1888), and the collection of A. Raeder, *L'arbitrage international chez les Hellènes* (Paris and Munich, 1912). The second volume of L. Picirilli, *Gli arbitrati interstatali greci,* is not yet published.

mediation to the quarreling cities of Cnossus and Gortyn (*IvMagnesia* 65 = Raeder 44); the Aetolians did the same for Messene and Phigalia (*Syll³* 472), Pergamon for Mytilene and Pitana (*IvPergamon* I 245 = Raeder 46), Cnossus for Lato and Olus (*Syll³* 712 = Raeder 77). After the Roman intervention, appeals to a Roman general or to the Senate for a befriended city became quite common: thus the Rhodians and the Athenians appealed to L. Cornelius Scipio for the Aetolians in 189 (Liv. 37.6.4–6 and 38.3.7); in the same year, Stymphalos and the Achaeans appealed to M'. Aquilius for Elatea (*SEG* 25, 445) and the Rhodians pleaded before the Senate in favor of the city of Soloi (Pol. 21.24.10–12).[32]

In this period of insecurity, due to wars and raids by pirates, many cities tried to ensure the consecration and the inviolability of their sanctuaries or of their whole territory (ἀσυλία).[33] We have in inscriptions a large number of decrees granting *asylia* to a city or a sanctuary: decrees for Cos,[34] for Magnesia on the Maeander,[35] for Teos;[36] decrees of the Aetolian League for different cities.[37] These documents confirm that the Greek cities really wanted peace and did what they could to prevent war for themselves and for other cities.

We also have many cases of material help in different circumstances. The lavish contributions of kings overshadow the more modest gifts of the cities, but these should not be ignored. In the year 315, when Cassander decided to rebuild the city of Thebes, many Greek cities not only from Greece but also from Sicily and Italy contributed to the undertaking because they took pity on the unfortunate and because of the glory of the city.[38] At the time of the First Punic War, several cities contributed with money and food to the foundation or refoundation of Entella.[39] By the middle of the third century, a small city of the Aetolian League, Kytinion, sent envoys to cities and kings to collect money for the reconstruction of their walls. The people of Xanthus, in their answer, regret-

32. See also *Syll³* 591 (Massilia for Lampsacus) and *Syll³* 656 (Teos for Abdera).

33. On territorial *asylia* see E. Schlesinger, "Die griechische Asylie" (Diss. Giessen, 1933); and P. Herrmann, "Antiochos der Grosse und Teos," *Anadolu* 9 (1965 [1967]): 121–128.

34. R. Herzog and G. Klaffenbach, *Asylieurkunden aus Kos,* Abh. Dtsch. Ak. Berlin (Berlin, 1952).

35. *IvMagnesia* 16–64.

36. *CIG* 3045–3058 = Le Bas–Waddington 3:60–85; *SEG* 4 (1929): 599f.; Herrmann, "Antiochos der Grosse," 121f.

37. *IG* 9.1² 135 (for Lysioi), 169 (for Cos), 189 (for Mytilene), 191 (for Tenos), 195 (for Chios).

38. Diod. 19.54. Ten years later, cities were still contributing to this reconstruction (*Syll³* 337).

39. *ASNP* 12 (1982): 778ff., especially no. 5 (= *SEG* 30.1121).

ted being unable to give substantial help because of their own difficulties, but nonetheless gave the envoys from Kytinion a modest contribution of 580 drachmae.[40] A few years later, the Rhodians did the same after the great earthquake that destroyed their city: Polybius, who reports the fact, says that it would be difficult to enumerate all the cities that contributed money according to their means (5.90.2). The Rhodians lent money without interest to the Argives;[41] the Thessalians gave money to the Ambraciots;[42] Cnidus allowed Miletus to borrow money from her citizens and guaranteed the debt.[43] After Aegina fell to the Romans in 209, the captured Aeginetans obtained from the Roman generals permission to beg their kindred cities for ransom (Pol. 9.42.5–8). Populations expelled from their own country were generously received in befriended cities— for instance, the Elateans in Stymphalus (*SEG* 25.445) and the Entellians in two unknown cities.[44] Also worth mentioning is the habit of sending colonists to depopulated cities.[45]

And finally, there is the phenomenon of the collective grant of citizenship (ἰσοπολιτεία).[46] It appears that the poleis of the Hellenistic period were much more generous in granting their citizenship, both to individuals and to whole communities, than either Athens or Sparta in the Classical period. Sometimes the already mentioned privilege of *proedria*— that is, the right to sit in the front rows at the festivals of the city—was added to *isopoliteia*.[47] We also have several examples of reciprocal *isopoliteia,* either by convention or by exchange of grant.[48]

All these acts of friendship and solidarity, all these grants of money, of citizenship, or of inviolability, have this in common: they are not based

40. The decree for Xanthus, known for more than twenty years (see H. Metzger, *RA* [1966]: 108), has now been published by J. Bousquet, *REG* 101 (1988): 12–53.

41. L. Moretti, *Iscr. stor. ell.* I, no. 40 = L. Migeotte, *L'emprunt public dans les cités grecques* (Québec and Paris, 1984), no. 19.

42. C. Habicht, "Ambrakia und der thessalische Bund zur Zeit des Perseuskrieges," in *Demetrias*, ed. V. Milojcic and D. Theocharis (Bonn, 1976): 1:175–180.

43. *Delphinion*, no. 138 = Migeotte, *Emprunt public*, no. 96.

44. *ASNP* 12 (1982): 780, nos. VII, VIII.

45. After the campaign of Timoleon in Sicily, the Corinthians sent envoys all over the Greek world to ask for colonists to resettle the devastated cities of Sicily, with the result that more than sixty thousand people answered the invitation (Diod. 16.82 and Plutarch *Timoleon* 22–23). Magnesia on the Maeander sent colonists to Antiocheia Persis (*Iv-Magnesia* 61).

46. See W. Gawantka, "Isopolitie," *Vestigia* 22 (Munich, 1975).

47. See *IvPriene* 5 (Priene for Athens); *Syll*³ 443 (the Aetolians for Chios); *ASNP* 12 (1982): 778ff. (Entella for various cities); R. Stroud, *Hesperia* 53 (1984): 193ff. (Argos for Aspendus).

48. See the list by Gawantka, *Sogenannte Polis,* 206ff. The best example of exchange of citizenship without formal convention is the decree *Delphinion* 143 (Miletus and Seleuceia Tralleis), erroneously entitled a "Vertrag" by the editor.

on formal obligations resulting from treaties, conventions, or contracts, nor are they imposed by force. Their only justification is the moral ties binding together the communities concerned; their result is a strengthening of these ties for the future. They all begin by recalling the friendship (φιλία, οἰκειότης) and the goodwill (εὔνοια) existing between the two communities.[49]

Most significant is the frequent evocation of the ties of kinship (συγγένεια) as a reason for the grant or gift.[50] This *syngeneia* was often historical, a result of common origin or colonization: for instance, the *syngeneia* between Magnesia and Teos (*IvMagnesia* 97), between Magnesia and Larbenus (*IvMagnesia* 101), or the kinship binding Priene and Colophon to Athens (*IvPriene* 5 and *IG* 2/3² 456).[51] It was often mythical[52] and sometimes even fictitious, as was the Cretan origin of Magnesia on the Maeander, "authenticated" by a forced decree of the Cretans.[53] But it does not matter whether the kinship was historical, pseudohistorical, or mythical. The important fact is that the cities, especially the small and weak ones, felt the need to renew and to intensify these ties by sharing with their kin their cults and festivals, by sharing with them their citizenship. The nicest example is the decree of Apollonia on the Rhyndacus for Miletus, which describes how the Milesians, after hearing the envoys from Apollonia, carefully examined the historians and various documents and came to the conclusion that Apollonia had actually been founded by their ancestors (*Delphinion* 155).[54] And these renewals were not merely meaningless exchanges of courtesies: they worked. As Diodorus says (10.34.3): "Children, when they are being ill-treated, turn for aid to their parents, but cities turn to the peoples who once founded them" (πρὸς τοὺς ἀποικίσαντας δήμους). Many of the acts of solidarity enumerated above illustrate this principle; they show that cities in diffi-

49. See P. Herrmann, "Die Selbstdarstellung der hellenistischen Stadt," in *Acts of the Eighth Epigraphical Congress* (Athens, 1984): 108–119.

50. See L. Robert, *BCH* 59 (1935): 498ff.; D. Musti, "Sull' idea di συγγένεια in iscrizioni greche," *ASNP* 32 (1963): 225–239; Herrmann, "Selbstdarstellung," 114ff.

51. On the relationship between metropolis and colony see J. Seibert, *Metropolis und Apoikie* (Würzburg, 1963) and A. J. Graham, *Colony and Mother City in Ancient Greece* (Manchester, 1964).

52. L. Robert gives two good examples in *BCH* 101 (1977): 120ff. (Argos and Aigai) and in *BCH* 102 (1978): 477ff. (Heracleia and the Aetolians). See also *SEG* 25.445, with the commentary of Habicht, *Pausanias' Guide to Ancient Greece* (Berkeley, 1985), 67–69 (Stymphalus and Elatea), and the recently published decree of Xanthus for Kytinion, *REG* 101 (1988): 19ff. (the Aetolians and the descendants of Heracles).

53. *IvMagnesia* 20. This decree of the Cretans, supposed to have been issued at the time of the foundation of Magnesia, was evidently recognized as a forgery by the editor.

54. See also *SEG* 12.511 (Antiocheia on the Pyramus "invites" Antiocheia on the Cydnus) and *IvPergamon* 1.156 (Tegea and Pergamon on the initiative of Tegea).

culty resorted by preference to kindred cities. This is true of the Aegi-
netans, when they wanted to obtain their ransom (Pol. 9.42.5: πρὸς τὰς
συγγενεῖς πόλεις); and of Heracleia on Mount Latmus, which success-
fully asked the Aetolians to intercede for them with King Ptolemy, al-
though their kinship was purely mythical.[55] The Magnesians offered
their mediation to Cnossus and Gortyn by invoking their—fictitious—
kinship with the Cretans (*IvMagnesia* 65). Acraiphia chose the city of
Larissa as arbitrator for the settlement of conflicts with her neighbors
because of the *syngeneia* that bound the Larissaeans with her and with all
Boeotians (*IG* 7.4130 = Raeder 70). It was normal for a city that needed
foreign judges for the settlement of its law cases to ask first a kindred
city,[56] as it was natural for a colony in distress to ask its metropolis for
aid or advice.[57] The Greeks took *syngeneia* more seriously than some
modern historians are inclined to believe.[58]

As I stated above, the cities proclaimed their gratitude and goodwill
to other cities at their annual festivals, in the presence of all the citizens
and of the invited foreigners who had been honored with the *proedria*.[59]
The decrees sometimes specify that the proclamation was to be made
at all festivals of the city[60] or that it was to be renewed every year.[61] It
was also a rule that the beneficiary of a grant or benefit asked her bene-
factors to proclaim her gratitude at their own festivals.[62] Thus, the
citizens of the poleis were reminded every year at the beginning of their
festivals of the ties that bound them to other poleis. The proclamations
made by the heralds constantly revived in them the awareness that they
were not an isolated community in a hostile world, but that they be-
longed to a commonwealth of communities where friendship, kinship,
and solidarity between community and community were not empty
words.

55. *FD* 3.3.144 with the commentary of Robert, *BCH* 102 (1978): 477ff.

56. See, e.g., *IvMagnesia* 15 (Cnidus and Magnesia), *IvMagnesia* 97 (Magnesia and
Teos), *IvMagnesia* 101 (Magnesia and Larbenus), *IvPriene* 50 (Erythrai and Priene), *Hellen-
ica* 11/12, 204ff. (Samos and Lebedus), *IvMagnesia* 65 (the fictitious *syngeneia* between Mag-
nesia and the Cretans).

57. See *CIG* 2.1837b with the commentary of Robert, *BCH* 59 (1935): 489–507 (Pha-
ros and Paros), and *SEG* 19.468 (Histros and Apollonia).

58. Musti, "Sull' idea di συγγένεια," 238f. mentions some of them.

59. See, e.g., *IvPriene* 54.31ff.: ἵν[α πᾶσιν φανερὸν ἦι, ὅτι ὁ δῆμο]ς ὁ Ἰασέων καὶ
πόλ[ε]ις καὶ τοὺς ἄνδρας τοὺς ἀγα[θοὺς τιμᾶι].

60. *IvMagnesia* 101, 1.76–78.

61. *IvMagnesia* 15b.4 and 97.48f.

62. The copy of the decree of Apollonia for Miletus found in the latter city (*Delphinion*
155) is an interesting illustration of this practice: it is headed by a crown surrounding the
words Ὁ δῆμος ὁ Ἀπολλωνιατῶν τῶν πρὸς τῶι Ῥυνδάκωι τὸν δῆμον τὸν Μιλησίων, which
are exactly the terms of the proclamations made at the festivals.

THE PANHELLENIC FESTIVALS

This commonwealth of Greek poleis had its regular meetings at the pan-hellenic festivals. It is again important to emphasize that these festivals were not gatherings of individuals; the competitions were not the confrontations of athletes fighting exclusively for their own glory. The panhellenic games were the festivals of the Greek poleis, which sent official delegations (θεωρίαι) to bring their offerings to the gods, to represent the community at the games, and to applaud their champions.[63] The victorious athletes brought glory and fame to their mother city, they consecrated to her the crown they had won and were rewarded by her with honors, privileges, and material advantages.[64]

We all know the famous statement of Isocrates in the *Panegyricus* (43):

> Now the founders of our great festivals are justly praised for handing down to us a custom by which, having proclaimed a truce and resolved our pending quarrels, we come together in one place where, as we make our prayers and sacrifices in common, we are reminded of the kinship which exists among us and are made to feel more kindly toward each other for the future, reviving our old friendships and establishing new ties.

The epigraphical material gives us an impressive image of the popularity of the panhellenic games, athletic or musical or both, in the Hellenistic period. The presence of twenty thousand exiles at Olympia in the year 324 to hear the proclamation of Alexander the Great ordering the return of all exiles (Diod. 18.8 and Dein. 1.82), the crowd assembled at the Isthmia in 196 to listen to the decision of the Senate after the Second Macedonian War (Pol. 18.46), are due to exceptional circumstances. But the great list of the *thearodokoi* of Delphi from the end of the third century, which bore the names of more than five hundred cities, is unquestionably testimony for this popularity.[65] Moreover, we observe the creation of a series of new panhellenic festivals, both gymnastic and musical.[66] About 280 BC, Ptolemy II instituted the Ptolemaia in honor of his father. We have decrees of acceptance from the Delphic Amphictyony and from the League of the Nesiotai, and we hear of delegations from Kalynda, Samos, Cos, and Argos.[67] The Aetolians celebrated their vic-

63. P. Boesch, *Theoros* (Berlin, 1908); L. Ziehen, *RE* 15 A (1934), col. 2228ff., s.v. "theoria," and col. 2244ff., s.v. "theoros."

64. See L. Robert, *RPh* 41 (1967): 14ff. (not in the *Op. min. sel.*).

65. Published by A. Plassart, *BCH* 45 (1921): 1–85.

66. See Tarn and Griffith, *Hellenistic Civilization,* 113f.

67. See H. Volkman, *RE* 23 (1959), col. 1578ff., s.v. "Ptolemaia."

tory over the Celts by inviting the Greek world to their Soteria.[68] In 243/2 the city of Cos dispatched embassies in all directions, even to Macedonia, Sicily, and Italy, to invite kings and cities to their penteteric Asclepieia, a musical and gymnastic festival.[69] Some time later, Aratus of Sicyon flattered his ally King Antigonus Doson by inventing the Antigoneia (Plut. *Ar.* 45.2). At the end of the century, Magnesia on the Maeander organized a spectacular and successful campaign for her penteteric games for Artemis Leucophryene. In the unique collection of decrees of acceptance found in that city,[70] we have answers from the kings, from the Cretan cities, and from most of the cities of the continent as far away as Ithaca, Corcyra, and Epidamnus; from Syracuse only a few years after her destruction by the Romans; and also answers from the other end of the Greek world, from Antiocheia in Persis, from Seleuceia on the Tigris, and from Seleuceia on the Red Sea.

The archives of Cos and Magnesia reveal the spirit of the institution of these new festivals and of the panhellenic games in general. Their ambition is to bring about the participation of all Greek poleis.[71] The envoys of Magnesia recall the good deeds of their ancestors in favor of many other Greek poleis as documented by the oracles of Apollo, the poets, and the honorary decrees of the poleis.[72] The decrees of acceptance praise the Magnesians for their piety toward the gods and for their philhellenism, they promise to send a delegation, and they appoint a citizen to give hospitality to the envoys who will come in the future to announce the festival every four years. Some decrees are of a more personal character. The people of Ithaca are thankful to the envoys for taking pains to visit them so far away (*IvMagnesia* 36.25–26). Antiocheia of Persis reminds us that at the time of Antiochus I the city of Magnesia had sent her a good number of colonists, thus establishing an authentic tie of kinship (*IvMagnesia* 61.14–20). We learn from the decrees of Ca-

68. See F. Pfister, *RE* 3 A (1927), col. 1223ff., s.v. "Soteria," and the decree of Abdera in *BCH* 64/5 (1940/41): 100ff.

69. Herzog and Klaffenbach, *Asylieurkunden aus Kos.* The festival is defined as penteteric, gymnastic, and musical in the decree of Camarina (no. 12), 15–16.

70. O. Kern, *Die Inschriften von Magnesia am Maeander* (Berlin, 1900), nos. 16, 18–64.

71. *IvMagnesia* 44.16ff.: παρεκάλουν τε καὶ ᾤοντο δεῖν παραδεξαμένους, καθὼς καὶ αἱ λοιπαὶ πόλιες αἱ Ἑλλανίδες, μετέχειν τάς τε θυσίας καὶ τοῦ ἀγῶνος. *IvMagnesia* 61.25f.: κατὰ πᾶσαν τὴν Ἑλλάδα.

72. *IvMagnesia* 61.36ff.: τὰς χρείας ἃς παρέσχηνται Μάγνητες πολλαῖς τῶν Ἑλληνίδων πόλεων. *IvMagnesia* 36.6ff.: ἀπελογίξαντο τὰς γεγενημένας ὑπὸ τῶν προγόνων αὐτῶν ἐν τοὺς Ἕλλανας εὐεργεσίας . . . διά τε τῶν χρησμῶν καὶ διὰ τῶν ποιητᾶν καὶ διὰ τῶν ψαφισμάτων τῶν ὑπαρχόντων αὐτοῖς παρὰ ταῖς πολίοις καλῶν τε καὶ ἐνδόξων. See also *Syll*³ 630.14ff.; [ἡ εὔνοια] πρὸς ἅπαντας τοὺς Ἕλληνας καὶ κατ᾽ ἰδίαν π[ρὸ]ς τὰς πόλεις.

marina and Gela for the Asclepieia of Cos that these cities had answered the appeal of Timoleon and the Corinthians favorably and had sent colonists to Sicily.[73] As Isocrates states, the panhellenic festivals really were an opportunity to revive old feelings and to create new ties.

They also gave the Greeks a chance to express spontaneously their sentiments for leading statesmen and leading powers. The unpopularity of Dionysius I of Syracuse, stirred up by the orator Lysias, provoked serious incidents at the Olympic Games of 388 (Diod. 14.109). Philip II was hissed at but did not care (Plut. *Mor.* 179a and 457–458). Antigonus Doson was praised by the Spartans as a savior and a benefactor in the presence of all Greeks (Pol. 9.36.5). Philopoemen was applauded at the Nemean Games as a champion of Greek freedom against Philip V (Paus. 8.50.3), while the pro-Roman Callicrates and his party were so hated, if we are to believe Polybius, that at the Antigoneia people refused to bathe with them and booed and hissed when one of them was proclaimed victor (Pol. 30.29). The panhellenic festivals were the agora of the Greek world, the place for the exchange of information, for political discussions, for comment and gossip. The talks and rumors that preceded and followed the proclamation of Flamininus at the Isthmus in 196 give us a good idea of the atmosphere.

Finally, these festivals provided the Greeks with a means of expressing their identity. I shall illustrate this by relating two incidents that seem to me particularly revealing. The first, narrated by Diodorus (17.100–101), occurred during the expedition of Alexander in India. At a banquet and after much drinking, a famous Athenian boxer, Dioxippus, was challenged by a Macedonian soldier named Coragus. The contest took place a few days later in the presence of the whole army. The Macedonians and their king favored Coragus because he was "one of them," while the Greeks encouraged the Athenian. To the great disappointment and anger of Alexander, Dioxippus was victorious and "left the field winner of a resounding victory and bedecked with ribbons by his compatriots, as having brought a common glory to all Greeks." The other incident, which we know from Polybius, is in the same vein. Polybius, who tries to explain, or more exactly to minimize, the popularity of King Perseus among the Greeks at the beginning of the Third Macedonian War, compares the feelings of the Greeks with the reactions of the public at athletic games. They are inclined to support the weaker against the stronger even if the latter is their champion. The historian proves his point by telling the story of the Theban boxer Cleitomachus, whose invincibility had made him the most famous fighter of his time. King

73. Herzog and Klaffenbach, *Asylieurkunden aus Kos,* nos. 12.9f., 13.6ff., where the people of Cos are called συνοικισταί.

Ptolemy was eager to have him beaten and trained a challenger. As the two athletes fought against each other at the Olympic Games, the crowd first took the part of the challenger, delighted as they were to see a fighter courageous enough to brave the invincible Cleitomachus. Cleitomachus was irritated by this attitude of the public, withdrew for a while from the fight to recover his breath, turned to the crowd, and asked them what they meant by cheering on Aristonicus; whether they did not understand that he, Cleitomachus, was now fighting for the glory of Greece and Aristonicus for that of King Ptolemy; whether they would prefer to see an Egyptian conquer the Greeks and win the Olympic crown, or to hear a Theban and Boeotian proclaimed by the herald as victor. The sentiments of the spectators changed at once and, concluded Polybius, Aristonicus was beaten by the crowd rather than by Cleitomachus.

As we see, the unity of the Greek commonwealth was not an idealistic abstraction. Despite geographical dispersion and different conditions of life, the Greeks remained a remarkably homogeneous society throughout the Hellenistic period. This homogeneity expressed itself at the numerous panhellenic festivals, old and new, which were more than ever meetings of the Greeks as Greeks. If we remember that there were several such festivals every year, to which hundreds of cities sent delegations to represent them and to offer sacrifices to the gods, if we imagine all these people spending several days together, attending the games, exchanging information, and discussing political or other events, then we understand better how the Greeks were able, in a changing world, to preserve their identity.

CONCLUSION

The traditional view that the Greek polis was, "by definition," an independent and individualistic city-state has distorted our understanding of the function of the polis in the Hellenistic world. It has been widely admitted that Philip II and Alexander the Great were responsible for the decline and fall of the polis, that the polis ceased to be the frame in which Greek civilization achieved its perfection. It has even been said that after Chaeronea the Greek polis no longer existed and that the Greek ceased to be a citizen of his city and became a citizen of the world.

The available material, especially the inscriptions, reveals that the polis was, first of all, a "partnership in living well," a community of a particular kind involving a specifically Greek way of living together. And it appears that in the Hellenistic period the polis preserved its identity better than ever. The gymnasium and the theater, which concretized this identity, became more and more the symbols of the Greek education of

body and mind, of the superiority of Greek culture and the Greek way of life. They differentiated the Greeks from other people, from the Jews, the Egyptians, or the Syrians.

But the polis had another, no less important function: it was the link between individual citizens and the Greek commonwealth as a whole. For the Greeks were not members of the Greek commonwealth as individuals, they belonged to it as members of a Greek polis. It was the function of the polis to create and entertain relations of friendship and solidarity with other poleis, it was its function to send official delegations to the great panhellenic festivals. The poleis were the subjects of what I called interhellenic relations. And this network of interhellenic relations between cities made of the Greek world a community of communities, a homogeneous society of poleis.

The scholars who have shown some interest in this network of relationships between cities and cities in the Hellenistic period consider this "overture" of the polis to the outside world to be the result of the political decline of Greece after Chaeronea. They think that the Greek cities discovered, at last, "the consciousness of their unity and solidarity, of the existence of vital common interests among them," that "Greek 'political' exclusiveness gradually gave way to a broader conception, of a kind of brotherhood among all who were entitled to call themselves 'Hellenes.'"[74]

This belief results from the evidence we have. Our knowledge of the ties of friendship and solidarity among cities depends mainly, and for some aspects almost exclusively, on the inscriptions. The literary sources, historians, orators, and philosophers, are not particularly concerned with the everyday life of the average polis and mention only incidentally these kinds of peaceful and—in a certain sense—banal relations. Since the epigraphical material is rather scanty for the Classical period and totally nonexistent for the Archaic, it is finally the lack of information that explains the common view that there was no or only very little solidarity among the Greek communities before Alexander.

But, despite the limitations of our evidence, we have in the literary sources some indications that this solidarity already existed in the Classical period and even before. We find in Herodotus several examples of solidarity which are quite similar to those attested by the inscriptions for the Hellenistic period. It was in recognition of old benefits that Sparta and Corinth came to the aid of the Samians against Polycrates (Her. 3.47–48). The Eretrians sent assistance to the Milesians for similar reasons (5.99). The Spartans had granted the Attic deme of Deceleia *ateleia*

74. Rostovtzeff, *SEHHW* 2:1109.

and *proedria* in acknowledgment of a—mythical—benefit of the Decelei-
ans at the time of the Trojan War (9.73.3). The Milesians were bound
together by a tie of reciprocal hospitality with Sybaris and decreed a
public mourning at the fall of this city (6.21). The Milesians asked the
Parians to send them their best citizens to settle their internal conflicts,
an interesting precedent for the practice of calling foreign judges (5.28).
The kinship of all Greeks in blood and speech and the likeness of their
way of life asserted by Herodotus in a famous statement (8.144.2) was
not an idealistic proclamation of faith, it expressed the fact that, despite
their quarrels and disputes, the Greek poleis already in early times con-
stituted a commonwealth of communities bound together by an intense
system of relationships.

In fact, the homogeneity of the Greek world with its network of
friendships goes back to the times of Homer, with the essential differ-
ence, however, that the world of Homer is a world of individuals, not a
world of cities.[75] The Homeric heroes are bound together by the con-
sciousness of a common origin (they are all offspring of Zeus), by ties of
hospitality and intermarriage. They pay visits to each other. They ex-
change gifts and countergifts. They help each other in cases of necessity
for common undertakings. They practice athletics in common and listen
to the rhapsodes who sing about the heroes of the past. The unity of the
Greek world is a creation of the Dark Ages.

The rise of the polis in the seventh and sixth centuries did not destroy
this system of personal relationships, which survived through the Ar-
chaic and the Classical periods.[76] But the polis, the community, progres-
sively superseded the individual as the subject of these relations. The
poleis established with each other relationships that were of the same
kind and were based on the same principles as the personal ties of Ho-
meric society. Thus, we find in Herodotus cities bound to other cities or
to kings by ties of hospitality (ξενία), which, in a typically Homeric way,
are concretized by exchanges of gifts and countergifts: for instance,
Sparta with Croesus, with Amasis, and with the Samians (Her. 1.69–70
and 3.47). The privileges granted by the Spartans to the Deceleians,
because these had revealed to the Dioscuri the place where their sister

75. See M. I. Finley, *The World of Odysseus*, 2d ed. (London, 1977). I share the opinion
of A. Lesky, *Geschichte der griechischen Literatur*, 3d ed. (Bern and Munich, 1971), 73ff., that
Homer essentially reflects the society and values of his own time (the problem of the "his-
toricity" of the Trojan War is, of course, quite another question).

76. See the interesting book by G. Herman, *Ritualised Friendship and the Greek City* (Cam-
bridge, 1987), and the remarkable, but unfortunately little known, article of A. Heuss,
"Die archaische Zeit Griechenlands als geschichtliche Epoche," *A&A* 2 (1946): 26–62 (re-
printed in *Zur griechischen Staatskunde*, ed. F. Gschnitzer, WdF 96 (Darmstadt, 1969),
36–96, at 68ff. (the best pages I know on Archaic tyranny).

Helen was hidden, are another nice illustration of this evolution. The consciousness of unity and solidarity among all Greeks is not a late discovery of the Hellenistic period: it is a direct inheritance from Homeric society; it is the result of the progressive transformation of a society of individual aristocrats into a society of poleis.

The rise of the polis is the victory of the community over the individual, the family, and the clan.[77] The life of most Greek cities was a constant fight for survival and independence, a fight against neighbors for land or for cattle, a fight against ambitious powers or against rivals; but it was not a fight against the unity of the Greek commonwealth as such. There was no incompatibility between political independence from neighbors and from hegemonic powers on the one hand, and solidarity with the Greek world on the other. The cities inherited from Homeric society the consciousness that all together, whether large or small, were related to each other by a common origin, a common way of life, and a common destiny. And despite their conflicts and wars, they were able to keep the unity of the Greek commonwealth throughout their history. The totally individualistic poleis, living in splendid isolation and caring nothing for one another, like the Cyclopes in their caves, never did exist.

77. See Glotz, *Cité grecque*, 5: "En réalité, la cité grecque, tout en conservant l'institution familiale, n'a pu grandir qu'à ses dépens. . . . La cité a dû longtemps lutter contre le génos, et chacune de ses victoires a été obtenue par la suppression d'une servitude patriarcale." See also Heuss, "Archaische Zeit Griechenlands," 57ff.

Response

Albrecht Dihle

Man, according to Aristotle, is a ζῷον πολιτικόν, a being that fulfills its nature only within the frame of a political community. The Stoics, whose anthropological doctrine presupposed the social conditions in the Greek world after Alexander's campaign, changed Aristotle's definition. They called man a ζῷον κοινωνικόν, that is to say, an animal whose destiny is to live in a human community of any kind.[1] This difference in defining the nature of man seems to corroborate what Professor Giovannini pointed out in his most stimulating paper. He stressed, as you will remember, the importance of the cities, of urban culture as the decisive factor in the life of a Greek during the Hellenistic period. However, he was inclined to value the institutions of a Hellenistic city, its temples, theaters, festivals, officials, as phenomena of social rather than political life.

This evaluation is undoubtedly correct, at least in many respects. Very few cities in the Hellenistic world enjoyed over an extended period of time what we would call full sovereignty and were capable of determining their own destiny.

Moreover, our problem today is the identity of a Greek individual in the Hellenistic world, or that of a Corinthian, Antiochene, or Magnete. Institutions like those mentioned above were typical of all Greek cities in the Hellenistic world. Everyone who shared the advantages or duties arising from these institutions was likely to feel as a Greek for this very reason, without regard for his political allegiance. Finally, I should like to mention that in the course of Hellenistic history the functions of municipal administration and the social reputation going with them became

1. Aristotle *Politica* 1253a3; *Stoicorum veterum fragmenta* 3.686.

more and more monopolized by the upper class, people of landed property and education.[2] The simple folks' share in the institutions of public life became that of consumers and spectators.

Yet in spite of all these restrictions which have to be taken into account, once you apply the term *political life* to the conditions prevailing in the Greek cities of the Hellenistic world, an average Greek in the third or second century BC would probably not have agreed on our differentiating between political and social life, state and society. And this disagreement would not have been only a question of terminology.

From early Hellenistic times down to the late Roman Empire, philosophers did not cease to discuss the problem of whether or not the σοφός, the wise and perfect man, should partake in political life, and if so, under which circumstances.[3] πολιτεύεσθαι, partaking in political life, was always regarded as strictly separate from service in the army or administration of a king. The term was used to denote only the public activity in the cities and the corporations called πολιτεύματα, which resembled in many ways an urban community.[4] The royal service took its officers from all over the world. There was no community to which its functionaries could have been attached in their quality as administrators.[5]

Even those cities that were founded by a king, used law as given by the king, and had even been given royal judges,[6] were meant to attain, in due time, the autonomy of a self-governing body; and the same applies to the πολιτεύματα, corporations of Greek subjects of a Hellenistic king. Although the royal administration and legislation of the great monarchies tended to unify the legal system all over the territory ruled by the king,[7] the principle according to which every city had its own laws was never seriously contested.

None of the Hellenistic monarchies developed a general law of citizenship applying to every inhabitant. Every individual and every ethnic, social, or professional group had their direct and personal relationship to the crown. Thus, the internal structure of a Hellenistic kingdom was exclusively vertical, without any bond uniting horizontally the ruled persons and groups. Perhaps the cult of the god Serapis, introduced by the first Ptolemy,[8] was meant to create such a horizontal connection between

2. M. Rostovtzeff, *Gesellschafts- und Wirtschaftsgeschichte der hellenistischen Welt* (Darmstadt, 1955), 408f., 888ff.

3. E.g., *SVF* 3.611, 616.

4. W. Ruppel, "Politeuma," *Philologus* 82 (1927): 269ff.

5. Rostovtzeff, *Gesellschafts- und Wirtschaftsgeschichte*, 256ff.

6. Ibid., 412ff., 1151f.; L. Robert, "Les juges étrangers dans la cité grecque" in *Xenion: Festschrift für P. J. Zepos*, ed. E. von Caemmerer (Athens, 1973) 1: 765ff.

7. E. Seidl, *Ptolemäische Rechtsgeschichte*, 2d ed. (Glückstadt, Hamburg, and New York, 1962), 2, 73f.

8. Tacitus *Historiae* 4.83ff.

all the individuals under the rule of his dynasty. But the attempt failed, since Serapis became a Greek god with a slightly exotic flavor instead of uniting Egyptians and Greeks in Egypt and elsewhere. The cult of the ruler, on the other hand, made the subjects realize the overwhelming power of the king and his dynasty rather than creating a feeling of togetherness among the ruled. Its religious importance seems to have been very little. No one sent his prayer to the godlike ruler, but many prayers are attested which were directed to the real gods for the health and well-being of the ruler.[9] No dedications to a ruler have been found so far, whereas we know of thousands of dedications in the sanctuaries of the gods; and sometimes the personified Demos could replace the divine ruler.[10]

The efficiency of the royal administration, at least in the early period of Hellenistic civilization, seems to have been something new and unheard-of in the previous epoch. But so was its lack of emotional appeal. It did not create much loyalty on the side of the ruled. This can be seen from a little detail. No Greek army during the Archaic and Classical periods moved into a campaign without seers and priests, whose activity was thought indispensable for military success. The legions of the Roman emperors also had their cult. Nothing of the sort is known for the Hellenistic armies. Moreover, no general, no official of the royal administration seems to have had any religious duties attached to his service, in contrast to the functions of the elected officials in a Greek city. It is hard to see how the subject of a Hellenistic ruler could be emotionally or religiously attached to the political order in which he lived.

Under these circumstances the public life in the Greek cities had its own and absolutely unique quality in the Hellenistic world. I am inclined to classify this quality as political, even in the modern sense of the word. I should explain this statement in more detail.

Politics can be defined as the art of establishing, preserving, and defending a system of social rule according to one's own or one's group's aspiration, and of developing and using the existing social and economic potential for this very purpose. Many among the Hellenistic rulers were masters of that art. But you can define politics quite differently, namely as the art of creating and preserving communities where the members are bound together by feelings of mutual loyalty—over the generations or even centuries and despite all differences in social standing, group adherence, or economic influence. In the world of the Hellenistic kingdoms only the Greek cities met this challenge.

9. For seeming exceptions, see M. P. Nilsson, *Geschichte der griechischen Religion* (Munich, 1974) 2 : 182f.

10. Cf. R. Mellor, *The Worship of the Goddess Roma in the Greek World* (Göttingen, 1975), 13ff.

They were able to provide their citizens with the sense of identity which is, after all, the main factor of political life, and not only a social phenomenon. The Greek city remained the point of reference for its citizens' identity even under Roman or Parthian rule.

This is not to idealize the social and economic conditions which prevailed in the Greek cities at that time. Many of them suffered from extreme social tensions, and the ruling class frequently turned out to be unable to identify the problem and solve it. Nearly all the Hellenistic kings, however, encouraged urban life and privileged the Greek cities, sometimes even encouraged their striving for autonomy.[11] This undoubtedly indicates that these rulers had delegated the second function of politics to their Greek cities. The city had to create the basis of political loyalty and identity. The utopian literature of the period always represents the ideal human community in the setting of a city,[12] never as a kingdom or a tribal community. The highest praise given to the Roman Empire in the famous speech of Aelius Aristides is implied in the statement that Rome has turned the whole civilized world into one city.[13]

So I believe we have to admit that the Greek cities of the Hellenistic world opened up a wide area for political activity—at least according to our second definition of the term and mainly to men of property and education. Yet this kind of political activity created the feeling of identity for all the inhabitants.

There was, however, a marked difference between political conditions in the cities of the Hellenistic world and those of the previous time, even apart from the loss of full sovereignty which I have already mentioned. In the Archaic and Classical periods the individual was inseparably bound to the city and community of his birth, so that the loss of one's home city usually meant the destruction of one's social existence. Alexander had opened up a wide area for Greek enterprise and many opportunities of mastering one's life, socially and economically, even outside one's ancestral home. There were many alternatives to political activity in the city of one's birth throughout the Hellenistic period. That is why the question raised by the philosophers, εἰ πολιτευτέον, pointed to a real choice, open to anyone of some initiative. Man, even if he belonged to the upper class, was no longer necessarily a ζῷον πολιτικόν.

We have been told that a Greek individual became aware of his ethnic and cultural identity mainly by participating in the public institutions of his city, that is to say, visiting the theater, entering the gymnasium, and so forth. All the Greek cities of the Hellenistic and Roman periods of-

11. Rostovtzeff, *Gesellschafts- und Wirtschaftsgeschichte*, 314ff., 666ff.
12. Euhemerus ap. Diodorus 6.1; Iambulus ap. Diod. 2.55ff.; Zenon *SVF* 1.258; 262.
13. Aristid. *Paneg. Rom.* 59ff.

fered a great many clubs, corporations, *thiasoi* of various kinds, and the individuality of a given city largely depended on the number and character of such corporations. This again was a political factor, because it was the main constituent of a city's character and thus created the basis for the patriotism of its citizens. This kind of social life replaced, to a certain extent, the traditional allegiance to ancestors, family, and ancestral home during the previous period. We can see this change from the fact that the cult of the deceased ancestors and their graves became rare or had to be supported by special donations and institutions because of the growing belief in an afterlife.[14] Many families in the new cities even had to create their ancestry, and the cities usually made their founders heroes of the place.[15] This clearly indicates awareness of a religious deficit in comparison with the ancient cities of the Greek mainland.

Yet the most important group to which loyalty could be extended was the civic community itself. Its legal order, its institutions with all the challenges they had to offer, together with the possibility of social care and peacemaking—all these factors provided security and social orientation to the inhabitants. I would like to call this a political phenomenon, since the civic community embraced people of very different social standing, education, and religious aspiration. In this respect, the civic community was far more effective than, say, a congregation of worshipers of Isis.

The political reality described above had its most convincing expression in the official cult of the city. Professor van Straten's impressive paper has warned us that we should not prematurely draw generalizing conclusions from the material available. This is wise and prudent advice, since Hellenistic culture produced extremely different or even contradictory phenomena. Moreover, the preservation of the monuments is largely due to chance. Nevertheless I must neglect his advice for a moment.

There can be little doubt that minor deities such as heroes, Asclepius, the deities of the private homestead, had always been of greater importance for the individual in his everyday life than the powerful and imposing gods or goddesses of the city. This applies to the Classical period as well as to postclassical times.[16] However, literary, epigraphical, and monumental evidence from Classical Athens testifies to largely the same attitude, which the Athenian showed in any religious practice regardless of the standing of the god involved and regardless of the public or private character of the cult or ceremony. The Athenians took the mutilation of the Hermai—that is to say, religious objects of entirely private

14. Nilsson, *Geschichte der griechischen Religion*, 233f.; 544ff.
15. T. J. Cornell, "Gründer," *RLAC* 12 (1983): 1141ff.
16. Cf. Menand. *Dysc.* 26off., 43off.

character—as seriously as the profanation of the Eleusinian Mysteries, one of the holiest institutions of the Athenian state.[17]

The picture looks different in Hellenistic times, and again philosophy gives a hint as to how to explain the difference.

Every philosophical school had its theological doctrine. This was necessary for two reasons: since the question of whether or not divine beings really existed had been raised in the context of the Sophistic movement,[18] no philosopher could ignore the problem. On the other hand, the part played by religious practice in Hellenistic society was still important, and any teacher of the art of the good life had to take it into account. The theological doctrines of the Hellenistic schools were multifarious. But apart from the Epicureans they all agreed on the conception of a great variety of divine beings. These they tried to classify, mainly according to the importance they may have for men and, consequently, according to their specific cults. This method can already be seen in the theology of Plato and his first successors.[19]

The gods whose cult was a public institution in the Greek cities are always given a prominent place in such classifications. This fits in very well with Aristotle's statement that the common religious practice of the community is one of the most important factors of political life and a constituent of the political order.[20] Accordingly, every Hellenistic city had its temple, its specific religious celebrations, which were the pride of the citizens and also the comfort of the poor.[21]

It is difficult to tell the feelings of the inhabitants of a Hellenistic city who celebrated an official and public sacrifice. The sacred laws that gave the rules for such a festival are mostly restricted to the order of procedures, and there are very few texts—in Strabo, Aristides Quintilianus, and Plutarch—which contain reflections on the meaning of religious festivals, the joy of the participants, and the like.[22] But the joyous communication with the powerful protector of one's own city seems to have been the dominant feeling of the congregation.

The gods of the Hellenistic cities mostly came from the traditional

17. Thucydides 6.27f., 6of.; Andocides 1.

18. A. Dihle, "Philosophie und Tradition im 5. Jh. v.C." in *HumBild*, Beiheft 1 (Stuttgart, 1986), 13ff.

19. E.g., Xenokrates F 23–25 Heinze; Ps. Plat. *Epin.* 984Dff.

20. Arist. *Pol.* 1328b5ff.

21. The motif is mentioned in the famous inscription of Antiochus of Commagene. Cf. H. Dörrie, *Der Königskult des Antiochos von Kommagene* (Göttingen, 1964), 77ff.

22. Strabo 10.3.9; Aristides Quintilianus 3.25; Plutarch *Non posse suav. viv. sec. Epic.* 1101E.f. Cf. A. Dihle, "Zur spätantiken Kultfrömmigkeit," in *Pietas: Festschrift für Bernhard Kötting,* ed. Ernst Dassmann and K. S. Frank (Munster, 1980) = *JbAChr Ergänzungsband 8,* 39–54.

pantheon of the Greek mainland. Those who were in reality local divinities or newly invented, such as Tyche, were always given the character and appearance of one of the old Olympians.[23] Above all, every one of them really cared for his city.

I do not know of any account about the army of a Hellenistic ruler miraculously saved through divine intervention that is comparable to the fighting heroes in the Battle of Marathon, the rain wonder that saved the troops of the emperor Marcus Aurelius, or the miracle of the Frigidus which caused the victory of Theodosius I. But Apollo and Artemis did save Delphi from the onslaught of the Celtic barbarians,[24] and similar accounts about a city saved by its god are known from Asia Minor. True, the Athenians put Demetrius Poliorcetes among the gods of the city. The story is well known, and so is the hymn which was composed and sung on this occasion.[25] But no miracle caused Demetrius' deification. The Athenians were only disillusioned with their traditional gods, as the text of the hymn indicates. As a religious phenomenon the cult of Demetrius seems to have been as meaningless as the cult of the rulers in general. This was quite different in the case of the traditional city cult, as can be seen from temples, festivals, offerings, votives, prayers and, above all, the political influence of the traditional oracles in the Hellenistic world.[26]

So the traditional cult of each city must have been of outstanding political importance,[27] for every city was independent and unique in this respect, as it was with regard to its laws, its calendar, or the election of its leading officials.

Some kings and emperors from Ptolemy I to Aurelian tried to introduce the cult of just one common god for all their subjects. All of them utterly failed in such attempts, mainly because every city had a firm tradition of its own and a specific public religious practice. We cannot discover, during the said epoch, any signs of opposition against henotheistic or monotheistic tendencies, which were necessarily implied in every universal state cult. On the contrary: most philosophers from the fourth century BC onward embraced the idea of one supreme god, the ruler of the universe, and interpreted the many gods of the religious tradition as his visible representatives or subordinate divine beings.[28] That is why

23. Nilsson, *Geschichte der griechischen Religion*, 207ff.

24. *SIG* (3) 398 (278 BC); Diodorus Siculus 22.9; Pausanias 10.23.

25. Athenaeus 6.253Dff.

26. Nilsson, *Geschichte der griechischen Religion*, 229ff.; interesting details of Hellenistic oracular practice discussed by L. Robert, "De Delphes à l'Oxus," *CRAI* (1968): 416ff.; idem, "Sur un Apollon oraculaire à Chypre," *CRAI* (1978): 338ff.

27. This can be seen, for example, from the impressive inscription *IvMagnesia* no. 98 (second century BC) which gives the description of the festival of Zeus Sosipolis.

28. E.g., Ps. Arist. *De mund.* 398a20ff.

some divinities that were not too closely attached to the religious tradi-
tion of just one city or region could easily be understood as the universal
or supreme god.[29] This happened to Isis, Helios the Sun God, the Great
Mother of Asia Minor, and others who had their worshipers all over the
Hellenistic world or the Roman Empire. Yet the political importance of
these cults was small.

This was rightly observed by the philosophers in their attempts to
classify the various kinds of religion.[30] They never omitted to mention
what they called political theology, that is to say the conception of the
divine as implied in the cult of the city gods. Being the citizen of a Greek
city always meant being under the protection of one or several specific
deities. Being conscious of one's own Greek identity was brought about
through participation in the cult of the city, regardless of one's own re-
ligious or philosophical predilections, regardless even of the attachment
to a minor deity or the god of mystery cult in the needs and sorrows of
private life. The inseparable link between political loyalty and religious
tradition which was typical of the Greek cities accounts for the unbroken
persistence of the traditional cults under changing conditions in intellec-
tual, social, and religious life during the Hellenistic and Roman periods.
Philosophers and emperors who tried to cope with the rise of Christi-
anity from the second century AD onward always insisted on the idea
that the great number of the gods and cults testifies to the truth of the
traditional religion, although their own creed was mostly more or less
monotheistic.[31] Yet the struggle against Christianity was primarily a
political one, and from the point of view of political loyalty religion
referred to many gods according to the tradition of the many Greek
cities. This tradition, however, was the only religious one in Hellenistic
and Roman times which can be classified as political in the true sense of
the word.

Hellenistic culture produced many kinds and types of religious prac-
tices. The political religion of the Greek cities which we have been de-
scribing is far from representing the enormous wealth of religious life
in that particular period. The wide extension of the Hellenistic world
and the mobility of its population created religious needs unheard of in
preceding centuries. Many people had to look for divine assistance out-
side the precinct of a Greek city; they turned to gods who were present
at many places and whose worshipers gathered in Asia Minor as well as
in Syria or Egypt.[32]

29. E.g., the hymn to Isis *POxy.* 1380.
30. *SVF* 2.1009; cf. G. Lieberg, "Die Theologia tripartita," *RhM* 125 (1982): 25ff.
31. E.g., Celsus in Origen *Contra Celsum* 8.2.
32. M. P. Nilsson, *Griechischer Glaube* (Bern, 1946), 106ff.

But none of the many religious phenomena in the Hellenistic world to be listed by the historian—such as oriental cults, mystery cults, oracles, astrology, healing gods, and so forth—turned out to be as persistent and hard-dying as the traditional cults of the city gods, the sole exception being perhaps modest local cults, whose receivers could easily be reinterpreted as Christian saints without the cult being substantially changed. Hellenistic philosophers were quite right in stressing the importance of what they called political theology.[33] The traditional cult of the traditional city gods turned out to remain the main factor of social integration for many centuries, far more so than ruler cult, oriental religious practice, or mystery cults. Philosophy did not supersede it but rather gave the interpretation of this religious phenomenon as pointing to and representing, in the visible world and for the benefit of the intellectually weak, some aspects of the cosmic order and its divine ruler. Oriental cults that were imported to the Greek world may be more interesting for the historians, as they were for Renan or Cumont. But the mainstream of political and religious life originated from the old Olympian gods, even in Hellenistic times.

33. The affinity of religion or theology and politics is stressed by Cicero (*De legibus* 1.22; *De natura deorum* 2.78).

Intellectuals and Images of the Philosophical Life

Introduction

A. A. Long

As a profession and as a cultural institution, philosophy had been firmly established in the Greek world since the later years of the fifth century BC. Its prestige was underlined by the great work of Plato and Aristotle during the first three-quarters of the fourth century. On a Hegelian view of intellectual history the achievements of these two thinkers mark philosophy's high point in the Greek world; what came next, in the Hellenistic period, was diffusion and decline. If we measure the significance of a cultural phenomenon simply by the qualities of its greatest representatives, the Hegelian judgment rings true. No other ancient philosophers match Plato and Aristotle in range and creative intelligence. That point is underlined by the afterlife of these thinkers in later antiquity, when Neoplatonism and commentary on Aristotle dominate the philosophical scene.

If, on the other hand, we look for an epoch in Western history when philosophy was at its richest in terms of diversity, interschool debate, and educational influence, the Hellenistic period is a top candidate. The scholarship of the past two decades has amply documented this point. A budding student in Hellenistic Athens had a wealth of philosophical options to choose among. The schools themselves came to be called *haireseis,* "choices," because now for the first time it made sense to ask, "Which philosophy do you espouse?" expecting the answer Stoic, Epicurean, or some other sect. Choice of a philosophical school was not comparable to selecting among universities. It was a decision about the whole orientation of one's life. People might, of course, shop around, listen to various philosophers' lectures, or shift their allegiances. But a committed Epicurean or Stoic stood for something, or rather for radically different things—divergent theologies, cosmologies, attitudes to

politics, and, above all, doctrines concerning what makes for the best human life. "Platonist or Aristotelian" was never a comparable disjunction.

The holistic character of Stoicism and Epicureanism is a sign of the times. When Zeno began teaching in Athens's "painted colonnade" (Stoa) and Epicurus founded his Garden School, neither philosopher could have foreseen the success his movement would enjoy over a period of some five hundred years. In origin these philosophical sects were experimental, simply two of the many alternatives available to the curious youth of Athens and to others who came to that city for their advanced education. What was it that ensured a great future for Stoicism and Epicureanism and, correspondingly, permitted them to supplant the Cynics, Cyrenaics, Eretrians, and other schools that were still active around the year 300 BC? One answer, and surely in large part a true one, is that Zeno and Epicurus had the philosophical genius to be able to defend their doctrines with compelling reasons. From the outset, it seems, their approach to philosophy was more systematic than that of the minor schools that they supplanted, and more in tune with the spirit of the times than that of their rival Platonists and Aristotelians. Yet, as with Socrates' extraordinary impact, an important explanatory factor must have been the personalities, living example, and lifestyles of the men themselves—the kind of image they projected, the way they were seen to live the philosophy they taught. Our access to this intriguing subject is hampered, of course, by a lack of reliable biographical data. Nonetheless, we seem to know quite a lot about the way Zeno and Epicurus struck their contemporaries and how they wanted to be viewed.

The image of these two philosophers had not been studied with the care it merits. Fernanda Decleva Caizzi has put that straight. Contrary to what one might have supposed, it is the austere Zeno rather than the hedonist Epicurus who appears to have been the more self-conscious in this regard. Caizzi finds a good explanation for this in the different demands the rival philosophies made on their followers' values and modes of life. The route to happiness professed by Zeno was exigent in its low valuation of most conventional goods. To make the point, Zeno seems to have taken poverty to extremes, exceeding even the doctrinal "indifference" attached to wealth by the Stoa. (His consistency or inconsistency on this point is well discussed by Julia Annas in her comments.) More generally, Caizzi is convincing in her suggestion that Zeno, living like Socrates in the public eye, wanted to be viewed as the Hellenistic counterpart to his illustrious predecessor; this must have been an important element in his success. Epicurus, by contrast, emphasized the ease and naturalness of living quietly. The life he recommended was, as Caizzi

says, "an attainable ideal." It did not require public demonstrations of its feasibility or highly personal exemplifications of what it required.

The new directions of philosophy in the Hellenistic world have often been viewed as a direct response to social and cultural conditions supposed to distinguish this era from what preceded—individualism, breakdown of civic cohesion, uncertainty about self-definition. Like most generalizations, this one is valuable so long as it is not regarded as complete and unqualified. The new Hellenistic schools were continuous in many respects with earlier philosophy. Zeno and Epicurus did not advance simplistic nostrums even if the souls to whom they particularly appealed were troubled. Hellenistic philosophers' insights were carefully grounded in arguments and analysis of concepts. The issues they debated, as Julia Annas makes clear, involve considerable sophistication in the understanding of a "final" good. It remains true, however, that Stoicism and Epicureanism were "philosophies of life" very directly and single-mindedly. That was their novelty. Their success was largely due to the fact that the extensive contributions they made to other areas of philosophy clearly cohered with and helped to sustain the central ethical theory.

In traditions where logic and metaphysics are studied purely for their own sake, holistic philosophies are often suspect. It may be thought a bad mistake to try to connect philosophies of life and the most difficult abstract questions; or worse, philosophies of life may be regarded as one person's idiosyncratic preferences masquerading as general recommendations. It would not be too difficult to defend Stoicism and Epicureanism against this objection. More to the point, the ethical dimension of Hellenistic philosophy is of central importance for understanding what speculative thought could contribute to ideas of the self at this period, and the extent to which individualism and self-concern were explicitly recognized notions.

Rivals though they were, Stoicism and Epicureanism had a common project in essence—to give persons willing to reflect on themselves and their experience a plan of life or a rational orientation to the world. By the time of Panaetius (second century BC), as Christopher Gill ably shows, a Stoic professor, while maintaining his school allegiance, could be sufficiently open-minded to draw creatively on anything that seemed useful in the philosophical tradition. His paper and Julia Annas' comments on it are too subtle to be summarized briefly. What they show, with differences of emphasis and interpretation, is the significant connections that were perceived between an ethical goal—for instance, peace of mind or virtue—and self-reflection or understanding one's hu-

man nature. It is clear from these wide-ranging discussions that Hellenistic philosophy played a major part in fashioning ideas about the self—what it means to take charge of one's own life, where autonomy lies, and how mental states can be monitored. Whether or not this constitutes an interest in individualism, the self-concern emphasized by Hellenistic philosophy plainly fitted the zeitgeist. True happiness was to be sought and found by discovering what human nature requires. That Hellenistic quest, like so much else in Hellenistic culture, helps to define where we are today.

The Porch and the Garden: Early Hellenistic Images of the Philosophical Life

Fernanda Decleva Caizzi

I

Alciphron, the rhetorician of the Roman imperial age, gives a nice description in one of his letters (3.19) of a group of Athenian philosophers, invited to a birthday party:

> Among the foremost present was our friend Eteocles the Stoic, the elderly man with a beard that needed trimming, the dirty one (ὁ ῥυπαρός), the one with his head unkempt (ὁ τὴν κεφαλὴν αὐχμηρός), his brow more wrinkled than his leather purse. Present also was Themistagoras of the Peripatetic school, a man whose appearance did not lack charm (οὐκ ἄχαρις ὀφθῆναι) and who prided himself on his curly whiskers. And there too was the Epicurean Zenocrates, not careless of his curls and also proud of his full beard, and Archibius the Pythagorean, "the famed in song" (for so everybody called him), his face overcast with a deep pallor (ὦχρον), his hair falling from the top of his head right down to his chest, his beard pointed and very long, his nose hooked, his lips drawn in and by their very compression and tightness hinting at the Pythagorean silence (τὴν ἐχεμυθίαν ὑποσημαίνων). All of a sudden Pancrates too, the Cynic, thrusting the crowd aside, burst in with a rush; he was supporting himself on a club of oak—his stick was studded with some brass nails where the thick knots were, and his wallet was empty and hung handily for the scraps. Now the other guests, from the beginning of the party to the end, kept to a similar or identical etiquette (ἀκολουθίαν), but the philosophers, as the drinking progressed and the loving-cup kept going its rounds, exhibited, each in turn, his brand of tricks. Eteocles the Stoic, for example, because of old age and a full stomach, stretched out and snored; and the Pythagorean, breaking his silence, hummed some of the Golden Verses to a musical tune. The excellent Themistagoras, since according to the Peripatetic doctrine he defined happiness not in terms of soul and body only, but also in terms of external goods, demanded more cakes and an abundant variety

of fine cuisine. Zenocrates the Epicurean took the harp girl in his arms, giving her languishing looks from half-closed eyes, and saying that this was "tranquillity of the flesh" (τὸ τῆς σαρκὸς ἀόχλητον) and "consolidation of pleasure" (τὴν καταπύκνωσιν τοῦ ἡδομένου). The Cynic, first of all, with Cynic indifference, relieved himself, loosening his robe and letting it drag on the floor; then he was ready to screw Doris, the singing girl, in full view of everyone, saying that nature is the starting point of reproduction.[1]

The passage describes the philosophers as looking and behaving differently from ordinary people—in this case the parasites, one of whom is the letter's author—and from each other. This is clearly connected with the different theory each philosopher is more or less faithfully reflecting and putting into practice.[2] Alciphron's witty account is entirely in line with a typology of philosophers from the Classical age, familiarized by comedy and also through the anecdotal tradition.

Earlier than Alciphron, Dio Chrysostom wrote a speech *On Deportment* (περὶ σχήματος, *Or.* 72), where he complains that people cannot help mocking and insulting "someone in a cloak but no tunic, with flowing hair and beard"; "and they do this although they know that the clothes he wears are customary with the so-called philosophers and display a way of life."[3]

In these passages—and many others one could quote from later sources—the philosopher clearly appears as somebody different from other people in his external features and, what is more interesting, as somebody whose external features and behavior are related to the contents of his philosophical thought. The biographical and anecdotal material concerning philosophers, assembled by Diogenes Laertius and Athenaeus, shows the same pervasive patterns. Even though emphasis on "deportment" may be considered typical of a later period, this kind of description is by no means restricted to the Roman imperial age.[4] It is found in the comic tradition as early as Aristophanes, and in many comic fragments about philosophers of the fourth and third centuries. Attic comedy is very important in fixing a sort of philosophical mask, and very influential on later authors like Alciphron and Lucian. Yet the features adopted to describe a particular philosopher, superficial and stereotyped though they may be, should not be dismissed without care-

1. *The Letters of Alciphron, Aelian and Philostratus*, with an English trans. by A. Rogers Benner and F. H. Fobes (Loeb Classical Library, 1979), adapted. I am greatly indebted to Tony Long for making this paper less unpalatable for Anglo-American readers than it originally was.

2. Cf. also Alciphron *Ep.* 4.7, on the supercilious and pompous Academic philosopher.

3. *Dio Chrysostom*, with an English trans. by H. Lamar Crosby (Loeb Classical Library, 1951), V, adapted.

4. Cf. J. Geffcken, *Kynika und Verwandtes* (Heidelberg, 1909), 53ff.

ful study; and perhaps they can offer a picturesque but not unsuitable way of introducing the main theme of this paper.

II

As far as I know, a general and comprehensive work concerning the image of the philosopher in Classical antiquity is still lacking. By "image" of a philosopher I mean two things: (a) the way he intends to show himself to other people, that is to say, how he conceives philosophical life and his own personal role compared with other ways of living, and what features he thinks consonant with the role he has chosen to play; and (b) the way he is viewed by others, whether by nonphilosophers, or by his pupils and followers, or by hostile persons (for instance, by professional rivals or those who attack him for any other reason). Both facets are important, though the first is harder to delineate, and the second cannot be entirely kept separate from it; we get the largest part of our information about the first aspect through sources of the second.

In most cases—and these include the Hellenistic philosophers—the sources obviously present a serious problem. Their reliability is often extremely hard to test. In addition, images of philosophers are mostly transmitted by the biographical tradition, which is usually late and full of fictional elements. Different philosophers are sometimes characterized in the same way. Nevertheless, in this paper I wish to maintain that, although much care is needed in handling such texts, it would be a mistake to dismiss them all as insignificant or false. Even as pieces of literary fiction, they offer a picture of what is presumed to be typical of a philosopher and so, indirectly, they may give us an idea of how a philospher wants other men to see him or of how we may suppose he behaved in order to give rise to a specific biographical or comic report concerning himself. Difficult though it is to distinguish earlier from later sources, the biographical tradition seems to have had a conservative tendency, so that in many cases no substantial novelty was added to the general features of the original picture.[5]

No inquiry into the image of Hellenistic philosophers can pass over Socrates; he is the first philosopher who is vividly described by a variety of sources. In fact, we are told a lot about the way he behaved, dressed, and acted, and we are made to feel that this is connected to and ex-

5. This comes out very clearly in Pyrrho's biography, where the Antigonus material on Pyrrho's extravagant behavior has been included and preserved in spite of its being very disturbing to the later Pyrrhonists. For an attempt to make use of its significance for studying Pyrrho's biography, cf. my commentary in *Pirrone: Testimonianze* (Naples, 1981), passim.

plained by his philosophical attitude. Moreover, it is well known that the
contemporary authors who described him have been enormously influ-
ential.[6] Irrespective of their relative historical value, they acquaint us
with a philosophical character whose name was Socrates, and whose typi-
cal features passed to the Hellenistic age via Attic comedy and the works
of the Socratic philosophers.

Generally speaking, in the philosophical literature the image of the
philosopher is connected with theoretical doctrines, mostly in the field
of ethics. In comedy—the other medium central to the Hellenistic age—
the philosopher is portrayed because he can interest the dramatist's au-
dience, either by the contrast between his outward behavior and the val-
ues of ordinary life or by the way his paradoxical theories are opposed
to common sense and common belief. In the biographical literature the
information collected about external features and behavior is often re-
lated to the philosophical theory, either as showing the consistency of
the philosopher or as showing a gap between theory and action.[7] We find
plenty of remarks of this kind in the biographies of Hellenistic philoso-
phers, revealing a particular interest in the practical and pedagogical
role of the philosopher. The occurrence of this theme is not just a sign
of a widespread literary fashion; and even if in some cases the details
about the philosophers' behavior look highly implausible, they must not
be considered complete fiction. It is more reasonable to think that they
reflect an actual tendency on the part of the philosopher to adopt and
display a certain way of life, and the expectation by the nonphilosophers
that he do so. The influence of Socrates' life and Socratic literature on
the later tradition must never be underrated.

Although I am deeply conscious of the danger one is exposed to in
making historical use of sources of this kind, I hope I will be able to
show that the risk is worth taking, and that such sources make it possible
to increase, or at least to confirm, our philosophical information and to

6. Among the works still available to us: Aristophanes' *Clouds,* some of the Platonic
dialogues (especially *Apology, Phaedo,* and *Symposium*), and some chapters of Xenophon's
Memorabilia. A. Dihle, *Die Entstehung der griechischen Biographie* (Göttingen, 1956), esp.
13ff., rightly ascribes to the figure of Socrates and to the *logoi Sokratikoi* a decisive impulse
to the birth of biographical literature, even if some sketches of earlier biographical work
may be found in the fifth century. What perhaps still need to be more investigated are the
models or patterns which Socrates himself evoked and through which his pupils saw him
and described him, but this subject would take us away from the Hellenistic age. This
important point was missed by G. Böhme, *Der Typ Sokrates* (Frankfurt a.M., 1988).

7. From this point of view, one should correct Wilamowitz's remarks about Antigonus
of Carystus (*Antigonos von Karystos* [Berlin, 1881], 33): it is true that Antigonus is not inter-
ested in the philosopher's theories per se, but most of the anecdotes he collects are in some
way related to them.

achieve a better understanding of the connection between a philosopher's theory, his personality, and his behavior in practical life.

In order to make clear what we are looking for, we may start from the obvious point that the Hellenistic philosopher proposes an ethical ideal, the state and the life of the "sage," corresponding to the *telos* one has to look for in order to live well and be happy. To the scholar investigating the image of the philosopher, the following questions arise at once. What is the relation between the philosopher and the sage he is speaking about? Does the philosopher present himself as a *sophos*? In what way does the peculiar quality of "being a sage" manifest itself? Can we detect a precise intention on his part to set himself up as a living paradigm for his pupils, or just to show them a paradigm through his words?[8]

Another important issue related to this one concerns the social role of the philosopher, the place he occupies in the surrounding community, his being popular or unpopular, and the causes of this—not only the external, contingent ones, but those that depend on his deliberate choice as well. What function does he attribute to his profession, how does he select pupils, what does he do for them? What kind of person does he attract? What is his attitude to political power, and what are the consequences of it?

Thanks to Diogenes Laertius (to whom one should add some important passages from Athenaeus), we are told a lot about the lives of the two most important Hellenistic philosophers, Zeno and Epicurus. Since the life of Epicurus has been the more thoroughly studied, I devote the main part of the paper to Zeno.

III

Zeno's conversion to philosophy is connected with Socrates through his reading Xenophon's *Memorabilia*[9] and also with Crates the Cynic, as the living philosopher most similar to Socrates. We are told that Zeno found it hard to practice Cynic "shamelessness" (*anaideia*). In spite of this information, Zeno's earliest work, *The Republic*, showed remarkable traces of Cynic influence (it had been written "on the dog's tail," as somebody said for a joke, DL 7.4). All this is well known, but I would like to stress

8. This set of problems goes back to Socrates as well, and to the portrait or portraits made by his pupils, in which ideal and reality were closely interwoven.

9. My argument is not affected by the different versions about the way this happened: DL 7.3, 31, and Themistius *Or.* 23 = *SVF* 1.9. For the philosophical presence of Socrates in Hellenistic philosophy, see now A. A. Long, "Socrates in Hellenistic Philosophy," *CQ* 38 (1988): 150–171.

the fact that Zeno's behavior in everyday life, as described in many an-
ecdotes, shows that "Cynicism," although in a less radical form than that
adopted by Crates or Diogenes, continued to be part of his image. This
may be explained either as a stereotype, a kind of literary topos, or as an
indication that Zeno aimed to preserve some connection with the Cynic
tradition. I take the latter alternative to be more plausible and to fit our
evidence better. In fact, Zeno accepted that part of the Cynic heritage
which he considered genuinely Socratic and which mostly concerned the
philosopher's role in the community and his protreptic and pedagogical
function.

At the end of his book devoted to the Cynics, Diogenes Laertius writes
(6.104): "For indeed there is a certain close relationship between the two
schools. Hence it has been said that Cynicism is a shortcut to virtue
(σύντομον ἐπ' ἀρετὴν ὁδόν); and it was in this way that Zeno of Citium
lived his life." [10]

This statement is important, and more compatible with what we read
in the biography of Zeno than scholars usually believe. I hope to show
that it is connected with the philosopher's image and its function and,
further, that in Zeno's case we can infer from sources of the *b* type some
conclusions of the *a* type.

Even if Zeno did not, in fact, adopt his teacher Crates' radical way of
living, nevertheless he held fast to some fundamental patterns of the
Socratic-Cynic tradition, the ones that helped to convey a philosophical
message, like a kind of school advertising. We are told about the place
Zeno chose for teaching: a public one, the Painted Colonnade (*stoa*)
alongside the agora, in the very center of the town, but at the same time
one that made it difficult for many people to listen to him, even if many
wanted to (see DL 7.5: "his object being to keep the place uncrowded"). [11]

This is a significant choice, especially if we compare it with other
schools' locations—Epicurus' Garden, the Academy—or with the crowd
of people who sometimes listened to Theophrastus' lectures. [12] Zeno's de-
cision seems to me to reveal a typical and important feature: the inten-
tion of *isolating himself while remaining under other people's eyes,* instead of
withdrawing completely from them. In this sense, he is a follower of

10. Diogenes Laertius, *Lives of Eminent Philosophers*, with an English trans. by R. D.
Hicks (Loeb Classical Library, 1958), adapted.
11. Cf. the story about Crantor, DL 4.24, who had retired to the temple of Asclepius
because of an illness, and people flocked round him while he walked up and down because
they thought he was starting a new "school." This gives us an idea of the Athenians' atti-
tude to philosophy.
12. DL 5.36–37; cf. the witticism in *SVF* 1.280: "And Zeno, seeing that Theophrastus
was admired for having many pupils, said, 'It is true his chorus is larger, but mine is more
harmonious.'"

Socrates' "displacement" (*atopia*) and of the Cynics, who spent all their time *among* people, even if not *with* people as such. If we may trust both Aristophanes and Plato on this point—and I believe we should—Socrates deliberately chose not to look or to behave in the way one could expect from him, given both his social status and his exceptional intellectual gifts.[13] This was a good way for somebody with a message to attract attention. Socrates was followed in this practice by Antisthenes and in a much more radical form by Diogenes. Socrates' personality stood out among his contemporaries and looked strange to people who did not understand the philosophical meaning of apparently paradoxical behavior. Plato, who spoke of wonder as the starting point of philosophy (*Tht.* 155c), connected it beautifully to Socrates in the *Phaedo*, describing the reactions of his pupils to his attitude to death (58a3; 58e1; cf. 59a5); and Alcibiades' famous description of Socrates in the *Symposium* is on much the same lines. It emphasizes the typical Socratic opposition between appearance and reality, which so much impressed his followers and friends and which was mocked in Aristophanes' *Clouds*.[14]

Wonder arises when we are confronted with something we don't expect, or someone behaving unusually. A precondition for wonder is visibility, and this is what some of the Socratics and the Cynics sought to achieve. Zeno likewise. He used to go around with two or three persons, asking for money in order to make people run away from him, and selecting students in various memorable ways. All this shows his attracting and repelling pupils at the same time. These activities are surely connected as deliberate ways for Zeno to distinguish himself from the crowd of contemporary philosophers performing in Athens.[15]

We are told that, although he agreed to take part in Antigonus Gonatas' symposia, he stayed by himself (DL 7.13–14) and avoided close contacts with the populace. He was "sour and his face was screwed up. He was very miserly and un-Greek in his stinginess, using economy as his excuse.[16] If he criticized anyone, he would do it concisely and not

13. This emerges from an important passage of Xenophon (*Mem.* 1.6), where Antiphon objects to Socrates that he does the opposite of what one should do to be happy: the interesting point is his deliberate refusal to make money out of philosophy, as his colleagues did and as he could easily have done. From a social point of view, this is a very strong form of *atopia*.

14. For instance, Socrates is described as somebody able to teach people how to be successful in order to get money and live easily, while he looked pale, hungry, and miserable.

15. Selecting pupils is a feature of Socrates as well, continuing in the Socratic tradition. In the Hellenistic age it became, of course, an urgent problem because of the strong rivalry between the schools; cf. Hieronymus on Timon, DL 9.112.

16. This is a typical commonsense explanation, perhaps coming from contemporary comedy; we shall see on the contrary that Zeno's *euteleia* has a clear philosophical meaning.

effusively, from a distance" (DL 7.16; Athenaeus 2, 55F): στυγνός, πικ-
ρός,[17] συνεσπασμένος, σκληρός are the terms used to describe him, all
of them, we may note in passing, rather far from the ideal image of
the Stoic sage, polite and gentle (ἀστεῖος). I will come back to this point
later.

Yet Zeno was held in high honor by citizens both of Athens and of
Citium (DL 7.6) and by Antigonus Gonatas, who "also favored him, and
whenever he came to Athens would hear him lecture and often invited
him to his court." It is likely that part of Zeno's ultimate popularity de-
pended on his attracting Antigonus' attention. The text of the decree
concerning Zeno voted by the Athenians and probably inspired in some
way by the king (DL 7.15) deserves attention and careful explanation
(DL 7.10–11):[18]

> ἐπειδὴ Ζήνων . . . ἔτη πολλὰ κατὰ φιλοσοφίαν ἐν τῇ πόλει γενόμενος[19]
> ἔν τε τοῖς λοιποῖς ἀνὴρ ἀγαθὸς ὢν διετέλεσε καὶ τοὺς εἰς σύστασιν αὐτῷ
> τῶν νέων πορευομένους παρακαλῶν ἐπ' ἀρετὴν καὶ σωφροσύνην παρ-
> ώρμα πρὸς τὰ βέλτιστα, παράδειγμα τὸν ἴδιον βίον ἐκθεὶς ἄπασιν ἀκό-
> λουθον ὄντα τοῖς λόγοις οἷς διελέγετο

Whereas Zeno . . . has for many years been devoted to philosophy in the
city and has continued to be a good man in all other respects, exhorting to
virtue and moderation those of the young who came to him to be taught,
directing them to what is best, exhibiting to everyone his own life as a
model consistent with the doctrines that he presented.

Many anecdotes treat the educational function of Zeno as comparable
to the one attested by Eubulus for Diogenes the Cynic's behavior toward
Xeniades' children.[20] The stories concerning Zeno's relation to pupils
and his own conduct show two apparently contrasting features: a mod-
erate one, so to speak, and a radical one. This corresponds to divergent

17. For πικρία, a kind of ὀργή, see SVF 3.395.
18. W. W. Tarn, Antigonos Gonatas (Oxford, 1913; repr. 1969), 309 and n. 106, thinks
that the text in Diogenes Laertius combined two different decrees, one in honor of Zeno
in his lifetime, and the other for his burial. This is not relevant to the way I shall make use
of it.
19. This is an important remark, indirectly showing that Athens was a place where
many ephemeral schools were opened and soon passed away. The importance of continu-
ity in philosophy—a typical Socratic theme—is underlined also by Epicurus on many
occasions.
20. Eubulus ap. DL 6.30 ff.; for Zeno see SVF 1.245; 246; 1.29; and the εὐπείθεια
theme in SVF 1.235. DL 7.27 shows that his frugality was proverbial, and this explains the
mention of σωφροσύνη in the decree. Zeno's struggle against moral τῦφος is also pure
Cynicism, in spite of Timon's attack, F 38 Diels: καὶ Φοίνισσαν ἴδον λιχνόγραυν σκιερῷ
ἐνὶ τύφῳ, which mainly refers, in my opinion, to the "dark smoke" of groundless (in Ti-
mon's eyes) knowledge.

information about Zeno's way of life. According to Antigonus of Carystus he was rich enough to use money for helping his master Crates and for public enterprises like any other citizen of Athens or Citium (DL 7.12); his diet is described as healthy but not at all ascetic (DL 7.13). Elsewhere (DL 7.26–27), however, descriptions of his way of life correspond rather closely to the Cynic one:

> He was extremely hardy and frugal; the food he ate did not require cooking and the cloak he wore was thin (ἦν δὲ καρτερικώτατος καὶ λιτότατος, ἀπύρῳ τροφῇ χρώμενος καὶ τρίβωνι λεπτῷ). Hence it was said of him: "He is the victor over winter's cold, incessant rain, blazing sun and dread disease. Public festivity does not sap his strength. Night and day he concentrates tirelessly on his teaching."[21]

This is certainly hyperbole, but the relevant question is: Why and what for? All the more so, as this is not an isolated text. Some comic fragments (DL 7.27) show that Zeno was usually described by contemporaries in similar terms. There is an unmistakable emphasis on poverty, and this is also apparent in Timon's verses on Zeno's followers (DL 7.16), a quotation that may well stem from Antigonus, who was well informed about the subjects of his biographies:[22]

> ἦσαν δὲ περὶ αὐτὸν καὶ γυμνορρυπαροί τινες, ὥς φησι καὶ ὁ Τίμων· "ὄφρα πενεστάων σύναγεν νέφος, οἳ περὶ πάντων / πτωχότατοί τ᾿ ἦσαν καὶ κουφότατοι βροτοὶ ἀστῶν."
>
> And he had about him some ragamuffins, as Timon says in these lines: "While he got together a crowd of the poor, who surpassed everyone in beggary and were the most poverty-stricken of people."

Antigonus reports a comment by Zeno which sounds like an apology (Athenaeus 13, 565D = SVF 1.242) and helps to confirm the general appropriateness of Timon's words:

> That wise Zeno of yours, as Antigonus of Carystus says, had a premonition, as it would seem, of your lives and of your hypocritical profession; he said that they who listened casually to his discourses and failed to understand them would be filthy and mean (ῥυπαροὶ καὶ ἀνελεύθεροι), just as those of Aristippus' school who have gone wrong are sensualist and aggressive.[23]

Dirtiness is a superficial sign of poverty, something one can adopt without any serious ethical intent, a mask to conceal a mean spirit (ἀνε-

21. Trans. A. A. Long. Together with the points of difference, we can clearly catch parallels to the endurance of Diogenes the Cynic and Crates.

22. For the Antigonean source of Zeno's *bios*, cf. Wilamowitz, *Antigonos*, 103 ff.

23. Cf. Alciphron's description of the Stoic philosopher as *ῥυπαρός* in the epistle quoted above.

λεύθερος in Antigonus' words). Polemics of the Roman imperial age against false Cynics are well known, but the problem of distinguishing a serious philosophical use of poverty from a merely exploitative one is as old as Socrates.[24] Plato describes Socrates' going "washed" (*leloumenon*) to Agathon's symposium as exceptional.[25] Poverty and a careless attitude to the body's toilet are often connected in descriptions of philosophers; but it is noteworthy that in other cases—for instance the Academics or the Peripatetics[26]—the emphasis is on just the opposite feature. That is why I believe that the features comic poets emphasized and made fun of, even though they doubtless exaggerated them, were real.

Zeno's sentence and Timon's satiric verses, combined with the evidence from poetry and comedy (DL 7.27–28), suggest a rather strong connection between early Stoicism and poverty.[27] In fact, if we look closer at it, we realize that the sentence quoted by Antigonus in Athenaeus assumes that the choice of life by Zeno's followers depended in some way on his attitude. We have a version of this sentence by Zeno's fellow Stoic Ariston which tends in the same direction (Cicero *ND* 3.77):

> If it is true, as Ariston of Chios was in the habit of saying, that philosophers do harm to their audience when the audience put a bad interpretation on good doctrines, since people could leave Aristippus' school sensualist and Zeno's austere (*acerbos*). . . .

Austerity (*acerbitas*), as we have seen, was just the quality attributed to Zeno by the biographers: that is to say, it may be considered part of his image.

All this can perhaps be better understood by reference to Diogenes the Cynic's words (DL 6.35):

> He used to say that he imitated the chorus trainers; for they too set the note a little high, to ensure that the rest should hit the right note.

24. Cf. the discussion in Aeschines' *Telauges* and Marcus Aurelius 7.66: Πόθεν ἴσμεν, εἰ μὴ Τηλαύγης Σωκράτους τὴν διάθεσιν κρείσσων ἦν;
25. Cf. Dover's commentary ad loc. One should surely distinguish between λούεσθαι and ἀπονίζεσθαι, but it would be a mistake to underrate the fact that comedy made fun of Socrates from this point of view; this implies that he looked like somebody who does not care very much for cleanliness, disturbing though this is to modern notions of hygiene (see again Dover's commentary to Aristophanes' *Clouds*, xli–xlii; 201–202).
26. Cf. Antiphanes F 33 (II p. 23 K.); Ephippus F 14 (II p. 257 K.) and T. B. L. Webster, *Studies in Later Greek Comedy* (Manchester, 1953), 52–53, who recalls Theophrastus *Char.* 26 on the oligarchic man and Plato *Rep.* 425a; for Aristotle, see I. Düring, *Aristotle in the Early Biographical Tradition* (Göteborg, 1957), 356.
27. The same sense should be given to Timon's joke about somebody not knowing how to cook perfectly (φρονίμως) a lentil soup, the typical Cynic meal (Lloyd Jones and Parsons, *Suppl. Hell.* 787–788); see also DL 7.3, a sort of initiation rite to Cynicism; for the Epicurean polemics, cf. below.

Equally relevant is Crates' description of the island of Pera (F 4 Diels = 351 Lloyd-Jones/Parsons v. 2): "fair, fruitful, rather squalid, owning nothing" (καλὴ καὶ πίειρα, περίρρυπος,[28] οὐδὲν ἔχουσα). In this verse the oxymoron between the two half-lines shows very aptly the difference between the true nature of the Cynic town and way of life (ὁ κυνικὸς βίος) and the way it appears to other people, who look at it from outside, that is, from their conventional world.

According to Stoic theory, both wealth and poverty are "indifferent": they make no difference to happiness, but wealth is "preferable" to poverty (DL 7.106 = SVF 3.127). Yet Zeno, in the biographical tradition, makes a strong didactic use of poverty; it is something he practices, and he expects others to do likewise. In a sense, then, poverty is presented as something "preferable," and the Stoic, at least from a practical-pedagogical point of view, seems to modify in some way the theory mentioned above.[29]

Athenaeus 6, 233 A–B (= SVF 1.239) reports:

> The Stoic Zeno, while he made an exception of the legitimate and honorable use of money, nevertheless deemed it in all other respects "indifferent," and discouraged both the pursuit and the avoidance of it, prescribing that one should preferably make use of plain and simple things.[30]

This text shows the same ambiguity in the attitude to wealth and poverty that we find in the biographical tradition. Anecdotes on Cleanthes (DL 7.168, 169–70) seem to confirm the emphasis on poverty and its significance. So too, for instance, does a story about the handsome and rich but untalented youth who wanted to attend Zeno's lectures (DL 7.22):

> First of all Zeno made him sit on the dusty benches, so that he might dirty his cloak; then he put him in the place where the beggars sat, so he would rub up against their rags. In the end the young man went away.[31]

Taking all the evidence into account, we may conclude that poverty was part of the Stoic philosopher's original image—I mean something essentially connected with him. We may also assume he stressed it on

28. Περίρρυπος is Stephanus' excellent emendation of περίρυπος (codd.), accepted by Lloyd-Jones and Parsons.

29. Cf. DL 6.87, about Crates turning his property into money and distributing it among his fellow citizens.

30. I follow Schweighäuser's text, accepting Casaubon's περιττῶν (which agrees with λιτῶν) instead of ἀπερίττων; and I translate προηγουμένως (προηγορευμένως codd.) in its technical sense.

31. Cf. also Euripides' verses that Zeno used to quote (DL 7.22): ἥκιστα δ' ὄλβῳ γαῦρος ἦν, φρόνημα δὲ / οὐδέν τι μεῖζον εἶχεν ἢ πένης ἀνήρ.

purpose, in spite of his actually being less poor than such sources might lead one to believe.

Contemporary comic poets confirm this feature of Zeno. In his play *Philosophers*,[32] Philemon wrote:

A single loaf, dessert of dried figs, water to drink—a newfangled philosophy this man adopts: he teaches poverty and gets disciples.

So too Theognetus in his play *The Ghost* or *Miser*:[33]

ἐκ τούτων . . . ,
ἄνθρωπε, ἀπολεῖς με. τῶν γὰρ ἐκ τῆς ποικίλης
στοᾶς λογαρίων ἀναπεπλησμένος νοσεῖς·
"ἀλλότριόν ἐσθ' ὁ πλοῦτος ἀνθρώπῳ, πάχνη·
σοφία δ' ἴδιον, κρύσταλλος. οὐδεὶς πώποτε
ταύτην λαβὼν ἀπώλεσ'."

You'll be the death of me, fellow, with all this! You have stuffed yourself sick with the silly doctrines of the Painted Porch, that "wealth is not man's concern, wisdom is his peculiar possession, standing as solid ice to thin frost; once obtained it is never lost."

When we turn to Epicurus' frugality, which is described as very similar in practice to that of the Stoics (cf. DL 10.11), one big difference from Zeno is evident. There is no hint that poverty as such was part of Epicurus' image. This is shown not only by the lack of positive evidence, which by itself is significant and to which I shall return, but also by statements like the following (*Ep. Men.* 130):

We also regard self-sufficiency as a great good, not with the aim of always living off little, but to enable us to live off little if we do not have much (καὶ τὴν αὐτάρκειαν δὲ ἀγαθὸν μέγα νομίζομεν, οὐχ ἵνα πάντως τοῖς ὀλίγοις χρώμεθα, ἀλλ' ὅπως ἐὰν μὴ ἔχομεν τὰ πολλά, τοῖς ὀλίγοις ἀρκώμεθα[34]), in the genuine conviction that they derive the greatest pleasure from luxury who need it least.[35]

Diogenes Laertius (10.119), reporting from Epicurus' second book *On Lives*, says that the Epicurean wise man will not become a Cynic or a beggar, and even when he has lost his sight he will not withdraw himself from life (οὐδὲ κυνιεῖν . . . οὐδὲ πτωχεύσειν. ἀλλὰ καὶ πηρωθέντα τὰς

32. DL 7.27 = F 85 (IV p. 29 M.).
33. F 1 (III p. 364 K.); cf. also Phoenicides ap. Stob. *Flor.* 6, 30 = IV, 511 Meineke for the topos of philosophical contempt for money.
34. χρώμεθα codd.
35. Trans. A. A. Long and D. N. Sedley, *The Hellenistic Philosophers*, vol. 1 (Cambridge, 1987), 114.

ὄψεις μὴ ἐξάξειν³⁶ αὐτὸν τοῦ βίου). Similarly, the Epicurean is advised to combine frugality with cleanliness.³⁷ All these passages look like polemics against Cynicism, and I believe we should take them as attacking early Stoicism as well, in its retention of Cynic features as part of the philosopher's image (in spite of an apparently similar sentence by Zeno [DL 7.22]). This is confirmed by some facts: (1) the connection in Epicurus' same book *On Lives* of Cynic and Stoic themes, such as an attack on the Stoic defense of well-reasoned suicide (*SVF* 3.757); (2) a fragment by Colotes (p. 166 Crönert) in which attacks on Stoics and Cynics show them to be virtually inseparable in Epicurean eyes; and (3) a passage in Stobaeus (2 p. 114 Wachsmuth = *SVF* 3.638) where the Stoics are quoted explicitly on the sage's Cynicism: "They say that the sage will be Cynic, this being identical to persisting in Cynicism, not that, being a sage, he will engage in Cynicism" (κυνιεῖν τε τὸν σοφὸν λέγουσιν, ἴσον ⟨ὂν⟩ τῷ ἐπιμένειν τῷ κυνισμῷ, οὐ μὴν σοφὸν ὄντα ἐνάρξεσθαι τοῦ κυνισμοῦ).³⁸

Zeno's *Republic* could hardly have been a permanent target of attack unless some relevant aspects of Cynicism were preserved by the Stoics even later. I take the meaning of Stobaeus' sentence to be a request that the Stoic, once he has become a "sage," should preserve that part of Cynic principles he had adopted in his previous progress toward virtue and that "practicing Cynicism" (κυνίζειν) must not be interpreted as inaugurating a Cynic "sect" (as far as one can use this term for Cynicism) in a stricter sense: this is just what I have previously labeled as part of the philosopher's "image."³⁹

What is left of Metrodorus' book *On Wealth* is even more helpful in order to understand the different attitudes to money of Zeno and Epicurus. What distinguishes them is precisely, in my opinion, Zeno's Cynic tendencies.

In fact, Zeno's public attitude to money and his deliberate roughness should be interpreted as exhibiting "the short way to virtue" to people who did not follow him on the long and hard route to philosophy. His

36. So Bywater (cf. DL 7.130); see H. S. Long's apparatus ad loc.

37. *VS* 63: Ἔστι γὰρ ἐν λεπτότητι καθαριότης, ἧς ὁ ἀνεπιλόγιστος παραπλήσιόν τι πάσχει τῷ δι' ἀοριστίαν ἐκπίπτοντι.

38. Cf. also Apollodorus ap. DL 7.121 = *SVF* 3.17. The passage, whose text has been much discussed, has been recently examined by M. O. Goulet-Cazé, *L'ascèse cynique: Un commentaire de Diogène Laërce VI 70–71* (Paris, 1986), 22 and n. 22. Even if the sentence reached Arius Didymus from Apollodorus, Epicurus' parallel text shows that the discussion on this theme started much earlier.

39. If I am right, perhaps our evidence on Epicurean anti-Cynic polemic should be reconsidered and also the traditional opinion on the lack of anti-Stoic attacks.

impressive image stood for a way of life which seemed to the Athenians' eyes to recall and restore the ancient and traditional civic virtues, above all *sophrosyne,* for which he was praised in the decree.[40]

In the same text much emphasis is laid on Zeno's consistency of theory and practice. By itself, this was nothing new:[41] "I hate a sophist who is not wise toward himself" (μισῶ σοφιστὴν ὅστις οὐχ αὑτῷ σοφόν) is a well-known sentence by Euripides (F 905 N.²) and later adopted by Menander (*Monost.* 332). If, as we have seen, Antigonus Gonatas might be considered the inspiration of the decree, it may be fruitful to look more closely into the relationship between the two men, as described by the sources.

> After Zeno's death, Antigonus is reported to have said: "What a life performance I have been deprived of."[42]

Plutarch accused Zeno of inconsistency because he spoke about politics without practicing it.[43] In fact, Zeno's attitude to political power is an important feature of his image and witness to his consistency: the Athenians appreciated his choice of "a peaceful lifestyle" (ἡσυχίαν ἄγειν) and the refusal to visit royal courts or to send messages to kings.[44] His allegedly silent response to royal ambassadors sharply contrasts with the traditional court-philosopher type.[45] This detached attitude is not called in question by the supposed letter he wrote to Antigonus Gonatas. As Wilamowitz rightly remarked,[46] the two letters quoted in Diogenes Laertius 7.7–9 are patently false, and his arguments can be supplemented.

The idea that Zeno refused to go to Macedonia purely because of his old age is totally inconsistent with the general picture we have of him. In our sources Antigonus is described as visiting him, inviting him, offering

40. Cf. DL 7.27: "He had almost become a proverb" . . . τοῦ φιλοσόφου Ζήνωνος ἐγκρατέστερος.

41. Cf. for instance, the Platonic συμφωνία, *Lach.* 193e; the Antisthenic ἀρετὴ τῶν ἔργων, DL 6.27–28, etc.; ἀκολουθία is a topos in Antigonus' biographies: see Pyrrho, DL 9.61, but it has an important role also in Colotes (Plutarch *Adv. Col.* 1117D).

42. DL 715: οἷον εἴη θέατρον ἀπολωλεκώς. This I believe to be the right meaning of the sentence, in spite of Tarn, *Antigonos,* 310, followed by Hicks, who translate θέατρον as "audience." For θέατρον as "life," see Porphyry *Ad Marcel.* 2. Epicurus' sentence (ap. Seneca *Ep.* 7, 11) quoted by Tarn (*satis enim magnum alter alteri theatrum sumus*) does not seem to me to controvert the interpretation given above.

43. *St. rep.* 1033B = *SVF* 1.27, where we read that Zeno wrote on politics less than his successors (ἐν ὀλίγοις).

44. *SVF* 1.284, in two versions, one concerning Ptolemy, the other Antigonus.

45. Cf. *SVF* 1.273, where Zeno reports a story about Crates reading Aristotle's *Protrepticus* in the shoemaker's shop and criticizing its dedication to Themison.

46. Wilamowitz, *Antigonos* 110 and n. 15.

him gifts, in other words as a king paying honor to the philosopher, never vice versa. So DL 7.15:

> And when asked why he admired him, he said: "Because, although I gave him many substantial presents, they never made him arrogant nor yet appear humble."

Old age as the only reason for refusing to go to Macedonia does not suit this picture, since it implies that, were it not for his age, Zeno would accept.

Besides, Antigonus' letter speaks about Zeno's "perfect happiness" (τῆς τελείας εὐδαιμονίας ἧς σὺ κέκτησαι). Zeno proposes to send his pupils, οἷς συνὼν οὐδενὸς καθυστερήσεις τῶν πρὸς τελείαν εὐδαιμονίαν ἀνηκόντων ("if you associate with these, you will in no way fall short of the conditions necessary for perfect happiness"). Addressed to a king, this is a flattering sentence, completely out of tune with what we are otherwise told about Zeno; and so in a sense is the "perfect happiness" attributed to the philosopher by the king, who was expected to be acquainted with his teaching. In fact, if we look carefully at the evidence concerning Zeno, we find no hint of his thinking or presenting himself as the perfectly virtuous and happy sage.

On the other side, the stories about Stoic philosophers of the earlier generation visiting a king's court sound rather unfavorable and look as if they were collected (or invented) in order to show off the philosopher's conceit about being a good politician (referring to the Stoic theory of the sage as the expert in politics) and failing in this undertaking. This is reported about Persaeus in his collaboration with Antigonus; and even Sphaerus is described as having to defend himself against Ptolemy's attempt to refute his claim to wisdom.

> Antigonus once, wishing to test him out [sc. Persaeus], caused some false news to be brought to him that his estate had been ravaged by the enemy, and his face fell: "Do you see," he said, "that wealth is not a matter of indifference?"[47]

"Testing out the philosopher" (διάπειραν δή ποτε βουληθεὶς λαβεῖν ὁ 'Αντίγονος κτλ.) is an aspect of the contest between the monarch and the philosopher which had been commonplace since the early Socratic tradition. Now, the emphasis is on the typical Hellenistic theme of con-

47. DL 7.36. Themistius (*Or.* 42, 358d = *SVF* 1.449) remarks that the philosopher's behavior contradicts the Stoic principle that the sage is ἀήττητος ὑπὸ τῆς τύχης, etc., and comments unsympathetically: ἔλεγξε δὲ ἡ φύσις τὰ λογάρια, ὅτι τῷ ὄντι λογάρια ἦν καὶ ἀσθενῆ καὶ οὐ μαρτυρούμενα ὑπὸ τῶν ἔργων. See also *SVF* 1.223a.

sistency, just as we find in the Athenian decree. It is worth noticing that
in this particular case Zeno, the philosopher who refuses invitations, is
the winner, while Persaeus, who accepts the king's invitation, is described
as losing his match.

In Sopater's *Celts* (Athenaeus 4, 160E = F 193 Kaibel) we read:

> καὶ μὴν φιλοσοφεῖν φιλολογεῖν τ' ἀκηκοὼς
> ὑμᾶς ἐπιμελῶς καρτερεῖν θ' αἱρουμένους,
> τὴν πεῖραν ἡμῖν λήψομαι τῶν δογμάτων
> πρῶτον καπνίζων· εἶτ' ἐὰν ὀπτωμένων
> ἴδω τιν' ὑμῶν συσπάσαντα τὸ σκέλος
> Ζηνωνικῷ πραθήσεθ' οὗτος κυρίῳ
> ἐπ' ἐξαγωγῇ, τὴν φρόνησιν ἀγνοῶν.

Among them it is the custom, whenever they win any success in battle, to
sacrifice their captives to the gods; so I, imitating the Celts, have vowed to
the heavenly powers that I shall burn three of those counterfeit dialecti-
cians on the altar. Look! Having heard that you diligently choose philoso-
phy and philology and that you have stoical endurance, I am going to
make a test of your doctrines first by smoking you; then, if I see one of
you during the roasting pulling up his leg, he shall be sold to a Zenonian
master for export, as one who knows no wisdom.

This passage recalls an apophthegm ascribed to Zeno (*SVF* 1.241),
that he would prefer to see one Indian being burnt (παροπτώμενον),
than to listen to all the arguments on labor (περὶ πόνου). It is remarkable
that in Sopater's text (which should be dated to about 270 BC) the mock-
ing is directed more against followers than against Zeno as the preacher
of endurance (*apatheia*). Shall we consider this a casual fact? Perhaps not,
if we take into account all the evidence I have collected.

If we look closer at this fact from our specific point of view, we realize
that Zeno's attitude to kings and his refusal to leave Athens[48] have two
aims, connected to each other: of staying under the Athenians' eyes and
of compelling a king *to look for* the philosopher. This seems to me to have
a very important consequence concerning the philosopher's image: one
could say that the king in visiting the philosopher becomes a kind of
advertising agent, in fact the best in an age in which the new political
trend strongly imposes some very powerful and impressive individuals
on public opinion, if I may use this anachronistic expression. One recalls
the deification of Demetrius by the Athenians, and the hymn that was

48. The same behavior was adopted by Cleanthes and Chrysippus. The latter, who is
said to have been an arrogant man (ὑπερόπτης), dedicated none of his writing to a king,
and "when Ptolemy wrote to Cleanthes requesting him to come himself or else to send
someone to his court, Sphaerus undertook the journey, while Chrysippus declined to go"
(DL 7.185).

composed in his and his wife's honor.[49] This corresponds to an increasing personality worship, inconceivable in Greece before Alexander's deeds, and relevant to our subject.

Writing about the Stoic sage, L. Edelstein stressed the importance of "the new consciousness of man's power that arose in the fourth century, the belief in the deification of the human being."[50] Taking this remark as a starting point, we may say that part of the success and renown of a particular type of philosopher in the first period of the Hellenistic age arises indirectly, as a kind of reflex of his political interlocutor's power and fame—not so much in the trivial sense that friendship with a king is useful to a philosopher for help and support, but in a more subtle sense: the more the philosopher resists the king, the more he consolidates his public image and role, as a kind of counterpower or alternative paradigm of the happy and successful life. I assume this to be an important feature not only of the ideal Stoic sage but even of the Stoic philosopher himself, as showing the way to the happy life.

This typically Hellenistic way of building a philosopher's image is familiar from accounts of the meeting between Diogenes the Cynic and Alexander. Most of the anecdotes concerning Diogenes' relation to political men must be considered complete fiction, and quite implausible historically. Yet as fiction, some of them have a special meaning and function, transcending the traditional monarch/philosopher opposition. DL 6.79:

> Demetrius in his work *On Men of the Same Name* asserts that on the same day on which Alexander died in Babylon Diogenes died in Corinth.

The invention of perfect synchronism between two events as important as death[51] has a symbolic purpose, as is evident in some of the other anecdotes. Two of these, surely the most famous ones, are particularly relevant; DL 6.60, 38:

> Alexander once came and stood in front of him and said, "I am Alexander the great king." "And I," he said, "am Diogenes the Cynic." (Ἀλεξάνδρου ποτὲ ἐπιστάντος αὐτῷ καὶ εἰπόντος, "ἐγώ εἰμι Ἀλέξανδρος ὁ μέγας βασιλεύς," "κἀγώ," φησί, "Διογένης ὁ κύων.")

> When he was sunning himself in the Craneum, Alexander came and stood in front of him and said, "Ask me anything you like." To which he replied, "Stand out of my light." (ἐν τῷ Κρανείῳ ἡλιουμένῳ αὐτῷ Ἀλέξανδρος ἐπιστάς φησι, "αἴτησόν με ὃ θέλεις." καὶ ὅς, "ἀποσκότησόν μου," φησί.)

49. Cf. Athenaeus 6, 253 D ff.

50. L. Edelstein, *The Meaning of Stoicism* (Cambridge, Mass., 1966), 13.

51. One could mention Plato's biography and the coincidence of dates between his birth and Apollo's, and the relation between him and Socrates through the same kind of remarks; cf. A. S. Riginos, *Platonica: The Anecdotes concerning the Life and Writings of Plato* (Leiden, 1976).

In both cases, the meeting and the remarks of the two men are impressive for their complete ease and economy of description. In the first text, perfect symmetry is the relevant feature; in the second, it is Diogenes' down-to-earth rejoinder to the king's conceited exhibition of power. We are clearly being confronted with two divergent ideals and contrasting images.[52]

The point of some other anecdotes, as has often been noticed, is to praise Alexander's magnanimity,[53] but another aspect needs to be stressed too: I mean the propaganda this kind of material offers to a philosopher, to enjoy in a parasitical way, so to speak, the extraordinary fame and glory of his interlocutor. The man who is a symbol of all the traditional contents of *eudaimonia* (youth, beauty, strength, power, wealth, glory) is contrasted with and in a sense defeated by somebody endowed with nothing of this sort, just the inner power of intelligence, *logos,* and virtue. As a result, all the king's qualities are metaphorically transferred to the philosopher. The symbolic event so described exhibits the perfect Cynic or, in more abstract terms, his perfect moral freedom.

These anecdotes probably arose in the period immediately following Diogenes' death. What seems worth stressing is their affinity with the evidence for Zeno's life and attitude to royal politics. The main difference in the anecdotes I have quoted between the image of Zeno and the one of Diogenes is that Diogenes and Alexander, in spite of their being historical figures, are symbolic or ideal characters, while Zeno is not, nor does he seem to encourage in any way the assimilation of his own person to the Stoic sage.[54] This recalls the fact that the Stoic sage was conceived as a model of rational perfection and, as he has been rightly called, "a bearer of ethical paradoxes" (*ein Trager ethischen Paradoxien*).[55] The sage could be concretely exemplified only through mythical or very remote historical personages.

A crucial feature of the Stoic theory about the sage is the radical opposition between the "virtuous" and the "vicious" person (ὁ σπουδαῖος, ὁ φαῦλος), and the absence of any ethical type in between. In addition, at least in theory, the Stoics held that a human being could become virtuous,[56] though the difficulty of finding an actual sage is emphasized by

52. The wit of these texts presumes Alexander to be at his fullest glory, hence they postdate his Asian adventure; of course, that is another reason to consider them deliberate fiction.

53. Cf. *Socraticorum reliquiae* VB31 Giannantoni and his commentary, vol. 3, 398 ff.

54. In the case of Zeno we don't seem to have anything comparable to the idealization of Plato in the Academy, which started with Speusippus' *Encomium Platonis,* or to Epicurus' deification.

55. E. Schwartz, *Ethik der Griechen,* ed. W. Richter (Stuttgart, 1951), 69.

56. This is presupposed in Cleanthes' *Hymn to Zeus.* Cf. Arius Didymus ap. Stob. 2.7, p. 65 Wachsmuth: πάντας γὰρ ἀνθρώπους ἀφορμὰς ἔχειν ἐκ φύσεως πρὸς ἀρετήν. For the

many sources.[57] Since happiness depends entirely on virtue, and every adult human is either virtuous or vicious, none of the latter could strictly be deemed happy (εὐδαίμων). Chrysippus (SVF 3.510) said:

> The man who progresses to the furthest point performs all proper functions without exception and omits none. Yet his life . . . is not yet happy, but happiness supervenes on it when these intermediate actions [sc. his performance of proper functions] acquire the additional properties of firmness and tenor and their own particular fixity.[58]

There is only one passage in Zeno's biography where he is described as "happy" (DL 7.28):

> In this species of virtue [i.e., self-control, ἐγκράτεια] and in dignity he surpassed everyone, and indeed in happiness. (τῷ γὰρ ὄντι πάντας ὑπερεβάλλετο τῷ τ' εἴδει τούτῳ καὶ τῇ σεμνότητι καὶ δὴ νὴ Δία τῇ μακαριότητι.)

Immediately after this we are told that Zeno died at a great age and in good health, which, according to popular morality, was a sign of *eudaimonia*. Such remarks, like the praise for his virtue and moderation in the public decree, show how a biographer could ignore Chrysippus' distinction between the state of the man who has progressed to the furthest point (τὸν ἐπ' ἄκρον προκόπτοντα, the text cited above) and the state of the sage. But to the Stoics themselves the distinction remained of capital importance. In fact, they stressed it so strongly that it became a commonplace even outside the school.

Baton, a comic poet familiar with philosophy,[59] in a passage from *The Murderer* quoted by Athenaeus (4, 163 B = III 326 Kock) has somebody deliver the following verses:

> τῶν φιλοσόφων τοὺς σώφρονας ἐνταυθοῖ καλῶ,
> τοὺς ἀγαθὸν αὑτοῖς οὐ διδόντας οὐδὲ ἕν,
> τοὺς τὸν φρόνιμον ζητοῦντας ἐν τοῖς περιπάτοις
> καὶ ταῖς διατριβαῖς ὥσπερ ἀποδεδρακότα.
> ἄνθρωπ' ἀλάστωρ, διὰ τί συμβολὰς ἔχων
> νήφεις;

argument on moral progress and the images adopted to describe it, see F. Decleva Caizzi and M. S. Funghi "Un testo sul concetto stoico di progresso morale (PMil Vogliano Inv. 1241)," in *Aristoxenica, Menandrea, fragmenta philosophica*, Studi e testi per il corpus dei papiri filosofici, 3 (Florence, 1988), 85–124.

57. Cf. A. Dyroff, *Die Ethik der alten Stoa* (Berlin, 1897 [repr. 1979]), 200, and the detailed discussion in R. Hirzel, *Untersuchungen zu Ciceros philosophischen Schriften* 2.1 (Leipzig, 1882).

58. Trans. Long and Sedley, *The Hellenistic Philosphers* 1:363.

59. Cf. Plutarch *De adul. et amico* 55C, and I. Gallo, "Commedia e filosofia in età ellenistica, Batone," *Vichiana* 5 (1976), 205–242.

I summon here the philosophers who are moderate, who never give them-
selves a single good thing, who look for the wise man in their strolls and
talks, as for one *who has run away*. Wretched fellow, why, when you have
the income, do you stay sober?

Baton likewise compares the Stoic sage to a runaway slave in a passage
where the goal of Epicurus is opposed to the Stoic *telos* (Athenaeus 3,
103 C–D = III 328 Kock):

οἱ γοῦν τὰς ὀφρῦς ἐπηρκότες
καὶ τὸν φρόνιμον ζητοῦντες ἐν τοῖς περιπάτοις
καὶ ταῖς διατριβαῖς ὥσπερ ἀποδεδρακότα
οὕτως, ἐπὰν γλαύκισκος αὐτοῖς παρατεθῇ,
ἴσασιν οὗ δεῖ πρῶτον ἅψασθαι τόπου
καὶ τὴν κεφαλὴν ζητοῦσιν ὥσπερ πράγματος,
ὥστ' ἐκπεπλῆχθαι πάντας.

Those at least with raised eyebrows, who seek on their walks and in their
discourses for the "wise man," as if he were a runaway slave, once you set
a strange fish before them, know what "topic" to attack first and seek so
skillfully for the "capital" point, that everybody is amazed.

In a long passage by Damoxenus, about a cook connecting his science
to Epicurean physics, Stoics and Epicureans are opposed in similar but
even more explicit terms (Athenaeus 3, 103B = III 349 Kock):

σοφὸν
Ἐπίκουρος οὕτω κατεπύκνου τὴν ἡδονήν·
ἐμάσατ' ἐπιμελῶς. οἶδε τἀγαθὸν μόνος
ἐκεῖνος οἷόν ἐστιν· οἱ δ' ἐν τῇ στοᾷ
ζητοῦσι συνεχῶς, οἷόν ἐστ' οὐκ εἰδότες.
οὐκοῦν ὅ γ' οὐκ ἔχουσιν, ἀγνοοῦσι δέ,
οὐδ' ἂν ἑτέρῳ δοίησαν.

In this way Epicurus condensed pleasure into the sum of wisdom [?]. He
could chew carefully. He is the only one who saw what the Good is. The
Stoics are always seeking for it, but they don't know what its nature is.
What, therefore, they have not got and do not know, they cannot give to
anyone else.

These verses may allude not only to the Stoic model of the sage but
also to discussion between Stoics and Academics. The main point, how-
ever, is their confirmation of the other sources—I mean that Zeno did
nothing to present himself as a wise man, but simply as somebody aiming
at virtue.[60]

60. In an epigram by Hegesander of Delphi (Athenaeus 4, 162A), among other neo-
logisms referring to the standard comic description of philosophers, we find ζηταρετησιά-

The joke about the Stoic searching for the sage, as if the latter were a runaway slave, recalls the story that Diogenes the Cynic went around with his lamp in daylight looking for a "man." In both cases the philosopher is described, in a Socratic way,[61] as not achieving completely what he is talking about; in spite of this, he may be praised for his "consistency" (ἀκολουθία) since the proposed model is a goal he aims at by rules of behavior that never lose sight of it and are never self-contradictory. As we have seen above in the case of politics, problems concerning the image of the Stoic philosopher arise when the difference between the ideal paradigm and its historical realization fades away. This did not seem to happen in the case of Zeno.

IV

In the case of Epicurus, what emerges is a very different picture of the philosopher's relation to the goal he proposes and to the philosophical life.

It is hardly necessary to describe Epicurus' school or his ideal of retired life. All this has been studied and is well known.[62] I would rather draw attention to the following facts. First, the lack of a biography by Antigonus of Carystus.[63] As for a biography written by members of the Epicurean school, Wilamowitz explained this by saying it was "as little necessary to them as a Goethe biography would be today";[64] thanks to Epicurus' letters, the school had a lot of material on the teacher and did not need a special collection of it.[65] "But the outsiders had execrated the person distasteful to them along with his doctrine."

I do not believe that a disagreement over theory is the main reason why Antigonus did not write a *Life* of Epicurus. Rather, we should look

δαι: "men looking for virtue." In the *Pyrrhus*, a late play by Philemon (ca. 287, ap. Stobaeus 4, 22 Meineke), somebody opposes his personal finding of what is good—that is, peace—to the ἀγαθόν on which the philosophers spend their time in vain: ἀρετὴν καὶ φρόνησίν φασι, καὶ πλήκουσι πάντα μᾶλλον ἢ τί ἀγαθόν.

61. This has been remarked, for Diogenes, by H. Niehues-Pröbsting, *Der Kynismus des Diogenes und der Begriff des Zynismus* (Munich, 1979), 82–83.

62. See now D. Clay, "Individual and Community in the First Generation of the Epicurean School," in ΣΥΖΗΤΗΣΙΣ: *Studi sull'Epicureismo greco e romano offerti a Marcello Gigante* (Naples, 1983) 1:255–279.

63. On Usener's attempt to read Antigonus instead of Ariston in DL 10.14, see G. Arrighetti, *Epicuro: Opere*, 2d ed. (Turin, 1973), 488.

64. Wilamowitz, *Antigonus*, 128 n. 1.

65. Diogenes Laertius quotes Apollodorus' *Life of Epicurus* and many other late sources, favorable or hostile; they show that after Epicurus' death the debate on his personality became increasingly sharp.

to the deliberate silence of Epicurus himself and of the school members, manifested in their living apart from people in a strict sense. This was a choice very different from other philosophers' ways of teaching and living, especially that of the Stoics, which can perhaps be compared to the Academic tradition.[66] No living image of Epicurus as a person was presented day by day to the Athenians' eyes, and what came out of the school was just one word, "pleasure" (ἡδονή): something apparently very easy for everybody to understand and attack, and very different from the remote "good" of the Stoics.

There is a kind of inverted symmetry between Stoics and Epicureans on the philosopher and the ethical goal: the Stoic was living in public and proposing a far-off ideal; the Epicurean was living in seclusion and proposed an attainable ideal, not only in a trivial sense, but, as we shall see, in a sense central to the philosophy itself.

To return for a moment to Antigonus—perhaps he did not write Epicurus' *Life* simply because the philosopher lacked a public image, a lack increased by a high feeling of protection toward the master which restrained his pupils from talking about him outside the school. The exceptions to this, collected by Diogenes Laertius at the beginning of his biography, show that the only possibility of getting news about Epicurus' behavior depended on somebody's leaving the school and slandering him.

Moreover, it is noteworthy that we have no comic passage concerning Epicurus' deportment, his way of dressing, hairstyle, and beard.[67] This proves he did nothing deliberately to make a vivid impression, and indirectly it shows that comedy deserves credit and attention as a source: it is likely that comic poets did not create a personage out of Epicurus because there was no living model under their eyes.[68] Instead, we may note that, in spite of its superficiality, the comic evidence of Epicurean ethical philosophy reflects at least in part its genuine character, as confirmed by Epicurean texts themselves. In the comic fragment already quoted a clear antithesis is drawn between Epicurus, who knows the nature of "good," and the Stoics, who look for it "in their strolls" (ἐν τοῖς περιπάτοις).[69] There is a rather striking parallel in a fragment by Epicurus (F 423 Usener):

66. Cf. the theme of the philosopher ἐκτοπίζων in Diogenes Laertius' lives of the Academics, which takes the place of Socrates' ἀτοπία.

67. Cf. A. Weiher, "Philosophen und Philosophenspott in der attischen Komödie" (Diss. Munich, 1913), 74–75; it is likely that the biographers would have quoted the evidence if there was any.

68. See, for instance, the hedonic Epicurean described by Alciphron.

69. Damoxenus loc. cit.: οἶδε τἀγαθὸν μόνος ἐκεῖνος, οἱ δ' ἐν τῇ στοᾷ ζητοῦσι συνεχῶς,

τὸ γὰρ ποιοῦν ἀνυπέρβλητον γῆθος τὸ παρ' αὐτὸ πεφυγμένον μέγα κακόν·
καὶ αὕτη φύσις ἀγαθοῦ, ἄν τις ὀρθῶς ἐπιβάλῃ, ἔπειτα σταθῇ καὶ μὴ κενῶς
περιπατῇ περὶ ἀγαθοῦ θρυλῶν.

The highest joy is to escape a big evil; this is the nature of "good," if one
understands it rightly, and then stops, not walking about chattering emp-
tily about the "good."

These words show clearly that the good can be grasped by the mind
and that the man who has done so will really possess it. Unlike Zeno,
Epicurus can state in simple words the "nature of the good." This is a
leitmotiv not only of Epicurean ethics, but also of Epicurus' image. Even
if, as previously stated, we have for Epicurus nothing similar to Antigo-
nus' biographies, a passage like the famous last letter to Idomeneus is in
itself very significant (DL 10.22):

On this blissful day, which is also the last of my life (τὴν μακαρίαν ἄγοντες
καὶ ἅμα τελευταίαν ἡμέραν τοῦ βίου), I write this to you. My continual
sufferings from strangury and dysentery are so great that nothing could
augment them; but over against them all I set gladness of mind (τὸ κατὰ
ψυχὴν χαῖρον) at the remembrance of our past conversations.

Epicurus deliberately speaks of himself as of somebody "living hap-
pily," and the remark is of course reinforced by the mention of such
terrible physical pain.[70] In the surviving Epicurean texts the terms μα-
κάριος and μακαριότης are typically used to indicate the state of happi-
ness, instead of the much more common εὐδαίμων, εὐδαιμονία. Of
course, the latter are not missing, but they occur with remarkably less
frequency.[71] From *Ep. Men.* 127 we would infer, at first sight, that Epi-
curus made a technical distinction between εὐδαιμονία and μακαριότης:

We must also reflect that of desires some are natural, others are ground-
less; and that of the natural some are necessary as well as natural, and
some natural only. And of the necessary desires some are necessary if we
are to be happy (πρὸς εὐδαιμονίαν), some if the body is to be rid of un-
easiness (πρὸς τὴν τοῦ σώματος ἀοχλησίαν), some if we are even to live.

Here εὐδαιμονία seems to refer to mental tranquillity, which, when
added to bodily freedom from pain, has as its result μακαρίως ζῆν. From
this point of view, μακαριότης is viewed as higher than εὐδαιμονία, as

οἷόν ἐστ' οὐκ εἰδότες. Baton loc. cit.: ὁ γοῦν Ἐπίκουρός φησιν εἶναι τἀγαθὸν τὴν ἡδονὴν
δήπουθεν κτλ.

70. A passage like this may be the source of DL 10.118: κἂν στρεβλωθῇ δ' ὁ σοφός,
εἶναι αὐτὸν εὐδαίμονα.

71. Cf. H. Usener, *Glossarium Epicureum*, ed. M. Gigante and W. Schmid (Rome,
1977), s.v.

unifying the soul and the body's state.[72] It is true that in general μακά-ριος and εὐδαίμων are synonyms, and Epicurus uses them so (for instance at the beginning of the *Letter to Menoeceus*). Still, a difference may be detected if we look at μάκαρ, the standard word for divine happiness since Homer.[73] Epicurus' preference for words of the same root may reveal, even in the language itself, the connection between divine and human happiness, which he emphasizes in so many passages of his ethics.

Ep. Men. 135 (end):

Practice these things and all that belongs to them, in relation to yourself by day, and by night in relation to your likeness, and you will never be disquieted, awake or in your dreams, but will live like a god among men. For quite unlike a mortal animal is a man who lives among immortal goods. (ζήσεις δὲ ὡς θεὸς ἐν ἀνθρώποις. οὐθὲν γὰρ ἔοικε θνητῷ ζῴῳ ζῶν ἄνθρωπος ἐν ἀθανάτοις ἀγαθοῖς).

The only divine quality man cannot have is indestructibility.[74] In the *Letter to Herodotus* (76–77, 78, 81; cf. *Ep. Men.* 123) μακαριότης μετ' ἀφθαρσίας is the property of the gods, while the former without the latter is regularly used for man (*Ep. Hdt.* 78, 79, 80). Nonetheless (F 141 Usener) Epicurus writes to Colotes, who had paid his teacher a sign of honor typically reserved for the gods:

You made us worship and honor you in our turn; go and be immortal and think of us as immortal. (ἐποίες οὖν καὶ ἡμᾶς ἀνθιεροῦν σὲ αὐτὸν καὶ ἀντισέβεσθαι. ἄφθαρτός μοι περιπάτει καὶ ἡμᾶς ἀφθάρτους διανοοῦ.)

The well-known similarity between the divine and the human condition is felt so strongly that even the epithet typically reserved for gods can be applied to the Epicurean. From this arose the famous comparison of Epicurus to a god, familiar from Lucretius.[75]

72. A similar distinction appears in Aristotle *EN* 1.1101a14–16: εἰ δ' οὕτως, ἄθλιος μὲν οὐδέποτε γένοιτ' ἂν ὁ εὐδαίμων, οὐ μὴν μακάριός γε, ἂν Πριαμικαῖς τύχαις περιπέσῃ. Epicurus' last letter to Idomeneus shows that one may be μακάριος even if suffering terrible pain.

73. Cf. C. De Heer, ΜΑΚΑΡ—ΕΥΔΑΙΜΩΝ—ΟΛΒΙΟΣ—ΕΥΤΥΧΗΣ: *A Study of the Semantic Field Denoting Happiness in Ancient Greek to the End of the Fifth Century BC* (Amsterdam, 1969).

74. *VS* 31: "In dealing with death all of us humans inhabit a town without walls."

75. 5.8 ff.; cf. Cicero *Tusc.* 1.48 and *Fin.* 5.3 for his images on rings and household objects. A recent study by B. Frischer, *The Sculpted Word: Epicureanism and Philosophical Recruitment in Ancient Greece* (Berkeley and Los Angeles, 1982) is devoted to the iconography of Epicurus. The main thesis of the book, that Epicurus' original statue at Athens was intended to recruit pupils, seems to me rather unconvincing, though Frischer's analysis of the typology of Epicurean sculptures is interesting in itself.

Pyrrho, another philosopher of the early Hellenistic age, is similarly praised by his follower Timon (T 61 Decleva Caizzi = F 67 Diels), but I would like to point out an important difference between the image of Epicurus and that of Pyrrho. Here are Timon's verses:

> τοῦτό μοι, ὦ Πύρρων, ἱμείρεται ἦτορ ἀκοῦσαι,
> πῶς ποτ' ἀνὴρ διάγεις ῥῆστα μεθ' ἡσυχίης
> αἰεὶ ἀφροντίστως καὶ ἀκινήτως κατὰ ταὐτά,
> μὴ προσέχων δίνοις ἡδυλόγου σοφίης
> μοῦνος δ' ἀνθρώποισι θεοῦ τρόπον ἡγεμονεύεις,
> ὃς περὶ πᾶσαν ἐλῶν γαῖαν ἀναστρέφεται,
> δεικνὺς εὐτόρνου σφαίρης πυρικαύτορα κύκλον.

This, Pyrrho, my heart yearns to know, how on earth you, though a man, live easily in peace, never taking thought, and consistently undisturbed, heedless of the whirling motions and sweet voice of wisdom? You alone lead the way for mankind, like the god who drives around the whole earth as he revolves, showing the blazing disk of his well-rounded sphere.[76]

Timon's picture of Pyrrho emphasizes the philosopher's unique achievement and contrasts it with the miserable crowd of "mortals." Timon's verses on Pyrrho, and Antigonus' anecdotes about his way of life, tally well.[77] Pyrrho himself is said to have described his ethical goal as "difficult" (χαλεπόν, T 15 Decleva Caizzi). In contrast with Epicurus, Pyrrho left no disciples whose lives resembled his at any deep level. The philosophers who revived his name much later made no attempt, so far as we can tell, to imitate Pyrrho's lifestyle.

Although the Epicureans venerated the founder of their philosophy, they did not conceive of the Epicurean life as one that was outside their own reach. On the contrary, once one has discovered, thanks to Epicurus, that pleasure is the beginning and end of the happy life (*Ep. Men.* 127: τοῦ μακαρίως ζῆν), the end is taken to be *easy to attain*. Epicurean texts are strikingly full of *eu*- compounds: pleasure and good are *easy* to get, evil and pain are *easy* to avoid.[78] Nothing similar is offered by Zeno's biography or fragments, and this is surely not accidental.

76. Trans. Long and Sedley. For some points in Pyrrho's ethical attitude which may have attracted Epicurus, see my commentary to T 28–31 (*Pirrone: Testimonianze*, 182 ff.) and my article, "Pirroniani e accademici nel III secolo a.C.," in *Aspects de la philosophie hellénistique*, ed. H. Flashar and O. Gigon, Fondation Hardt, Entretiens 32 (Vandoeuvres and Geneva, 1986), 147 ff.

77. See my commentary, passim.

78. *Ep. Men.* 131: τὸ τῶν ἀγαθῶν πέρας . . . εὐσυμπλήρωτόν τε καὶ εὐπόριστον; *Tetrapharmakos* 196, p. 548 Arrighetti: τἀγαθὸν μὲν εὔκτητον, τὸ δὲ δεινὸν εὐεκκα[ρ]τέρητον; *KD* 21: εὐπόριστόν ἐστι τὸ ⟨τὸ⟩ ἀλγοῦν κατ' ἔνδειαν ἐξαιροῦν καὶ τὸ τὸν ὅλον βίον παντελῆ καθιστᾶν; F 469 Usener: χάρις τῇ μακαρίᾳ φύσει, ὅτι τὰ ἀναγκαῖα ἐποίησεν εὐπόριστα,

Epicurus speaks of becoming godlike, but this is very different from what Plato intended by "likeness to god." In the Platonic tradition the goal is something one approaches but never attains in ordinary life, just as one cannot attain perfect knowledge and truth in an embodied state; the dichotomy between intelligible and sensible, divine and human, is influential at every level. In Epicurus, divine does not signify a different order of reality from human. Long and Sedley have argued that the gods, according to Epicurean theory, are paradigms of everybody's ethical goal, idealized models of what man wants to achieve, "paragons of the Epicurean good life."[79] If it is correct to maintain—as they convincingly do—that in the original theory the gods are thought-contents, with no independent reality outside human minds, we can understand the meaning of Epicurus' ethical goal even better.

A remark about Epicurus' emphasis on "self-sufficiency" will serve as an appropriate conclusion.[80] Self-sufficiency can have two meanings: to need nothing because one is content with what one has, and to need nothing because one has everything. Epicurean texts use it in the first sense, while Stoic ones use it mainly in the second. In fact, contrary to what one could expect, *autarkeia* is not a pervading theme of early Stoic texts, and as far as I know it is attributed to Zeno only in an epigram by Zenodotus, a pupil of Diogenes of Babylon (cf. DL 7.30).[81] Apart from the well-known doxographical formula about the self-sufficiency of virtue, only one early occurrence of the term, as cited in the index to von Arnim's collection, is significant, SVF 2.604, from Chrysippus' *On Providence* (Περὶ προνοίας): "Only the cosmos is said to be self-sufficient, since it alone has in itself everything it needs" (αὐτάρκης δ' εἶναι λέγεται μόνος ὁ κόσμος, διὰ τὸ μόνος ἐν αὐτῷ πάντα ἔχειν ὧν δεῖται). This statement agrees with the traditional meaning of *autarkeia* as a divine qual-

τὰ δὲ δυσπόριστα οὐκ ἀναγκαῖα; KD 15: ὁ τῆς φύσεως πλοῦτος καὶ ὥρισται καὶ εὐπόριστός ἐστιν.

79. Long and Sedley, *Hellenistic Philosophers* 1:144 ff.

80. See Arrighetti's "Indice delle parole principali," in *Epicuro: Opere*, and Usener's *Glossarium Epicureum* s.vv. αὐτάρκεια and αὐτάρκης.

81. Cf. line 1: "You made self-sufficiency your rule, rejecting vainglorious wealth" (ἐκτίσας αὐτάρκειαν, ἀφεὶς κενεαυχέα πλοῦτον). As far as I know, this is the only testimony, imprecise though it is, for the first sense of αὐτάρκεια in early Stoic texts. In fact, self-sufficiency is usually related to "lack of need" (cf. Sextus *M.* 1.271, quoting Euripides. F 892 N²), and only indirectly to the idea of "rejecting" something, which is rather the sphere of "self-control" or "restraint" (ἐγκράτεια). For a typical instance of the latter as a Stoic virtue, cf. Sextus *M.* 9.153 = SVF 3.274: "For a man, they say, is continent (ἐγκρατεύεται) not when he abstains from an old woman with one foot in the grave, but when he has the power of enjoying Laïs or Phryne or such a charmer and he abstains." Cf. Epicurus *Ep. Men.* 130 on αὐτάρκεια (quoted above) for a very different attitude.

ity.[82] So, according to the Stoics, it belongs strictly only to the cosmos (and, we may easily infer, to the ideal sage who possesses virtue, not to the man who is not yet virtuous). According to Epicurus, on the other hand, self-sufficiency is a condition every individual can and should achieve in his lifetime, in order to adapt his needs to what he has and be happy, just as every man can make himself godlike (*Letter to Mother,* ap. Diog. Oen. F 62 Grilli = 53 W.):

> [οὐ] γὰρ μει-
> κρὰ οὐδέ[ν τ᾽ ἰσχ]ύοντα
> περιγείνεται ἡ[μ]ε[ῖ]ν
> τάδ᾽ οἷα τὴν διάθεσιν
> ἡμῶν ἰσόθεον ποιεῖ
> καὶ οὐδὲ διὰ τὴν θνη-
> τότητα τῆς ἀφθάρτου
> καὶ μακαρίας φύσεως
> λειπομένους ἡμᾶς
> δείκνυσιν.

Neither small, nor of no importance are the things which now happen to us, such as to make our soul's disposition equal to the divine one, and to show that, not even because of mortality are we inferior to the immortal and blessed nature.

82. Cf. the texts quoted by A.-J. Festugière, *Epicure et ses dieux* (Paris, 1946), 96 and n. 3. See also Xenophon *Mem.* 1.6, 10: ἐγὼ δὲ νομίζω τὸ μὲν μηδενὸς δεῖσθαι θεῖον εἶναι, τὸ δ᾽ ὡς ἐλαχίστων ἐγγυτάτω τοῦ θείου.

Panaetius on the Virtue
of Being Yourself

Christopher Gill

(a) *The man who wants contentment* [*or "peace of mind"*] *should not undertake many activities, on his own or in company with others, nor should he choose activities beyond his own capacity and nature* [ὑπέρ τε δύναμιν . . . τὴν ἐωυτοῦ καὶ φύσιν].

<div align="right">

DEMOCRITUS F 3 DK[1]

</div>

(b) *So not every activity suits everyone; but you should follow the Pythian inscription, "know yourself," and apply yourself to the one activity for which you are naturally suited* [χρῆσθαι πρὸς ἓν ὃ πέφυκε] *and not force yourself to aspire to one kind of life after another, doing violence to your nature* [παραβιάζεσθαι τὴν φύσιν].

<div align="right">

PLUTARCH PERI EUTHUMIAS 472C

</div>

(c) *So even Epicurus thinks that those who are fond of honor and reputation should not remain in private life but should follow their natural inclinations* [τῇ φύσει χρῆσθαι] *by entering public life and engaging in politics. Because of their nature* [πεφυκότας], *they are more likely to be agitated and distressed by staying in private life and not getting what they want.*

<div align="right">

PLUT. PE 465F–466A

</div>

(d) *Each person should hold firmly on to his own qualities* [tenenda sunt sua cuique], *provided they are individual without being immoral* [non vitiosa, sed tamen propria], *so that the propriety* [decorum] *that we are looking for may be maintained. We must act in a way that does not conflict with our common human nature but which (with this proviso) allows us to follow our own individual nature. So we should use our own nature as the yardstick* [regula] *for our choice of projects* [studia], *even if other projects are weightier and better.*

<div align="right">

CICERO DE OFFICIIS 1.110

</div>

(e) *Most of all, the mind* [animus] *must be recalled from all external things into itself* [se ipsum]. *Let it trust itself, rejoice in itself, value its own concerns, retire as far as possible from what is not its own* [alienis] *and involve itself with itself* [se sibi adplicet], *not feel losses, and regard even adversities in a positive spirit.*

<div align="right">

SENECA DE TRANQUILLITATE ANIMI 14.2

</div>

1. H. Diels, *Die Fragmente der Vorsokratiker*, 10th ed., rev. W. Kranz (Berlin, 1952), hereafter cited as DK. All translations from Greek and Latin in this essay are mine.

(f) *So unperceptive and graceless forgetfulness comes over the masses and takes possession of them* . . . *and does not allow life to become one* [οὐκ ἐᾷ τὸν βίον ἕνα γενέσθαι] *by weaving together the past and the present; but separating the person of yesterday from the one of today, and the one of tomorrow from the one of today, as though each person were different, it makes all events nonexistent, because they are not remembered.*

<div align="right">PLUT. PE 473C–D</div>

(g) *[Nothing] affords one's life so much calm as a mind* [ψυχή] *that is pure of evil acts and intentions and that has, as the source of its life, a character* [ἦθος] *which is undisturbed and unstained, from which flow fine deeds in which one can take pride, and memory which is sweeter and more reliable than hope.*

<div align="right">PLUT. PE 477A–B</div>

In this essay, I have two aims in view. One is to offer an account of the philosophical theories which provide the informing framework for the preceding quotations, all of which, I shall suggest, constitute versions of the advice to "be yourself."[2] The other is to reconstruct the main lines of Panaetius' lost work *On Peace of Mind* (*Peri euthumias*). These two objectives are related, in that the theme of "being yourself" is one to which Panaetius seems to have given special emphasis, both in his work *On Proper Function* (*Peri tou kathekontos*) as well as in *On Peace of Mind*. Although Panaetius was a Stoic, and a head of the school, he was unusually open to other philosophical approaches.[3] I want to suggest that his treatment of the theme of "being yourself" in *On Peace of Mind*, in particular, constitutes an interesting and original synthesis of Stoic and Democritean-Epicurean approaches. Hence, studying Panaetius' thinking on this subject gives us access to a whole strand of thinking in Hellenistic ethics, and one in which the interplay between different schools is as important as their independent theoretical positions.

How does this essay relate to our larger concerns in this volume? For one thing, I hope that my discussion will complement Fernanda Decleva Caizzi's vivid contrast between Zeno and Epicurus, as regards their ethical stances and styles of self-presentation. In studying Panaetius' thinking on this subject, I shall try to explore some points of contact between

2. The evident difference between the senses in which these passages convey the meaning "be yourself" (i.e., "observe your own nature," passages *a–d;* and "be your *essential* self" and "unify yourself," passages *e–g*) is one of the main points I shall discuss.

3. Panaetius (ca. 185–ca. 109 BC) was head of the Stoic school ca. 129–109. For Panaetius as φιλαριστοτέλης καὶ φιλοπλάτων, see M. van Straaten, *Panaetii Rhodii Fragmenta*, 3d ed. (Leiden, 1962), F 57; cf., more generally, J. M. Rist, *Stoic Philosophy* (Cambridge, 1969), chap. 10.

these divergent positions, and thus to trace, in this respect, the origins of the philosophical eclecticism which is so marked a tendency in the later Hellenistic and Roman periods.[4]

At the same time, my theme bears directly on the overall subject of this volume and of the conference on which it is based, self-definition in the Hellenistic world. So far in the volume, the question has not, I think, been raised whether the notion we have been deploying, that of self-definition, has any equivalent in the conceptual framework of Hellenistic Greece. To say this is not to criticize the procedure we have been following. The notion of self-definition typically belongs to a "second-order" vocabulary (that of social psychology or social anthropology, say), in terms of which we offer explanations for actions originally conceived in other terms. Hence, it is entirely natural that we should analyze as modes of "self-definition" social practices (such as those of commemorating one's vows to the gods, or to one's dead relatives) whose "ideology," or overt function, is explicated in the culture—if at all—in quite different terms.[5] However, it is also worth asking whether Hellenistic culture deploys any such notion as self-definition; and it is, in part, an interest in this question that has directed me toward an aspect of Hellenistic intellectual discourse that is markedly reflexive or self-related in character.

There is a further aspect of Hellenistic culture that makes this topic one of special interest. Although the social practices of any culture can, in principle, be studied as a means of self-definition, it seems more appropriate to do so when it matters to the society concerned that it is a *self* which is being defined. When the culture concerned is sufficiently individualistic or self-conscious in its ethics to make it a matter of explicit concern how an individual defines himself or herself, the subject of *self-definition* takes on a special relevance.[6] It is commonly claimed that Hel-

4. On this tendency, see J. M. Dillon and A. A. Long, eds., *The Question of "Eclecticism": Studies in Later Greek Philosophy,* Hellenistic Culture and Society 2 (Berkeley, 1988). At the Berkeley conference, Paul Zanker suggested to me that we can find in Hellenistic art a parallel to the kind of transition I describe in this essay (from the bold, uncompromising doctrines of the early Hellenistic philosophers to the more nuanced and less doctrinal thinking of thinkers like Panaetius). The parallel lies in the transition from the innovative, "baroque" styles of third-century art to the more subtly modulated, "rococo" style of the second century, a style which (like that of Panaetius) is more readily acceptable to conventional taste and attitudes. (I hope I have reported his suggestion correctly.)

5. I allude to the essays of Paul Zanker and Folkert van Straten, above. Interestingly enough, both the implied "vocabulary" of second-century grave reliefs discussed by Zanker, above, and the ideological justifications of kingly benefaction discussed by Klaus Bringmann, above, are sometimes couched in the language of social roles and virtues which Panaetius deploys in propounding his model of "self-definition," as presented in Cicero *De officiis* 1.

6. See further, on the issue of the relationship between the conceptual framework of

lenistic culture had such an ethos, one promoted especially by the re-
drawing of the politico-cultural map by Alexander and his successors
and the consequential confrontations between Greek and non-Greek
cultures; and several of the essays in the volume have brought out the
way in which the project of "defining oneself" became a matter of some
urgency for Hellenistic monarchs, for philosophers, and for Greek so-
ciety as a whole.[7] The theme of the importance of "being yourself"
in Hellenistic ethics seems to provide a means of exploring how *self-
consciousness* was understood, at least in one area of the culture's dis-
course; and also of seeing how far, and in what sense, the stance adopted
is an "individualistic" one.[8] Also, the study of the reflexive mode in Hel-
lenistic philosophical vocabulary seems to offer a special point of access
to the understanding of the conception of the self in that age;[9] and this
seems relevant, in a different way, to our theme of self-definition, as well
as to my own current research interests.[10]

I

As I have said, I think that Panaetius' thinking on the importance of
"being yourself" in *On Peace of Mind* constitutes an original synthesis of

those investigating and those being investigated, especially in connection with the notion
of self, M. Carrithers, S. Collins, and S. Lukes, eds., *The Category of the Person: Anthropology,
Philosophy, History* (Cambridge, 1985), esp. Lukes, "Conclusion," 282–301. This issue is
raised in connection with the ancient world by W. Burkert, and A. J. Malherbe, "Craft
versus Sect," in *Self-definition in the Graeco-Roman World*, ed. B. F. Meyer and E. P. Sanders
(Philadelphia, 1983), 1–3, 46.

 7. See esp. the essays of Ludwig Koenen, R. R. R. Smith, and Fernanda Decleva Caizzi,
above.

 8. In the modern period, the call to "be yourself" has often been associated with mark-
edly individualistic stances (cf. the discussion of Nietzsche in V below), and it is of interest
to see if a study of this theme bears out the common claim that Hellenistic philosophy is
characteristically individualistic. See, most recently, M. Hossenfelder, "Epicurus—Hedonist
Malgré Lui," in *The Norms of Nature: Studies in Hellenistic Ethics*, ed. M. Schofield and G.
Striker (Cambridge, 1986), 245–263, esp. 246–249. One of the problems in testing this
claim lies in determining what "individualism" means; on the complex strands in the mod-
ern understanding of "individualism," see S. Lukes, *Individualism* (Oxford, 1973), and
T. C. Heller, M. Sosna, and D. E. Wellbery, eds., *Reconstructing Individualism: Autonomy,
Individuality, and the Self in Western Thought* (Stanford, 1986). See further below.

 9. As S. Toulmin underlines, one cannot simply equate the use of reflexive vocabulary
with consciousness of "the self" as a distinct entity; see Toulmin, "Self-knowledge and
Knowledge of the Self," in *The Self: Psychological and Philosophical Issues*, ed. T. Mischel
(Oxford, 1977), 291–317. However, in the context of ethical theories in which there are
already indications of a concern with "the self" as a psychological entity, reflexive language
can help to indicate the kind of self presupposed and the stance adopted toward that self.

 10. I pursue these questions in *The Self in Dialogue: Personality in Greek Epic, Tragedy,
and Philosophy* (Oxford, forthcoming).

Democritean-Epicurean and Stoic approaches; and I want to begin by outlining the two lines of approach which he synthesizes. I will then examine these two strands in more detail, drawing, for the Stoic side of the synthesis, on Panaetius' own thinking in *On Proper Function* (as represented in Cicero's *De officiis*).[11] In my reconstruction of *On Peace of Mind*, I shall draw, like other scholars, on points of similarity between Cicero's *De officiis* and two later works on peace of mind, by Seneca and Plutarch, which are apparently based on that of Panaetius.[12] But my main concern will be to bring out the synthesis of Democritean-Epicurean and Stoic lines of thought, and to show how this synthesis results in the theme of "being yourself" acquiring a new depth and complexity of meaning.

I shall begin by outlining the principal differences between the Democritean-Epicurean and Stoic approaches to the subject of peace of mind.[13] The essential difference, from which all the other differences flow, lies in their thinking about the final goal or end of life (*telos*), a difference which has been seen since antiquity as the central point of ethical difference between the Epicureans and Stoics. For Democritus and Epicurus, peace of mind, understood as *euthumia* or *ataraxia*, was regarded as man's proper goal (or part of it), a goal to be pursued deliberately, albeit one which was compatible with the practice of virtue in certain forms. For the Stoics, on the other hand, virtue was the only proper goal for deliberate pursuit, the only real "good"; absence of emotional disturbance, in its strongest form *apatheia*, was seen rather as a byproduct of this pursuit, insofar as it was characteristic of the state of mind of the completely virtuous or "wise" man.[14]

11. On Cicero's work as a reliable source for Panaetius *Peri tou kathekontos*, see, e.g., L. Labowsky, *Der Begriff des* πρέπον *in der Ethik des Panaitios* (Leipzig, 1934), and M. Pohlenz, *Antikes Führertum: Cicero, De Officiis, und Das Lebensideal des Panaitios*, Neue Wege zur Antike, 2d series, vol. 3 (Leipzig and Berlin, 1934).

12. Cf. G. Siefert, *Plutarchs Schrift* περὶ εὐθυμίας, Beilage zum Jahresbericht der königlichen Landesschule Pforta (Naumburg, 1908); A. Grilli, *Il problema della vita contemplativa nel mondo greco-romano* (Milan and Rome, 1953), 137–161; H. Broecker, *Animadversiones ad Plutarchi libellum* περὶ εὐθυμίας, Habelts Dissertationsdrucke, Reihe klassische Philologie 2 (Bonn, 1954), esp. 201–214; and J. Dumortier and J. Defradas, eds., *Plutarque, Oeuvres morales* 7.1 (Paris, 1975), 90–93.

13. In this outline I will (*a*) lump together Democritus and Epicurus on the one hand and the early Stoics and Panaetius on the other and (*b*) ignore common ground between the two approaches. Subsequently, I will (*a*) unpick the components of these two strands and (*b*) explore the degree of common ground between them.

14. See A. A. Long and D. N. Sedley, *The Hellenistic Philosophers*, 2 vols. (Cambridge, 1987) 21B, esp. 4, 6; 21O, P; 58A; 61A; 63 passim, esp. A, F, L, M. Cf. ibid. 1:398–399, where the authors emphasize that the Stoics, like most other philosophical schools, accepted that the "end" of life was happiness (*eudaimonia*) but argued that this goal was constituted by virtue. It is worth pointing out that this new collection of texts, translations,

From this central difference, related differences flowed. In the Stoic approach, the choice of one's role in life was seen as the selection of a context in which one could give expression to the desire to act "well," that is, virtuously; hence, they stressed the importance of choosing a role that one's talents and inclinations allowed one to practice well, and to carry through to the end (or to one's own end). In the Democritean-Epicurean version, on the other hand, the choice of role was viewed primarily in terms of whether or not it was likely to produce euthumia or ataraxia. In this version too, one was urged to maintain one's natural talents and inclinations; but this was presented as a means of obtaining peace of mind rather than of finding the most appropriate role for virtuous action.

A comparable difference exists in their attitude to meeting life's unchosen contingencies (as distinct from choosing a role for one's life). Both sides emphasize the importance of a rational critique of desires in enabling one to counter contingencies, and both emphasize the possibility of achieving in this way a kind of "self-sufficiency" (*autarkeia*). For Democritus and Epicurus, the means of achieving this lies in discouraging desires for objects which one might not in practice obtain (or which do not in fact yield pleasure), and discouraging emotions (such as fear of death) which are inherently distressing or which may have distressing consequences. The Stoics too practiced a kind of "preparation for future evils" (*praemeditatio futurorum malorum*). But the essential feature of this lay in the insistence on the radical distinction between what is and is not "up to us," and on the fact that only the former category of things (that is, virtuous or non-virtuous actions) constitutes what is genuinely good or bad; external contingencies are "matters of indifference."[15] Similar differences are evident in the way in which each side approaches the theme of shaping one's life and giving it unity. The Stoics saw consistency and stability as being, like *apatheia*, natural by-products of the wise man's state of mind and his adoption of virtue as an absolute priority. Insofar as this attitude interpenetrated a person's whole life, that life would acquire the "good flow" (*eurhoia*) that Zeno identified with happiness.[16]

and commentaries is an invaluable aid to future research (note, e.g., the bibliography at 2:476–512), and that it makes the charting of the terrain of Hellenistic philosophy a real possibility.

15. For *autarkeia* in Democritus, see F 176, 210 DK; cf. 119, 146, 191; in Epicurus, Long and Sedley, *Hellenistic Philosophers*, 21B (4) and Caizzi, above; in Stoicism, Diogenes Laertius 6.128, cited by Annas, below.

16. See esp. Long and Sedley, *Hellenistic Philosophers*, 61A (= Diog. Laert. 7.89): "virtue is a consistent character (*diathesis*), choiceworthy for its own sake and not from fear or hope or anything external. Happiness consists in virtue since virtue is a soul which has

Democritus and Epicurus seem also to have seen one's life as being unifiable, though rather by a self-conscious process of focusing one's projects and desires. They also advocated the management of memories and anticipation so as to maximize one's sense of well-being and to guarantee a pleasurable unity of consciousness.

II

Let us look at these two positions in more detail, beginning with that key fragment of Democritus which is often cited by later writers on euthumia:

> The man who wants contentment [or "peace of mind": εὐθυμεῖσθαι] should not undertake many activities, on his own or in company with others, nor should he choose activities beyond his own capacity and nature [ὑπέρ τε δύναμιν . . . τὴν ἑωυτοῦ καὶ φύσιν]. But he should be on his guard, so that, when good fortune strikes and leads him delusively [τῷ δοκεῖν] toward excess, he rejects this and does not attempt more than he can [τῶν δυνατῶν]. A reasonable load is safer than a great mass.[17]

From this fragment, taken in conjunction with others, several points emerge about Democritus' position. One is that euthumia is conceived as a goal (perhaps *the* goal) in life,[18] and that the appraisal of one's natural capacities and inclinations is seen as a means to achieving that goal. A second point, reiterated in what seem to be versions or glosses of Democritus' view, is that one should give focus to one's life, not choosing a plurality of objectives or roles (nor restlessly oscillating between them); and that the kind of life chosen should not be one which "forces" or "constrains" one's nature.[19]

These aspects of Democritus' thinking are those in which the theme of "being yourself" (in the sense of "adhering to your own nature") is

been fashioned to achieve consistency in the whole of life." Cf. also 63A on *eudaimonia* as a *eurhoia biou*.

17. F 3 DK; cf. Epicurus fragment given by Diogenes of Oenoanda (F 53 Grilli; F 40 Chilton), cited in DK, F 3 n. 1; Sen. *Tranq.* 13.1; Plut. *PE* 465c.

18. Cf. J. C. B. Gosling and C. C. W. Taylor, *The Greeks on Pleasure* (Oxford, 1982), 29–31; and M. Nill, *Morality and Self-interest in Protagoras, Antiphon, and Democritus* (Leiden, 1985), 76–77. The idea that Democritus' ethical thinking is centered on a single *telos* may be anachronistic; cf. C. Kahn, "Democritus and the Origins of Moral Philosophy," *AJPh* 106 (1985): 1–31, esp. 25–26; and M. R. Wright, review of Nill, *AncPhil* 8 (1988): 117–21. But he was certainly viewed in this light by some later ancient writers and was probably so viewed by Epicurus and Panaetius.

19. Cf. Epicurus fragment cited in n. 17, above, esp. βιάζεσθαι τὴν (δύναμιν) ἑαυτοῦ; Plut. *PE* 472c, esp. παραβιάζεσθαι τὴν φύσιν. See further Plut. *PE* chaps. 12–13 entire; Sen. *Tranq.* 2.9–12, 12.1; Broecker, *Animadversiones*, 46–47, 118–119.

most evident. But these aspects are related to a more general strategy of self-management. The core of this strategy lies in encouraging satisfaction with what "is present" (that is, present in one's own life and present at any one time), and discouraging the desire for what "is absent" (but present in someone else's life or potentially present in one's own future life). A related theme is that "fools" mismanage their sense of time, failing to appreciate the available satisfactions of the present and looking restlessly toward imaginary future advantages.[20] Another aspect of this strategy emerges in the claim that, just as "great joys come from contemplating fine deeds," so consciousness of having performed "just and lawful deeds" gives one freedom from care and euthumia, whereas someone who is aware of having done wrong "is afraid and torments himself."[21] One of the features of Democritus' fragments which has recently attracted attention is the commendation of virtuous acts (apparently) for their own sake, a feature which is not obviously compatible with the presentation of euthumia as an overall goal.[22] A line of explanation suggested by the fragments quoted is that it is the *consciousness* of having performed good acts which contributes to one's mental well-being (although it does not follow that the good acts are envisaged as having been performed *for the sake of* achieving such well-being).[23] If so, there are a number of respects in which Democritus' strategy for self-management was developed by Epicurus and, it would seem, by Panaetius in *On Peace of Mind*.[24]

Epicurus, like other thinkers, took note of Democritus' comments on the importance of not going "beyond [your] capacity and nature," if you are to achieve euthumia.[25] Indeed, he seems to have been sufficiently impressed by the importance of this point to make an exception, for those naturally inclined to political action, to his general discouragement of political involvement—on the grounds that, "because of their nature [πεφυκότας] [such men] are more likely to be agitated and distressed by staying in private life and not getting what they want."[26] However, the

20. See esp. F 191, 202 DK (also 58, 200–201, 203–206, 284–286); cf. Sen. *Tranq.* 9.1, 10.5; Plut. *PE* chaps. 8–9, 14–15; Siefert, *Plutarchs Schrift περὶ εὐθυμίας*, 19–24; and discussion below.

21. F 194, 174 DK; cf. 211, 215, and Plut. *PE* 466a (supposedly a quotation of Democritus; Broecker, *Animadversiones*, 61).

22. See, e.g., F 96, 107a, 264 DK; cf. Kahn, "Democritus," 27–28; Nill, *Morality and Self-Interest*, 85ff.

23. An analogous question arises with Epicurus; cf. below, esp. ref. in n. 30.

24. Cf. Siefert, *Plutarchs Schrift περὶ εὐθυμίας*, 32–33; refs. in nn. 20–21; Plut. *PE* 477a, c, f; and discussion below.

25. Cf. refs. in nn. 17 and 19, above.

26. Plut. *PE* 465f–466a (= Epicurus F 555 Usener). His position is the inverse of the

main respect in which Epicurus developed Democritus' thinking in this area lay in his great elaboration of the theme of self-management as regards desires, emotions, and attitude to time; and these developments are strongly reflected in subsequent writings on peace of mind.

Thus, for instance, Democritus' theme that "fools" mismanage their attitude to time, by living for an imagined future of illusory advantages, is clearly taken up by Epicurus and contrasted with the wise man's achievement of peace of mind through a proper attitude to past, present, and future.[27] The idea that one's life can be unified by consciousness of past, present, and future pleasures (an idea which seems to have been taken up by Panaetius) is implied, at least, in Epicurus' writings.[28] There are indications too that Epicurus pursued the related line of thought that mental well-being can be enhanced by pleasurable consciousness of one's own virtuous actions.[29] This raises again the issue whether Epicurus' conception of pleasure as the ultimate goal can allow for the idea that virtue is intrinsically good or good only as a means of maximizing pleasure. This is an issue that Epicurus may have confronted himself, though, if so, it is not easy to determine his final position.[30] But it seems likely at least that Epicurus saw pleasurable consciousness of one's own good acts (toward friends, for instance) as a significant part of the kind of memory that can make one's present awareness pleasurable and also give one confidence for the future; and in this respect too he probably provided the basis for subsequent elaboration of this means of self-unification.[31]

III

These Democritean and Epicurean theories represent one of the two principal strands on which Panaetius drew in formulating his ideas on

Stoic one, according to which only special circumstances (including exceptional natural talent) validate exemption from political involvement; cf. Cic. Off. 1.71–72, discussed below. For a significant clarification of Epicurus' position on political involvement, cf. Long and Sedley, *Hellenistic Philosophers* 1 : 136–137; and ref. in n. 73, below.

27. See, e.g., Cic. *De finibus* 1.57–63, *Tusculan Disputations* 5.95; cf. n. 20, above.

28. Cf. Broecker, *Animadversiones*, 138, 141; the related idea that one can, by understanding the nature and limits of the pleasures available in a lifetime, make one's own life "complete" (παντελής) is expressed in Long and Sedley, *Hellenistic Philosophers*, 24C; cf. 24D and commentary on 1 : 154.

29. See, e.g., Cic. *Fin.* 1.57–58; for the related point that criminals cannot escape from anxiety and distress, Long and Sedley, *Hellenistic Philosophers*, 22A (5), B (3), L (7).

30. Cf. J. Annas, "Epicurus on Pleasure and Happiness," *Philosophical Topics* 15 (1987): 5–21; Long and Sedley, *Hellenistic Philosophers* 1 : 137–138.

31. On Epicurus' (complex) position on friendship, see Long and Sedley, *Hellenistic Philosophers* 1 : 137–138; cf. Plut. *PE* 477a–c, f.

"being yourself" in *On Peace of Mind*. The other strand consists of Stoic thinking on comparable topics. As it happens, the two most relevant passages fall within Cicero's *De officiis* 1, which is based closely on Panaetius' *On Proper Function*.[32] The two passages are (1) the discussion of peace of mind (*tranquillitas animi*) in connection with greatness of spirit and (2) the discussion of the "fitting" (*decorum*) in connection with self-control, and especially the four-*personae* theory.[33] Both these discussions take up topics analogous to those we have considered in Democritus and Epicurus, namely the criteria for choosing one's role in life, the relevance of one's nature to this choice, and the best way of unifying one's life and character. And both discussions do so from a Stoic ethical standpoint, in which virtue is conceived as the overall goal of purposive life.

However, there are some important differences of approach, which go beyond the difference in their specific subject matter. Although both passages seem to be quite closely based on Panaetius' treatment in *On Proper Function*, the discussion of *decorum* is generally recognized as representing the most elaborate and innovative part of Panaetius' work.[34] It also reflects what seems to be a well-marked feature of his thought, namely a greater willingness than is normal in Stoicism to engage with the concerns of imperfect, if well-intentioned, people to accept that different people may validly pursue virtue in significantly different ways.[35] Associated with this difference is a rather different treatment, indeed a rather different valuation, of the importance of one's own nature, in the two passages. Also, the passage on *decorum* is couched in a more reflexive style, both in the sense that it invites the reader to reflect on the implications *for himself* of the advice given (implications which necessarily differ for different people), and in the sense that it lays great stress on the importance of maintaining *your own* nature in choosing your role. In doing so, this passage has a similar emphasis to some of the comments of Democritus and Epicurus already considered. And, although Panaetius' overall approach clearly remains a Stoic one, the passage on *decorum* shows some indications of interest in the alternative, Democritean-Epicurean, approach to "being oneself" and peace of mind, an interest which becomes much more marked in *On Peace of Mind*.

Let me begin with the discussion of courage (conceived as "greatness

32. For Cic. *Off.* 1 as evidence both for *On Proper Function* and *On Peace of Mind*, cf. refs. in nn. 11 and 12, above; as far as I know, we have no way of telling which of these two works of Panaetius was written first.

33. Cic. *Off.* 1.66–81, 92; 93ff., esp. 107–21.

34. Cf. Pohlenz, *Antikes Führertum*, 55ff.

35. Cf. Long and Sedley, *Hellenistic Philosophers*, 63G, 66C, D, E, and commentary, 1:66–67.

of spirit," *megalopsuchia* or *magnitudo animi*) and with the strategy out-
lined here for obtaining peace of mind. This discussion consistently re-
flects the orthodox Stoic view that virtue is the only proper goal for de-
liberate pursuit and that absence of emotional disturbance (*apatheia*) is a
by-product of this pursuit, insofar as it is characteristic of the character
(*diathesis*) of the wise man. It is from the recognition that only what is
"fine" (*honestum*) is "good" (*bonum*) that there derive the indifference to
externals (*rerum externarum despicientia*) and the freedom from distur-
bance of mind (*perturbatio animi*) that is characteristic of an *animus* that
is *fortis et magnus* (Cic. *Off.* 1.66–67). It is these same factors that bring
with them *tranquillitas animi et securitas,* and which enable one to sur-
mount the misfortunes of life without losing one's *dignitas* (sense of
worth) and *constantia* (Cic. *Off.* 1.67, 69).

The Stoic thesis that you attain peace of mind by pursuing virtue, not
peace of mind, is underlined by discussion of the ways in which most
people, ill-advisedly, *do* take peace of mind as their objective, typically
by seeking *otium* in the country as a means of escaping *negotia publica.*
Cicero criticizes those whose reasons for seeking *otium* are poor ones (for
instance, those who do so because they want to live "like kings," so as "to
live as you please," *sic vivere ut velis*);[36] and those whose alleged reason (a
contempt for glory) conceals a weakness of character that makes them
unwilling to confront the vicissitudes of public life (Cic. *Off.* 1.71). He
does note various factors which qualify as legitimate grounds for exemp-
tion from public involvement, including the possession of an exceptional
natural talent (*ingenium*) for philosophy.[37] But for those whose nature
allows this as a possibility, the public role is strongly recommended as
being a means by which, above all, mankind can be benefited and *mag-
nitudo animi* expressed (Cic. *Off.* 1.70–71). For those who make this
choice, and who achieve greatness of spirit in this role, *tranquillitas animi*
and *constantia* accrue, as a by-product of the tenacious maintenance of a
role to which they attach proper ethical weight.[38]

It is worth underlining the ethical strategy involved here, to sharpen
comparison with the passage on *decorum.* The key elements are: (1) the
ethical ideal (the *animus fortis et magnus*), (2) one's individual nature and
capacities, and (3) the project or life chosen (notably, the *bios praktikos* or

36. Cic. *Off.* 1.70; on the connotations of the latter phrase, cf. Pohlenz, *Antikes Führer-
tum,* 46.

37. Ill health is also allowed as grounds for exemption (71); in 92, further valid forms
of *vita otiosa* are noted as giving scope for *magnitudo animi,* although the public role is still
given priority; cf. A. Dyck, "On Panaetius's Conception of μεγαλοψυχία," *MH* 38 (1981):
153–161, esp. 158–159.

38. 72–73, cf. 80–81, 83.

theoretikos). The basic thesis is that the main determinant in one's choice should be (1), the ethical ideal. Attention is also paid to (2), one's individual nature, but rather as a limiting factor than as a central concern. It is the achievement of (1) that is presented as conferring consistency of life and peace of mind. When we turn to the passage on *decorum,* and especially to the four-*personae* theory, we find a strategy that is, on the face of it, simply a more elaborate version of this. The four *personae* (masks, roles, or statuses) are presented as normative reference points to guide our selection of what is "fitting" for us and so to enable us to achieve "self-control" (*sophrosune/temperantia*). The four *personae* consist of the three elements identified above, with one addition. The first *persona* is our common human nature as rational agents capable of self-direction and virtue (hence this *persona* constitutes the central ethical ideal), and the second is our specific nature as individuals. The third element of the earlier discussion is subdivided into two further *personae:* (3), the social position and status in which we find ourselves at any one time, and (4), the project or *bios* we choose for ourselves. The essence of the theory is that, as well as acting in a way that is "fitting" to each *persona,* we should harmonize these *personae* to each other if we are to achieve the kind of lifelong consistency (*aequabilitas . . . universae vitae*) which constitutes *decorum.* Above all, the two most important *personae,* our nature as (virtue-bearing) human beings and as individuals, must be harmonized to each other.[39]

In broad outline, the two passages express the same (Stoic) thesis that all other considerations (the choice of a role, one's attitude toward one's nature, the unification of a life) are subordinate to, and depend on, the pursuit of virtue. However, there are significant differences of emphasis, notably the much greater stress, in the *decorum* passage, on the importance of maintaining one's own natural characteristics and of treating one's own nature as a key normative reference point in one's choice of life and as a crucial factor in the achievement of a unified, self-consistent life.[40] Indeed, of all ancient texts, this is the one in which the theme of

39. See 93ff., esp. 98, 100, 107–121; cf. my "Personhood and Personality: The Four-*Personae* Theory in Cicero's *De Officiis* I," *OxfStAncPhilos* 6 (1988): 169–199. This discussion does not present *tranquillitas animi* as a concomitant of the achievement of virtue (as 1.66ff. does); rather, making oneself *tranquillus* and free from *perturbatio* is presented as part of the "self-control" involved in acting "appropriately" to our nature as human beings; see 101–102, 131, and 136.

40. See esp. *tenenda sunt sua cuique . . . propria . . . propriam nostrum naturam sequamur . . . studia nostra nostrae naturae regula metiamur* (cf. passage *d* at the start of this essay). *neque attinet naturae repugnare . . . nihil decet adversante et repugnante natura* (110), cf. further 111–112; *id enim maxime quemque decet, quod est cuiusque maxime suum* (113); *suum quisque igitur noscat ingenium . . .* (114); *ad suam cuiusque naturam consilium est omne revocandum* (119). Cf. 120.

the importance of "being yourself," in this sense, is most emphatically affirmed.

I have suggested in another context that, although the basic theory is a coherent one, there are certain problems and incoherences in the detailed working out of the theory, and that these seem to go back to Panaetius himself. These consist, in essence, in a failure to stress sufficiently the importance of maintaining consistency with all the four *personae* (especially the crucial one of our universal nature as rational moral agents) and, relatedly, a failure to confront the difficulties which such a project entails.[41] The emphasis, for instance, on maintaining one's individual nature, and on the importance of this for the achievement of lifelong consistency (*aequabilitas* and *constantia*), is not matched by an equal emphasis, in the same context, on the importance of maintaining our common human *persona*.[42] In my other discussion, I have been inclined to ascribe this to a certain conventionality of thinking on Panaetius' part. As a Rhodian aristocrat and a friend of Scipio Aemilianus, he assumed rather readily that there would be no fundamental difficulty in meeting the claims of virtue, one's social position, and one's nature (interpreted in the light of social expectations) at one and the same time and to an equal degree.[43] However, an alternative line of approach would be to suggest that, in adopting and developing Democritus' theme of the importance of following one's nature (if, indeed, it is from Democritus that he takes up the theme), he gives it an emphasis which is to the detriment of his own larger (Stoic) thesis.[44] I do not want to press this point unduly;

41. Thus, e.g., the importance of maintaining consistency with our common human nature is stressed most in 97–98, 100–106 (prior to the formal presentation of the four-*personae* theory), while the conduct appropriate to determinate ages and social roles is presented as a kind of appendix in 122–125 (cf. the continuing discussion of "fitting" styles of behavior, 126ff.), without explicit reference to the overall theory. See further Gill, "Personhood and Personality," where I contrast Epictetus' more rigorous handling of a *persona* theory in 1.2, 2.10.

42. Cf. refs. in n. 40, above; note also the awkwardness of the advice to retain your nature even at the cost of being one of those *qui quidvis perpetiantur, cuivis deserviant, dum, quod velint, consequantur* (109). There *is* some stress in 110–121 on retaining your common human nature; but the main stress is on one's individual nature, with parenthetic "glosses" on the importance of not pressing "individuality" to the extent that it becomes positively *vitiosa* (11), cf. *vitia* (114), *vitiosae* (120).

43. For such conventionality, see esp. 104, 116, and 126ff., esp. 128, 138–140, and 148. See further, on Panaetius' background and the "Aristokratisierung der Ethik," Pohlenz, *Antikes Führertum*, 130ff.; P. Brunt, "Aspects of the Social Thought of Dio Chrysostom and of the Stoics," *PCPhS* 19 (1973): 9–34, esp. 19ff.

44. One cannot be certain that Panaetius' emphasis on this theme derives from that of Democritus; Panaetius, as φιλοπλάτων (F 57 van Straaten), might simply be developing one of the main theses of Plato's *Republic*, that virtue (especially justice and *sophrosune*) consists in "doing one's own job," that is, fulfilling one's *phusis* in a way that is consistent with our essential nature as rational moral agents (cf. *Rep.* 4, esp. 430dff., 442–444). However,

the larger differences bctween the Democritean and the Stoic approach (even in its Panaetian version) remain substantial. But the shared emphasis on consistency with one's nature does seem to be an indication of the interest in the Democritean-Epicurean approach that is so marked in *On Peace of Mind*.

One other possible indication, in the *decorum* passage, of interest in the Democritean approach, is the emphasis on quasi-aesthetic appreciation of one's own virtue. As we saw earlier, both Democritus and Epicurus seem to have stressed the contribution to one's mental well-being of consciousness of one's own virtuous actions; and the theme is developed in markedly aesthetic language in Plutarch's *On Peace of Mind*, where it is firmly linked with the theme of self-unification.[45] The idea that *decorum* (both as an aspect of virtue in general and of *temperantia* in particular) can confer a kind of moral "beauty" on one's life is widely recognized as being a central element in Panaetius' ethical theory, and one which is sometimes linked with the theme of *constantia* ("self-consistency").[46] The treatment of the idea in *De officiis* has a rather different emphasis from that in the other texts, in that there is more stress on the visibility of this beauty to *others,* and less on its visibility to *oneself.*[47] This presumably reflects a larger difference of strategy: in Panaetius' *On Proper Function*, at least, the aim is to celebrate the inherent beauty of the virtuous life, rather than to illustrate the contribution of one's consciousness of virtue to one's personal happiness. However, this additional sign of Panaetius' possible interest in the Democritean-Epicurean approach is worth noting, especially given the elaboration of this idea (in a way that is closer to Democritus and Epicurus) in *On Peace of Mind*.

IV

It is to the reconstruction of this latter work that I now want to turn. The one thing we know for certain about the work is that Panaetius included Anaxagoras' dictum on his son's death, "I knew my son was mortal," a dictum which became famous as an expression of "Stoic" emo-

given the apparent echo of Democritus' stress on not "going beyond" (or, as Epicurus and Plutarch put it, not "forcing") one's nature (F 3 DK, cf. refs. in n. 19, above), in 110–121 (esp. 110, *naturae repugnare, adversante et repugnante natura,* 113–114 and 120, *cum . . . natura pugnare*), and given the Democritean contribution to *On Peace of Mind,* this seems the most direct source of influence.

45. Cf. refs. in nn. 21, 24, 27–29, above; Plut. chaps. 8–9, 14–15, discussed below.

46. See, e.g., 93, 95, 98 (esp. *constantiae, constantia*), 102 (esp. *ex quo elucebit omnis constantia*), 103; cf. Pohlenz, *Antikes Führertum,* 55ff.; Brunt, "Dio Chrysostom," 19 n. 2 and refs.

47. See esp. 98: *hoc decorum, quod elucet in vita, movet approbationem eorum, quibuscum vivitur;* cf. 126ff., esp. 130–132, 142, 145–146 (one should learn to "tune" one's conduct by using the guidance and implied moral criticism of the reactions of others), and 147.

tional fortitude.[48] In fact, we have more than just this isolated quotation to work on. Plutarch's citation of the dictum, in the treatise on peace of mind and elsewhere, provides an immediate context of significance, and one which is confirmed both by analogous passages of Seneca's treatise on this subject and by parts of the discussion of courage in Cicero's *De officiis*. The common theme is the classic Stoic practice of *praemeditatio futurorum malorum*, surmounting evils by anticipating them.[49] The principal recurrent motifs in the discussions are (1) a studied anticipation of future possible disasters, so that nothing will occur to make one say "I had not thought of that";[50] and (2) an insistence on the radical distinction between external contingencies (which do not depend on our agency) and our state of mind and character (which do), a distinction expressed in terms of the maintenance of calm within a storm.[51]

On the face of it, the resemblances between these works provide an adequate basis for a reconstruction of Panaetius' general strategy in the treatise. The fact that the immediate context of Panaetius' citation of Anaxagoras' dictum has marked points of resemblance to the discussion of courage in the *De officiis* suggests that this is the context in which to look for the Panaetian strategy in the treatise on peace of mind. Indeed, one might outline a plausible strategy along the following lines. Whereas Democritus, in his treatise on euthumia, focused on the role of *sophrosune* in moderating desires and ambitions (and was followed in this line of approach by Epicurus),[52] Panaetius focused rather on the role of courage (*andreia*) or greatness of spirit (*megalopsuchia*). In effect (one might conjecture), his claim was that peace of mind came not from restricting one's desires to the attainable (and so minimizing the disappointment and distress which the contingencies of fortune might bring), but by preparing oneself mentally to meet any misfortune; thus, Anaxagoras is enabled to meet his son's death with the ringing declaration that he knew he had begotten a mortal. Panaetius' strategy, as so reconstructed, is an orthodox Stoic one (like the account of courage in *On*

48. ἤδειν θνητὸν γεννήσας: Plut. *PE* 474d, *De cohibenda ira* 463d; Diog. Laert. 2.13; Cic. *Tusc.* 3.30, 58. The dictum is often cited elsewhere; cf. Plut. Budé 7.1, 309 n. 5 (*notes complémentaires* to p. 121), and Broecker, *Animadversiones*, table IV, attached to 156–157.

49. Cf. Cic. *Tusc.* 3.29ff., 52ff.; I. Hadot, *Seneca und die griechisch-römische Tradition der Seelenleitung* (Berlin, 1969), 60–62.

50. Cic. *Off.* 1.80–81; Sen. *Tranq.* 11, 14, esp. 6–9; Plut. *PE* chap. 16, esp. 474d–e. Cf. also Aulus Gellius 13.28 (= F 116 van Straaten) which elaborates the theme of *praemunitio* and which seems to derive from a context of *Peri kathekontos* adjacent to *Off.* 1.80–81. Cf. A. Dyck, "The Plan of Panaetius's περὶ τοῦ καθήκοντος," *AJPh* 100 (1979): 408–416.

51. Cic. *Off.* 1.83 (cf. 67, 72–73); Sen. *Tranq.* 14, esp. 10; Plut. *PE* chaps. 17–18, esp. 475e–476a.

52. Cf. discussion above, esp. nn. 20 and 27.

Proper Function), and one designed to confront the existing Democritean and Epicurean ones.

As a matter of fact, I think this general characterization of Panaetius' aims is not wholly wide of the mark; but I also think it does not quite capture the scope or the character of Panaetius' project. For one thing, as Pohlenz pointed out, the very choice of the topic of euthumia (as opposed to, say, apatheia) indicates that Panaetius is moving further into the terrain of Democritus and Epicurus than one might expect in an orthodox Stoic work.[53] Consistent with this is the fact that both the later treatises (by Seneca and Plutarch) combine what one might call a Democritean approach to euthumia, emphasizing the importance of restricting desires to what is attainable, with the Stoic emphasis on preparing oneself to meet the vicissitudes of life with equanimity.[54] More striking still is the fact that, in taking up the Democritean approach, they also take up a theme which is common to Democritus, Epicurus, and the *decorum* section of the *De officiis:* namely that any project we undertake should be one that matches our own individual capacities and inclinations, whether or not it corresponds to the highest ambitions we can conceive.[55] In other words, just as it is possible to recognize a network of connections between the two later treatises and the courage section of *De officiis* (giving us the context of Anaxagoras' dictum), so too it is possible to see a network of connections between the two later treatises and the *decorum* section, centering on the theme of the importance of "being yourself" (in the sense of matching your project to your individual nature) if you are to achieve peace of mind.

However, these points of connection raise fundamental questions about the character of Panaetius' overall position in *On Peace of Mind*. Earlier I suggested that, although the emphasis on retaining one's nature in the *decorum* section resembled Democritus', it still remained part of a recognizably distinct and basically Stoic position. What was the case in *On Peace of Mind*? Did Panaetius here move closer to the Democritean position and situate the theme of retaining one's nature in the context of the pursuit of euthumia rather than virtue? And if so, how did this

53. Pohlenz, *Antikes Führertum*, 134.

54. For Democritean elements, see Sen. *Tranq.* 8.9, 9.1–2, 10.5, 12–13.1 (cf. 2.9–12), 15; Plut. *PE* chaps. 7, 12, 13 (cf. Broecker, *Animadversiones*, table on 203). The assimilation was rendered easier, in that Democritus also emphasized that the "storehouse and treasury" of evils lies within us (F 149 DK; cf. Broecker, *Animadversiones*, 138–139, 209–210; Siefert, *Plutarchs Schrift περὶ εὐθυμίας*, 28–29); Democritus also stressed the desirability of a psyche which γαληνῶς καὶ εὐσταθῶς . . . διάγει ὑπὸ μηδενὸς ταραττομένη (Diog. Laert. 9.451; cf. Siefert, *Plutarchs Schrift περὶ εὐθυμίας*, 17–18).

55. Cf. refs. in nn. 17, 19, and 40, above; also Sen. *Tranq.* 6.2, 7.2; Plut. *PE* chap. 13, esp. 472c.

square with the more orthodox Stoic approach indicated by the citation of Anaxagoras' dictum? I think there is a possible answer to these questions, and that it goes beyond suggesting that Panaetius' approach was simply *additive,* combining different strategies without mutual assimilation.

I think that Panaetius tried to synthesize the approaches by focusing on their common elements and by deemphasizing the fundamental point of divergence between them, namely their differing conceptions of the *telos* of life. He focused on the fact that (1) both approaches emphasize the extent to which our happiness and unhappiness depend on ourselves, as rational agents; (2) both approaches emphasize the extent to which the unification of our lives and characters depends on ourselves; and (3) both approaches emphasize the importance of being (and being conscious of being) virtuous.[56] He underlined this common ground by giving an additional sense to the idea of "being yourself," namely that of being your "real" or "essential" self, that of the rational moral agent; and of stressing the role of *that* self in giving one's life unity. This sense of "being yourself" is not new to Greek philosophy; one can find striking antecedents in Plato and Aristotle.[57] But it is not an idea that seems to have been deployed in the earlier writings on euthumia; and Panaetius' introduction of it seems to represent a deliberate move to underline the common ground in these two approaches.

I want to conclude this reconstruction of Panaetius' *On Peace of Mind* by noting some passages in Seneca and Plutarch in which this strategy is exemplified. Clearly, some of the examples and coloring have been added, but I believe the basic approach is Panaetian. It is worth noting in advance that these passages are couched predominantly in reflexive terms, that is, in terms of one's relations with oneself. This indicates that, in the treatise on peace of mind, Panaetius extended to the treatment of *praemeditatio malorum* and greatness of spirit the reflexive mode of exposition that is characteristic of the *decorum* passage; and thus he added the implied thesis that acting in the way recommended constitutes "being yourself" in a deep sense. Thus Seneca, for instance, advocates that we meet misfortune by having the mind (*animus*) recalled from all external things into itself (*se ipsum,* 14.2);[58] and, in a related context, he praises the attitude of the wise man who regards "not just his possessions and social worth but also his body, eyes and hand . . . and indeed himself

56. Cf. refs. in nn. 20–21, 27–29, 31, 38–39, 45–47, 49–51, above.

57. See, e.g., Pl. *Alcibiades* 1.132–135, esp. 133b–c; Pl. *Rep.* 611c–612a; Arist. *Nicomachean Ethics* 1166a13–23, 1168b34–69a3, 1178a2–7; the "self" so singled out is reason, either in its practical or theoretical functions.

58. For the context, see passage *e* at the start of this essay.

(*se . . . ipsum*) as transitory (or "loaned," *precaria*, 11.1)." This second
passage may seem to contradict the first; but the common theme is that
one's self (that is, one's real self) is identical only with one's agency, or
what is "up to us," and that even that self is "loaned" to us for the dura-
tion of our lives. Seneca's point, in these cases, is that by thinking about
ourselves in this way we will meet death with equanimity.

The figures that Seneca idealizes in these passages are those who re-
alize the nature of the self, and who are thereby enabled to meet death
with equanimity and peace of mind. Hence, he praises the rational de-
tachment of Julius Canus, who approached his end determined to watch
and see "whether the *animus* is conscious of leaving in that swiftest of
moments" (14.9). "No one," as Seneca puts it "played the philosopher
longer," and, in so doing, he exhibited "calm (*tranquillitas*) in the midst
of a storm and a mind (*animus*) worthy of immortality" (14.10). Implied
in Seneca's commendation is the idea that such a man has performed
virtuously in playing to the end a worthwhile role.[59] Hence, Julius Canus'
stance is similar to that of the wise man in 11.3 who is able to say to
fortune, "receive back a mind (*animus*) which is better than the one you
gave." Although the stance idealized is more obviously Stoic than Epi-
curean, the Epicureans too could appreciate heroic indifference in the
face of, or at the prospect of, death.[60] Similarly, there is nothing in the
basic doctrine of the passage (that an understanding of the "real" nature
of the self can give us the equanimity to confront death and disaster)
that either school would find unacceptable, or that would force into the
open the deep ethical differences between the schools. And the implied
message, that we should, in this sense, "be ourselves" (or realize that
this *is* our self) seems designed to serve as a focus for such shared
convictions.

The same strategy is evident in the cognate parts of Plutarch's treatise,
including the context that contains the quotation of Anaxagoras' dictum.
Thus, as part of an argument that reflecting on possible disasters can
help us to confront them, Plutarch urges us to realize that fortune has
power only over our "unsound" part (our body), whereas "we ourselves
have power over the better part, in which the greatest of our goods is
situated, namely sound beliefs and learning and arguments which issue

59. For this view of the role as ethical vehicle, including the role of philosopher as well
as statesman, see Sen. *Tranq.* 1.10–12, 3–5, esp. 4.1–6 and 5.1–3 (Socrates as an exemplar
of *virtus* confronting *fortuna*); the whole passage seems to be a response to Cic. *Off.* 1.69–
73, or its Panaetian original.

60. On the "philosophical" death, cf. M. Griffin, "Philosophy, Cato, and Roman Sui-
cide," *G&R* 33 (1986): 65–77, 192–202, who brings out the nondoctrinal status of this
ideal. See further Long and Sedley, *Hellenistic Philosophers*, 24, esp. A, D, E; and n. 62,
below.

in virtue." Hence, we should appreciate that, while fortune can make one ill or poor, it cannot take away the character of a man who is "good and brave and great-spirited," a man whose wise disposition (*diathesis*) can bring "calm" in physical and emotional storms.[61] In a passage that is reminiscent of Seneca's presentation of Julius Canus, Plutarch claims that the best protection against fear of death is an understanding of "the nature of the psyche," and a realization that death is a change to the better or at least to nothing worse, so that, if things are externally bad, "the harbor is near" and we can "swim away from the body as from a leaky boat."[62] As in Seneca, the capacity to survive disasters without loss of peace of mind is taken to depend on a proper understanding of our "real" self, the rational agency on which our happiness ultimately depends. And, again as in Seneca, awareness of oneself as a good moral agent makes a crucial contribution to one's peace of mind. Hence, nothing "affords one's life so much calm (*galene*) as a mind that is pure of evil acts and intentions and that has, as the source of its life, a character (*ethos*) which is undisturbed and unstained."[63]

Thus far, Plutarch's evidence simply confirms the version of Panaetian strategy given by Seneca; but in some other contexts Plutarch places a further informing gloss on this strategy. In discussing the *decorum* theory, I noted the Panaetian emphasis on the idea that our conduct and character can acquire a certain moral "beauty." In the *decorum* section the stress is on the visibility of this beauty to others; but in Plutarch's treatment it is on the visibility of this beauty to the person concerned. He suggests that we can, by reflecting on our lives and emphasizing the good rather than the bad, endow our lives with the kind of beauty that promotes a sense of well-being.[64] As in the *decorum* passage, awareness of the beauty of one's life is associated with awareness of its unity and self-consistency. This latter theme is developed in a related passage, in which Plutarch emphasizes the role of memory in constituting personal identity or, as he puts it, in allowing "life to become *one* by weaving together the past and the present."[65] In the conclusion of the work Plu-

61. Plut. *PE* chap. 17, 475d–476a; for the philosophical background, cf. nn. 51 and 54, above.

62. Plut. *PE* chaps. 17–18, esp. 476a–c; the attitude and the language have both Stoic and Epicurean parallels, cf. Broecker, *Animadversiones*, 177–179.

63. Plut. *PE* 477a–b; for fuller quotation, see passage *g* at the start of this essay; cf. Sen. *Tranq.* 11.3 and 14.10.

64. See Plut. *PE* chaps. 8–9, esp. 469a ("blending" the worse elements with the better) and 470a (the folly of admiring works of art instead of one's own life). See also chap. 15, esp. 473f (mixing one's experiences in one's psyche "as on a palette") and 474a–b (combining the different "notes" in one's life to make a harmonious fusion). Cf. n. 47, above.

65. Plut. *PE* chap. 14, esp. 473d (cf. fuller quotation in passage *f* at the start of this

tarch alludes to this theme of self-unification through the management of time, saying that this enables us to conjoin happy memories of the past with cheerful hope for the future (477f). In a related passage, he refers to the importance of having "fine deeds" of one's own to remember so that one can view one's life with equanimity (477b). These passages seem to give us access to a further strand in Panaetius' complex strategy in this work. He combines the Epicurean theme of unifying one's life by recollection of past pleasures with the Stoic theme of coping with future evils by preparing for them. These themes are normally kept separate, or indeed contrasted;[66] but Panaetius seems to have combined them as part of a policy of seeking peace of mind through self-unification (a policy which figures in both the approaches on which he draws). The theme of self-unification is naturally related to that of "being yourself" in the sense he emphasizes in this work, that is, being your "true" self as a rational moral agent. Whether or not Panaetius' composite strategy is, at bottom, *philosophically* coherent is a question one might want to pursue further; but I feel reasonably clear that this was his strategy in this work, and that it is a sufficiently distinctive and interesting one to be worth trying to recover.

V

I will conclude this discussion by returning to the question I raised at the beginning: does this account put us in a better position to say what, if anything, "self-definition" meant in the Hellenistic thought-world? Clearly, the area of discourse studied (philosophical ethics) limits the scope of any conclusions we can draw; but, given the ethical centrality of the topic, and the relatively "popular" level of the texts, there is some reason to think that the attitudes expressed may be indicative of more general patterns of thought within the culture. In particular, I will take up the question whether the material studied bears out the claim that Hellenistic ethical theory, like the culture from which it derived, was

essay). The theme is linked with an allusion to a contemporary debate about growth and identity over time that curiously anticipates some modern preoccupations. Cf. D. Parfit, *Reasons and Persons* (Oxford, 1984), esp. part 3; see, e.g., 446: "On the Reductionist View [which Parfit advocates], the unity of our lives is something we can affect. We may want our lives to have a greater unity, in the way that an artist may want to create a unified work. And we can *give* our lives greater unity, in ways that express or fulfill our particular values and beliefs." For a different modern version of "self-creation," cf. Nietzsche, discussed below.

66. See refs. in nn. 27–28 and 49–51, above. Cf. also Siefert, *Plutarchs Schrift περὶ εὐθυμίας*, 66 (on this unusual combination of themes); and on the themes as, normally, alternatives, cf. Cic. *Tusc.* 3.32ff.; Hadot, *Seneca*, 60–63.

distinctively "individualistic."[67] Is it such individualism that makes the
call to "be yourself" a recurrent one in this age?[68] The question is a
difficult one to answer, in part because of the complexity (and elusive-
ness) of the notion of individualism. But I will try to open up the ques-
tion a little, indicating, as I do so, what sense of "individualism" I have
in view at any one time. My comments will be based especially on Pan-
aetius' *On Peace of Mind*, as I reconstruct this, though, to a lesser extent,
on this whole strand of Hellenistic thinking.

In some respects, the material studied bears out the suggestion that
the theme of the importance of "being yourself" is associated with the
adoption of an individualistic stance. Even if such works have specific
addressees, the basic appeal is to *any* person, regardless of the precise
character of his polis and his family and social background.[69] In the case
of Panaetius' *On Peace of Mind* and its descendants, the nondoctrinaire
character of the work widens the scope of the potential audience, who
need not be committed Stoics or Epicureans. The individual addressee
is treated as a significant unit (and not simply as the occupant of a given
social space), capable, in principle, of choosing his role and shaping his
life by those guiding norms whose validity he recognizes. And he is
treated as being capable of doing so by reference to *himself;* that is (as
On Peace of Mind presents it) by reference both to his specific capacities
and inclinations, as he understands these, and to his own conception of
his "real" or "essential" self. Also, a central concern of this type of litera-
ture, at least from Panaetius onward, is to prepare one for a situation in
which one has to function as a bare individual, deprived of political,
social, and economic support. "Have you the kind of moral and emo-
tional *autarkeia* to be able to say, with Anaxagoras, 'I knew my son was
mortal,' and to surmount the negation of these kinds of support without
losing your peace of mind?"[70] This is the kind of question these texts
put to their readers; and the emphasis on "being yourself" is a crucial
part of the answer they offer. The answer, in essence, is that one can, at
best, find in oneself, and in one's consciousness of one's life as a unified
and significant whole, sufficient moral and emotional strength to survive
the loss of all external supports. Such an answer is clearly, in one sense
at least, an "individualistic" one.

67. Cf. n. 8 and discussion above.
68. As L. Trilling has shown, *Sincerity and Authenticity* (Oxford, 1972), the call to "be
yourself" has in the modern period been a clarion for (various kinds of) "individualism";
cf. below on Nietzsche.
69. I will ignore for the present the presumption that the reader will be an educated
male of sufficient means to give time and attention to this subject, although at least this
much is clearly assumed about the reader. The works by Cicero, Seneca, and Plutarch have
named addressees, though it is not clear if Panaetius' two works were so addressed.
70. Cf. refs. in nn. 15, 48–51, above.

However, it is important to define the nature and the limits of this "individualism." For one thing, although these texts set out to prepare a person for political and social isolation, they do not presume that such isolation is desirable in itself, or that it constitutes the basis of an ethical position. The fact that one is expected to shape one's own life does not entail that one must shape a life *on one's own*. The attitude toward social and political involvement advocated by the Hellenistic schools clearly varies; indeed it is one of the points by which the various schools were standardly distinguished. But, while the Stoics positively advocate political involvement (at least, as an expression of virtue),[71] Epicurus, as we have seen, sometimes allows it to be advisable.[72] And his objection, as Tony Long has argued persuasively, is not so much to political involvement as such, but to involvement based on false beliefs and desires.[73] Panaetius evidently presumes that familial, social, and political engagement go to make up the fabric of the life one is setting out to shape; and that it is in this context that one is to appraise one's specific capacities and inclinations.[74] This kind of presumption also underlies, to an extent, the recurrent theme that consciousness of one's virtue can contribute crucially to one's peace of mind. There is, of course, scope for debate about what, exactly, "virtue" meant to the different schools, and how their versions relate to the understanding of "virtue" in other parts of society. But it seems clear that the "fine deeds" which are held, from Democritus onward, to contribute to mental well-being derived, in part at least, from ethical engagement in social contexts. It is consciousness of such engagement that contributes to one's sense of "self," and to one's "thread of life" and thereby gives one the inner confidence to survive the loss of such contexts without losing peace of mind.

Also, and perhaps more importantly, the fact that one is invited to formulate one's own stance toward one's life does not entail that the stance to be adopted constitutes what one might call "radical individualism," in which simply being a unique and distinctive individual is regarded as inherently valuable. As an example of such a stance, we might take the significance given by Nietzsche to the call to "be yourself," or to "become who you are."[75] Some of the implications of this stance come out in the following passage:

71. Cf. refs. in n. 59, above.

72. Cf. refs. in n. 26, above.

73. A. A. Long, "Pleasure and Social Utility: The Virtues of Being Epicurean," in *Aspects de la philosophie hellénistique*, ed. H. Flashar and O. Gigon, Fondation Hardt, Entretiens 32 (Vandoeuvres and Geneva, 1986), 283–324.

74. Cf. Cic. *Off.* 1.107–121, and refs. in n. 55, above.

75. Cf. A. Nehamas, *Nietzsche: Life as Literature* (Cambridge, Mass., 1985), chap. 6: "How One Becomes What One Is," esp. 171–172.

One thing is needful.—To "give style" to one's character—a great and
rare art! It is practised by those who survey all the strengths and weak-
nesses of their nature and then fit them into an artistic plan until every
one of them appears as art and reason and even weaknesses delight the
eye. . . . Here the ugly that could not be removed is concealed; there it has
been reinterpreted and made sublime. . . . In the end, when the work is
finished, it becomes evident how the constraint of a single taste governed
and formed everything large and small. Whether this taste was good or
bad is less important than one might suppose, if only it was a single taste! [76]

It is interesting that this passage articulates the quasi-aesthetic atti-
tude toward oneself and one's life which, we have seen, is characteristic
of Panaetius, both in *On Proper Function* and *On Peace of Mind*. [77] But
whereas Panaetius is concerned with a kind of moral beauty, or at least
a beauty that is fully compatible with morality, Nietzsche's stance, here
as elsewhere, is resolutely "immoralist." [78] The essence of his art of "self-
creation" is that the difference between "strengths and weaknesses,"
"good and bad," matters less than whether the creation is determined by
a "single taste." As Nehamas suggests, what Nietzsche urges is that we
appraise ourselves by the same criteria as we judge figures in literature:
what matters about Shakespeare's Richard III or Dostoyevsky's Fyodor
Karamazov is not whether he is good or bad but whether he is a distinc-
tive and interesting *individual,* and the same standards should be applied
in our "self-creation." [79] One might define the difference between Nietz-
sche and Panaetius by couching Nietzsche's theories in terms of the two
senses of "being yourself" Panaetius deploys in *On Peace of Mind*. Nietz-
sche seems to want to make the specific, individual self (which Panaetius
thinks we should take account of, in choosing our role) into the sole
normative criterion, or rather into the "essential" self that Panaetius
presents as the deeper ethical norm. There may be scope for asking if
Panaetius has fully worked out the normative relationship between those
two senses of "oneself." [80] But it is clear that he does not want to collapse
the second into the first and to make our particularity (in both its good
and its bad aspects) the only basis for shaping our lives. The "individu-

76. Friedrich Nietzsche, *The Gay Science*, trans. W. Kaufmann (New York, 1974), 290.

77. Cf. nn. 47 and 64, above.

78. On Nietzsche's "immoralism" as a serious and challenging *moral* position, cf. P.
Foot, *Virtues and Vices* (Oxford, 1978), chap. 6; Nehamas, *Nietzsche*, chap. 7.

79. Nehamas, *Nietzsche*, 192–194.

80. I suggested that some problems existed in the working out of the relationship be-
tween the first and second *personae* in the passage on *decorum* in Cic. *Off.* 1 (n. 41, above),
and the same might be true in the case of the two senses of "being yourself" in *On Peace of
Mind* (though given the speculative nature of my reconstruction it might be hard to estab-
lish this firmly).

alism" implied in Panaetius' call to "be oneself" thus falls well short of Nietzsche's, and the comparison with Nietzsche helps us to define those limits.

In conclusion, I will raise—though not try to answer—one important, final question: namely, whether the kind of "individualism" I have ascribed to Panaetius in *On Peace of Mind* constitutes a distinctively Hellenistic stance, or one which could be paralleled in earlier Greek philosophy. The question is an important one because it is difficult to answer. If one thinks of Pythagoras, say, or Heraclitus, or Socrates, it is clear that the adoption of a stance of reflective detachment from (or postreflective involvement in) one's society is characteristic of Greek philosophers from an early period, and that these earlier figures too reserve the right to formulate *their own* criteria for such stances.[81] As I have noted in passing, we can find in earlier Greek philosophy some equivalents for the concerns associated with "being yourself" in the Hellenistic writings on euthumia, namely with natural aptitude and inclination and with one's "essential" self.[82] Also, the idea that a degree of "self-knowledge" (in some sense) and consciousness of a life committed to an ethically valued role can provide the basis for equanimity in the face of mortal danger already underlies Plato's *Apology*—a fact which explains Socrates' role as an exemplar in these texts.[83] Clearly, to confront this question adequately, we should need to define the pre-Hellenistic analogues of the euthumia topic and the several analogues of the theme of "being yourself" (including, of course, the "choice of lives" theme),[84] and proceed systematically to analyze the points of similarity and difference. I have no intention of trying to do so here. But I simply note the seriousness of the problem as an indication of the fact that, whatever is true of other areas of Greek culture, "individualism" of a sort has deep roots in earlier Greek philosophy.[85]

81. I would be interested to see how M. Hossenfelder would respond to this point, in view of the reasons he offers for regarding Hellenistic philosophy as distinctively "individualistic" (n. 8, above).

82. Cf. refs. in nn. 44 and 57, above.

83. Cf. Pl. *Apology*, esp. 21–22, 28–30; Sen. *Tranq.* 5.1–3; Plut. *PE* 475e.

84. See, e.g., Xenophon *Memorabilia* 2.1.21–34; Pl. *Gorgias* 484c–486c; Pl. *Rep.* 360e–361d, 588b–592b; Arist. *Eth. Nic.* 10.7–8.

85. This is a heavily revised version of the paper given at the Berkeley conference. I have taken full account of Julia Annas' incisive criticisms, while also trying to state in a clearer form the points I was trying to make in that paper. I am grateful for helpful written comments by Tony Long and Walter Englert, and also for Paul Zanker's interesting suggestion (n. 4, above); and I am also appreciative of the invitation to participate in this stimulating interdisciplinary venture.

Response

Julia Annas

Fernanda Decleva Caizzi has focused, in her fascinating and learned paper, on images of the philosophical life in two ways: the way the philosopher presents himself to other people, and the way other people tend to see the philosopher. Christopher Gill has focused in a highly original way on one ethical philosopher, Panaetius, and the way in which he tries to unite seemingly rather distinct ethical strategies as to how one should achieve one's ethical goal. These two papers are distinct in their subjects and hence in their treatments, and in these remarks I shall deal with each paper separately. But before doing this I think that it is worthwhile briefly to discuss the way that both papers highlight, in different ways, an important point about Hellenistic philosophy which is immediately relevant to the overall theme of this conference: self-definition in the Hellenistic world. Gill has made some remarks on this in his paper, but perhaps a little more can usefully be said on this point.

It is a commonsense assumption in the ancient world that you and I and everyone have a "final end"—that is, I do not just have some projects and plans and commitments in an unrelated jumble but have, at some level, a unified view of how they fit together, of how they form my life as a whole, of where my life is going. All of us have this view in an inexplicit way,[1] and the complacent and stupid among us may never do more. But it is a mark of the reflective person that he brings to consciousness this fact about himself, that his projects and commitments

1. Arius Didymus (ap. Stobaeus *Eclogae* 2.47.12–48.5) says that we have a prerational "pre-end" or ὑποτελίς which we articulate as our τέλος or end as we mature. All previous philosophers, he says, recognized this although they did not have a word for it. That is, organizing our deliberations around a final end and so seeing our lives as unities is something that we have an instinctive tendency to do, though we need reason to do this articulately.

354

hang together as a whole. And it is this point, of conscious self-concern, which forms the entry point for ethical reflection. For ancient ethics is about how best to live your life, about what your aims should be and how you can be happy. And so it is that a kind of concern about yourself raises questions which can only be answered by philosophy; for it is the philosophers who have thought long and hard about happiness and virtue and the problems that these engender. Any intelligent person, then, will be led to ponder a range of philosophical alternatives just given the natural outcome of a kind of self-concern, namely awareness of herself as a person whose concerns and projects form a whole life which is going in one way rather than another. This does not mean, of course, that ethics is all that there is to philosophy, or that ethics dictates conclusions to other parts of philosophy like logic and epistemology (as has been too readily believed by past scholars). But it does show how a very ordinary kind of self-concern leads people to direct concern with philosophy (in a way for which we have no modern parallel). It shows why both a philosopher and his audience would be naturally concerned about the image of his life. For philosophy enters into our reflections by way of offering us reasoned answers as to how to live; and it is natural to ask, when considering one of these answers, whether it works for the person offering it. Does Zeno, or Epicurus, not only talk about but present a life that I find attractive or compelling as an improvement on my own? So the image of the philosopher is relevant to his message in a direct way. And the fact that we are led to philosophy by thoughts about ourselves shows that the issue in Panaetius that is highlighted is one at the heart of Hellenistic ethics. If I am led to philosophize about happiness and virtue by way of thoughts about myself, it is a real question how far thoughts about myself can legitimately persist in the development of the answer, and what form they will take. And so both papers point up the way that the question, "How best should I live?" is both natural to any intelligent person thinking about herself, and the main question that philosophy answers, both by argument and in presenting a certain picture of a life.[2]

I

Decleva Caizzi points out that it is in the Hellenistic period that we find the emergence of *stereotypes* of philosophers, that is, images of philoso-

2. It might be objected that the question, "How am I to live?" is the entry point for ethical reflection in all periods of Greek ethics and does not specifically characterize the Hellenistic period. This is true, but it is also true that in this period the question acquires a new urgency, both in that ordinary people are more self-consciously aware of its importance and in that philosophy as a whole is more sharply focused on ethical answers to it.

phers which show aspects of their theories in their way of life and behavior. We are dependent for this, of course, on the biographical material in authors like Diogenes Laertius, and it is obvious that most of this reveals more about the thought patterns of the originators of the material than it does about its subjects. Nevertheless, Decleva Caizzi is surely right that these stories are of great value in showing that philosophers were expected to act in a way revealing of their theories. And this expectation does seem to be decisively new. We have, for example, no comparable stereotype of Plato or even Aristotle. Their "biographies" contain much material, most of it transparently projected from the works, but no illustrative images of this kind. There is a large amount of this kind of material about Socrates, but it proves precisely the point at issue. The stories, anecdotes, and so on, told about Socrates reflect the philosophical school for which the author is claiming Socrates as figurehead. The stories show great variety because in the Hellenistic period Stoics and Skeptics laid claim to Socrates as a forefather,[3] as well as hedonists,[4] in competition with the pictures we find in Xenophon and Plato. Aristotle's ethics requires, given the stress he lays on the development of dispositions, that one's actions express one's ethical beliefs; but he only once makes the point in connection with appearance and details of behavior—his notorious claim that the μεγαλόψυχος will have a deep voice and will not hurry along.[5] And the result is not very happy. But Theophrastus' *Characters* develops in a quite thorough way the thought that the kind of character trait you have will show up in the kind of thing you do and your general appearance.[6] The *Characters* develops this only for particular traits, but the idea is not far off that the priorities and dominant concerns in your life as a whole will find expression in the kinds of things you do and the way you present yourself to and interact with others.

Decleva Caizzi contrasts the images of Zeno and Epicurus that we find preserved in Hellenistic biography, and she notes a significant contrast. Zeno's image is that of someone setting himself apart from most people in a striking way. He makes a point of his poverty and of the independence of the powerful which his philosophical stance entitles him to, at

3. See A. A. Long, "Socrates in Hellenistic Philosophy," *CQ* 38 (1988): 150–171.

4. The Cyrenaics claimed descent from Socrates, and Diogenes Laertius sees them this way, listing them as Socratics in book 2. For the tradition of Socrates as hedonist, see the papyrus fragment *P. Köln* 205 (discussed by M. Schofield, "Coxon's Parmenides," *Phronesis* 32 [1987]: 349–359).

5. Aristotle *Eth. Nic.* 1125a12–16.

6. Thus grossness and stinginess show up in one's appearance; cowardice about the gods shows up in silly, superstitious behavior over trivialities; failures of intelligence show up in tactless comments at weddings, boring chatter to strangers, and so on.

least in his own eyes. By contrast the details of Epicurus' life do not stand out, and the Epicurean school makes no attempt to show their leader as a striking or dominant personality. I find this contrast convincing, and my comments are limited to details. I wonder whether this self-presentation by Zeno is linked as closely as Decleva Caizzi suggests to a specifically *Stoic* conception of the philosophical life, rather than a Cynic or Socratic one. And I have a few comments to make on what she says about Epicurus' image, and the accessibility, and the godlike nature, of the Epicurean final end.

Decleva Caizzi does not, of course, underestimate the Cynic elements in the image of Zeno that she discusses. But she also claims that it shows something important about Stoicism, and that Zeno's emphatic poverty, for example, shows some kind of modification of the Stoic view that wealth is a preferred indifferent. It seems to me that there are more problems than she suggests in combining this kind of ostentatious poverty and at times antisocial behavior with Stoic ethics as we know that from our major sources.[7] If this is so, then Zeno's image is not the *right* image for Stoicism, as that developed after Chrysippus, and I think that some later Stoics were right to find it embarrassing and to distance themselves from it.[8]

Decleva Caizzi mentions Zeno's uncompromising attitude to Antigonus as an example of a consciously adopted philosophical attitude, comparing it with the famous stories about Diogenes and Alexander. I would like to note that Zeno's attitude can also be explained in political rather than philosophical terms, but I do not have enough knowledge of the historical background to pursue this.[9] So I shall concentrate on Zeno's poverty. Decleva Caizzi mentions many stories which indeed show a self-conscious, didactic use of poverty, surely meant to recall Socrates, and I won't repeat them. What I would like to stress is that this sits ill with some other facts. One is that Zeno brought a lot of money to Athens and

7. Cicero *De finibus* 3; Diogenes Laertius 7.84–131; Arius Didymus ap. Stob. *Ecl.* 2.57.13–116.18. Arius and Diogenes derive from common sources, which seem to be textbook accounts of Stoic ethics that may well go back to Chrysippus. They display an ambivalent relation to Cynicism. Cf. Arius 114.24–25, discussed by Caizzi, above; Cic. *Fin.* 3.68. Diog. Laert. 121 preserves a more positive attitude, but in isolated form. Panaetius seems to have been more violently anti-Cynic; cf. Cic. *Off.* 1.128, 148.

8. This is quite distinct from the later attempts to emend or suppress Zeno's *Republic;* this concerns Stoic theory itself, and since it was about the ideal state, it has no direct implications for how the Stoic will behave in actual society. Chrysippus, whose image and behavior were quite different from Zeno's, wrote a *Republic* which seems to have been just as extreme as Zeno's as to what the ideal Stoic society would be like.

9. The political interpretation is argued by Andrew Erskine in *The Hellenistic Stoa* (London, 1990).

used it to finance shipping loans.[10] Now even if we can't trust this just as it stands (and it contrasts with the stories of shipwreck before Zeno came to Athens), the fact that it is in Diogenes Laertius' biography shows at least that in the ancient tradition it was accepted that Zeno was not really poor. Further, as Decleva Caizzi points out, Antigonus of Carystus reports evidence that he was wealthy enough to contribute toward public works.[11] In this he contrasts with Cleanthes, who was most unusual in that he really had to earn his living.[12] But Zeno had a private income, like most ancient philosophers; and so conspicuous poverty on his part shows a deliberate attempt to reject the advantages given him by fortune, like Crates the Cynic, who gave away great riches.[13]

What Stoic grounds would Zeno have for doing this? Nature, in Stoic ethics, motivates us to seek what is natural for us, and this includes all the preferred indifferents, which Aristotle called external goods—health, fitness, and so on. Wealth is always regarded as one of these, and indeed how could it not be? Wealth is, as Rawls puts it, a primary good; whatever else you may want, it increases your resources for doing that. How could it be rational to disable yourself from achieving your ends? And so we find that in standard Stoic theory wealth is a preferred indifferent, and the Stoics even discuss at great length what are the best ways of making money and claim that the Stoic σοφός is the only true money maker (as well as the only true king, etc.).[14] Decleva Caizzi suggests that Zeno modified this idea to some degree, quoting a passage from Athenaeus to the effect that Zeno made an exception for the legitimate and honorable use of money but in other respects classified it as an indifferent and discouraged pursuit and avoidance of it, saying that one should use plain and simple things in a preferable way.[15] We should note that this passage is not a very good witness, since its author seems not to understand Stoic theory. For Zeno money could not be anything other than indifferent. But an honorable use of money is not an exception to this, nor is it reasonable to discourage pursuit and avoidance of an indifferent. That something is an indifferent in no way implies that one should minimize one's concern with it. It implies only that its value is different in kind from the value of virtue, and the latter always overrides it. That one's money is indifferent implies neither that one should increase it nor that one should renounce it; it implies only that its use should be unquestionably constrained by virtue.

10. Diog. Laert. 7.13.

11. Diog. Laert. 7.12; see Caizzi, above.

12. Zeno took some of his wages (Diog. Laert. 7.169), making him even poorer.

13. Diog. Laert. 4.87.

14. Arius 95.9–23. Cf. esp. 21–22: μόνον δὲ τὸν σπουδαῖον ἄνδρα χρηματιστικὸν εἶναι.

15. Athenaeus 6.233b–c; SVF 1.239. See Caizzi, above.

Still, the Athenaeus passage, despite confusion, does suggest that Zeno was thought more negative toward wealth than most. Is this attitude consistent with Stoic ethical theory? He could certainly have made it consistent by appealing to the idea of "circumstances."[16] It is reasonable to follow our natural motivation to protect our own resources—except in certain circumstances; perhaps Zeno thought that his circumstances were special, so that poverty rather than comfort was appropriate for him. And he may well have thought this if he cast himself as a Socrates, especially a Socrates in the Cynic mode (we should remember that the leaders of the skeptical Academy consciously cast themselves as Socratic teachers without affecting poverty). For Zeno what was crucial was to get the message across to people, and this he could not effectively do unless he stood out in the people's minds as a teacher dedicated to his message more than to his own concerns. Zeno's image would then be appropriate from a "practical-pedagogical point of view," as Decleva Caizzi says. But this is achieved at a certain cost. For Zeno's striking image is not that of the life appropriate for the average Stoic. Becoming a Stoic requires you to use your wealth virtuously; to think that it requires you to renounce it is just a mistake. But then becoming a Stoic does not require you to become at all like Zeno. Zeno's image is immediately comprehensible as that of the unworldly, Socratic teacher; but even if it is appropriate to what he sees as his mission, it is importantly in conflict with his message. It is not surprising that none of his successors imitated his didactic use of poverty. Cleanthes simply was poor, a very different thing; and from Chrysippus onward the heads of the school followed their own theory and treated wealth as just another indifferent requiring no special attitude. Later Stoics could treat Zeno as special, his position as founder of the school excusing his "missionary" fervor. But if they were troubled by it they were right, for it is a cardinal point in ancient ethics that your life should match your theories, and Zeno's life makes him an exception to his own theory, and his image does not present the kind of life that a convert to Stoicism would lead.[17]

Epicurus, by contrast, does not appear as a striking figure at all, and his limited lifestyle is, as Decleva Caizzi claims, not an adoption of pov-

16. Ariston's theory depends heavily on the use of this idea, so it is reasonable to assume that it was available to Zeno.

17. In all this I have been following Caizzi's assumption that what we find in the ancient biographies, especially the one by Diogenes Laertius, represents settled fact, if not about Zeno at least about his image in the Stoic school. It is possible, of course, that what we have is only one of several versions; certainly Diogenes seems to be following a particularly "Cynicizing" version (see Jaap Mansfeld, "Diogenes Laertius on Stoic Philosophy," in *Diogene Laerzio: Storico del pensiero antico,* Elenchos 7 [Naples, 1986], 295–382). But the fact that there was such a version at all shows that Cynic influences on the beginning of the Stoa were thought to be important.

erty but a strategy for ensuring the right kind of (static) pleasure. One reason for this not mentioned in the paper: Epicurus stressed the value of community and cooperation as opposed to ambition and emulation. In the first generation of Epicureans, at least, there seems to have been an attempt to present Epicureanism as a joint effort. Even the doctrines sometimes float in their attribution between Epicurus and other leaders of the school, such as Hermarchus and Metrodorus. This side of the school has been well discussed by Diskin Clay.[18] Later, of course, Epicurus' own image predominated in the school, in the form of capsule doctrines as well as in the form of pictures on rings and cups.[19] But in his own lifetime there seems to have been some attempt to present him as *primus inter pares* and the Epicurean way of life as one in which Epicurus' level of achievement was one that others could reach as well; and this may be important in accounting for the lack of an exemplary image with telling detail.

Two more minor points: Epicurus does talk of Epicurean happiness as being equal to that of the gods, but I wonder whether this is distinctively Epicurean. The Stoics also say that the wise person's happiness is not inferior to that of Zeus,[20] and the idea in both cases is the same: happiness is, when attained, "complete"; that is, it cannot be increased, and does not get better by lasting longer, for it is not the kind of thing that can be quantified at all. There is thus no sense in which human happiness is inferior to that of the gods merely because it is shorter-lasting. This idea is common to both schools (despite its extreme difficulty). I am also not convinced that the "divine" nature of Epicurean happiness is implied by the preponderance of μακάριος over εὐδαίμων in Epicurean texts. Apart from the fact that our sources are not extensive enough for us to generalize safely, we have one Hellenistic source, Arius Didymus, who says firmly that it makes no difference which word you use.[21] Stylistically μακάριος is the "loftier" word and thus more appropriate for the gods, but there seems to be no difference of meaning or of reference.

I wonder also whether the Stoics are as indifferent to αὐτάρκεια as Decleva Caizzi suggests. Their claim that virtue is αὐτάρκης for happiness is central and frequent, and its being a "doxographical formula" suggests its importance in Stoic thought rather than the reverse. The thought behind it is a striking one; see Diogenes Laertius 6.128:

18. D. Clay, "Individual and Community in the First Generation of the Epicurean School," in ΣΥΖΗΤΗΣΙΣ: *Studi offerti a Marcello Gigante* (Naples, 1983), 255–279.

19. Cic. *Fin.* 5.3.

20. Arius 98.19–99.2. It is as choiceworthy, as fine, and as lofty.

21. Arius 48.6–11. Unfortunately there is a corruption at the end of the sentence, but this does not affect the present point.

"For if," he says, "high-mindedness (μεγαλοψυχία) is self-sufficient (αὐτ-άρκης) for putting us above everything, and if it is part of virtue, then virtue too is self-sufficient for happiness, despising even the things that seem annoying."

"He" here is Hecaton, but the thought is ascribed to Zeno and Chrysippus as well.

II

Christopher Gill's ambitious attempt to reconstruct the main lines of Panaetius' *On Peace of Mind* results in a very rich paper in which many points of interest are raised; I shall focus on just a few.[22]

Gill contrasts two approaches to the topic of εὐθυμία or peace of mind, which he calls the Democritean-Epicurean and the Stoic approach. Panaetius, he argues, seems to have made an interesting combination of both approaches in his essay on peace of mind, a combination we can trace in the later works of Plutarch and Seneca on the same topic. I do not have any direct criticisms of Gill's project, but I would like to take up some aspects of what he calls the Democritean-Epicurean approach.

Seneca opens his own book on *tranquillitas* (εὐθυμία) by commenting that Democritus has written an excellent book on this. It strikes me as worthy of comment that in the Hellenistic period we find a resurgence of interest in Democritus as an ethical theorist. This side of his thought is completely neglected by Plato and even by Aristotle, who pays minute attention to his physical theories. Even in the Hellenistic period he was regarded as a somewhat unsophisticated predecessor; Cicero says patronizingly that what he said was fine but not very polished, for he said little about virtue, and what he did say was not very articulate.[23] And yet he has acquired the rank of a major ethical theorist. He plays a strikingly large role in the introductory portion of Arius Didymus' account of ethics. Admittedly this is selective and seems to have been shortened at least once from a longer version; still, it is noteworthy that Democritus figures prominently twice alongside Plato. He and Plato both "put εὐδαι-μονία in the soul";[24] and there is a lengthy and interesting comparison of Democritus with the position of Plato's *Laws* on reason and pleasure.[25]

While the fragments we possess contain much of interest, as Gill

22. The present version of the paper is considerably revised and recast from the one read at the Berkeley meeting; and since many of my original comments have been met or overtaken by the revised version, the present comments are substantially new.

23. *De finibus* 5.87–88.

24. Arius 52.13–53.1.

25. Arius 53.1–20.

shows, they scarcely explain so notable a rehabilitation. It is only from
the Hellenistic sources that we learn that Democritus located εὐδαιμονία
in the soul, and called it εὐθυμία and the like;[26] εὐθυμία is our final
good, though this seems to be distinct from the happy life, which consists
in the pursuit of knowledge;[27] εὐθυμία is not pleasure but a calm and
stable state of soul.[28] Although our situation is rendered difficult by the
unsatisfactoriness of the fragments we possess, and although we should
heed Cicero's warning that Democritus' position was not very well
worked out, we can perhaps conjecture what it was about Democritus'
position that appealed to the much more sophisticated Hellenistic think-
ers. Democritus seems to have been seen as internalizing happiness:
happiness, our final end, is seen not as consisting in a certain life (the
pursuit of knowledge), but in the way the agent feels and is disposed in
living this life. In characterizing this as cheerfulness and well-being
Democritus could well seem a forerunner of Epicurus in ethics as well
as in physics, though Epicurus' view of pleasure is considerably more
sophisticated.

Ethical thinkers after Aristotle all share a common formal framework
for ethics. We seek a final end; this is given a thin specification as hap-
piness; the work goes into showing what it is that happiness consists in.
Gill begins from the sharp difference between Epicureans and Stoics on
this score: Epicurus claims that happiness consists in ἀταραξία; the
Stoics, that virtue is sufficient for happiness. From this difference, he
claims, flow others, notably that for the Stoics one's strategy for living
well consists in finding a context in which one can act virtuously; peace
of mind is not a goal one should aim at directly but is what results when
one has succeeded in becoming virtuous. The Democritean-Epicurean
approach, by comparison, is to aim directly at peace of mind, a strategy
which will result in, for example, discouraging desires one cannot fulfill.
The Democritean-Epicurean approach encourages the agent to modify
desires she already has and to give focus to and unify her life as it is,
with the aim of achieving greater peace of mind, while the Stoic ap-
proach is to focus only on becoming virtuous; there is no independent
value given to organizing or modifying one's desires as they are to
achieve peace of mind. Gill raises the interesting question of whether
Panaetius, who in many matters was prepared to modify orthodox Sto-
icism toward a more intuitive position, was prepared to combine Stoic
with Democritean-Epicurean strategies in his work On Peace of Mind. On

26. Arius 522.13–53.1. The list is interesting: εὐδαιμονία is called εὐθυμία, εὐεστώ,
ἁρμονία, συμμετρία, and ἀταραξία.
27. Cic. Fin. 5.87–88.
28. Diog. Laert. 9.45.

the face of it no compromise seems possible: if one's final end is virtue, then the only way to seek peace of mind is through being virtuous. Gill suggests that Panaetius sought to reconcile these different approaches by stressing the theme of "being yourself": I am most truly myself when thinking and acting as a rational moral agent, and it is focusing on this self that gives my life unity and produces peace of mind.

Gill's paper directs our attention to the way in which, in the Hellenistic period, different ethical schools were prepared to find common ground and to recast their own positions in terms taken over from or acceptable to their opponents. This phenomenon, very marked in Panaetius, has often been regarded as a weakness of later Hellenistic thought, but we are now beginning to appreciate it more justly.[29] Broadly, there are two motives for taking over parts of one's opponent's position, the combative and the irenic. The combative is what one finds in areas of intense debate: by taking over your opponent's position you show that you can accommodate it within your theory, thus neutralizing it as an objection to you.[30] The irenic arises from the desire to minimize differences, to show that different positions are putting forward basically the same idea. Panaetius' motive here seems to have been irenic; he is showing, as Seneca was later to do, that even Epicurus is in agreement with some basic points that seem uncompromisingly Stoic.

Whether an irenic compromise is giving too much away depends on how really distinct the different positions are to begin with. I will suggest that the kind of contrast that Gill draws between Epicurean and Stoic views of the final end does not capture interesting aspects of the Epicurean approach, and that the approaches of the two schools may not have been as distinct as he suggests.

It is common ground to all the schools, as I remarked above, that we seek a final end or good, and that this is happiness. Further, all the schools[31] accept that the final good, whatever its content, must be complete: it is not sought as a means to or part of any further good, whereas all the other goods we seek are sought as means to or parts of it. Epicurus certainly accepted this: the exposition of Epicurean ethics in *De fini-*

29. Cf. J. M. Dillon and A. A. Long, eds., *The Question of "Eclecticism": Studies in Later Greek Philosophy*, Hellenistic Culture and Society 2 (Berkeley, 1988), to which Gill also refers.

30. This is what we find, I believe, in the version of Peripatetic ethics in Arius Didymus; the author expounds Aristotelian ethics on the basis of οἰκείωσις, thus showing that starting from οἰκείωσις does not compel one to end up with a Stoic conclusion about the final end. See my paper, "The Hellenistic Version of Aristotle's Ethics," *The Monist* 73 (Jan. 1990): 80–96.

31. With the interesting exception of the Cyrenaics, who thought that we should maximize particular intense pleasures, without regard to our life as a whole (Diog. Laert. 2.37).

bus 1 contains the unambiguous point that "the highest or final or ultimate good (which the Greeks call τέλος) is that which itself has no further object, whereas it is the object of everything else."[32] Epicurus thus accepts that right from the start there is an important *formal* constraint on his final good, pleasure: it has to be pleasure so understood as to be a *complete* goal, a goal that includes all our other goals.

It is less certain that Democritus was aware of the need for such a formal constraint on his final end. We run up against the problem that our Hellenistic reports of his ethics make them sound more sophisticated than anything we find in the fragments, and we do not know how far Hellenistic thinkers recast his thoughts to fit more modern molds. In what follows I stick to the firmer ground of Epicurus' thought, though I am sure that Gill is right that Democritean elements were studied and developed alongside those of Epicurus in the Hellenistic period.

This formal constraint, which Epicurus never disputes, has crucial consequences for the way in which he conceives of the pleasure that we are to aim at. Pleasure, if it is to fit this role, cannot simply be a feeling; it must be something more lasting and capable of unifying all our projects. Thus Epicurus is led to distinguish kinetic from static pleasure: what we aim at in life is static pleasure, and this is ἀταραξία, peace of mind.[33] Ἀταραξία, however, is not just peace of mind in the intuitive sense, freedom from the things that are actually bothering you now. Right now I may be feeling free from care, but thinking one has peace of mind does not make it so. I will not actually have achieved ἀταραξία unless two substantial conditions are met: I must be experiencing the pleasure of being in the *natural* state, and I must be virtuous. Satisfying both these requirements takes us some way from our intuitions, but there is no doubt that Epicurus requires them.

Ἀταραξία, being static pleasure, is the pleasure of being in the natural state.[34] For it is the pleasure I get when I fulfill only natural desires. Epicurus' division of desires is too complex to deal with adequately here, but it is at least clear that he opposes natural desires to empty desires, which depend on "empty" beliefs, beliefs which are false and dysfunctional to the agent.[35] Natural desires spring from human nature; empty desires are based on false beliefs. Even this much makes it clear that we shall not be able correctly to identify desires as natural or as empty without knowing what human nature is and requires, and which beliefs are

32. *De finibus* 1.42.
33. For the distinction, see *De finibus* 1.37–39, 2.9; Diog. Laert. 10.136 (a very vexed passage); Usener 68; *Kuria doxa* 3.
34. See Usener 416, 417; Diogenes of Oenoanda F 2.8–13 Chilton.
35. *Letter to Menoeceus* 127; *Kuria doxa* 29; *Vatican Saying* 21.

false; and on both these issues Epicureans come to very different conclusions than do other people. The agent will identify very different desires as natural before and after internalizing Epicurean theory, for that theory will have greatly revised her views as to which beliefs are false. Epicurus does not remove this problem by telling us that natural desires are *easy* to fulfill,[36] for what normally counts as easy depends on what your means are, and he clearly does not mean that a desire for caviar is natural if it is easy for you to fulfill it, having lots of money. He means that natural desires are easy to fulfill for the person who has a right understanding of human nature. And thus seeking ἀταραξία turns out to require, not just an attitude to one's own desires now, as one is, but a correct understanding of one's human nature, and of which of one's beliefs are false—it turns out in fact to require quite a lot of Epicurean theory.

Achieving ἀταραξία further requires that the agent be virtuous, something that is not surprising if one gives due prominence to the requirement that one's final good must be complete, must include all of one's goals. Epicurus insists that to achieve the kind of pleasure that can be the agent's final good, it is necessary for him to be virtuous. For virtue alone is inseparable from pleasure, while all other goods can be separated from it;[37] pleasure and the virtues mutually entail each other;[38] and the virtues have grown to be a part of pleasure.[39] There is room for discussion as to whether Epicurus regarded virtue as having intrinsic value and as forming and making up the pleasant life to be aimed at, or whether he regarded it (as some of his language sometimes suggests) as having at best instrumental value.[40] But this does not affect the point that virtue is unavoidably necessary for the person seeking ἀταραξία. Peace of mind cannot be attained by doing bad things and then trying to forget them or to keep one's mind off them; one must live courageously, wisely, justly, and temperately to get the only kind of pleasurable peace of mind that can serve as one's final good.

The upshot of this is that I do not think Gill is right to characterize the Epicurean strategy as one in which peace of mind is "man's proper goal . . . a goal to be pursued deliberately, albeit one which was compatible with the practice of virtue in certain forms."[41] Rather, virtue, with-

36. Usener 469; *Kuria doxa* 15.
37. Diog. Laert. 10.138; Usener 506; *Letter to Menoeceus* 132.
38. *Kuria doxa* 5; *De finibus* 57; *Letter to Menoeceus* 132.
39. *Letter to Menoeceus* 132; the word is συμπεφύκασι.
40. I have argued for the former in "Epicurus on Pleasure and Happiness," *Philosophical Topics* 15 (1987): 5–21.
41. Gill, 334 above.

out any qualification of "certain forms," is essential to achieving peace of mind. One can, of course, act badly and in ignorance of what human nature requires, and feel good about it; but that is not peace of mind. The attainment of ἀταραξία demands that one accept Epicurean theory about human nature, that this be a *true* theory, and that one have the virtues.

I do not find, therefore, the large difference of approach that Gill does between Stoics and Epicureans here. In particular, I do not see why the Epicurean approach should be committed to greater concessions to individuals' natures as they are, or to focusing and unifying their lives as they are. Stoics and Epicureans are equally committed to the position that most people radically misconceive their own good; for neither of them is it true that we should seek peace of mind independently of being virtuous and of trying to understand human nature.

Gill produces a very startling comment ascribed to Epicurus from Plutarch's essay *On Peace of Mind* (465f–466a). People who care about honors and reputation, it goes, should enter public life, since they will be frustrated if they don't; and twice this is said to be because of their nature. If this is really an Epicurean dictum, it stands in the sharpest contrast to the Epicurean position as I have put it forward. For we find explicit concession to the way people actually are, and to their individual nature, even where that is highly faulty by Epicurean standards. One of the most central Epicurean tenets is that one should not go into public life, for its rewards are illusory and its frustrations certain. The idea that humans need public life and political involvement rests, according to Epicurus, on a wrong conception of what it is that humans do need, which is really fulfilled in small Epicurean gardens. It was this revisionary notion of what human nature requires, more than any other, which called forth opposition from the other schools.[42] It is extremely hard to see why Epicurus would have put forward the advice we find in Plutarch. It *can* be seen as advice for the beginner: someone who starts out with ambitions for public life is encouraged to fulfill them at first, lest frustrations interfere with his project of becoming an Epicurean. But this does not solve the problem, since it would be *bad* advice; political ambitions rest on false beliefs, and the more they are encouraged the more false and empty beliefs the agent will acquire, making it even more difficult for him to become an Epicurean. In fact, given Plutarch's open hostility to Epicureanism, and his policy of collecting passages in Stoic and Epicurean works that he sees as "contradicting" one another, it is hard not

42. Plutarch devotes a whole essay to it; it is prominent among the difficulties raised for the Roman Torquatus in *De finibus* 2.

to suspect that we have a passage which is misunderstood, or disingenuously misrepresented. But if Plutarch is being honest, and understanding what he is reporting, we must conclude that Epicurus did on occasion say things that contradicted his main theses.

If what I have suggested is right, Panaetius is not so much uniting different strategies as recognizing the extent of what Stoics and Epicureans share. While they differ on the content of the final good and of the status of virtue in it, they agree that it requires virtue and understanding of human nature. And rather than continue the debate on the content, Panaetius was happy to absorb whatever seemed of independent value in the rival approach: unifying one's life by memory and anticipation, for example, or stress on the management and redirection of one's desires.

If Panaetius tried to do this, as Gill suggests, by stressing the notion that the real self is the rational self, he was doing so on terms more favorable to Stoicism than to its rival, for there is a certain unclarity in Epicureanism as to the role of the rational self. There are many passages that stress the way that the agent can, by recalling past pleasures, negate the effect of present pain; the most famous is of course Epicurus' last letter. And these imply that a present experience acquires its significance from the person's rational attitude to it. But there is an obvious problem in reconciling these passages with the notorious thesis that "all good and evil lie in sensation," which is put to such crucial use in the argument that death is nothing to us.[43] Plutarch criticizes that argument on the reasonable ground that it is not true of us that all good and evil lie in sensation; this is precisely to neglect the rational component of our idea of the self. It is because we are rational beings that we care about our lives as wholes, and have attachments to things whose value transcends our lives.[44]

I agree with Gill, however, that Panaetius is certainly making a concession from orthodox Stoicism in considering peace of mind at length at all. My own explanation of this would put less stress than Gill does on the desire to incorporate a rival approach that makes peace of mind more prominent. For, as we have seen, Panaetius could certainly not compromise with the Epicureans on the *content* of the final good; while given their formal similarities, and the resulting concessions of the Epicureans to virtue, he could take over some of their strategies without qualm. Rather, I would see the increased importance that Panaetius gives to peace of mind as fitting in with his other attempts to decrease

43. *Letter to Menoeceus* 124–125.
44. Cf. 1098d–1099b.

the distance between Stoic theory and educated opinion, along with deemphasis of the role of the ideal agent and an increased interest in aspects of human nature other than the moral.[45]

All the Hellenistic schools agree that there are formal constraints on our final good, and that taking these seriously may involve us in considerable redefinition of happiness from what we intuitively take it to be. Once we grasp what the formal conditions require, we will be led to revise our priorities, and with them our conception of what it is that makes life worthwhile and happy. The Stoics take this process furthest: they claim that virtue is sufficient for happiness, for only virtue meets the formal conditions that happiness must. This violates our intuitions, indeed is the most notorious Stoic "paradox"; and although, like many other Stoic claims, it appears considerably less outrageous once we take into account the whole theory and the way it meets our intuitions overall, it remains one of the obvious stumbling blocks to ready acceptance of the theory. In giving peace of mind extended separate treatment, Panaetius may well have been attempting to show that the Stoic theory made more contact than commonly thought with intuitive demands on happiness; for peace of mind plays some part in most conceptions of happiness. In so doing he was not compromising orthodox Stoicism, though he was, in the spirit of his day, incorporating in an irenic way strategies and thoughts of value offered even by rival views.

45. Cf. Gill "Personhood and Personality: The Four-*Personae* Theory in Cicero's *De Officiis* I," "*OxfStAncPhilos* 6 (1988): 169–199.

SELECT BIBLIOGRAPHY

This bibliography lists the full titles of most of the secondary works referred to in the notes. Abbreviations used for titles of journals, series, and standard works are generally those to be found in *L'Année philologique* and the *Archäologischer Anzeiger,* though consistency has not always been possible.

Alföldi, A. *Caesar in 44 v. Chr.* 2 vols. Antiquitas Reihe 3. Abhandlungen zur Vor- und Frühgeschichte, zur klassischen und provinzial-römischen Archäologie und zur Geschichte des Altertums, nos. 16–17. Bonn, 1974–85.

———. "From the Aion Plutonios of the Ptolemies to the *Saeculum Frugiferum* of the Roman Emperors." In *Greece and the Eastern Mediterranean in Ancient History and Prehistory: Studies Presented to Fritz Schachermeyr on the Occasion of his Eightieth Birthday,* edited by K. H. Kinzl, 1–30. Berlin and New York, 1977.

———. *Studien über Caesars Monarchie.* Bulletin de la Societé Royale des Lettres de Lund, 1952–1953. Lund, 1953.

Anderson, G. *Ancient Fiction.* London, 1984.

Andrews, N. E. "The Poetics of the Argonautica of Apollonius of Rhodes: A Process of Reorientation. The Libyan Maidens." Diss., Harvard, 1989.

Annas, J. "Epicurus on Pleasure and Happiness." *Philosophical Topics* 15 (1987): 5–21.

———. "The Hellenistic Version of Aristotle's Ethics." *The Monist* 73 (Jan. 1990): 80–96.

Arrighetti, G. *Epicuro: Opere.* 2d ed. Biblioteca di cultura filosofica, no. 41. Turin, 1973.

Assmann, J. *Ägyptische Hymnen und Gebete.* Zurich and Munich, 1975.

Austin, C. *Comicorum graecorum fragmenta in papyris reperta.* Berlin and New York, 1973.

Austin, M. M. *The Hellenistic World from Alexander to the Roman Conquest: A Selection of Ancient Sources in Translation.* Cambridge, 1981.

Bachofen, J. J. *Gesammelte Werke.* Edited by K. Meuli. 10 vols. Basel, 1943–67.

Bagnall, R. S. *The Administration of the Ptolemaic Possessions outside Egypt.* Columbia Studies in the Classical Tradition, no. 4. Leiden, 1976.

——. "Egypt, the Ptolemies, and the Greek World." *Bulletin of the Egyptological Seminar* 3 (1981): 5–21.

——. "Greeks and Egyptians: Ethnicity, Status, and Culture." In *Cleopatra's Egypt,* edited by the Brooklyn Museum, 21–27. [See separate entry.]

Bean, G. E. "Notes and Inscriptions from Pisidia." *AnatSt* 9 (1959): 67–117.

Beckerath, J. von. *Handbuch der ägyptischen Königsnamen.* Münchener Ägyptologische Studien, no. 20. Munich and Berlin, 1984.

Bélis, A. "L'aulos phrygien." *RA* (1986): 21–40.

——. "Kroupezai, scabellum." *BCH* 112 (1988): 323–339.

Bell, L. "Luxor Temple and the Cult of the Royal Ka." *JNES* 44 (1985): 251–94.

Benoit, P., J. T. Milik, and R. de Vaux. *Discoveries in the Judaean Desert,* vol. 2, *Les grottes de Murabba'at.* Oxford, 1961.

Bergemann, J. "Pindar. Das Bildnis eines Konservativen Dichters." *AM* 106 (1991): 157–189.

Bernabé, A. *Poetarum epicorum graecorum testimonia et fragmenta.* Vol. 1. Leipzig, 1988.

Bernand, A. *Le delta égyptien d'après les textes grecs.* Mémoires publiés par les membres de l'institut français d'archéologie orientale du Cairo, no. 91. Cairo, 1970.

Bernand, E. *Recueil des inscriptions grecques du Fayoum.* Vol. 1, Leiden, 1975; vols. 2–3, Institut français d'archéologie orientale du Caire, Bibliothèque d'étude, nos. 79–80. Cairo, 1981.

Beschi, L. "Il monumento di Telemachos, fondatore dell'Asklepieion Ateniese." *ASAA* 45/46 (NS 29–30) (1967/1968): 381–436.

——. "Rilievi votivi attici ricomposti." *ASAA* 47/48 (NS 31–32) (1969/1970): 85–132.

——. "Il rilievo di Telemachos ricompletato." *AAA* 15 (1982): 31–43.

Betz, H. D., ed. *The Greek Magical Papyri in Translation, Including the Demotic Spells.* Chicago, 1986.

Bey, E. "Relief votif du Musée Impérial Ottoman." *BCH* 32 (1908): 521–528.

Beye, C. R. *Epic and Romance in the Argonautica of Apollonius.* Carbondale, 1982.

Bianchi, R. S. "The Pharaonic Art of Ptolemaic Egypt." In *Cleopatra's Egypt,* edited by the Brooklyn Museum, 55–80. [See separate entry.]

——. "Ptolemaic Egypt and Rome: An Overview." In *Cleopatra's Egypt,* edited by the Brooklyn Museum, 13–20. [See separate entry.]

Bichler, R. *"Hellenismus": Geschichte und Problematik eines Epochenbegriffs.* Impulse der Forschung, no. 41. Darmstadt, 1983.

Bieber, M. *Ancient Copies: Contributions to the History of Greek and Roman Art.* New York, 1977.

——. *The History of the Greek and Roman Theater.* 2d ed. Princeton, 1961.

——. *"Romani Palliati,* Roman Men in Greek *Himation." ProcPhilSoc* 103 (1959): 374–417.

——. *The Sculpture of the Hellenistic Age.* 2d ed. New York, 1961.

Binder, G. *Die Aussetzung des Königskindes: Kyros und Romulus.* Beiträge zur klassischen Philologie, no. 10. Meisenheim, 1964.

Bing, P. "Boves Errantes." *ZPE* 56 (1984): 16.

————. "Callimachus' Cows: A Riddling Recusatio." *ZPE* 54 (1984): 1–8.

————. "A Note on the New 'Musenanruf' in Callimachus' *Aetia*." *ZPE* 74 (1988): 273–275.

————. *The Well-Read Muse: Present and Past in Callimachus and the Hellenistic Poets.* Hypomnemata, no. 90. Göttingen, 1988.

Bing, P., and R. Cohen. *Games of Venus: An Anthology of Greek and Roman Erotic Verse from Sappho to Ovid.* New York, 1991.

Bingen, J. "Économie grecque et société égyptienne au IIIᵉ siècle." In *Das ptolemäische Ägypten*, edited by H. Maehler and V. M. Strocka, 211–219. [See separate entry.]

————. "Les Thraces en Égypte ptolémaïque." In *Semaines philippopolitaines de l'histoire et de la culture thrace*, 72–79. Thracia praehistorica. Supplementum pulpudeva 4. Academie bulgare des sciences. Institut de thracologie, Musée archéologique Plovdiv, Plovdiv 3–17 octobre 1980. Sofia, 1983.

————. "L'Égypte gréco-romaine et la problématique des interactions culturelles." In *Proceedings of the XVI International Congress of Papyrology, New York, 24–31 July 1980*, edited by R. S. Bagnall, G. M. Browne, A. E. Hanson, and L. Koenen, 3–18. American Studies in Papyrology, no. 23. Chico, Cal., 1981.

————. *Le papyrus Revenue Laws: Tradition grecque et adaptation hellénistique.* Rheinisch-Westfälische Akademie der Wissenschaften, Geisteswissenschaften, Vorträge G 231. Opladen, 1978.

————. "Présence grecque et milieu rural ptolémaïque." In *Problèmes de la terrre en Grèce ancienne*, edited by M. I. Finley, 215–222. Civilisations et sociétés, no. 33. Paris, 1973.

————. "La canéphore Nymphaïs et le calendrier sous Philopator." *CE* 50 (1975): 239–248.

Blumenthal, H. J. "Callimachus, Epigram 28, Numenius fr. 20, and the Meaning of κυκλικός." *CQ* 28 (1978): 125–127.

Boesch, P. *Theoros: Untersuchung zur Epangelie griechischer Feste.* Berlin, 1908.

Bol, P. C., and F. Eckstein. "Die Polybios-Stele in Kleitor/Arkadien." In *Antike Plastik*, no. 15, edited by F. Eckstein, 83–93. Im Auftrage des Deutschen Archäologischen Instituts. Berlin, 1975.

Bonnet, H. *Reallexikon der ägyptischen Religionsgeschichte.* Berlin, 1952.

Bousquet, J. "La stèle des Kyténiens au Létoon de Xanthos." *REG* 101 (1988): 12–53.

Bowersock, G. W. "Historical Problems in Late Republican and Augustan Classicism." In *Le classicisme à Rome*, edited by H. Flashar, 57–75 (discussion, 76–78). [See separate entry.]

Breasted, J. H. *Ancient Records of Egypt: Historical Documents from the Earliest Times to the Persian Conquest.* 5 vols. Chicago, 1906–7.

Bringmann, K. *Studien zu den politischen Ideen des Isokrates.* Hypomnemata, no. 14. Göttingen, 1965.

————. *Untersuchungen zum späten Cicero.* Hypomnemata, no. 29. Göttingen, 1971.

Broecker, H. *Animadversiones ad Plutarchi Libellum περὶ εὐθυμίας.* Habelts Dissertationsdrucke, Reihe klassische Philologie, vol. 2. Bonn, 1954.

Brooklyn Museum. *Cleopatra's Egypt: Age of the Ptolemies.* Catalog of an exhibition

held at the Brooklyn Museum, Oct. 7, 1988 – Jan. 2, 1989; the Detroit Institute of Arts, Feb. 14 – Apr. 30, 1989; and Kunsthalle der Hypo-Kulturstiftung in Munich, Germany, June 8 – Sept. 10, 1989. New York, 1988.

Brunkhorst, M. *Tradition und Transformation: Klassizistische Tendenzen in der englischen Tragödie von Dryden bis Thomson.* Komparatistische Studien, no. 10. Berlin and New York, 1979.

Brunner, H. *Die Geburt des Gottkönigs: Studien zur Überlieferung eines altägyptischen Mythos.* Ägyptologische Abhandlungen, no. 10. Wiesbaden, 1964.

Brunt, P. "Aspects of the Social Thought of Dio Chrysostom and of the Stoics." *PCPhS* 19 (1973): 9–34.

Buchner, E. "Zwei Gutachten für die Behandlung der Barbaren." *Hermes* 82 (1954): 378–384.

Bulloch, A. W. *Callimachus: The Fifth Hymn.* Cambridge Classical Texts and Commentaries, no. 26. Cambridge, 1985.

———. "The Future of a Hellenistic Illusion: Some Observations on Callimachus and Religion." *MH* 41 (1984): 209–230.

———. "Hellenistic Poetry." In *The Cambridge History of Classical Literature*, vol. 1, *Greek Literature*, 541–621. Cambridge, 1985.

Bundy, E. L. *Studia Pindarica.* 2 vols. University of California Publications in Classical Philology, no. 18.1–2. Berkeley, 1962; reprinted 1986.

Burkert, W. "Craft versus Sect: The Problem of Orphics and Pythagoreans." In *Self-definition in the Graeco-Roman World*, edited by B. F. Meyer and E. P. Sanders, 1–22. [See separate entry.]

———. "Krieg, Sieg und die olympische Götter der Griechen." In *Religion zu Krieg und Frieden*, edited by F. Stolz, 67–87. Zurich, 1986.

———. "Offerings in Perspective: Surrender, Distribution, Exchange." In *Gifts to the Gods: Proceedings of the Uppsala Symposium, 1985*, edited by T. Linders and G. Nordquist, 43–50. Acta Universitatis Upsaliensis: Boreas. Uppsala Studies in Ancient Mediterranean and Near Eastern Civilization, no. 15. Stockholm, 1987.

Burstein, S. M. "Pharaoh Alexander: A Scholarly Myth." *AncSoc* 22 (1991): 139–145.

———. Review of *The Cambridge Ancient History*, 2d ed., vol. 7.1. *CPh* 82 (1987): 164–168.

Cadoux, C. J. *Ancient Smyrna: A History of the City from the Earliest Times to 324.* Oxford, 1938.

Cairns, F. *Tibullus: A Hellenistic Poet at Rome.* Cambridge, 1979.

Caizzi, F. Decleva. *Pirrone: Testimonianze.* Elenchos, no. 5. Naples, 1981.

———. "Pirroniani ed accademici nel III secolo a.C." In *Aspects de la philosophie hellénistique*, edited by H. Flashar and O. Gigon, 147–178 (discussion, 179–183). [See separate entry.]

Caizzi, F. Decleva, and M. S. Funghi. "Un testo sul concetto stoico di progresso morale (PMil Vogliano Inv. 1241)." In *Aristoxenica, Menandrea, fragmenta philosophica*, edited by A. Brancacci, 85–124. Studi e testi per il corpus dei papiri filosofici greci e latini, no. 3. Studi (Accademia toscana di scienze e lettere La Colombaria), no. 91. Florence, 1988.

Cameron, A. "Poetae Novelli." *HSCP* 84 (1980): 135–141.

Capovilla, G. *Callimaco*. 2 vols. Studia philologica, no. 10. Rome, 1967.

Carrithers, M., S. Collins, and S. Lukes, eds. *The Category of the Person: Anthropology, Philosophy, History*. Cambridge, 1985.

Casson, L. "The Grain Trade of the Hellenistic World." *TAPhA* 85 (1954): 168–187.

Caulfield, T., A. Estner, and S. Stephens. "Complaints of Police Brutality (P. Mich. inv. no. 6957, 6961, and 6979)." *ZPE* 76 (1989): 241–254.

Cerfaux, L., and J. Tondriau. *Le culte des souverains dans la civilisation gréco-romaine*. Bibliothèque de Théologie, 3d series, no. 5. Tournai, 1957.

Chambers, R. R. "Greek Athletics and the Jews, 165 BC – AD 70." Diss., University of Miami, Ohio, 1980.

Charbonneaux, J. *La sculpture grecque et romaine au Musée du Louvre*. Paris, 1964.

Cheshire, W. "Zur Deutung eines Szepters der Arsinoe II. Philadelphos." *ZPE* 48 (1982): 105–111.

Clarysse, W. "Egyptian Estate-Holders in the Ptolemaic Period." In *State and Temple Economy in the Ancient Near East*, edited by E. Lipinski, 731–743. [See separate entry.]

———. "Une famille alexandrine dans la chora." *CE* 63 (1988): 137–140.

———. "Greeks and Egyptians in the Ptolemaic Army and Administration." *Aegyptus* 65 (1985): 57–66.

———. "Hakoris, an Egyptian Nobleman and His Family." *AncSoc* 22 (1991): 235–243.

———. "Literary Papyri in Documentary 'Archives.'" In *Egypt and the Hellenistic World*, edited by E. van 't Dack, P. van Dessel, and W. van Gucht, 43–61. [See separate entry.]

———. "Ptolemaeïsch Egypte: Een maatschappij met twee gezichten." *Handelingen XLV der Koninklijke Nederlandse Maatschappij voor Taal- en Letterkunde en Geschiedenis* (1991): 21–38.

———. "Some Greeks in Egypt." In *Life in a Multi-Cultural Society: Egypt from Cambyses to Constantine and Beyond*, edited by Janet H. Johnson, 51–56. Studies in Ancient Oriental Civilization, no. 51. Chicago, 1992.

Clarysse, W., and G. van der Veken with the assistance of S. P. Vleeming. *The Eponymous Priests of Ptolemaic Egypt*. Papyrologica Lugduno-Batava, no. 24. Leiden, 1983.

Clausen, W. "Cicero and the New Poetry." *HSCP* 90 (1986): 159–170.

Clay, D. "Individual and Community in the First Generation of the Epicurean School." In ΣΥΖΗΤΗΣΙΣ: *Studi sull'epicureismo greco e romano offerti a Marcello Gigante*, 255–279. 2 vols. Bibliotheca della Parola del Passato, no. 16. Naples, 1983.

Clayman, D. L. "Callimachus' *Iambi* and *Aitia*." *ZPE* 74 (1988): 277–286.

Collectanea Papyrologica. See under A. E. Hanson, ed.

Cornell, T. J. "Gründer" (A. Nichtchristlich). *RLAC* 12 (1983): 1107–1145.

Corsten, T. *Die Inschriften von Apameia (Bithynien) und Pylai*. Inschriften griechischer Städte aus Kleinasien, no. 32. Bonn, 1987.

Crawford, D. J. "The Good Official of Ptolemaic Egypt." In *Das ptolemäische Ägypten*, edited by H. Maehler and V. M. Strocka, 195–202. [See separate entry.]

———. *Kerkeosiris: An Egyptian Village in the Ptolemaic Period*. Cambridge, 1971.

————. "The Opium Poppy: A Study in Ptolemaic Agriculture." In *Problèmes de la terre en Grèce ancienne*, edited by M. I. Finley, 223–251. Civilisations et sociétés, no. 33. Paris, 1973.

Criscuolo, L., and G. Geraci, eds. *Egitto e storia antica dall'ellenismo all'età araba: Atti del colloquio internazionale, Bologna, 31 agosto – 2 sett., 1987.* Bologna, 1989.

Crowther, N. B. "Greek Games in Republican Rome." *AC* 52 (1983): 268–273.

Cumont, F. V. M. *Recherches sur le symbolisme funéraire des Romains.* Haut-commissariat de l'état français en Syrie et au Liban, Service des antiquités, Bibliothèque archéologique et historique, no. 35. Paris, 1942.

Cunningham, I. C. *Herodas: Mimiambi.* Oxford, 1971.

Daszewski, W. A. *Corpus of Mosaics from Egypt,* vol. 1, *Hellenistic and Early Roman Period.* Aegyptiaca Treverensia, no. 3. Mainz, 1985.

Daumas, F. *Les moyens d'expression du grec et de l'égyptien comparés dans les décrets de Canope et de Memphis.* Supplément aux Annales du Service des antiquités de l'Égypte, no. 16. Cairo, 1952.

Daux, G. *Delphes au IIe et au Ier siècle, depuis l'abaissement de l'Étolie jusqu'à la paix romaine, 191–31 av. J.-C.* Bibliothèque des écoles françaises d'Athènes et de Rome, no. 140. Paris, 1937.

David, M., B. A. van Groningen, and E. Kiessling. *Berichtigungsliste der griechischen Papyrusurkunden aus Ägypten.* Vol. 3. Leiden, 1958.

Davies, N. de G. *The Rock Tombs of El Amarna.* 6 vols. Egypt Exploration Fund, Archaeological Survey of Egypt Memoirs, nos. 13–18. London, 1903–8; reprinted Oxford, 1973–75.

Del Corno, D. *Menandro: Le commedie.* Vol. 1. Milan, 1966.

Delia, D. Review of *Greeks in Ptolemaic Egypt* by N. Lewis. *The International History Review* 10.2 (1988): 309–311.

Delorme, J. *Gymnasion: Étude sur les monuments consacrés à l'éducation en Grèce (des origines à l'Empire romain).* Bibliothèque des écoles françaises d'Athènes et de Rome, no. 196. Paris, 1960.

Dentzer, J. M. *Le motif du banquet couché dans le proche-orient et le monde grec du VIIe au IVe siècle avant J.-C.* Bibliothèque des écoles françaises d'Athènes et de Rome, no. 246. Paris and Rome, 1982.

Derchain, P. "La garde 'Égyptienne' de Ptolémée II." *ZPE* 65 (1986): 203–204.

Diakonoff, I. "Artemidi Anaeiti Anestesen: The Anaeitis-Dedications in the Rijksmuseum van Oudheden at Leyden and Related Material from Eastern Lydia." *BABesch* 54 (1979): 139–188.

Dickins, G. *Catalogue of the Acropolis Museum.* 2 vols. Cambridge, 1912–21.

Diels, H. *Die Fragmente der Vorsokratiker.* 10th ed. Revised by W. Kranz. Berlin, 1952.

————. *Laterculi Alexandrini.* Berlin, 1904.

Diepolder, H. *Die attischen Grabreliefs des 5. und 4. Jahrhunderts.* Berlin, 1931.

Diggle, J. *Euripides: Phaethon.* Cambridge Classical Texts and Commentaries, no. 12. Cambridge, 1970.

Dihle, A. *Die Entstehung der griechischen Biographie.* Abhandlungen der Akademie der Wissenschaften zu Göttingen, Philologisch-Historische Klasse, 3. Folge, no. 37. Göttingen, 1956.

————. *Griechische Literaturgeschichte.* Stuttgart, 1967; 2d ed., Munich, 1991.

————. "Philosophie—Fachwissenschaft—Allgemeinbildung." In *Aspects de la*

philosophie hellénistique, edited by H. Flashar and O. Gigon, 185–223. [See separate entry.]

———. "Philosophie und Tradition im 5. Jh. v.C." In *Wegweisende Antike: Zur Aktualität humanistischer Bildung: Festgabe für Günter Wöhrle,* edited by O. Herding and E. Olshausen, 13–24. *Humanistische Bildung,* Beiheft 1. Stuttgart, 1986.

———. "Zur spätantiken Kultfrömmigkeit." In *Pietas: Festschrift für Bernhard Kötting,* edited by E. Dassmann and K. S. Frank, 39–54. *JbAChr* 8. Münster, 1980.

Dillon, J. M., and A. A. Long, eds. *The Question of "Eclecticism": Studies in Later Greek Philosophy.* Hellenistic Culture and Society, no. 2. Berkeley, 1988.

Dodds, E. R. *Euripides: Bacchae.* 2d ed. Oxford, 1960.

Doerrie, H. *Der Königskult des Antiochos von Kommagene im Lichte neuer Inschriftenfunde.* Abhandlungen der Akademie der Wissenschaften in Göttingen, 3. Reihe, no. 60. Göttingen, 1964.

Dohrn, T. "Gefältete und verschränkte Hände: Eine Studie über die Gebärde in der griechischen Kunst." *JDAI* 70 (1955): 50–80.

Dover, K. J. *Greek Homosexuality.* Cambridge, Mass., 1978. (Updated ed. 1989)

———. *Theocritus: Select Poems.* London, 1971.

Drew-Bear, T. *Nouvelles inscriptions de Phrygie.* Studia Amstelodamensia ad epigraphicam, ius antiquum et papyrologicam pertinentia, no. 16. Zutphen, 1978.

Droysen, J. G. *Geschichte des Hellenismus.* 2 vols. Berlin and Hamburg, 1836–43.

Düring, I. *Aristotle in the Ancient Biographical Tradition.* Acta Universitatis Gothoburgenis. Göteborgs universitets årsskrift, v. 63, 1957, 2 (= Studia Graeca et Latina Gothoburgensia, no. 5). Göteborg, 1957; reprinted New York, 1987.

Durrbach, F., et al., eds. *Inscriptions de Délos.* 7 vols. Paris, 1926–1972.

Duthoy, R. "Qu'est-ce qu'une *polis*? Esquisse d'une morphologie succincte." *LEC* 54 (1986): 3–20.

Dyck, A. "On Panaetius' Conception of μεγαλοψυχία." *MH* 38 (1981): 153–161.

———. "The Plan of Panaetius's περὶ τοῦ καθήκοντος." *AJPh* 100 (1979): 408–416.

Dyroff, A. *Die Ethik der alten Stoa.* Berliner Studien für classische Philologie und Archaeologie, neue Folge, Bd. 2, Heft 2–4. Berlin, 1897; reprinted 1979.

Easterling, P. E., and B. M. W. Knox, eds. *Cambridge History of Classical Literature,* vol. 1, *Greek Literature.* Cambridge, 1985.

Edelstein, L. *The Meaning of Stoicism.* Martin Classical Lectures, no. 21. Cambridge, Mass., 1966.

Edgar, C. C. *Zenon Papyri.* 4 vols. Catalogue général des antiquités égyptiennes du Musée de Caire, vols. 79, 82, 85, 90. Cairo, 1925–31.

———. *Zenon Papyri in the University of Michigan Collection.* University of Michigan Studies, Humanistic Series, no. 24. Ann Arbor, 1931.

Edwards, C. M. "Greek Votive Reliefs to Pan and the Nymphs." Diss., New York, 1985.

Effe, B., ed. *Hellenismus.* Vol. 4 of *Die griechische Literatur in Text und Darstellung,* edited by H. Gorgemanns. Stuttgart, 1985.

Ehrenberg, V. *The Greek State.* Oxford, 1960.

————. *Der Staat der Griechen.* 2 vols. Leipzig, 1957–58. [Reprinted Darmstadt, 1960; Zurich and Stuttgart, 1965.]

Eichgrün, E. "Kallimachos und Apollonios Rhodios." Diss., Berlin, 1961.

Encyclopédie photographique de l'art. Paris, 1936.

Erskine, A. *The Hellenistic Stoa.* London, 1990.

Eucken, C. *Isokrates: Seine Position in der Auseinandersetzung mit den zeitgenössischen Philosophen.* Untersuchungen zur antiken Literatur und Geschichte, no. 19. Berlin and New York, 1983.

Evans, J. A. "The Temple of Soknebtunis." *YCS* 17 (1961): 149–283.

Fantham, E. "Roman Experience of Menander in the Late Republic and Early Empire." *TAPhA* 114 (1984): 299–309.

Faraone, C. A. "Callimachus Epigram 29.5–6." *ZPE* 63 (1986): 53–56.

Fecht, G. "Amarna-Probleme." *ZAeS* 85 (1960): 83–118.

Fehr, B. *Bewegungsweisen und Verhaltensideale: Physiognomische Deutungsmöglichkeiten der Bewegungsdarstellung an griechischen Statuen des 5. und 4. Jh. v. Chr.* Bad Bramstedt, 1979.

Ferguson, W. S. "The Attic Orgeones." *HThR* 37 (1944): 62–140.

————. "Orgeonika." In *Commemorative Studies in Honor of Theodore Leslie Shear,* 130–163. Hesperia, supplement no. 8. Princeton, 1949.

Festugière, A.-J. *Épicure et ses dieux.* Paris, 1946; 2d ed., Mythes et religions, no. 19, 1968; 3d ed., Collection "Quadrige," no. 64, 1985.

Festugière, A.-J., ed. *Historia Monachorum in Aegypto.* Subsidia Hagiographica 34. Brussels, 1961.

Finley, M. I. *The World of Odysseus.* 2d ed. London, 1977.

Firatli, N. *Les stèles funéraires de Byzance gréco-romaine.* Bibliothèque archéologique et historique de l'Institut français d'archéologie d'Istanbul, no. 15. Paris, 1964.

Fishwick, D. "Statues Taxes in Roman Egypt." *Historia* 38 (1989): 335–347.

Fittschen, K. "Zur Rekonstruktion griechischer Dichterstatuen. 1. Teil: Die Statue des Menander." *AM* 106 (1991): 243–279.

Flashar, H. "Die klassizistische Theorie der Mimesis." In *Le classicisme à Rome,* edited by H. Flashar, 79–97 (discussion, 98–111). [See separate entry.]

Flashar, H., ed. *Le classicisme à Rome aux 1ers siècles avant et après J.-C.* Fondation Hardt, Entretiens, no. 25. Geneva, 1979.

————. *Die Philosophie der Antike,* vol. 3, *Ältere Akademie, Aristoteles, Peripatos.* Grundriss der Geschichte der Philosophie. Basel and Stuttgart, 1983.

Flashar, H., and O. Gigon, eds. *Aspects de la philosophie hellénistique.* Fondation Hardt. Entretiens, no. 32. Geneva, 1986.

Foot, P. *Virtues and Vices.* Oxford, 1978.

Forbes, C. A. "Expanded Uses of the Greek Gymnasium." *CPh* 40 (1945): 32–42.

Fraenkel, H. *Noten zu den Argonautika des Apollonios.* Munich, 1968.

Fränkel, M. *Die Inschriften von Pergamon.* 2 vols. Altertümer von Pergamon, nos. 8.1–2. Berlin, 1890–95.

Frankfort, H. *Kingship and the Gods: A Study of Ancient Near Eastern Religion as the Integration of Society and Nature.* Chicago, 1948.

Fraser, P. M. *Ptolemaic Alexandria.* 3 vols. Oxford, 1972.

Frel, J. *The Getty Bronze.* Malibu, Cal., 1978; rev. ed. 1982.

Freyer-Schauenburg, B. "Io in Alexandria." *Röm. Mitt.* 90 (1983): 35–49.

Friedrich, G. *Catulli Veronensis liber.* Leipzig and Berlin, 1908.

Friis Johansen, K. *The Attic Grave-Reliefs of the Classical Period: An Essay in Interpretation.* Copenhagen, 1951.

Frisch, P. *Die Inschriften von Ilion.* Inschriften griechischer Städte aus Kleinasien, no. 3. Bonn, 1975.

Frischer, B. *The Sculpted Word: Epicureanism and Philosophical Recruitment in Ancient Greece.* Berkeley, 1982.

Fuchs, W. "Attische Nymphenreliefs." *MDAI(A)* 77 (1962): 242–249.

Furtwängler, A. *Kleine Schriften.* Edited by J. Sieveking and L. Curtius. 2 vols. Munich, 1912–13.

Gabathuler, M. "Hellenistische Epigramme auf Dichter." Diss., Basel, 1937.

Gagos, T., L. Koenen, and B. McNellen. "A First Century Archive from Oxyrhynchos or Oxyrhynchite Loan Contracts and Egyptian Marriage." In *Life in a Multi-Cultural Society: Egypt from Cambyses to Constantine and Beyond,* edited by Janet H. Johnson, 181–205. Studies in Ancient Oriental Civilization, no. 51. Chicago, 1992.

Gaiser, K. *Platons ungeschriebene Lehre: Studien zur systematischen und geschichtlichen Begründung der Wissenschaften in der platonischen Schule.* Stuttgart, 1963.

Gallo, I. "Commedia e filosofia in età ellenistica. Batone." *Vichiana* 5 (1976): 206–242.

Garlan, Y. "À propos des nouvelles inscriptions d'Iasos." *ZPE* 9 (1972): 223–224.

———. "Décret d'Iasos en l'honneur d'Antiochos III." *ZPE* 13 (1974): 197–198.

Gauthier, P. *Les cités grecques et leurs bienfaiteurs.* Bulletin de correspondance hellénique, Supplement no. 12. Paris, 1985.

Gawantka, W. *Die sogenannte Polis: Zur Entstehung, Geschichte und Kritik der modernen althistorischen Grundbegriffes der griechische Staat, die griechische Staatsidee, die Polis.* Wiesbaden, 1985.

———. *Isopolitie: Eine Beitrag zur Geschichte der zwischenstaatlichen Beziehungen in der griechischen Antike.* Vestigia, no. 22. Munich, 1975.

Geffcken, J. *Kynika und Verwandtes.* Heidelberg, 1909.

Gehrke, H.-J. *Geschichte des Hellenismus.* Oldenbourg Grundriss der Geschichte, no. 1A. Munich, 1990.

———. "Der siegreiche König: Überlegungen zur hellenistischen Monarchie." *AKG* 64 (1982): 247–277.

Gelzer, T. "Aristophanes 12, der Komiker (Nachtrag)." *RE* Suppl. 12 (1970): 1392–1569.

———. "Kallimachos und das Zeremoniell des ptolemäischen Königshauses." In *Aspekte der Kultursoziologie: Aufsatze zur Soziologie, Philosophie, Anthropologie und Geschichte der Kultur: Zum 60. Geburtstag von Mohammed Rassem,* edited by J. Stagl, 13–30. Berlin, 1982.

———. "Klassizismus, Attizismus und Asianismus." In *Le classicisme à Rome,* edited by H. Flashar, 1–41. [See separate entry.]

———. "Mimus und Kunsttheorie bei Herondas, Mimiambus 4." In *Catalepton: Festschrift für Bernhard Wyss zum 80. Geburtstag,* edited by C. Schäublin, 96–116. Basel, 1985.

Gentili, B. *Poetry and Its Public in Ancient Greece: From Homer to the Fifth Century.* Translated by A. T. Cole. Baltimore, 1988.

Ghedini, F. *Sculture greche e romane del Museo Civico di Padova.* Collezioni e musei archeologici del Veneto, no. 12. Rome, 1980.

Gill, C. "Personhood and Personality: The Four-*Personae* Theory in Cicero *De Officiis* I." *OxfStAncPhilos* 6 (1988): 169–199.

———. *The Self in Dialogue: Character and Personality in Greek Literature and Philosophy.* Oxford, forthcoming.

Giovannini, A. "Le statut des cités de Macédoine sous les Antigonides." In *Ancient Macedonia: Papers Read at the Second International Symposium Held in Thessaloniki, 19–24 August, 1973,* 465–472. Institute for Balkan Studies, no. 155. Thessaloniki, 1977.

———. *Untersuchungen über die Natur und die Anfänge der bundesstaatlichen Sympolitie in Griechenland.* Hypomnemata, no. 33. Göttingen, 1971.

Giuliani, L. *Bildnis und Botschaft: Hermeneutische Untersuchungen zur Bildniskunst der römischen Republik.* Frankfurt, 1986.

Gladigow, B. "Der Sinn der Götter: Zum kognitiven Potential der persönlichen Gottesvorstellung." In *Gottesvorstellung und Gesellschaftsentwicklung,* edited by P. Eicher, 41–62. Forum Religionswissenschaft, no. 1. Munich, 1979.

Glotz, G. *La cité grecque.* Paris, 1928.

Goldstine, H. H. *New and Full Moons, 1001 B.C. to A.D. 1651.* Memoirs of the American Philosophical Society, no. 94. Philadelphia, 1973.

Gomme, A. W., and F. H. Sandbach. *Menander: A Commentary.* Oxford, 1973.

Gosling, J. C. B., and C. C. W. Taylor. *The Greeks on Pleasure.* Oxford, 1982.

Goudriaan, K. *Ethnicity in Ptolemaic Egypt.* Dutch monographs on ancient history and archaeology, no. 5. Amsterdam, 1988.

Goulet-Cazé, M.-O. *L'ascèse cynique: Un commentaire de Diogène Laërce VI 70–71.* Histoire des doctrines de l'antiquité classique, no. 10. Paris, 1986.

Gow, A. S. F. *Theocritus.* 2 vols. Cambridge, 1952.

Gow, A. S. F., and D. L. Page, eds. *Hellenistic Epigrams.* 2 vols. Cambridge, 1965.

Goyon, J.-C. "Ptolemaic Egypt: Priests and the Traditional Religion." In *Cleopatra's Egypt,* edited by the Brooklyn Museum, 29–39. [See separate entry.]

Graham, A. J. *Colony and Mother City in Ancient Greece.* Manchester, 1964.

Grayson, A. K. *Babylonian Historical-Literary Texts.* Toronto Semitic Texts and Studies, no. 3. Toronto, 1975.

Griffin, M. "Philosophy, Cato, and Roman Suicide." *G&R* 33 (1986): 64–77.

Griffith, J. G. *Plutarch's De Iside et Osiride.* Cardiff, 1970.

Griffiths, F. T. *Theocritus at Court.* Mnemosyne, supplement no. 55. Leiden, 1979.

Grilli, A. *Il problema della vita contemplativa nel mondo greco-romano.* Milan and Rome, 1953.

Grimal, P. "Les éléments philosophiques dans l'idée de monarchie de Rome à la fin de la république." In *Aspects de la philosophie hellenistique,* edited by H. Flashar and O. Gigon, 233–273. [See separate entry.]

Grimm, G. "Die Vergöttlichung Alexanders des Großen in Ägypten und ihre Bedeutung für den ptolemäischen Königskult." In *Das ptolemäische Ägypten,* edited by H. Maehler and V. M. Strocka 103–112. [See separate entry.]

Gross, W. H. *Herakliskos Commodus.* Akademie der Wissenschaften, Göttingen. Philologisch-historische Klasse Nachrichten, 1973, No. 4. Göttingen, 1973.

Gruen, E. S. "The Coronation of the Diadochoi." In *The Craft of the Ancient Historian: Essays in Honor of Chester G. Starr,* edited by J. W. Eadie and J. Ober, 253–271. Lanham, 1985.

———. *The Hellenistic World and the Coming of Rome.* 2 vols. Berkeley, 1984.

Grzybek, E. *Du calendrier macédonien au calendrier ptolémaïque: Problèmes de chronologie hellénistique.* Schweizerische Beiträge zur Altertumswissenschaft, no. 20. Basel, 1990.

Gschnitzer, F., ed. *Zur griechischen Staatskunde.* Wege der Forschung, no. 96. Darmstadt, 1969.

Guarducci, M. "L'offerta di Xenokrateia nel santuario di Cefiso al Falero." In *Phoros: Tribute to B. D. Meritt,* edited by D. W. Bradeen and M. F. McGregor, 57–66. Locust Valley, N.Y., 1974.

Guéraud O., and P. Jouguet. *Un Livre d'écolier du IIIe siècle avant J.-C.* Publications de la société Fouad I de papyrologie, textes et documents, no. 2. Cairo, 1938.

Günther, W. *Das Orakel von Didyma in hellenistischer Zeit. Eine interpretation von Steinurkunden.* Istanbuler Mitteilungen, Beiheft no. 4. Tübingen, 1971.

Habicht, C. "Ambrakia und der thessalische Bund zur Zeit des Perseuskrieges." In *Demetrias,* edited by V. Milojcic and D. Theocharis, 1:157–173. Beiträge zur ur- und frühgeschichtlichen Archäologie des Mittelmeer-Kulturraumes, no. 12. Bonn, 1976.

———. *Gottmenschentum und griechische Städte.* 2d ed. Zetemata, no. 14. Munich, 1970.

———. "Makedonen in Larisa?" *Chiron* 13 (1983): 21–32.

———. *Pausanias' Guide to Ancient Greece.* Sather Classical Lectures, no. 50. Berkeley, 1985.

———. *Studien zur Geschichte Athens in hellenisticher Zeit.* Hypomnemata, no. 73. Göttingen, 1982.

———. "Über eine armenische Inschrift mit Versen des Euripides." *Hermes* 81 (1953): 251–256.

———. *Untersuchungen zur politischen Geschichte Athens im 3. Jahrhundert vor Christus.* Vestigia, no. 30. Munich, 1979.

Hadot, I. *Seneca und die griechisch-römische Tradition der Seelenteilung.* Quellen und Studien zur Geschichte und Philosophie, no. 13. Berlin, 1969.

Hafner, G. *Späthellenistische Bildnisplastik: Versuch einer landschaftlichen Gliederung.* Berlin, 1954.

Hagedorn, D., U. Hagedorn, and L. Koenen. *Didymos der Blinde: Kommentar zu Hiob IV.1.* Papyrologische Texte und Abhandlungen, no. 33.1. Bonn, 1985.

Hamdorf, F. W. *Griechische Kultpersonifikationen der vorhellenistischen Zeit.* Mainz, 1964.

Hammond, N. G. L., and F. W. Walbank. *A History of Macedonia,* vol. 3, *336–167 B.C.* Oxford, 1988.

Handley, E. W. "Comedy." In *The Cambridge History of Classical Literature,* vol. 1, *Greek Literature,* 355–425. Cambridge, 1985.

———. *The Dyskolos of Menander.* London, 1965.

———. *Menander and Plautus: A Study in Comparison.* London, 1968.

Hanson, A. E., ed. *Collectanea Papyrologica: Texts Published in Honor of H. C. Youtie.* 2 vols. Papyrologische Texte und Abhandlungen, nos. 19–20. Bonn, 1976.

Harder, A. "Callimachus and the Muses: Some Aspects of Narrative Technique in *Aitia* 1–2." *Prometheus* 14 (1988): 1–14.

Hauben, H. "Arsinoé II et la politique extérieure." In *Egypt and the Hellenistsic World,* edited by E. van 't Dack, P. van Dessel, and W. van Gucht, 99–127. [See separate entry.]

———. "Aspects du culte des souverains a l'époque des Lagides." In *Egitto e storia antica dall'ellenismo all'età araba,* edited by L. Criscuolo and G. Geraci, 441–467. [See separate entry.]

———. "L'expédition de Ptolemée III en Orient et la sédition domestique de 245 av. J.-C." *APF* 36 (1990): 29–37.

Hausmann, U. *Griechische Weihreliefs.* Berlin, 1960.

———. *Kunst und Heiltum: Untersuchungen zu den griechischen Asklepiosreliefs.* Potsdam, 1948.

Hazzard, R. A. "The Regnal Years of Ptolemy II Philadelphus." *Phoenix* 41 (1987): 140–158.

Heer, C. De. MAKAP—ΕΥΔΑΙΜΩΝ—ΟΛΒΙΟΣ—ΕΥΤΥΧΗΣ. *A Study of the Semantic Field Denoting Happiness in Ancient Greek to the End of the Fifth Century B.C.* Amsterdam, 1969.

Heichelheim, F. "Sitos." *RE* Suppl. 6 (1935): 819–892.

———. *Wirtschaftliche Schwankungen der Zeit von Alexander bis Augustus.* Beiträge zur Erforschung der wirtschaftlichen Wechsellagen, Aufschwung, Krise, Stockung, no. 3. Jena, 1930.

Heinen, H. "Aspects et problèmes de la monarchie ptolémaïque." *Ktema* 3 (1978): 177–199.

———. "L'Égypte dans l'historiographie moderne du monde hellénistique." In *Egitto e storia antica dall'ellenismo all'età araba,* edited by L. Criscuolo and G. Geraci, 105–135. [See separate entry.]

———. "Heer und Gesellschaft im Ptolemäerreich." *AncSoc* 4 (1973): 91–114.

———. Review of *Greeks in Ptolemaic Egypt* by N. Lewis. *Gnomon* 62 (1990): 531–534.

———. "Die Tryphe des Ptolemaios VIII. Euergetes II. Beobachtungen zum ptolemäischen Herrscherideal und zu einer römischen Gesandtschaft in Ägypten (140/39)." In *Althistorische Studien Hermann Bengtson zum 70. Geburtstag dargebracht,* edited by H. Heinen, 116–130. Historia Einzelschriften, no. 40. Wiesbaden, 1983.

Heldmann, K. *Antike Theorien über Entwicklung und Verfall der Redekunst.* Zetemata, no. 77. Munich, 1982.

Heller, T. C., M. Sosna, and D. E. Wellbery, eds. *Reconstructing Individualism: Autonomy, Individuality, and the Self in Western Thought.* Stanford, 1986.

Hengstl, J. *Griechische Papyri aus Ägypten als Zeugnisse des öffentlichen und privaten Lebens.* Munich, 1978.

Henrichs, A. "Callimachus *Epigram* 28: A Fastidious Priamel." *HSCP* 83 (1979): 207–212.

———. "Ein Meropiszitat in Philodems *De Pietate.*" *Cronache Ercolanesi* 7 (1977): 124–125.

———. "Riper Than a Pear: Parian Invective in Theokritos." *ZPE* 39 (1980): 7–27.

———. "Zur Meropis: Herakles' Löwenfell und Athenes zweite Haut." *ZPE* 27 (1977): 69–75.

Henrichs, A., and L. Koenen. "Der Kölner Mani-Kodex (P. Colon. inv. nr. 4780): περὶ τῆς γέννης τοῦ σώματος αὐτοῦ. Edition der Seiten 1–72." *ZPE* 19 (1975): 1–85.

———. "Der Kölner Mani-Kodex (P. Colon. inv. nr. 4780): περὶ τῆς γέννης τοῦ σώματος αὐτοῦ. Edition der Seiten 99, 10–120." *ZPE* 44 (1981): 201–318.

Herman, G. "The 'Friends' of the Early Hellenistic Rulers: Servants or Officials?" *Talanta* (Proceedings of the Dutch Archaeological and Historical Society) 12/13 (1980/81): 103–149.

———. *Ritualised Friendship and the Greek City.* Cambridge, 1987.

Hermann, A. *Die ägyptische Königsnovelle.* Leipziger Ägyptologische Studien, no. 10. Glückstadt, Hamburg, and New York, 1938.

Herrmann, J. "Zum Begriff γῆ ἐν ἀφέσει." *CE* 30 (1955): 95–106.

Herrmann, P. "Antiochos der Grosse und Teos." *Anadolu* 9 (1965 [1967]): 29–160.

———. "Ergebnisse einer Reise in Nordostlydien." *Denkschriften der Gesamtakademie. Österreichische Akademie der Wissenschaften Wien,* no. 80. Graz, Vienna, and Köln, 1962.

———. "Milesier am Seleukidenhof: Prosopographische Beiträge zur Geschichte Milets im 2. Jhdt. v. Chr." *Chiron* 17 (1987): 171–192.

———. "Neue Urkunden zur Geschichte von Milet im 2. Jarhundert v. Chr." *MDAI(I)* 15 (1965): 71–117.

———. "Die Selbstdarstellung der hellenistischen Stadt in den Inschriften. Ideal und Wirklichkeit." In *Acts of the VIII Epigraphical Congress, Athens, 1982,* vol.1, 108–119. Athens, 1984.

Herrmann, P., and K. Z. Polatkan. "Das Testament des Epikrates und andere neue Inschriften aus dem Museum von Manisa." *Österreichische Akademie der Wissenschaften, Philosophisch-Historische Klasse, Sitzungsberichte,* no. 265,1. Vienna, 1969.

Herter, H. "Die Haaröle der Berenike." In *Medizingeschichte in unserer Zeit: Festgabe für Edith Heischkel-Artelt und Walter Artelt zum 65. Geburtstag,* edited by H. H. Eulner, G. Mann, G. Preiser, R. Winau, and O. Winkelmann, 54–68. Stuttgart, 1971. [Reprinted in *Kallimachos,* edited by A. D. Skiadas, 186–206 (Wege der Forschung, no. 296; Darmstadt, 1975); and in H. Herter, *Kleine Schriften,* 417–432 (Studia et testimonia antiqua, no. 15; Munich, 1975).]

Herzog, R. *Die Wunderheilungen von Epidauros: Ein Beitrag zur Geschichte der Medizin und der Religion.* Philologus Supplement, no. 22.3. Leipzig, 1931.

Herzog, R., and G. Klaffenbach. *Asylieurkunden aus Kos.* Sitzungsberichte der Deutschen Akademie der Wissenschaften zu Berlin. Klasse für Sprachen, Literatur und Kunst 1952.1. Berlin, 1952.

Hesberg, H. von. "Bildsyntax und Erzählweise in der hellenistischen Flächenkunst." *JDAI* 103 (1988): 309–365.

Heuss, A. "Die archaische Zeit Griechenlands als geschichtliche Epoche." *A&A*

2 (1946): 26–62. [Reprinted in *Zur griechischen Staatskunde*, ed. F. Gschnitzer, 36–96; see separate entry.]

Himmelmann-Wildschütz, N. "Der Entwicklungsbegriff der modernen Archäologie." *Marburger Winckelmann-Programm* 1960 (1961): 13–40.

Hirzel, R. *Untersuchungen zu Ciceros philosophischen Schriften.* 3 vols. Leipzig, 1877–83.

Holleaux, M. "Questions épigraphiques." *REG* 10 (1897): 24–57.

Holmes, L. "Myrrh and Unguents in the Coma Berenices." *CPh* 87 (1992): 47–50.

Höpfner, W., and E.-L. Schwandner. *Haus und Stadt im klassischen Griechenland.* Wohnen in der klassischen Polis, no. 1. Munich, 1986.

Hopkinson, N. *A Hellenistic Anthology.* Cambridge, 1988.

Horn, R. *Hellenistische Bildwerke auf Samos.* Samos, no. 12. Bonn, 1972.

———. *Stehende weibliche Gewandstatuen in der hellenistischen Plastik. MDAI(R)* Ergänzungsheft no. 2. Munich, 1931.

Hornblower, S. *Mausolus.* Oxford, 1982.

Hornung, E. *Conceptions of God in Egypt: The One and the Many.* Translated from *Der Eine und die Vielen* (Darmstadt, 1971) by J. Baines. Ithaca, N.Y., 1982.

———. "Der Mensch als 'Bild Gottes' in Ägypten." In *Die Gottebenbildlichkeit des Menschen,* edited by O. Loretz, 123–156. Schriften des Deutschen Instituts für Wissenschaftliche Pädagogik. Munich, 1967.

———. "Politische Planung und Realität im alten Ägypten." *Saeculum* 22 (1971): 48–65.

Hossenfelder, M. "Epicurus: Hedonist Malgré Lui." In *The Norms of Nature: Studies in Hellenistic Ethics,* edited by M. Schofield and G. Striker, 245–263. Cambridge, 1986.

Houghton, A. "A Colossal Head in Antakya and the Portraits of Seleucus I." *AK* 29 (1986): 52–62.

Hunter, R. L. *Eubulus: The Fragments.* Cambridge Classical Texts and Commentaries, no. 24. Cambridge, 1983.

———. "'Short on Heroics': Jason in the *Argonautica*." *CQ* 38 (1988): 436–453.

Huss, W. "Die in ptolemäischer Zeit verfaßten Synodal-Dekrete." *ZPE* 88 (1991): 189–208.

———. "Staat und Ethos nach den Vorstellungen eines ptolemäischen Dioiketes des 3. Jh. Bemerkungen zu P. Teb. III 1, 703." *APF* 27 (1980), 67–77.

———. *Untersuchungen zur Außenpolitik Ptolemaios' IV.* Münchener Beiträge zur Papyrusforschung und antiken Rechtsgeschichte, no. 69. Munich, 1976.

Hutchinson, G. O. *Aeschylus: Septem contra Thebas.* Oxford, 1985.

———. *Hellenistic Poetry.* Oxford, 1988.

Huxley, G. L. "Arsinoe Lokris." *GRBS* 21 (1980): 239–244.

———. "Βουπόρος Ἀρσινόης." *JHS* 100 (1980): 189–190.

Huys, M. *Papyri Bruxellenses Graecae.* Vol. 2. Brussels, 1991.

Ijsewijn, J. *De sacerdotibus sacerdotiisque Alexandri Magni et Lagidarum eponymis.* Verhandelingen van de Koninklijke Academie voor Wetenschappen, Letteren en Schone Kunsten van België, Klasse der Letteren, no. 42. Brussels, 1961.

Inscriptions de Délos: see under Durrbach, F.

Irigoin, J. *Histoire du texte de Pindare.* Paris, 1952.

Jacoby, F. *Apollodors Chronik: Eine Sammlung der Fragmente.* Philologische Untersuchungen, no. 16. Berlin, 1902.

Jacoby, F., ed. *Die Fragmente der griechischen Historiker.* 3 parts in 15 vols. Berlin and Leiden, 1923–58.

Jacques, J. M. "Sur un acrostiche d'Aratos." *REA* 62 (1960): 48–61.

Jaeger, W. *Paideia.* 4th ed. 3 vols. Berlin, 1959. [4th ed. of English translation in 3 vols., Oxford, 1954–61.]

Jamot, P. "Fouilles de Thespies." *BCH* 19 (1895): 321–385.

Jannaris, A. N. *An Historical Greek Grammar.* London, 1897.

Jenkins, G. K. *Ancient Greek Coins.* New York, 1972.

Johnson, J. H. "The Role of the Egyptian Priesthood in Ptolemaic Egypt." In *Egyptological Studies in Honor of Richard A. Parker,* edited by L. H. Lesko, 70–84. Hanover and London, 1986.

Johnson, J. H., ed. *Life in a Multi-Cultural Society: Egypt from Cambyses to Constantine and Beyond.* Studies in Ancient Oriental Civilizations, no. 51. Chicago, 1992.

Kahn, C. "Democritus and the Origins of Moral Philosophy." *AJPh* 106 (1985): 1–31.

Kamal, Ahmed-Bey. "Stèle de l'an VIII, de Ramsès II." *Recueil de travaux relatifs à la philologie et à l'archéologie égyptiennes et assyriennes* 30 (1908): 213–218.

Kaploni-Heckel, U. "Zum demotischen Baugruben-Graffito vom Satis-Tempel auf Elephantine." *MDAI(K)* 43 (1987): 155–172.

Karouzou, S. "Bemalte attische Weihreliefs." In *Studies in Classical Art and Archaeology: A Tribute to Peter Heinrich von Blanckenhagen,* edited by G. Kopcke and M. B. Moore, 111–116. Locust Valley, N.Y., 1979.

———. *National Archaeological Museum, Collection of Sculpture: A Catalogue.* Archaeological Guides of the General Direction of Antiquities and Restoration, no. 15. Athens, 1968.

Kasher, A. "The Jewish Attitude to the Alexandrian Gymnasium in the First Century AD." *AJAH* 1 (1976): 148–161.

Kassel, R. *Die Abgrenzung des Hellenismus in der griechischen Literaturgeschichte.* Berlin and New York, 1987.

———. *Menandri Sicyonius.* Kleine Texte für Vorlesungen und Übungen, no. 185. Berlin, 1965.

———. "Wilamowitz über griechische und römische Komödie." *ZPE* 45 (1982): 271–300.

Kerkhecker, A. "Ein Musenanruf am Anfang der Aitia des Kallimachos." *ZPE* 71 (1988): 16–24.

Kern, O. *Die Inschriften von Magnesia am Maeander.* Berlin, 1900.

Keydell, R. "Eine Nonnos-Analyse." *AC* 1 (1932): 173–202. [Reprinted in *Kleine Schriften zur hellenistischen und spätgriechischen Dichtung (1911–1976),* 485–514. Opuscula, no. 14. Leipzig, 1982.]

Kindstrand, J. F. *Bion of Borysthenes: A Collection of the Fragments with Introduction and Commentary.* Studia graeca Upsaliensia, no. 11. Uppsala, 1976.

Klein, L. "Die Göttertechnik in den Argonautika des Apollonios Rhodios." *Philologus* 86 (1931): 18–51, 215–257.

Kloft, H. *Liberalitas Principis: Herkunft und Bedeutung. Studien zur Prinzipatsideologie.* Kölner historische Abhandlungen, no. 18. Köln, 1970.

Knox, P. E. "The Epilogue to the *Aetia*." *GRBS* 26 (1985): 59–65.

Koenen, L. "Die Adaption ägyptischer Königsideologie am Ptolemäerhof." In *Egypt and the Hellenistic World*, edited by E. van 't Dack, P. van Dessel, and W. van Gucht, 143–190. [See separate entry.]

———. *Eine agonistische Inschrift aus Ägypten und frühptolemäische Königsfeste.* Beiträge zu klassische Philologie, no. 56. Meisenheim, 1977.

———. "Der brennende Horusknabe." *CE* 37 (1962): 167–174.

———. "Die demotische Zivilprozeßordnung." *APF* 17 (1960): 11–16.

———. "The Dream of Nektanebos." In *Classical Studies Presented to W. H. Willis*, edited by D. Hobson and K. McNamee, 171–194. *BASP* 22 (New York, 1985).

———. "Egyptian Influences in Tibullus." *ICS* 1 (1976): 127–159.

———. "Kleopatra III. als Priesterin des Alexanderkultes (P. Colon. inv. nr. 5063)." *ZPE* 5 (1970): 61–84.

———. "Manichaean Apocalypticism at the Crossroads of Iranian, Egyptian, Jewish, and Christian Thought." In *Codex Manichaicus Coloniensis: Atti del simposio internazionale, Rende-Amantea, 3–7 settembre 1984*, edited by L. Cirillo, 285–332. Università degli Studi della Calabria, Centro interdipartimentale di scienze religiose, studi e richerche, no. 4. Cosenza, 1986.

———. *Eine ptolemäische Königsurkunde (P. Kroll).* Klassisch-philologische Studien, no. 19. Wiesbaden, 1957.

———. "Θεοῖσιν ἐχθρός." *CE* 34 (1959): 103–119.

———. "Die Unschuldbeteuerungen des Priestereides und die römische Elegie." *ZPE* 2 (1968): 31–38.

Koenen, L., and R. Merkelbach. "Apollodoros (Περὶ Θεῶν), Epicharm und die Meropis." In *Collectanea Papyrologica*, edited by A. E. Hanson, 1:3–26. [See separate entry.]

Koenen, L., and D. B. Thompson. "Gallus as Triptolemos on the Tazza Farnese." *BASP* 21 (1984): 110–156.

Kontes, I. D. "Artemis Brauronia." *AD* 22 A′ (1967): 156–206.

Krafft, P. "Zu Kallimachos' Echo-Epigramm (28 Pf.)." *RhM* 120 (1977): 1–29.

Krahmer, G. "Stilphasen der hellenistischen Plastik." *MDAI(R)* 38/39 (1923/24): 138–184.

Kramer, B., and D. Hagedorn. "Zwei ptolemäische Texte aus der hamburger Papyrussammlung, 1. Eingabe an den König." *APF* 33 (1987): 9–16.

Kranz, W. "Die Urform der attischen Tragödie und Komödie." *Neue Jahrbücher für die klassische Altertumsgeschichte und deutsche Litteratur und für Pädagogik 43*, Jg. 22 (1919): 145–168.

Krauss, R. *Sothis- und Monddaten: Studien zur astronomischen und technischen Chronologie Altägyptens.* Hildesheimer Ägyptologische Beiträge, no. 20. Hildesheim, 1985.

Kreeb, M. *Untersuchungen zur figürlichen Ausstattung delischer Privathäuser.* Chicago, 1988.

Kreissig, H. "Die Polis in Griechenland und im Orient in der hellenistischen Epoche." In *Hellenische Poleis*, edited by E. C. Welskopf, 2:1074–1084. 4 vols. Berlin 1974.

Kroll, W. *Studien zum Verständnis der römischen Literatur.* Stuttgart, 1924.

Kruse-Bertoldt, V. "Kopienkritische Untersuchungen zu den Porträts des Epi-
kur, Metrodor, und Hermarch." Diss., Göttingen, 1975.

Kuhrt, A., and S. Sherwin-White, eds. *Hellenism in the East: The Interaction of Greek
and Non-Greek Civilizations from Syria to Central Asia after Alexander.* Hellenistic
Culture and Society, no. 2. London and Berkeley, 1987.

Kyrieleis, H. *Bildnisse der Ptolemäer,* DAI, Archäologische Forschungen, no. 2.
Berlin, 1975.

———. "Καθάπερ Ἑρμῆς καὶ Ὧρος." In *Antike Plastik,* no. 12, edited by F. Eck-
stein, 133–146. Im Auftrage des Deutschen Archäologischen Instituts. Ber-
lin, 1973.

Labowsky, L. *Die Ethik des Panaitios. Untersuchungen zur Geschichte des decorum bei
Cicero und Horaz.* Leipzig, 1934.

Lanciers, E. "Die ägyptischen Priester des ptolemäischen Königskultes (Zusam-
menfassung)." In *Life in a Multi-Cultural Society: Egypt from Cambyses to Constan-
tine and Beyond,* edited by Janet H. Johnson, 207–208. Studies in Ancient
Oriental Civilization, no. 51. Chicago, 1992.

———. "The Cult of the Theoi Soteres and the Date of Some Papyri from the
Reign of Ptolemy V Epiphanes." *ZPE* 66 (1986): 61–63.

———. "Die Vergöttlichung und die Ehe des Ptolemaios IV. und der Arsinoe
III." *APF* 34 (1988): 27–32.

Lane, E. *Corpus Monumentorum Religionis Dei Menis.* 4 vols. Études préliminaires
aux religions orientales dans l'Empire romain, no. 19. Leiden, 1971.

Lasserre, F. "Prose grecque classicisante." In *Le classicisme à Rome,* edited by H.
Flashar, 135–163 (discussion, 164–173). [See separate entry.]

Laubscher, H. P. "Ein ptolemäisches Gallierdenkmal." *AK* 30 (1987): 131–154.

———. "Skulpturen aus Tralles: Zu einem neuen Zweifiguren relief." *MDAI(I)*
16 (1966): 115–129.

———. "Triptolemos und die Ptolemäer." *Jahrbuch des Museums für Kunst und
Gewerbe Hamburg* 6/7 (1988): 11–40.

Launey, M. *Recherches sur les armées hellénistiques.* 2 vols. Bibliothèque des écoles
françaises d'Athènes et de Rome, 1st ser., fasc. 169. Paris, 1949–50.

Lauter, H. *Die Architektur des Hellenismus.* Darmstadt, 1986.

Lawall, G. "Apollonius' *Argonautica*: Jason as Anti-Hero." *YClS* 19 (1966): 119–
169.

Lebek, W. D. "Drei lateinische Hexameterinschriften" *ZPE* 20 (1976): 167–177.

Lefkowitz, M. R. "The Pindar Scholia." *AJPh* 106 (1985): 269–282.

Lehnus, L. *Bibliografia Callimachea 1489–1988.* Dipartimento di Archeologia,
Filologia Classica e Loro Tradizioni, new series, no. 123. Genoa, 1989.

Lenger, M.-T. *Corpus des ordonnances des Ptolémées, bilan des additions et corrections
(1964–1988), compléments à la bibliographie.* Papyrologica Bruxellensia, no. 24.
Brussels, 1990.

Lesky, A. *Geschichte der griechischen Literatur.* 3d ed. Bern and Munich, 1971.

Lewis, N. *Greeks in Ptolemaic Egypt: Case Studies in the Social History of the Hellenistic
World.* Oxford, 1986.

Lichtheim, M. *Ancient Egyptian Literature: A Book of Readings.* 3 vols. Berkeley,
1973–80.

Lieberg, G. "Die Theologia tripartita als Formprinzip antiken Denkens." *RhM* 125 (1982): 25–53.

Linfert, A. "Die Deutung des Xenokrateiareliefs." *MDAI(A)* 82 (1967):149–157.

———. *Kunstzentren hellenistischer Zeit: Studien an weiblichen Gewandfiguren.* Wiesbaden, 1976.

Lipinski, E., ed. *State and Temple Economy in the Ancient Near East: Proceedings of the International Conference Organized by the Katholieke Universiteit Leuven from the 10th to the 14th of April, 1978.* 2 vols. Orientalia Lovaniensia analecta, nos. 5–6. Leuven, 1979.

Lippold, G. *Die griechische Plastik.* Handbuch der Archäologie im Rahmen des Handbuchs der Altertumswissenschaft, no. 3.1. Munich, 1950.

Lissarrague, F. *The Aesthetics of the Greek Banquet: Images of Wine and Ritual.* Translated by A. Szegedy-Maszak. Princeton, 1990. (*Un flot d'images: Un esthétique du banquet grec.* Paris, 1987.)

Livrea, E. "Der Liller Kallimachos und die Mausefallen." *ZPE* 34 (1979): 37–42.

———. "La morte di Clitorio." *ZPE* 68 (1987): 21–28.

———. "Polittico Callimacheo: Contributi al testo della Victoria Berenices." *ZPE* 40 (1980): 21–26.

Lloyd-Jones, H. *Greek Comedy, Hellenistic Literature, Greek Religion, and Miscellanea.* Oxford, 1990.

———. *Greek Epic, Lyric, and Tragedy.* Oxford, 1990.

———. "A Hellenistic Miscellany." *SIFC* 77 (1984): 52–72. [Reprinted in *Greek Comedy, Hellenistic Literature, Greek Religion, and Miscellenea.*]

———. "Menander's *Aspis.*" *GRBS* 12 (1971): 175–195. [Reprinted in *Greek Comedy, Hellenistic Literature, Greek Religion, and Miscellenea.*]

———. "Menander's *Samia* in the Light of the New Evidence." *YClS* 22 (1972): 119–144. [Reprinted in *Greek Comedy, Hellenistic Literature, Greek Religion, and Miscellenea.*]

———. "Menander's *Sikyonios.*" *GRBS* 7 (1966): 131–157. [Reprinted in *Greek Comedy, Hellenistic Literature, Greek Religion, and Miscellenea.*]

———. "The *Meropis.*" In *Atti del XVII Congresso Internazionale di Papirologia, Napoli, 19–26 maggio 1983,* 1:41-150. 3 vols. Centro Internazionale per lo Studio dei Papiri Ercolanesi. Naples, 1984.

———. Review of *Scenes from Greek Drama* by Bruno Snell. *Gnomon* 38 (1966): 12–17. [Reprinted in *Greek Epic, Lyric, and Tragedy.*]

Lloyd-Jones, H., and P. Parsons, eds. *Supplementum Hellenisticum.* Texte und Kommentare, no. 11. Berlin and New York, 1983.

Long, A. A. "Pleasure and Social Utility: The Virtues of Being Epicurean." In *Aspects de la Philosophie Hellénistique,* edited by H. Flashar and O. Gigon, 283–324. [See separate entry.]

———. "Socrates in Hellenistic Philosophy." *CQ* 38 (1988): 150–171.

Long, A. A., and D. N. Sedley. *The Hellenistic Philosophers.* 2 vols. Cambridge, 1987.

Lord, K. O. "Pindar in the Second and Third Hymns of Callimachus." Diss., University of Michigan, Ann Arbor, 1990.

Lowenstam, S. *The Death of Patroklos: A Study in Typology.* Beiträge zur klassische Philologie, no. 133. Königstein, 1981.

Ludwig, A. "Die Kunst der Variation im hellenistischen Liebesepigramm." In *L'épigramme grecque*, edited by O. Reverdin, 297–334 (discussion, 335–348). Fondation Hardt, Entretiens, no. 14. Geneva, 1967.

Lukes, S. *Individualism*. Oxford, 1973.

Lullies, R., and M. Hirmer. *Griechische Plastik*. 4th ed. Munich, 1979.

Maehler, H., and V. M. Strocka, eds. *Das ptolemäische Ägypten: Akten des internationalen Symposions, 27.–29. Sept. 1976 in Berlin*. Mainz, 1978.

Magie, D. *Roman Rule in Asia Minor: To the End of the Third Century after Christ*. Princeton, 1950.

Malherbe, A. J. "Self-definition among Epicureans and Cynics." In *Self-definition in the Graeco-Roman World*, edited by B. F. Meyer and E. P. Sanders, 46–59. [See separate entry.]

Mansfeld, J. "Diogenes Laertius on Stoic Philosophy." In *Diogene Laerzio: Storico del pensiero antico. Atti del convegno internazionale tenutosi a Napoli e Amalfi dal 30 sett. al 3 ott. 1985*, 295–382. *Elenchos*, no. 7. Naples, 1986.

Marinone, N. *Berenice da Callimaco a Catullo*. Ricerche di storia della lingua latina, no. 17. Rome, 1984.

Marrou, H.-I. *Histoire de l'éducation dans l'antiquité*. Paris, 1965.

Marshall, A. J. "The Survival and Development of International Jurisdiction in the Greek World under Roman Rule." *ANRW* 2.13 (1980): 626–661.

Martinez, D. G. *P. Michigan XVI: A Greek Love Charm from Egypt (P. Mich. 757)*. American studies in papyrology, no. 30: Michigan papyri, no. 16. Atlanta, 1991.

Mathieu, G. *Les idées politiques d'Isocrate*. Paris, 1925; reprinted 1966.

Matz, F. "Belli facies et triumphus." In *Festschrift für Carl Weickert*, edited by Gerda Bruns, 41–58. Berlin, 1955.

Mayer, C. *Das Öl im Kultus der Griechen*. Würzburg, 1917.

Mayser, E. *Grammatik der griechischen Papyri aus der Ptolemäerzeit*. Revised by H. Schmoll. Berlin, 1970.

McCormack, J. M. R. "The Gymnasiarchal Law of Beroia." In *Ancient Macedonia II: Papers Read at the Second International Symposium Held in Thessaloniki, 19–24 August 1973*, 139–150. Institute for Balkan Studies, no. 155. Thessaloniki, 1977.

McShane, R. B. *The Foreign Policy of the Attalids of Pergamon*. Illinois Studies in the Social Sciences, no. 53. Urbana, 1964.

Mehl, A. "Δορίκτητος χώρα." *AncSoc* 11/12 (1980/81): 173–212.

———. *Seleukos Nikator und sein Reich*, vol. 1, *Seleukos' Leben und die Entwicklung seiner Machtposition*. Studia Hellenistica, no. 28. Leuven 1986.

Meillier, C. *Callimaque et son temps: Recherches sur la carrière et la condition d'un écrivain à l'époque des premiers Lagides*. Publications de l'Université de Lille, no. 3. Lille, 1979.

Mélèze-Modrzejewski, J. "Le statut des hellènes dans l'Égypte lagide." In "Bulletin de bibliographie thématique: Histoire," *REG* 96 (1983): 241–268.

Mellor, R. *The Worship of the Goddess Roma in the Greek World*. Hypomnemata, no. 42. Göttingen, 1975.

Mendel, G. *Catalogue des sculptures grecques, romaines et byzantines*. 3 vols. Istanbul: Arkeoloji Muzeleri: Klasik Eserler Muzesi. Constantinople, 1912–14.

Meritt, B. D. "Greek Inscriptions." *Hesperia* 5 (1936): 355–441.
———. "Greek Inscriptions." *Hesperia* 36 (1967): 57–101, 225–241.
Merkelbach, R. "Ein ägyptischer Priestereid." *ZPE* 2 (1968): 7–30.
———. "Altägyptische Vorstellungen in christlichen Texten aus Ägypten." In *Mélanges Etienne Bernand,* edited by N. Fick and J.-C. Carriere, 337–342. Annales Littéraires de l'Université de Besançon, no. 444. Paris, 1991.
———. "Die Erigone des Eratosthenes." In *Miscellanea di studi Alessandrini in memoria di A. Rostagni,* 469–526. Turin, 1963.
———. "Fragment eines satirischen Romans: Aufforderung zur Beichte." *ZPE* 11 (1973): 81–87.
———. *Isisfeste in griechisch-römischer Zeit: Daten und Riten.* Beiträge zur klassischen Philologie, no. 5. Meisenheim, 1963.
———. "Das Königtum der Ptolemäer und die hellenistischen Dichter." In *Alexandrien: Kulturbegegnungen dreier Jahrtausende im Schmelztiegel einer mediterranen Großstadt,* 27–35. Aegyptiaca Treverensia, no. 1. Mainz, 1981.
———. "'Loi sacrée' dans l'Égypte gréco-romaine." *AncSoc* 11/12 (1980/81): 227–240.
———. *Die Quellen des griechischen Alexanderromans.* 2d ed. Zetemata, no. 9. Munich, 1977.
Mette, H. J. *Urkunden dramatischer Aufführungen in Griechenland.* Texte und Kommentare, no. 8. Berlin and New York, 1977.
Meuli, K. "Entstehung und Sinn der Trauersitten." *Schweizerisches Archiv fur Volkskunde* 43 (1946): 91–109. [Reprinted in *Gesammelte Schriften* 1 : 333–351.]
———. *Gesammelte Schriften.* Edited by T. Gelzer. 2 vols. Basel, 1975.
Meyer, B. F., and E. P. Sanders, eds. *Self-definition in the Graeco-Roman World.* Vol. 3 of *Jewish and Christian Self-definition.* London and Philadelphia, 1983.
Michel, C. *Recueil d'inscriptions grecques.* Paris, 1900.
Migeotte, L. *L'emprunt public dans les cités grecques: Recueil des documents et analyse critique.* Québec and Paris, 1984.
Mineur, W. H. *Callimachus, Hymn to Delos.* Mnemosyne, supplement no. 83. Leiden, 1984.
Mitropoulou, E. "Attic Workshops." *AAA* 8 (1975): 118–123.
———. *Corpus 1: Attic Votive Reliefs of the Sixth and Fifth Centuries BC.* Athens, 1977.
Mitten, D. G., and S. F. Doeringer. *Master Bronzes from the Classical World.* Catalog of an exhibition at the Fogg Art Museum, City Art Museum of St. Louis, and the Los Angeles County Museum of Art. Mainz, 1967.
Möbius, H. "Eine bemalte Grabstele." In *Festschrift A. Rumpf: Zum 60. Geburtstag dargebracht von Freunden und Schülern, Köln im Dez. 1950,* 116–118. Krefeld, 1952.
Modrzejewski, J. "Chrématistes et laocrites." In *Le monde grec: Pensée, littérature, histoire, documents. Hommages à Claire Préaux,* edited by Jean Bingen, Guy Cambier, and Georges Nachtergael, 699–708. Université libre de Bruxelles, Faculté de philosophie et lettres, no. 62. Brussels, 1975.
Moftah, R. *Studien zum ägyptischen Königsdogma im Neuen Reich.* DAI Kairo, Sonderschrift, no. 20. Mainz, 1985.
Mollard-Besques, S. *Catalogue raisonné des figurines et reliefs en terre-cuite grecs,*

etrusques et romains. 4 vols. Musée de Louvre: Département des antiquités grecques et romaines. Paris, 1954–63.

Mommsen, T. *Römische Geschichte.* 9th ed. 5 vols. Berlin, 1902–4.

Mooren, L. *The Aulic Titulature in Ptolemaic Egypt: Introduction and Prosography.* Verhandelingen van de Koninklijke Academie voor Wetenschappen, Letteren en Schone Kunsten van België, Klasse der Letteren, no. 37.78. Brussels 1975.

———. "The Nature of the Hellenistic Monarchy." In *Egypt and the Hellenistic World,* edited by E. van 't Dack, P. van Dessel, and W. van Gucht, 205–240. [See separate entry.]

Moret, A. *Du caractère religieux de la royauté pharaonique.* Annales du Musée Guimet. Bibliothèque d'études, no. 15. Paris, 1902.

Müller, C. W. *Erysichthon: Der Mythos als narrative Metapher im Demeterhymnos des Kallimachos.* Mainz: Akademie der Wissenschaften und der Literatur, Abhandlungen der Geistes- und Sozialwissenschaftlichen Klasse, no. 13. Stuttgart, 1987.

Muller, W. M. *Egyptological Researches.* 3 vols. Carnegie Institution of Washington, publication no. 53. Washington, 1906–20.

Musti, D. "Sull'idea di συγγένεια in iscrizioni greche." *ASNP* 32 (1963): 225–239.

Mylonas, G. E. *Eleusis and the Eleusinian Mysteries.* Princeton, 1961.

Nachtergael, G. "Bérénice II, Arsinoé III et l'offrande de la boucle." *CE* 55 (1980): 240–253.

———. "La chevelure d'Isis." *AC* 50 (1981): 584–606.

Nehamas, A. *Nietzsche: Life as Literature.* Cambridge, Mass., 1985.

Nesselrath, H.-G. *Die attische mittlere Komödie: Ihre Stellung in der antiken Literaturkritik und Literaturgeschichte.* Untersuchungen zur antiken Literatur und Geschichte, no. 36. Berlin and New York, 1990.

Neumann, G. *Probleme des griechischen Weihreliefs.* Tübinger Studien zur Archäologie und Kunstgeschichte, no. 3. Tübingen, 1979.

Neuser, K. *Anemoi: Studien zur Darstellung der Winde und Windgottheiten in der Antike.* Archaeologica, no. 19. Rome, 1982.

Niehues-Pröbsting, H. *Der Kynismus des Diogenes und der Begriff des Zynismus.* Humanistische Bibliothek: Reihe 1, Abhandlungen, no. 40. Munich, 1979.

Nietzsche, F. W. *The Birth of Tragedy.* Translated by W. A. Haussmann. New York, 1974.

———. *The Gay Science.* Translated by W. Kaufmann. New York, 1974.

Nill, M. *Morality and Self-interest in Protagoras, Antiphon, and Democritus.* Philosophia antiqua, no. 43. Leiden, 1985.

Nilsson, M. P. *Geschichte der griechischen Religion.* 3d ed. 2 vols. Handbuch der Altertumswissenschaft, no. 5.2. Munich, 1967–74.

———. *Griechischer Glaube.* Sammlung Dalp, no. 64. Bern, 1946.

———. *Opuscula Selecta.* 3 vols. Schrifter utg. av Svenska institutet i Athen (Acta Instituti Atheniensis Regni Sueciae), no. 80.2. Lund, 1951–60.

Nisbet, R. G. M., and M. Hubbard. *Commentary on Horace Odes Book II.* Oxford, 1978.

Noll, R. *Griechische und lateinische Inschriften der wiener Antikensammlung.* Vienna, 1962.

Norden, E. *Die antike Kunstprosa: Vom 6. Jahrhundert v. Chr. bis in die Zeit der Re-naissance.* 2d ed. 2 vols. Leipzig, 1915–18.

Obbink, D. "Hymn, Cult, Genre." Forthcoming.

Oikonomides, A. N. *The Two Agoras in Ancient Athens: A New Commentary on Their History and Development, Topography and Monuments.* Chicago, 1964.

Onasch, C. "Zur Königsideologie der Ptolemäer in den Dekreten von Kanopus und Memphis." *APF* 24–25 (1976): 137–155.

Otto, W., and H. Bengtson. *Zur Geschichte des Niederganges des Ptolemäerreiches: Ein Beitrag zur Regierungszeit des 8. und des 9. Ptolemäers.* Abhandlungen der Bayerische Akademie der Wissenschaften, Phil.-hist. Abteilung, no. 17. Munich, 1938.

Page, D. L., ed. *Further Greek Epigrams.* Cambridge, 1981.

Palagia, O. "Imitation of Herakles in Ruler Portraiture: A Survey, from Alexander to Maximinus Daza." *Boreas* 9 (1986): 137–151.

Papyri Greek and Egyptian Edited by Various Hands in Honour of Eric Gardner Turner on the Occasion of His Seventieth Birthday. Egypt Exploration Society, Graeco-Roman Memoirs, no. 68. London, 1981.

Parfit, D. *Reasons and Persons.* Oxford, 1984.

Parsons, P. J. "Callimachus: Victoria Berenices." *ZPE* 25 (1977): 1–50.

Peek, W. *Griechische Grabgedichte.* Berlin, 1960.

———. *Griechische Vers-Inschriften,* vol. 1, *Grab-Epigramme.* Berlin, 1955.

Perdrizet, P. "Reliefs mysiens." *BCH* 23 (1899): 592–599.

Peremans, W. "Le bilinguisme sous les Lagides." In *Egypt and the Hellenistic World,* edited by E. van 't Dack, P. van Dessel, and W. van Gucht, 253–280. [See separate entry.]

———. "Classes sociales et conscience nationale en Égypte ptolémaïque." In *Miscellanea in honorem J. Vergote,* edited by P. Naster, H. de Meulenaere, and J. Quaegebeur, 443–453. Orientalia Lovaniensia Periodica, no. 6/7. Louvain, 1975/76.

———. "Les Égyptiens dans l'armée de terre des Lagides." In *Althistorische Studien Hermann Bengtson zum 70. Geburtstag dargebracht von Kollegen und Schülern,* edited by H. Heinen, 92–102. Historia Einzelschriften, no. 40. Wiesbaden, 1983.

———. "Égyptiens et étrangers dans l'armée de terre et dans la police de l'Égypte ptolémaïque." *AncSoc* 3 (1972): 67–76.

———. "Égyptiens et étrangers dans l'organisation judiciaire des Lagides." *AncSoc* 13/14 (1982/83): 147–159.

———. "Étrangers et Égyptiens en Égypte sous le règne de Ptolémée Iᵉʳ." *AncSoc* 11/12 (1980/81): 213–226.

———. "Un groupe d'officiers dans l'armée des Lagides." *AncSoc* 8 (1977): 175–185.

———. "Les ἑρμηνεῖς dans l'Égypte gréco-romaine." In *Das römisch-byzantinische Ägypten: Akten des internationalen Symposions 26.–30. September 1978 in Trier,* 11–17. Aegyptiaca Treverensia, no. 2. Mainz, 1983.

———. "Les Lagides, les élites indigènes et la monarchie bicéphale." In *Le système palatial en Orient, en Grèce et à Rome: Actes du Colloque de Strasbourg 19–22 juin 1985,* edited by E. Lévi, 327–343. Travaux du Centre de Recherche sur le Proche-Orient et la Grèce antiques, no. 9. Leiden, 1987.

———. "Notes sur les traductions de textes non littéraires sous les Lagides." *CE* 60 (1985): 248–262.

———. "Sur le bilinguisme dans l'Égypte des Lagides." In *Studia Paulo Naster oblata*, edited by J. Quaegebeur, 2:143–154. Orientalia Lovaniensia Analecta, no. 13. Louvain, 1982.

———. "Über die Zweisprachigkeit im ptolemäischen Aegypten." In *Studien zur Papyrologie und antiken Wirtschaftsgeschichte Friedrich Oertel zum achtzigsten Geburtstag gewidmet*, 49–60. Bonn, 1964.

———. *Vreemdelingen en Egyptenaren in Ptolemaeïsch Egypte*. Academiae Analecta, Mededelingen van de Koninklijke Academie voor Wetenschappen, Letteren en Schone Kunsten van België, Klasse der Letteren, no. 49.1. Brussels, 1987.

Peschlow-Bindokat, A. "Demeter und Persephone in der attischen Kunst des 6. bis 4. Jahrhunderts." *JDAI* 87 (1972): 60–157.

Pestman, P. W. *Chronologie égyptienne d'après les textes démotiques: 332 av. J.-C. – 453 ap. J.-C.* Papyrologica Lugduno-Batava, no. 15. Leiden, 1967.

———. "The Competence of Greek and Egyptian Tribunals According to the Decree of 118 B.C." *BASP* 22 (1985): 265–269.

———. *A Guide to the Zenon Archive*. Papyrologica Lugduno-Batava, no. 21A. Leiden, 1981.

Petzl, G. *Die Inschriften von Smyrna*. 2 vols. Inschriften griechischer Städte aus Kleinasien, no. 23–24. Österreichische Akademie der Wissenschaften, Rheinisch-Westfalische Akademie der Wissenschaften. Bonn, 1982–87.

Pfeiffer, R. "Βερενίκης πλόκαμος." *Philologus* 87 (1932): 179–228. [Reprinted in *Kallimachos*, edited by A. D. Skiadas, 100–152. Wege der Forschung, no. 296. Darmstadt, 1975.]

———. *Geschichte der klassischen Philologie: Von den Anfängen bis zum Ende des Hellenismus*. Reinbek b. Hamburg, 1970.

———. *History of Classical Scholarship from the Beginnings to the End of the Hellenistic Age*. Oxford, 1968.

———. *Kallimachosstudien: Untersuchungen zur Arsinoe und zu den Aitia des Kallimachos*. Munich, 1922.

Pfuhl, E. "Das Beiwerk auf den ostgriechischen Grabreliefs." *JDAI* 20 (1905): 47–96, 123–155.

———. "Zur Darstellung von Buchrollen auf Grabreliefs." *JDAI* 22 (1907): 113–132.

Pfuhl, E., and H. Möbius. *Die ostgriechischen Grabreliefs*. 2 vols. Mainz, 1977–79.

Pickard-Cambridge, A. *The Dramatic Festivals of Athens*. Oxford, 1953. 2d ed. revised by John Gould and D. M. Lewis. Oxford, 1968.

Pietrzykowski, M. *Rzezby Greckie z Sarapeum Memfickiego: Studium ikonograficzne*. Warsaw, 1976.

Pircher, J. *Das Lob der Frau im vorchristlichen Grabepigramme der Griechen*. Commentationes Aenipontanae, no. 26; Philologie und Epigraphik, no. 4. Innsbruck, 1979.

Plassart, A. "Inscriptions de Delphes, la liste des Théodoriques." *BCH* 45 (1921): 1–85.

Pleket, H. W. "Religious History as the History of Mentality: The 'Believer' as Servant of the Deity in the Greek World." In *Faith, Hope, and Worship*, edited by H. S. Versnel, 152–192. [See separate entry.]

Pohlenz, M. *Antikes Führertum: Cicero, De Officiis, und Das Lebensideal des Panaitios.* Neue Wege zur Antike, 2d series, Interpretation, no. 3. Leipzig and Berlin, 1934.

Poland, F. *Geschichte des griechischen Vereinswesens.* Furslich Jablonowskische Gesellschaft der Wissenschaften, Leipzig Preisschriften, no. 38. Leipzig, 1909.

Pomeroy, S. B. *Women in Hellenistic Egypt.* 2d ed. Detroit, 1990.

Poulsen, V. *Les portraits grecs.* Publications de la glyptothèque Ny Carlsberg, no. 5. Copenhagen, 1954.

Préaux, C. *L'économie royale des Lagides.* Brussels, 1939.

———. *Le monde hellénistique: La Grèce et l'Orient (323–146 av. J.-C.).* 2 vols. L'histoire et ses problèmes, no. 6. Paris, 1978.

Preisshofen, F. "Kunsttheorie und Kunstbetrachtung." In *Le classicisme à Rome,* edited by H. Flashar, 263–277 (discussion, 278–289). [See separate entry.]

Price, S. R. F. *Rituals and Power, The Roman Imperial Cult in Asia Minor.* Cambridge, 1984.

Pritchett, W. K. *The Greek State at War.* 5 vols. Berkeley, 1971–91.

Puelma, M. "Kallimachos-Interpretationen II. Der Epilog zu den 'Aitien.'" *Philologus* 101 (1957): 247–268. [Reprinted in *Kallimachos,* edited by A. D. Skiadas, 43–69. Wege der Forschung, no. 296. Darmstadt, 1975.]

Pugliese, G. Carratelli. "Il decreto della stele di Rosetta." *PP* 208 (1983): 55–60.

———. "Nuovo supplemento epigrafico di Iasos." *ASAA* 47/48 (NS 31/32) (1969/1970): 371–405.

———. "Supplemento epigrafico di Iasos." *ASAA* 45/46 (NS 29/30) (1967/1968): 437–486.

Quaegebeur, J. "Cleopatra VII and the Cults of the Ptolemaic Queens." In *Cleopatra's Egypt,* edited by the Brooklyn Museum, 41–54. [See separate entry.]

———. "Cultes égyptiens et grecs en Égypte." In *Egypt and the Hellenistic World,* edited by E. van 't Dack, P. van Dessel, and W. van Gucht, 303–324. [See separate entry.]

———. "Documents concerning the Cult of Arsinoe Philadelphos at Memphis." *JNES* 30 (1971): 239–270.

———. "Documents égyptiens et role économique du clergé en Égypte hellénistique." In *State and Temple Economy in the Ancient Near East,* edited by E. Lipinski, 707–729. [See separate entry.]

———. "Egyptian Clergy and the Ptolemaic Cult." *AncSoc* 20 (1989): 93–113.

———. "Greco-Egyptian Double Names as a Factor of a Bi-cultural Society." In *Life in a Multi-Cultural Society: Egypt from Cambyses to Constantine and Beyond,* edited by Janet H. Johnson, 265–272. Studies in Ancient Oriental Civilization, no. 51. Chicago, 1992.

———. "Ptolémée II en adoration devant Arsinoé II divinisée." *BIFAO* 69 (1971): 191–217.

———. "Reines ptolémaïques et traditions égyptiennes." In *Das ptolemäische Ägypten,* edited by H. Maehler and V. M. Strocka, 245–62. [See separate entry.]

Quirke, S., and C. Andrews. *The Rosetta Stone: Facsimile Drawing.* British Museum Publications. London, 1988.

Raeder, A. *L'arbitrage international chez les Hellènes.* Publications de l'Institut Nobel norvegien, no. 1. New York, 1912.

Raith, O. "Unschuldsbeteuerung und Sündenbekenntnis im Gebet des Enkolp an Priap (Petr. 133.3)." *StudClass* 13 (1971): 109–125.

Rapin, C. "Les textes littéraires grecs de la trésorerie d'Aï Khanoum." *BCH* 111 (1987): 232–244.

Reinhardt, K. *Die Krise des Helden: und andere Beiträge zur Literatur- und Geistesgeschichte*. Munich, 1962.

———. *Tradition und Geist: Gesammelte Essays zur Dichtung*. Edited by Karl Becker. Göttingen, 1960.

Reinmuth, O. W. "A New Ephebic Inscription from the Athenian Agora." *Hesperia* 43 (1974): 246–259.

Richter, G. M. A. *Portraits of the Greeks*. Abridged and revised by R. R. R. Smith. Ithaca, N.Y., and Oxford, 1984.

———. *The Portraits of the Greeks*. 3 vols. London, 1965.

Ridgway, B. S. "Musings on the Muses." In *Festschrift für Nikolaus Himmelmann: Beiträge zur Ikonographie und Hermeneutik*, edited by H.-U. Cain, H. Gabelmann, and D. Salzmann, 265–272. *Bonner Jahrbücher*, Beiheft 47. Mainz, 1989.

———. "Painterly and Pictorial in Greek Relief Sculpture." In *Ancient Greek Art and Iconography*, edited by W. G. Moon, 193–208. Madison, 1983.

Ridley, R. T. "The Hoplite as Citizen." *AC* 48 (1979): 508–548.

Riginos, A. S. *Platonica: The Anecdotes Concerning the Life and Writings of Plato*. Leiden, 1976.

Rist, J. M. *Stoic Philosophy*. Cambridge, 1969.

Robert, L. "De Delphes à l'Oxus: Inscriptions grecques nouvelles de la Bactriane." *CRAI* (1968): 416–457.

———. "Documents d'Asie Mineure I–IV." *BCH* 101 (1977): 43–132.

———. "Documents d'Asie Mineure V–XVII." *BCH* 102 (1978): 395–543.

———. "Documents d'Asie Mineure XVIII." *BCH* 105 (1981): 331–360.

———. "Documents d'Asie Mineure XIX–XXII." *BCH* 106 (1982): 309–378.

———. "Documents d'Asie Mineure XXIII–XXVIII." *BCH* 107 (1983): 492–599.

———. *Die Epigraphik der klassischen Welt*. Bonn, 1970. (Translation of "L'histoire et ses méthodes.")

———. *Études anatoliennes: Recherches sur les inscriptions grecques de l'Asie Mineure*. Paris, 1937.

———. *Hellenica: Recueil d'épigraphie de numismatique et d'antiquités grecques*. 13 vols. Limoges, 1940–65.

———. "L'histoire et ses méthodes." In *Encyclopédie de la Pléiade*, 453–497. Paris, 1961.

———. "Inscription hellénistique de Dalmatie." *BCH* 59 (1935): 489–513.

———. "Les juges étrangers dans la cité grecque." In *Xenion: Festschrift für Panagiotes J. Zepos anlässlich seines 65. Geburtstages am 1. Dezember 1973*, edited by E. von Caemmerer, 765–782. 3 vols. Athens, 1973.

———. "Malédictions funéraires grecques." *CRAI* (1978): 241–289.

———. "Monnaies et textes grecs." *JS* (1978): 145–163.

———. *Opera minora selecta*. 4 vols. Amsterdam, 1969–74.

———. "Sur des inscriptions d'Ephèse." *RPh* 41 (1967): 7–84.

———. "Sur un Apollon oraculaire à Chypre." *CRAI* (1978): 338–344.

———. "Sur un décret d'Ilion et sur un papyrus concernant des cultes royaux."

In *Essays in Honor of C. Bradford Welles,* edited by A. E. Samuel, 175–210. American Studies in Papyrology, no. 1. New Haven, 1966.

———. "Trois oracles de la Théosophie et un prophète d'Apollon." *CRAI* (1968): 568–599.

Robertson, M. *A History of Greek Art.* 2 vols. Cambridge, 1975.

Rostovtzeff, M. *Gesellschafts- und Wirtschaftsgeschichte der hellenistischen Welt.* Darmstadt, 1955.

———. *Social and Economic History of the Hellenistic World.* 3 vols. Oxford, 1941.

Rowlandson, J. "Freedom and Subordination in Ancient Agriculture: The Case of the *Basilikoi Georgoi* of Ptolemaic Egypt." In *Crux: Essays in Greek History Presented to G. E. M. de Ste. Croix,* edited by P. A. Cartledge and F. D. Harvey, 327–347. London, 1985.

Rühfel, H. *Das Kind in der griechischen Kunst: Von der minoisch-mykenischen Zeit bis zum Hellenismus.* Kulturgeschichte der antiken Welt, no. 18. Mainz, 1984.

Ruijgh, C. J. "Le dorien de Théocrite." *Mnemosyne* 37 (1984): 56–88.

Ruppel, W. "Politeuma: Bedeutungsgeschichte eines staatsrechtlichen Terminus." *Philologus* 82 (1927): 268–312, 434–454.

Russell, D. A. *"Longinus" On the Sublime.* Oxford, 1964.

Russell, D. A., and N. G. Wilson, eds. *Menander Rhetor.* Oxford, 1981.

Rusten, J. S. *Dionysius Scytobrachion.* Abhandlungen der Rheinisch-Westfalischen Akademie der Wissenschaften, Sonderreihe Papyrologica Coloniensia, no. 10. Opladen, 1982.

Samuel, A. E. *From Athens to Alexandria: Hellenism and Social Goals in Ptolemaic Egypt.* Studia Hellenistica, no. 26. Louvain, 1983.

———. *Ptolemaic Chronology.* Münchener Beiträge zur Papyrusforschung und antiken Rechtsgeschichte, no. 43. Munich, 1962.

———. *The Shifting Sands of History: Interpretations of Ptolemaic Egypt.* Publications of the Association of Ancient Historians, no. 2. Lanham, New York, and London, 1989.

Sandbach, F. H. *"Lucreti Poemata* and the Poet's Death." *CR* 54 (1940): 72–77.

———. "Menander's Manipulation of Language for Dramatic Purposes." In *Ménandre,* edited by E. G. Turner, 111–136 (discussion, 137–143). Fondation Hardt, Entretiens, no. 16. Geneva, 1970.

———. "Plutarch on the Stoics." *CQ* 34 (1940): 20–25.

Sandman, M. *Texts from the Time of Akhenaten.* Bibliotheca Aegyptiaca, no. 8. Brussels, 1938.

Schadewaldt, W. *Iliasstudien.* 3d ed. Darmstadt, 1966.

Schalles, H.-J. *Untersuchungen zur Kulturpolitik der pergamenischen Herrscher im 3. Jahrhundert v. C.* Istanbuler Forschungen, no. 36. Tübingen, 1985.

Schede, M. *Die Ruinen von Priene.* 2d ed., revised by G. Kleiner and W. Kleiss. Deutsches Archäologisches Institut. Abteilung Istanbul. Berlin, 1964.

Schibli, H. "Fragments of a Weasel and Mouse War." *ZPE* 53 (1983): 1–25.

Schlegel, A. W. von. "Vorlesungen über dramatische Kunst und Literatur, Erster Teil." In *Kritische Schriften und Briefe,* edited by E. Lohner, vol. 5. Stuttgart and Berlin, 1966.

———. *Vorlesungen über schöne Litteratur und Kunst.* 3 vols. Heilbronn, 1884.

Schlegel, F. von. *Studien des klassischen Altertums.* Kritische Friedrich-Schlegel-Ausgabe, no. 1. Paderborn, 1979.

Schlesinger, E. "Die griechische Asylie." Diss., Giessen, 1933.

Schmaltz, B. *Griechische Grabreliefs.* Erträge der Forschung, no. 192. Darmstadt, 1983.

Schmid, W., and O. Stählin. *Geschichte der griechischen Literatur.* 6th ed. 3 vols. Handbuch der klassischen Altertumswissenschaft, no. 7. Munich, 1912–24.

Schober, A. "Vom griechischen zum römischen Relief." *ÖJh* 27 (1931): 46–63.

Schofield, M. "Coxon's Parmenides." *Phronesis* 32 (1987): 349–359.

Schubart, W. "Das hellenistische Königsideal nach Inschriften und Papyri." *APF* 12 (1937): 1–26.

———. "Das Königsbild des Hellenismus." *Die Antike* 13 (1937): 272–288.

Schulze, W. *Kleine Schriften.* 2d ed. Edited, with supplements, by W. Wissmann. Göttingen, 1966.

Schürer, E. *The History of the Jewish People in the Age of Jesus Christ (175 BC – AD 135).* 3 vols. Translated by T. A. Burkill and revised and edited by G. Vermes and F. Millar. Edinburgh, 1973–87.

Schwartz, E. *Ethik der Griechen.* Edited by W. Richter. Stuttgart, 1951.

Schwarz, G. *Triptolemos: Ikonographie einer Agrar- und Mysteriengottheit.* Grazer Beiträge, Supplementband no. 2. Graz, 1987.

Schwendner, G. "Literary and Non-Literary Papyri from the University of Michigan Collection." Diss., University of Michigan, Ann Arbor, 1988.

Schwertheim, E. "Denkmäler zur Meterverehrung in Bithynien und Mysien." In *Studien zur Religion und Kultur Kleinasiens: Festschrift für Friedrich Karl Dörner zum 65. Geburtstag am 28. Februar 1976,* edited by S. Sahin, E. Schwertheim, and J. Wagner, 791–837, 2 vols. Études préliminaires aux religions orientales dans l'Empire romain, no. 66. Leiden, 1978.

———. *Die Inschriften von Kyzikos und Umgebung.* Inschriften griechischer Städte aus Kleinasien, no. 18. Bonn, 1980.

Schwinge, E.-R. *Künstlichkeit von Kunst: Zur Geschichtlichkeit der alexandrinischen Poesie.* Zetemata, no. 84. Munich, 1986.

Schwinzer, E. *Schwebende Gruppen in der pompejanischen Wandmalerei.* Beiträge zur Archäologie, no. 11. Würzburg, 1979.

Seibert, J. *Metropolis und Apoikie.* Würzburg, 1963.

Seidl, E. "Der Eid im ptolemäischen Recht." Diss., Munich, 1929.

———. "Griechisches Recht in demotischen Urkunden." In *Akten des XIII. internationalen Papyrologenkongresses Marburg-Lahn, 2–6 August 1971,* edited by E. Kiessling and H. A. Rupprecht, 381–388. Münchener Beiträge zur Papyrusforschung und antiken Rechtsgeschichte, no. 66. Munich, 1974.

———. *Ptolemäische Rechtsgeschichte.* 2d ed. Ägyptologische Forschungen, no. 22. Glückstadt and New York, 1962.

Shear, T. L., Jr. "Kallias of Sphettos and the Revolution of Athens in 286 BC." Hesperia Supplement, no. 17. Princeton, 1978.

Shelton, J. "Land Register: Crown Tenants at Kerkeosiris." In *Collectanea Papyrologica,* edited by A. E. Hanson, 1:111–151. [See separate entry.]

———. "Notes on the Ptolemaic Salt Tax under Ptolemy III." *ZPE* 71 (1988): 133–136.

Sherk, R. "The Eponymous Officials of Greek Cities." *ZPE* 83 (1990): 249–288; *ZPE* 84 (1990): 231–295; *ZPE* 88 (1991): 225–260; *ZPE* 93(1992): 223–272.

Sichtermann, H. "Der Knabe von Tralles." In *Antike Plastik,* no. 4, edited by

W. H. Schuchhardt, 71–85. Im Auftrage des Deutschen Archäologischen Instituts. Berlin, 1965.

Siefert, G. *Plutarchs Schrift περὶ εὐθυμίας*. Beilage zum Jahresbericht der königlichen Landesschule Pforta. Naumburg, 1908.

Skeat, T. C. *The Reigns of the Ptolemies*. Münchener Beiträge zur Papyrusforschung und antiken Rechtsgeschichte, no. 39. Munich, 1954.

Slater, W. J. "Pindar's Myth." In *Arktouros: Hellenic Studies Presented to Bernard M. W. Knox on the Occasion of His 65th Birthday*, edited by G. W. Bowersock, W. Burkert, and M. C. J. Putnam, 186–206. Berlin and New York, 1979.

Smith, A. H. *A Catalogue of Sculpture in the Department of Greek and Roman Antiquities, British Museum*. 3 vols. London, 1892–1904.

Smith, R. R. R. *Hellenistic Royal Portraits*. Oxford, 1988.

———. "Late Roman Philosopher Portraits from Aphrodisias." *JRS* 80 (1990): 127–155.

Snell, B. *Scenes from Greek Drama*. Sather Classical Lectures, no. 34. Berkeley, 1964. [Revised as *Szenen aus griechischen Dramen*. Berlin, 1971.]

Soffel, J. *Die Regeln Menanders für die Leichenrede*. Beiträge für klassischen Philologie, no. 57. Meisenheim, 1974.

Sokolowski, F. "Divine Honors for Antiochos and His Wife Laodike." *GRBS* 13 (1972): 171–176.

———. *Lois sacrées des cités grecques*. École française d'Athènes, travaux et mémoires, no. 18. Paris, 1969.

———. *Lois sacrées des cités grecques: Supplément*. École française d'Athènes, travaux et mémoires, no. 11. Paris, 1962.

Sonne, E. *De arbitris externis quos Graeci adhibuerunt ad lites et internas et peregrinas componendas quaestiones epigraphicae*. Göttingen, 1888.

Spiegelberg, W. *Der demotische Text der Priesterdekrete von Kanopos und Memphis (Rosettana) mit den hieroglyphischen und griechischen Fassungen und deutscher Übersetzung nebst demotischem Glossar*. Heidelberg, 1922.

Stemplinger, E. *Das Plagiat in der griechischen Literatur*. Leipzig, 1912.

Stewart, A. *Attika: Studies in Athenian Sculpture of the Hellenistic Age*. Society for the Promotion of Hellenic Studies, Supplementary Paper no. 14. London, 1979.

———. *Faces of Power: Alexander's Image and Hellenistic Politics*. Hellenistic Culture and Society, no. 11. Berkeley, 1993.

Stroud, R. "An Argive Decree from Nemea Concerning Aspendos." *Hesperia* 53 (1984): 193–216.

Strunk, K. "Frühe Vokalveränderungen in der griechischen Literatur." *Glotta* 38 (1960): 74–89.

Sudhoff, K. "Handanlegung des Heilgottes auf attischen Weihetafeln. Reliefstudie." *Archiv für Geschichte der Medizin* 18 (1926): 233–250.

Susemihl, F. *Geschichte der griechischen Literatur der Alexandrinerzeit*. 2 vols. Leipzig, 1891–92.

Süsserott, H. K. *Griechische Plastik des 4. Jahrhunderts v.C.: Untersuchungen zur Zeitbestimmung*. Frankfurt, 1938.

Svoronos, J. N. *Das athener Nationalmuseum*. 5 vols. Athens, 1908–37.

Swiderek, A. "La société indigène en Égypte au III^e siècle avant notre ère d'après les archives de Zénon." *JJurP* 7–8 (1954): 231–284.

Syndikus, H. P. *Catull: Eine Interpretation.* 3 vols. Impulse der Forschung, nos. 46, 48, 55. Darmstadt, 1984–90.

Taeger, F. *Charisma: Studien zur Geschichte des antiken Herrscherkultes.* 2 vols. Stuttgart, 1957–60.

Tarn, W. W. *Antigonos Gonatas.* Oxford, 1913; reprinted 1969.

Tarn, W. W., and G. T. Griffith. *Hellenistic Civilisation.* 3d ed. London, 1952.

Tcherikover, V. A. *Corpus papyrorum Judaicorum.* 3 vols. Cambridge, Mass., 1957–64.

Thierry, G. J. *De religieuze betekenis van het aegyptische koningschap.* Leiden, 1913.

Thissen, H.-J. *Studien zum Raphiadekret.* Beiträge zur klassischen Philologie, no. 23. Meisenheim, 1966.

Thomas, R. F. "Menander and Catullus 8." *RhM* 127 (1984): 308–316.

———. "New Comedy, Callimachus, and Roman Poetry." *HSCP* 83 (1979): 179–206.

Thompson, D. B. "More Ptolemaic Queens." In *Eikones: Studien zum griechischen und römischen Bildnis: Hans Jucker zum sechzigsten Geburtstag gewidmet,* edited by R. A. Stucky, I. Jucker, and T. Gelzer, 181–184. Antike Kunst, Beiheft 12. Bern, 1980.

———. *Ptolemaic Oinochoai and Portraits in Faience: Aspects of the Ruler-Cult.* Oxford, 1973.

Thompson, D. J. "Literacy and the Administration in Early Ptolemaic Egypt." In *Life in a Multi-Cultural Society: Egypt from Cambyses to Constantine and Beyond,* edited by Janet H. Johnson, 323–326. Studies in Ancient Oriental Civilization, no. 51. Chicago, 1992.

———. *Memphis under the Ptolemies.* Princeton, 1988.

Threatte, L. *The Grammar of Attic Inscriptions.* Vol. 1. Berlin and New York, 1980.

Tondriau, J. "Princesses ptolémaïques comparées ou identifiées à des déesses." *BSAA* 37 (1948): 12–33.

———. "Rois lagides comparés ou identifiés à des divinités." *CE* 23 (1948): 127–146.

Totti, M. *Ausgewählte Texte der Isis- und Sarapisreligion.* Subsidia Epigraphica, no. 12. Hildesheim, 1985.

Toulmin, S. "Self-knowledge and Knowledge of the Self." In *The Self: Psychological and Philosophical Issues,* edited by T. Mischel, 291–317. Oxford, 1977.

Tracy, S. B. "IG II². 937: Athens and the Seleucids." *GRBS* 29 (1988): 383–388.

Trilling, L. *Sincerity and Authenticity.* Oxford, 1972.

Turner, E. G. "A Fragment of Epicharmus? (or 'Pseudoepicharmea'?)." *WS* (NF) 10 (1976): 48–60.

Uebel, F. "Jenaer Kleruchenurkunden." *APF* 22/23 (1974): 89–114.

———. *Die Kleruchen Ägyptens unter den ersten sechs Ptolemäern.* Abhandlungen der Deutschen Akademie der Wissenschaften zu Berlin, Klasse für Sprachen, Literatur und Kunst, 1968, no. 3. Berlin, 1968.

———. Review of *Ptolemaic Chronology* by A. E. Samuel. *Bibliotheca Orientalis* (Nederlandsch Archaeologisch-Philologisch Instituut voor het Nabije Oosten) 21 (1964): 309–313.

Usener, H. *Glossarium epicureum.* Edited by M. Gigante and W. Schmid. Lessico intellettuale europeo, no. 14. Rome, 1977.

van Straaten, M. *Panaetii Rhodii Fragmenta.* 3d ed. Philosophia antiqua, no. 5. Leiden, 1962.

―――. *Panétius, sa vie, ses écrits et sa doctrine avec une édition des fragments.* Amsterdam, 1946.

van Straten, F. T. "Daikrates' Dream: A Votive Relief from Kos and Some Other *kat' onar* Dedications." *BABesch* 51 (1976): 1–27.

―――. "Did the Greeks Kneel before Their Gods?" *BABesch* 49 (1974): 159–189.

―――. "Gifts for the Gods." In *Faith, Hope, and Worship,* edited by H. S. Versnel, 65–151. [See separate entry.]

―――. "Greek Sacrificial Representations: Livestock Prices and Religious Mentality." In *Gifts to the Gods: Proceedings of the Uppsala Symposium, 1985,* edited by T. Lindars and G. Nordquist, 159–170. Acta Universitatis Upsaliensis. Boreas, no. 15. Uppsala and Stockholm, 1987.

van 't Dack, E. "L'armée de terre lagide: Reflet d'un monde multiculturel?" In *Life in a Multi-Cultural Society: Egypt from Cambyses to Constantine and Beyond,* edited by Janet H. Johnson, 265–272. Studies in Ancient Oriental Civilization, no. 51. Chicago, 1992.

―――. Review of *Untersuchungen zur Aussenpolitik Ptolemaios' IV.,* by Werner Huss (Munich, 1976). *Gnomon* 51 (1979): 346–351.

van 't Dack, E., P. van Dessel, and W. van Gucht, eds. *Egypt and the Hellenistic World: Proceedings of the International Colloquium, Leuven, 24–26 May 1982.* Studia Hellenistica, no. 27. Louvain, 1983.

Vérilhac, A.-M. "L'image de la femme dans les épigrammes funéraires grecs." In *La femme dans le monde méditerranéen,* vol. 1, *Antiquité,* edited by A.-M. Vérilhac and C. Vial, 85–112. Travaux de la Maison de l'Orient, nos. 10, 19. Lyon, 1985–90.

Vermaseren, M. J. *Corpus Cultus Cybelae Attidisque.* 7 vols. Études préliminaires aux religions orientales dans l'Empire romain, no. 50.1–7. Leiden, 1977–89.

―――. *Cybele and Attis: The Myth and the Cult.* London, 1977.

Vermeule, C. "Dated Monuments of Hellenistic and Graeco-Roman Popular Art in Asia Minor: Ionia, Lydia, and Phrygia." In *Mélanges Mansel (Essays by International Scholars Honoring the 65th Birthday of Prof. Arif Mufid Mansel)* 1:119–126. 3 vols. Turk Tarih Kurumu yayinlari, no. 7.60. Ankara, 1974.

Versnel, H. S., ed. *Faith, Hope, and Worship: Aspects of Religious Mentality in the Ancient World.* Studies in Greek and Roman Religion, no. 2. Leiden, 1981.

Veyne, P. "Une évolution du paganisme gréco-romain: Injustice et piété des dieux, leurs ordres ou 'oracles.'" *Latomus* 45 (1986): 259–283.

Vogt, E. "Das Akrostichon in der griechischen Literatur." *A&A* 13 (1967): 80–95.

Walbank, F. W. "Könige als Götter. Überlegungen zum Herrscherkult von Alexander bis Augustus." *Chiron* 17 (1987): 365–382.

―――. *Philip V of Macedon.* Cambridge, 1940.

―――. "Were There Greek Federal States?" *SCI* 3 (1976/77): 27–51.

Walbank, F. W., and A. E. Astin, eds. *The Cambridge Ancient History,* vol. 7, part 1, *The Hellenistic World.* 2d ed. Cambridge, 1984.

Walter, O. "Die heilige Familie von Eleusis." *ÖJh* 30 (1936–37): 50–70.

————. "Kniende Adoranten auf attischen Reliefs." *ÖJh* 13 (1910) Beiblatt: 229–244.

————. "Die Reliefs aus dem Heiligtum der Echeliden in Neu-Phaleron." *AE* (1937): 97–119.

Webster, T. B. L. *Studies in Later Greek Comedy.* Manchester, 1953.

Wehrli, F. "Demetrios von Phaleron." In *Die Philosophie der Antike,* edited by H. Flashar. [See separate entry.]

Weiher, A. "Philosophen und Philosophenspott in der attischen Komödie." Diss., Munich, 1913.

Weiler, I. *Der Sport bei den Völkern der alten Welt: Eine Einführung.* Darmstadt, 1981.

Welwei, K.-W. *Die griechische Polis: Verfassung und Gesellschaft in archaischer und klassischer Zeit.* Stuttgart, 1983.

————. *Könige und Königtum im Urteil des Polybios.* Herbede, 1963.

West, M. L. *Greek Metre.* Oxford, 1982.

————. *The Hesiodic Catalogue of Women: Its Nature, Structure and Origins.* Oxford, 1985.

————. *Studies in Greek Elegy and Iambus.* Untersuchungen zur antiken Literatur und Geschichte, no. 14. Berlin and New York, 1974.

West, S. "*Joseph and Asenath*: A Neglected Greek Romance." *CQ* 24 (1974): 70–81.

————. "Venus Observed? A Note on Callimachus, Fr. 110." *CQ* 35 (1985): 61–66.

Westermann, W. L., C. W. Keyes, and H. Liebesny, eds. *Zenon Papyri,* vol. 2. Columbia Papyri, Greek Series, no. 4. New York, 1940.

Wilamowitz-Moellendorff, U. von. *Antigonos von Karystos.* Philologische Untersuchungen, no. 4. Berlin, 1881.

————. *Der Glaube der Hellenen.* 2 vols. Berlin, 1931–32; reprinted Basel, 1973.

————. "Die griechische Literatur des Altertums." In *Die griechische und lateinische Literatur und Sprache.* 3d ed., 3–318. Die Kultur der Gegenwart, ihre Entwicklung und ihre Ziele, no. 1.8. Leipzig and Berlin, 1912.

————. *Hellenistische Dichtung in der Zeit des Kallimachos.* 2 vols. Berlin, 1924.

————. *Kleine Schriften,* 6 vols. Berlin, 1935–72.

————. *Menander, Das Schiedsgericht.* Berlin, 1925.

————. *Timotheos, Die Perser.* Leipzig, 1903.

Wilcken, U. *Griechische Ostraka aus Aegypten und Nubien.* 2 vols. Leipzig and Berlin, 1899. [Reprinted Amsterdam, 1970, with addenda by P. J. Sijpesteijn.]

————. *Urkunden der Ptolemäerzeit (ältere Funde),* vol. 1, *Papyri aus Unterägypten.* Berlin and Leipzig, 1927. Vol. 2, *Papyri aus Oberägypten.* Berlin, 1935–57.

Will, E. *Histoire politique du monde hellénistique, 323–30 av. J.-C.* 2d ed. 2 vols. Annales de l'Est, Mémoires nos. 30, 32. Nancy, 1979–82.

Willis, W. H. "Census of the Literary Papyri from Egypt." *GRBS* 9 (1968): 203–241.

Wilson, N. G. Review of *History of Classical Scholarship* by R. Pfeiffer. *CR* (NS) 19 (1969): 366–372.

Wimmel, W. *Kallimachos in Rom: Die Nachfolge seines apologetischen Dichtens in der Augusteerzeit.* Hermes-Einzelschriften, no. 16. Wiesbaden, 1960.

Winnicki, J. K. *Ptolemäerarmee in Thebais.* Polska Akademia Nauk, Komitet Nauk o Kulturze Antycznej, Archiwum Filologiczne, no. 38. Warsaw, 1978.

———. "Das ptolemäische und das hellenistische Heerwesen." In *Egitto e storia antica dall'ellenismo all'età araba,* edited by L. Criscuolo and G. Geraci, 213–230. [See separate entry.]

Winnicki, K. "Bericht von einem Feldzug des Ptolemaios Philadelphos in der Pithom-Stele." *JJurP* 20 (1990): 157–167.

Winter, E. "Der Herrscherkult in den ägyptischen Ptolemäertempeln." In *Das ptolemäische Ägypten,* edited by H. Maehler and V. M. Strocka, 147–160. [See separate entry.]

Wolff, H. J. "The Political Background of the Plurality of Laws in Ptolemaic Egypt." In *Proceedings of the XVI International Congress of Papyrology, New York, 24–31 July 1980,* edited by R. S. Bagnall, G. M. Browne, A. E. Hanson, and L. Koenen, 313–318. American Studies in Papyrology, no. 23. Chico, Cal., 1981.

Wörrle, M. "Epigraphische Forschungen zur Geschichte Lykiens II." *Chiron* 8 (1978): 201–246.

Wortmann, D. "Neue magische Texte." *BJ* 168 (1968): 56–111.

Wrede, H. "Bildnisse epikureischer Philosophen." *AM* 97 (1982): 235–245.

Wright, M. R. Review of *Morality and Self-Interest* by M. Nill. *AncPhil* 8 (1988): 117–121.

Wyss, B. *Antimachi Colophonii Reliquiae.* Berlin, 1936.

Xanthakis-Karamanos, G. *Studies in Fourth-Century Tragedy.* Athens, 1980.

Youtie, H. C. "The Papyrologist: Artificer of Fact." *GRBS* 4 (1963): 19–32. [Reprinted in *Scriptiunculae* 1 : 9–23. Amsterdam, 1973.]

Yoyotte, J. "Religion égyptienne et culture grecque à Edfu." In *Religions en Égypte hellénistique et romaine,* 121–141. Bibliothèque des centres supérieures specialisés, Université . . . de Strasbourg. Paris, 1969.

Zandee, J. *Death as an Enemy According to Ancient Egyptian Conceptions.* Studies in the History of Religions, no. 5. Leiden, 1960.

Zanker, G. *Realism in Alexandrian Poetry: A Literature and Its Audience.* London and Sydney, 1987.

Zanker, P. *Augustus und die Macht der Bilder.* Munich, 1987.

———. "Zur Bildnisrepräsentation führender Männer in mittelitalischen und campanischen Städten zur Zeit der Späten Republik und der julisch-claudischen Kaiser." In *Les "bourgeoisies" municipales italiennes aux IIe et Ier siècles av. J.-C.,* 251–266. Colloques internationaux du centre national de la recherche scientifique, no. 609. Bibliothèque de l'institut français de Naples, 2e série, no. 6. Naples and Paris, 1983.

———. *The Power of Images in the Age of Augustus.* Jerome Lectures, no. 16. Ann Arbor, 1990.

———. "Zur Funktion und Bedeutung griechischer Skulptur in der Römerzeit." In *Le classicisme à Rome,* edited by H. Flashar, 283–306 (discussion, 307–314). [See separate entry.]

Ziegler, K. *Das hellenistische Epos: Ein vergessenes Kapitel griechischer Dichtung.* 2d ed. Leipzig, 1966.

Zwierlein, O. "Weihe und Entrückung der Locke der Berenike." *RhM* 130 (1987): 274–290.

LIST OF CONTRIBUTORS

Julia Annas	Professor of Philosophy, University of Arizona
Klaus Bringmann	Professor of Ancient History, University of Frankfurt
Anthony Bulloch	Professor of Classics, University of California, Berkeley
Fernanda Decleva Caizzi	Professor of the History of Philosophy, University of Milan
Albrecht Dihle	Professor of Classics, University of Heidelberg
Thomas Gelzer	Professor of Greek, University of Bern
Christopher Gill	Senior Lecturer, University College of Wales, Aberystwyth
Adalberto Giovannini	Professeur Ordinaire, University of Geneva
Erich Gruen	Professor of History and Classics, University of California, Berkeley
Albert Henrichs	Professor of Greek Literature, Harvard University
Ludwig Koenen	Professor of Greek Literature, University of Michigan, Ann Arbor
Anthony Long	Professor of Classics, University of California, Berkeley
Peter Parsons	Regius Professor of Greek, Oxford

Brunilde Sismondo Ridgway	Rhys-Carpenter Professor of Archaeology, Bryn Mawr College
R. R. R. Smith	Assistant Professor of Ancient Art, Institute of Fine Arts, New York University
Andrew Stewart	Professor of Greek and Roman Art, University of California, Berkeley
Folkert van Straten	Universitair Docent, University of Leiden
Frank Walbank	Emeritus Professor of Ancient History and Classical Archaeology, Liverpool University
Paul Zanker	Professor of Classical Archaeology, University of Munich

INDEX

Achaean League, 21
Achelous, 251
Achilles, 194
Acraiphia, 279
acrostichs, 164
Actium, Battle of, 11, 172
Aegina, 21, 277, 279
Aelius Aristides, 259
Aeschines
 "Aeschines type," 227, 235, 236
 portrait of, 205
 statue of, 217
Aeschylus, 151, 158
Agatharchides, 159, 160
Agathe Tyche, 27, 70, 199
Ai Khanoum, 152, 153
Aigai, 278
Aion, 76, 77, 81
Alcaeus, 161, 165
Alcibiades, 309
Alcidamas, 157
Alciphron, 303
 and comedy, 304
Alcman, 151
Alexander, 23, 44, 47, 50, 53, 54, 60, 152,
 154, 164, 166, 177, 208, 280, 319
 and Achilles, 148, 208
 and Amun, 45
 and Aristotle, 8, 141
 and Diogenes, 319
 and Dionysus, 239
 as avenger, 63

as patron, 177
conqueror of the world, symbolization
 of, 45
coronation of, 60, 71, 74, 79
cult of, in Alexandria, 57
death of, 266
founder of Alexandria, 239
in India, 282
portraits of, 206, 240
Alexander Romance, 128
Alexander Sarcophagus, 240
Alexandria, 27, 44, 50, 57, 77, 80, 134,
 144, 155, 156, 159, 160, 167, 239,
 266
Alexandrianism, 131, 134
Amasis, 285
Ambracia, 277
Amenothes, 160
Amesysia, 39
Ammon, 63
Amphiaraus, 258
Amphiareion
 Oropus, 258
 Rhamnous, 258
Amun-Re, 5, 45, 58, 59, 60, 63, 65, 71
anacleteria, 75, 77, 80
anagrams, 164
Anaxagoras, 343, 344
ancestor worship, 68, 291
Antidorus, 154
Antigoneia, 281, 282
Antigonus Doson, 281, 282

403

Compositor: G&S Typesetters, Inc.
Text: 10/12 Baskerville
Display: Baskerville
Printer: Maple-Vail Book Mfg. Group
Binder: Maple-Vail Book Mfg. Group